CURIOUS CAMERAS

Date: 3/14/16

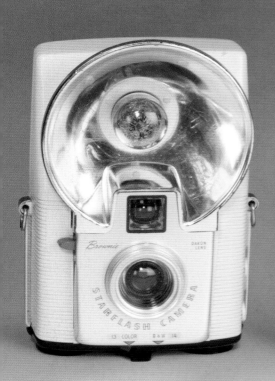
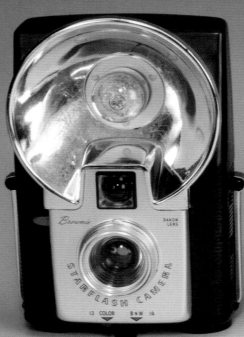
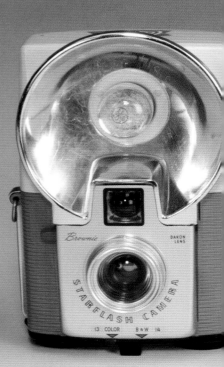

GEORGE EASTMAN HOUSE

CURIOUS CAMERAS

183 COOL CAMERAS FROM
THE STRANGE TO THE SPECTACULAR

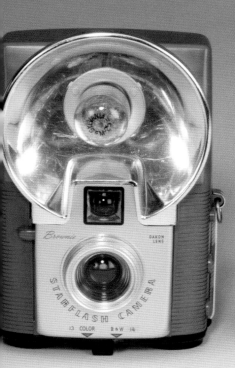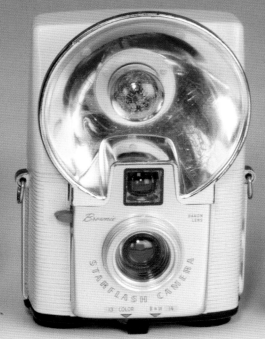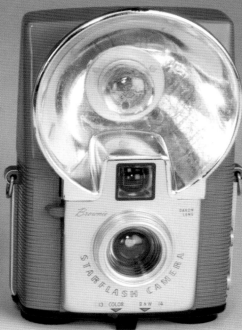

TODD GUSTAVSON

Sterling Signature
NEW YORK

Sterling Signature
NEW YORK

An Imprint of Sterling Publishing
1166 Avenue of the Americas
New York, NY 10036

This is an abridged and revised edition of *500 Cameras: 170 Years of Photographic Innovation*,
published by Sterling Publishing Co., Inc. in 2011.

ISBN 978-1-4549-1551-5

Distributed in Canada by Sterling Publishing
c/o Canadian Manda Group, 664 Annette Street
Toronto, Ontario, Canada M6S 2C8
Distributed in the United Kingdom by GMC Distribution Services
Castle Place, 166 High Street, Lewes, East Sussex, England BN7 1XU
Distributed in Australia by Capricorn Link (Australia) Pty. Ltd.
P.O. Box 704, Windsor, NSW 2756, Australia

For information about custom editions, special sales, and premium and corporate purchases, please
contact Sterling Special Sales at 800-805-5489 or specialsales@sterlingpublishing.com.

Manufactured in China

2 4 6 8 10 9 7 5 3 1

www.sterlingpublishing.com

Pages ii–iii: Brownie Starflash, ca. 1957. Eastman Kodak Company, Rochester, New York.
Gift of Eastman Kodak Company. 1996.0474.0001.

CONTENTS

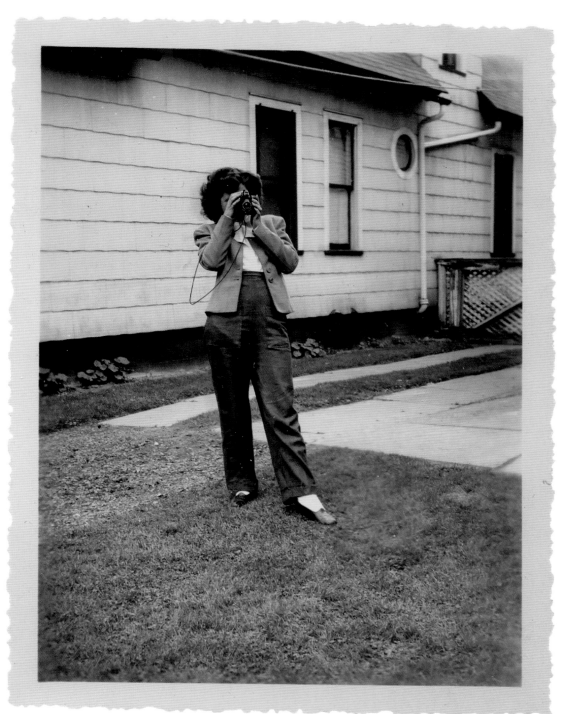

Left: Unidentified photographer. [*Portrait of Marguerite Struble; "Me and My Trusty Camera"*], 1943. Gelatin silver print. Gift of Joseph Struble.

INTRODUCTION

TODD GUSTAVSON

At their hearts, no matter how elaborate or curious their trimmings, all cameras begin as a box. Regardless of age, size, or process for which they were designed, all are evolved from the camera obscura, an optical device that uses a small aperture to project an inverted rendition of the scene in front of it. Originally demonstrated centuries ago, the camera obscura—Latin for "dark chamber"—began as a walk-in room. Over time, after the addition of a lens for improved viewing quality and a series of size reductions for portability, the seemingly magical images of the camera obscura were captured with the use of light-sensitive chemicals. The device used for the process called photography became known as a camera.

Illustrated and described in this volume are 183 cameras from the George Eastman House collection of photographic technology. This collection, consisting of more than 16,000 artifacts from the days before photography to today's integrated, handheld digital devices, is one of the world's leading archives of photographic hardware. The collection also includes published documentation related to the business, manufacturing, and marketing of the photographic industry, which was the main information source used to prepare this book.

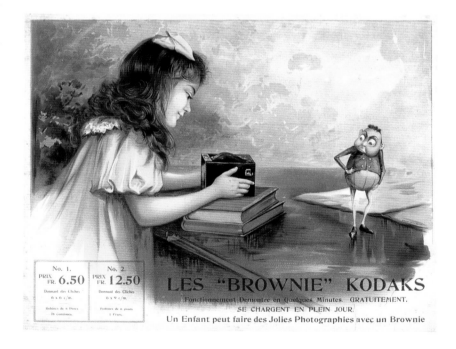

Right: Eastman Kodak Company (American, estab. 1892). "Les 'Brownie' Kodaks" advertising poster, ca. 1905. Museum Collection.

Following Pages: Detail view, Cirkut Camera No. 10 (see pages 123–24).

EASTMA
succ
CENTURY
ROC

	110°			FOCUS	90°
				24 IN.	37½
	46			IN.	28½
60½	34½	19			17
37½	21				
23					

THE THREE LOWER ROWS OF FIGURES INDICATE IN INCHES THE LEN

DAGUERREOTYPE
Silver Alchemy

The daguerreotype, publically announced in Paris, France, on August 19, 1839, was a wonder of its day. Formally attributed to Louis-Jacques-Mandé Daguerre (1787–1851), the process was the culmination of work by many investigators looking to find a way to make permanent the image viewed in the camera obscura.

The process required not only the designing and building of a camera and lens system but also the knowledge of the chemistry needed to make and keep an image. The difficulty, as it turned out, was not the making of the image—it was long known that certain salts of silver turned dark when exposed to light. It was the stopping of this phenomenon, in essence the ability to control and maintain it in a fixed state, that proved the most difficult.

To accomplish this, Daguerre applied metallic silver to a copper printing plate; the silver side was cleaned and polished to a mirror-like surface. In a room illuminated by amber light, the plate was then made light sensitive by placing it over a box of elemental iodine flakes. The iodine fumed the silver surface forming silver iodine, a light-sensitive material. The plate was then mounted into a light-proof holder so it could be moved into the camera. In the camera,

Right:
Unidentified photographer (active ca. 1850). [*Apothecary, interior view of chemist at work*], ca. 1852. Daguerreotype. Gift of Greg French, George Eastman House Collection.

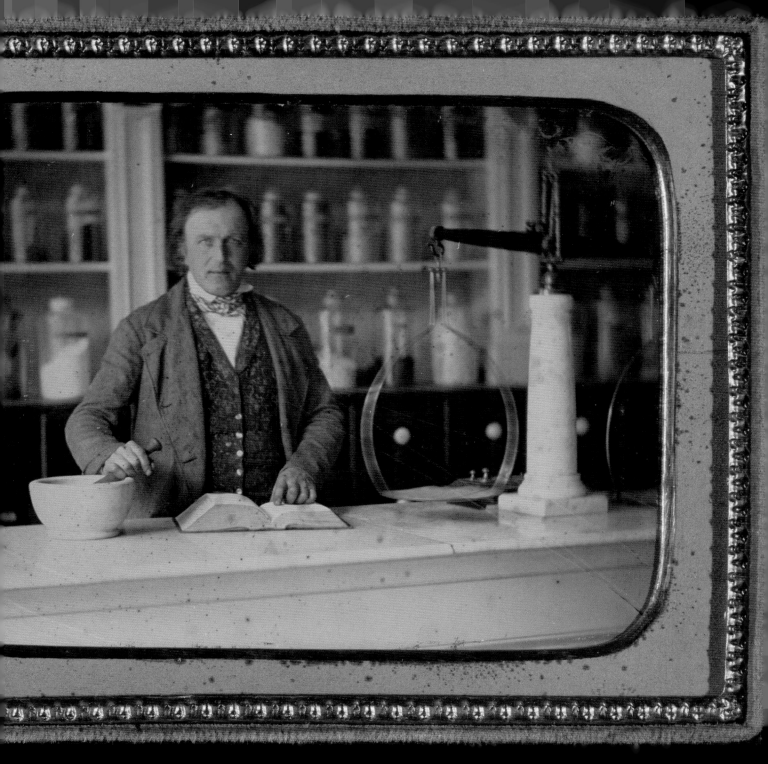

the plate was exposed by uncapping the lens; the exposure time for Daguerre's original process was about fifteen minutes (improvements to the process, not by Daguerre, soon shortened the exposure time to a few seconds). After exposure, the plate, still contained in its light-proof holder, was processed in a second box over heated mercury. The result of the process was a nearly perfect yet reversed (mirror-image) black-and-white likeness of what was in front of the camera. Unlike all other forms of photography, the image resides on the surface of the daguerreotype plate and is quite fragile; they were usually cased for protection. Due to the materials used in the process, daguerreotypes were relatively expensive to make. And as the process was rather complex, the images were made by only professional or very dedicated amateur photographers. To this day, the daguerreotype process yields the highest resolution photographs. They are unique images; to make a copy, a second daguerreotype is made of the first image. ↻

Above:
Daguerre and Niépce de St. Victor, ca. 1845, by Albert Chéreau. Lithograph with applied color.
From series *Les Grands Inventors, Anciens et Modernes*, by Alfred des Essart, ca. 1845.
Gift of Eastman Kodak Company.

PORTABLE REFLEX CAMERA OBSCURA

ca. 1820 | Unidentified manufacturer, France

Gift of Eastman Kodak Company, ex-collection Gabriel Cromer. 1989.1341.0001

The camera-obscura phenomenon—that light passing through a small hole into a darkened chamber projects an inverted image of the outside scene upon the opposite wall—has been known for thousands of years. In the 1500s, it was observed that simple lenses improved the resolution and sharpness of the image created by cameras obscura. Introduced in the 1600s, portable reflex cameras obscura were used by artists as an aid to correctly render perspective. All photographic cameras descend from the camera obscura.

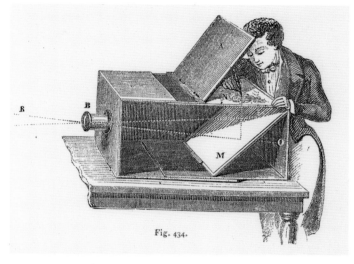

Above: Illustration of artist using a portable reflex camera obscura. From: A. Ganot, *Traité élémentaire de physique* (Paris, 1855). George Eastman House Collection. 1984-0407-0001.

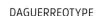

FULL-PLATE DAGUERREOTYPE CAMERA

1839 | Alphonse Giroux, Paris, France

Gift of Eastman Kodak Company, ex-collection Gabriel Cromer. 1978.1631.0001

The Giroux daguerreotype apparatus is photography's first camera manufactured in quantity. On June 22, 1839, L.-J.-M. Daguerre and Isidore Niépce (1805–68), (the son of Daguerre's deceased partner, Joseph Nicéphore Niépce, 1765–1833) signed a contract with Alphonse Giroux (a relative of Daguerre's wife) granting him the rights to sell the materials and equipment required to produce daguerreotype images. Scientist and politician François Arago publicly announced the new daguerreotype process in a speech to a joint meeting of the French Academy of Fine Arts and the Academy of Sciences on August 19, 1839, and the first advertisement promoting the process appeared in the August 21 issue of *La Gazette de France*. Within three short weeks, Giroux met with popular success both in and outside of France; the first export of his company's cameras arrived in Berlin, Germany, on September 6, 1839.

The Giroux camera was an improved version of the apparatus used by Daguerre in his groundbreaking experiments in photography, now fitted with a landscape-type lens produced by Charles Chevalier, a renowned designer of optical systems for microscopes and other viewing devices. The camera is a fixed-bed, double-box camera with an attached 15-inch f/15 Chevalier lens, accompanied by a slightly smaller rear box that slides inside for picture focusing. It measures a robust 12 x 15 x 20 inches and produces an image of 6½ x 8½ inches, a size format known as a full- or whole-plate daguerreotype. It also houses a mirror held at a forty-five degree angle from the focusing glass on which an image is composed prior to loading and exposing a sensitized plate.

The Giroux was sold as an outfit consisting of a camera, lens, plate holder, iodine box for sensitizing daguerreotype plates, mercury box for chemical development, and an assortment of other items necessary to produce the unique, mirror-like images. In a nod to product marketing in an emergent and competitive industrial age, Giroux "branded" his outfit with trademark authority when he attached a plaque to his cameras inscribed with the statement, "No apparatus is guaranteed if it does not bear the signature of Mr. Daguerre and the seal of Mr. Giroux."

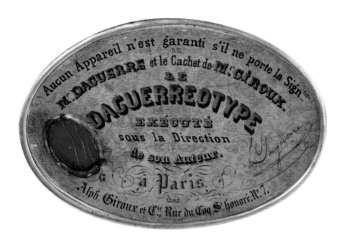

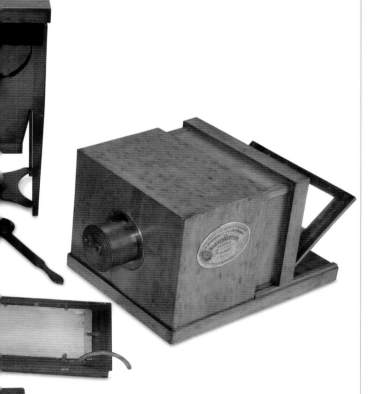

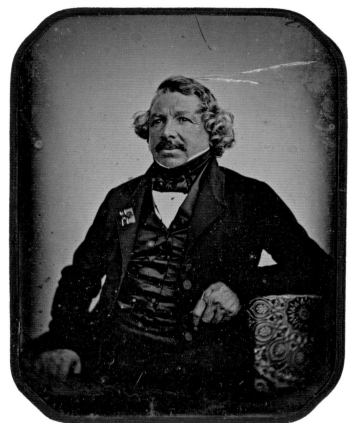

Above: Jean-Baptiste Sabatier-Blot (French, 1801–81). *LOUIS-JACQUES MANDÉ DAGUERRE*, 1844. Quarter-plate daguerreotype. George Eastman House Collection. 1976:0168:0043.
.

BELLOWS CAMERA (owned by Isidore Niépce)

ca. 1840 | Unidentified manufacturer, France

Gift of Eastman Kodak Company, ex-collection Gabriel Cromer. 1974.0037.2113

Thought to be the first to use a bellows, this quarter-plate camera was acquired in 1933 by French photographer and collector Gabriel Cromer from J. Batenet, a childhood friend of Isidore Niépce. Isidore's father, Joseph Nicéphore Niépce, is credited as the first to apply the bellows to photographic instruments (though not cameras). He had earlier employed a similar device to induce air into what he called the *pyréolophore*, an internal combustion engine he and his brother Claude built in 1807.

According to Cromer, Isidore had this camera constructed "at the earliest time of the Daguerreotype," using a bellows in place of the more typical double-box system of focusing. An additional feature is that the camera's base also functions as its carrying case. The front standard and bellows can be detached from the bed and stowed in a compartment in the base, enabling more convenient transport.

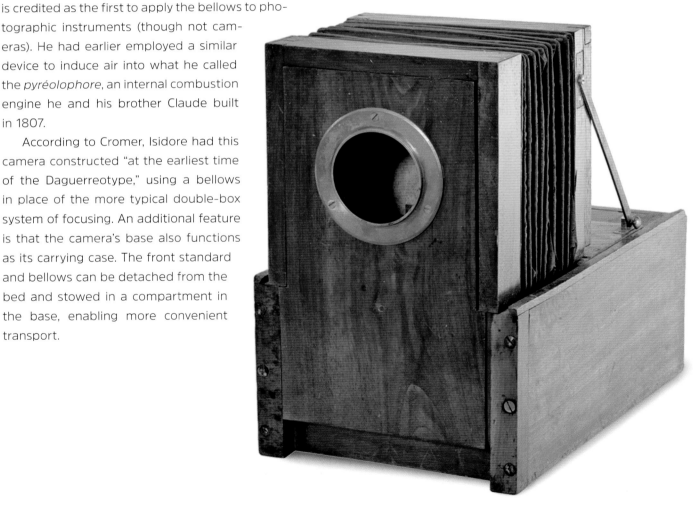

FULL-PLATE DAGUERREOTYPE CAMERA (owned by S. A. Bemis)

1840 | Alphonse Giroux (attrib.), Paris, France

Gift of Eastman Kodak Company. 1978.1792.0001

Samuel A. Bemis (1793–1881), a Boston dentist and amateur daguerreotypist, bought one of the first cameras sold in the United States. Fortunately, he and his heirs saved not only the camera but also its receipt. While it is too late to return the camera, the receipt is useful as evidence of what is probably the earliest documented sale of an American daguerrean outfit. Thanks to the dentist's pack-rat ways, we know that on April 15, 1840, he paid $76 to François Gouraud, Giroux's agent in the States, for a "daguerreotype apparatus," twelve whole plates at $2 each, and a freight charge of $1. The apparatus, which Gouraud advertised as consisting of sixty-two items, included the camera, lens, plate holder, iodine box for sensitizing plates, mercury box for developing plates, holding box for unused plates, and a large wooden trunk to house the entire system. Quite large, the

camera weighs about thirteen pounds and can produce full-plate images, 6½ x 8½ inches in size. Bemis made his first daguerreotype on April 19, 1840, from the window of his Boston office, and during the next several years went on to expose more than three hundred images, most of them in his beloved White Mountains of New Hampshire. The George Eastman House collection also contains a second Bemis camera and nineteen of his images.

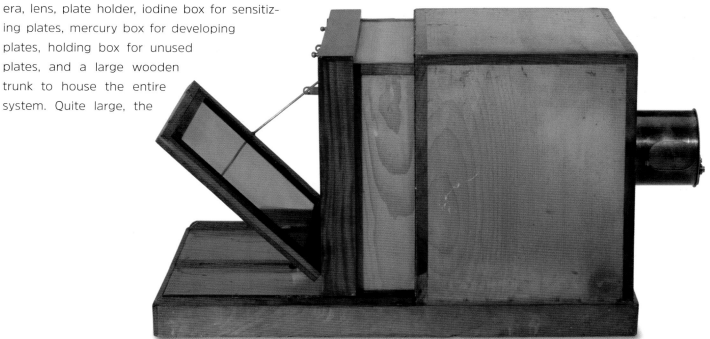

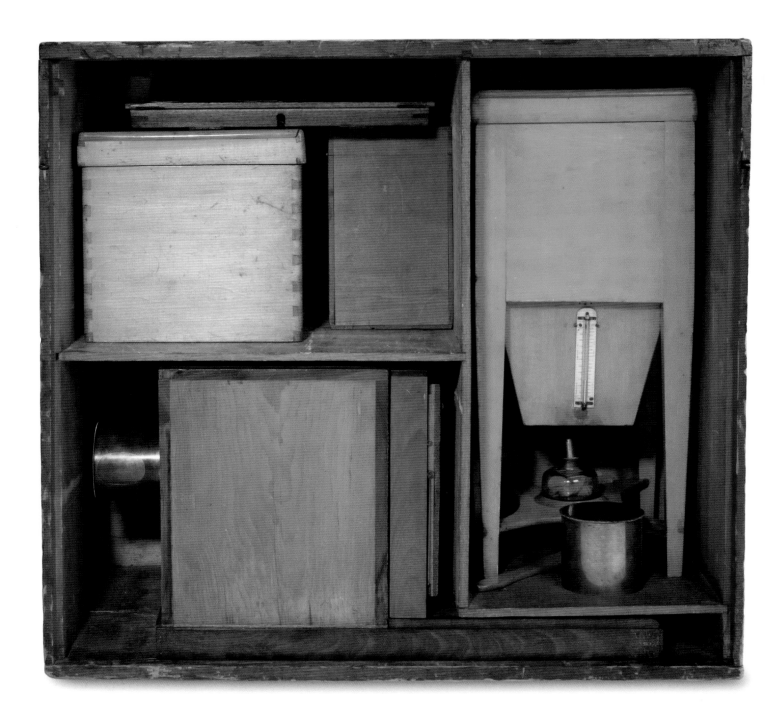

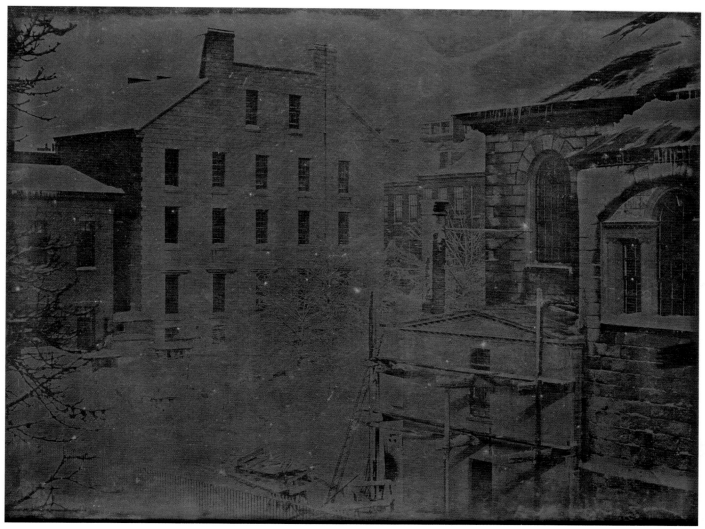

Above: Samuel A. Bemis (American, 1793–1881). [*King's Chapel burying ground, Tremont Street, Boston, winter*], ca. 1840–41. Full-plate daguerreotype. 1980:0788:0013.

Opposite: The various components of the Samuel Bemis full-plate daguerreotype camera of 1840 in their shipping crate.

NOUVEL APPAREIL GAUDIN

ca. 1841 | N. P. Lerebours, Paris, France

Gift of Eastman Kodak Company, ex-collection Gabriel Cromer. 1974.0028.3543

Another early departure from Daguerre's Giroux camera design was the Nouvel Appareil Gaudin. Designed by Gaudin of Paris, France, the body of this sixth-plate (2¾ x 3 in) camera is made of two brass tubes that slide within each other to adjust focus. The camera is built into its carrying case, which is large enough to transport the sensitizing and developing boxes as well as the rest of the items required to make daguerreotypes. On the top of the carrying case is a piece of black cloth that was raised and lowered over the lens, acting as a very simple shutter. The f/4 doublet lens was faster than that of the Giroux, which, when combined with the sixth-plate image size, made the camera suitable for portraiture. George Eastman House owns a portrait that, according to Gabriel Cromer, was made with a Gaudin camera. On front of the lens is mounted a wheel stop, a metal disc with three proportional holes used for controlling the amount of light exposing the plate.

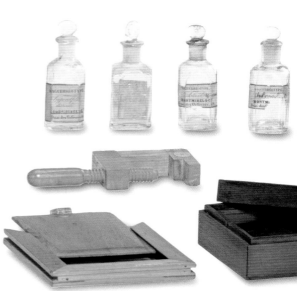

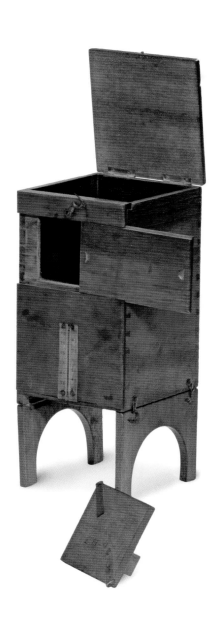

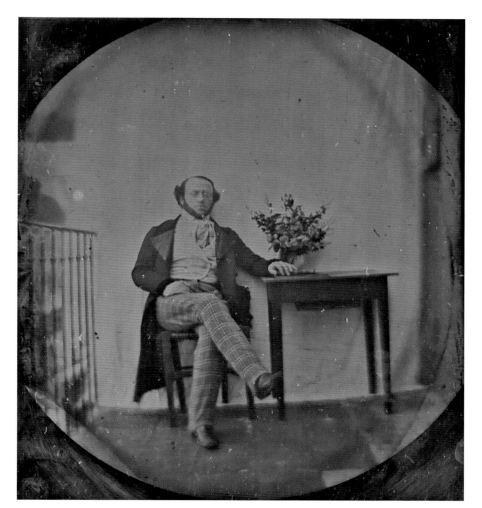

Above: Unidentified photographer. [*Portrait of a man at a table*], 1840. Daguerreotype, 1/6 plate (circular). Gift of Eastman Kodak Company: ex-collection Gabriel Cromer. 76:0168:0158.

PLUMBE DAGUERREOTYPE CAMERA

ca. 1842 | John Plumbe Jr., Boston, Massachusetts

Gift of Eastman Kodak Company. 1974.0037.0093

Dating from the early 1840s, the Plumbe daguerreotype camera is the oldest American-made camera in the George Eastman House collection. Of the double-box style, the Plumbe is similar in design to the Bemis camera, but it produced the smaller 3¼ x 2¾-inch images known as sixth plates. Unlike the Bemis, it was intended as a portrait camera. A label on the camera's back identifies it as a product of Plumbe's Daguerreotype Depot, United States Photographic Institute, Boston.

John Plumbe Jr. (1809–57) was a civil engineer, early promoter of a transcontinental railroad, author, daguerreotypist, and publisher. He may have studied the daguerreotype process with François Gouraud in Boston in March 1840, though he certainly opened a studio in that city by late that fall. The next year, he established the United States Photographic Institute, also in Boston, and opened a gallery-studio, which he called a "photographic depot." Plumbe continued to set up many more new "depots" and in 1843 opened one on Broadway in New York—a city that would soon be the center of his operations. The first American to create and franchise a chain of daguerreotype galleries, he had founded establishments in at least twenty-five towns and cities by the time of his bankruptcy in 1848. In addition to being a working daguerreotypist, "professor" of the process, and franchiser, Plumbe also distributed daguerrean materials and equipment bearing his name.

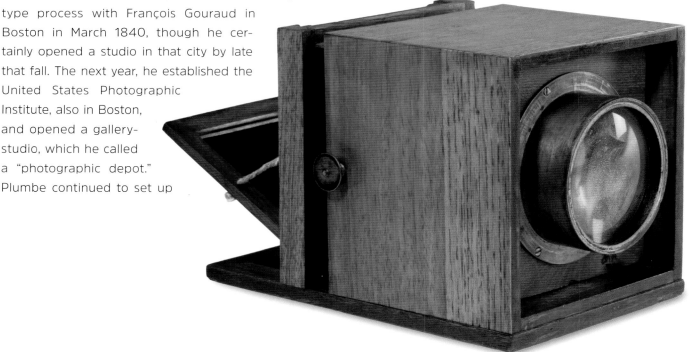

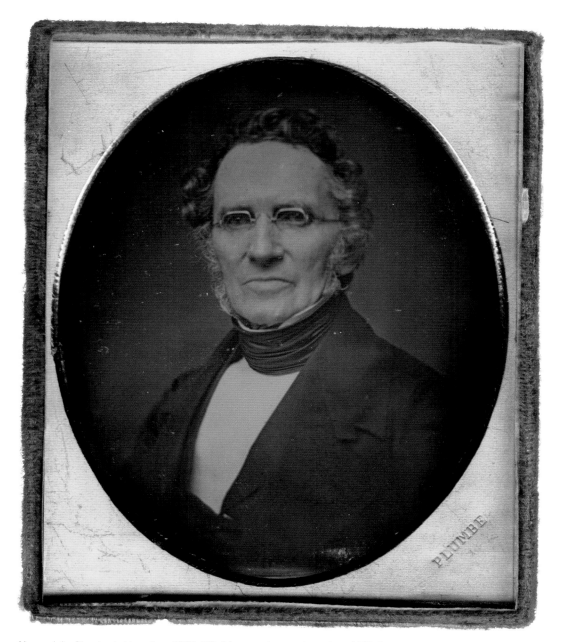

Above: John Plumbe Jr. (American, 1809–57). [*Man wearing eyeglasses*], ca. 1850. Daguerreotype. Purchase, ex-collection Zelda P. Mackay.

RICHEBOURG DAGUERREOTYPE OUTFIT (QUARTER-PLATE)

ca. 1842 | A. Richebourg, Paris, France

Gift of Eastman Kodak Company, ex-collection Gabriel Cromer. 1982.0237.0007

Pierre-Ambroise Richebourg was apprenticed to optical instrument maker Vincent Chevalier, who supplied Daguerre with his experimental equipment. Following Chevalier's death in 1841, Richebourg took over the business of supplying cameras and lenses and expanded into giving lessons in daguerreotypy and producing portraits.

This quarter-plate Richebourg camera is of the fixed-bed double-box type, fitted with a landscape lens, with provision for correcting mirror. It is shown with its sensitizing and developing boxes and a box for six plate holders, all of which fit into a wooden trunk bearing the Vincent Chevalier and Richebourg label inside the lid.

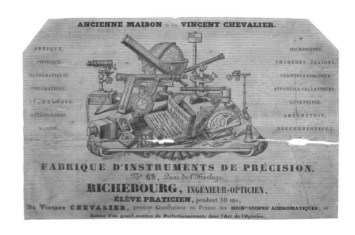

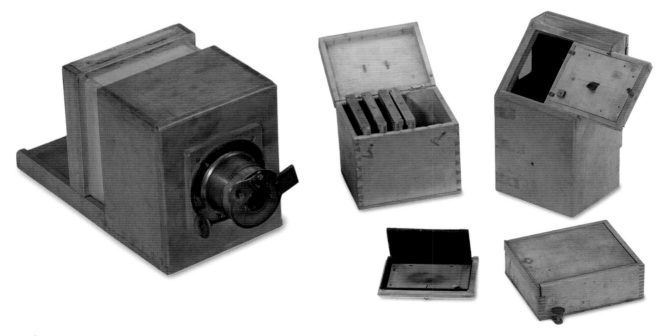

GRAND PHOTOGRAPHE

ca. 1843 | Charles Chevalier, Paris, France

Gift of Eastman Kodak Company, ex-collection Gabriel Cromer.
1974.0028.3313

About 1843, Charles Chevalier introduced a full-plate camera designed to be portable. The camera is of the double-box style, but the sides of the boxes are hinged. Removing the lens board at the front of the camera and the track for the plate holder at the rear allows the camera to collapse vertically from 11 inches to 3½ inches. The camera also features a rack-and-pinion focusing system; turning the large brass knob on the top of the camera adjusts the focus by moving the inner box toward and away from the lens.

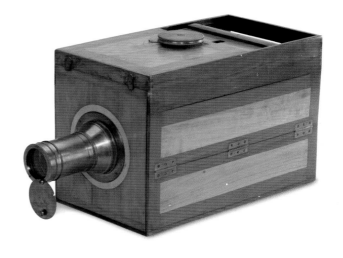

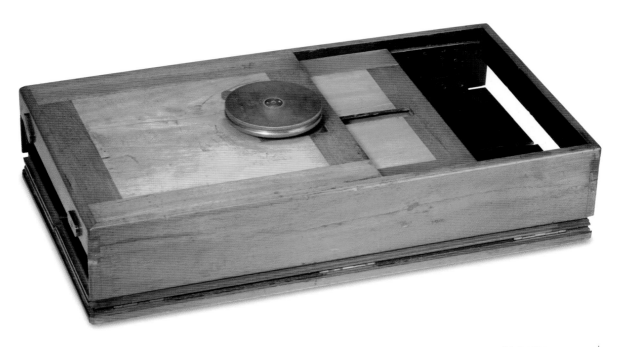

QUARTER-PLATE FRENCH TRIPLE SLIDING-BOX CAMERA

ca. 1845 | Unidentified manufacturer, France

Gift of Eastman Kodak Company, ex-collection Gabriel Cromer.
1974.0037.2916

This fixed-bed French quarter-plate daguerreotype camera employs an unusual three-box focusing system, instead of the traditional two-box design. The extra box allows the camera to telescope much like a bellows would, though there is no apparent technical advantage over the usual construction. Also unusual is the landscape lens, which is fitted with a pivoting aperture used to control the exposure.

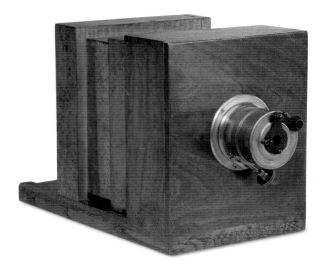

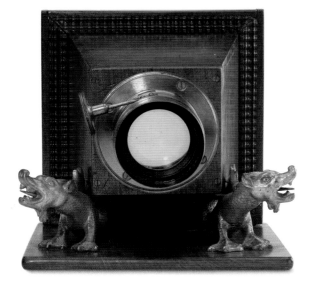

BOURQUIN CAMERA

ca. 1845 | Bourquin, Paris, France

Gift of Eastman Kodak Company, ex-collection Gabriel Cromer.
1977.0850.0007

Judging from the way the ground glass and plate holder affix to the camera, the Bourquin dates from about 1845. It is a French-made single-box-style camera fitted with a Petzval-type portrait lens; the only means of focus is the lens's rack and pinion. Mounted on either side of the lens are dragons, which appear to support the lens but more likely were used to hold the attention of the subject, a sort of daguerrean-era version of "watch the birdie."

NINTH-PLATE SLIDING-BOX CAMERA

ca. 1850 | Unidentified manufacturer, France

Gift of Eastman Kodak Company, ex-collection Gabriel Cromer. 1995.2625.0001

This is the smallest double-box camera in the George Eastman House collection. Fitted with a Hermagis landscape lens, it produced an unusually sized 1½ x 2-inch image. Accompanying the camera is a glass-lined iodizing box, the earliest style used to sensitize daguerreotype plates. A second accessory is a daylight magazine-loading plate box, suggesting the camera may have had a long working life, perhaps in an amateur's hands. The box would have allowed the camera to use dry plates, which appeared on the photographic scene nearly forty years after the camera was manufactured.

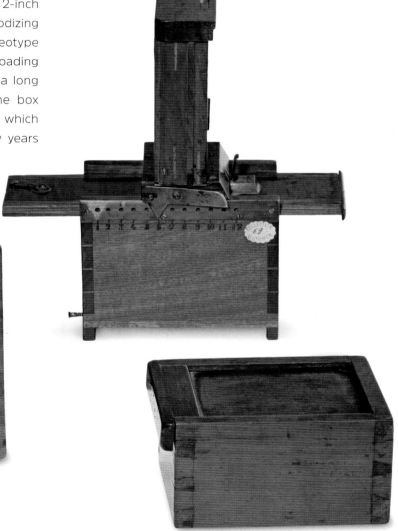

LEWIS DAGUERREOTYPE CAMERA (QUARTER-PLATE)

ca. 1851 | W. & W. H. Lewis, New York, New York

Gift of Robert Henry Head. 1974.0037.2887

In 1851, W. & W. H. Lewis of New York City introduced a fixed-bed bellows camera that became one of the most popular with daguerrean studio photographers. Similar in appearance to the earlier American-style chambered box camera, this style had the bellows inserted into the middle of the camera body. This was done to facilitate the copying of daguerreotypes, which, being unique objects, could be duplicated only as a second, in-camera copy of the original. This particular camera is half-plate in size; others were made in half-plate and full-plate sizes.

Opposite: Unidentified photographer. [*Portrait of the grandmother of Wallis Warfield Simpson when a young woman*], ca. 1850. Daguerreotype with applied color. Purchase, ex-collection Zelda P. Mackay.

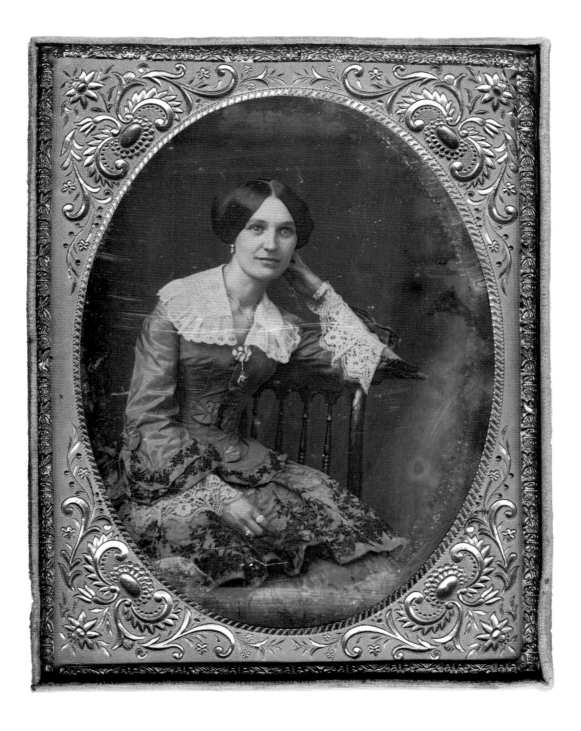

COLLODION
Wet-Plate Photography

English gentleman scholar and inventor William Henry Fox Talbot (1800–77) began investigations into photography in the mid-1830s. His process, "photogentic drawing," used paper sensitized to light with silver chloride; this produced a negative rendition of objects placed in contact with the paper after its exposure to sunlight.

The announcement of Daguerre's process prompted Talbot to go to the Royal Society in 1839 to show them images he had made three years earlier. Two years later, Talbot improved his process by exposing paper sensitized with silver iodine, which was much more light sensitive. He patented his new version, now named the "calotype" (also known as "talbotype"), which like his earlier process, created a paper negative—however, this time it was developed in gallic acid. A positive image could be made by placing the negative in contact with sensitive silver chloride paper and exposing it to sunlight. There was no chemical developer required to bring out the image. The calotype had the advantage of allowing the photographer to create multiple prints from the same negative. However, the images were nowhere near as detailed as daguerreotypes.

Right:
André-Adolphe-Eugène Disdéri (French, 1819–89). *DUC DE COIMBRA*, ca. 1865. Albumen silver print, uncut carte-de-visite sheet. Gift of Eastman Kodak Company: ex-collection Gabriel Cromer.

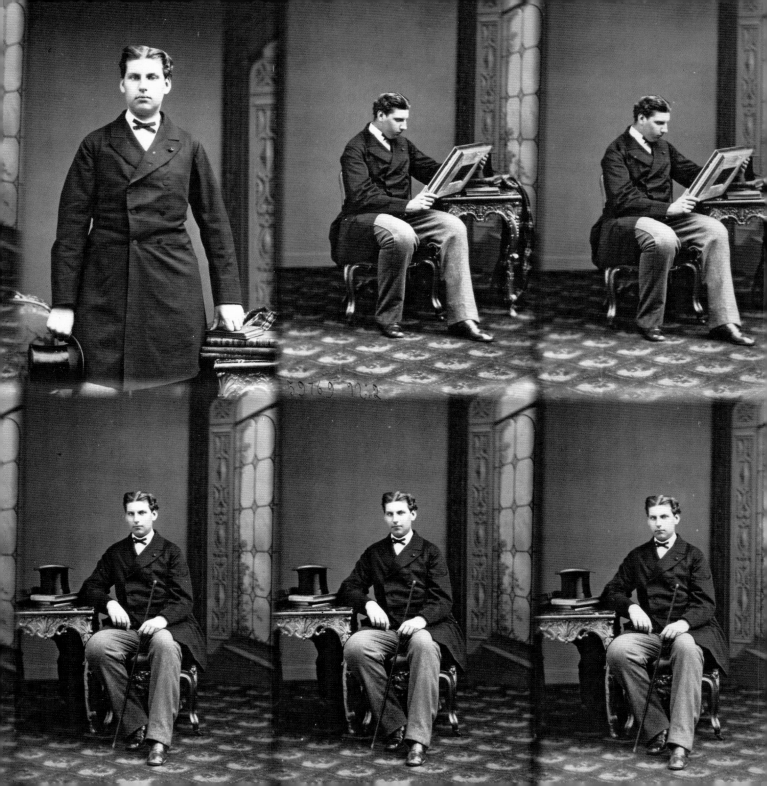

British sculptor and inventor Frederick Scott Archer (1813–57), dissatisfied with the resolution of the calotype, began experimenting with using glass as the support for sensitized materials in 1848. Three years later he described his process in an article in the English magazine the *Chemist*. Archer did not patent his process, nor did he name it, preferring to make it available to the world for free. The wet-collodion process, as it is usually referred to, used a thin layer of collodion—a compound used in medicine as a bandage adhesive, made from nitrated cellulose (nitrocellulose or guncotton) dissolved in ether—containing potassium iodide. This mixture was poured onto a common window-glass plate and allowed to set. Then, in a darkened room, the plate was sensitized by placing it into a bath of silver nitrate. The plate was then placed in a light-tight holder and moved into the camera for use. The plate was exposed, the holder removed from the camera, and in an amber-illuminated room, the plate was developed with a mixture of pyrogallic acid and glacial acetic acid. Finally, it was fixed with sodium thiosulfate.

Archer's wet-collodion process created high-resolution negative images that, like the calotype, could be used to print paper positives in almost limitless copies. As the emulsion support was glass, it cost less to make wet-collodion images than either calotypes or daguerreotypes. Like daguerreotypes, however, the resolution of Archer's process was quite high and the process was quite complicated, generally practiced only by the professional or serious amateur photographer.

There were several variations to the wet-collodion process. In 1854, a positive version known as the "ambrotype" was patented by American photographer and inventor James Ambrose Cutting of Boston (1814–67; his middle name was originally Anson but he later changed it to Ambrose after the process). In this method, a developed wet-collodion–glass image was placed against a black background, which gave the image the appearance of a positive image. Archer and a colleague, Peter W. Fry, had originated the ambrotype process in England as well, in 1851, but they did not patent it.

Ambrotypes were usually cased in a manner similar to daguerreotypes. American scientist Hamilton Smith (1819–1903) patented a process in 1856, commonly known as the tintype, where the glass-imaging support was replaced with japanned, black sheet iron. As was typical of the time, the images were cased. Tintype portraits were especially popular among soldiers during the American Civil War. ♻

UNIVERSAL IMPROVED KINNEAR CAMERA (10 X 8)

ca. 1857 | W. W. Rouch & Company, London, England

Gift of John Howard. 1974.0037.2100

The pleated leather bellows was first used in cameras as a way to adjust the distance between the lens and the sensitized plate. In the 1850s it occurred to Scottish photographer Charles George Hood Kinnear (1832–94) that designing a bellows with tapered sides would allow it to fold almost flat. A camera using Kinnear's patented bellows design could be folded into a much smaller package for storage or transport. Kinnear built his own cameras but also licensed his bellows to other firms, such as W. W. Rouch of London. Their 1857 Rouch Universal Improved Kinnear Camera was made in several sizes besides this 10 x 8-inch version. The Rouch's front standard was rigidly attached to the baseboard, which was rabbeted so it could move freely in the grooved wooden guides on each side. Turning the brass crank below the rear of the mahogany body rotated a threaded rod that moved the base in or out for focusing. The lens was a Triple Achromatic made by J. H. Dahlmeyer, also of London. The Rouch was a handy field camera that didn't take up much space in the knapsack or buggy.

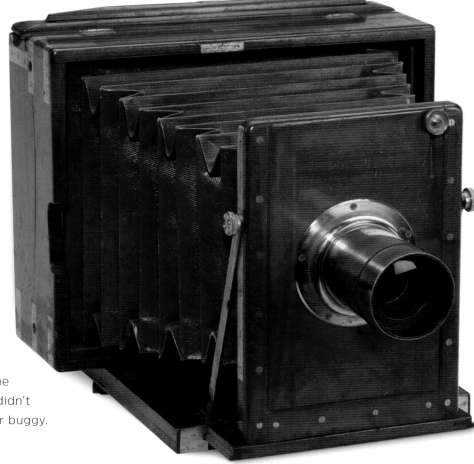

PISTOLGRAPH

1859 | Thomas Skaife, London, England

Gift of Eastman Kodak Company, ex-collection Gabriel Cromer. 1974.0084.0007

Thomas Skaife's Pistolgraph, the first camera to incorporate a mechanical shutter, was capable of instantaneous photography. Its small image size, coupled with a fast f/2.2 Petzval-type lens and a rubber-band-actuated double-flap shutter with an estimated speed of 1/10 second, allowed one to photograph some moving subjects. Somewhat resembling a small pistol, the camera mounted to the top of a wooden box—which also doubled as its storage case—with a ball-and-socket mechanism. At the camera's rear was a rectangular compartment used to both hold and sensitize a one-inch square wet plate.

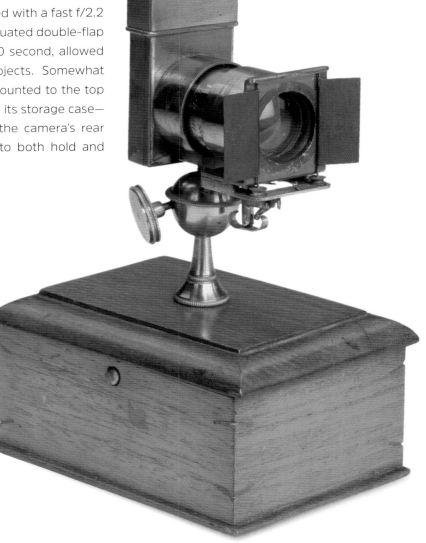

CHAMBRE AUTOMATIQUE DE BERTSCH

ca. 1860 | Adolphe Bertsch, Paris, France

Gift of Eastman Kodak Company, ex-collection Gabriel Cromer. 1974.0028.3315

Adolphe Bertsch's Chambre Automatique was a portable wet-plate kit consisting of a camera, darkroom, and the rest of the equipment and chemistry necessary to sensitize and process wet-plate images. The carrying case also served as the darkroom, complete with an amber glass safelight mounted in the lid; a wooden panel with a sleeve covered an opening at the box's hinged front to allow light-tight access. The term "Automatique" in the kit's name refers to the fixed-focus nature of the camera and lens. Images were composed within the black wire frame finder located on the camera's top.

CARTE-DE-VISITE CAMERA (owned by André-Adolphe-Eugène Disdéri)

ca. 1860 | Unidentified manufacturer, France

Gift of Eastman Kodak Company, ex-collection Gabriel Cromer. 1974.0037.2590

Photography studio operators depended on a steady flow of customers in order to make ends meet, and this often meant coming up with novel products and services. Since portraiture made up the bulk of their business, variations on the form were in order. Starting in the late 1850s in Europe, and a bit later in America, a very popular portrait format was the carte-de-visite, a fits-in-your-palm, 2½ x 3½-inch, card-mounted paper photograph that people exchanged with family, friends, and business associates. In order to make production faster and cheaper, cameras with multiple lenses were designed to take two or more identical images in a single exposure.

Photographer André-Adolphe-Eugène Disdéri (1819–89) patented a method of producing eight carte-de-visite images on a single wet collodion plate. Produced by an unidentified French manufacturer, the camera shown here belonged to Disdéri himself. The camera is of the double-box type with

a repeating back, which allowed the plate holder to slide from side to side, doubling the number of images per plate. Access to focus the four Petzval portrait lenses was through the hinged doors mounted on the camera's sides. In essence, the Disdéri carte-de-visite system lowered the cost of making portraits.

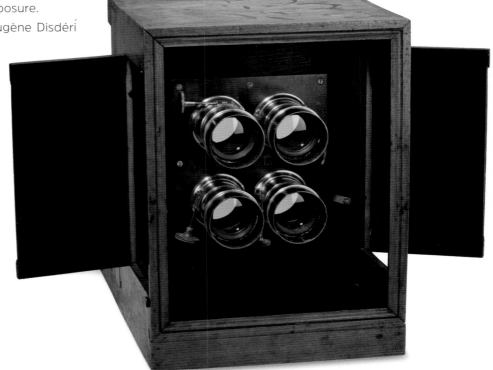

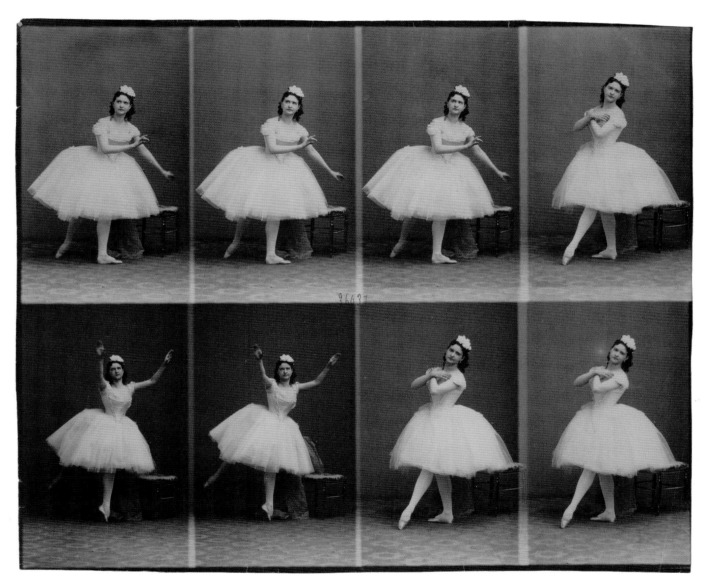

FOLDING TAIL-BOARD CAMERA (owned by Nadar)
ca. 1860 | Unidentified manufacturer, France

Gift of Eastman Kodak Company, ex-collection Gabriel Cromer. 1974.0028.3510

According to the collector Gabriel Cromer, this camera belonged to the well-known French portrait photographer Nadar (Gaspard-Félix Tournachon, 1820–1910). The camera is a folding-bed 5 x 7-inch wet-plate bellows type, and it employs a bed-mounted rack-and-pinion focusing system. It was produced by an unidentified French manufacturer.

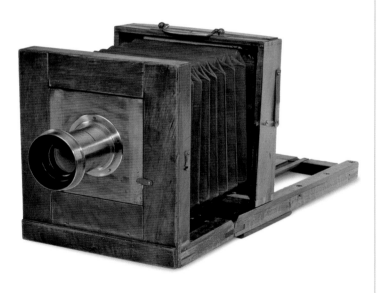

Above: Gaspard-Felix Tournachon Nadar (French, 1820–1910). *GEORGE EASTMAN*, 1890. Albumen silver print. Gift of George Dryden.

SLIDING-BOX CAMERA (owned by M. B. Brady Studio)

ca. 1860 | Nelson Wright (attrib.), New York, New York

Gift of Graflex, Inc. 1974.0028.3261

Fixed-bed double-box cameras date back to the original design specified by Daguerre. They were made in numerous sizes and remained popular into the 1860s. This quarter-plate (3¼ x 4¼-inch) version was made by Nelson Wright and is fitted with a C. C. Harrison Petzval-type portrait lens. Both manufacturers were acquired by Scovill Manufacturing Company, one of the oldest photographic manufacturing firms in the United States. The camera was found with an assortment of Mathew B. Brady (1822–96) glass plates in Auburn, New York, hence the Brady Studio association.

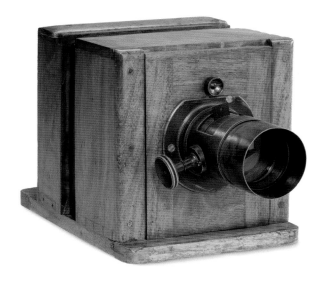

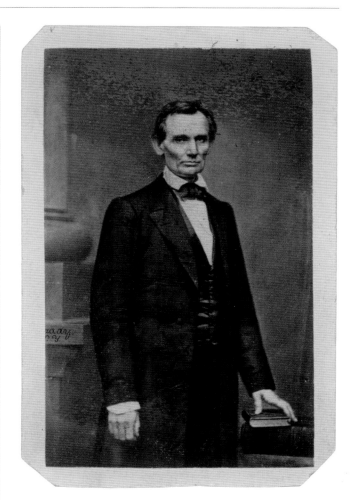

Above: Mathew B. Brady (American, 1822–96). *ABRAHAM LINCOLN*, February 27, 1860. Albumen silver print. Gift of Alden Scott Boyer.

WET-PLATE MONORAIL VIEW CAMERA

ca. 1860 | Charles Chevalier (attrib.), Paris, France

Gift of Eastman Kodak Company, ex-collection Gabriel Cromer. 1978.1371.0055

Chevalier's monorail camera, of about 1860, is the earliest camera of this style in the George Eastman House collection. As the name implies, the design made use of a monorail, employing a single beam to support both front and back standards of the camera and connecting them with a light-tight flexible leather bellows. This allowed maximum movements for perspective control. The monorail was an integrated part of the tripod, with both standards attached to the rail by thumbscrews. The fixed standards gave a rigidity to the camera that made for easier transport.

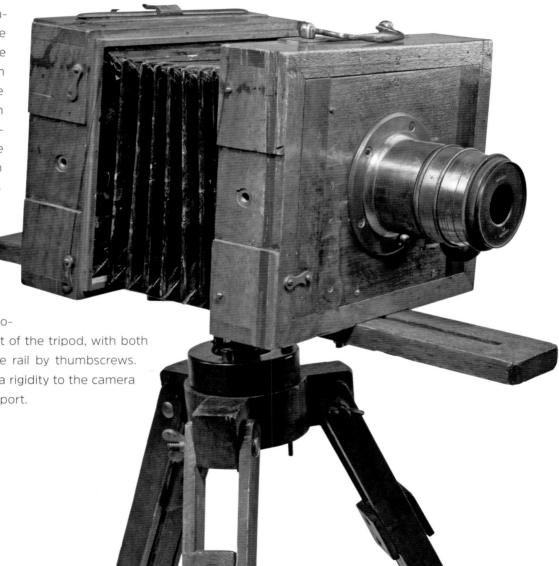

STEREO WET-PLATE CAMERA WITH GLOBE LENSES

ca. 1860 | Unidentified manufacturer, United States

Gift of 3M Foundation, ex-collection Louis Walton Sipley. 1977.0112.0001

Most likely manufactured by one of the New York City camera companies in the early 1860s, this fixed-bed double-box stereo camera is fitted with a pair of Harrison & Schnitzer globe lenses. One of the earliest type of wide-angle lens, the globe lens is named for the shape of its exterior. Using a hinged flap "shutter," the camera exposed stereoscopic images on 5¼ x 8¾-inch wet plates. When printed, the images were separated, cropped to 3 x 3 inches, and paired on standard 3¼ x 6¾-inch stereograph cards.

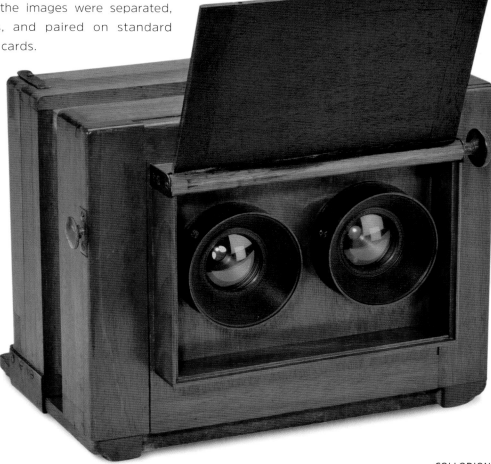

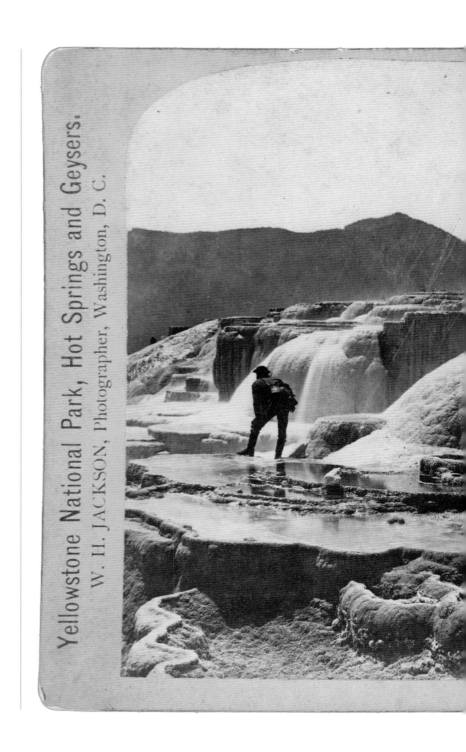

Yellowstone National Park, Hot Springs and Geysers.
W. H. JACKSON, Photographer, Washington, D. C.

Right: William Henry Jackson (American, 1843–1942).
UPPER BASINS—SODA SPRINGS, GARDINER'S RIVER, 1871.
Albumen silver print. Museum accession.

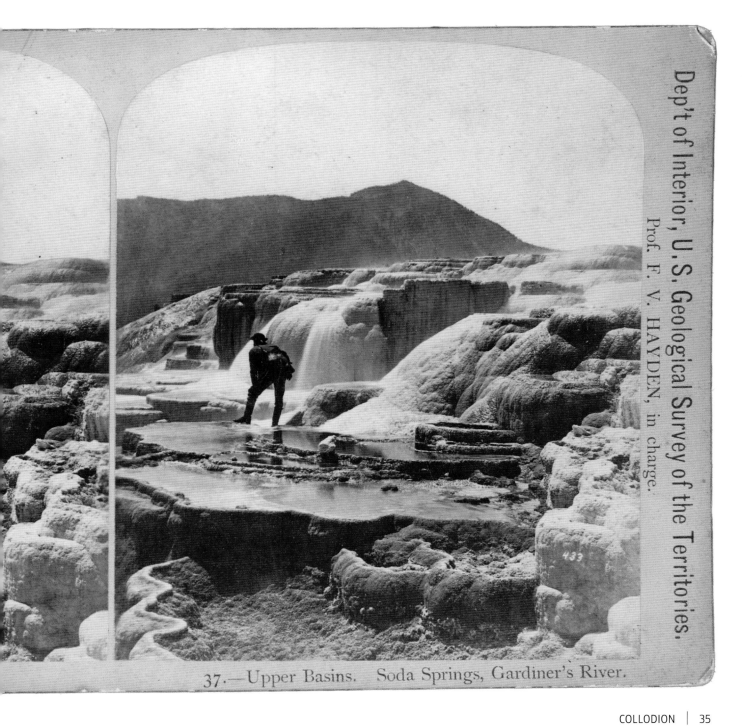

37.—Upper Basins. Soda Springs, Gardiner's River.

LEWIS WET-PLATE CAMERA

ca. 1862 | H. J. Lewis, New York, New York

Gift of Polaroid Corporation. 1981.2814.0005

Manufactured by H. J. Lewis of New York City and typical of Civil War–vintage studio equipment, this repeating back-bellows camera produced two 3¼ x 4½-inch images on 4½ x 6½-inch wet plates. The large box at the back of the camera was used to index the plate holder. The camera's finish has a lovely patina, acquired from both age and heavy use, illustrating its workhorse status. Manufacturer and camera were directly related to W. & W. H. Lewis and their daguerreotype camera. Genealogically, Henry James Lewis was the second son of William and younger brother to William H., while the camera is stylistically a direct descendant of the daguerreotype apparatus, even retaining the Lewis cast-iron bed locknut.

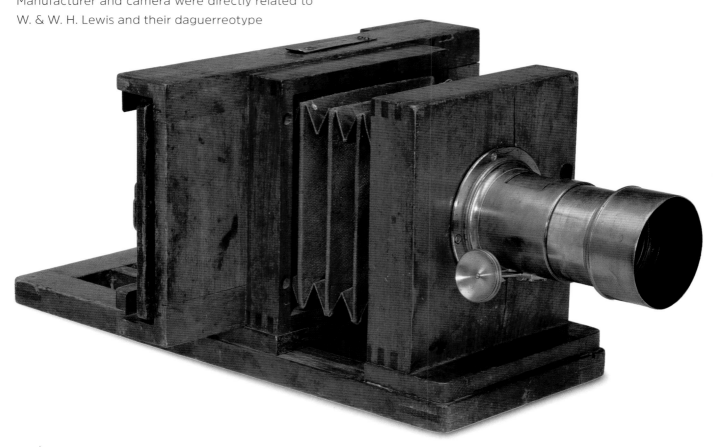

THOMPSON'S REVOLVER CAMERA

ca. 1862 | A. Briois, Paris, France

Gift of Eastman Kodak Company, ex-collection Gabriel Cromer. 1974.0037.0090

One of the earliest handheld cameras, Thompson's Revolver produces four one-inch diameter images on a single three-inch diameter wet plate, making it among the first to yield multiple images on circular plates. It also is one of the first "inconspicuous" cameras, meaning it has an atypical appearance. Of course, someone carrying such a camera will surely be conspicuous in the usual sense. In use, the 40mm f/2 Petzval-type lens locks at the top of the camera for focusing and framing the image. Pressing the button located at the three o'clock position on the camera's drum-shaped body allows the lens to then slide down to the picture-taking position, trip the rotary shutter, and expose the plate. Afterward, the disc rotates ninety degrees for the next exposure.

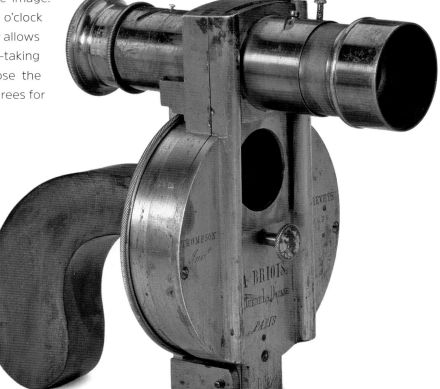

WING MULTIPLYING CAMERA

ca. 1862 | Simon Wing, Boston, Massachusetts

Gift of the Wing Estate. 1974.0037.2889

In the early 1860s, Simon Wing (1826–1910) of Boston, Massachusetts, introduced a number of studio multiplying cameras that, as the name suggests, allowed photographers to make an increased number of images on a single plate. This was achieved by moving either the lens or the back to allow exposure of different areas of the plate. Such cameras were commonly used in the production of tintypes, which were inexpensive direct-positive collodion images on a thin metal plate. Wing recognized the popularity of his apparatus for making tintypes and in 1863 patented a card mount that enabled the metal images to be displayed in the pages of photographic albums.

This particular camera could be fitted with a single lens or a set of four lenses. Depending on the lens and back configuration, a single image or up to seventy-two images could be produced on a single 4 x 5–inch plate.

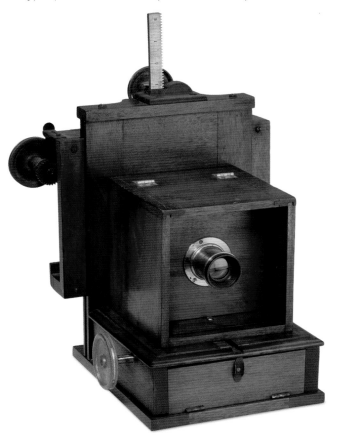

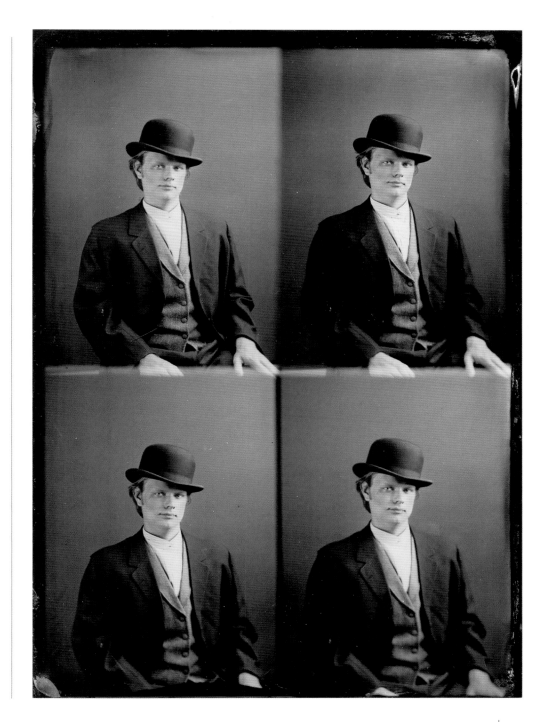

Right: Mark Osterman (American, b. 1955). *RYAN BOATWRIGHT*, 2006. Tintype, uncut bonton group. Courtesy Mark Osterman.

STANHOPE CAMERA

ca. 1864 | René Prudent Dagron (attrib.), Paris, France

1983.1421.0085

The microscope plays a role in the production of two types of photography with confusingly similar names: photomicrography and microphotography. In a practice almost as old as photography itself, photomicrographs picture very small things that have been magnified, usually through a microscope. On the other hand, microphotographs are very small images that can be viewed only through magnification. The first examples of these also date to the infancy of the medium and were made by Englishman John Benjamin Dancer (1812–87), though it would be another decade or so before he made any of a high technical quality. When Dancer shared his tiny images with Sir David Brewster, the Scottish scientist suggested using Lord Stanhope's magnifying lens as a simple way to view them.

René Prudent Dagron (1819–1900), a daguerreotypist by trade, designed and patented a camera system to mass produce microphotographs, or what he called *bijoux photographiques* (photographic jewels), more commonly known as Stanhopes. Dagron's method involved copying a photographic negative through a series of exposures that resulted in as many as 450 positive 2 x 2–mm images on a single plate. The reducing camera's lens board had an arrangement of twenty-five very small lenses mounted in five rows and five columns. As the lens board was shifted vertically to reposition the array for each new exposure, the repeating back, which held a sensitized plate, was moved horizontally. The stability of the nearly six and one-half-pound solid brass apparatus permitted the precise movements needed to compactly fill a 4.5 x 8.5–cm wet-collodion plate with microscopic images. After processing, the images were cut out and affixed to a Stanhope lens, a glass cylinder with a refracting surface at one end, which could be mounted in a variety of ornamental objects.

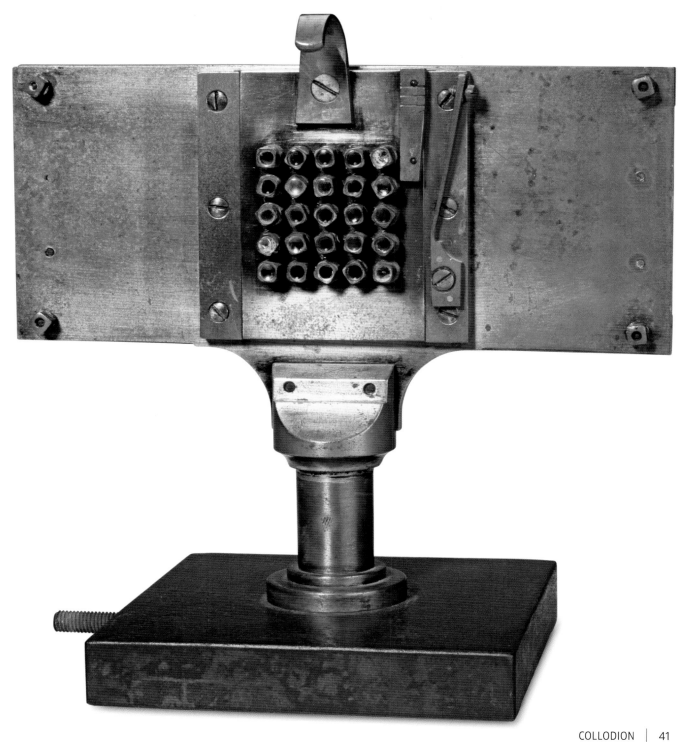

STEREO CAMERA (owned by M. B. Brady Studio)

ca. 1864 | John Stock & Company, New York, New York

Gift of Graflex, Inc. 1974.0028.3542

John Stock & Company manufactured double-box and stereo cameras in New York City during the 1860s. This camera, a folding-bed stereo model fitted with C. C. Harrison Petzval portrait lenses, made a pair of 4½ x 4¼-inch stereoscopic images on a 4½ x 8½-inch wet plate. After printing, the images were separated, cropped to 3 x 3 inches, and coupled again on standard 3¼ x 6¾-inch stereograph mounts.

Both this and the Nelson Wright double-box camera were found with an assortment of Mathew B. Brady (1822–96) glass plates in Auburn, New York, hence the Brady Studio association.

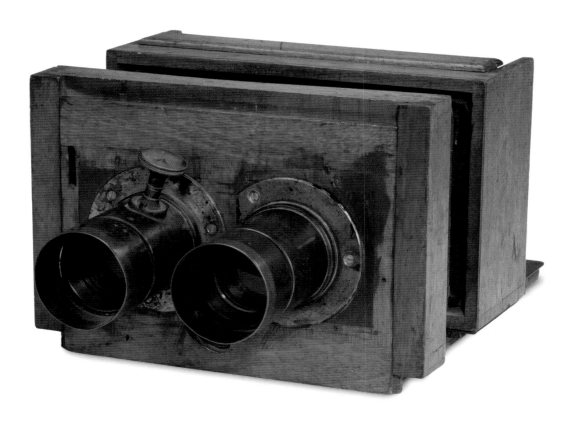

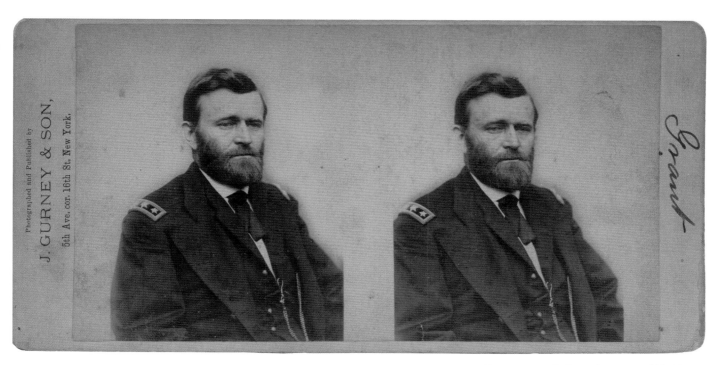

Above: Mathew B. Brady (American, 1822–96). *GENERAL ULYSSES S. GRANT*, 1863. Albumen silver print. Purchase: ex-collection Richmond W. Strong.

DRY PLATE
Factory-Made Photos

Dry-collodion emulsions were experimented with in the mid-1860s, and while some success was achieved, the sensitivity did not compare well with the wet-collodion process. The first breakthrough with dry-plate emulsions was made by the English physician and photographer Richard Leach Maddox (1816–1902), who produced silver-bromide gelatin dry plates in 1871.

Maddox's first dry plates were less light sensitive (slower) than wet-collodion plates, but as they were made from less-volatile chemicals and could be prepared for use ahead of time, they were more convenient to use. By the late 1870s, the speed issue was largely solved, but professional photographers, always leery about staking their photographic reputations on new, unfamiliar systems, were reluctant to use the gelatin dry plates.

Commercial manufacturing of gelatin dry plates began in the United States about 1880. John Carbutt of Philadelphia, Gustav Cramer of St. Louis, and George Eastman of Rochester, New York, were among the first. Eastman was the most successful but also the most unlikely as he had little education and came to photography as an amateur.

In 1877, George Eastman (1854–1932), a bank clerk in Rochester, was contemplating visiting Santo Domingo (now the Dominican

Right:
F. Jay Haynes (American, 1853–1921). *ONEONTA GORGE, OREGON*, ca. 1890.
Albumen silver print. Gift of Harvard University.

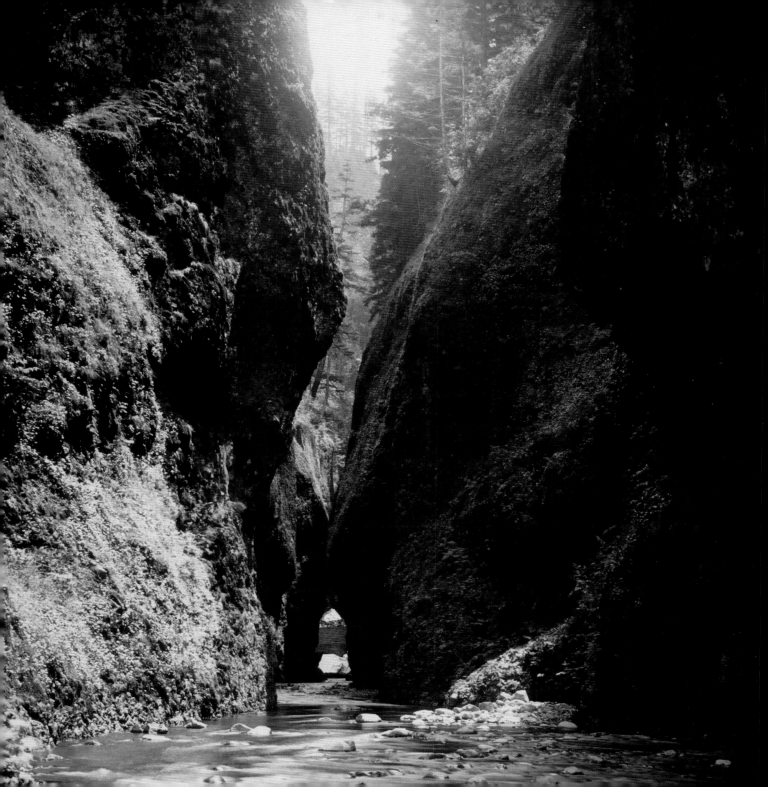

Republic) to purchase land. He had heard the Grant administration was considering the purchase of land around Samana Bay and thought this might be a good investment. A bank colleague of his who had been a photographer's assistant suggested Eastman document the expedition with a camera.

At the time, the wet-collodion system was in vogue; as it was rather complex, Eastman took lessons from George Monroe, a Rochester professional photographer. Unhappy with the cumbersome wet-collodion process, Eastman sought a better way. He researched various amateur journals from England that focused more on dry-plate photography. Putting Santo Domingo aside, he began experimenting in his mother's kitchen during his spare time and came up with a successful recipe for gelatin dry plates, designing and patenting a dry-plate coating machine in 1879. The following April, he rented a loft at 73 State Street in Rochester and began manufacturing photographic plates, which he sold to local photographers—including his old mentor George Monroe. Monroe was acquainted with Edward Anthony of E. & H. T. Anthony, a major photography-supply retailer in New York City, and he brought Eastman's plates to Anthony's attention. Anthony became the distributor of Eastman's plates the following September.

Eastman's business sense impressed fellow Rochesterian Henry Strong, whose family owned a successful business manufacturing buggy whips. Strong became acquainted with the industrious George Eastman while staying at Eastman's mother's boarding house during the construction of his home. Strong and Eastman signed a partnership agreement forming the Eastman Dry Plate Company on December 23, 1880. Strong, with his $1,000 investment, was named president; Eastman invested $100 and was named treasurer.

Eastman resigned his position with Rochester Savings Bank on September 5, 1881, to fully devote himself to his newly formed company. In 1885, he became disillusioned with Anthony as his plate distributor and formed his own sales agency. The Eastman Dry Plate Company continued to expand, moving to 101 and 103 State Street. The dry-plate business turned out to be rather volatile, and many firms entered and left the business. Yet Eastman, with the financial backing of Henry Strong, withstood the ups and downs of business cycles and became the most successful dry-plate manufacturer in the country. ↻

PHOTO-BINOCULAR

ca. 1867 | Geymet & Alker, Paris, France

Gift of Eastman Kodak Company, ex-collection Gabriel Cromer. 1974.0084.0015

Manufactured by the French firm of Geymet & Alker in 1867, the Jumelle, which means "binocular" in French, is known as the "Photo-Binocular" camera in English. The entire camera is contained in one side of the binocular, while the other houses the viewfinder. A removable drum magazine holds fifty collodion dry plates, 4 x 4 cm each. By inverting the camera after exposure, the plate would be returned to the magazine and the dial rotated to drop another. The Photo-Binocular is sometimes called a detective camera because with the drum removed, the photographer appears to be looking through a pair of binoculars instead of operating a camera. The drum could be worn with a shoulder strap, making it look like a canteen.

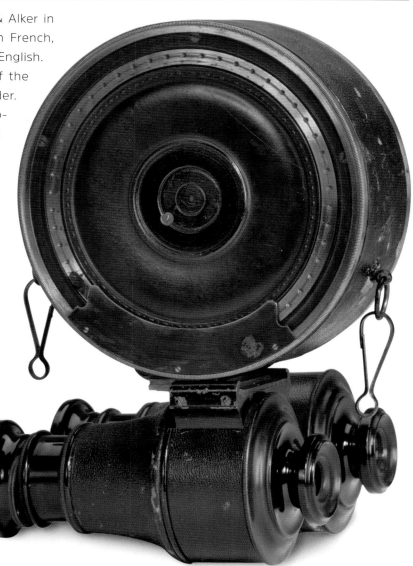

SCÉNOGRAPHE

ca. 1874 | E. Deyrolle Fils, Paris, France

Gift of Eastman Kodak Company, ex-collection Gabriel Cromer. 1974.0037.1970

An early dry plate camera, the Scénographe was designed in 1874 to be the last word in lightweight portable cameras. E. Deyrolle Fils of Paris kept its bulk to a minimum by using thin brass sheet for the metal parts and a non-pleated cloth bag as a collapsible bellows. The folding finder and its plumb-bob leveler were made of brass wire. Thin hardwood supports were used to keep the bellows taut when the camera was opened. The bottom bellows support had a tripod socket, for this camera was not for handheld use. The recently introduced gelatin dry plates were slow, making exposure times long, and only when supported on the tripod could the flimsy structure remain motionless long enough to take a blur-free 10 x 15-cm picture. As the name implies, the Scénographe was intended for scenic views and came appropriately fitted with a 180mm f/20 landscape lens. Exposures were controlled by the removal and replacement of a brass lens cap.

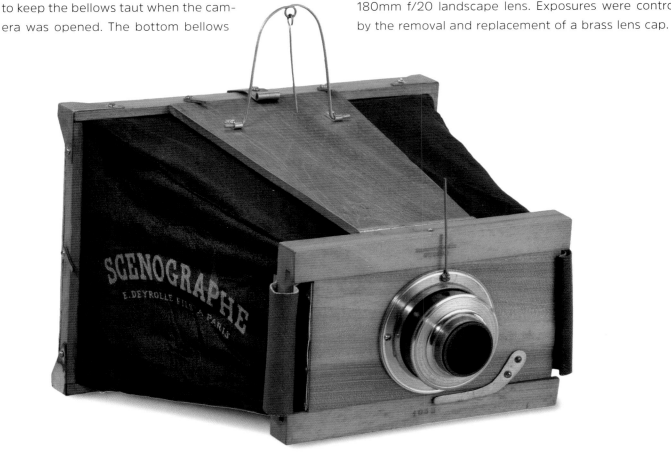

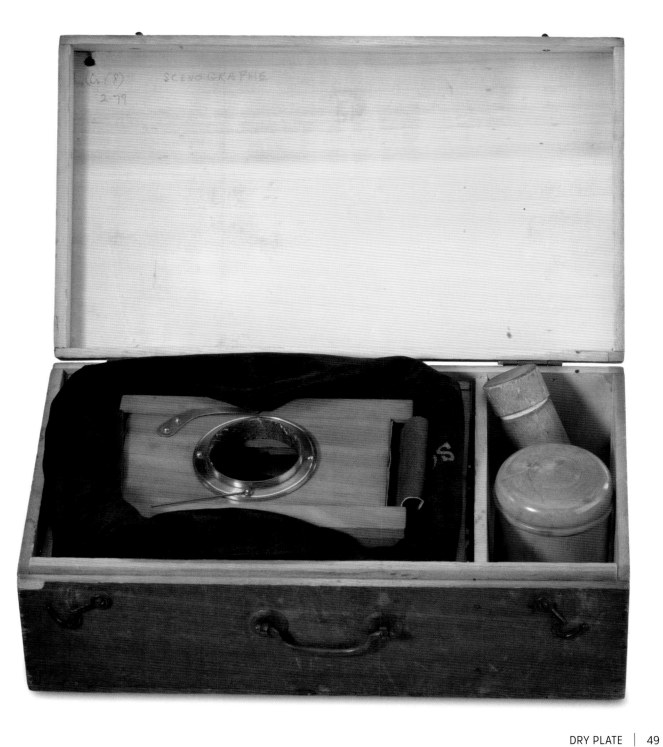

MICROMÉGAS

ca. 1875 | J. Fleury Hermagis, Paris, France

Gift of Eastman Kodak Company, ex-collection Gabriel Cromer.
1974.0037.1676

One of the few collapsible box cameras produced in the last quarter of the nineteenth century, J. Fleury Hermagis's pocket-sized Micromégas is reminiscent of Charles Chevalier's much larger Grande Photographe, manufactured some thirty years earlier. Made of polished French walnut with hinged edges, the 8.5 x 9.5-cm format camera folded flat with its focusing glass and lens board removed. Focus was accomplished by rotating the helical thread lens in its mount.

The choice of the camera's name was inspired by a 1752 short story by the French writer and philosopher Voltaire (François-Marie Arouet). Recognized as an early precursor of the literary genre of science fiction, Voltaire's tale shares its title with the name of the primary character, Monsieur Micromégas, an absurdly gigantic alien who wonders at the smallness of the earth and its inhabitants, amidst the vastness of the universe. A narrative based on the interplay of earthly and celestial proportion and scale, Micromégas had great public appeal in the eighteenth and nineteenth centuries for its questioning of conventional knowledge and wisdom. Like Voltaire's story, the design of this camera reveled in an unorthodox approach to comprehending the world.

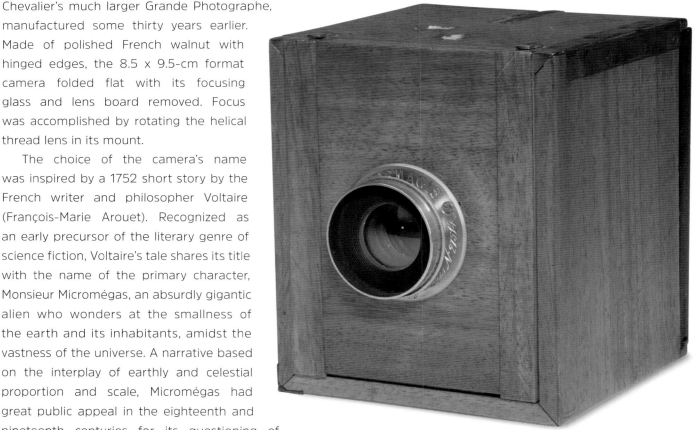

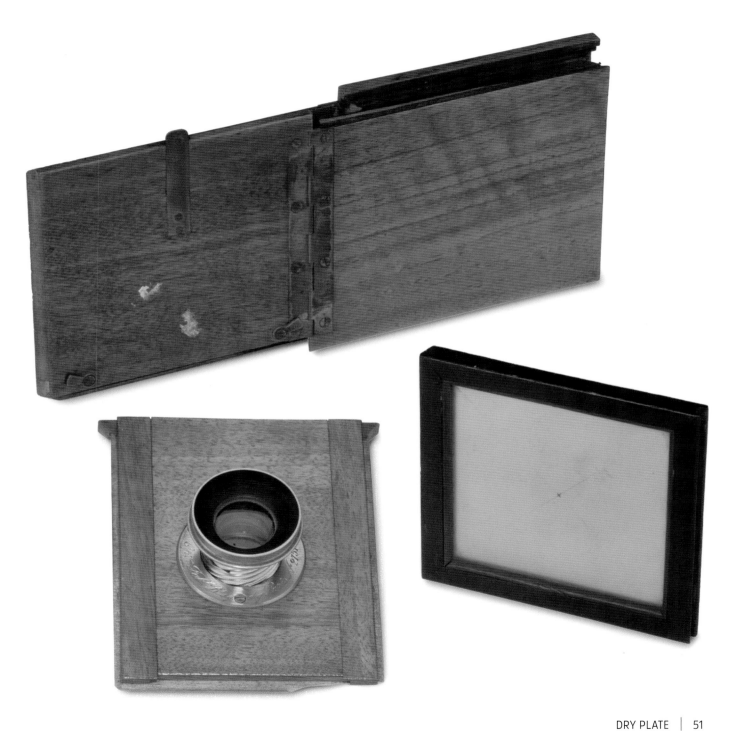

GEM APPARATUS

ca. 1880 | J. Lancaster & Son, Birmingham, England

Gift of Eastman Kodak Company, ex-collection Gabriel Cromer. 1983.1421.0081

The Lancaster Gem Apparatus, of about 1880, produced twelve identical "gem"-sized images (less than one-inch square) with a single exposure. Small, inexpensive photographs produced on ferrotype plates were very popular in the 1880s and 1890s. The lenses were simultaneously focused on a ground glass, and internal partitions kept the images separated.

An opening in the sliding front panel served as the shutter, making manually "timed" exposures. The camera's back accommodated wide plates for making more than a single group of images on a plate. Its list price was £5.

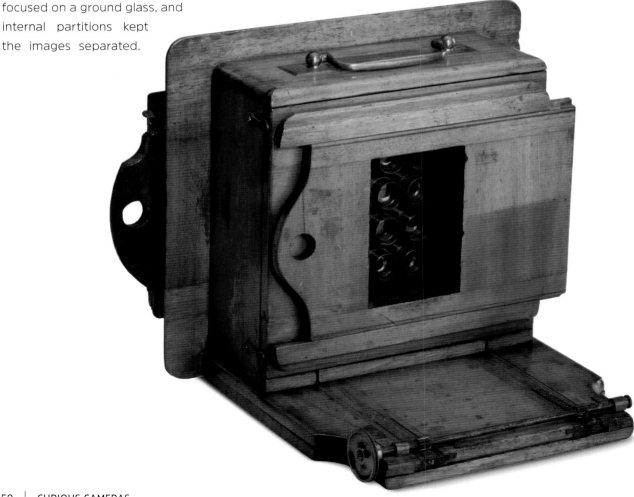

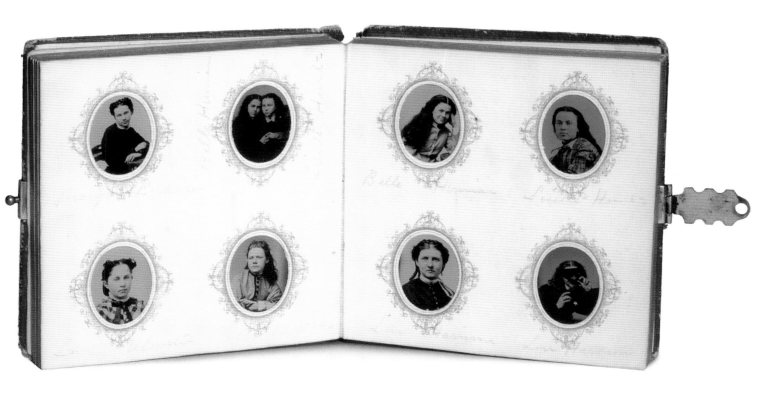

Above: Gem tintype portrait album owned by Emma M. Griswold, Lexington, Massachusetts, February 24, 1866. 94 tintypes. Gift of Alden Scott Boyer.

TOUROGRAPH NO. 1

ca. 1881 | Blair Tourograph & Dry Plate Company, Boston, Massachusetts

Gift of H. Edward Bascom. 1974.0037.2469

Designed for the challenges of landscape photography, the 1881 Blair Tourograph No. 1 was the first dry-plate camera manufactured in the United States. The self-contained and portable apparatus was touted as "Photography in a Nut Shell." Sliding front doors protected the lens, and the 5 x 7-inch dry plates were stored within the camera body for transport. In use, an indexed magazine of twelve plates was held in the smaller box located above the camera. Opening a brass dark slide located under each plate allowed the plate to gravity drop into the gate for exposure. Afterwards, the photographer manipulated the exposed plate back into the magazine through a cloth sleeve located at the back of the camera, then closed the dark slide. This procedure was repeated until all plates were used.

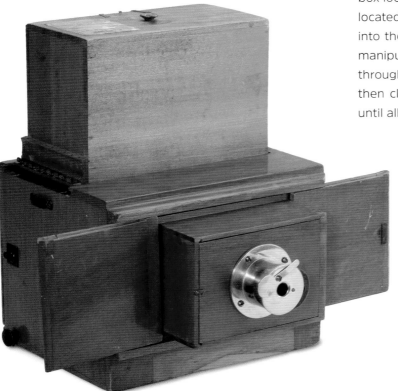

Above: Blair Tourograph No. 1, detail of camera magazine label.

PHOTO-REVOLVER DE POCHE

ca. 1882 | E. Enjalbert, Paris, France

Gift of Eastman Kodak Company, ex-collection Gabriel Cromer. 1974.0084.0022

The 1882 Photo-Revolver de Poche not only looked like a handgun, it was operated like one. Ammunition in the form of ten 20 x 20-mm dry plates was loaded in the cylinder, waiting to be exposed by the periscopic 70mm f/10 lens inside the nickel-plated brass barrel. The shutter release was, naturally, the pistol's trigger. After each picture, the shooter thumbed the hammer back, rotated the cylinder a half-turn, and listened for the click indicating the exposed plate had entered the storage chamber. Turning the cylinder back again placed a new plate in position behind the shutter. The camera had no viewfinder, but it did have a front sight to help you draw a bead on your target.

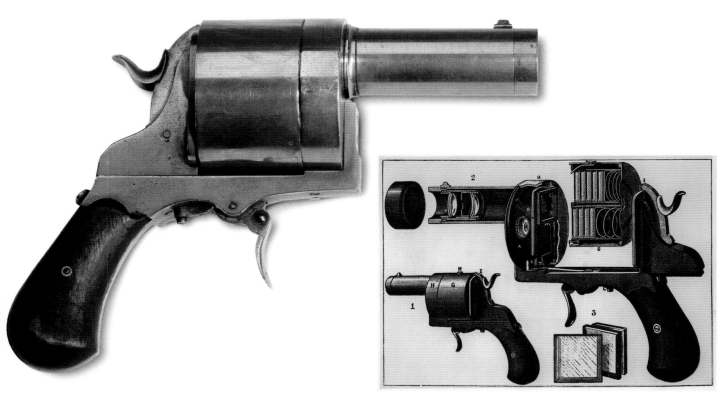

Above: Illustration showing cutaway view of E. Enjalbert Photo-Revolver de Poche, 1883.

COMPACT CAMERA

1883 | G. F. E. Pearsall, Brooklyn, New York

1974.0037.1048

In early 1883, George Frank E. Pearsall patented and marketed the Compact Camera, considered to be the first American-made self-casing camera. This rare apparatus, of which fewer than a handful are known to exist, is a self-contained, box-like folding-bed camera with a top-mounted leather handle for easy transport. The front panel opens ninety degrees to become the bed and reveals two parallel rails used to guide the lens standard for focusing. The camera's back opens to disclose a bellows-like focusing hood and a patented silk, roller-blind screen used for image composition and focus, instead of the much heavier traditional ground glass. Of the known examples of the Compact Camera, this is the only one finished with black paint and is thought to be the first one made.

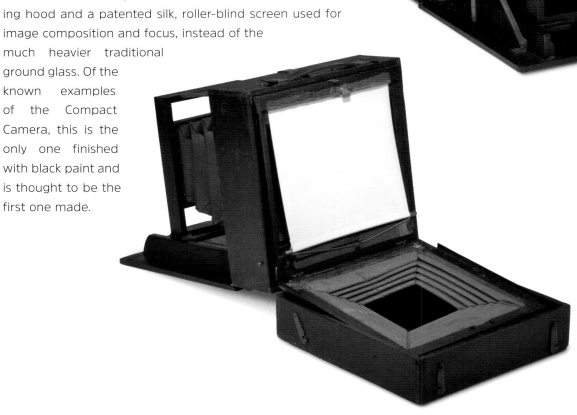

METAL MINIATURE CAMERA

ca. 1884 | Marion & Company Ltd., London, England

1974.0084.0033

In the 1880s, Marion & Company of London advertised its Metal Miniature Camera at 2⅜ x 2⅞ x 5¾ inches as "easily carried in the pocket," which may have been possible with the clothing styles of the time. The availability of dry plates had simplified photography, and manufacturers responded by designing smaller cameras. The Metal Miniature had a cast brass body and rear door, rack-and-pinion focusing, and a brass shutter operated by gravity when the release lever was pressed. A ground glass was used to focus the 55mm f/5.6 Petzval-type lens, and a tiny knob on the lens barrel operated the diaphragm. Two-inch square dry plates could be developed and printed at home, using the equipment and chemicals included in the £5 10s. outfit packed in a polished walnut case.

RACETRACK CAMERA (owned by Eadweard Muybridge)

ca. 1884 | Scovill Manufacturing Company (attrib.), New York, New York

Gift of George E. Nitzsche. 1978.1371.0047

During the 1870s, pioneering English photographer Eadweard Muybridge (1830–1904) worked with Leland Stanford, the California governor and railroad baron who founded Stanford University, to prove that a trotting horse briefly (very briefly) had all four hooves in the air. At Stanford's farm in Palo Alto, Muybridge constructed a fifty-foot shed with a painted backdrop marked with vertical, numbered lines to measure intervals of space. Opposite the backdrop, he placed twelve cameras (including the one shown here), each equipped with electro-mechanical trip-shutter and 1/1000 exposure—high-speed photographic technology of his own design. Pulling a two-wheeled sulky, Stanford's horse raced past the twelve cameras, tripping them in sequence as the iron rim of the sulky wheel contacted wires stretched across his path and closed an electrical circuit to trip the shutter. Muybridge not only proved that the horse's four feet did, indeed, leave the ground at the same time, he also found his niche—motion photography.

Above: Eadweard J. Muybridge (English, 1830–1904). *GALLOP; THOROUGHBRED BAY MARE, ANNIE G.*, ca. 1884–87. From the series *Animal Locomotion*. Collotype print. Gift of Eastman Kodak Company; ex-collection of Dr. George E. Nitzsche.

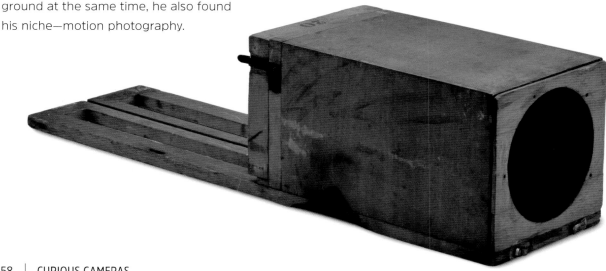

LANCASTER'S PATENT WATCH CAMERA

1886 | J. Lancaster & Son, Birmingham, England

Gift of Eastman Kodak Company. 1974.0084.0040

The Lancaster Patent Watch Camera was introduced in 1886 and manufactured by J. Lancaster & Son, Birmingham, England. It was made in men's or ladies' versions to resemble a pocket watch, with a self-erecting design using six spring-loaded tubes to function as a bellows upon opening. The men's version held a 1½ x 2-inch plate, while the smaller ladies' version used a 1 x 1½-inch plate. The original list price was £1 11s. 6d.

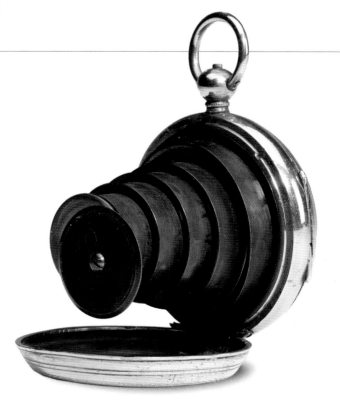

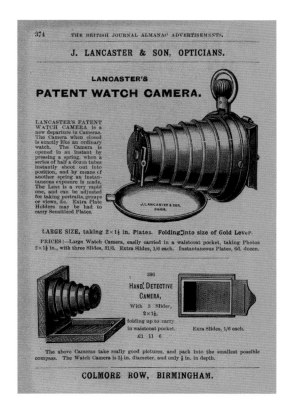

Left: Advertisement from the 1892 *British Journal Photographic Almanac* illustrating Lancaster's Patent Watch Camera.

"AMERICA" DETECTIVE CAMERA

ca. 1887 | Rudolf Stirn, Berlin, Germany

Gift of Eastman Kodak Company. 1974.0028.3317

In 1885, the Eastman Dry Plate Company simultaneously introduced Eastman's American Film, a paper-backed stripping film that came in rolls, and a series of film holders known as Eastman-Walker roll holders. Adaptable to a number of different cameras, the roll holders were necessary because initially there was no camera made specifically for the new film. This would soon change. In March 1886, George Eastman and Franklin M. Cossitt applied for a U.S. patent for a detective camera that used the film. Later that year, in October, Robert D. Gray and Henry E. Stammers filed a patent application for a camera in which a roll holder was an integral, nonremovable part. On the very day the Gray and Stammers patent was issued in 1887, Carl P. Stirn filed for a patent in Germany for the same invention. The two Americans invented the camera, but C. P. Stirn assumed responsibility for its further development and manufacture by his brother Rudolf in Berlin.

Debuting in 1887 as a hand-held box camera known as the "America" detective camera, the mahogany box camera made twenty-five 2⅞ x 4-inch exposures on Eastman's film. The Stirn apparatus had a unique form of image register that employed a spring-mounted lever whose end pointed to an engraved scale. As the film was wound

with a key, the lever advanced to the next engraved marking with a snapping of the spring, thus indicating one full exposure had been advanced; this motion also cocked the fixed-speed shutter. The film frame was slightly curved to compensate for the curved field of the lens, a component that would frequently be used in later years on inexpensive cameras such as the Baby Brownie. Other features included a single reflecting waist-level finder, a 105mm f/17 lens, and a sector shutter. Introduced at a retail price of 50 marks, the America was warmly received. Previously, the Eastman-Walker roll holders alone had been priced at 50 to 75 marks.

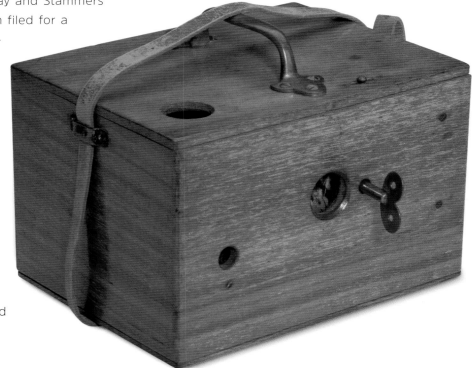

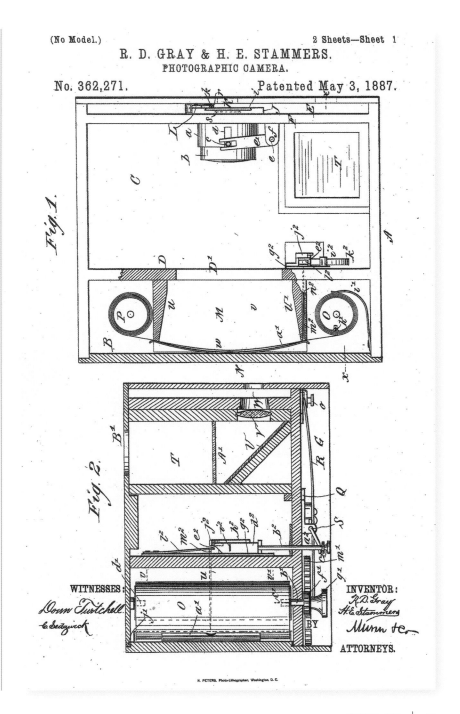

Right: Patent no. 362,271 for the "America" Detective Camera, issued May 3, 1887, filed by Robert D. Gray and Henry E. Stammers.

OMNIGRAPHE

ca. 1887 | E. Hanau, Paris, France

Gift of Eastman Kodak Company, ex-collection Gabriel Cromer.
1974.0037.2314

A benefit of dry-plate photography was that it allowed a photographer to carry a supply of ready-to-use plates. For manufacturers, a logical design step would be a camera that carried extra plates inside; another would be a camera that allowed the plates to be easily changed. Hanau of Paris took these steps and, using a pull-push plate changer, incorporated them into its 1887 Omnigraphe folding camera. After exposing a 9 x 12-cm plate, the photographer needed only to pull the nickel-plated brass handle on the magazine to allow the used plate to fall into the bottom of the chamber. A tambour door rolled out with the plates to keep them covered, and when the drawer was pushed back inside the camera, a fresh plate was in position. A counter on the back of the Omnigraphe tracked the number of shots. Scissors, or "lazy tongs," folding struts supported the Rapid Rectilinear lens. This version had a single speed rotating disc shutter.

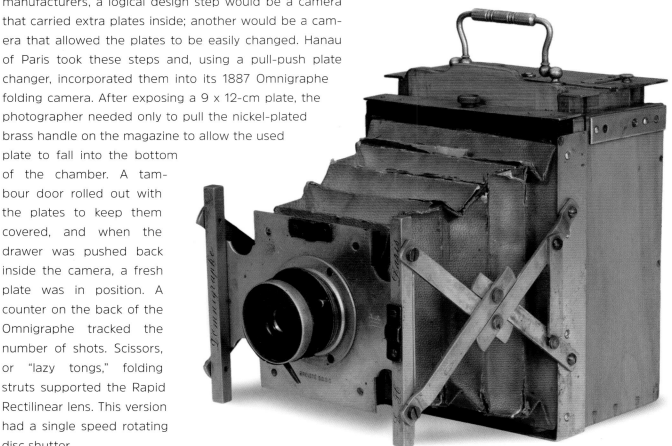

PHOTO-LIVRE

ca. 1888 | H. Mackenstein, Paris, France

Gift of Eastman Kodak Company, ex-collection Gabriel Cromer.
1974.0037.1815

Rudolf Krügener was a nineteenth-century German photographer with many camera-related patents to his credit. In 1888, he introduced his Taschenbuch, a box camera disguised as a small book. Book cameras weren't new, but Dr. Krügener's featured a clever mechanism for changing the 4 x 4-cm dry plates in the camera's built-in twenty-four-exposure magazine. The Taschenbuch was manufactured under different names for sale in various countries. This Photo-Livre version was made to be sold by Mackenstein of Paris. The 65mm f/12 lens was hidden in the "spine," and the shutter was actuated by pulling strings on either side of the camera. There was no viewfinder because using one to aim the camera would have revealed the ruse. Other manufacturers continued a tradition of the book camera, using roll films and even 110 Pocket Instamatic cartridges, so we may see a digital version one day.

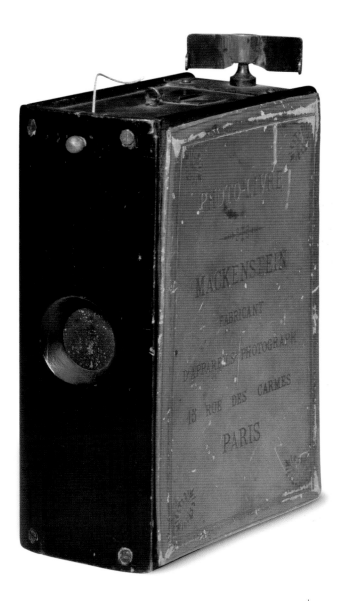

CONCEALED VEST CAMERA, NO. 1

1888 | C. P. Stirn, New York, New York

1974.0037.2288

Walking about with a hidden camera has long had its appeal. Judging by the sales figures for Stirn's Patent Concealed Vest Camera, in the 1880s there were plenty of surreptitious photographers willing to pay $20 for the seven-inch-diameter device. Although originally designed by American inventor R. D. Gray, Stirn purchased the rights, and the cameras were produced in Berlin, Germany. The camera was worn low on the chest, suspended by a neck cord. The lens and exposure advance knob protruded through buttonholes and the shutter was operated by pulling a string attached to a shaft near the bottom edge of the brass body. The circular dry plates were loaded into the camera by opening

the clamshell rear door and inserting a six-exposure disc. This had to be done in a darkroom, as did the unloading. Included in the camera's price was a wooden storage box that had a threaded plate for tripod mounting. A small door on the box opened to reveal the lens and advance knob, and a hole was provided for the shutter string.

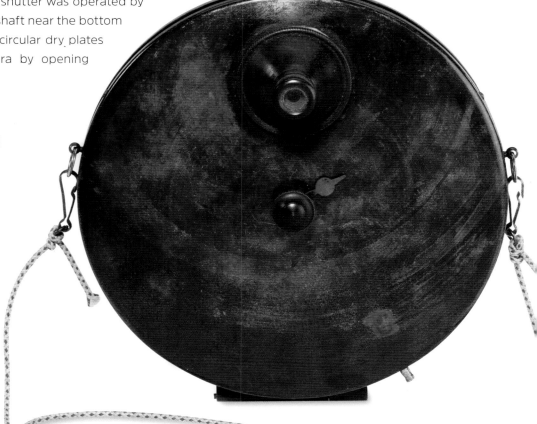

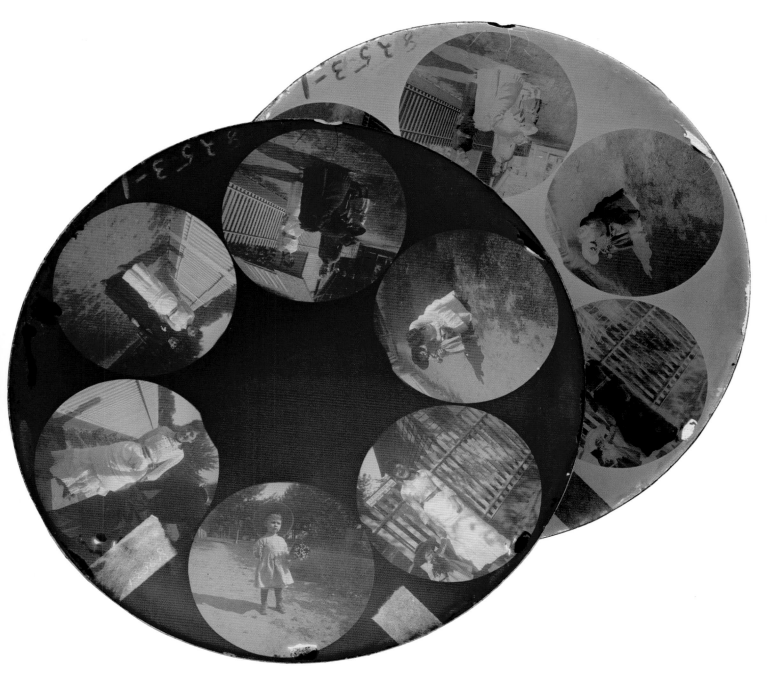

Above: Unidentified photographer. [*Six images made with Stirn's Concealed Vest Camera*], ca. 1890. Gelatin dry plate negative.

DEMON DETECTIVE CAMERA NO. 1

ca. 1889 | American Camera Company, London, England

Gift of Eastman Kodak Company, ex-collection Gabriel Cromer. 1982.0237.0002

Invented in 1889 by Walter O'Reilly, the Demon Detective Camera No. 1 was manufactured for the American Camera Company of London, England. Stamped from nickel-plated brass, the back was quite decoratively embossed. Sitting at the end of the funnel-shaped front, the achromatic doublet lens and simple flap shutter made a single, circular, instantaneous exposure on a dry plate. There was no viewfinder to aid in aiming the camera. A hinged door at the bottom gave access for changing the plate. An advertisement announcing the larger No. 2 model claimed 100,000 of the smaller No. 1 model sold in twelve months. Its list price was five shillings, including plates and chemicals.

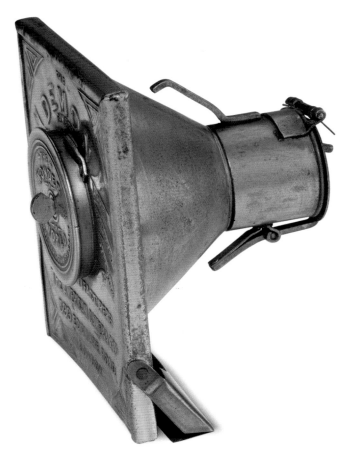

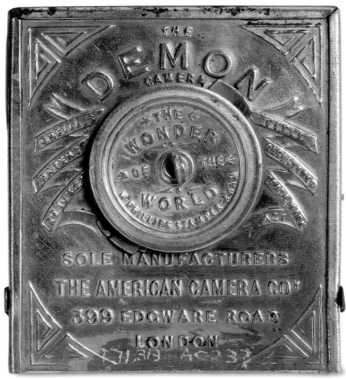

TOM THUMB CAMERA

ca. 1889 | Max Juruick, Jersey City, New Jersey

Gift of Eastman Kodak Company. 1974.0037.2580

The Tom Thumb Camera falls into the category of detective cameras, its disguise being the finished wooden carrying case. It also could be removed from the case and used as a handheld camera. Invented by James Ford and manufactured by Max Juruick of Jersey City, New Jersey, in 1889, the early versions were labeled Ford's Tom Thumb Camera. It used dry plates and produced 2½-inch square images that could be made round by inserting a circular mask.

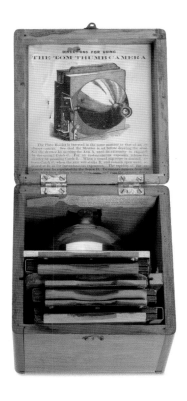

Left: Detail showing inside of Tom Thumb camera.

PHOTOSPHERE

ca. 1889 | Compagnie Française de Photographie, Paris, France

Gift of Eastman Kodak Company, ex-collection Gabriel Cromer. 1974.0037.1816

As the ranks of amateur photographers swelled in the 1880s, camera manufacturers were pressured to make their products easier to tote along, yet robust enough to take the bumps encountered on photo outings. Compagnie Française de Photographie of Paris answered with their Photosphere in 1889. Made of pre-tarnished, silver-plated brass, this odd-looking device used a rigid lens housing instead of a collapsing design. The lens was a periscopic 95mm f/13. The hemispherical part of the bell-shaped structure housed the spring-powered shutter, which had a matching shape. A tiny knurled knob on the side adjusted the spring tension for shutter speed settings, but it was strictly guesswork. Bubble levels on adjacent sides helped frame the subject, no matter which orientation of the 9 x 12-cm plates the photographer chose. A finder could be clipped on either of the two mounting shoes. Options like a twelve-plate magazine back and a clamp to secure the camera to your bicycle kept Photosphere popular and sales going along until the turn of the century.

IMPROVED EMPIRE STATE VIEW CAMERA (14 X 17)

ca. 1890 | Rochester Optical Company, Rochester, New York

Gift of 3M Foundation, ex-collection Louis Walton Sipley. 1977.0415.0374

In the 1890s, the Rochester Optical Company made some very large view cameras, including this 14 x 17-inch Improved Empire State View, part of a line that included sizes up to 20 x 24 inches. Unlike the smaller models, this camera featured a fixed front standard and rear focus. Made of mahogany with polished brass fittings, it offered movements to satisfy professional photographic needs. The 1893 catalog shows two models, single and double swing, priced at $50 and $55 respectively (excluding lens).

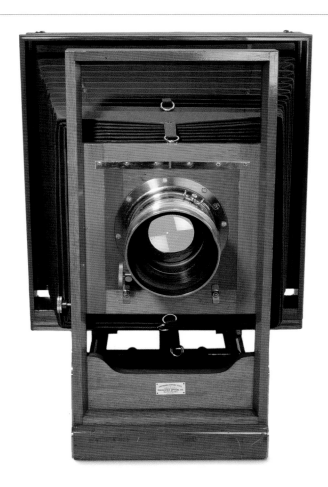

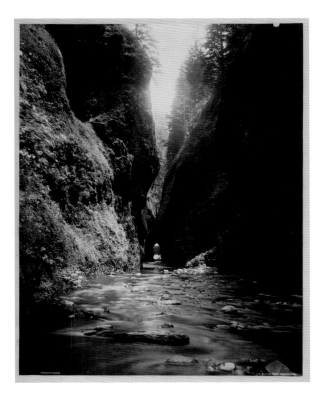

Left: F. Jay Haynes (American, 1853–1921).
ONEONTA GORGE, OREGON, ca. 1890.
Albumen silver print. Gift of Harvard University.

PHOTO-CRAVATE

1890 | Edmund & Leon Bloch, Paris, France

Gift of Eastman Kodak Company, ex-collection Gabriel Cromer. 1974.0084.0050

Designed by Edmund Bloch of Paris, the Photo-Cravate had a tiny camera concealed behind an innocent-looking piece of 1890s men's neckwear. The body of the all-brass camera was only seven millimeters thick, but it contained six 25-mm square dry plates in holders attached to a tiny conveyor chain. A small knob on the camera protruded through the tie like a shirt button and was turned to bring a fresh plate behind the 25mm f/16 lens, which was positioned on the necktie to resemble a stickpin jewel. Making an exposure meant squeezing and relaxing a rubber bulb with a tube that operated the pneumatic shutter. The savvy photographer would vary the exposure time according to the lighting conditions, holding the bulb longer to keep the shutter open. Known in English-speaking markets as the Detective Photo Scarf, the Photo-Cravate was priced at $21 in 1891, with replacement ties in various colors and patterns available separately.

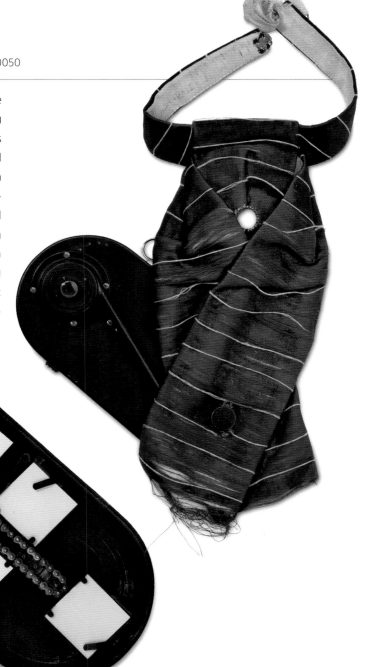

SCOVILL & ADAMS COMPANY BOOK CAMERA

1892 | Scovill & Adams, New York, New York

1974.0084.0053

One of the rarest of all the detective cameras is the Scovill & Adams Company Book Camera of 1892. Disguised as a bundle of three schoolbooks, titled *French, Latin,* and *Shadows*, and secured by a leather carrying strap, its cover would be blown when put to photographic use. The multiple manipulations needed to prepare the camera for imaging required the group of books to be inverted, spines-up, in a most unnatural position. The retail price was $25.

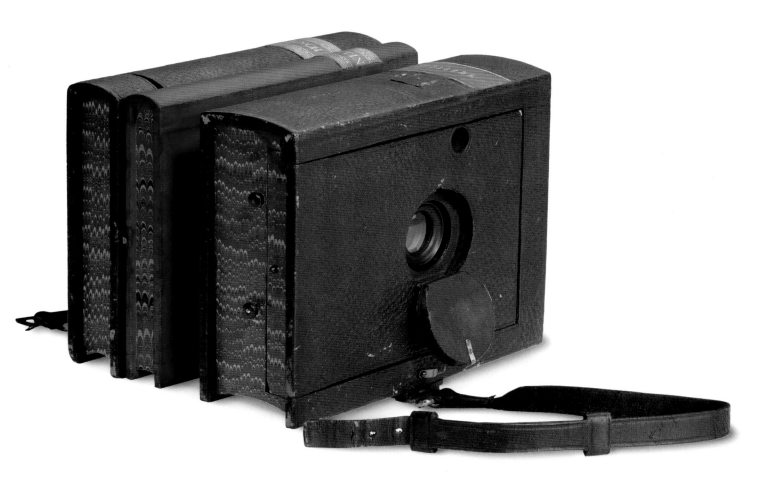

PHOTORET

ca. 1893 | Magic Introduction Company, New York, New York

Gift of Eastman Kodak Company. 1974.0084.0066

In the 1890s, almost every man carried a pocket watch. No one then would have looked twice at someone with a watch in his hand. In 1893, American inventor Herman Casler (1867–1939) was granted a patent on his Photoret camera, a nickel-plated metal device shaped like an ordinary timepiece of the day. It was advertised as having "the exact size and appearance of a gent's watch." For $2.50, the buyer received a sliding-lid wooden box containing the camera and a tin of six film discs. Similar to that of the Kodak Disc camera, which would appear nearly a century later, the Photoret disc rotated after each exposure until all frames were complete. Film needed to be loaded and unloaded in the dark. Camera operation was simple. Unlike the later Expo and Ticka (see page 126) watch cameras, the Photoret lens was in the watch body, not the stem. Moving the stem sideways brought a fresh film sector into position, with a counter keeping track. The watch was aimed and the stem depressed to trip the shutter. Despite its tiny lens and 12 x 12-mm negatives, the Photoret's images could be enlarged to snapshot size with good sharpness.

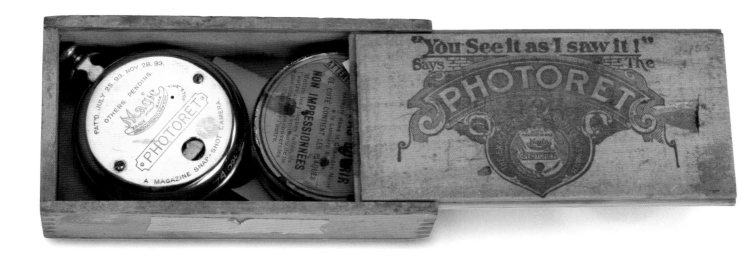

KAUFFER PHOTO-SAC À MAIN

ca. 1895 | Charles Alibert, Paris, France

Gift of Eastman Kodak Company, ex-collection Gabriel Cromer. 1974.0037.1549

Though not really a detective camera, the Photo-Sac à Main was disguised, or at least housed, in a leather-covered wooden case resembling an elegant ladies handbag. Manufactured by Charles Alibert of Paris in 1895, the camera used a strut-mounted leather bellows concealed by overlapping front flaps whose elegant nickel-plated trim and stylish latch enhanced the guise. The bag's rear compartment was roomy enough for three double 9 x 12-cm dry-plate holders, along with a ground-glass back.

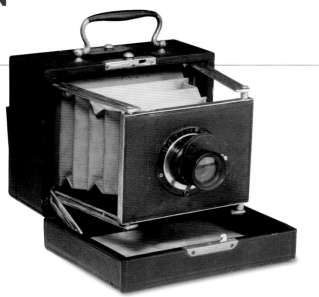

PHOTAKE

ca. 1896 | Chicago Camera Company, Chicago, Illinois

Gift of Eastman Kodak Company. 1974.0084.0070

The Photake camera was manufactured starting in 1896 by the Chicago Camera Company. It had a four-inch diameter cylindrical metal body resembling a coffee can. Five dry plates were arranged around the inner circumference of the can, and by rotating the outer cover, which contained the lens, the photographer could expose the next plate. Advertised as "An ideal Christmas gift," the camera was packaged in a wooden box along with six dry plates and enough chemicals and paper to make twelve prints. It retailed for $2.50.

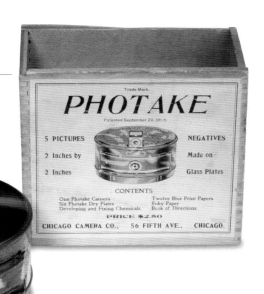

POCKET KOZY (ORIGINAL MODEL)

ca. 1897 | Kozy Camera Company, Boston, Massachusetts

Gift of Eastman Kodak Company. 1995.0151.0001

The Pocket Kozy camera, first introduced in 1897 by the Kozy Camera Company of Boston, was different from traditional self-casing, folding cameras. Instead of using the classic drop-bed design, Hiram A. Benedict created a novel camera that opened like a book, with red leather bellows fanning out like pages. Eventually there were three versions, but the camera shown here is the first model, and surely fewer than a handful survive today. The first model had a flat front and opened with the bellows facing the rear of the camera, with the lens and shutter located in the "spine" position. The second and third models placed the bellows to the side with the lens on the curved front. All versions made twelve or eighteen 3½ x 3½-inch exposures on roll film. In 1897 the camera sold for $10 and could be purchased on a time payment plan. Benedict hoped to sell 100,000 units, though it is safe to assume that goal was not reached.

VEST POCKET MONROE

1898 | Monroe Camera Company, Rochester, New York

1974.0037.1553

Introduced in 1897 by the Monroe Camera Company of Rochester, New York, the Vest Pocket Monroe is most likely the first tongs-style "vest pocket" type of miniature-plate camera. From a collapsed size of less than 1½ inches, including the double-plate holder, the camera extended to 4¼ inches on brass lazy-tong struts. The first versions' struts were nickel plated; shown here is the 1898 version, which has brass struts. The Vest Pocket Monroe sold at a retail price of $5 and produced 2 x 2½-inch images.

Monroe Camera Company, along with the Premo, Poco, Rochester, and Ray Camera companies, was absorbed into the Rochester Optical Company in 1899, which was acquired by Eastman Kodak Company in 1903.

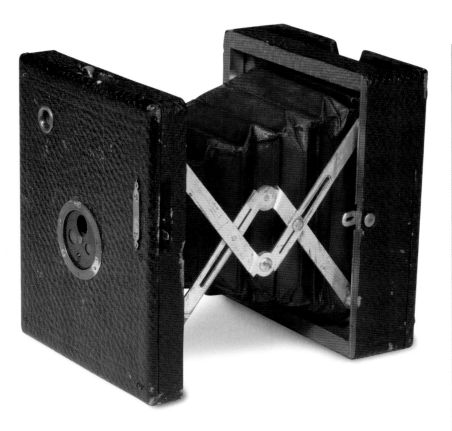

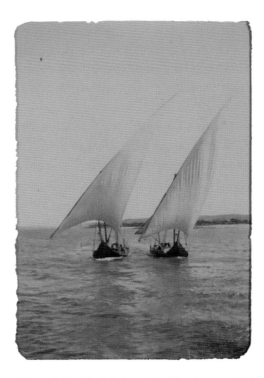

Above: Unidentified photographer. [*Amateur snapshot made with the Vest Pocket Monroe*], ca. 1900. Gelatin printing-out paper (POP). Gift of Michael Auer.

IVES KRŌMSKŌP TRIPLE CAMERA

ca. 1899 | F. E. Ives, Philadelphia, Pennsylvania

Gift of Raymond O. Blanchard. 1977.0037.1043

IVES KRŌMSKŌP MONOCULAR VIEWER

ca. 1899 | F. E. Ives, Philadelphia, Pennsylvania

Gift of 3M Foundation, ex-collection Louis Walton Sipley. 1977.0415.0217

The Ives Krōmskōp system consisted of a paired apparatus for the capture and viewing of still images in full color. Offered in both monocular and stereoscopic versions, it was an additive color system developed and patented in the late 1890s by Frederic Eugene Ives (1856–1937) of Philadelphia, a prolific inventor and perfecter of the inventions of others with more than seventy patents to his name, including those for the practical printing of pictures in newspapers and magazines.

The Ives Krōmskōp Triple Camera simultaneously made three color-separation records of the scene behind red, green, and blue filters. A set of positive transparencies from these records, when viewed in perfect mechanical alignment through filters of the same colors, reproduced the colors of the original scene. The camera used a single 2½ x 8-inch glass plate, exposing the three 2¼ x 2½-inch images side by side. Positives made from these negatives were strung together with cloth tapes so that an image set, or Krōmogram, could be laid over the step-like structure of the Krōmskōp viewer. Looking into the viewing lens revealed a magnified full-color image. For times when daylight was not available for the viewer, a night illuminator (not shown here) was provided.

On the outside, the camera was a simple mahogany box with brass-mounted lens, sliding-plate shutter, and brass carrying handle. Inside, the camera's prisms deflected light to the left and right for the red and green exposures. Undeflected light passed straight back to make the blue exposure. Adjustable masks balanced the light for the individual records according to the sensitivity of the plate being used. The ivorine label above the lens shows September 5, 1899, as the patent date. The lower label lists seven patents on the system from 1890 to 1899.

The Krōmskōp Monocular Viewer was a brass-bound mahogany box with a brass-mounted viewing lens and an adjustable reflector. Each step was capped by a colored filter, which was, in descending order, red, blue, and green. The Krōmogram's cloth strips, acting as hinges, allowed the three images to be arranged on the steps in the proper sequence.

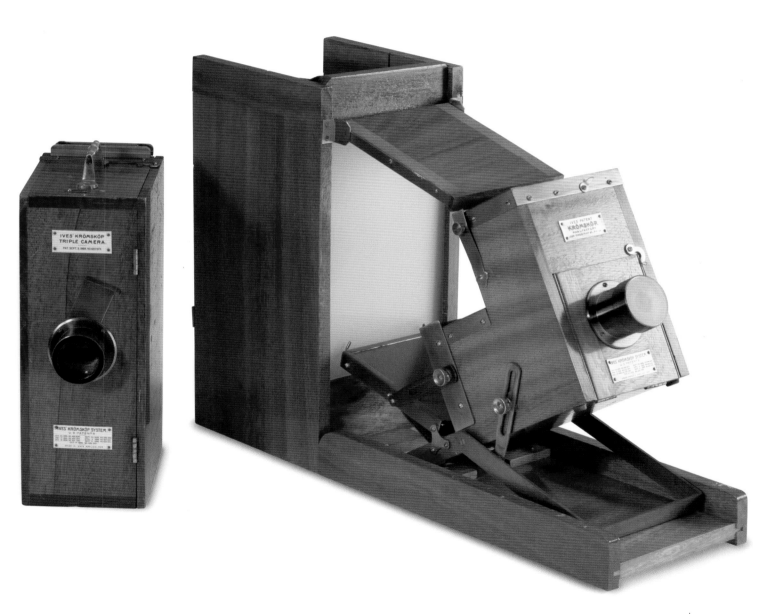

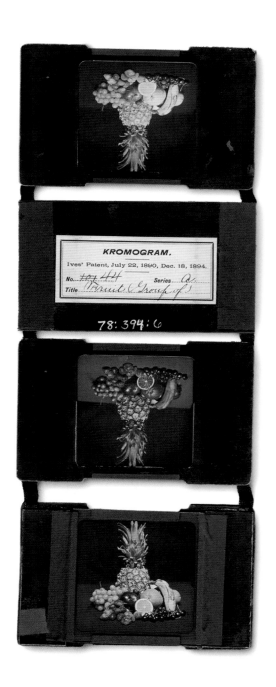

Above: Ives Krömsköp Triple Camera, detail showing color filters inside camera.

Left: Frederic E. Ives (American, 1856–1937). [*Fruit arrangement*], ca. 1894. Transparency, gelatin on glass (Kromograms). Museum accession.

SIGRISTE

1899 | J. G. Sigriste, Paris, France

1974.0037.0025

This beautiful leather-covered wooden-box camera was manufactured by the Swiss Jean Guido Sigriste in Paris. With its tapered form, a style sometimes referred to as a Jumelle, the Sigriste camera looks much like a fine piece of French furniture. Introduced in 1899, it was a mechanical marvel made in several format sizes, including stereo versions. The Sigriste featured a focal-plane shutter with one hundred available speed combinations from 1/40 to 1/2500 second, which were accomplished through the adjustment of spring tension and slit width. An internal bellows was fixed behind the lens and tapered to an adjustable slit in the focal plane that traveled across the plate. The push-pull magazine changer held twelve plates that were protected by a tambour door as the box was withdrawn. This particular 4.5 x 6-cm model has a 110mm f/3.6 Krauss Zeiss Planar lens in a helical focusing mount. The retail price, without lens, was 350 francs.

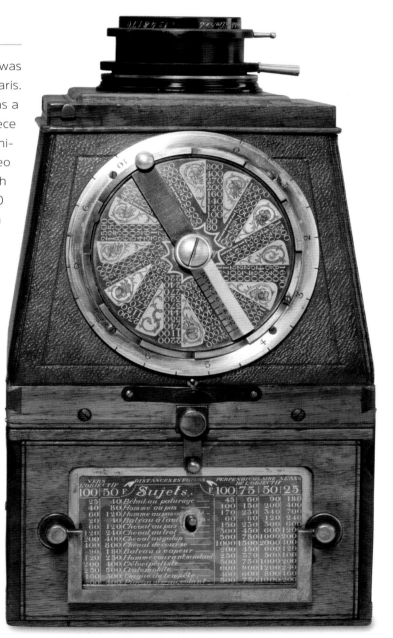

LE CHAMPION APPAREIL PHOTOGRAPH-COMPLET

1900 | M. L. Friard, Paris, France

Gift of Eastman Kodak Company, ex-collection Gabriel Cromer. 1974.0028.3475

If you were at the Paris Exposition in 1900 and had forgotten your camera, for fifty centimes you could buy a Le Champion Appareil Photograph-Complet. In a packet about 3 inches square by 1/2-inch thick, M. L. Friard of Paris gave you everything needed to produce four pictures. Once opened, the heavy paper camera was unfolded and snapped together. In place was a sensitized dry plate, ready to be exposed by pulling the shutter string. A folded paper finder atop the camera helped compose the scene, and once the scene was captured, chemicals included in the kit developed the plate for printing. The outfit even included a paper funnel. Four sheets of print paper were inside, as well as a printing frame and the necessary chemistry. A set of detailed instructions guided the user through the process. The Le Champion is the oldest one-time-use camera in the Eastman House collection.

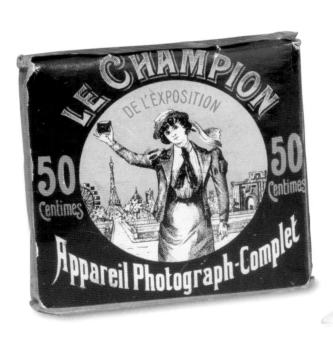

TÉLÉPHOT-VÉGA

ca. 1900 | Véga SA, Geneva, Switzerland

1974.0037.2810

Today's photographers give little thought to how easily they can remove a camera lens and replace it with a tele-photo, or move a control on their camera and greatly mag-nify the image of a faraway subject. Nineteenth-century photographers didn't have that luxury. Only by moving closer to their subject were they able to create a larger image on their sensitized plates. This posed a major prob-lem for wildlife and naturalist work, which required pictures of creatures in the wild, undisturbed by camera-wielding intruders. Large diameter, long focal-length optics were an established part of astronomy, but adapting this tech-nology to photography presented engineers with great challenges. Not until the 1890s did a workable telephoto lens become available.

The problem of accommodating a forty-inch lens in a camera that didn't require a pack animal to tote it was successfully addressed by the Swiss firm of Véga SA. The solution was to use a mirror to "fold" the light path linking the lens to the 7⅛ x 9½-inch film plate, which immediately reduced the length of the camera by half. When combined with a hide-away upper portion, the result was an instrument of reasonable size, considering what it could do.

Preparing the Téléphot-Véga for duty was not unlike setting up a tent. Raising the front and rear panels tightened the bag they were attached to, and locking the struts kept it all in place and aligned. The lens board and bellows were adjusted for focus by the familiar rack-and-pinion

method. Folded flat against the lower body was the gun-sight finder, ready to swing out when needed. Setting, adjusting, and tripping the optional roller-blind shutter was all handled by controls on the body of the Thornton-Pickard unit. Basic operation was the same as with any other camera of the day. The difference was that with the Téléphot-Véga, the focused-on subject was much farther from the photographer than it would have been with an ordinary camera—perhaps an important distinction when recording the behavior of a tiger in its native habitat.

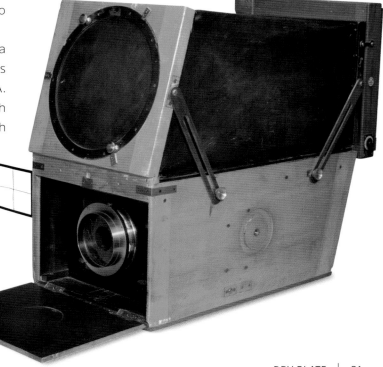

DECEPTIVE ANGLE GRAPHIC

ca. 1901 | Folmer & Schwing Manufacturing Company, New York, New York

Gift of Graflex, Inc. 1974.0037.2326

The Deceptive Angle Graphic was manufactured by Folmer & Schwing Manufacturing Company in New York City. At the time of its introduction in 1901, the public was fascinated by candid photography that used "detective" or "deceptive-angle" cameras. It was designed to look like a stereo camera with a pair of fake lenses on the front while an obscure lens mounted on the side of the camera, ninety degrees to the photographer's perceived line of vision, took the actual pictures. The retail price, with Rapid Rectilinear lens, was $67 in 1904.

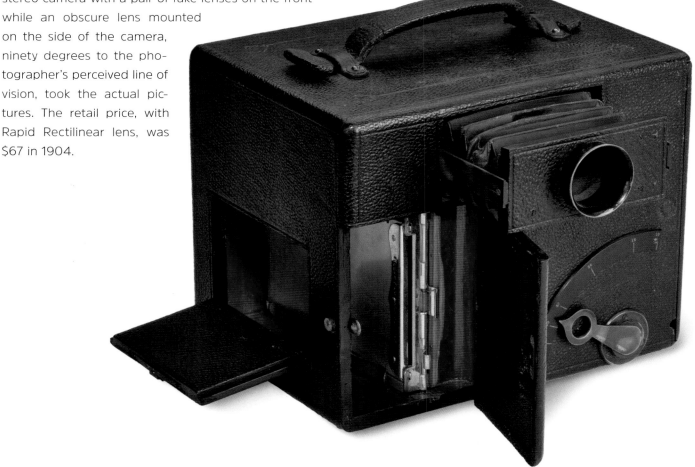

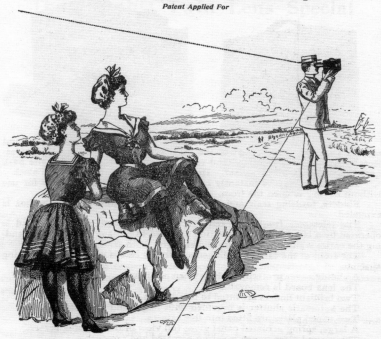

The Deceptive Angle Graphic

Patent Applied For

This camera is in every sense of the word a detective camera, being thoroughly disguised to resemble a stereo camera and so arranged as to photograph subjects at right angles to its apparent line of vision.

It is of the twin lens type, fitted with regular lens and shutter for exposure and a matched lens through which the subject is seen in the same size as on the focusing screen.

This camera possesses unequalled advantages for detective camera work. It is carefully constructed of selected, kiln dried mahogany and covered with the best quality of black grained leather.

The side of the camera is fitted with a pair of dummy stereo lenses and imitation finder apparently in the direct line of vision when the operator is focusing.

The rack and pinion focusing device is concealed inside the camera with the exception of a small focusing lever operated by the thumb from the outside.

The point of the focusing lever acts as an index on a graduated focusing scale for off-hand, snapshot work when in use without focusing screens.

The front of the camera is hinged and may be opened to change or clean the lenses.

Two rectangular apertures are provided in the front through which the lenses work.

STEREO GRAFLEX

ca. 1903 | Folmer & Schwing Manufacturing Company, New York, New York

Gift of Dr. Henry Ott. 1983.0836.0006

Unique among stereo cameras, Folmer & Schwing's Stereo Graflex of 1903 provided stereoscopic viewing on a ground glass by incorporating dual eyepiece magnifiers—just as in a stereoscope viewer. The reflex viewing of the Graflex cameras enabled the operator to arrange and study the composition right up to the time of exposure. The image would be seen upright, though still laterally reversed. The minimum focal length was 5⅞ inches and the telescoping front allowed a maximum of nine inches. Designed to use 5 x 7-inch dry plates, this camera sold for the lofty price of $318, including the matched pair of Goerz Celor Series III lenses.

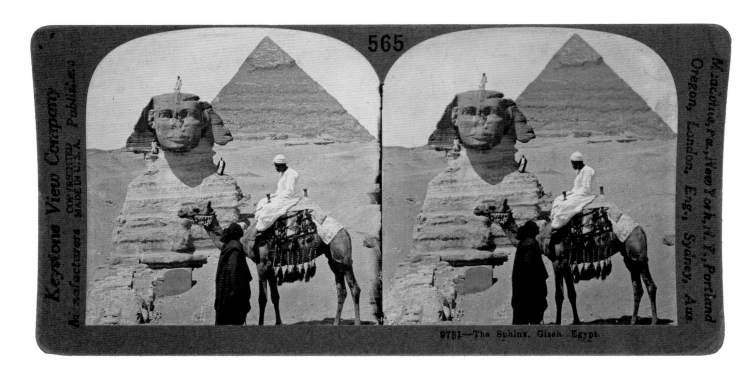

Above: Keystone View Company (American, 1890–1940). *THE SPHINX, GIZA, EGYPT,* ca. 1900. Albumen silver print. Museum accession.

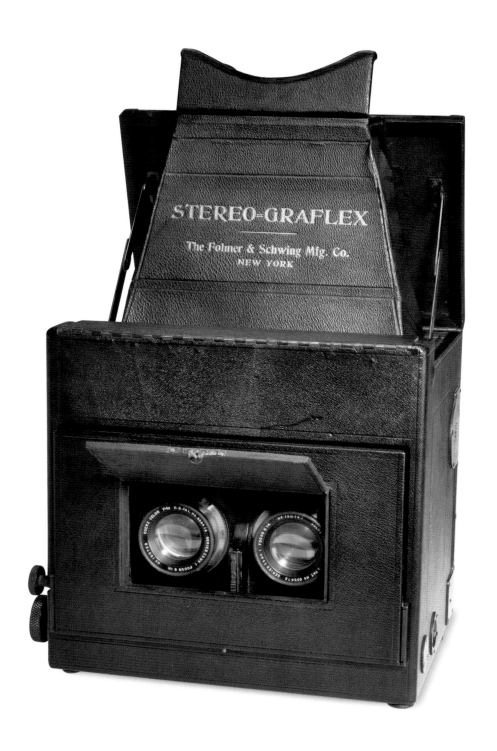

CENTURY GRAND STUDIO CAMERA

ca. 1904 | Century Camera Company, Rochester, New York

1978.1371.0057

It would seem to go without saying that the essential tools of the portrait photographer would be a studio and a camera. And yet, for the portrait photographer of the past, it was not as simple as that. Just as any hammer won't do the job right for the carpenter, most cameras were not suited to the work of the portrait photographer. When nails are pounded, the tool of choice is a claw hammer, not a mallet or ball-peen or sledge, and when formal portraits were made, the best camera for the job was a studio, not a field, detective, or subminiature model. Cameras, like hammers, are designed for specific purposes.

For more than fifty years, the Century Studio camera was the prime apparatus used for portraiture. The company began producing cameras in 1900 and within two years listed studio cameras in its catalogs. Eastman Kodak Company acquired Century in 1903 and Folmer & Schwing Manufacturing in 1905, merging the two to create its professional apparatus division, which produced studio cameras through 1926. After that, the division was spun off and the new company continued to make the Century Studio Camera, first as Folmer Graflex (1926–46) and then as Graflex, Inc. (1946–55). The camera was sold separately or in a grouping known as the Century Universal Studio Outfit, which consisted of the camera, the Semi-Centennial Stand, and one plate holder. Numerous styles of backs were offered, allowing the photographer a choice of image sizes.

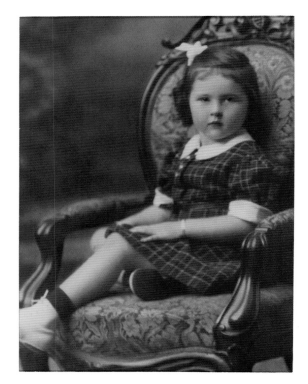

Above: Unidentified photographer. [*Portrait of little girl*], ca. 1920. Gelatin silver print with applied color. Gift of 3M; ex-collection Louis Walton Sipley.

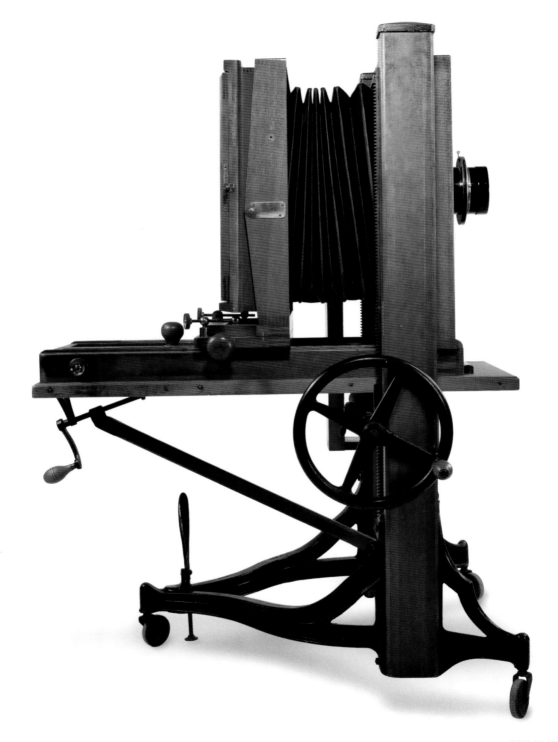

NATTIA

ca. 1905 | Adams & Company Ltd., London, England

Gift of Graflex, Inc. 1974.0037.2313

Making photography easy and convenient for amateurs kept many camera designers busy after George Eastman's extraordinary success with the Kodak. The goal for companies such as Adams was to offer a sturdy, capable camera that could be carried in a coat pocket or purse. In 1905, the engineers at Adams's London works created what they called "The Best" pocket camera available. The versatile Nattia could use dry plates, cut film, or roll film, simply by changing from one holder to another. Focusing was easy with the rack and pinion with distance scale, and a bright finder made for fast framing of subjects. The shutter behind the Ross 9-inch f/6.3 Zeiss Patent Protar lens was set with a push-pull rod and tripped with a button at the exact location of the user's index finger.

Being an Adams camera, the Nattia had the features of larger cameras, such as a rising front and two bubble levels (for vertical and horizontal images). Best of all, the nineteen-ounce Nattia folded into a tight, tidy package that could be toted along and be ready for action in seconds. It was priced under £17.

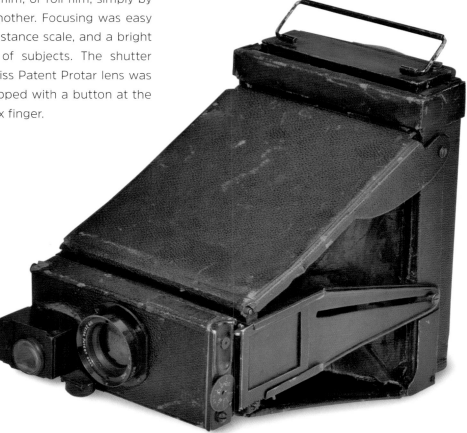

SOHO TROPICAL REFLEX

ca. 1905 | Marion & Company Ltd.,
London, England

1974.0037.2909

Based on a design by A. Kershaw in London, England, this type of tropical camera was originally distributed by Marion & Company Ltd., also of London. Due to several mergers and company name changes and a production run of more than forty years, cameras of this design have worn numerous manufacturer labels. This specific example is made by Soho Limited and dates from the 1940s. Constructed of French polished teakwood and brass hardware, the Soho Tropical Reflex camera has a special red leather bellows and focusing hood, making it among the most attractive cameras ever produced. It incorporates some novel mechanics, with the reflex mirror moving back as it retracts, allowing the use of shorter focal length lenses. The rotating back is matched with a rotating mask in the reflex viewer to accommodate horizontal and vertical use.

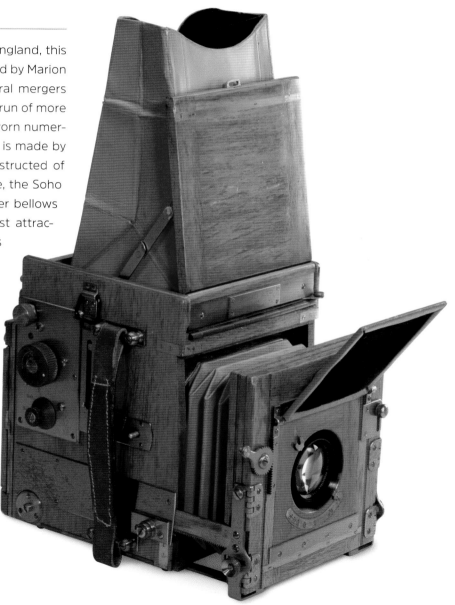

TELEPHOT VEGA STEREOSCOPIC CAMERA

1906 | Véga SA, Geneva, Switzerland

Gift of Roland Leblanc. 1974.0037.2009

What may look like a 1950s vintage clock radio is actually the Telephot Vega Stereoscopic Camera of 1906. Manufactured by Véga SA in Geneva, Switzerland, the ingenious lens paths made this telephoto stereo camera special. Using two mirrors in each lens path, it not only shortened the twenty-two-inch focal length to make the camera body smaller, it also crossed the projected images, left lens to right image, so that the images are in the correct position and prints can be made without inversion. The lenses individually rack forward for focus, and the plate holder slides out three inches to further aid in the compactness of the camera. Intended for telephoto photography, the lenses are spaced approximately ten inches apart, more than triple a "normal" interocular distance, for a heightened stereo effect.

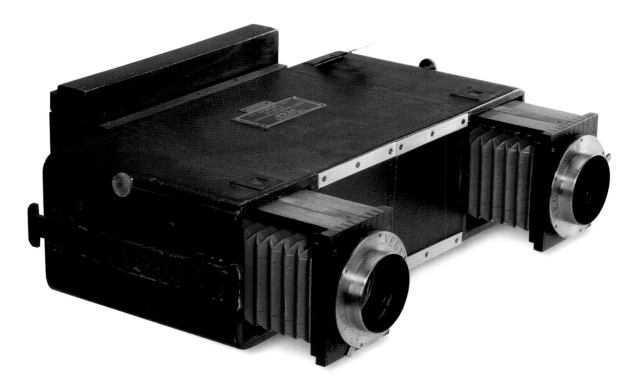

NATURALISTS' GRAFLEX

1907 | Folmer & Schwing Division of Eastman Kodak Company, Rochester, New York

Gift of David Fischgrund. 1990.0011.0001

The Naturalists' Graflex was designed especially for naturalists' work—photographing birds and wild animals with long-focus or telephoto lenses. The camera was manufactured by the Folmer & Schwing Division of Eastman Kodak Company of Rochester from 1907 to 1921. It was similar to many of the Graflex cameras of the period, with the exception of its very long extension front that accommodated lenses up to 26 inches in focal length. Features included a spring back to hold individual plates or film packs, a focal-plane shutter curtain, and a large reflex viewing hood that was contoured to the photographer's face. From the second year of production, the viewing hood was hinged so it could be rotated upward. The Naturalists' Graflex was available only in the 4 x 5-inch size and the retail price, without lens, was $190.

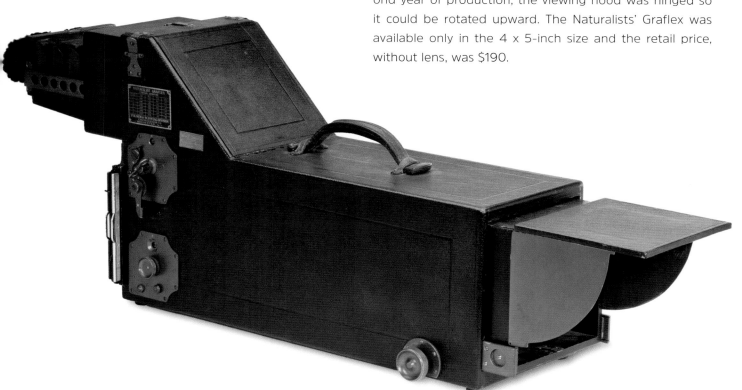

KORONA PANORAMIC VIEW

ca. 1914 | Gundlach-Manhattan Optical Company, Rochester, New York

Gift of Mrs. Allen E. Kappelman. 1978.1371.0010

Panoramic cameras didn't come any simpler than the Korona Panoramic View. Instead of relying on gears, springs, and moving parts to shift lens and film, the Gundlach-Manhattan model was basically a view camera that was much wider than it was tall. This type of panoramic camera was fitted with a wide-angle lens that could cover the width, leaving the top and bottom of the image cropped to create the extra-wide prints. There was no need for a curved film plane, clock motor, or any of the other complexities of cameras like the Cirkut (see pages 122–27). While the Korona didn't have the field of view of the motorized cameras, it was more than adequate for most panoramic work.

The Panoramic View was built in three sizes: 5 x 12 inches, 7 x 17 (pictured here and listed for $50 in 1914), and 8 x 20. Gundlach-Manhattan made its own lenses under the Turner-Reich name,

and for this camera they recommended a T-R Anastigmat twelve-inch f/6.8, costing $90 with shutter. At ten pounds, the 7 x 17-inch version of the camera was easily packed for outdoor work, and its elegant cherry and bright-finish metal construction could withstand the rigors of professional duty.

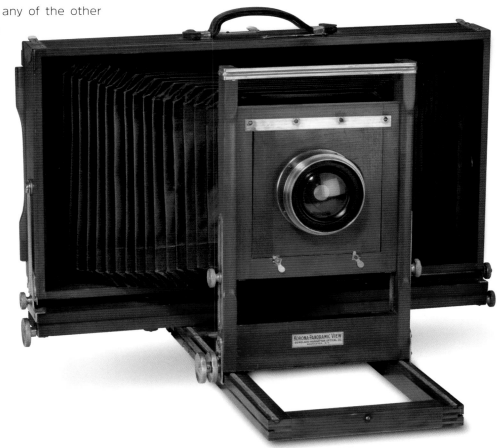

The cropped wide-angle method of making panoramas has been used as recently as the 1990s, when companies such as Kodak and Nikon incorporated retractable masking panels at the film plane of some of their small 35mm and APS point-and-shoot cameras. Printing the cropped negatives on 4 x 10-inch paper allowed anyone with a good eye for composition to create dramatic images, as demonstrated by the photograph of policemen from about 1915 on the following pages.

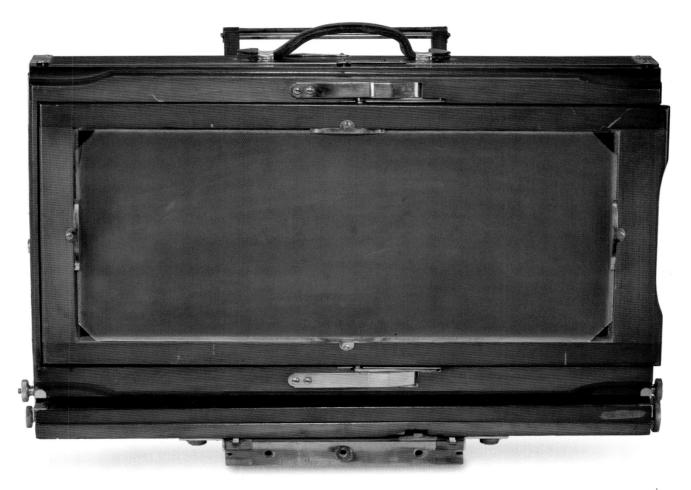

Above: Frederick W. Brehm (American, 1871–1950). [*Rochester policemen posed on the grounds of the Memorial Art Gallery, behind Anderson Hall, University of Rochester Campus*], ca. 1915. Gelatin silver print. Museum accession.

FILM
Photography for the Masses

The search for a lightweight, flexible support dates to the earliest days of photography. William Henry Fox Talbot (see page 22) used paper as a support for his photographic processes in the early 1830s. In the mid-1850s, the idea of using a length of sensitized paper held in place by rollers was suggested by the English photographer Arthur Melhuish (1829–95).

Methods similar to this were used in curved-plane panoramic cameras in the 1860s. The first manufactured camera to use paper-supported roll film was Stebbing's Automatic Camera of 1883, but it was not a commercial success.

The first relatively successful roll film holder was built as a collaboration between George Eastman and William H. Walker (1846–1917) and sold as the Eastman-Walker roll holder. Walker, whom Eastman hired in 1884, had introduced his Pocket Camera three years prior; it was the first to use interchangeable parts for dry plates. The Eastman-Walker roll holder originally used Eastman's Negative Film, a paper-supported gelatin emulsion introduced in 1884. The next year, Eastman's American Film was introduced; it was also a paper-supported gelatin film, but in this case, the exposed emulsion was stripped off the paper support and mounted on glass for

Right:
Unidentified photographer. [*Columbian Exposition, boy using No. 2 Kodak, Chicago*], 1893.
Collodion printing out paper (POP) print from album. Gift of John Kuchera.

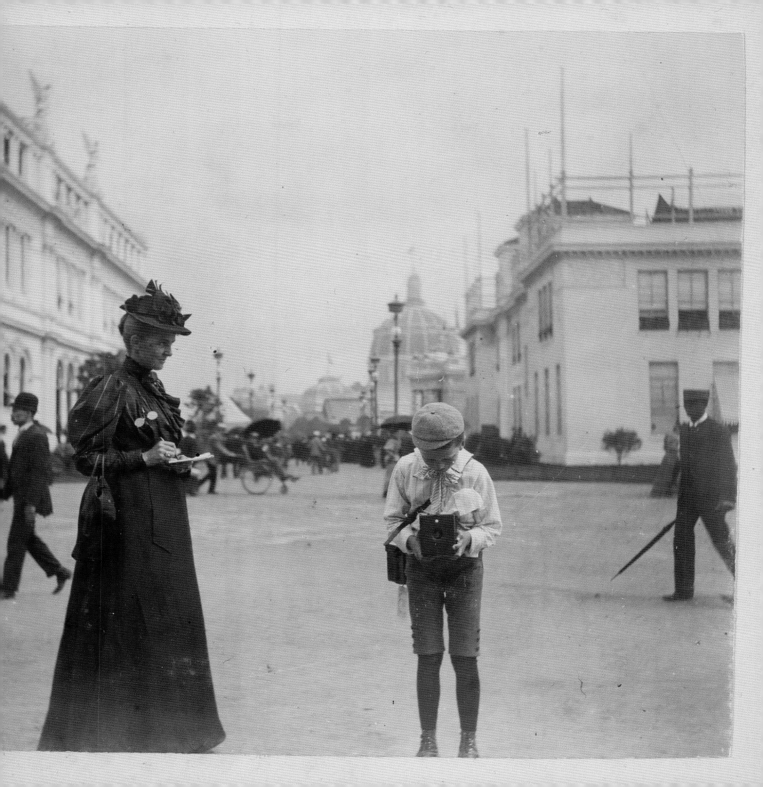

printing. Eastman-Walker roll holders were designed to fit on most cameras, in sizes from 3¼ x 4¼ to 25 x 30 inches. These products were mainly intended for the professional photographer. But as the Negative Film produced soft images due to its paper support and the American Film was not easy to process, neither product was very successful.

Eastman decided to look for a new market for his products. Working with an employee, Frank Cossitt, he set out to design and produce a handheld box camera for the amateur market. Eastman's "detective camera"—the name given to handheld cameras at the time—was supposed to use his American Film, but the complications of camera building were new to the company; only a few cameras were actually completed before the product was abandoned. Undeterred, Eastman undertook the development of a second, smaller detective camera, this time with the aid of Frank Brownell, a clever cabinetmaker-turned-camera manufacturer whose shop happened to be across the street from Eastman's establishment. Eastman's previous foray into handheld camera production, along with the general lack of excitement among professional photographers for his American Film, led Eastman to market this small camera to a new audience—the novice photographer. The revolutionary idea was to offer a photo-finishing service for users of this camera, named the Kodak. A year after its introduction, Eastman offered a new and improved film for the Kodak. This film, a transparent based nitro-cellulose product, was also used by Thomas Edison's assistant, the Scottish inventor W. K. L. Dickson (1860–1935) for the Kinetoscope, the first motion picture film-viewing machine.

A number of other firms offered flexible-film products. The most significant was Boston Camera Company's Bull's-Eye camera, which used a numbered paper-backed roll film for exposure indexing. Eastman, knowing a good idea when he saw it, purchased Boston Camera to acquire the rights for the paper-backed roll film; this system is still in use today for professional 120-roll film.

Eastman continued to invest in the future by establishing a corporate research laboratory, one of the first in the world. The main goal of the Kodak Research Laboratories was to improve film technology. Advances such as nonflammable-base safety film and panchromatic film were first achieved by the Kodak labs. Eastman hired two American musicians, Leopold Godowsky Jr. and Leopold Mannes, who were also experimenting with a color film process. The result of their work, Kodachrome—usually considered the first practical color film—was commercialized by the Kodak Research Laboratories. The labs made many other contributions to film technology, including Kodacolor and Ektachrome films, both introduced after the Second World War. Over the next decades, film speeds increased nearly tenfold, culminating in the 1990s with the T-grain (tabular-grain) films with an ISO of 1000 or more. ↻

STEBBING'S AUTOMATIC CAMERA

ca. 1883 | E. Stebbing, Paris, France

1974.0037.1501

Stebbing's Automatic Camera, the first camera with an integral roll holder, was invented and manufactured in 1883 by Professor E. Stebbing of Paris. Stebbing used the word "automatic" in the name of his all-wood box camera to indicate that it required no focus. "Focusing is useless," he said. "It is controlled with too much care."

The camera produced sixty to eighty 6-cm square exposures on roll film or gelatino-bromide paper, and it could also produce single exposures on dry plates. The Stebbing's Automatic had several interesting features, including an audible click when enough film had been advanced for the next exposure, as well as a moveable pressure plate to precisely place the film in the exposure plane. The pressure-plate action pierced the film to mark where it later should be cut for development. The concept had great promise and seemed to offer simplicity and ease of use, but the film proved troublesome, requiring lengthy drying time and suffering dimensional instability. This, coupled with the introduction of Eastman's roll film and the Eastman-Walker roll holder, which adapted to almost any camera, caused the demise of the $12 camera after only a few years.

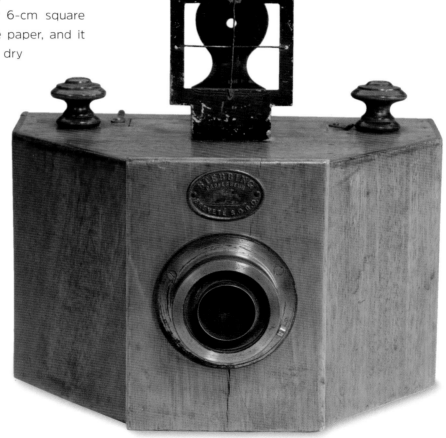

SCHMID'S PATENT DETECTIVE CAMERA (improved model)

ca. 1883 | E. & H. T. Anthony & Company, New York, New York

Gift of Mrs. Lyle R. Berger. 1974.0037.1435

Patented in 1883, Schmid's Patent Detective Camera was the first commercially produced handheld camera in the United States. Its small size, inconspicuous operation, and "instantaneous" exposures introduced the "detective camera" concept, which was applied to apparatus that could be operated without the knowledge of the person being photographed. The term wasn't given only to those cameras disguised as some other object. In fact, it was most often used to describe relatively small but normal-looking cameras that were capable of taking a picture quickly with little setup necessary. Schmid's camera eliminated the need for a ground glass to focus by instead using a focusing register and pointer to set the estimated subject distance. A ground glass was used to calibrate the scale. This "second version" shows a hinged brass handle and has an Eastman-Walker roll holder, custom fitted to the 3½ x 4¼-inch size. The price in 1891 ranged from $55 to $77, depending on the lens included.

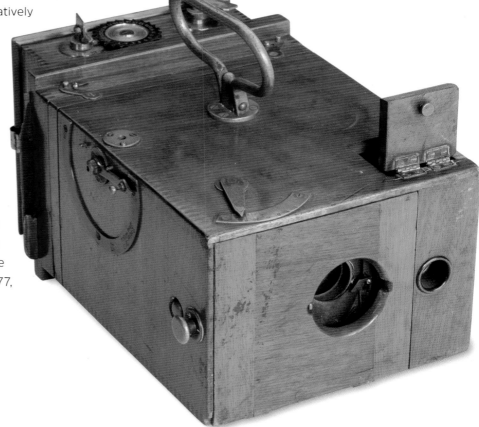

KODAK CAMERA (barrel shutter)

1888 | Eastman Dry Plate & Film Company, Rochester, New York

Gift of Eastman Kodak Company. 1990.0128.0001

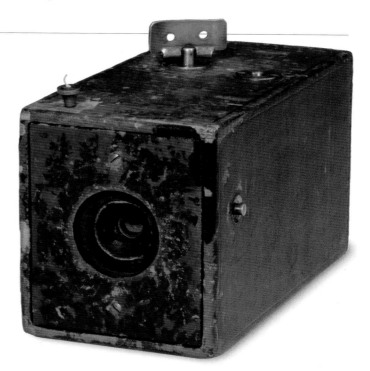

In 1888, the world first learned to say "Kodak," which originally was the name of this handheld box camera rather than an entire company. The camera was manufactured by Frank Brownell of Rochester, New York, for Eastman Dry Plate & Film Company, also of Rochester. The name was coined by George Eastman, who is said to have favored the letter "K" and wanted something memorable and pronounceable in multiple languages.

Expensive for the time, the purchase of a Kodak at $25 included a factory-loaded roll of sensitized film, enough for one hundred 2½-inch circular images. After exposure, the still-loaded camera was returned to Rochester, where the film was developed, prints made, and a new roll inserted, all for $10. This ease of use was such a key selling point that Eastman soon promoted sales with his slogan, "You press the button, we do the rest."

An early "point-and-shoot" camera, the Kodak revolutionized the photographic market with its simplicity of use and freedom from the mess of darkroom chemistry. The first successful camera to use roll film, it stood for convenience. Looking to build on this reputation, over several months in late 1889 George Eastman introduced a modified version of the original Kodak, now designated the No. 1, and three fresh models bearing the Kodak name, all loaded with the new Eastman's Transparent film.

Those first Kodaks marked the beginning of photography as a tool and pastime for the common person. Even more important than their sales figures was the major role they played in establishing what would become Eastman Kodak Company (in 1892) as the first international photofinishing concern. Soon, a seemingly endless line of new Kodak models offered more features and larger images, all contributing to the worldwide identification of the Kodak brand with the growing popularity of amateur photography. Some 5,200 Kodak barrel-shutter cameras were made before a running change was made replacing the barrel shutter with a simpler sector-shutter mechanism. The "improved" camera was still called a Kodak until the introduction of the larger No. 2 Kodak (with a 3½-inch diameter image) in October 1889, when the improved model was renamed the No. 1 Kodak.

NO. 1 KODAK

1889 | Eastman Dry Plate & Film Company, Rochester, New York

George Eastman House collection. 1974.0037.2532

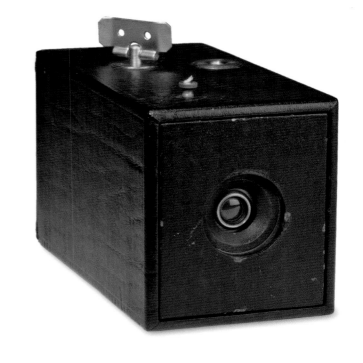

The switch from the barrel shutter to the sector shutter (patent number 408,596) for the Kodak camera began somewhere in the 5192 to 5259 serial-number range. In October 1889, the revised model was renamed the No. 1 Kodak, which coincided with the introduction of the larger No. 2 Kodak. The retail price remained the same as the original version at $25.

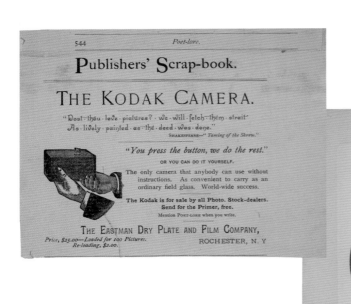

Far Left: Eastman Kodak Company (American, estab. 1892). Advertisement for the Kodak camera, ca. 1889. Museum Collection.

Left: Unidentified photographer. *DRIVE—PROSPECT PARK*, ca. 1890. Albumen silver print. Gift of Mrs. Alden Scott Boyer.

NO. 2 KODAK

1889 | Eastman Dry Plate & Film Company, Rochester, New York

Gift of Eastman Kodak Company. 1974.0037.1939

The No. 2 Kodak was introduced at the 1889 Exposition Universelle in Paris. The No. 2 came loaded with film for sixty images, three-and-a-half inches in diameter. According to production records, about 13,500 examples were produced, making the No. 2 the most common of the first series of Kodak cameras. Its original selling price was $32.50.

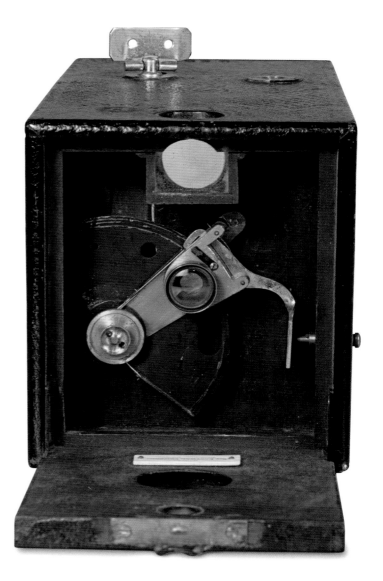

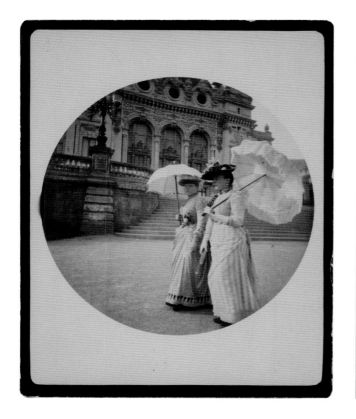

Left: Frederick F. Church (American, 1864–1925).
"TYPES"—MONTE CARLO, ca. 1890.
Gift of Margaret C. Weston. 1981.2601.0030.

NO. 3 KODAK

1889 | Eastman Dry Plate & Film Company, Rochester, New York

Gift of Eastman Kodak Company. 1974.0037.1049

The No. 3 Kodak was available for purchase in December 1889. It produced sixty images, 3¼ x 4¼-inches in size. This example's serial number is 1, making it the first from production. It originally sold for $40.

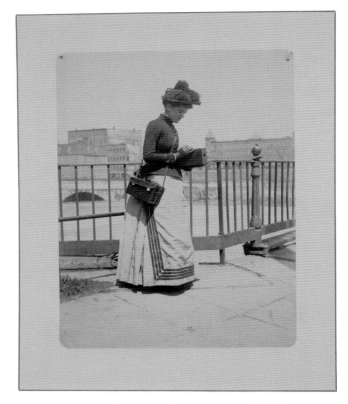

Above: Eastman Kodak Company (American, estab. 1892). [*Kodak model Kittie Kramer with camera*], ca. 1895. Albumen silver print. Gift of Eastman Kodak Patent Museum.

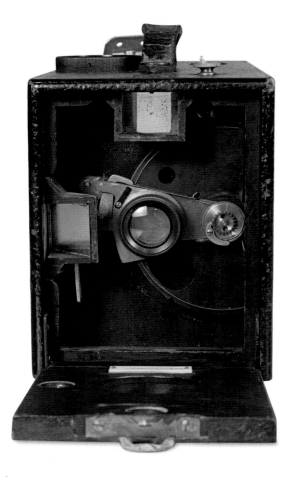

NO. 4 KODAK (used by Robert E. Peary)

1889 | Eastman Dry Plate & Film Company, Rochester, New York

Gift of Eastman Kodak Company. 1994.1480.0001

This No. 4 Kodak is one of several then-U.S. naval lieutenant Robert E. Peary used on his 1897 expedition to Greenland. Introduced in 1889 for $50, it was capable of producing 48 or 100 pictures of 4 x 5 inches and weighed 4½ pounds. Still, Kodak literature claimed it was "much smaller than cameras by other makers for making single pictures." The camera featured an instantaneous shutter, rotating stops, adjustable speed, rack-and-pinion focusing, and two tripod sockets for horizontal or vertical timed exposures.

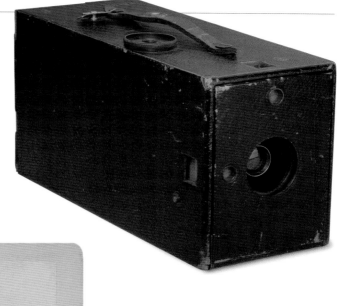

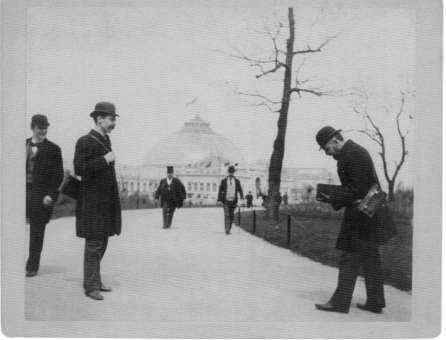

Left: Unidentified photographer. [*Man photographing another man at the World's Columbian Exposition in Chicago*], ca. 1893. Collodion or gelatin printing out paper (POP) print. Gift of Mrs. Lyndon Wells.

NO. 4 FOLDING KODAK (improved model)
1893 | Eastman Kodak Company, Rochester, New York

Gift of Eastman Kodak Company. 1974.0037.1513

The No. 4 Folding Kodak (improved model) of 1893, manufactured by Frank Brownell for Eastman Kodak Company of Rochester, New York, embodied several improvements over Kodak's original model of 1890. A folding-bellows camera with a drop front and a hinged top cover that gave access to the Eastman-Walker roll holder, it was capable of making forty-eight 4 x 5-inch exposures on Eastman transparent roll film. Improvements in the 1893 model included a new Bausch & Lomb iris shutter, the flexibility of using either roll film or plates, and a hinged baseboard that permitted drop front movements. The retail price was $60.

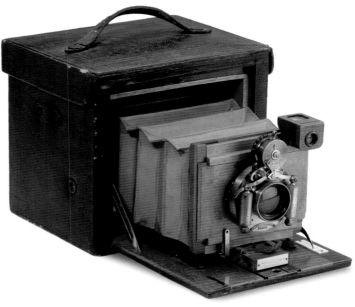

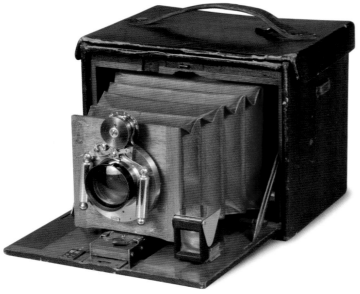

NO. 5 FOLDING KODAK
1889 | Eastman Dry Plate & Film Company, Rochester, New York

Gift of Eastman Kodak Company. 1981.1296.0012

Producing a 5 x 7-inch image, the No. 5 Folding Kodak was the largest of the Kodak family of cameras. It was sold with a 32-exposure length of film. This example does not have a serial number and is likely a pre-production model. The No. 5 Folding Kodak originally sold for $65.

Above: Unidentified photographer. [*George Eastman, restrained by another man, aiming a box camera at a third man in a tree*], ca. 1900. Albumen silver print. Museum Collection. 1982.1848.0001.

ESCOPETTE

ca. 1888 | E. V. Boissonas, Geneva, Switzerland

Gift of Eastman Kodak Company, ex-collection Gabriel Cromer. 1974.0037.0014

Eastman's 1888 Kodak introduced many people to photography and spurred the design of cameras built around Eastman roll films. Swiss inventor Albert Darier took advantage of the readily available Eastman 70mm-wide films with his Escopette, also in 1888. The handsome hardwood box with dovetail joinery housed a 110-exposure roll and the film-winding mechanism, while a bottle-shaped metal nose contained the spherical shutter and Steinheil periscopic 90mm f/6 lens. The shutter speed was adjusted by a ridged wheel with ratchet stops that set the spring tighter with each click. A brass key under the ratchet set the shutter, so it could be tripped by the photographer's trigger finger as the camera was held by the pistol-grip handle. The handle became part of a tabletop stand when the two adjustable brass legs were pivoted open. Carrying on the firearm theme, the metal parts were lacquered or gun-blued. E. V. Boissonas manufactured the Darier design and priced the camera at 190 francs.

CYCLOGRAPHE Á FOYER VARIABLE (focusing model)

1890 | J. Damoizeau, Paris, France

Gift of Eastman Kodak Company, ex-collection Gabriel Cromer. 1974.0037.2331

As roll-film technology progressed, so did panoramic pho-
tography. Introduced in 1890 by J. Damoizeau of Paris,
the Cyclographe á Foyer Variable had a key-wound clock
drive motor to turn a brass wheel on the camera's under-
side that rotated the mahogany and brass camera on its
pivot dowel. The drive wheel was geared to the transport
to move the 9-inch-wide film over a narrow slit at the
same speed, but in the opposite direction. This made a
360-degree sweep possible. A bellows adjusted by a rack
and pinion allowed focusing of the Darlot landscape lens.

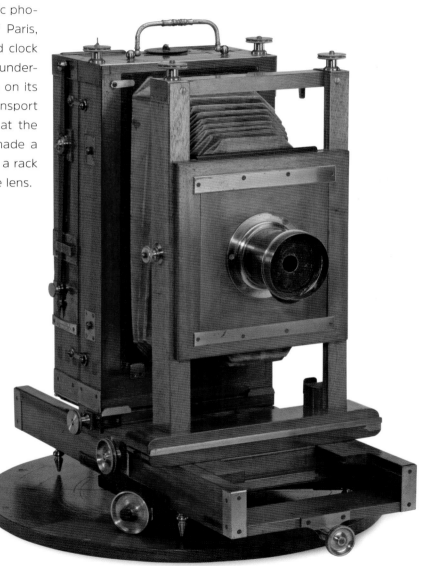

WONDER PANORAMIC CAMERA

1890 | Rudolf Stirn, Berlin, Germany

Gift of the Damon Runyan Fund. 1974.0084.0048

The Wonder Panoramic Camera, made by Rudolf Stirn in Berlin, depended on the photographer for its motive power. A string, hanging through a hole in the tripod screw, wound around a pulley inside the wooden box camera. When set up to take a panoramic photo, the user swiveled the metal cap away from the lens to start the exposure. Once the string was pulled, the inside pulley rotated, and through a clockwork mechanism the take-up spool turned and pulled the 3¼-inch-wide Eastman film past a one-millimeter-wide slit where it was exposed by the 75mm f/12 lens. The rotation could be set for a full 360-degree sweep, producing an 18-inch-long negative, or three shorter lengths at 90-degree intervals. For $30 you got the Wonder, a roll of film, folding tripod, and carrying case.

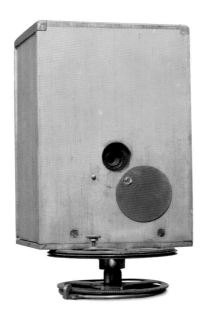

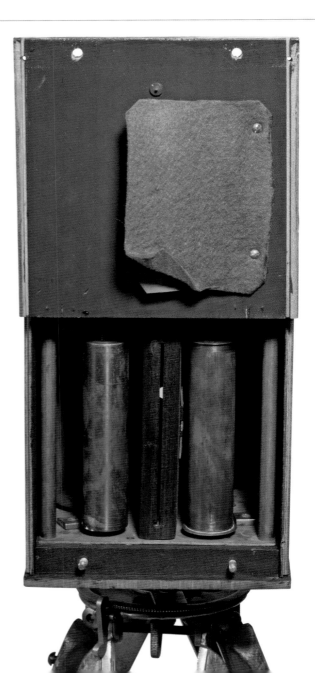

BULL'S-EYE CAMERA

1892 | Boston Camera Manufacturing Company, Boston, Massachusetts

1974.0084.0063

The Bull's-Eye Camera was marketed in 1892 by Samuel Turner and his Boston Camera Manufacturing Company. It was a simple roll-film box camera producing 3½-inch square images. The original Bull's-Eye Camera was the first to use printed-paper backing on its film, with frame numbers visible through a small red celluloid window that became the standard for roll-film cameras. George Eastman, who always knew a good idea when he saw one, introduced a similar box camera called the Bullet in 1895. That same year, rather than continue payments on the red-window patent, Eastman bought Turner's company and the right to manufacture Bull's-Eye cameras. An original Bull's-Eye sold for $7.50, with extra 12-picture film cartridges priced at fifty-five cents. The earliest examples, as shown here, have the "D"-shaped celluloid window; the later models have "O"-shaped windows.

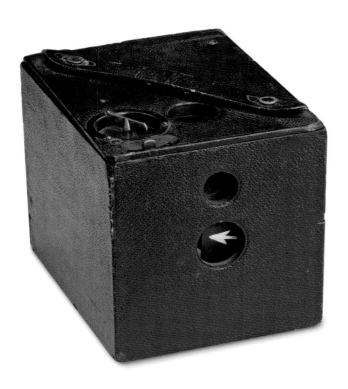

Above: Unidentified photographer. *EDGE OF THE NILE*, ca. 1903. From the album *Egypte, Assouan*. Collodion or gelatin printing out paper (POP) print. Exchange with Michel Auer. 1973.0011.0208.

KOMBI

ca. 1892 | Alfred C. Kemper, Chicago, Illinois

Gift of Walter D. Marshall. 1974.0084.0064

The photography boom of the 1890s had many manufacturers eager to meet the demand. Simplification and portability were required by amateurs, which encouraged Alfred C. Kemper of Chicago to set up production of his tiny Kombi in 1892. An all-metal box camera roughly the size of a modern 35mm film carton, the Kombi was named for its dual purpose, being both camera and viewer. The roll holder for the 1⅛-inch-wide film slipped onto the body and was held in place by friction. Film had to be loaded in the dark, requiring that one be familiar with the holder assembly. The shutter was spring-loaded and held with a latch but was not self-capping; a finger had to be kept over the lens while the shutter was cocked. To use the Kombi as a graphoscope (viewing device), images were transferred to positive film and a cap on the holder removed. With a positive roll in the holder, the lens was brought to the eye and the film end aimed at a light source, just like a souvenir-shop viewer. The Kombi retailed for $3.50, a price that included masks for square and round pictures. Its catalog offered a wide selection of equipment for processing and printing.

POCKET KODAK

1895 | Eastman Kodak Company, Rochester, New York

Gift of Eastman Kodak Company. 1974.0037.1507

Continuing George Eastman's goal of bringing affordable photography to the common person, the Pocket Kodak was introduced in 1895 by Eastman Kodak Company, Rochester, New York. Enormously popular, it was a small, leather-covered wooden box camera. Easily held in the palm of the hand, it used either roll film or individual plates to produce images 1½ x 2 inches in size. It was attractive in either red or black leather covering and retailed for $5.

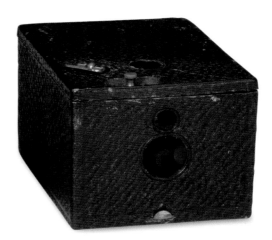

Left: Eastman Kodak Company (American, estab. 1892). Sales sample of an image made with the Pocket Kodak camera, 1895. Collodion or gelatin printing out paper (POP) print. Gift of Eastman Kodak Company.

PRESTO

ca. 1896 | Magic Introduction Company, New York, New York

Gift of 3M Foundation, ex-collection Louis Walton Sipley. 1977.0085.0011

Improvements in photographic plates and film allowed camera manufacturers to miniaturize their products. One of the smallest designs was the Presto camera of 1896, made by the Magic Introduction Company of New York. An all-metal construction, the Presto could be used with roll film to take 1¼-inch square pictures, or the roll holder could be removed and a mechanism holding four glass plates substituted. The pillbox body was stamped from brass as was the removable cover, which was held in place by friction. The shutter was dropped by gravity when the button was pressed, and then reset by turning the camera upside down. A rotating disc on the front had three selectable aperture sizes.

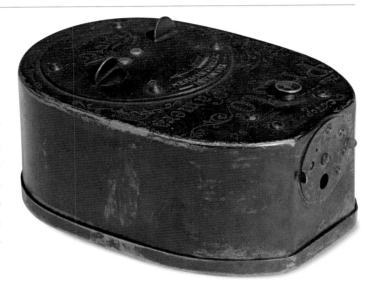

FOLDING POCKET KODAK

1897 | Eastman Kodak Company, Rochester, New York

Gift of Eastman Kodak Company. 1991.2641.0002

The first of a long series of folding cameras, the 1897 Folding Pocket Kodak made pictures in a new format of 2¼ x 3¼ inches and collapsed to a thickness of only 1½ inches. The slim camera could be carried in a (large) pocket or on a bicycle in the separately available case. Simple in operation, the self-setting shutter was always ready to make an exposure. The "Film Cartridge System" allowed loading in daylight. Distinctly different from later models, the lens window was a recessed conical shape. It was priced at $10 without film.

LE PASCAL

ca. 1900 | Japy Fréres & Cie, Belfort, France

Gift of Eastman Kodak Company, ex-collection Gabriel Cromer. 1974.0037.1526

Designed by François Pascal and introduced in 1899 by Japy Fréres & Cie of Belfort, France, Le Pascal was a small, leather-covered wooden box camera, unique for its film transport. The first roll-film camera to feature a rapid advance mechanism, it was claimed that a full roll of twelve exposures could be completed in less than six seconds. To operate, the user loaded the roll film into the camera, then wound the advance key, which simultaneously wound the spring motor, moved all the film to the take-up spool, and activated the shutter. Upon triggering the shutter release button, each exposure was rewound onto the original spool. This reverse film action would be used eighty years later in some 35mm cameras. A folding view-finder also functioned as an interlock, preventing the shutter's release when folded flat. The original list price was 15 francs.

NO. 3 FOLDING POCKET KODAK DE LUXE

ca. 1901 | Eastman Kodak Company, Rochester, New York

1974.0037.1347

The No. 3 Folding Pocket Kodak De Luxe was a specially trimmed version of the standard No. 3, manufactured by Eastman Kodak Company, Rochester, New York, in 1901. A vertical-style folding bed camera, the No. 3 produced 3¼ x 4¼-inch images on No. 118 roll film. The most popular of the Folding Pocket Kodak line, around 300,000 units were manufactured by 1915, when it was replaced with the Autographic models.

The De Luxe version was trimmed in brown Persian morocco covering, including the lens board, and featured a gold silk bellows. It had a Kodak nameplate of solid silver and came in a hand-sewn carrying case with silver trim. Only seven hundred De Luxe models were produced. The retail price was $75, compared to $17.50 for the standard model. This camera is an unnumbered factory model that was never offered for sale.

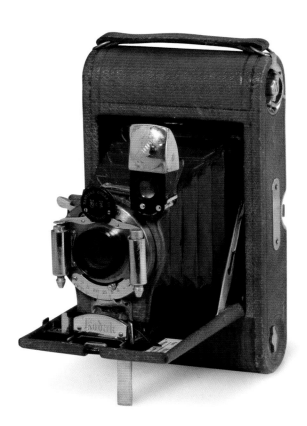

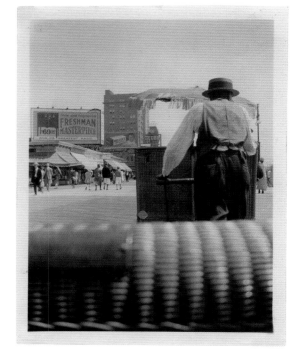

Above: Unidentified photographer. [*Amusement park vendor*], ca. 1905. Collodion or gelatin printing out paper (POP) print. Courtesy Joseph Struble

BROWNIE (original model)

1900 | Eastman Kodak Company, Rochester, New York

1978.1657.0002

Introduced by Eastman Kodak Company in 1900, the Brownie camera was an immediate public sensation due to its simple-to-use design and inexpensive price of $1. Every individual, irrespective of age, gender, or race could afford to be a photographer without the specialized knowledge or cost once associated with the capture and processing of images. An important aspect of the Brownie's rapid ascendancy in popular culture as a must-have possession was Kodak's innovative marketing via print advertising. The company took the unusual step of advertising the Brownie in popular magazines of the day, instead of specialty magazines with limited readership. George Eastman derived the camera's name from a literary character in popular children's books by the Canadian author Palmer Cox. Eastman's astute union of product naming, with a built-in youth appeal, and inventive advertising placement had great consequence for the rise of modern marketing practices and mass consumerism in the twentieth century.

The Brownie was designed and manufactured for Eastman Kodak Company by Frank A. Brownell, who produced all of Kodak's cameras beginning in 1888. The use of inexpensive materials in the camera's construction, and George Eastman's insistence that all distributors sell the camera on consignment rather than allowing them to set their own price, enabled the company to control the camera's $1 price tag and keep it within easy reach of consumers' pocketbooks.

More than 150,000 Brownies were shipped in the first year of production alone, a staggering success for a company whose largest single-year production to date had been 55,000 cameras (the No. 2 Bullet, in 1896). The Brownie launched a family of nearly two hundred camera models and related accessories, which during the next sixty years helped to make "Kodak" a household name.

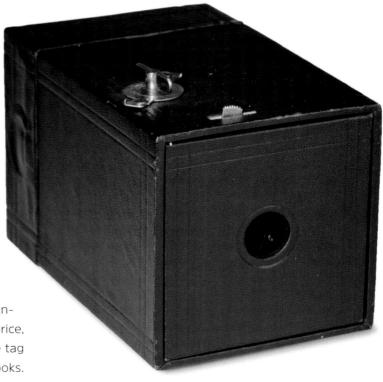

NO. 1 BROWNIE (owned by Ansel Adams)

ca. 1901 | Eastman Kodak Company, Rochester, New York

Gift of Ansel Adams. 1974.0037.1963

The No. 1 Brownie, introduced in October 1901, was actually the original Brownie with running changes included. Upon the introduction of the larger No. 2 Brownie, the original Brownie was renamed the No. 1, still using No. 117 film and producing 2¼-inch square images. No. 2 also had the hinged rear cover, a revision to the original Brownie's box lid cover that had proved troublesome. The original price was $1.

The camera shown here was the boyhood camera of iconic American photographer Ansel Adams (1902–84). It was a gift to him from his aunt for his first visit to Yosemite National Park in the summer of 1916. The fourteen-year-old Ansel was awestruck by the grandeur of the mountains and immediately began taking pictures.

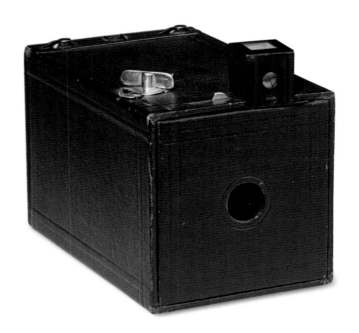

NO. 2 BROWNIE

ca. 1901 | Eastman Kodak Company, Rochester, New York

1974.0037.1116

The No. 2 Brownie camera (opposite), introduced in 1901, was still a cardboard box camera, but it included several important changes. It was sized for a new film, originally known as No. 2 Brownie film but renamed No. 120 in 1913 when Kodak gave numerical designations to their different films. No. 120 roll film is still in production today. In addition to the new film, which produced larger 2¼ x 3¼-inch images, the camera now sported two built-in reflecting finders and a carrying handle. With a retail price of $2, the No. 2 proved very popular, selling 2.5 million cameras before 1921 and remaining in production for more than thirty years.

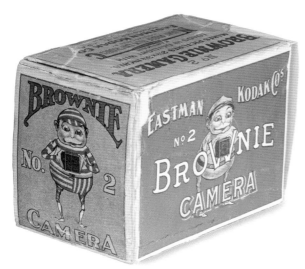

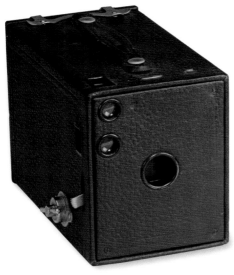

Above: Unidentified photographer. [*Portrait of boy sitting on hood of a car (1940 Plymouth Sedan)*], ca. 1940. Gelatin silver print. Courtesy Joseph Struble.

BEN AKIBA

ca. 1903 | A. Lehmann, Berlin, Germany

Gift of Eastman Kodak Company, ex-collection Gabriel Cromer. 1974.0084.0086

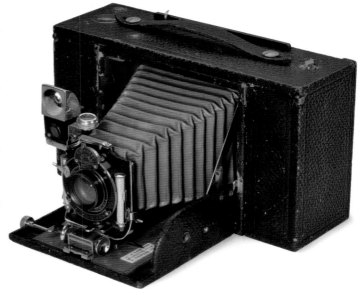

Cameras have been disguised in just about every type of fashionable accessory, from hats to handbags, with many seemingly more likely found among the wares of the haberdashery than the camera shop. In this case, the camera is hidden in the handle of a gentleman's walking stick. Patented by Emil Kronke and manufactured by A. Lehmann, both of Germany, the Ben Akiba produced twenty images, 1.3 x 2.5 cm in size, on roll film. Given the small image size and the emulsion of the time, the quality of the images produced was not very good, relegating the cane camera to the novelty category. On the other hand, it may have been the turn-of-last-century answer to that age-old question: What to give the dapper gent who has everything?

NO. 4 SCREEN FOCUS KODAK, MODEL A

1904 | Eastman Kodak Company, Rochester, New York

Gift of Paul Lange. 1974.0037.1235

The 1904 No. 4 Screen Focus Kodak permitted focusing on a ground glass without removing the roll of film from the camera. Thus, accurate focusing could be done for each exposure as with a plate camera. To do so, the roll holder, protected with a dark slide, was rotated away ninety degrees from the focal plane. An extension bed allowed focusing on subjects as close as twenty-two inches. With daylight-loading film, the camera could make twelve exposures of 4 x 5 inches. By removing the roll holder, it could operate as a plate camera. In total, about four thousand cameras were manufactured and sold over a six-year period. The Screen Focus Kodak initially sold for $30 and was available with a wide variety of lenses and shutters.

RUNDBLICK

ca. 1907 | Heinrich Ernemann AG, Dresden, Germany

1974.0037.1497

Panoramic cameras of the swinging-lens variety or the wide-angle fixed lens type were effective for fields-of-view up to about 120 degrees, but for scenes requiring more than that, only a rotating camera would do. Such cameras were usually powered by wind-up spring motors and necessarily mounted on a sturdy tripod. When making a picture, the camera rotated at a constant speed while the film moved at the same speed in the opposite direction, thanks to the same spring motor. The best-known example of the rotating camera was the Cirkut, introduced in 1904 (see pages 124–25).

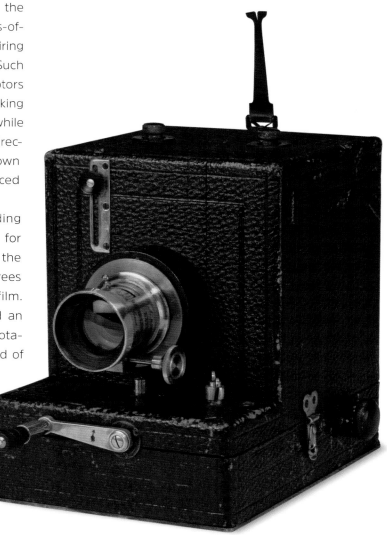

Heinrich Ernemann AG, which started building cameras in 1889, introduced the Rundblick (German for "looking around") in 1907. Much more compact than the Cirkut types, though just as heavy, it rotated 360 degrees to make a 12 x 92-cm negative on special-roll film. The front-mounted crank wound up the spring, and an indicator pointer allowed the panoramist to vary the rotation angle. As with the swing-lens cameras, the speed of travel controlled what the shutter-speed dial did for conventional cameras, but the Rundblick also had an adjustable slit that functioned as an aperture control. The Ernemann Doppel-Anastigmat 135mm f/5.4 lens had a vertical shift adjustment for perspective correction. Marketed for five years, especially to the military and to artists, the camera was used to photograph landscapes and very large groups of people.

PRESS GRAFLEX

ca. 1908 | Folmer & Schwing Division of Eastman Kodak Company, Rochester, New York

Gift of Graflex, Inc. 1974.0037.2593

Manufactured by Eastman Kodak Company's Folmer & Schwing Division in Rochester, New York, from 1907 to 1923, the Press Graflex shared features with many Graflex cameras of the time. These included an extensible front with no bed, a detachable spring back holding individual plates or a film pack, a focal-plane shutter curtain, and a large reflex viewing hood that was contoured to the photographer's face. The Press Graflex was available only in the 5 x 7-inch size and, as the name implies, was targeted to the newspaper photographer. The retail price with a Bausch & Lomb Zeiss Tessar lens was $169.50.

Opposite: Lewis W. Hine (American, 1874–1940). [*Man on girders, mooring mast, Empire State building*], ca. 1931. Gelatin silver print. Transfer from Photo League Lewis Hine Memorial Committee; ex-collection of Corydon Hine. 1977.0161.0038.

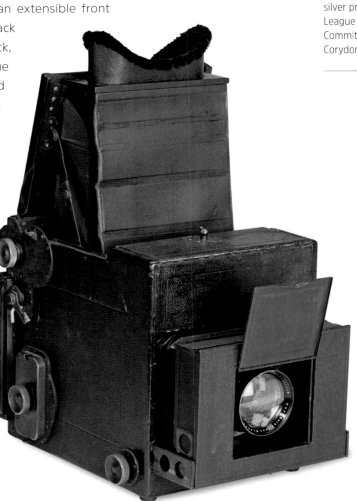

CIRKUT CAMERA NO. 10

ca. 1910 | Century Camera Division, Eastman Kodak Company, Rochester, New York

Gift of Eastman Kodak Company. 2000.0805.0001

The No. 10 Cirkut Camera was designed to make panoramic photographs up to 10 inches tall by 12 feet in length. To accomplish this, a small pinion gear, mounted at the bottom of the camera and driven by a spring-wound motor, rotated the camera on a gear-head tripod. As the camera revolved, the roll film was exposed as it advanced past a narrow slit shutter, creating images—generally group portraits or landscapes—in a manner similar to that of a digital flatbed scanner. In 1916, the list price was $290, including the Series II Turner-Reich Convertible lens and shutter. The example here is a new old-stock camera fitted with the factory original, undrilled lens board. It lacks the bed-mounted focusing scales, which would have been custom matched to a lens-and-gear set. Produced for nearly fifty years, it was sold under numerous Rochester-based company nameplates: Rochester Panoramic Company, 1904–5; Century Camera Company, 1905–7; Century Camera Division, Eastman Kodak Company, 1907–15; Folmer & Schwing Division, Eastman Kodak Company, 1915–26; Folmer-Graflex, 1926–45; and Graflex, Inc., 1947–49.

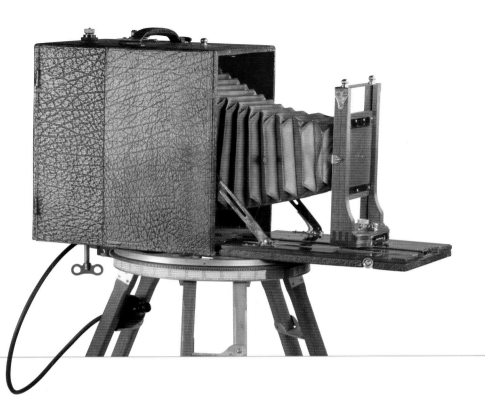

Below: Frederick W. Brehm (American, 1871–1950). [*Group of several company baseball teams*], ca. 1915. Gelatin silver print. Museum Collection.

TICKA

ca. 1910 | Houghtons Ltd., London, England

Gift of Eastman Kodak Company. 1974.0037.0036

The 1910 Ticka was a milestone in miniaturization made possible by continuous improvement in the quality of roll films. Introduced by Expo Camera of New York, the pocket watch-shaped camera was also licensed to Houghtons Ltd., in London. The watch's winding stem hid a 30mm f/16 meniscus lens that worked through a simple guillotine shutter; the knob served as a lens cap. The dial and hands looked functional but were just for effect, though the hands were positioned to serve as a viewfinder. Sold in special daylight-loading cassettes, the film dropped right into place when the dial face was removed. A winding key on the back advanced the film to the next of its twenty-five exposures. The Ticka sold for under $5 at introduction.

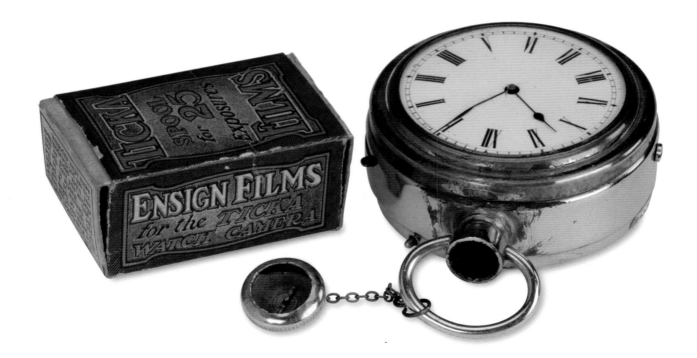

VEST POCKET KODAK (owned by Ansel Adams)

1912 | Eastman Kodak Company, Rochester, New York

Gift of 3M Foundation, ex-collection Louis Walton Sipley. 1974.0037.1248

"So flat and smooth and small as to go readily into a vest pocket" was the claim in Kodak's 1912 catalog that introduced the new Vest Pocket Kodak. When closed, this camera was one inch thick, but in use its lens and shutter pulled out on struts known as "lazy tongs." It made exposures of 1⅝ x 2½ inches and enlargements could be made to postcard size for fifteen cents. The meniscus achromatic lens was pre-focused, and the ball bearing shutter offered settings for Time, Bulb, 1/25, and 1/50 second. The beginning of a long-lived series, it was originally offered for a price of $6.

The camera shown here, a Vest Pocket Autographic Kodak Special, was used by the young Ansel Adams on his second visit to Yosemite National Park in 1917. Having photographed Yosemite the previous year with his No. 1 Brownie, Adams now used this new camera, which had a better lens, the f/7.7 Kodak Anastigmat. At the young age of fifteen, he was already concerned about the quality of his photography, though he wouldn't make it his profession until about 1930.

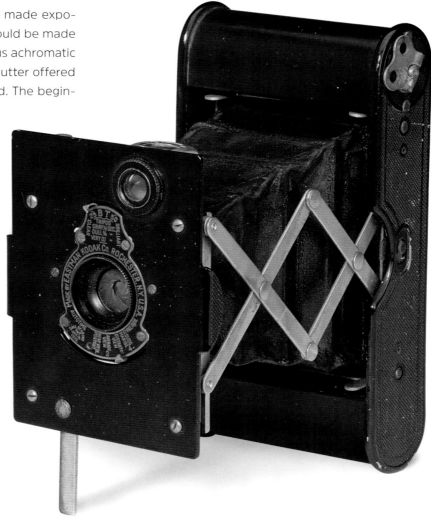

HOMÉOS

1914 | Jules Richard, Paris, France

Gift of Eastman Kodak Company, ex-collection Gabriel Cromer. 1974.0037.2003

The Jules Richard firm of Paris was noted for its line of Verascope stereo cameras dating back to the 1890s. Added to the Richard catalog in 1914, the Homéos was the first stereo camera to use perforated 35mm ciné film instead of glass plates or larger film rolls. Taking full advantage of the film's narrowness, the designers created a very compact body. The lenses, either Optis or Krauss 28mm f/4.5, made stereo pairs measuring 19 x 24 mm. A folding Newton finder and bubble level atop the body helped the stereographer compose scenes. A similar finder on the left side of this 1920 model, which had a slide to cover one lens for single-frame non-stereo pictures, was for shooting single-frame horizontal-format pictures with a vertically held camera.

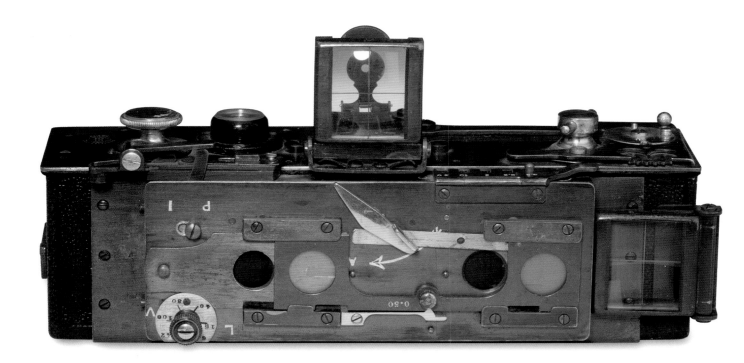

SIMPLEX

1914 | Multi Speed Shutter Company, New York, New York

1982.2412.0001

The great popularity of the 35mm camera in pre-digital days began in the late nineteenth century when Thomas Edison's laboratory selected 35mm as the width of the film they would use for their motion picture system. Movie studios used large rolls of the perforated film stock and made available short leftover lengths. It wasn't long before still cameras were built around this film size, and the 1914 Simplex was one of the earliest. The Multi Speed Shutter Company of New York already built movie cameras, so they knew well the film they chose for the Simplex. Movie frames were set at 24 x 18 mm and, at first, the 35mm still cameras adopted this format. However, by removing a metal mask from the film plane, the Simplex's Bausch & Lomb Zeiss Tessar 50mm lens could cover two frames, producing a 24 x 36-mm negative. This "double-frame" size soon became the standard for 35mm cameras, leading to designs such as the Leica in the 1920s. Fifty feet of film could be loaded into a Simplex. That was enough for 400 double-frame exposures, or twice as many 24 x 18-mm images.

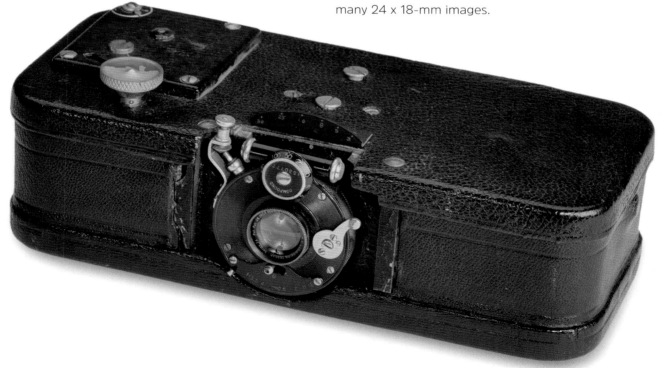

TOURIST MULTIPLE

1914 | New Ideas Manufacturing, New York, New York

Gift of Mrs. John S. Ames. 1974.0084.0106

In the early part of the twentieth century, Henry Herbert, co-founder of a New York photographic supply company, learned he could buy leftover motion picture film for a penny per foot. Herbert saw an opportunity in that, and in 1914 introduced one of the first still cameras designed to use 35mm film. The pound-cake-sized Tourist Multiple was a well-made, superbly engineered product designed to take professional-quality photos. Its recessed Bausch & Lomb Zeiss Tessar 50mm f/3.5 lens could be focused as close as twenty-four inches from the subject. The lens board was movable for perspective corrections, and the pop-up Newton finder followed the lens. The all-metal focal-plane shutter was self-capping, with a maximum speed of 1/200 second. A half-turn of a nickel-plated lever reset the shutter and precisely advanced the film for the next shot.

The Tourist Multiple was billed as the "Camera of the Future," which was more than typical marketing hype. The design was revolutionary and truly ahead of its time. A single daylight-loading magazine held fifty feet of Eastman Kodak ciné film that provided 750 exposures of 18 x 24-mm images. For just $4, a traveler could document an entire vacation without giving any further thought to film. Back at home, the camera could be mounted to the New Ideas Lantern and projected on a ten-foot screen. The Tourist Multiple sold for $175, a considerable sum in 1914. With the projector included, the price was $250. Unfortunately, World War I put a severe damper on tourism, and sales of the camera were poor. It was discontinued after a production of only one thousand.

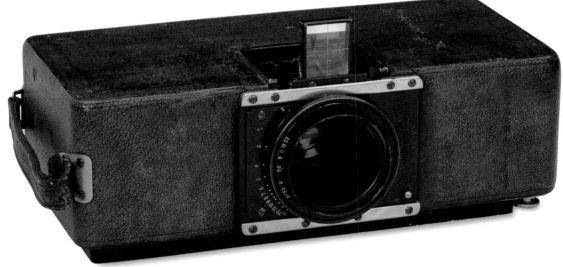

EASTMAN GUN CAMERA

ca. 1915 | Eastman Kodak Company, Rochester, New York

Gift of Eastman Kodak Company. 1994.1486.0001

The Eastman Gun Camera, designed by John A. Robertson, was produced from 1915 to 1920 by Eastman Kodak Company, Rochester, New York. A training device, the gun camera was used to practice shooting, using photographs as ersatz bullets. Prior to this invention, army airmen trained with live ammunition, shooting at kites, pennants, or balloons that were towed by other planes, endangering both pilots and planes. The camera, similar in style and weight to the Lewis machine gun that gunners fired in the field, allowed for much safer training. It shot a 4.5 x 6-cm image of the target with a superimposed crosshair of the bullet's location on No. 120 roll film. In effect, it was a forerunner of a training process now done with computer simulation.

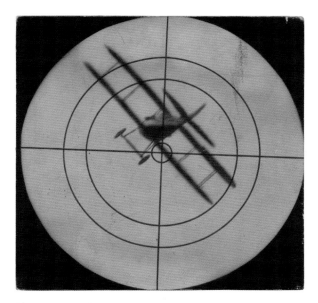

Above: Unidentified photographer. [*Sample image from Eastman Gun camera*], ca. 1914. George Eastman House Technology Collection.

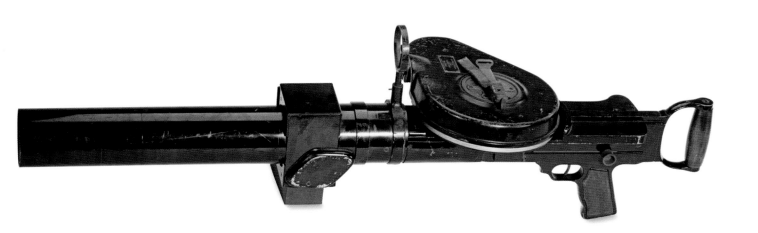

WILLIAMSON AEROPLANE CAMERA

ca. 1915 | Williamson Manufacturing Company Ltd., London, England

Gift of Eastman Kodak Company. 1992.0140.0001

Designed for aerial reconnaissance photography around 1915, the Williamson Aeroplane Camera produced 4 x 5-inch images on roll film, exposed in either single or continuous mode. Its cloth-curtain shutter, which had to be manually set when the film was loaded, used different speeds of 1/25, 1/50, and 1/100 second. The camera was attached to the aircraft's belly with thumbscrews located on the top of the apparatus. Winds blowing through the aluminum propeller located on the camera's front provided ample power for both shutter and film advance.

NO. 3A AUTOGRAPHIC KODAK SPECIAL, MODEL B WITH RANGEFINDER

ca. 1916 | Eastman Kodak Company, Rochester, New York

Gift of Thomas E. Hunt. 1987.0380.0001

The No. 3A Autographic Kodak Special, Model B, was introduced in 1916 by Eastman Kodak Company of Rochester, New York, as a running change of the No. 3A Folding Pocket Kodak. The 3A Autographic Special was the first camera to offer a coupled rangefinder. Not a small camera, it produced images in the popular 3¼ x 5½-inch postcard size on No. A-122 roll film. Indeed, Kodak claimed, "We have been careful not to let the desire for mere compactness destroy the optical efficiency." With a rising front, rack-and-pinion focusing, f/6.3 Zeiss Kodak Anastigmat lens, a finish of genuine Persian morocco leather, and the coupled rangefinder, this was a quality instrument at a retail price of $66. It remained in production for twenty-one years.

Above: Unidentified photographer. [*Fishing party, including Loren O. Graves and wife, with string of fish displayed on canoe*], ca. 1925. Gelatin silver print. Museum Collection. 1982.1903.0134.

SEPT

ca. 1922 | Établissements André Debrie,
Paris, France

1974.0037.2071

André Debrie of Paris, manufacturer of the Sept (French
for the number seven), named their 1922 camera for the
seven very different functions it was designed to perform.
This multifunctioned $225 apparatus shot 35mm ciné film
in eighteen-foot lengths and could take either motion
pictures or still photographs. It also could
project movies or be used as an enlarger
to print negatives onto either photo-
graphic paper or positive film. A spring
motor both drove the movie mechanism
and could advance frames for the still
camera, which could shoot individual
frames, timed exposures, or a burst of
shots in quick succession. Movie studios
were a market for short lengths of 35mm
film, and the demand for shorts fueled
the development of the 35mm cameras
that would eventually become the
prevalent format around the globe.

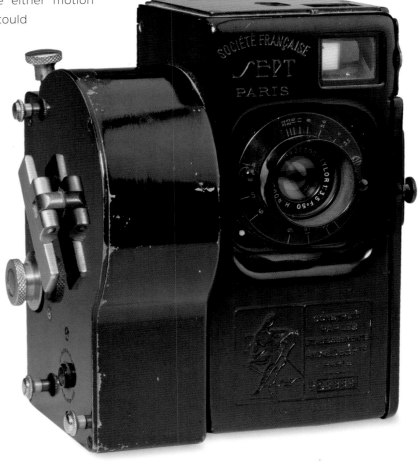

O-SERIES LEICA

1923 | Ernst Leitz GmbH, Wetzlar, Germany

1974.0084.0111

Starting about 1905, when he worked at the firm of Carl Zeiss in Jena, Germany, Oskar Barnack (1879–1936), an asthmatic who hiked for his health, tried to create a small pocketable camera to take on his outings. At the time, cameras using the most common format of 13 x 18 cm (5 x 7 inches) were quite large and not well suited for hiking. Around 1913, Barnack, by then an employee in charge of the experimental department of the microscope maker Ernst Leitz Optical Works in Wetzlar, designed and hand-built several prototypes of a small precision camera that produced 24 x 36-mm

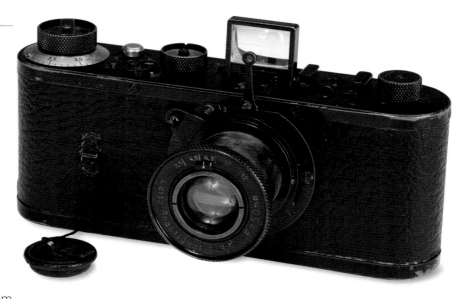

images on leftover ends of 35mm motion picture film. Three of these prototypes survive. The most complete one has been dubbed the "Ur-Leica," meaning the very first or "Original Leica," and is in the museum of today's firm of Leica Camera AG in Solms, Germany.

Barnack used one of his cameras in 1914 to take reportage-type pictures of a local flood and of the mobilization for World War I. That same year, his boss, Ernst Leitz II, used one on a trip to the United States. However, no further development of the small camera took place until 1924, when Leitz decided to make a pilot run of 25 cameras, serial numbered 101 through 125. Still referred to as the Barnack camera, these prototypes were loaned to Leitz managers, distributors, and professional photographers for field testing. Interestingly, the evaluations were not enthusiastic, as the testers thought the format too small and the controls too fiddly, which they were. For instance, the shutter speeds were listed as the various distances between the curtains, instead of the fraction of a second it would allow light to pass. In spite of its reviews, Leitz authorized the camera's production, basing his decision largely on a desire to keep his workers employed during the post–World War I economic depression. An improved version of the "O-Series Leica," the Leica I, or Model A, with a noninterchangeable lens was introduced to the market at the 1925 Spring Fair in Leipzig. The name "Leica," which derives from Leitz Camera, appeared only on the lens cap.

Shown here is a O-Series Leica, serial number 109. It is one of three known examples with the original Newton viewfinder.

DEARDORFF COMMERCIAL CAMERA

1923 | L. F. Deardorff & Sons, Chicago, Illinois

Gift of Eastman Kodak Company. 1997.2438.0001

In 1923, L. F. Deardorff & Sons produced its first series of ten 8 x10-inch wooden view cameras, which were hand-made—including the hardware—using recycled tools and materials. The mahogany for the woodwork came from tavern counters scrapped during Prohibition. Sold as the Deardorff Commercial Camera, it remained on the market with few alterations (the hardware was changed from brass to nickel plate in 1938; front swings were added in 1949) and became the professional workhorse view camera. As described in their 1935 catalog, it was "a definitely new camera specially designed and constructed to meet the demands of modern advertising." Some consider the Deardorff as the Harley-Davidson of view cameras, both being iconic products originally from small family-owned companies. The camera illustrated here is the second camera made from the first series; it has never been used.

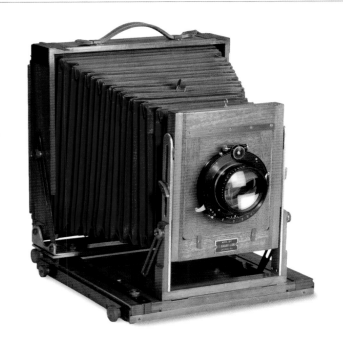

HILL'S CLOUD CAMERA

ca. 1923 | R. & J. Beck, Ltd., London, England

Gift of Ralph Steiner. 1974.0037.2840

The Hill's Cloud Camera of 1923 (opposite) was manufactured by R. & J. Beck, Ltd., of London. Designed by Robin Hill, it was intended to photograph the entire sky on a 3¼ x 4¼-inch plate. The polished mahogany body measures 5¾ inches square by 1⅝ inches deep and is used horizontally, with the lens pointed up and fixed for correct focus. Hill's design covered a field of 180 degrees, making it the earliest "fisheye" or "sky" lens. The camera has three apertures and three orange/red filters to enhance contrast and differentiate between cloud types. When used in pairs for stereoscopic viewing, it was possible to estimate the relative altitudes of clouds. The camera could also be used to project a negative back to a normal perspective.

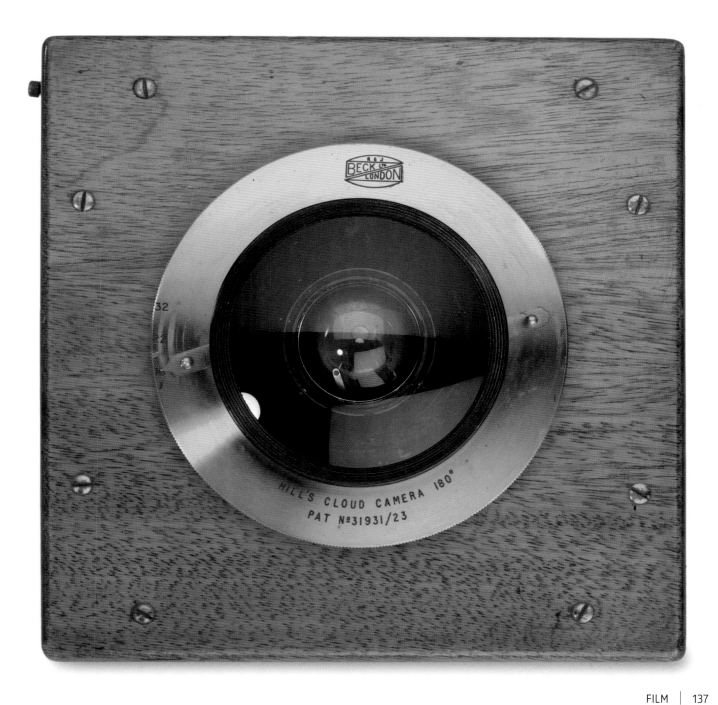

ERMANOX (4.5 X 6 CM)

ca. 1924 | Ernemann-Werke, Dresden, Germany

Gift of Mike Kirk. 2001.0484.0001

Before the Ermanox, indoor pictures and other low-light situations needed very long exposure times or some form of flash device. In 1924, the Ernemann-Werke in Dresden, Germany, announced a different approach to available light photography with what they billed as "the most efficient camera in existence." The Ermanox's massive 10cm f/2 Ernostar lens dwarfed the cigarette-pack-sized body and could focus enough light on a 4.5 x 6-cm film plate to record scenes using normal room light with a shutter speed fast enough to freeze motion. The focal-plane shutter had a 1/1000-second top speed and was quiet enough for unobtrusive use during a theater performance. Focus could be done three ways: through the lens with a ground-glass screen, using the distance scale on the lens ring, or using the folding Newton finder on the top of the camera.

The camera was priced at $190.65, which included a film-pack adapter, three plate holders, and a carrying case. Larger Ermanox models were added, such as an 9 x 12 cm with a collapsing bellows and a 16.5cm f/1.8 lens, which otherwise was a scaled-up version of the original camera. It sold for $550 in 1926.

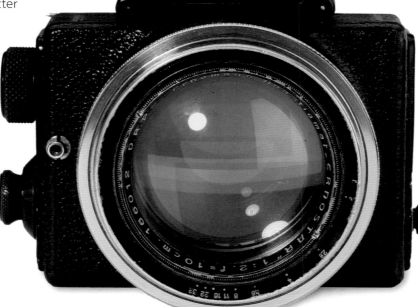

LEICA I MODEL A

1925 | Ernst Leitz GmbH, Wetzlar, Germany

1974.0037.2925

Introduced in 1925 at the Leipzig Spring Fair in Germany, the Leica I Model A was the first production model of the Leica camera manufactured by the firm of Ernst Leitz GmbH in Wetzlar, Germany. It claimed to be "the smallest camera with a focal plane shutter." A horizontally running focal-plane shutter provided speeds from 1/25 to 1/500 second. It came with a noninterchangeable, collapsible 50mm f/3.5 lens sold in three variations, Anastigmat, Elmax, and Elmar, the Elmar being the most common. The black enamel body had a placement of feature controls that was imitated so often it became a standard. Early examples like this one had a large mushroom-shaped shutter-release button. The camera sold for $114, and the optional "FODIS" range-finder accessory cost $11. The serial number of the camera shown here is 5283.

VEST POCKET ENSIGN (mounted in handbag)

ca. 1925 | Houghton-Butcher, Ltd., London, England

Gift of Eastman Kodak Company. 1974.0037.1671

Concealed and disguised cameras have always intrigued people. Designers loved dreaming up clever ways to incorporate photographic devices into everyday items. "Purse cameras" first appeared in the nineteenth century with bulky dry-plate apparatuses in big Victorian-era handbags. By the time Samuel Aspis of London patented his "combination of hand bag or like portable receptacle and collapsible photographic camera" in 1928, roll-film vest pocket cameras were at the height of their popularity. Aspis designed his version around an ordinary Ensign Vest Pocket, which folded flat enough to mount inside a special leather clutch purse. To take photos, the purse flap was flipped over and a mirror panel unsnapped. The camera faceplate had to be pulled out to lock the struts, and it was then ready to begin filling up the roll of No. 127 film with pictures. Metal brackets riveted to the purse held the camera securely. The Aspis purse camera wasn't intended for surreptitious photography, but rather as a convenient way to always have a camera ready to use. And one would assume the fashion-conscious dame of the time would have shoes and earrings to match the Ensign clutch.

3A PANORAM KODAK

1926 | Eastman Kodak Company, Rochester, New York

Gift of Eastman Kodak Company. 1974.0037.2662

The 3A Panoram Kodak was basically a box camera for taking pictures of broad landscapes or large groups of people. To expose the long, narrow picture, the spools and rollers were located to hold the film against a curved guide, while the lens was mounted on a pivot, allowing it to swing 120 degrees when the shutter button was pressed. However, instead of a shutter, a flattened, funnel-shaped tube attached to the inside of the lens swept the light across the film. The result was a 3¼ x 10⅜-inch image that allowed everyone to be in the picture. The lens funnel opening was lined with a plush material and parked firmly against a stop covered with the same black fabric, making a light-tight seal. To assist the photographer in holding the camera straight, two bubble levels were located near the viewfinder. The 3A Panoram cost $40 in 1926. The size A-122 film was available in either three- or five-exposure rolls.

Below: Unidentified photographer. *ILE DE SÉHEL*, ca. 1903. From the album *Egypte, Assouan.* Collodion or gelatin printing out paper (POP) print. Exchange with Michel Auer.

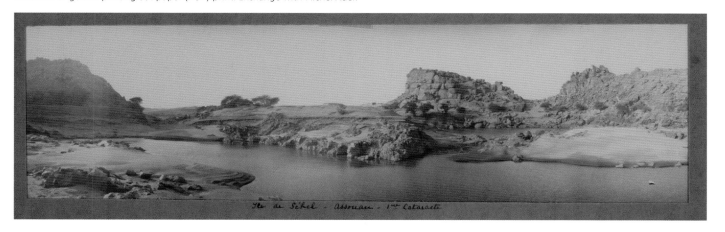

ROLLEIFLEX I

ca. 1929 | Franke & Heidecke, Braunschweig, Germany

1974.0084.0121

Introduced in 1929 by Franke & Heidecke of Braunschweig, Germany, the Rolleiflex was an instant classic. Rollei's compact twin-lens reflex design was constantly improved and manufactured well into the 1990s and was copied by many companies throughout the world. What made it popular was that the 6-cm square format, being more than four times larger, made sharper enlargements than 35mm film. The large reflex finder screen, although it gave a mirror image of the subject, was bright and made it easy to focus the 7.7cm f/3.8 Carl Zeiss Jena Tessar lens. The Compur shutter with rim-set controls had a maximum speed of 1/300 second. Rolleiflexes were favorites of professionals and serious amateurs alike, prized for their superior optics, durable all-metal construction, and extensive catalog of accessories. The Rolleiflex I cost $75 in 1929.

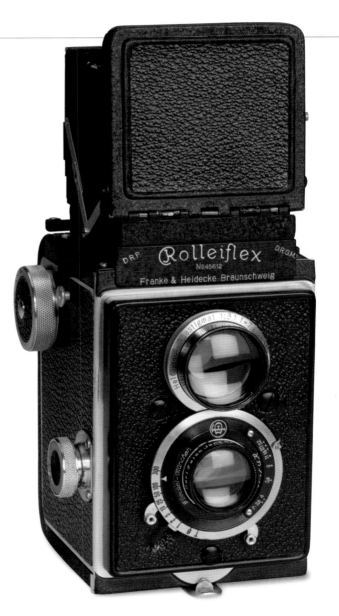

GIFT KODAK

1930 | Eastman Kodak Company, Rochester, New York

Gift of Eastman Kodak Company. 1993.1392.0001

The Gift Kodak, introduced in 1930, like the Ensemble and the Coquette, was aimed at the holiday gift-giving season. Unlike the other two, the Gift Kodak had a distinctly masculine appeal. A special version of the 1A Pocket Kodak with a bed and shutter plate design in brown and red enamel and polished nickel, it produced 2½ x 4¼-inch images from No. 116 roll film. The camera was covered in brown leatherette, and the gift box was an ebony-finished cedar box with an inlaid cover matching the camera face. The retail price was $15.

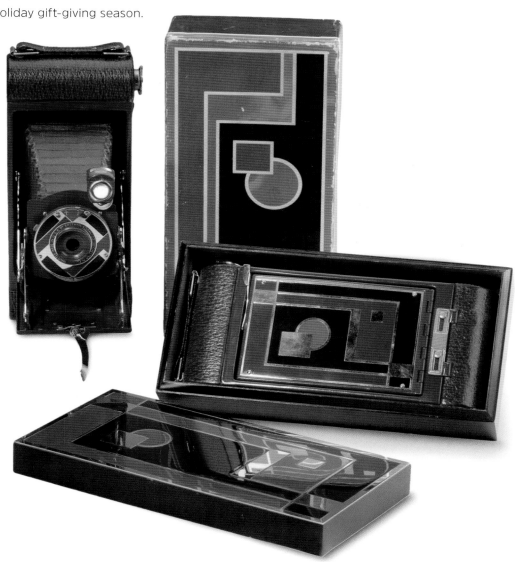

KODAK COQUETTE

ca. 1930 | Eastman Kodak Company, Rochester, New York

Gift of Eastman Kodak Company. 1974.0028.3452

The Kodak Coquette, introduced in 1930, included a Kodak Petite camera, like the Ensemble of the previous year. This time, the color selection was strictly blue. The exterior was a striking face with a geometric art deco pattern in two tones of blue enamel and nickel designed by American industrial designer Walter Dorwin Teague. Inside, the camera used No. 127 roll film to produce 1⅝ x 2½-inch images. Packaged with a matching lipstick and compact, the Coquette aimed at high style and was marketed as being for "the smart, modern girl . . . a bit of Paris at your Kodak dealer's." The Teague-designed gift box was a striking silver and black with a geometric pattern. Including cosmetics by Coty, the retail price was $12.50.

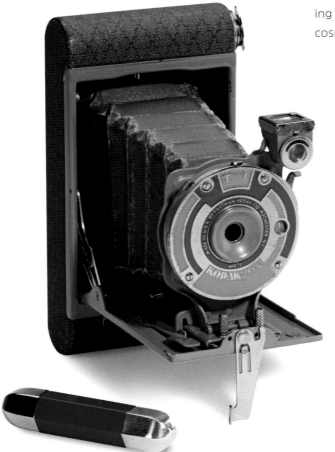

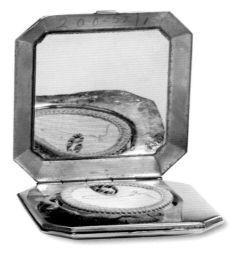

CONTAX I (540/24)

ca. 1932 | Zeiss Ikon AG, Dresden, Germany

Gift of 3M Foundation, ex-collection Louis Walton Sipley. 1977.0415.0004

The success of the Leica camera following its debut in 1925 was not lost on Zeiss Ikon AG of Dresden, Germany. Their entry into this new market was the Contax in 1932. It differed from the Leica in many ways, beginning with its brick-shaped body. The removable back made film loading much easier than the Leica. The Contax had a coupled long-base rangefinder for accurate focus of the ten available bayonet-mount lenses. A ridged wheel next to the shutter button made it easy to focus quickly and make the exposure. The Contax shutter was a metal focal plane that moved vertically and had a top speed of 1/1000 second, twice as fast as rival Leica's. A large knob next to the lens was turned to wind the shutter and advance the film. The Contax used either standard 35mm magazines or a pair of special cassettes. The model pictured has a fast 5cm f/1.5 Carl Zeiss-Jena Sonnar lens and cost $256.

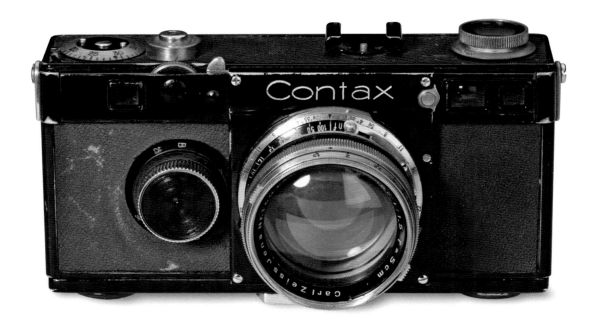

ENSIGN MIDGET 55

ca. 1934 | Houghton-Butcher Ltd., London, England

Gift of Dr. Rudolf Kingslake. 1993.0525.0001

The Ensign Midget 55 was "no wider than a sixpence" when folded, according to the London firm's 1935 catalog. The top of the Midget line, the Model 55 designation came from its fifty-five shilling price tag. Featuring an Ensar f/6.3 focusing lens, adjustable aperture, and three-speed shutter, it looked like a child's toy but produced images sharp enough to enlarge on the six-exposure rolls of 35mm-wide Ensign E10 film. The designers of the Midget series allowed no wasted space and managed to include a two-position reflex finder, folding eye-level bull's-eye finder, prop stand, and locking struts that held the lens board rigidly in position. Many "vest pocket" folding cameras were available then, but none were smaller than the Houghton-Butcher Ltd. series of Midgets.

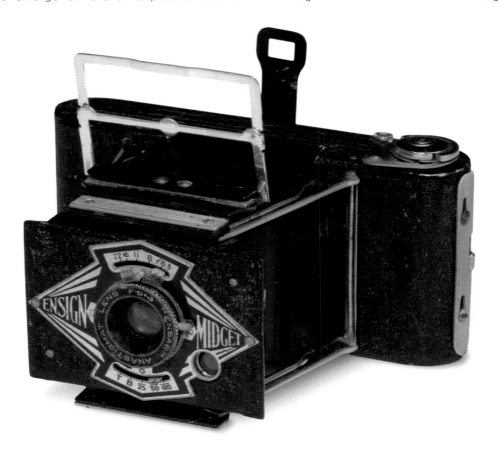

RETINA I (TYPE 117)

1934 | Kodak AG, Stuttgart, Germany

Gift of Eastman Kodak Company. 1992.0259.0001

The Retina I (Type 117) was Kodak's first 35mm miniature camera. Introduced in December 1934, it was manufactured by Kodak AG, the German subsidiary of Eastman Kodak Company in Stuttgart. The Retina I was the first camera designed and released by the renowned innovator Dr. August Nagel after his company was acquired by Eastman Kodak Company. It was a compact, leather-covered metal body with self-erecting lens, and it was the first camera to use the now-familiar Kodak 35mm daylight-loading film magazine. The retail price with f/3.5 lens was $57.50.

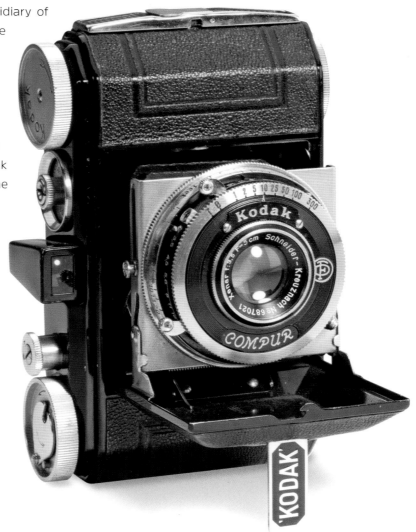

RETINA I STEREO

ca. 1935 | Kodak AG, Stuttgart, Germany

2007.0234.0001

Stereo photography, which was perfected not long after the medium's invention, first used individual cameras mounted on a common stand or board. The two cameras were later replaced by a pair of lenses mounted in the same apparatus. Camera bodies needed to be wider than normal to accommodate the side-by-side optics. To maintain costs, most manufacturers of stereo equipment based their designs on regular 2-D models. With the rise of miniature cameras, it wasn't long before 3-D versions were proposed and evaluated. The French Homéos pioneered the use of 35mm film for stereo pairs in 1914. Fifteen years later, Leitz's Oskar Barnack built a stereo Leica designed to make two 24 x 36-mm images with a single press of the shutter release. The camera never made it past the prototype stage for a number of technical reasons, one being that just one focal-plane shutter served both lenses. The gap in the shutter curtains could sweep across only one frame at a time, and good stereo photos require both pictures to be exposed simultaneously.

The experimental Retina I Stereo solved the problem of simultaneous exposure by using leaf shutters in the lenses, with the releases linked by a connecting rod. The camera used Kodak 35mm daylight-loading cassettes, and, like the Leica, made 24 x 36-mm pairs. Many of the parts used for this test mule came from the Retina I parts bins, though the body was specially made. Two 50mm Xenar lenses and Compur-Rapid shutters were set 2⁹⁄₁₆ inches apart, and had to be focused individually. Neither the speed nor aperture dials were linked in the prototype, but most certainly would have been had the project continued beyond this trial instrument. Numerous companies would revive the 35mm stereo idea after World War II, but Kodak AG was not among them.

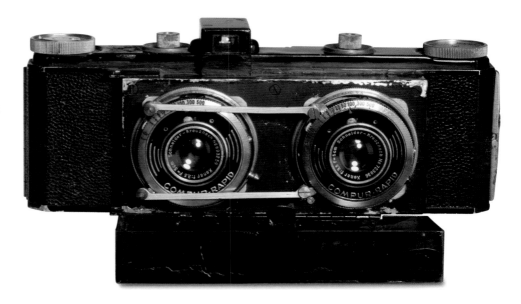

BANTAM SPECIAL

ca. 1936 | Eastman Kodak Company, Rochester, New York

Gift of Eastman Kodak Company. 1991.2845.0001

The Kodak Bantam Special, introduced in 1936, was a self-erecting roll-film camera using No. 828 film (also known as Bantam, as it was introduced for this camera). Another striking design by Walter Dorwin Teague in his trademark art deco style, it displayed strong horizontal bright metallic lines on a black enamel die-cast body. In addition to being stylish, it was a compact camera fitted with a 45mm f/2.0 Kodak Anastigmat lens (later renamed the Kodak Ektar lens); it is the first Eastman Kodak Company camera featuring a lens of this speed. Other features included a 1/500 second shutter and a split image rangefinder focus. It retailed for $110 in 1936.

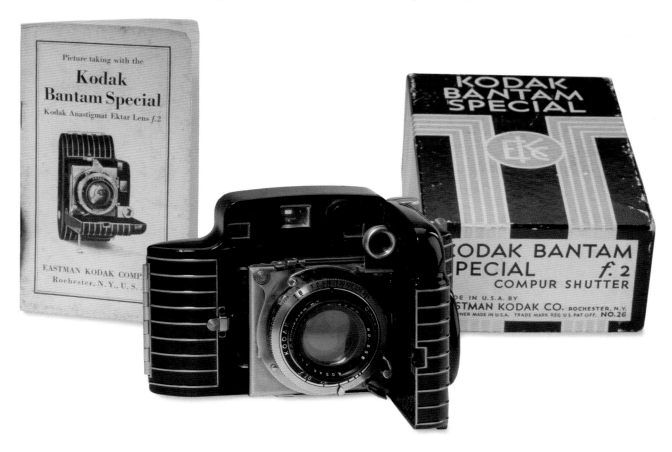

MINOX (original model)

ca. 1937 | Valsts Electro-Techniska Fabrica, Riga, Latvia

Gift of Eastman Kodak Company. 1974.0084.0130

The original Minox, designed as a pocket-sized hiking camera, was destined to become the world famous "spy camera" as seen in the movies. It was designed by Walter Zapp and manufactured in 1937 by Valsts Electro-Techniska Fabrika, in Riga, Latvia. The first of many tiny Minox cameras, it was initially made from stainless steel and later changed to lighter aluminum. Though the camera had all the usual controls, its main feature was that it was made instantly ready by merely pulling the sliding inner case out, which simultaneously exposed the viewfinder, advanced the film, and set the shutter. Later versions of the camera kept up with advancing technology by adding innovations such as parallax correction, electronic flash, and auto exposure. The original retail price in 1937 was $79.

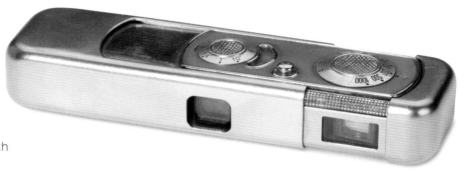

SUPER IKONTA B (530/16)

ca. 1937 | Zeiss Ikon AG, Dresden, Germany

Gift of Homer W. Smith. 1982.2231.0001

The Zeiss Super Ikonta B, manufactured by Zeiss Ikon AG, Dresden, was a medium-format camera that folded flat for convenience. It provided a 6-cm square image on No. 120 roll film. The 530/16 model was produced from 1937 through 1956 and featured a combined rangefinder and viewfinder window. With the Zeiss Tessar lens, the Super Ikonta B is considered by many to be the best folding roll-film camera ever made. The retail price in 1937 was $150.

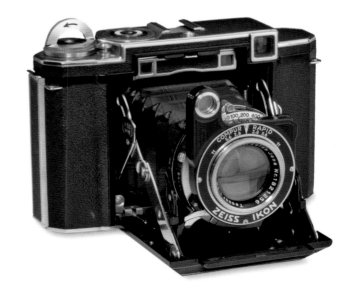

KINE EXAKTA I (rectangular magnifer)

ca. 1937 | Ihagee Kamerawerk, Dresden, Germany

1974.0037.1597

The Ihagee Kamerawerk in Dresden, Germany, introduced a single-lens reflex design in 1933 they named Exakta. This wedge-shaped camera took size 127-roll film and had a folding viewfinder hood and a mirror that allowed the photographer to compose and focus through the same lens used for making the exposure. Though not a new idea, Exakta utilized it in a very small body. In 1936, Ihagee built the Kine Exakta I, which used a 35mm film magazine, making it the world's first 35mm SLR camera. It had a cloth focal-plane shutter with a maximum speed of 1/1000 second and interchangeable lenses. The film advance lever and shutter release were on the left side. Lens choices included Ihagee's own Exaktar 5.4cm f/3.5 and various Zeiss Ikon and Schneider units. The Kine Exakta remained on the market for about ten years and sold for up to $275 with a Zeiss Biotar f/2 lens. The example shown here is the Kine Exakta I, fitted with a rectangular magnifier on the viewing hood; the first version, the Exakta, used a smaller round magnifier.

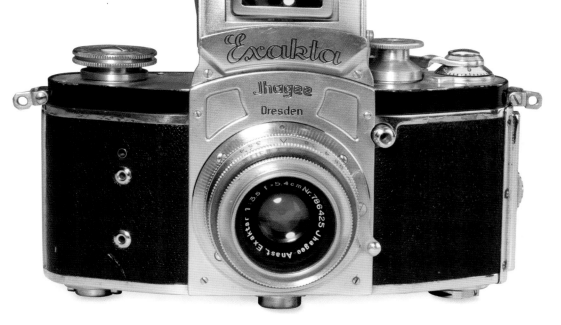

CANON S

ca. 1938 | Seiki Kogaku Kenkyusho, Tokyo, Japan

Gift of Harry G. Morse. 1981.2297.0029

Working from a single room in a Tokyo apartment in November 1933, motion picture camera repairman Goro Yoshida, together with his brother-in-law Saburo Uchida and Takeo Maeda, founded Seiki Kogaku Kenkyusho (Precision Optical Instruments Laboratory), later known as the Canon Camera Company. These men were determined to build a 35mm rangefinder camera comparable in design to the Leica II, introduced in Germany in 1932, but with a price more accessible to the Japanese public. With funding from a friend, Dr. Takeshi Mitarai, they embarked on a research project that resulted in the camera prototype Kwanon, named after the thousand-armed Kwannon, the Buddhist goddess of mercy. As early as June 1934, the company publicized its new camera in print advertisements, seeking to drum up public support. However, the Kwanon camera and subsequent design variants never reached the production stage for want of quality optical elements.

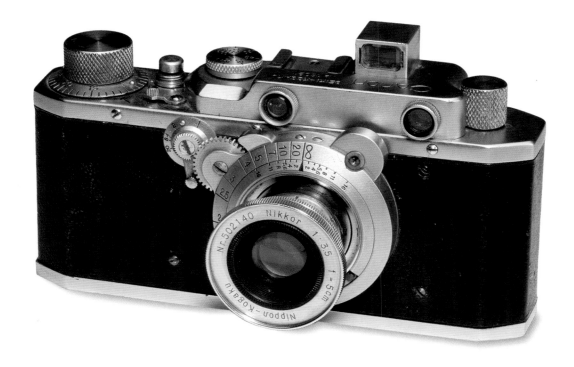

COMPASS

ca. 1938 | Jaeger-LeCoultre & Cie, Switzerland

1974.0028.3309

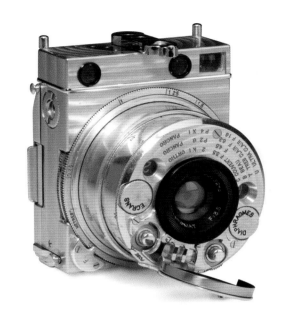

The Compass camera was manufactured by Jaeger-LeCoultre, Switzerland, for Compass Cameras Limited, London, in 1937. It had a precision, fully machined aluminum body that produced 24 x 36-mm images on glass plates, sheet film, or 35mm roll film. No. 828 roll film also could be used with an available back. The compact camera possessed advanced features such as a coupled rangefinder, extinction meter, right-angle viewer, ground glass focusing, and interchangeable backs. The retail price in 1937 was £30.

SUPER KODAK SIX-20

1938 | Eastman Kodak Company, Rochester, New York

Gift of Eastman Kodak Company. 2001.0636.0001

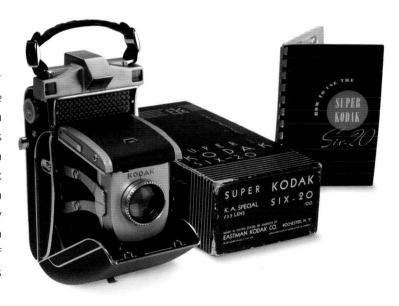

Introduced in 1938 as the world's first automatic exposure camera, the Super Kodak Six-20 used a large selenium photocell to control the aperture before the exposure was made. With a clamshell design styled by Walter Dorwin Teague, it featured a wide base rangefinder and a crank wind film advance and produced 2¼ x 3¼-inch images on No. 620 roll film. Though advanced—it took nearly twenty years before the rest of the world caught up—the camera was unreliable, which, coupled with a high retail price of $225, made it the least widely sold of the Kodak cameras aimed at the general public.

LEICA IIID

1940 | Ernst Leitz GmbH, Wetzlar, Germany

Gift of Gerald Lippes. 2008.0428.0027

Manufactured from 1940 to 1946 in Wetzlar, Germany, the IIIc was the first Leica with a die-cast body and one-piece top plate; it was slightly longer than earlier models. The next edition, the IIId, was the same as the IIIc, but for an added self-timer, which was the first one fitted to a Leica. According to company records, only 457 IIId cameras were made, and in two batches: serial numbers 360,001 to 360,134 and 367,001 to 367,325.

Also notable is the material used for the shutter curtains during wartime production of both cameras. Prior to World War II, Leitz acquired shutter curtain material from the Rochester, New York-based Graflex, Inc. However, with the outbreak of war, this arrangement was rendered impossible, and Leitz had to find a new curtain material suitable for camera shutters. The substitute curtain, which was red on one side and black on the other, was used as a "stop gap" during wartime production. After the war, an all-black parachute material was found to be satisfactory and used for both new production and repaired cameras. Historically, Leitz offered a program to update older camera models to new specifications, a policy that was quite effective, especially after the war. This practice was likely responsible for frequent replacement of the red shutter material with the more common black, making those cameras still fitted with the original red curtains quite rare.

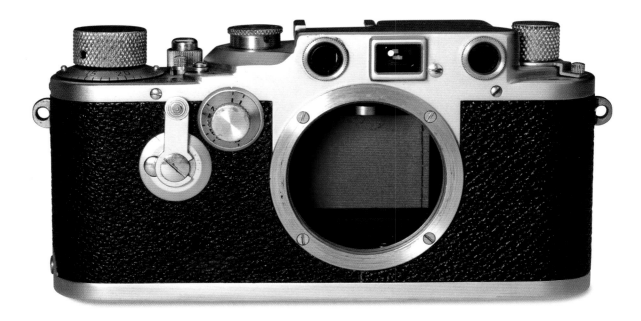

SPARTUS PRESS FLASH

ca. 1940 | Utility Manufacturing Company, Chicago, Illinois

1974.0037.0140

Introduced in 1939, the Spartus Press Flash was arguably the first camera with a built-in flash reflector. A Bakelite box camera with art deco design elements on the body and nameplate, it had a flash reflector for Edison base bulbs built into the top surface and produced 2¼ x 3¼-inch images on No. 120 roll film. At introduction, the retail price was $5.95. The Spartus Press Flash was virtually identical to the Falcon Press Flash (shown here). Both were manufactured by the Utility Manufacturing Company of Chicago, which had a tangled corporate history. Operating from a building on West Lake Street, the company went through numerous ownership changes and brand names, marketing cameras under the names Falcon, Spartus, Herold, Galter, Regal, Monarch, Monarck, and Spencer, among others.

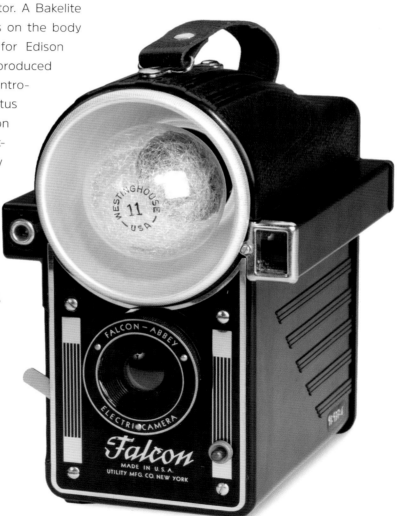

SIX-20 FLASH BROWNIE

ca. 1940 | Eastman Kodak Company, Rochester, New York

Gift of Eastman Kodak Company. 1974.0037.1181

Eastman Kodak Company's first internally synchronized flash camera, produced from 1940 to 1954, was known initially as the Six-20 Flash Brownie and later as the Brownie Flash Six-20. It was a trapezoidal metal box camera producing 2¼ x 3¼-inch images on No. 620 roll film. The flash holder used the large General Electric No. 11A (Washbash 00) flash bulb, though an adapter was available for the smaller No. 5 bulb. The retail price was $5.75, with flash holder.

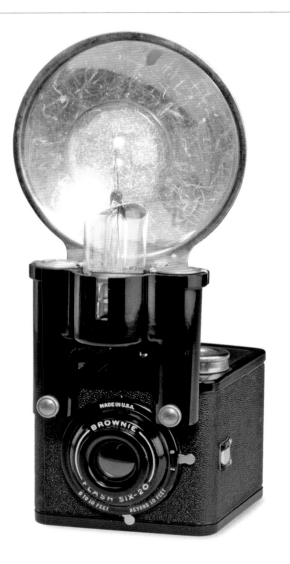

Above: Unidentified photographer. [*Snapshot of men fishing*], ca. 1920. Gelatin silver print. George Eastman House Collections.

LITTLE BERTHA

ca. 1941 | Graflex, Inc., Rochester, New York

1974.0028.3537

Long lenses are used for photographing objects to which the photographer cannot get physically close, such as sporting events or animals in the wild. The Little Bertha, like its predecessor, the Naturalists' Graflex (see page 91), was designed for such purposes. Also like the Naturalists', Little Bertha was based on a production Graflex model, in this case, a 4 x 5 RB Graflex Super D. Modifications were added to the camera base to support the 30-inch (and 40-pound!) f/8 lens. To allow for fast focusing, a chain-drive system, complete with three adjustable focus points, was added to the side of the camera. For example, when shooting baseball, it could be pre-focused on the different bases. This camera was used in the 1940s at the *Chicago Sun Times*, probably for stadium sports photography.

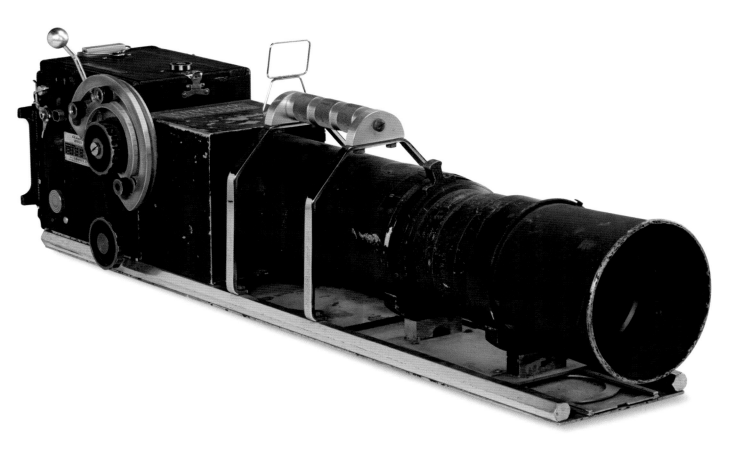

EKTRA (35MM)

ca. 1941 | Eastman Kodak Company,
Rochester, New York

Gift of Ruth Yuster. 1991.0274.1–6

In the late 1930s, Eastman Kodak Company felt it had the ability and technology to design the globe's best camera, and they set out to do so. The result was introduced in 1941 as the "world's most distinguished camera." The Kodak Ektra was a high-quality, precision camera system using 35mm film and interchangeable lenses that were considered among the best. A number of features were firsts for 35mm rangefinder cameras. They included six coated lenses, ranging in focal length from 35mm to 153mm, interchangeable backs, parallax-compensated finder, built-in optical zoom finder, lever film advance, film rewind lever, and a very long-based coupled rangefinder. Such a marvelous camera came with a high price. The camera and 50mm f/1.9 lens retailed for $300 in 1941. All five accessory lenses cost an additional $493.

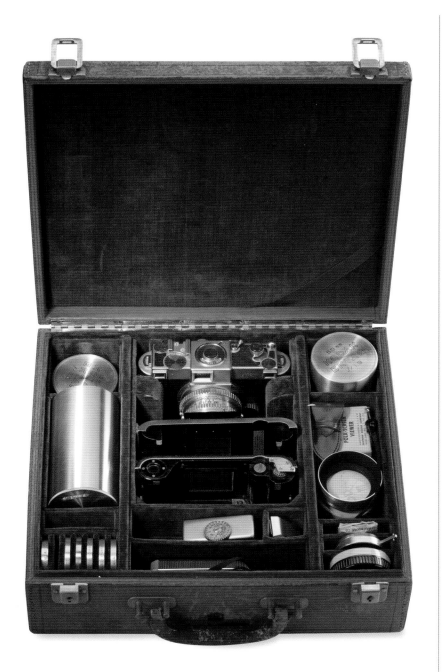

Above: Unidentified photographer. [*Young women at Camp Keuka, Keuka Lake, NY*], ca. 1940. Kodachrome print. Courtesy Joseph Struble.

EASTMAN MATCHBOX CAMERA

1945 | Eastman Kodak Company, Rochester, New York

Gift of Eastman Kodak Company. 2001.0636.0002

Named for its size, the Eastman Matchbox Camera (also known as Camera "X") was small enough that the sleeve of a standard European matchbox could slip over it as a disguise while the lens peered discreetly through a side panel. A true spy camera, it was designed when the U.S. intelligence agency the OSS (Office of Strategic Services) approached Kodak for a small photographic instrument to be used in occupied Europe by American and European agents and resistance members. The top-secret project shipped 500 units in early 1944, with another 500 in 1945. Using 16mm film in cassettes to produce 30 half-inch square images, the Matchbox also had a stand with a close-up lens for document copying. Patented in February 1945, production was discontinued just months later with the war's end.

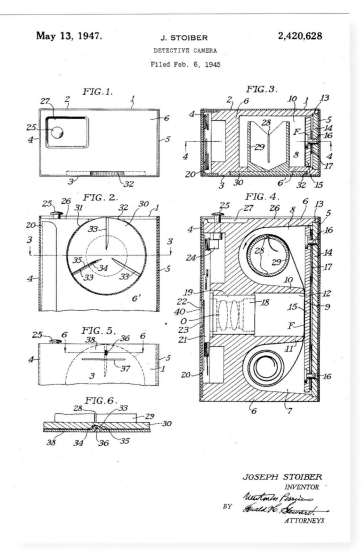

Above: Patent no. 2,420,628 for the "Detective" Matchbox Camera, dated May 13, 1947, filed by Joseph Stoiber for Eastman Kodak.

NIKON

1947 | Nippon Kogaku K. K., Tokyo, Japan

Gift of Eastman Kodak Company. 1990.0128.0005

Taking the best features of Leica and Contax rangefinder cameras as its starting point, the original Nikon (usually referred to as the Nikon I by collectors), the first production camera from Nippon Kogaku, sought to improve upon both. Introduced in 1948, it combined a horizontal cloth focal-plane shutter and a rangefinder similar to the Leica with a body shape, focusing controls, and bayonet lens mount derived from the Contax.

Nippon Kogaku was new to camera manufacturing but had been a leading producer of optics since 1917. Accordingly, the Nikkor lenses supplied for its new camera were already in use on Canon and other cameras of the time. The Nikon came with either an f/3.5 or f/2 collapsible 5cm lens. Additional Nikkors with focal lengths of 3.5cm, 8.5cm, and 13.5cm were also available. As with all Japanese products intended for export in the years immediately following World War II, the camera and lenses were engraved "Made in Occupied Japan."

The 24 x 32-mm image size used by the Nikon allowed forty exposures on a standard roll of 35mm film. Unfortunately, this size was incompatible with U.S. standard Kodachrome mounts, a problem quickly recognized by the Overseas Finance and Trading Company (OFITRA), the first American importer of the Nikon, as a severe limitation to U.S. market acceptance of the camera. Ultimately, only several hundred cameras were manufactured before the format increased to a still nonstandard 24 x 34 mm with the introduction of the Nikon M in 1949. The Nikon S, introduced in 1951, became the first camera from Nippon Kogaku to use the standard 24 x 36-mm format.

HASSELBLAD 1600F
1948 | Victor Hasselblad AB, Göteborg, Sweden

Gift of Eastman Kodak Company. 1974.0037.0072

During World War II the Royal Swedish Air Force asked inventor Victor Hasselblad if he could make an aerial camera like one they had found in a wrecked German airplane. His answer was, "Well, not exactly. I can do better." The resulting aerial camera bore a striking resemblance to the eventual Hasselblad 1600F, which was officially introduced in 1948 as the Hasselblad camera. Only after the subsequent release of the 1000F model did it become known as the 1600F. All Hasselblad cameras have been manufactured by Victor Hasselblad Aktiebolag, Göteborg, Sweden.

In Hasselblad's effort to produce the "ideal camera" for the professional photographer, his 1600F was near perfection. It was the first camera designed with a modular concept; his single-lens reflex design was farsighted. The central camera body could accept a variety of interchangeable lenses, film magazines, and viewing systems. Measuring less than four inches square and six inches long, the medium-format camera boasted a fast 1/1600-second shutter speed and a thin, lightweight, stainless steel foil focal-plane shutter. Tapping into a longstanding family relationship with Eastman Kodak Company, Hasselblad had Kodak design the camera's standard 80mm Ektar lens, as well as the 55mm, 135mm, and 254mm lenses.

The retail price at introduction for a complete 1600F camera (body, lens, and magazine) was $548 but was reduced to $479 by 1953.

SAKURA PETAL (octagonal model)

ca. 1948 | Sakura Seiki Company, Tokyo, Japan

Gift of C. A. Vander. 1978.0642.0002.

The Sakura Petal, manufactured in 1948 by the Sakura Seiki Company of Japan, was a subminiature camera just over one inch in diameter. It made six exposures, each about ⅛-inch in diameter, on a round piece of film about one inch across. The octagon-shaped body shown here was rarer than the earlier round body.

RECTAFLEX ROTOR

ca. 1952 | Rectaflex, Rome, Italy

1974.0037.2536

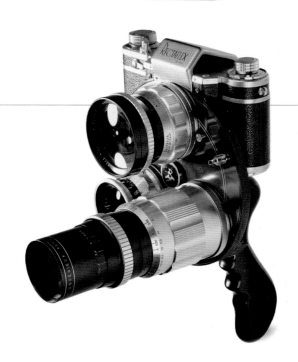

The 1952 Rectaflex Rotor was a 35mm SLR camera with a rotating three-lens turret, a successful feature on movie cameras since the 1920s. In the days before zoom lenses, the idea was to make lens swapping easier. The Rectaflex's pistol-grip handle had a trigger linked to the shutter actuator. Its rotor lock release was an easy-to-press thumb button and allowed the photographer to select a normal, wide-angle, or telephoto lens, all while keeping the subject framed in the finder. Designed with many features desirable to the serious shooter, the camera's weight wasn't among them.

ASAHIFLEX IIB

1954 | Asahi Optical Company, Ltd., Tokyo, Japan

Gift of Asahi Optical Company. 1981.1296.0025

Introduced in 1954 by the Asahi Optical Company, the Asahiflex IIB was a further evolution of the Asahiflex I, Japan's first 35mm SLR, which appeared in 1952. The Asahiflex IIB was the first 35mm SLR to use an instant-return mirror, which became the world standard. By 1957, the Asahi camera line was known as Asahi Pentax cameras, although in the United States, they were labeled Honeywell Pentax for the American corporation that imported them into the 1970s. Since then, the name on the plate has been simply Pentax. In June 2007, after an earlier attempt at a merger failed, Hoya Corporation announced a buyout of Pentax Corporation that would make it a wholly owned subsidiary while retaining its brand name.

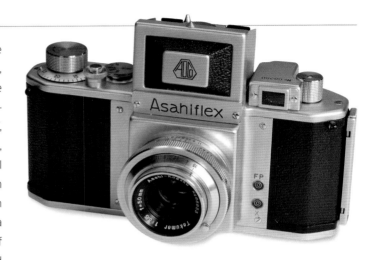

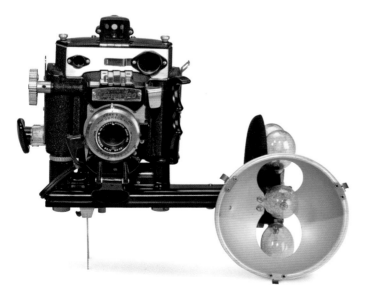

OMEGA 120

ca. 1954 | Simmon Brothers, Inc., Long Island City, New York

Gift of Simmon Brothers, Inc. 1974.0037.0088

Better known for their Simmon Omega enlargers, Simmon Brothers, Inc. also made the Omega 120 medium-format professional camera, which produced 2¼ x 2¾-inch images on No. 120 roll film. Its novel feature was an automatic film advance that, with the single action of pulling out and pushing back a lever, advanced the film, counted the exposure, set the shutter, and even changed the bulb in the Repeater-Action flash holder. The retail price in 1954 was $239.50, and with a flash unit was an additional $49.50.

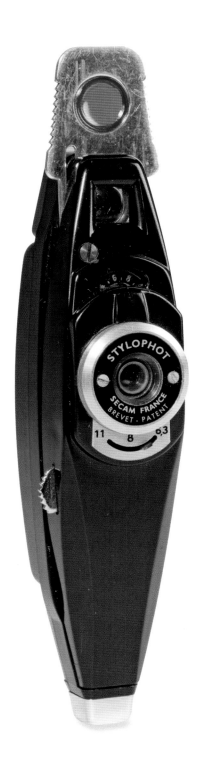

STYLOPHOT

ca. 1955 | Secam Corporation, Paris, France

1974.0028.3311

The public's fascination with espionage during World War II continued through the Cold War years, boosting sales of subminiature or "spy" cameras. Some, like the Minox (see page 150), were costly, high-quality instruments, but most were sold as inexpensive trinkets. Secam offered the plastic-bodied Stylophot in 1955; its bloated fountain-pen shape, handy pocket clip, and $14.95 price tag placed it firmly in the novelty market. Special cassettes held perforated 16mm ciné film for eighteen pictures in either *noir* or *couleur* (black-and-white or color). Operation was simple. The film was advanced and the shutter cocked, then a chrome slide called the "transport plate" was pulled out. The tiny fixed-focus 27mm f/6.3 coated lens fed light to the film through one of the two stops, and a ridged metal thumb tab actuated the 1/50-second shutter for each 10 x 10-mm image.

LEICA M3 (double stroke)

1954 | Ernst Leitz GmbH, Wetzlar, West Germany

Gift of Eastman Kodak Company. 1999.0161.0002

Introduced in 1954 at the Photokina trade show in Cologne, West Germany, the Leica M3 quickly became a favorite of photojournalists for its nearly silent operation. Many of its features were improvements over previous models: the lens mount changed to bayonet-type; shutter speeds were on a single dial; the viewfinder automatically compensated for aiming errors resulting from the distance between the taking lens and the viewer (parallax); the film was advanced and the shutter cocked by means of a lever that required two quick strokes; and a hinged door on the camera's back simplified film loading. It cost $288 for the body alone, and adding a faster lens like the 50mm f/1.5 Summarit brought the total to $469.

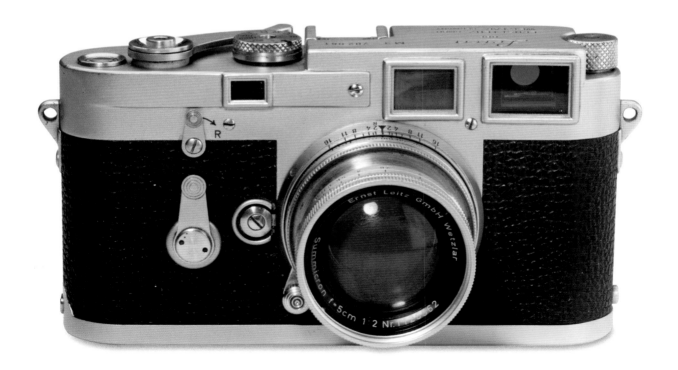

Above: Unidentified photographer. [*Couple with dog at the Coconut Grove Sailing Club*], ca. 1957. Kodacolor print. Gift of 3M, ex-collection Louis Walton Sipley.

NOBLE 3-35

1956 | Noble Camera Manufacturing Company, Detroit, Michigan

1997.2369.0001

One of the most unusual 35mm cameras ever made was the Noble 3-35. Designed by Sam Noble, an ex-Army photographer, the 3-35 was an attempt to eliminate the need for photographers to carry multiple cameras on assignment. Typically, professional photographers using 35mm equipment juggled multiple cameras, loaded with different film types and/or fitted with lenses of different focal lengths. Noble's camera had the unique feature of simultaneously accepting three different rolls of film, allowing the photographer to expose combinations of black-and-white or color films without having to switch camera bodies or media. This was accomplished by rotating the lens shutter assembly, the most expensive part of any camera, to the appropriate roll film. The camera's other features were common to the 35mm equipment of the day: interchangeable lenses, rangefinder focusing, and flash sync for either flash bulbs or electronic flash. Whether due to price ($299.50 in 1957), distribution (Noble sold direct and apparently had trouble filling orders), or yet another reason, the 3-35 didn't catch on. This is thought to be the only surviving example.

PETIE VANITY

ca. 1956 | Walter Kunik KG, Frankfurt, West Germany

Gift of Fred Spira. 1985.1044.0004

Camera manufacturers have a long history of promoting their products as being ideal gifts for "that special someone." Boxed outfits from major brands like Kodak and Ansco got the full-page color treatment in popular magazines every December. Both firms went a step further in the 1930s and made vanity packages that included a colorfully styled camera in a case with various cosmetic items. This idea was behind the creation of the Petie Vanity sold by Kunik, which was a subminiature, toy-like item similar to the Hit cameras from post-war Japan. Stamped from thin metal, the Petie used tiny spools of paper-backed film for making 14-mm square negatives. A crude shutter and lens made pictures of poor-to-fair quality, and few people used these cameras more than once.

The Petie Puderdose (powder puff) version was housed in a nicely finished metal case the size and shape of a Vanity Kodak. While one side of the case had a space for the Petie to slip into, the other side had a small door that opened to reveal a mirror and face powder. Next to the camera were two removable metal tubes, one marked "film" that was long enough to store a couple of spare rolls, and one that held lipstick. The case was a handsome piece, although its art deco trim was about twenty years out of style. Bright chrome contrasted with shiny enamel, available in several colors, for about eight 1956 dollars. Kunik also sold a cigarette lighter with a slip-in Petie, as well as a music-box version.

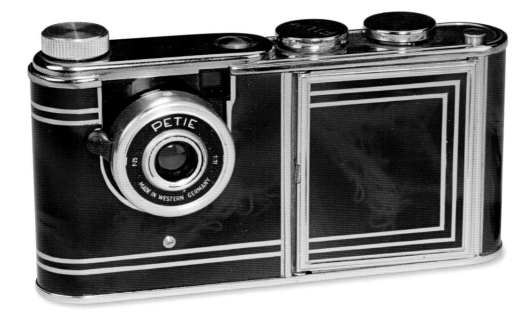

BROWNIE STARFLASH

ca. 1957 | Eastman Kodak Company, Rochester, New York

Gift of Eastman Kodak Company. 1996.0474.0001

The Brownie Starflash, produced from 1957 to 1965, was the first Kodak camera with a built-in flash. A popular item, it used No. 127 roll film to produce twelve images, 1⅝ inches square in size. With Ektachrome transparency film, newly available in that size, it also could make "super slides," the largest image to still fit a 2-inch square mount. First issued only in black, the cameras were available in colors during the middle of the run—in red, white, or blue—but only as part of an outfit. A rare Coca-Cola version was offered as a premium. In 1957, the camera alone retailed for $8.50 and with the outfit for $9.95.

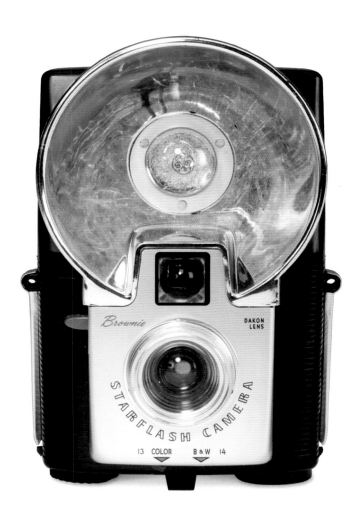

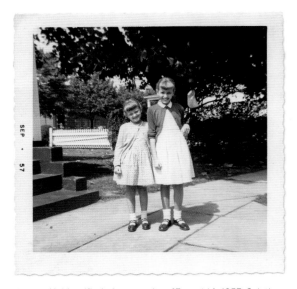

Above: Unidentified photographer. [*Two girls*], 1957. Gelatin silver print. Courtesy Joseph Struble.

GOLDEN RICOH 16

1957 | Riken Optical Industries, Ltd., Tokyo, Japan

Gift of James Sibley Watson Jr. 1981.0790.0043

Riken touted its Golden Ricoh 16 as "the most modern subminiature in the world" when it debuted in 1957. While that claim is debatable, the Golden was certainly one of the most attractive of the many tiny 16mm cameras of its day. The gold-colored metal parts contrasting the black leather-grain covering was an homage to the Luxus (deluxe or luxury) cameras favored by the well-heeled prior to World War II. The Golden Ricoh had many features of a 1950s 35mm camera but was small enough to hide in one's palm. It used 16mm film in special cassettes that could be reloaded. Like most subminiature cameras, this one had a supply and a take-up cassette, but unlike its competitors, the two pieces were connected by a metal bracket that made loading and removal easier.

The controls of the Golden Ricoh were much the same as those on larger cameras, including a single-stroke film advance lever, an automatic exposure counter, and top-mounted release button. A knob for selecting one of three (plus bulb) shutter speeds was on the top next to the PC socket. The aperture setting was made by rotating a ring on the 25mm f/3.5 Riken fixed-focus lens. A lens cap no bigger than a dime protected the glass when not in use. The thread-mount lens could be interchanged with a 40mm f/5.6 telephoto, which, unlike the normal lens, had focus adjustment. A cable release could be threaded into the shutter button, and the camera mounted on a tripod using the socket on the side. The Golden Ricoh 16 was priced at $39.95 for the camera with leather field case. For an additional $20, you got a complete outfit, including a slide viewer, all in a metal jewel case. The heyday of subminiature cameras continued through the 1960s but came to an end when Kodak announced its Pocket Instamatic in 1972.

LEICA MP

1957 | Ernst Leitz GmbH, Wetzlar, West Germany

Gift of Gerald Lippes. 2008.0428.0059

In 1955, celebrated photojournalists Alfred Eisenstaedt (1898–1995) and David Douglas Duncan (b. 1916) were supplied with special versions of the 1954 Leica M3, fitted with the Leicavit trigger-wind film advance mechanism. The Leica MP was derived from these customized cameras, as other working professionals would benefit from a faster-handling camera. Production began in October 1956 with a small batch of eleven cameras, serial numbered 1 through 11, while the rest of the run, which totaled 402 cameras, was made the next year. Cameras serial numbered 12 through 150 were finished in black enamel paint, and those numbered 151 through 402 were finished in chrome.

Easily identified by the "MP" serial number prefix, these cameras were based on the M3, but with several changes: the top plate was fitted with the manual-set film counter used on the Leica M2; the brass film-advance gears were replaced with ones made from more durable hardened steel; and a Leicavit trigger-wind film advance mechanism, with the MP designation, was supplied with each camera. The pristine condition of this example is unusual, as MPs typically received hard use by photojournalists working on assignment in the field. It is fitted with the optical viewfinder version of the 35mm f/2 Summicron. The "bugeyes," in conjunction with the M3 and MP cameras' rangefinder/viewfinder, adapt the viewfinder to accurately frame the image made by the wide-angle 35mm lens.

MAKO SHARK

1957 | Healthways, Inc., Los Angeles, California

2008.0554.0002

Dick Klein found fame as the brains behind Healthways, Inc., of Los Angeles, a supplier of diving equipment, and for trademarking the name SCUBA—the acronym for Self-Contained Underwater Breathing Apparatus, coined by the U.S. Navy—for his line of underwater air supplies. Underwater photography was a popular activity with divers, so Healthways soon had a special camera in its catalog. The Mako Shark appeared in 1957 priced at $19.95, much less than the typical submersible cameras of the day. Healthways was able to keep costs low by basing the Mako Shark on an existing mass-produced design, the Kodak Brownie Hawkeye Flash Model. Inside the Mako Shark's round plastic body was the front half of the Brownie, containing the lens, shutter, and film transport. A spring-loaded release button and a winding knob on the Mako Shark's front housing connected to the corresponding parts of the Kodak. For a few dollars more, a diver could buy the Mako Shark with external connectors for flash, activated by being wired to the Brownie's flash connections.

The entire rear portion of the Mako Shark was removed by unscrewing it like a pickle jar lid. With the back opened, the roll of 620 film could be loaded or removed. Each roll was sufficient for twelve 2¼-inch square negatives. With the back of the housing replaced and tightly secured, you were ready for your dive. The camera was rated to a maximum depth of one hundred feet. A molded handle and a big gunsight finder made shooting easy, as did the large bright red shutter button. What wasn't easy was keeping track of the exposure count through the red plastic window on the back side. Divers would compensate for this by remembering the number of turns required to bring the next frame of film into place.

NIKON F

1959 | Nippon Kogaku K. K., Tokyo, Japan

Gift of Ralph Alexander. 1977.0051.0001

Perhaps no camera better represents photojournalism in the 1960s than the Nikon F, an omnipresent image-maker that seemingly covered every event of the period. At the time, many professional photographers already saw the 35mm rangefinder as a bit old-fashioned, and the Nikon entry into the field crystallized the clear advantages of the more advanced SLR. Not that the Nikon F was the first from Japan—most other Japanese camera manufacturers already had one on the market—but it quickly became *the* 35mm SLR. A number of features would recommend the Nikon F, but what sold it was its renown for quality and durability that may have almost single-handedly repositioned the Japanese photographic industry, upending a post-war reputation for shoddy production. In describing the F's robust construction, famed camera repairman Marty Forcher called it "a hockey puck."

Introduced in 1959 at the list price of $329.50 (Nikon Fs were many things, but cheap wasn't one of them), the F was Nippon Kogaku's first 35mm single-lens reflex camera. Intended as the centerpiece of the Nikon System, it was sold alongside the rangefinder Nikon SP, an older sibling that shared about

40 percent of its parts. But the Nikon System was about more than just cameras. It was a complete integration of compatible components that would eventually include a plethora of accessories: lenses from 6mm to 2000mm in focal length; motor drives; interchangeable viewfinders and viewing screens; close-focusing bellows; flash units; and, when necessary for a specialized job, custom-built items. All were made to accommodate the needs of the professional photographer. The flow of new accessories was so constant that a 1971 Nikon F ad declared, "There has never been an up-to-date photograph made of the Nikon System."

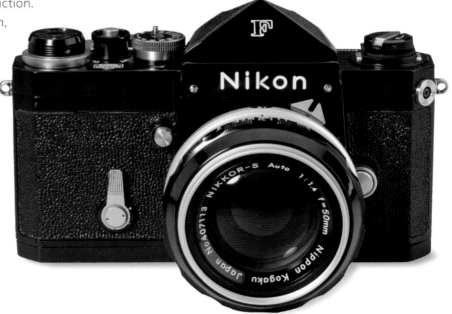

F21 BUTTON CAMERA

ca. 1960 | KMZ, Krasnogorsk, USSR (Russia)

Gift of Jerry Friedman. 2006.0265.0006

Made in the Krasnogorsk (KMZ) factory from the 1960s through the 1980s, the F21 Button Camera was used by the Soviet KGB for espionage purposes. In appearance, it resembled a miniature version of the Robot camera manufactured by German company Otto Berning (founded in 1934), featuring a similar top-wind spring-motor film advance, though no viewfinder. It produced 19 x 24-mm images on 21mm unperforated roll film. In use, the camera was disguised in a jacket with the lens protruding through the buttonhole. The lens was covered by a four-hole button, complete with what appeared to be thread; during exposures, the button then split in half, allowing the picture to be made.

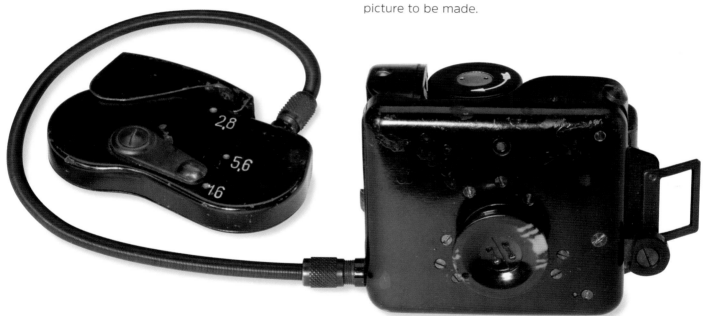

CALYPSO

ca. 1960 | La Spirotechnique, Levallois-Perret, France

Gift of John and Zarnaz Arlia. 2006.0251.0001–2

NIKONOS

ca. 1963 | Nippon Kogaku K. K., Tokyo, Japan

Gift of Ehrenreich Photo-Optical Industries (EPOI), Inc. 1974.0028.3164

The first commercial camera produced specifically for amphibious photography, the Calypso was designed for French oceanographer Jacques Cousteau and manufactured by La Spirotechnique of Levallois-Perret, France, in 1960. Its O-ring-sealed body was watertight without need of an external housing, yet the same size as a normal 35mm camera. Tested to 200 feet, it was also tropicalized and protected against corrosion, sand, and mud. The covering is a gray imitation sealskin. The design was later sold to Nikon and evolved into the Nikonos line of cameras.

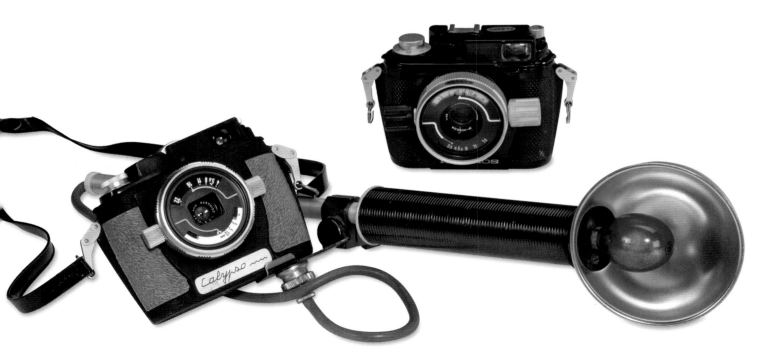

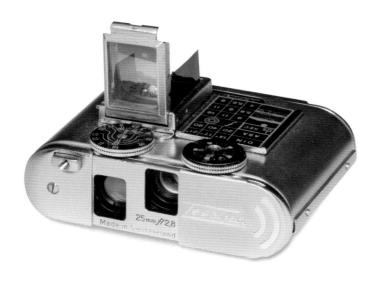

TESSINA 35

ca. 1960 | Concava SA, Lugano, Switzerland

1978.0763.0001

The Tessina 35, introduced in 1960 as the "world's smallest and lightest 35mm camera," is a side-by-side twin-lens reflex 35mm camera about the size of an iPod Nano. The viewing lens reflects up to the waist-level, or spy, finder, and the taking lens reflects down to the film, which is spring-motor driven across the bottom of the camera. Accessories include a pentaprism finder, high-magnification finder, right-angle finder, and a wrist strap that allows the camera to be worn like a watch. Despite all the "spy" features, this is not a toy; it's a fine piece of Swiss workmanship, offering all the features of a subminiature with the convenience of 35mm film.

STEREO MIKROMA II

ca. 1961 | Meopta, Prague, Czechoslovakia

1974.0037.2989

Introduced in 1961, the Stereo Mikroma II was a revised version of the Stereo Mikroma, having added automatic shutter cocking with film advance. Both models originated as a stretch of the original Microma 16mm subminiature, which used single perforated 16mm film. The stereo versions produced twenty-two horizontal stereo pairs, 13 x 12 mm in size, from a roll of film. The cameras were available in black, brown, and green, and accessories included ever-ready cases, viewers, film cutters, and close-up attachments. The manufacturer was founded in Czechoslovakia as Optikotechna around 1938, and became Meopta after World War II. Today Meopta is a major optical supplier worldwide.

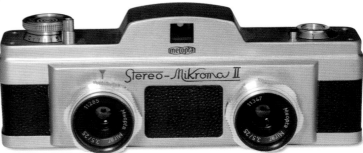

INSTAMATIC 100

1963 | Eastman Kodak Company, Rochester, New York

Gift of Eastman Kodak Company. 1974.0037.0246

The Kodak Instamatic 100 camera was introduced in 1963. In various forms, the Instamatic line would stay in production for more than twenty years. The 100 was a simple little plastic box camera with fixed focus, a pop-up flash gun, and rapid-lever wind. Its use of a drop-in cartridge was not novel. Attempts to utilize cartridge loading began in the 1890s, but none was as successful as the Kodak No. 126 cartridge, which revolutionized the snapshot industry. The Instamatic 100 outfit retailed for $16 in 1963.

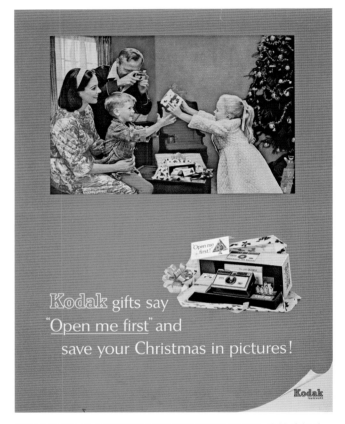

Above: Kodak advertisement for Instamatic 100 camera, 1963. Gift of Eastman Kodak Company.

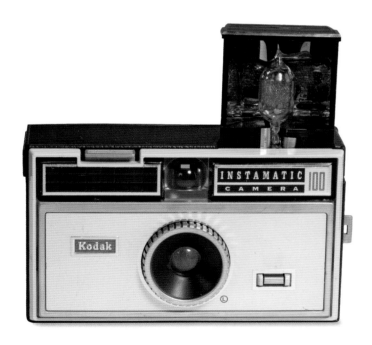

CANON 7S

ca. 1964 | Canon K. K., Tokyo, Japan

1977.0138.0001

The 35mm rangefinder has been a popular camera design since the 1930s. Canon of Tokyo made their reputation with the coupled rangefinder featuring interchangeable lenses. The cameras of the Canon 7 series had threads for screw-mount lenses but also a breechlock bayonet mount for the huge 50mm f/0.95 unit billed as the "World's Fastest Lens." A focal-plane shutter with a maximum speed of 1/1000 second allowed for full use of the massive lens. Selling for almost $500 in 1964, the 7S added an improved battery-operated CDS light meter and a top-mounted accessory shoe to its earlier sibling model, the Canon 7. The last rangefinder Canon camera, it had available lenses in focal lengths from 19mm to 1000mm.

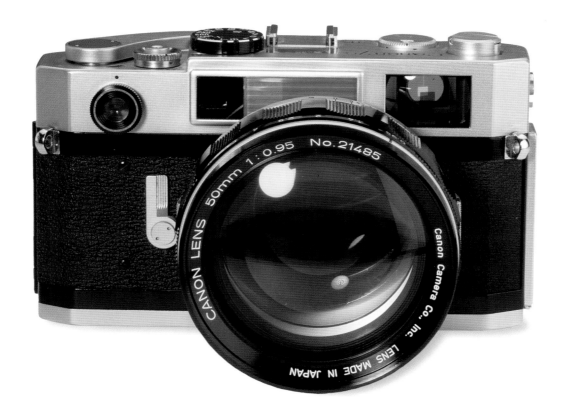

LUNAR ORBITER CAMERA PAYLOAD

1967 | Eastman Kodak Company, Rochester, New York

Gift of Frank Marussich. 1981.0795.0001

In the early 1960s, NASA began to develop a Lunar Orbiter program that would photographically map both sides of the moon to aid in site selection for the planned manned lunar landings of the Apollo space program. After compiling specifications, NASA solicited design proposals from aerospace firms, ultimately awarding the contract to Boeing, with Eastman Kodak Company and RCA being major subcontractors. While Boeing built the mission vehicle, Kodak's contribution to the project was a photographic subsystem that included a 65mm film media for image capture, two lenses, onboard film processing that used the Kodak Bimat process to eliminate the use of "wet" chemicals in the development, and a scanner and video system.

Once the photographs were taken, the film was processed and electronically scanned, and the negative images were transmitted as analog video to ground receiving stations back on Earth. They were then written back to film and shipped to Kodak in Rochester for final reconstruction. A total of eight subsystems were built by Kodak, five of which made one-way trips aboard Orbiter spacecraft in 1966 and 1967. During the five missions, the many images made provided a wealth of knowledge to NASA scientists. The apparatus shown here was originally unfinished, as it wasn't needed for the program. It was acquired at government auction by Rochester's Genesee Tool and Die Corporation, completed, and donated to George Eastman House.

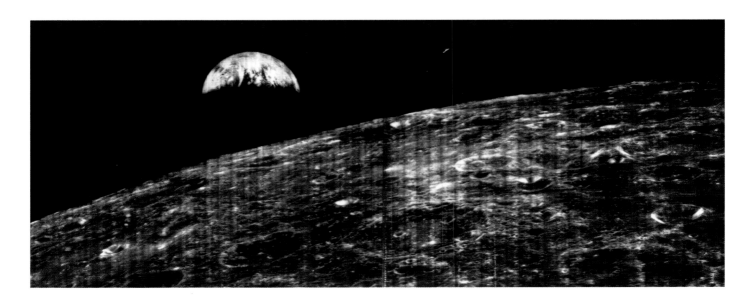

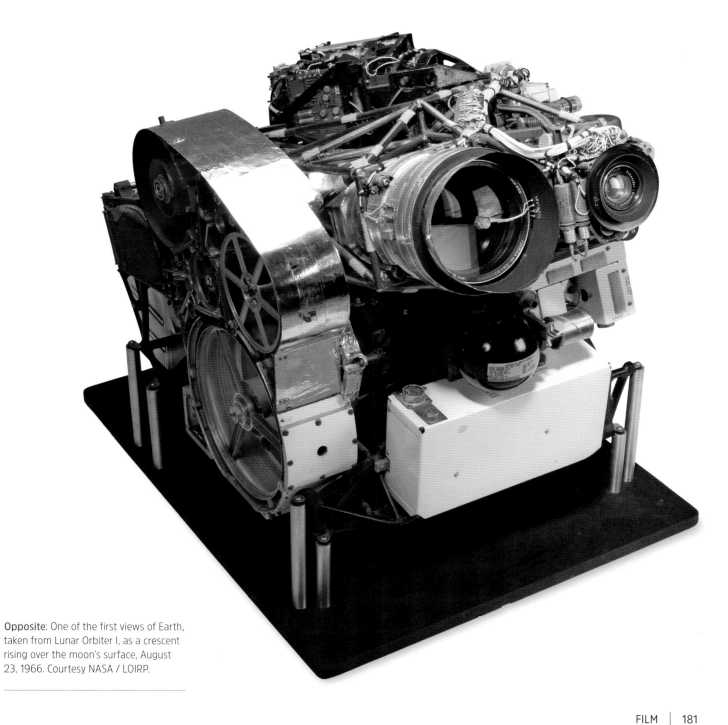

HASSELBLAD ELECTRIC CAMERA (HEC)

ca. 1969 | Victor Hasselblad AB, Göteborg, Sweden

Gift of Victor Hasselblad AB. 1974.0028.3081

The first Hasselblad camera used in space was a 500C carried onboard Mercury *Sigma 7*, which flew October 3, 1962. A standard off-the-shelf model, it was purchased at a Houston camera store by astronaut Walter Schirra (1923–2007) and modified slightly by NASA, with the leather panels removed and the camera body painted black to reduce reflections. That mission's high-quality photographs prompted NASA to contract Hasselblad to build special models for the space program. Since then, Hasselblad cameras have served on virtually every NASA manned flight.

The Hasselblad Electric Camera (HEC), a modified version of the Hasselblad EL/70, first flew on Apollo 8 in December 1968 and was used for the remainder of the Apollo Program, including the moon landing missions, as well as the Skylab and space shuttle missions of the early 1980s. It is worth noting that all the cameras used on moon landings were left there. Due to weight concerns at the lunar takeoff, only the film magazines returned to Earth.

The example shown here did not travel into space—it was donated personally by Dr. Victor Hasselblad to the George Eastman House Technology Collection in March 1972.

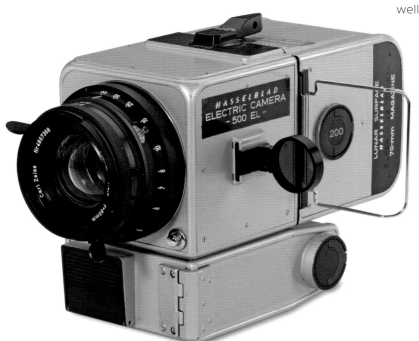

Opposite: The historic Apollo 11 mission: Buzz Aldrin is photographed walking on the surface of the moon by Neil A. Armstrong, July 20, 1969. Courtesy NASA.

POCKET INSTAMATIC 20

1972 | Eastman Kodak Company, Rochester, New York

Gift of Eastman Kodak Company. 1974.0028.3049

In 1972, Eastman Kodak Company of Rochester, New York, introduced a new film format and a line of cameras to use it. The film was the 110 size, using 16mm roll film with paper backing in a drop-in cartridge, similar to the 126 cartridge. The new cameras were small enough to slip into a shirt pocket and were named Pocket Instamatic 20, 30, 40, 50, and 60. Available films included black-and-white, a new finer grain color print emulsion, and two color slide films. The retail price of the Pocket 20 was $27.95.

Above: Unidentified photographer. [*Snapshot made with 110 camera*], ca. 1972. Kodacolor print. Courtesy Joseph Struble.

CANON AE-1

ca. 1976 | Canon, Inc., Tokyo, Japan

Gift of Canon USA, Inc. 1985.0966.0003

Introduced in 1976, the Canon AE-1 was a shutter-preferred, auto-exposure camera and the first 35mm SLR to use a central processing unit (CPU). The CPU regulated operations like exposure memory (known then as exposure lock), aperture value control, and the self-timer. The rest of the camera's circuitry, which controlled functions such as shutter speeds and the exposure counter, was traditional analog. An aggressive advertising campaign and automated modular construction techniques that lowered production costs resulted in sales of five million units, making the AE-1 the best-selling 35mm SLR of its day and Canon the top Japanese camera manufacturer.

NIKON F3

ca. 1980 | Nikon, Inc., Tokyo, Japan

Gift of Nikon, Inc. 1981.3208.0001

In 1980, Nikon passed the torch to a new flagship model, the F3. Built on the system approach used by its predecessors the F and F2, it still shared the same bayonet lens mount but was fitted with a more accurate electronically controlled titanium foil shutter, a battery-saving built-in LCD meter, and automatic exposure control. Also like the earlier cameras, it accepted interchangeable finders and viewing screens, making the camera adaptable to just about any photographic assignment. Famed Italian auto designer Giorgetto Giugiaro consulted on the camera's exterior design, creating an appealing look. The Nikon F3 was one of the cameras used by NASA on the Space Shuttle, and Eastman Kodak Company chose the F3 as the basis for its Kodak DCS 100 professional digital camera in 1991.

At introduction, the F3 retailed for $1,174.90, including a 50mm f/1.4 lens. It remained in production for more than twenty years, some five years longer than its older sibling, the F model. An autofocus model, the F3AF, was introduced in 1983. Three sequential models concluded with the Nikon F6. A true workhorse, the F3 no doubt cut the mustard in the field, yet it never really gained the iconic status held by its older mechanical siblings.

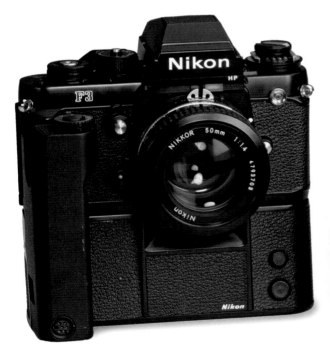

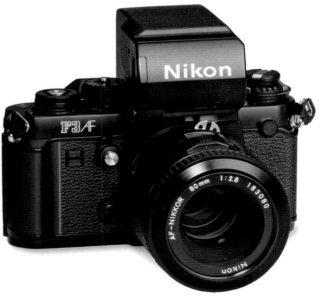

ROLLEIFLEX 2.8F AURUM

ca. 1983 | Franke & Heidecke, Braunschweig, West Germany

Gift of Berkey Marketing Companies, Inc. 1983.0694.0001

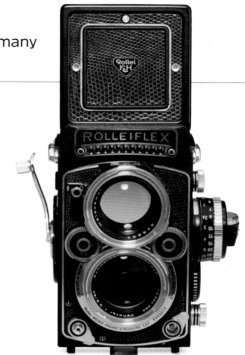

Descended from a distinguished line of twin-lens reflex cameras dating back to 1929, the Aurum (Latin for "gold") was finished in black with alligator leather and gold-plated metal parts. Otherwise it was a standard 2.8F model, regarded as one of the finest cameras produced anywhere. It took twelve 6-cm square images on a roll of 120 film, or twice as many on 220, for cameras so equipped. The 80mm f/2.8 lenses, Compur shutter, bright focus screen, and coupled meter made it a favorite medium-format tool, especially for location shots where its ruggedness and reliability were important. The cameras were mounted with either Zeiss Planar or Schneider-Kreuznach Xenotar lenses.

OLYMPUS O-PRODUCT

ca. 1988 | Olympus Optical Company, Ltd., Tokyo, Japan

Gift of Mr. and Mrs. Robert L. Freudenheim. 2003.1101.0002

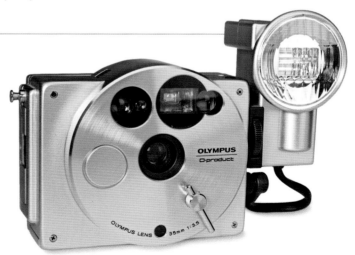

The O-Product, despite its unusual styling, was a point-and-shoot 35mm camera with features and specifications similar to the Olympus Stylus 35. Made in limited quantities, it had an aluminum body with a unique shape. The lens cover opened and closed via a chrome lever resembling an alarm clock key, and the shutter release was a dime-sized button flush with the front panel. The detachable flash was plastic painted the same silver as the body. Automatic exposure, auto-focus, and power wind/rewind helped the O-Product live up to the motto revealed when the film door was opened: "Functional imperatives molded to artistic form."

IN-CAMERA PROCESSING AND THE DIGITAL REVOLUTION

The desire to combine the camera and image processing—developing an image in the same apparatus in which it was exposed—is as old as photography itself; a number of early inventors tinkered with the concept, which is usually described as in-camera processing.

Although some success was attained, the results were by no means elegant. The first system to be remotely successful was the Dubroni camera from French inventor and photographer Jules Bourdin (1832–93). The Dubroni was a small wet-collodion box camera that also doubled as the darkroom. Considered the best-selling camera of the wet-collodion era, the Dubroni required its user to mix and add the chemicals into the camera, making it far from "instant." It also had to be thoroughly cleaned after each use to avoid contamination, which was problematic for users.

It was not until the mid-twentieth century when American scientist and Polaroid Corporation founder Dr. Edwin Land (1909–91) made instant photography a reality. Land designed a folding camera in 1947 using his "instant" roll film, built to satisfy his three-year-old daughter's impatience—the toddler didn't understand why she had to wait to see her picture once it was taken. Land added color instant film in the mid-1960s, but the crowning jewel

Right:
Steven J. Sasson (American, b. 1950). Playback of photograph produced with Electronic Camera, from Kodak Apparatus Division Research Laboratory Technical Report "A Hand-held Electronic Still Camera and Its Playback System," by S. J. Sasson, 1977.

was his SX-70 camera of 1972 with its battery-powered color film. Pressing the shutter release button on the camera took the picture and then ejected the image, which processed outside the camera in about a minute.

In 1974, a Kodak research scientist named Bryce Bayer designed and patented his Bayer color-filter array. This checkerboard pattern of red, green, and blue, when placed in front of a grid of photo sensors, allowed for the capture of vivid color images.

The next year, Steven Sasson, an electronic engineer from Eastman Kodak Company, was charged with investigating the imaging potential of a charge-coupled device (CCD), a tool used for manipulating electronic charges (see page 204). Sasson decided to expand the assignment into solving how to build a camera around the CCD. The resulting work, completed late in 1975 and patented two years later, was the world's first digital camera and playback system (in black-and-white), whose existence was kept secret until 2001.

The Kodak Research Labs continued to investigate solid-state imagers, and in 1986, designed and publically demonstrated their M1 imaging sensor; it was a monochrome megapixel imager. The next year, the company's Federal Systems division was asked by a U.S. government client if it would be possible to use the M1 sensor in a single-lens reflex camera. The result was a one-of-a-kind DSLR called the Electro-Optic camera, built on a Canon F-1 camera. Based on a similar technology, Eastman Kodak then introduced the Kodak DCS in 1991. Fitted with the Bayer filter array, it was the world's first commercial color DSLR.

In 1994, in collaboration with Apple Computer, Kodak commercialized the Bayer filter array, creating the world's first consumer color digital camera: the Apple QuickTake. From this point on, digital photography expanded exponentially due to numerous factors, including increased use of the Internet, reduced cost of storage memory, and rising demand for digital images. The first megapixel consumer camera, the Kodak DC210, was introduced in 1997. In 2002, the Nokia 7650 was the first integrated camera-phone combination to be sold in the United States. And most recently, the iPhone of 2007 combined the camera, phone, and Internet connectivity, changing forever the way pictures are captured and shared. ↻

APPAREIL DUBRONI NO. 1

ca. 1864 | Maison Dubroni, Paris, France

Gift of Eastman Kodak Company, ex-collection Gabriel Cromer. 1974.0037.2285

The first in-camera processing model to sell in quantity was the Dubroni, an anagram of the family name of Jules Bourdin, the Frenchman who patented the camera in December 1864. Sold as a kit, it included everything necessary to produce images in-camera. The apparatus consisted of a small box camera with a glass or ceramic container fitted inside. A glass plate was coated with iodized collodion and loaded into the camera. Silver nitrate was then introduced with a pipette onto the plate through a hole at the top of the camera, which sensitized the plate. After exposure, the plate was left in the camera and developer was introduced by a second pipette, its action observed through the amber glass inspection window at the camera's back. When development was finished, the solution was drained with a pipette. Finally, the plate was washed with water and then taken from the camera for fixing and another wash—yielding a fully processed negative ready for printing.

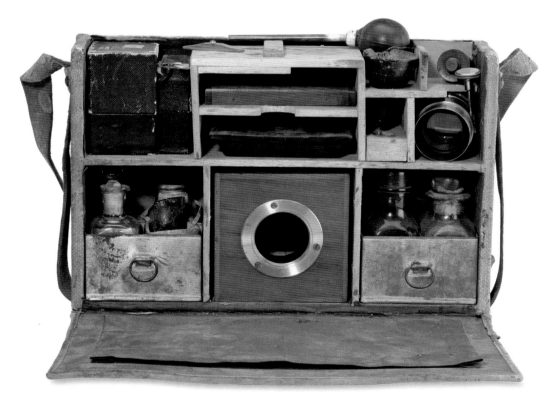

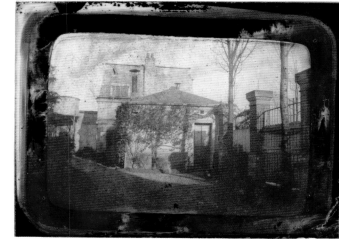

Right: Unidentified photographer. [*Photograph made with Dubroni wet plate camera*], ca. 1865. Digitally reversed scan of collodion on glass negative. Museum Collection.

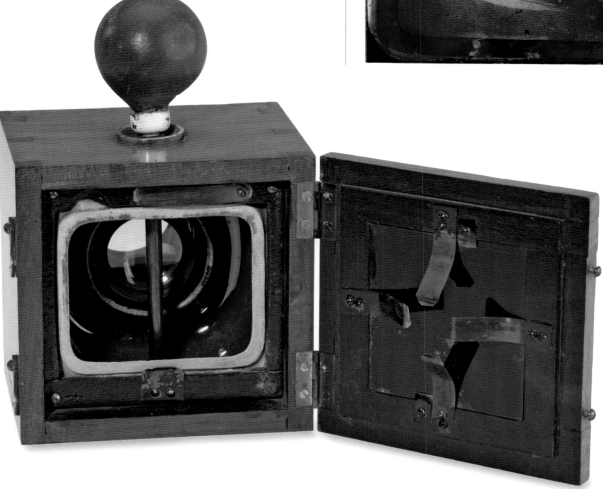

WONDER AUTOMATIC CANNON PHOTO BUTTON MACHINE

ca. 1910 | Chicago Ferrotype Company, Chicago, Illinois

2000.0413.0001

Earning a living as a portrait photographer usually involved a considerable investment for equipment, supplies, and studio. Additional money had to be spent on advertising your services. In 1910, the Chicago Ferrotype Company offered an alternative. For $30, they would deliver the Wonder Automatic Cannon Photo Button Machine and enough supplies for you to start business immediately. The idea was to set up the four-pound Wonder Cannon in busy public areas and offer passers-by a metal button with their picture on it for five cents. One hundred one-inch diameter sensitized blanks could be loaded into the nickel-plated brass cannon's breech in daylight. When the subject was centered in the sights, the photographer squeezed the rubber bulb to operate the shutter. The exposed buttons didn't have to be removed for developing. A quick push-pull of the "bolt" dropped the button into a tank of developer, and thirty seconds later it could be removed, rinsed, and popped into a pinback frame . . . all this for a nickel.

RÄDERKANONE

ca. 1912 | Romain Talbot GmbH, Berlin, Germany

Gift of Kodak Pathé. 1988.0099.0001

A button-portrait camera was a familiar sight at tourist attractions, carnivals, and other gatherings where souvenirs were sold. The Räderkanone of 1912 was made by Romain Talbot GmbH of Berlin for concessionaire use and could deliver your portrait on a one-inch-diameter metal button in a minute. Made mostly of polished hardwood, it was styled like a field gun, right down to its brass wheels. More than fifteen inches in length, the camera was loaded from the rear with a tube full of tintype blanks. Using the scope atop the barrel, the vendor centered the customer's face in the circle. A spring-loaded plunger moved the blanks forward to be exposed by the f/4 lens when the shutter at the muzzle end was tripped. A push of the transfer plate dropped the exposed button into the tank of developer beneath the barrel. When the photographer retrieved the developed button and finished washing it, the customer handed over a five-cent piece and walked away happy.

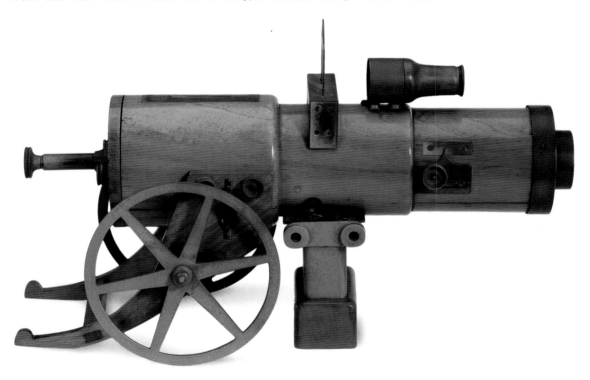

TEDDY CAMERA

ca. 1924 | Teddy Camera Company, Newark, New Jersey

Gift of Eastman Kodak Company. 1990.0458.0007

Long before Edwin Land's 1947 Polaroid camera made it look so easy, there were many attempts at cameras that processed their own prints after exposures were made. In 1924, the Teddy Camera Company of Newark, New Jersey, added their $2 answer to that list. Tin-can technology made the low price possible, but like most tries at "instant" cameras, this one required extra work both before and after the shot. The Teddy Model "A" didn't use film. Exposures were made on a sensitized card that was transferred to the developing tank hanging from the underside. To do this in darkness, the user had to slip a hand through the flannel sleeve on the back cover. Teddy sold a combined developing and fixing solution, Del-Fix, that was poured into the removal tank. Handheld photos were seldom possible with a Teddy because of the long exposure times needed for the direct-positive prints.

LAND CAMERA MODEL 95

ca. 1948 | Polaroid Corporation, Cambridge, Massachusetts

1974.0028.3137

In February 1947, inventor Dr. Edwin H. Land (1909–91) demonstrated the Polaroid Land Camera, the world's first instant camera. It went into production in 1948 and became an immediate success. The first Polaroid camera, the model 95, used roll film and produced finished 3¼ x 4¼-inch prints in just sixty seconds. After exposing the image, the photographer pulled a tab, which caused the roll of negative film to join with the print paper as they were drawn through rollers. At the same time, the rollers spread developer evenly across the interface surface to process the print.

Over time, film improvements meant that a film pack replaced the roll film and allowed for the print to develop outside the camera, letting the user immediately take another picture. Faster film required only ten seconds to the finished black-and-white print, and color film was added. Camera advances included sonar auto focusing, and a later model, the SX-70, was a folding SLR. The retail price for the original Model 95 was $89.75.

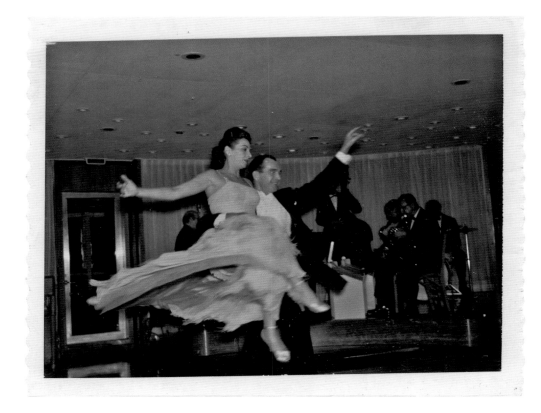

Right: Unidentified photographer. [*Photograph made with Polaroid Model 95 camera*], ca. 1950. Color print, internal dye diffusion (Polaroid) process. Museum Collection.

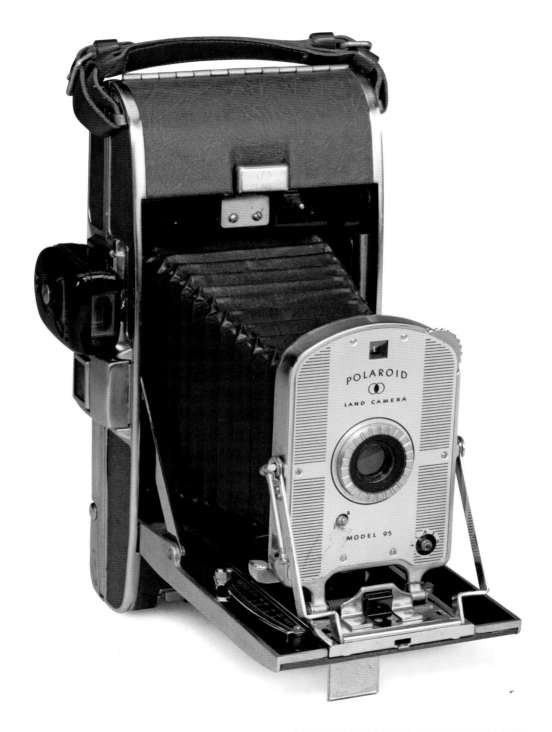

SWINGER MODEL 20 LAND CAMERA

ca. 1965 | Polaroid Corporation, Cambridge, Massachusetts

Gift of Eastman Kodak Company. 1996.0473.0001

Polaroid's Swinger, introduced with great fanfare in 1965, was heavily advertised on television. Aimed at the teen market, the all-plastic Swinger was Polaroid's entry-level instant camera. Pinching the shutter button let the user know whether there was enough available light. If "YES" appeared in the viewfinder, you were ready. "NO" meant you had to pop in a flash bulb first. Once the button was pressed, all you had to do was pull a tab to start the developing process—which took place outside the camera—wait sixty seconds, and peel the finished picture free.

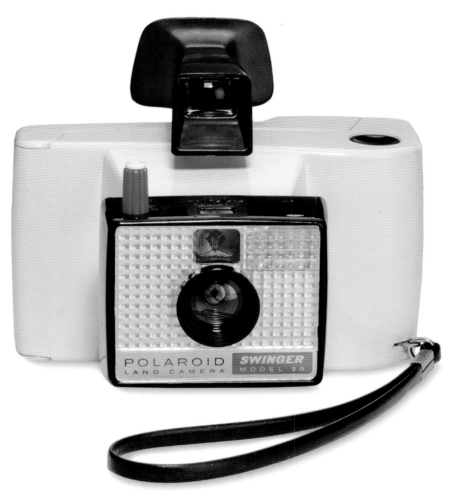

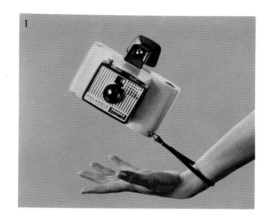

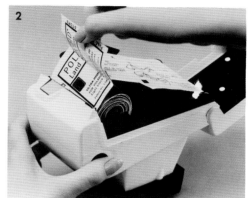

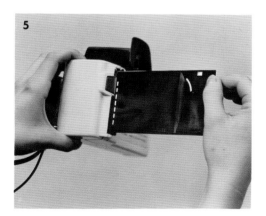

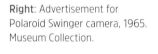

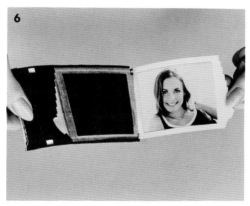

SX-70 LAND CAMERA

1972 | Polaroid Corporation, Cambridge, Massachusetts

Gift of Eastman Kodak Company. 1999.0140.0001

Polaroid's SX-70 Land Camera made its spectacular debut in 1972, even showing up on the cover of *LIFE* magazine. The futuristic look and fresh technology was a startling break from any previous Polaroid product. When opened, it resembled no other camera, and when folded for carrying, didn't look like a camera at all. The film itself was an extraordinary piece of design. You simply unwrapped the flat pack and slipped it into the camera base. Each pack had its own battery that powered the print-eject motor, electronics, and flashbar. The viewfinder was large and bright, making it easy to focus down to 10½ inches.

The real fun began when you pressed the shutter button. It did the rest! Almost immediately, the distinctive song of the SX-70 print-ejection motor heralded the arrival of an exposed print from the front of the camera. An image began to appear on the blank white sheet and a minute later it was fully developed, whether you held it in the light or put it in your pocket. Photographers had no peel-off waste or chemical goop to deal with because everything was contained in the print and activated when the whirring motor squeezed it through a pair of rollers on its way out. All this was available for a list price of $180. Later versions of the camera had sonar autofocus. The SX-70's technology migrated to new lower-priced Polaroids, as well as into some nonphotographic products.

Above: Frank Pflaumer (American). [*George Eastman House Garden*], 1976. Color print, internal dye diffusion-transfer (Polaroid SX-70) process. Gift of Frank Pflaumer.

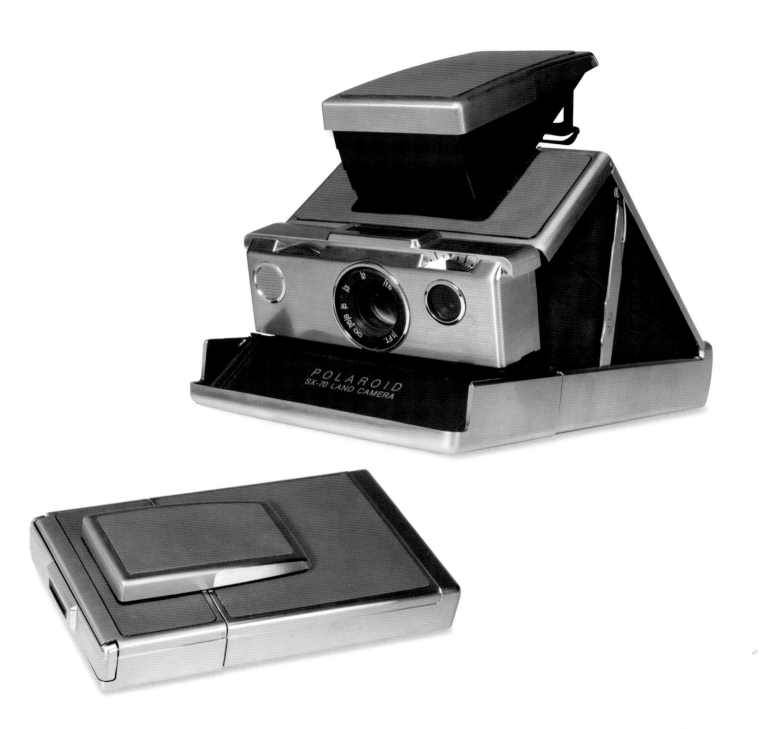

KODAK HANDLE INSTANT CAMERA

ca. 1977 | Eastman Kodak Company, Rochester, New York

Gift of Eastman Kodak Company. 1981.2812.0006

Introduced in 1977, the Kodak Handle Instant Camera was a solid body, direct light path, inexpensive instant camera, named for the large handle molded into its body. Instead of folding bellows or mirrors, it used a long snout for direct path imaging. It also used a folding crank handle for picture ejection. A popular premium version of the Handle was manufactured for Coca-Cola as the Happy Times camera. The Handle retailed for $39.95 at introduction.

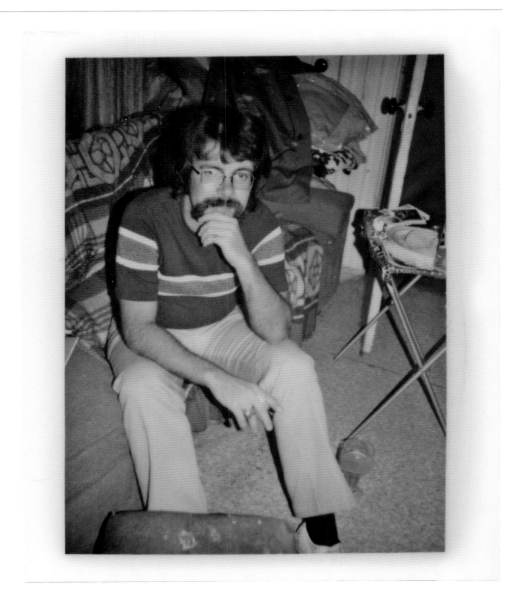

Right: Unidentified photographer. [*Portrait of Joseph Struble*], 1978. Color print, internal dye diffusion-transfer (Kodak Instant) process. Courtesy Joseph Struble.

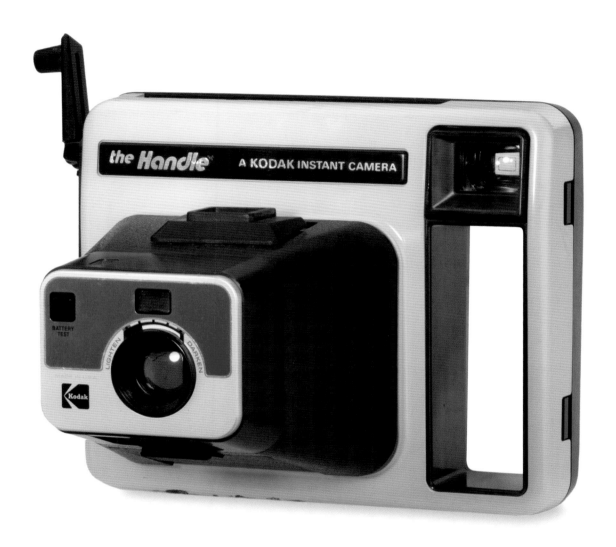

SASSON DIGITAL CAMERA

1975 | Eastman Kodak Company, Rochester, New York

Courtesy of Eastman Kodak Company. L2014.0205.0001

In a 1977 report titled "A Hand-Held Electronic Still Camera and Its Playback Unit," Eastman Kodak Company electrical engineer Steven J. Sasson predicted new digital technologies might "substantially impact the way pictures will be taken in the future." How right he was! Sasson was the first Kodak employee assigned to the momentous task of building a complete camera using an electronic sensor, known as a charge-coupled device or CCD, to capture optical information and digitally store the captured images. Primitive by today's standards, the CCD provided to Sasson by Fairchild Semiconductor realized 0.01 megapixels and black-and-white optical information. Undaunted, Sasson incorporated the CCD with Kodak movie-camera parts, other commercially available components, and circuitry of his own design to create the world's original digital camera in 1975. His resulting camera weighed more than eight pounds and measured the size of a toaster. The unwieldy camera required twenty-three seconds to record an image to a cassette tape and another twenty-three seconds for the image to be read from the tape to a stand-alone playback unit for display on a TV screen. With this groundbreaking innovation, Sasson helped to introduce digital technology in camera and photography systems and claim for Eastman Kodak Company its first digital camera patent in 1978.

Left: Steven J. Sasson (American, b. 1950). Playback of photograph produced with Electronic Camera, from Kodak Apparatus Division Research Laboratory Technical Report "A Hand-held Electronic Still Camera and Its Playback System," by S. J. Sasson, 1977.

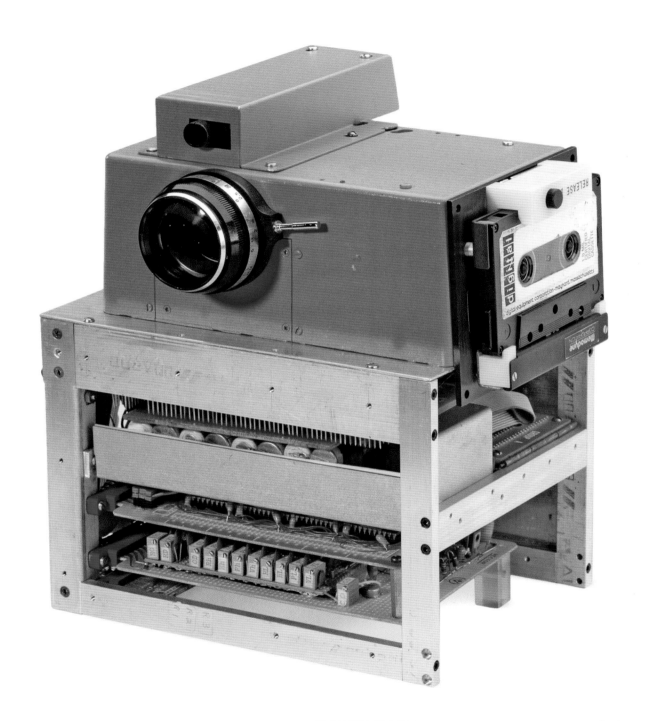

TACTICAL CAMERA

1988 | Eastman Kodak Company, Rochester, New York

Gift of Exelis. 2012:0185:0001

Tactical Camera is the oldest known digital single-lens reflex camera (DSLR). Designed by James McGarvey, an engineer in Eastman Kodak's Federal Systems Division, it was a follow-up model to the Electro-Optic camera (E-O), a one-of-a-kind camera built for the U.S. government. Tactical Camera was produced to be a working sample to investigate the viability of the DSLR business. Both E-O and Tactical Camera used Canon New F-1 camera bodies and lenses, as specified by the customer, fitted with Kodak's M1 (monochrome megapixel) imaging sensor, designed by Kodak in 1986.

Both E-O and Tactical Camera used tethered-image storage systems, with Tactical Camera using a more robust aluminum-extruded housing for its DRAM (dynamic random access memory) image storage and power source. Only two Tactical Cameras were built. A year later, the Hawkeye II Imaging Accessory (at the time Kodak referred to these cameras as imaging accessories, much like film) systems were produced (see opposite page). Like the previous models, Kodak adapted its digital imaging system to existing film cameras, in this case the Nikon F3, with either a built-in or tethered storage device. In turn, these cameras would lead to the Kodak DCS (see page 209), the first production DSLR camera introduced in 1991.

Above: James McGarvey (American). [*Culver Road Armory, Rochester, NY*], 1988. Sample image made with Tactical Camera. Digital file. Courtesy James McGarvey.

HAWKEYE II IMAGING ACCESSORY

1989 | Eastman Kodak Company, Rochester, New York

Gift of Exelis. 2012:0185:0002 & 0003

Eastman Kodak Company continued the development of the DSLR with the Hawkeye II Imaging Accessory (Kodak did not call them cameras), due to the high level of interest generated by Tactical Camera demonstrations. Like Tactical Camera, the Hawkeye II used the company's M1 megapixel monochrome imaging sensor, but mated to the Nikon F3 camera body—the camera used by most professional photographers, the intended market for the camera. Two versions were built, one with removable internal five-MB DRAM storage, and a slightly smaller version using tethered image storage. The tethered version of the Hawkeye II evolved into the Kodak DCS of 1991, which was the first commercially available DSLR.

SONY MAVICA MVC-5000

ca. 1989 | Sony Corporation Ltd., Tokyo, Japan

Gift of Rochester Institute of Technology. 2006.0113.0001

Photojournalism has always been driven by pressure to decrease the time lag of getting images to press. Generally, any new technology that helps to cut the gap is put to good use. Yet, in some parts of the world, the latest technology may not be the way to go. A current example is the use of videophone cameras in reporting from remote areas of Afghanistan. Sony began experimenting with Mavica (magnetic video camera) in the early 1980s and eventually produced the MVC-5000 still video camera in 1989. By that time, its two-chip 500 raster-line TV resolution was far from the cutting edge. Still, when used in conjunction with the Sony DIH 2000 (digital image handler), the Mavica MVC-5000 could transmit analog still-color images over telephone lines. Shortly after the camera's introduction, the television network CNN used a Mavica to avoid Chinese censors and deliver images of the Tiananmen Square student protests. The news value of the subject matter more than compensated for the poor technical quality of the images. This example was used by Reuters during the first Gulf War.

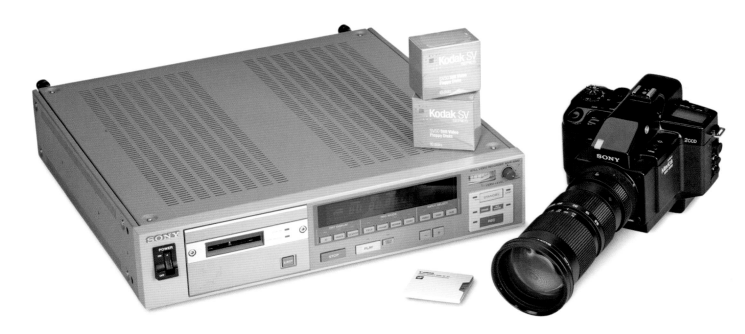

KODAK DCS

ca. 1991 | Eastman Kodak Company, Rochester, New York

Gift of Eastman Kodak Company. 2001.0106.1–3

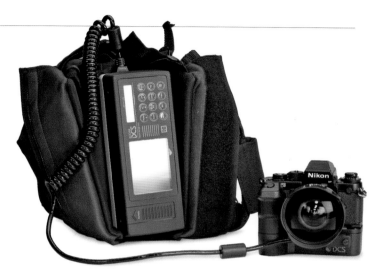

Introduced by Eastman Kodak in 1991, the Digital Camera System was the earliest commercially available professional system of its kind. The first model was the DCS, which consisted of a camera and separate digital storage unit (DSU). A standard Nikon F3 body with a Kodak-designed charge-coupled device (CCD) back and a power winder, the camera was the first DSLR. In operation, light reaching the CCD was converted to charge packets, which were then electronically measured and converted into numeric values. These digital values were exported from the camera body via a connecting cable to the DSU, a battery-powered, 200-MB recorder that stored about 150 uncompressed or 600 compressed images. Virtually all of today's digital cameras work in this manner.

DYCAM MODEL I

ca. 1991 | Dycam Inc., Chatsworth, California

Gift of Rochester Institute of Technology. 2006.0106.0001

The Dycam Model I is considered the world's first completely digital consumer camera; prior "digital camera" offerings were, in fact, still video cameras. Introduced in 1991, the Dycam could attach to a PC or Macintosh and produced black-and-white photos at 320 x 240 resolution; thirty-two compressed images could be stored on 1 MB RAM. It worked similarly to the Canon XapShot except that the digitizing hardware was in the camera itself. Also marketed as the Logitech FotoMan, the Dycam Model I retailed at $995.

KODAK DCS 200

1992 | Eastman Kodak Company, Rochester, New York

Gift of Eastman Kodak Company. 1998.1440.0001

Following the model of its earlier DCS camera, Eastman Kodak added a CCD digital-imaging system to a Nikon camera body—this time the N8008—creating the DCS 200. Unlike the earlier camera, the 200 was fitted with a built-in 80-MB hard drive, for image storage of up to fifty 1.5 megapixel images. The drive and the circuitry to run it were located in a housing beneath the camera, much like the battery-powered motor-drive units used on film cameras of the day, making the 200 a completely self-contained unit. Freed from the tethered, backpack image-storage unit of the earlier DCS, photographers could use the 200 in the same manner as the standard N8008.

In 1994, Kodak partnered with the Associated Press to produce the AP NC 2000, a special version of the DCS 200+ camera, now built on the Nikon N90 body and fitted with internal removable mini hard drives and battery. These cameras were popular with the AP photographers for their "time shifting," shortening the time required to get the image from photographer to the publisher—essential to news photography. With the NC 2000, photographers with access to a phone line and modem could e-mail photos to nearly anywhere in the world in just a few minutes.

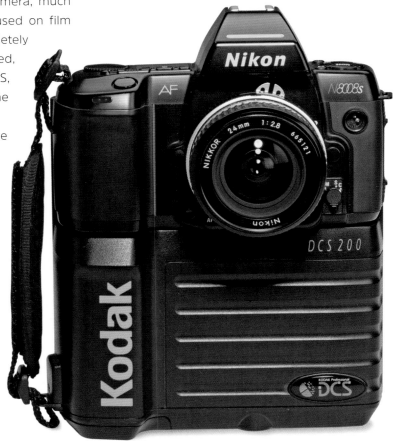

KODAK DC40

ca. 1995 | Eastman Kodak Company, Rochester, New York

Gift of Eastman Kodak Company. 1998.1440.0003

In 1995, Eastman Kodak Company introduced the Kodak DC40 digital camera, their branded version of the Apple QuickTake 100, which Kodak had manufactured for Apple Computer the previous year. Both cameras were significant to the new digital photography industry. The DC40 had 0.38 megapixels of resolution with 4 MB of internal memory. Although each used the same Kodak sensor (model KAF-0400), they differed in detail. The Apple produced images of 640 x 480 pixels with 1 MB of internal storage memory, while the Kodak produced images of 512 x 768 pixels with 4 MB of internal storage memory. Removable storage cards and LCD viewing screens were still in the future, but these cameras produced color images and retailed for just under $1,000, a milestone at the time.

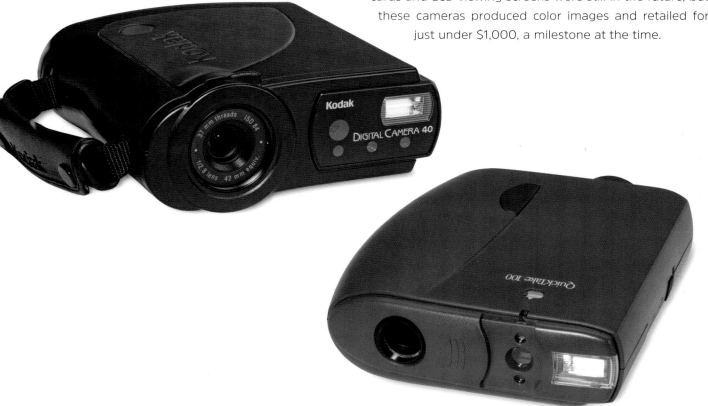

KODAK DC210

1997 | Eastman Kodak Company, Rochester, New York

Gift of Eastman Kodak Company. 2004.0720.0002

Introduced in late 1997, the Kodak DC210 was a pioneering one-megapixel digital camera with the popular characteristics of a snapshot camera. Its attractive body design boasted the reliability and ease of handling of a traditional point-and-shoot camera, and its picture quality rivaled that of traditional analog snapshot cameras. The DC210 incorporated features now familiar in manufactured digital cameras: a color LCD image viewing screen, first introduced with the 1995 Casio QV-10; easy-to-use operator interface controls, including a thumbwheel for selecting operational modes; and a removable memory card image storage system.

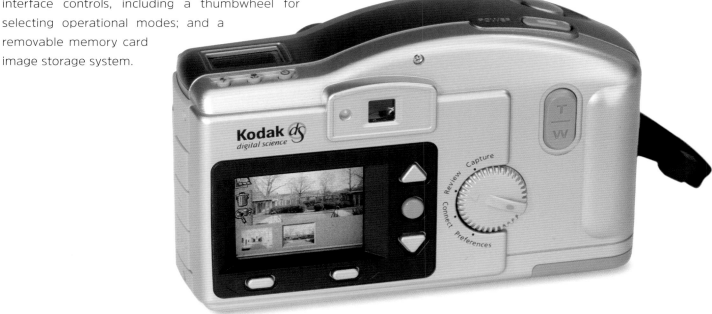

KODAK DCS 520

1998 | Eastman Kodak Company, Rochester, New York

Gift of Eastman Kodak Company. 2014.0428.0007

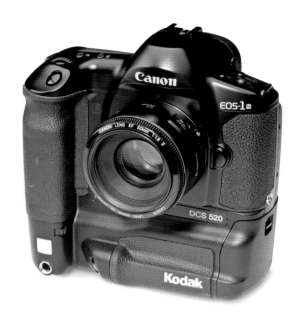

Canon began a partnership with Kodak in 1995 with the EOS-DCS X. Three years later, the Kodak DCS 5 series cameras were introduced. Fitted with the Kodak M15 imager (2.0 megapixel), this camera was capable of image bursts of up to 3.6 frames per second. It was a popular camera with both sports and news photographers. Fitted with a LCD image review panel on the camera's back, the 5 series cameras are considered to be the first modern DSLRs.

NOKIA CAMERA PHONE

ca. 2003 | Nokia, Helsinki, Finland

Gift of Nokia. 2003.0811.0001

Introduced in late 2001, and first available (in Europe) in 2002, the Nokia 7650 was one of the first commercial cell phones with an integrated digital camera sold in the United States. Its image size, quite small by today's standards, was 300 kilopixels (0.3 megapixels) and used onboard memory of 1 MB for storage of up to 55 basic-level images. Nokia advertised their new product as the "mobile phone that lets you show what you mean," highlighting an obvious advantage over noncamera phones.

EPSON R-D1

2004 | Seiko Epson Corporation, Tokyo, Japan

Gift of Seiko Epson Corporation. 2006.0415.0001

At Photokina 2004, the biennial trade fair held in Cologne, Germany, Seiko Epson Corporation of Tokyo introduced the Epson R-D1, the world's first digital rangefinder camera. In terms of styling and handling, it was a traditional camera, suggestive of the classic Leica M cameras introduced in 1954. It accepted most M-mount Leica lenses and used analog controls for focus, shutter speed, and lens aperture. On the camera's top plate was a status gauge that somewhat resembled a chronograph watch and displayed information about the current image settings, such as image quality, number of remaining exposures, available battery power, and white balance setting.

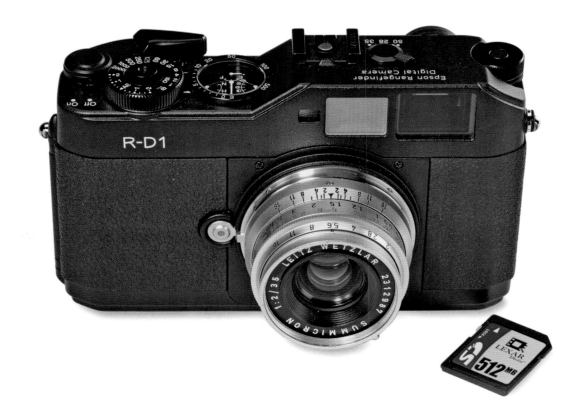

KODAK PRO 14N

ca. 2004 | Eastman Kodak Company, Rochester, New York

Gift of Eastman Kodak Company. 2004.0300.0001

The Kodak Pro 14n digital camera was the world's first Nikon-mount digital camera to use a full-frame 35mm (24 x 36 mm) CMOS sensor, producing 13.89 megapixel resolution. Announced at Photokina in September 2002, its high resolution and low price took the world by surprise. Though assumed to have been built on a production Nikon N80 camera, it actually had a body made especially for Kodak in a magnesium alloy with a unique vertical format shutter release. The release price was $4,995. In 2004, the same camera was upgraded with a new imager and improvements in power management and noise performance. This improved model was called the DCS Pro SLR/n; an upgrade package for the 14n was offered at $1,495.

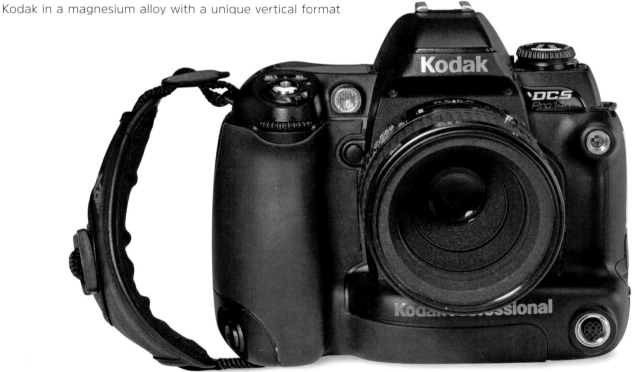

KODAK EASYSHARE ONE

2006 | Eastman Kodak Company, Rochester, New York

Gift of Eastman Kodak Company. 2006.0344.0020

The Kodak EasyShare One was introduced in 2005 as the world's first wireless consumer digital camera with the ability to e-mail images directly from the camera. In addition to WiFi capability, it had an articulated three-inch LCD display screen and 3x optical zoom, and it allowed online browsing of photo albums at the Kodak EasyShare Gallery. Initially offered with four megapixels of resolution at $599, it was soon joined by a six-megapixel version.

Above: Todd Gustavson (American, b. 1957). [*Wake from Chris Craft Riviera Runabout Walbokat, Chautauqua Lake*], 2006. Sample image made with Kodak EasyShare One. Digital file. Courtesy of the author.

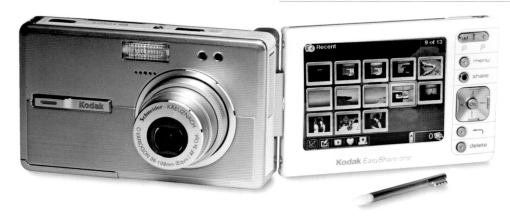

IPHONE

2007 | Apple Computer, Inc., Cupertino, California

Gift of Ryan Donahue. 2014.0191.0001

The first version of the iPhone was introduced by Apple co-founder Steve Jobs (1955–2011) at the January 9, 2007, MacWorld convention. It was a smartphone touchscreen PED (personal electronic device), supplied with Apple's iTunes and Safari web browser, and a fixed-focus two-megapixel camera. At $499 for the 4 GB version and $599 for 8 GB, the phone was not cheap. Even so, with the numerous mobile applications available at the App store (currently estimated at more than 250,000) and from third-party developers (now practically a cottage industry), the iPhone soon became one of the hottest consumer products to hit the market in years. Apple continued to both update the line and lower the price: the 2008 3G with 8 GB sold for $199, and the 16-GB version for $299. The iPhone 3GS of 2009 added a 3-MB still camera and digital video, and of course more speed. Apple produced a steady line of improvements to iPhone photography with the 5-MG camera in the 4G of June 2010, the 6-MB camera in the 5C of 2012, and the current 8-MG camera in the iPhone 6. No doubt they will continue to offer better cameras and other innovative improvements in coming years.

LEICA M8

2007 | Leica Camera AG, Solms, Germany

Gift of Leica Camera AG. 2007.0351.0001

In 2007, the Leica M8 was awarded "Camera of the Year" by the editors of *American Photo* magazine. Introduced in 2006 at Photokina in Cologne, Germany, the M8 advanced Leica's fortunes in a crowded digital-photography market. Drawing its incomparable design from the company's celebrated M-series rangefinders—the gold standard for professional and amateur photographers alike—the 10-megapixel camera uses the Eastman Kodak Company KAK-10500 image sensor, designed especially for Leica.

Company founder Ernst Leitz II (1870–1956) began manufacturing high-quality and high-performance 35mm handheld cameras in 1925. Their impact on the development of aspiring photographic genres such as photojournalism and fine art photography was monumental. In 1954, the company introduced the now legendary M3, a camera still considered the benchmark of 35mm rangefinders. Its current model descendants, the MP and M7, longtime favorites and immediate antecedents to the digital M8, remain in production today.

In 1998, the Leica Camera Group embarked on digital-camera production with the award-winning S1, its first high-end, scanning-back digital camera. The M8 was the company's first digital version of their renowned M-series cameras. Now known as Leica Camera AG, based in Solms, Germany, the company owes its success in the rapidly evolving and highly competitive field of digital-camera technology to Dr. Andreas Kaufmann, who became sole owner in 2006. Kaufmann's energy and vision have propelled Leica to new heights in both innovative production and the marketplace.

Above: Todd Gustavson (American, b. 1957). [*George Eastman House garden, Rochester, NY*], 2014. Sample image made with Leica M8. Digital file. Courtesy of the author.

PHANTOM 2 QUADCOPTER WITH HERO 3 CAMERA

2014 | DJI Innovations, Shenzhen, China

Museum purchase. 2014.0195.0001

First used by the CIA and now widely used both commercially and by hobbyists, the camera-equipped UAV (Unmanned Aerial Vehicle) is now a consumer product. The Phantom 2 Quadcopter, fitted with a three-axis (yaw, pitch, and roll), gimbal-mounted Hero 3 camera, provides a steady base for both digital video (1080p60) and still images (12 megapixel/30 frames-per-second burst). The easy-to-fly 'copter is remote controlled, has GPS (Global Positioning System), is equipped with extra stability to compensate for use in light wind, can be run in programmed mode with a smartphone app, and has a fail-safe landing mode just in case. It runs on four AA batteries, allowing up to twenty-eight minutes of flying time and a maximum horizontal speed of 22 mph.

Above: Todd Gustavson (American, b. 1957). Phantom 2 Quadcopter, fitted with gimbal-mounted Hero 3 camera, flying over George Eastman House garden, 2014. Digital file. Courtesy of the author.

Right: Frank Cost (American). Remote image made with the Phantom 2 Quadcopter, fitted with gimbal-mounted Hero 3 camera, at George Eastman House, 2014. Digital file. Courtesy Frank Cost.

TOY CAMERAS
A New Market

Building and maintaining a customer base is a challenge for any business, and the secret with photography has long been to start them young.

Eastman Kodak Company introduced the $1 Brownie in 1900 and gave free box cameras to twelve-year-olds in 1930, in both cases hoping to create lifelong photographers from among its many young customers. Toy-like cameras have been another way to attract future shutterbugs.

Beginning in the 1960s, the production of working cameras that resembled popular children's characters expanded the practice of photography among young people. The Kodapak 126 plastic-film cartridge, introduced in 1963, provided toy manufacturers with a relatively easy entrance into the camera business. The cartridge encased the film, which was sandwiched together with an exposure-numbered paper backing in a light-proof housing, and its easy drop-in loading made it ideally suited for young hands. With the resolution of film handling and exposure counting (two of the most complex aspects of camera design), a toy camera designer could concentrate on the camera's exterior. In fact, acquiring the rights to use certain characters was likely a more complicated process than the actual camera design. In any event, the resulting cameras were colorful and fun and, as intended, they created a new generation of shutterbugs. ↻

Right:
Detail view, *Kookie Kamera* (see page 224).

KOOKIE KAMERA

ca. 1968 | Ideal Toy Corporation, Hollis, New York

Gift of Andrew H. Eskind. 1974.0028.3534

From its manhole-cover base to its saucepan flashcube holder, Ideal Toy Corporation's Kookie Kamera was a wonder of whimsy. This 1968 toy was a real working camera that made direct-positive pictures on rolls of sensitized paper in plastic "Kookie Kassettes." The lens housing was modeled after an empty soup can, which distorted the image and could be rotated to alter the effect. The photographer sighted the subject through the bloodshot-eye viewfinder and then pressed the shutterbug to make the exposure. After snapping the picture, the "cranker" knob advanced the paper into the developer tank under the camera and a push-pull slide actuated a cutoff blade. A swiveling egg timer told the user when three minutes had elapsed, so the print could be removed and rinsed in water. "A ridiculous thing from . . . Ideal" was printed on the box, but in the course of having fun with their Kookie Kameras, kids absorbed some valuable knowledge about photography.

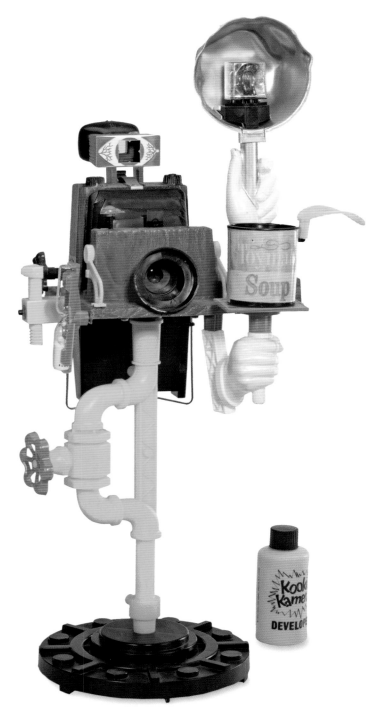

CHARLIE TUNA

ca. 1970 | Whitehouse Products Inc.,
Brooklyn, New York

2004.0298.0001

The Charlie Tuna camera was modeled from the popular cartoon character in the Starkist Tuna TV commercials of the 1970s. Charlie's dream was to be selected by Starkist for cooking and canning, but while he always tried to demonstrate his "good taste," Starkist wanted tuna that would taste good. This large camera was easy to use. Instamatic 126 film cartridges were simply dropped in place; the lens was hidden in Charlie's wide smiling mouth, and his hat served as the flashcube socket. Whitehouse Products produced the Charlie Tuna in Brooklyn, New York, where they had been building less colorful cameras since the 1940s.

MICK-A-MATIC

ca. 1971 | Child Guidance Products, Bronx, New York

1974.0028.3059

The Mick-A-Matic was more than a toy. Produced in 1971 by Child Guidance Products in New York, it was a functional camera that used drop-in 126 Instamatic film cartridges. The lens was in Mickey Mouse's nose, and his right ear served as the shutter release. A flash attachment could be mounted between the ears. The shape of the Mick-A-Matic made it attractive to children, though somewhat difficult for their small hands to operate. The camera was sold mostly in toy departments. Well-known artist/photographer Betty Hahn (b. 1940) employed a Mick-A-Matic to create a popular series of flower images in the 1970s.

BUGS BUNNY

ca. 1978 | Helm Toy Corporation, New York, New York

Gift of F. S. Spira. 1982.0501.0001

The Bugs Bunny was one of several cartoon-character cameras made by Helm Toy Corporation of New York City in the 1970s. Helm's simple plastic box design for the ubiquitous Instamatic 126 film cartridge made it possible to use different style front covers for a variety of characters. The Bugs Bunny front showed the "cwazy wabbit" reclining over the lens, his elbow resting on a sign that read, "EH DOC SMILE!" While sold as toys, these cameras introduced many children to the fun of photography and made them photographers for life.

SNOOPY-MATIC

ca. 1982 | Helm Toy Corporation, New York, New York

Gift of F. S. Spira. 1982.0501.0002

The Snoopy-Matic was the high point of the novelty camera fad made possible by the popular Instamatic 126 film cartridge. Helm Toy Corporation of New York produced this all-plastic doghouse design in 1982, along with other cartoon character-based cameras. Snoopy's door functioned as the lens, with the two windows serving as viewfinder and shutter button. Flashcubes could be snapped onto the chimney for low-light situations. Despite their whimsical styling, many of these odd-shaped novelties delivered decent-quality pictures.

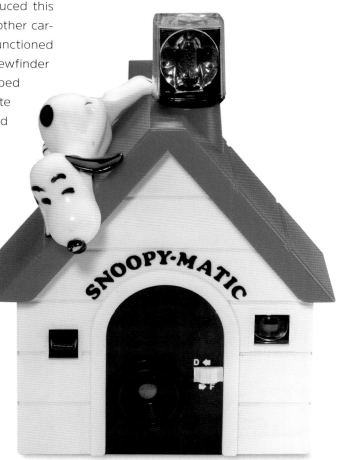

SPIDER-MAN

ca. 1982 | Vanity Fair Industries, Melville, New York

Gift of F. S. Spira. 1982.0501.0003

Produced by Vanity Fair Industries of Melville, New York, the Spider-Man camera was one of several cameras that used the same style plastic body. By molding in various colors and applying different decals, the cameras were marketed under the names of many cartoon characters and superheroes. The Spider-Man, like most novelty cameras of the 1960s and 1970s, used Instamatic 126 film cartridges, ideal for children. The built-in handle, large shutter button, and thumb-lever film advance made it easy to use. Flashcubes could be used for indoor pictures. A lens housing with a simulated knurled ring and a stepped-up ramp for the flash mount gave it a shape just like the cameras Mom and Dad used.

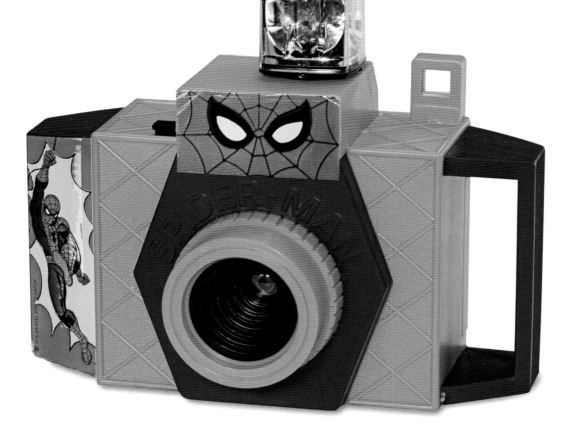

PANDA 110

ca. 1985 | Kiddie Camera, Taiwan

Gift of Eastman Kodak Company. 2003.0263.0001

This Panda camera is one of a series of "character head" designs found on toy aisles in the 1980s. Made in various Taiwanese factories, they were available as dogs, bears, clowns, and even Santa Claus.

Despite their whimsical appearance, these cameras were real and made actual pictures. The nose on the character's face was made of soft material and served as a lens cover. To take photos, the disc-shaped back cover was removed and a 110-film cartridge dropped in place. With the cover replaced, the ridged winding wheel below one of the eyes was turned until the film stopped for the first exposure. With the nose removed

and safely stored in the budding paparazzo's pocket, the shot was framed through the viewfinder and the oblong button near the critter's ear pressed. While it's not easy to take devices like these seriously, there's no denying the excitement of picking up the first packet of one's own pictures from the photofinisher, even if the quality isn't suitable for framing.

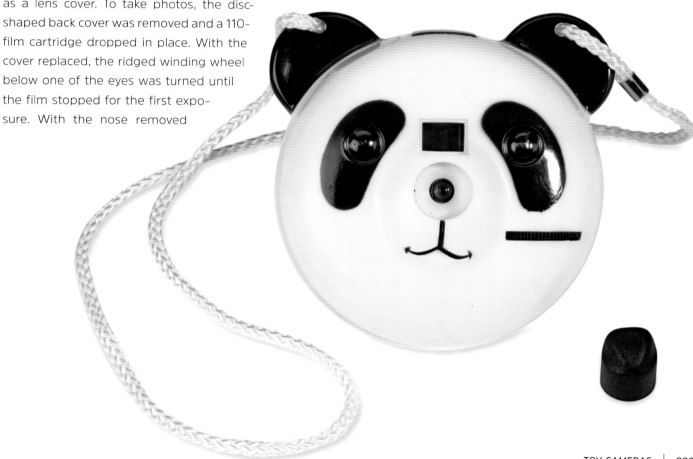

PHOTO MISSION ACTION MAN

ca. 1998 | Hasbro, Pawtucket, Rhode Island

Gift of Jerry Friedman. 2004.0989.0001

Cameras disguised as toys were easy to design around the Instamatic 110 film cartridge. Hasbro of Pawtucket, Rhode Island, offered one in 1998 as part of their Action Man series, based on a popular British children's animated TV show. The all-plastic twelve-inch-tall hero, packaged as Photo Mission Action Man, had a video camcorder on his shoulder. Inside his torso was a working 110 still camera that shot through the lens in his chest armor. A button near his right shoulder blade tripped the shutter and captured whatever image was framed by the viewfinder atop the shoulder camcorder. Film was loaded by removing a panel on his back and advanced with the ridged thumbwheel on the belt. The film pack was oriented vertically, as were the pictures.

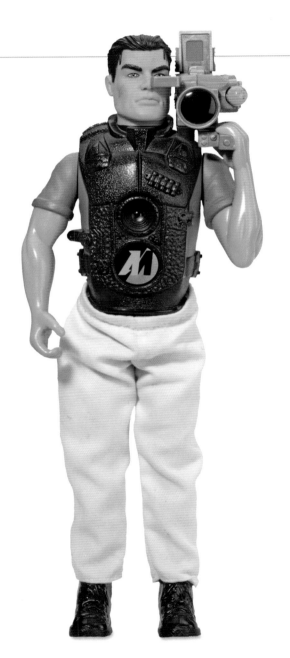

TAZ INSTANT CAMERA

ca. 1999 | Polaroid Corporation, Cambridge, Massachusetts

1999.1031.0001

The 1990s were a tumultuous decade for the photographic industry, especially Polaroid Corporation in Cambridge, Massachusetts. The groundbreaking technology of the 1972 SX-70 had matured to the point where it was relegated to cameras marketed to children. Polaroid's 1999 Taz was a special version of its OneStep 600, molded in brown-and-tan plastic. The flip-up Tazmanian Devil head housed the electronic flash and opened to reveal the fixed-focus lens and Taz teeth decals, while a Looney Tunes logo served as the shutter-release button. Polaroid made special film for the camera, sheets preprinted with Taz and other Looney Tunes characters in the border, but it could also use normal ten-exposure Polaroid 600 Instant–film packs. Cartoon-character-themed cameras were once common items in toy departments, but Taz was one of the last to be made.

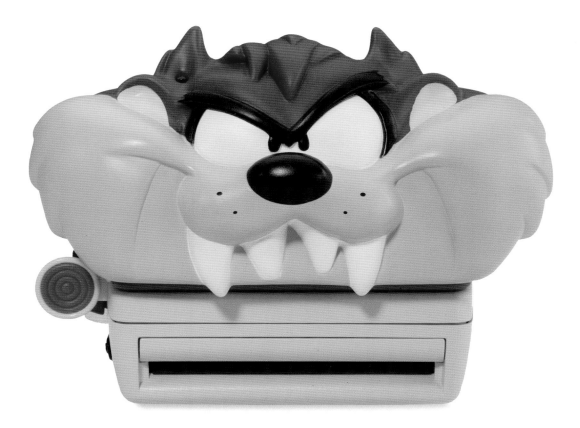

DIANA

ca. 1965 | Great Wall Plastic Factory, Kowloon, Hong Kong

Gift of Eastman Kodak Company. 2001.0120.0001

When the Great Wall Plastic Factory in Hong Kong began producing Diana cameras in the early 1960s, no one could imagine that this flimsy novelty would one day be revered by an avid cult of art photographers. Intended as little more than a toy, the Diana was molded entirely of thin, low-grade plastic, including the single-element lens. Sold for $1 or less, these featherweights were popped out in huge numbers by several factories, mostly identical in appearance but branded with more than one hundred different names. Regardless of the label, each camera took sixteen 4-cm square images on a roll of 120 film. Many were handed out as premiums at gas stations or sales conventions, only to end up at the bottom of toy boxes or in landfills. It's not that these cameras were difficult to operate. The only controls were the shutter release and two sharp-edged metal tabs to set the aperture and select instant or bulb shutter action. Those tabs were rough on the fingers, and with the dawn of the Kodak Instamatic, which spelled the end for many makers of cheap cameras, the Diana line ended in the 1970s.

The entire enterprise would have been long forgotten but for the quality deficiencies of the body and lens, both of sloppily molded plastic. No two lenses were alike. Every one produced distorted images, blurred areas, and unpredictable color saturation. The body and rear cover rarely sealed well enough to keep out light, causing some of the picture to look washed out or smudged. All were reason enough to discard the thing and invest in a decent camera, yet hobbyists began exhibiting their Diana pictures. Suddenly, those drawbacks became assets. Demand for the former giveaways began climbing, and asking prices hit the hundred-dollar-plus mark. As the Diana supplies dwindled, new cameras were marketed with carefully engineered flaws that mimicked the old Hong Kong classics. Now there are smartphone applications that imitate toy cameras, and there are Diana-like apps one can download.

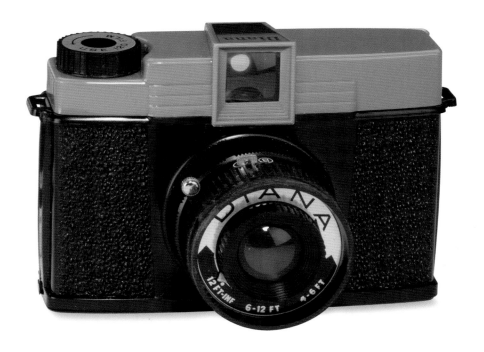

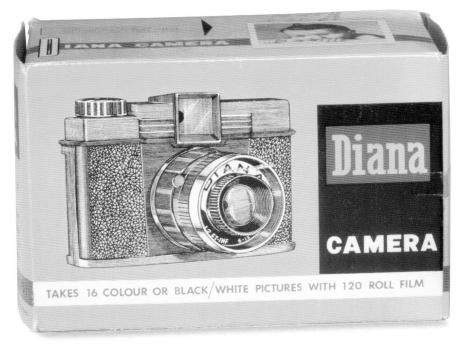

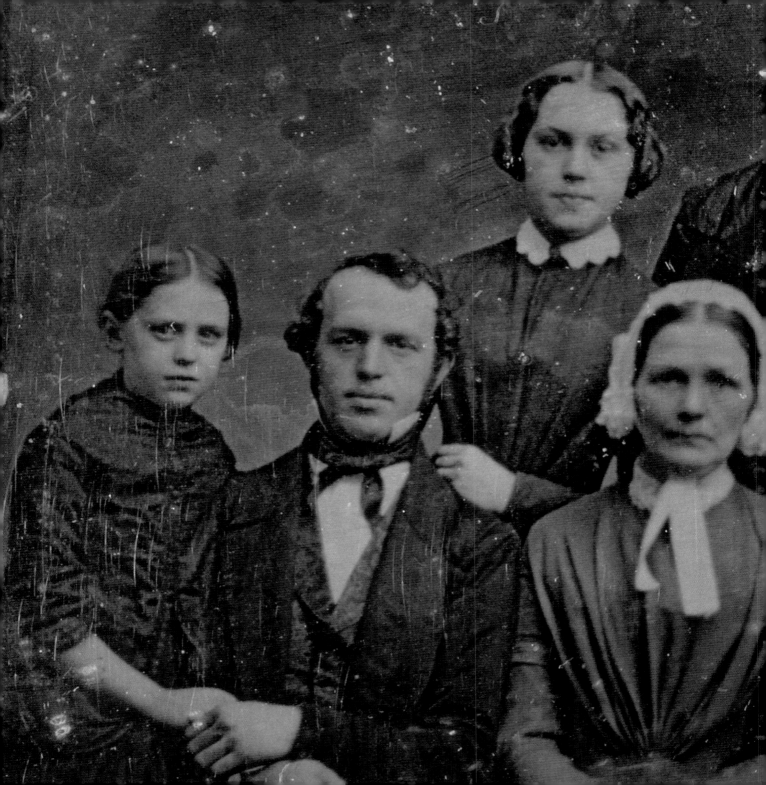

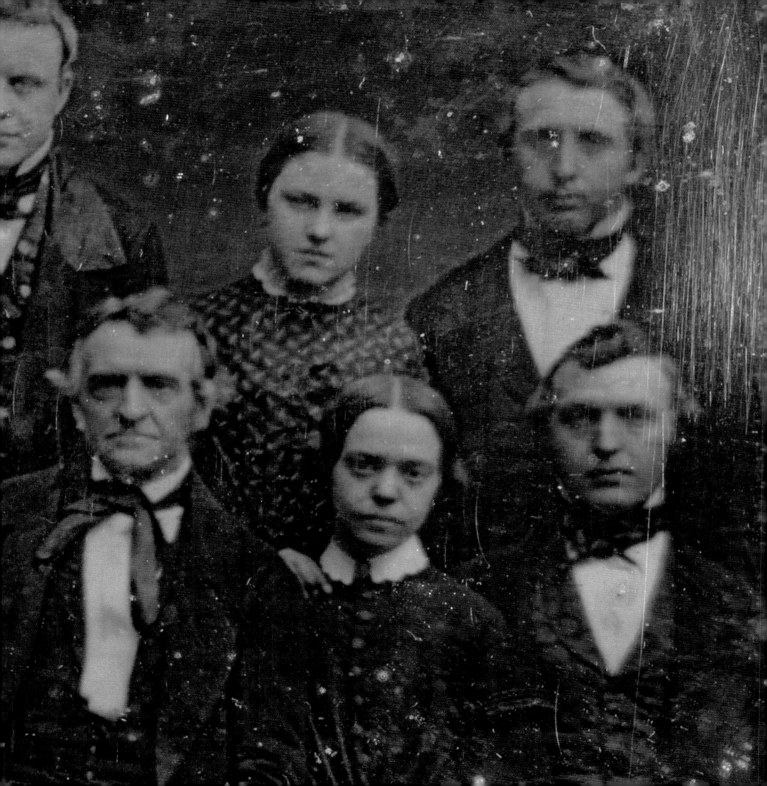

ACKNOWLEDGMENTS

The Technology Collection at George Eastman House is one of the world's finest; producing a book of this type would be very difficult without such an expansive collection. It would not exist without support from the numerous corporations and individuals who have donated generously to the museum from its inception. The photographic world is richer for their assistance in the creation and maintenance of this collection.

First and foremost, I would like to thank the museum's trustees and Bruce Barnes, Ph.D., the Ron and Donna Fielding Director, George Eastman House, for their support of this publication.

I offer my sincerest appreciation to my friends and colleagues who assisted in the preparation of this book.

From the George Eastman House staff, I would like to thank:
- Peter Briggs, for keeping the project on track
- Kathy Connor and Jesse Peers, for their knowledge of all things George Eastman
- Barbara Galasso, for her exceptional photography
- Ross Knapper and William Green, for editing the snapshot captions
- Mark Osterman, for his unparalleled knowledge of photographic process

I would also like to thank:
- Greg Drake, fact-checker extraordinaire
- Dr. K. Bradley Paxton, the best "sparky" I know
- Robyn Rime, for her superb editing skills
- Steve Sasson, Mr. Digital photography

And lastly, I would like to thank the good folks from Sterling Publishing, especially Barbara Berger and the project team, for making the book possible.

Todd Gustavson
Curator, Technology Collection
George Eastman House

Previous pages: Philander H. Benedict (American, 1826–87). [Portrait of unidentified family], ca. 1855. Daguerreotype, 1/2 plate. George Eastman House Collection. 2002:0725:0001.0001.

Opposite: Detail view, No. 3A Autographic Kodak Special, Model B with Rangefinder (see page 133).

For Dolly

Above: Elias Goldensky (American, b. Russia, 1867–1943). DR. FRANKLIN, ca. 1900. Gum bichromate print. Gift of 3M, ex-collection Louis Walton Sipley.

INDEX

CREDITS

All images courtesy of George Eastman House except where noted next to the image and/or noted below:

Page 38: Courtesy Mark Osterman
Pages 61, 160: United States Patent and
 Trademark Office
Pages 159, 170, 184, 202: Courtesy Joseph Struble
Page 180: Courtesy NASA / LOIRP

Page 182: Courtesy NASA
Page 206: Courtesy James McGarvey
Pages 216, 218, 220cl: Courtesy Todd Gustavson
Pages 220–21b: Courtesy Frank Cost

Original book design concept by Gavin Motnyk
Book production and layout: gonzalez defino, ny /
gonzalezdefino.com

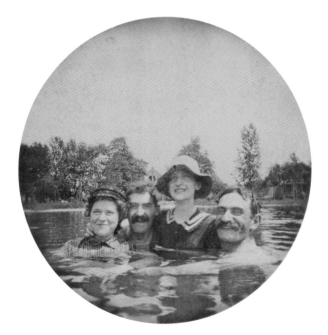

Above: Unidentified photographer. [*No. 1 Kodak snapshot of group at Conesus Lake*], 1893. Albumen silver print. Museum Collection.

Crimean Chersonesos

Crimean

Chersonesos

City, Chora, Museum, and Environs

Institute of Classical Archaeology (ICA)

National Preserve of Tauric Chersonesos (NPTC)

Institute of Classical Archaeology
The University of Texas at Austin
Austin, Texas USA

Library of Congress Cataloging-in-Publication Data

Crimean Chersonesos : city, chora, museum, and environs / [Glenn R. Mack, Joseph Coleman Carter editors].
 p. cm.
Includes biographical references and index.
ISBN 0-9708876-2-2 (pbk.)
1. Chersonese (Extinct city)—History. 2. Monuments—Ukraine—Chersonese (Extinct city). 3. Ukraine—Civilization—Greek influences. 4. Crimea (Ukraine)—History. I. Mack, Glenn Randall, 1963– II. Carter, Joseph Coleman. III. University of Texas at Austin. Institute of Classical Archaeology IV. Natsional'nyi zapovidnyk "Khersones Tavriis'kyi"
 DK508.C544C75 2003
 939'.5-dc21 2003007710

Scientific Editor: Joseph Coleman Carter
Production Editor: Glenn R. Mack
Scientific Advisors: Stanislav Ryzhov, Larissa Sedikova,
 Antonina Shevchenko, Tatiana Yashaeva
Research Coordinator: Ludmila Grinenko
Photography: Christopher Williams
Maps: Jessica Trelogan
Plans/Maps: Jodi Lane
Printing/Graphics: Margaret Zappi Paine, PrintGlobe

Published by
Institute of Classical Archaeology
The University of Texas at Austin
3925 West Braker Lane
Austin, Texas 78759
Please send your comments to
utica@uts.cc.utexas.edu.

See also *www.chersonesos.org.ua.*

Cover: Aerial view of Ancient City, with church and Sevastopol Bay in distance, 2001 (C. Williams); Half-title page: Detail of Theodosian capital with acanthus leaves, 5th century AD (C. Williams); Title page: Greek painting fragment, Head of a Youth, excavated from Tower of Zeno, ca. 325 BC (C. Williams); Back Cover: Anthemion funerary art, late 4th–early 3rd centuries BC (C. Williams).

The Institute of Classical Archaeology (ICA) is an Organized Research Unit of The University of Texas at Austin. In order to study, document, and preserve sites, monuments, and artifacts of past life for present and future generations, ICA conducts archaeological fieldwork and training in ancient Greek rural territories on the Black Sea and the Mediterranean. ICA engages in interdisciplinary research and publication, and it provides technical assistance and expertise in cultural heritage management. *http://www.utexas.edu/research/ica*

The National Preserve of Tauric Chersonesos and
the Institute of Classical Archaeology
gratefully dedicate this book to

The Packard Humanities Institute

for all that it has done and is doing
to give back to Ukraine and the world
one of their long-hidden archaeological treasures.

National Preserve of Tauric Chersonesos (NPTC)

Leonid Marchenko, Director
Nikolay Alekseenko
Irina Averina
Olga Dem'yanova
Tatiana Dianova
Olga Grabar'
Ludmila Grinenko
Ludmila Golovchenko
Elena Kochetkova
Ludmila Kovalevskaya
Nonna Krasovskaya
Nataliya Kulëva
Galina Nikolaenko
Stanislav Ryzhov
Julia Ryzhova
Ludmila Ryzhova
Larissa Sedikova
Antonina Shevchenko
Inga Shvedova
Tatiana Yashaeva
Galina Zhestkova
Miron Zolotarëv

Institute of Classical Archaeology (ICA)

Joseph Coleman Carter, Director
Taissa Bushnell
Carol Cook
Pat Irwin
Paul Lehman
Glenn Mack
Albert Prieto
Jennifer Sacher
Asele Surina
Jessica Trelogan
Christopher Williams

Collaborators

Nikolay Andrushchenko, *State Architecture and Urban Planning, Kyiv*
Paul Arthur, *University of Lecce, Italy*
Tatiana Bazhanova, *State Architecture and Urban Planning, Kyiv*
Carlos Cordova, *Oklahoma State University*
Sergey D'yachkov, *Kharkiv National University*
Douglas Edwards, *University of Puget Sound*
Larissa Golofast, *Institute of Archaeology of RAS, Moscow*
Carl Holiday, *Llano Design, Austin*
Nikita Khrapunov, *Tauric National University, Simferopol*
Jodi Lane, *architect, Austin*
Victor Lebedinski, *Institute of Oriental Studies of RAS, Moscow*
Alma Maldonado, *Llano Design, Austin*
Andrei Opait, *archaeologist, Toronto*
Margaret Zappi Paine, *graphic designer, Austin*
Amy Papalexandrou, *art historian, Austin*
Glenn Peers, *University of Texas at Austin*
Richard Posamentir, *Ruhr-Universität Bochum*
Tadeusz Sarnowski, *University of Warsaw*
Roman Sazonov, *New Haven*
Adela Sobotkova, *photography, Brno*
Sergey Sorochan, *Kharkiv National University*
Svetlana Telenkova, *Kyiv*
John Twilley, *conservation scientist, New York*
Rosemary Wetherold, *editor, Austin*
Toby Yuen, *editor, New York City*
Vyacheslav Zarubin, *Committee for the Protection of Cultural Heritage, Crimea*
Denis Zhuravlëv, *State Historical Museum, Moscow*
Vitaly Zubar, *Institute of Archaeology of NAS, Kyiv*

Contents

Marble relief of seated griffin. 2nd–3rd century AD, 87 x 87 x 14 cm. Belov, 1935. The griffin is one of the symbols of modern Crimea, found on its coat of arms with the motto "Prosperity in unity." (C. Williams)

Foreword

At Chersonesos, all the meanings and myths and narratives of the Black Sea converge at one place. It was on these shores that, for the first time in European experience, settled people encountered wandering, nomadic people—the "Other"—whose strangeness led to the opposed concepts of civilization and barbarism. It was around the northern shores of the Black Sea that colonists from the Mediterranean and Aegean worlds first met the prodigious fecundity of nature: the seething abundance of fish at the outfall of great rivers, the limitless steppes whose soil could feed the cities of the known world with grain, and the forests of the Caucasus whose timber could fit out a thousand navies.

And the Black Sea littoral, above all the beautiful Crimean Peninsula on which Chersonesos stands, has generated through three millennia a blind longing to possess it, by cultivation or by conquest. Nomad armies migrating out of Central Asia; Roman or Byzantine armies sailing up from the Bosporos; Ottoman and Russian armies in their conflict that lasted for three bloody centuries; French, British, and Sardinian armies fighting the Crimean War; and finally, the Soviet and Nazi divisions that inflicted the monstrous slaughter that covered the hills around Sevastopol with corpses and smoking metal—the invaders have all succumbed to this lust.

But the city of Chersonesos somehow survived. By stout defense, by diplomacy, or by luck, it lived on for almost 2,000 years into an epoch when all the other Greek-founded cities of the northern Black Sea had fallen. It was only in the thirteenth century that the city was stormed and razed by the Mongols. Even then, it seems, some people crept back and made a life for themselves in the ruins. When the Polish envoy Marcin Broniewski went there in the late sixteenth century, fresh water was still trickling from the pipes in silent, roofless palaces.

Even when reduced to ruins, the place has lived on. Paradoxically, war and the threat of war have helped to preserve the site. For more than a century, the presence next door of Sevastopol, the base of Russia's Black Sea Fleet, kept the area closed to visitors. The acres of broken houses, temples, and basilicas were not built over, and the city's chora—the grid of Greek colonial farmsteads that covers almost the whole Herakleian Peninsula—remained a banned zone, whose latticework ground pattern was still plainly visible to American satellite cameras during the cold war.

Chersonesos is the most majestic and touching archaeological site in the whole Black Sea region—and for many reasons. The first is the sheer size and significance of the place: a Greek trading city founded in the fifth century BC, then a Roman imperial port and military base, and later a rich Byzantine metropolis embellished with Christian basilicas and tiny street-corner churches, protected by a circuit of enormous walls, which are mostly still visible. But nothing is more moving and evocative than to stand in the remains of a Greek farmstead out in the chora. Here, looking at a fortified stone tower atop a wine magazine, it

is easy to imagine what a family went through during one of the repeated Scythian attacks: the smoke rising from the neighbor's farmhouse a few hundred yards away, the screams as the attackers broke in, the waiting to know if this house was going to be the next.

The second reason for awe is what we find here, from all periods. It is not only the superb sculpture and ceramics, the unique Greek stele engraved with the Civic Oath to the polis and its laws, or the painted gravestones preserved because they were used to strengthen the stonework of the Tower of Zeno. It is the presence, everywhere, of war's tragic evidence—the charred layers in those farmsteads, the skeletons of dead Soviet and German soldiers from the 1940s, the soil sown with metal fragments from cast-iron Crimean mortar bombs and Nazi artillery shells.

Another reason for fascination is the meaning of the public archaeology of Chersonesos. Here, it is demonstrably true that archaeology happens in the present, rather than in the past, and is concerned with the living at least as much as with the dead. This cultural landscape is important to many different groups and interests, whose agendas are distinct and sometimes hard to reconcile.

Chersonesos matters to archaeologists and to the Ukrainian state, embodied in the National Preserve of Tauric Chersonesos (NPTC), its staff, and the on-site Museum in a converted monastery. It matters to the Orthodox community. Here, they believe, Prince Volodymyr of Kyiv was baptized in 989, and they revere the city as the gate through which Christianity entered the East Slav lands. It fascinates the Sevastopol authorities and the new post-communist entrepreneurs, who long to develop the site for tourism and profit from the stream of visitors. And the ruins matter, finally, to the hard-pressed working people of Sevastopol. Chersonesos is their bathing beach, and for generations, families have carried their picnics past Byzantine churches and temple columns down to the familiar shore beyond. Their claim is at least as valid as any other.

A new and brilliant future is opening for Chersonesos. Its fame is spreading, and visitors from many lands are beginning to find their way there by air or by cruise ship. The National Preserve, in partnership with the Institute of Classical Archaeology (ICA) at The University of Texas, is preparing a fifty-year plan for the exploration and management of the area that will attempt to do justice to all those strands of public interest. It may be that Chersonesos will become home to an international institute for training Black Sea archaeologists. This extraordinary site, hauntingly beautiful and yet still only partly understood and explored, is increasingly being recognized as a treasure in the cultural heritage of the world.

—NEAL ASCHERSON, author of *Black Sea* and editor of *Public Archaeology*

Preface

Chersonesos is a magical place. I felt it on my first visit in 1992. No one can see the sun setting over the Ancient City and the columns of the "1935 Basilica" and remain unmoved. Now, after ten years of collaboration with the National Preserve of Tauric Chersonesos, my enchantment with the area has not diminished nor lost any of the first excitement. The more I learn about its history and its current problems, the greater my resolve to see the site and Sevastopol, its near neighbor and host city, take their place as a world cultural center. This would have seemed an impossible dream only a dozen years ago. Sevastopol, the home base of the Black Sea Fleet, was among the most secretive places in the former Soviet Union, and the military was in evidence everywhere. The city's fame is forever associated with acts of war and heroism. Submarines were docked under a mountain cliff in nearby Balaklava Harbor. Today, they are gone, and Ukraine has banned nuclear weapons entirely. Sevastopol is an "open city," on the brink of new life, prosperity, and fame—establishing a new economy based on peaceful activities such as international tourism and technology, open to new initiatives as it attempts to protect its wealth of historic, cultural, and natural treasures.

Crimean Chersonesos is a guide to the history of Chersonesos, its Museum, and its chora. In the spirit of change and cooperation, it aims to reach a wide audience. We present the archaeology of Chersonesos in its geographic and historic setting, trace the larger historical picture, and discuss its exceptional monuments. So that the monuments tell their own story, they are arranged approximately in chronological order, with easily determined walking itineraries. Beyond the Ancient City, we explore modern Sevastopol and other sites of historical significance in the region. In addition to the Greeks, Romans, Byzantines, and Slavs who made this part of the world their home, there are numerous cultures about which we can only hint—Scythian, Sarmatian, Gothic, Alani, Theodoro, Khazar, Karaite Jewish, Mongol, Genoese, Crimean Tatar, and Ottoman. One day, too, their sites and stories will be more accessible for visitors to western Crimea, who will begin to comprehend their long and complex history and admire their beauty. We publish this book to share the treasures of Chersonesos and to inspire the global attention that the site justifiably deserves.

—JOSEPH COLEMAN CARTER, Director of the Institute of Classical Archaeology

Acknowledgments

Crimean Chersonesos is the result of a collaborative effort between the National Preserve and ICA—a tangible result of hard work and goodwill by all involved. This book is the first introduction to the world at large of a unique historical and archaeological site, which for political and military reasons has remained off limits to all but a handful of Russian and Ukrainian specialists for most of the twentieth century. Our combined staffs wrote the text, provided original research, and supplied the fine and abundant illustrations, most of which have never before appeared in print. ICA organized the project, designed the book, and published it, and NPTC staff provided firsthand experience and knowledge of the site. *Crimean Chersonesos* is truly a group effort.

The book might not have been possible at all, and certainly not in the form you see now, if not for the generous support of the Packard Humanities Institute. The crucial factor has been the personal interest of Dr. David Packard in the site—its excavations, conservation efforts, Web site, and database project—which in less than three years has made this one of the most advanced and exciting places to conduct archaeological research in Ukraine.

From the time when Professor Joseph Carter first arrived in 1992 at Chersonesos, he has worked tirelessly on behalf of the Preserve. He has made the site known to the West and around the world, while at the same time providing us with access to developments in archaeology, conservation, and cultural resource planning that facilitates our reentry into the international archaeological community.

We are grateful also for the interest in Chersonesos shown by former U.S. Ambassador William Green Miller, his wife, Suzanne, and the current ambassador, Carlos Pascual. They are true friends of Chersonesos and of Ukrainian culture. We are also grateful to the private foundations in the United States, as well as to private donors who have given so generously to our joint programs of research and conservation.

Special thanks must be given to our head librarian, Ludmila Grinenko, for her daily patience in coordinating the U.S. and Ukrainian deadlines. While many participated in the creation of the book, archaeologists Stanislav Ryzhov, Larissa Sedikova, Tatiana Yashaeva, and Antonina Shevchenko put their considerable talents to work writing and verifying the descriptions of monuments and objects in light of the most recent research available. Archivists Nonna Krasovskaya and Tatiana Dianova went beyond the call of duty to bring to life the historic illustrations that so richly adorn this publication. Photographer Chris Williams has been documenting and cataloging the efforts of our joint project in Chersonesos since 1994. The majority of the contemporary photographs in this book are a sample of his technical skill and trained eye. Jessica Trelogan, a classicist and GIS specialist, has been at the center of our joint project for the past seven seasons. Glenn Mack has put his creativity and his organizational, journalistic, and computer skills to the test as production editor. As

the projects grow in size and scope, the ever-steady Taissa Bushnell has been a godsend, coordinating the transoceanic logistics on a daily basis. I truly appreciate the efforts of the entire staff of our respective institutions—the joint team—for supporting this publication.

—LEONID MARCHENKO, Director of the National Preserve of Tauric Chersonesos

A Note of Gratitude

The impetus for this book has been the joint Ukrainian-U.S. collaboration at Chersonesos since 1994 between the National Preserve and ICA in the areas of excavation, research, and conservation; study of the collections in the Museum and storerooms; and archival preservation. None of this would have been possible without the generous financial and moral support of the loyal friends and donors who, over the years, have sustained the activities of ICA. We want to thank here the agencies and foundations based in the United States that have played a vital role at Chersonesos: the Bernard and Audré Rapoport Foundation, the Brown Foundation, the National Aeronautics and Space Administration (NASA), the International Board for Research and Exchanges (IREX), the James R. Dougherty, Jr., Foundation, the Samuel H. Kress Foundation, the Speros Martel Foundation, the Trust for Mutual Understanding, and, especially, the Packard Humanities Institute. The overriding debt of gratitude of both ICA and the Preserve is acknowledged in the dedication.

—JOSEPH COLEMAN CARTER, Director of the Institute of Classical Archaeology

HON. YURI PETROVICH BOHUTSKY, *Minister of Culture and Arts of Ukraine*

The significance of Chersonesos as an archaeological treasure lies not only in its having survived for two thousand years in a very complete form. More importantly, it also bears the ancient roots of democracy and civic responsibility transplanted from Greece and maintained throughout much of its long life. The Greek tradition of democracy is represented in one of the most precious displays of the Museum, the Civic Oath of Chersonesos inscribed in marble. Chersonites pledged to defend the entire territory of the colony from traitors and enemies and to work with their fellow citizens for the development and good of the polis. Ukraine, as a young state, cannot afford to forget that a tradition of democracy existed in her lands. Indeed, one glance at the oath reminds contemporary Ukrainians that they have a great responsibility to sustain this tradition and, like the ancient Greeks, to work with their fellow citizens for the development and good of their country.

The modern science of archaeology in Slavic lands owes much to Chersonesos. Because it was the cradle and transit point of cultural and spiritual life from Byzantium to the Slavic lands, it raised the interest of those who sought Slavic cultural heritage already in the nineteenth century. The first archaeological excavations in Chersonesos date from 1827, and scholars have been excavating and researching the ancient city and its environs year after year since then. At first, their goal was to unearth the evidence for their Christian heritage, but they found major monuments of Greek, Roman, and indigenous civilizations. The science of archaeology in Ukraine evolved here in the nineteenth and twentieth centuries. Today, Chersonesos is a center of international scientific collaboration. Scholars from Ukraine, Poland, Russia, Belarus, Italy, the United States, and elsewhere participate in interdisciplinary research.

Today's National Preserve of Tauric Chersonesos reflects the history, the culture, and the ethnic interrelations of the local and foreign peoples. Archaeology in Chersonesos provides modern humanity with the opportunity to become acquainted with these cultures of the past. This knowledge not only affords a better understanding of the people who lived in our territory but also proves relevant to contemporary cultures and world affairs. Just as individuals find themselves in their roots, so Ukraine will better understand itself by looking at its history. In truth, all humankind has inherited Chersonesos, a site that will indeed reward the world's attention.

HON. CARLOS PASCUAL, *Ambassador of the United States of America to Ukraine*

Ancient Chersonesos is a site that deserves to be better known, both by scholars and by people around the world who are fascinated by the evidence of past civilizations. One of the

consequences of the breakup of the Soviet Union and the rebirth of independent Ukraine has been the opening of hitherto undreamed-of opportunities for contacts and exchanges among Ukrainian scholars and specialists and their counterparts in the United States, Europe, and elsewhere. For the past decade, Professor Joseph Coleman Carter and his associates at the Institute of Classical Archaeology at The University of Texas have worked closely with the National Preserve of Tauric Chersonesos in a unique collaboration to study and conserve the cultural heritage of this ancient Greek city and its surrounding farmsteads, whose history stretches back to the fifth century BC. Their scientific and technical collaboration has already achieved significant results, including the creation of a development plan that addresses the larger issues of the Preserve's management and its evolution into an archaeological park and major tourist destination in Crimea. This book is an integral part of that plan, introducing Chersonesos to both actual and armchair tourists, telling the story of this incredible place that has survived as Greek colony, Roman outpost, Byzantine trading center, and meeting place of cultures and religions. I hope that the book will inspire many to come and see for themselves and to be struck, as I was, by the magic of Chersonesos and its meaning for our civilization.

HON. WILLIAM GREEN MILLER, *Former U.S. Ambassador to Ukraine*

Painting by Yuriy Khymych with the 1935 Basilica and St. Volodymyr's Church, still showing damage to the cupola from World War II. (W. Miller)

There is a remarkable landscape painting by one of Ukraine's best artists, Yuriy Ivanovich Khymych, that captures the spell of Chersonesos. Khymych depicts the Greek and Byzantine ruins against the late afternoon sky and the juxtaposed St. Volodymyr's Church. The entrance to Sevastopol Harbor, so laden with recent history, is also a compelling part of the magnificent Khymych essay in color, architecture, and cultural heritage. Anyone who is fortunate enough to go to Chersonesos recognizes that this is a sacred place.

Chersonesos was a revelation to me. I thank Leonid Marchenko and Galina Nikolaenko and my close friend Joseph Carter for their learned care in teaching me and many others the importance of this site, sacred to so many peoples and civilizations. Countless

generations, going back to even before the Scythians and the Greeks, have stepped into the Black Sea and swum from the marbled beach, an integral part of these treasured ruins. The government of Ukraine and its archaeologists and historians are, thankfully, taking the steps necessary to protect and preserve this world treasure for the enjoyment and education of future generations.

I returned to Chersonesos as often as possible during the four and a half years I was ambassador to Ukraine, and I have visited each year since leaving in 1998. I know few places in the world so rich in the tangible evidence of successive civilizations. Here, in a setting of great natural beauty, as yet unspoiled, it is possible to contemplate and feel and see how our distant ancestors lived. The government of Ukraine is to be commended for its wisdom in fully supporting the National Preserve of Tauric Chersonesos and maintaining the integrity of this historic Crimean city and its chora. Their fragile beauty could easily be lost.

For me, as an American who believes in democracy as a political system, the Civic Oath of Chersonesos has particular meaning in this time of Ukraine's new democracy. Many Ukrainians have placed their fingertips, as I have, on the oath carved in Greek letters on the marble stele from the fourth century BC. The oath has real relevance now for the people and government of Ukraine:

I shall carefully guard all of these
for the demos of the people of Chersonesos.
I shall not put down the democracy.

Detail of the marble stele containing the Civic Oath of Chersonesos, 4th–3rd centuries BC. For full oath, photograph, and text, see page 136. (C. Williams)

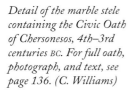

The relationship between the Institute of Classical Archaeology at The University of Texas and the National Preserve of Tauric Chersonesos is the best possible proof of close, serious intellectual and cultural ties between Ukrainians and Americans. The joint work of archaeological scholars and practitioners of the two nations speaks of a mutual and deeply civilized understanding of the importance of preserving such a significant treasure of world history.

Note on Translation and Transliteration

Any system of transliteration has both advantages and shortcomings, not to mention politicized inferences. Because this book spans so many eras and cultural groups, it is inevitable that there will be unintended inconsistencies. Foreign terms will be italicized and defined on first usage, and not thereafter. Names of cities and towns are transliterated from Greek when they date to the Hellenic period. Most Greek terminology is based on the *Oxford Classical Dictionary*, 3rd edition. In translating Greek names, we have generally followed the practices adopted by Richmond Lattimore in his 1951 translation of the *Iliad* of Homer (Chicago, 497).

It is a frequent, though not universal, practice to latinize Greek names, then anglicize the Latin forms, at least in pronunciation. I have generally avoided this practice, but have followed it on some occasions. Names ending in *ees* have been made to end in *es*; some names end (falsely) in *an*, as Danaan, Boiotian. Some endings in *e* have been changed to *a*, as Ida (not Ide), Hera (not Here). Other Anglo-Latin forms are: Apollo, Argives, Athens, Centaurs, Egypt, Hades, Helen, Hermes, Jason, Myrmidons, Priam, Rhodes, Thrace and Thracian, Titans, Trojans, Troy.

Byzantine-era terminology follows the *Oxford Dictionary of Byzantium* (1991). Ukrainian geographic names for cities and rivers are employed for modern references. An exception is found in archaeological and geographic sites in the Russian language that are part of the historical record of Chersonesos and the National Preserve. Russian and Ukrainian words are transliterated using the system of the U.S. Board on Geographic Names. Some geographic names, such as Cossack and Quarantine Bays, entered the English language during the Crimean War. Names of contributors are spelled according to their preference. For Turkic and Crimean Tatar spellings, we defer to the system employed by Allworth (1998). Ukrainian geographic names are consistent with those found in Magocsi (1996).

Since Chersonesos was founded as a Greek city, we used a Greek spelling to refer to earlier periods in many instances where Latin or English names may be more familiar (e.g., Trapezos, instead of Trapezus, though there are later references as Trebizond). Even the name "Chersonesos" is fraught with possibilities. Though variously spelled in other works as Chersonesus, Chersonese, Cherson, Khersonesos, Kherson, Korsun', etc., we have used "Chersonesos" even in discussions of the Byzantine period, when the city was called Cherson. "Chersonites" is used to describe inhabitants of Chersonesos throughout all periods. "Ancient City," capitalized, refers to the excavated portion of Chersonesos that is part of the Preserve's open-air exhibit, as originally envisioned by Karl Kostsyushko-Valyuzhinich, the Museum's first director. When in lowercase, "ancient city" refers to Chersonesos in general, not the excavated ruins.

Pre-Chersonesan Crimea

40,000 BC	Paleolithic era.
8,000 BC	Mesolithic era.
ca. 5500–2500 BC	Neolithic period and Eneolithic period in Crimea.
ca. 2500–1000 BC	Bronze Age in Crimea.
	Pit Grave culture, Kemi-Oba culture (2500–2000 BC).
	Catacomb Grave culture (2000–1500 BC).
	Timber Grave culture (1500–1000 BC).
10th–5th centuries BC	Iron Age in Crimea.
	Kizil-Koba culture in Crimean Mountains.
	Nomadic Cimmerians, of eastern origin, are driven from Crimea by Scythians, 7th century BC.
	Scythians begin erecting conical earthen mounds over elite burials (kurgans).
ca. 625 BC	Greek colonization begins. Founding of Pantikapaion in eastern Crimea.
525–480 BC	Earliest Greek artifacts at Chersonesos.
ca. 450	Athenian leader Perikles' expedition to Black Sea. Spartokid dynasty rules Bosporan Kingdom from Pantikapaion, expands grain trade with Greeks.

Era of Chersonesos

422–421 BC	Traditional date for founding of Chersonesos.
350–275 BC	Division of the Herakleian Peninsula, the chora of Chersonesos into equal lots, still visible in many places; Chersonesan hegemony over much of coastal southwestern Crimea.
300 BC–AD 250	Late Scythians, capital at Neapolis (modern Simferopol), raid Chersonesos.
ca. 110 BC	Mithradates VI Eupator of Pontos seizes power at Pantikapaion and his general Diophantes incorporates Chersonesan and Scythian territories into his Bosporan Kingdom.
63 BC	Mithradates commits suicide after defeat; Bosporan Kingdom and Chersonesos become virtual Roman dependencies.
44–36 BC	Chersonesos probably receives first charter of eleutheria (freedom) from Rome.
31 BC	Triumph of Octavian over Mark Anthony and Cleopatra marks collapse of the Republic, beginning of Roman Empire.
AD 50–200	Sarmatian tribes begin to displace Late Scythians in Crimea.
88–97	St. Clement exiled to Chersonesos. His relics returned to Rome by St. Cyril in ninth century AD.
ca. 140–250 or later	Roman legions continuously in Chersonesos.
ca. 250–270s	Goths from northern Europe move into Crimea and attack Roman provinces.
312	Emperor Constantine the Great legalizes Christianity.
330	Imperial residence transferred from Rome to Constantinople, which effectively becomes capital of Roman Empire.
ca. 370	Huns move westward, invade Crimea, and destroy Gothic and Greek communities.
527–565	Reign of Emperor Justinian I. Western Crimea fortified against barbarians.
655	Pope Martin exiled to Chersonesos, now called Cherson.
ca. 670s–850	Khazar Khanate gains hegemony over Crimea.
695–711	Byzantine emperor Justinian II, exiled to Chersonesos, regains the Byzantine throne.

829–842	Emperor Theophilos establishes military and administrative provinces in Crimea.
860–861	St. Cyril, and perhaps St. Methodios, the translators of the Bible in Old Church Slavonic, visit Chersonesos.
988–989	Prince Volodymyr of Kyiv besieges Cherson. His baptism results in conversion of Kyivan Rus' to Christianity. Cherson influences Christianization of the north.
13th century	Italian cities establish trade colonies along northern coast; Genoa dominates Black Sea trade.
1223	First Mongol incursion into Crimea.
ca. 1250	Major fire destroys much of Byzantine Chersonesos.
1347	Black Death decimates Genoese city of Caffa (modern Feodosiya, Crimea) and passes to Europe.
mid–15th century	Further decline of Chersonesos.

Post-Chersonesos Crimea

1427	Crimean Tatar Khanate established.
1453	Ottoman Turks capture Constantinople, ending Byzantine rule.
1472	Marriage of Ivan the Great to Sophia, niece of last Byzantine emperor. Byzantine influence continues in both court and culture in Slavic lands.
1475	Ottomans conquer Crimea; Crimean Tatar Khanate becomes vassal of the Turks.
1783	Russia annexes Crimea; Sevastopol founded by Catherine the Great.
1827	First archaeological excavation in Chersonesos.
1853–1856	Crimean War. The chora is again a battleground.
1891	St. Volodymyr's Church and monastery completed; consecrated in 1888.
1892	Archaeological museum established in Chersonesos.
1917–1921	Revolution and Civil War; creation of the Crimean Autonomous Soviet Socialist Republic.
1939–1945	World War II. Ukraine and Crimea are major battlegrounds.
1942	Germans occupy Sevastopol after heroic 247-day Soviet defense.
1944	Red Army retakes Sevastopol. Tatars, Bulgarians, Greeks, and other ethnic groups deported from Crimea.
1945	Yalta conference—Roosevelt, Churchill, and Stalin divide Europe.
1954	Nikita Khrushchev cedes Crimea to Ukraine Soviet Socialist Republic.
1991	On August 24, Ukraine proclaims independence from USSR.
1992	National Preserve of Tauric Chersonesos and Institute of Classical Archaeology at The University of Texas at Austin begin cooperation.
1993	Unilateral denuclearization of Ukraine.
1994	Ukrainian Parliament places National Preserve of Tauric Chersonesos under jurisdiction of Ministry of Culture and Arts. Crimea designated an autonomous region of Ukraine.
1996	Sevastopol becomes an "open city." Chersonesos listed as one of the 100 Most Endangered Monuments of world cultural importance by the World Monuments Fund.
1997	Black Sea Fleet divided between Russia and Ukraine.
1999	Major funding from the Packard Humanities Institute gives greatly increased impetus to research and conservation of the Ancient City and its chora.
2000	Official status of Chersonesos as a Ukrainian National Preserve reaffirmed.

Tauric Chersonesos

Chersonesos was continuously inhabited for nearly two millennia through Greek and Roman antiquity and the Middle Ages. Ancient cities with such a long, uninterrupted history can be counted on one hand. Chersonesos began life as a Greek colony in the fifth century BC and then became a major ally of the Romans in a strategic spot facing the barbarian hordes. During its second thousand years, it was the head of a Byzantine *theme* (military administrative unit) and a center for Christianity. Through it all, Chersonesos maintained a unique degree of autonomy. Greek language and culture, though not exclusive, predominated in its history. The city and its extensive chora and hinterland shared a history with other groups from its beginning: indigenous Taurians,

Figure 1.1
Winter scene of the Ancient City with the 1935 Basilica against the Black Sea. Chersonesos was among the northern-most of the Greek colonies. (V. Ganenko)

Scythians, Sarmatians, Goths, Huns, Khazars, Rus', and finally the Genoese. All these cultures left behind conspicuous monuments of their presence. Chersonesos, multi-ethnic in every period, set an excellent example for the modern world of how such a heterogeneous society can not only succeed but also prosper.

Major Events

The story of Chersonesos was hardly uneventful. Its life as a Greek colony and Roman ally constitute a full chapter in this volume. The establishment of democracy on the north coast of the Black Sea in the fifth or early fourth century BC, a century after the first democratic governments in Athens and some other Greek cities, is worthy of particular note. A remarkable inscription on marble in the Museum's Greek Gallery—the Civic Oath of Chersonesos— is one of the few complete documents of early democracy in existence. Ukraine, which became an independent country in 1991 and adopted a democratic constitution in 1994, has an excellent precedent on its own territory.

Few places in Ukraine are as central to the country's history as is Chersonesos. The conversion of Kyivan Rus' to Christianity in the late tenth century AD altered the history of eastern Europe. Chersonesos is the site where Prince Volodymyr (Vladimir), the ruler of Rus', married the Byzantine princess Anna—for which he was both converted and baptized in AD 989. With his conversion came that of all the eastern Slavic peoples. Architects, artists, and priests of Chersonesos were directly involved in creating the splendid Christian capital

city of Kyiv in the late tenth and early eleventh centuries AD. After the Mongol-Turkic conquest of Kyiv (1240), the center of power moved north and Orthodox Christianity spread throughout Russia.

Unique Monuments in the Ancient City and Chora

The economy of the ancient world was, to a large extent, based on agriculture, and much of its population lived out their lives in the countryside. Historians, relying mainly on ancient writers, themselves from elite urban culture, have seriously misrepresented the ancient world as an urban world, and archaeologists, following that precedent until recently, have also focused on cities. Only in the last three decades has a new generation of excavators and survey archaeologists turned to the countryside to discover—not surprisingly—that around many ancient cities, the *chorai*, or agricultural territories, were indeed densely occupied, and not just by slaves or a subaltern labor force but by citizen farmers.

The systematic exploration of an ancient countryside, for the first time ever, began at Chersonesos in the early twentieth century, revealing the complexity of rural life in the ancient Greek world. Ancient farmhouses, some of great size, and the grid system of country roads were excavated because, as the great historian Mikhail Rostovtsev observed, they could reveal much about the social and economic history of Greek civilization. This precocious work went on with few interruptions throughout the twentieth century—anticipating similar efforts in the Mediterranean by half a century. Work on the chora continues today in joint projects involving teams of excavators from the United States, Russia, and Poland, as well as Ukraine.

Figure 1.3
Aerial view of a conserved farmhouse at Site 151 in the chora of Chersonesos. (C. Williams)

The importance of the countryside in ancient life is now being recognized at sites throughout the Mediterranean and Black Sea worlds. The chora of Metaponto in Magna Grecia (southern Italy) is perhaps the most fully investigated in the West. Still, the chora of Chersonesos is simply the best-preserved monument of its kind in the world.

More than 500 hectares (1,200 acres) of open fields have been preserved out of the 10,000 hectares (25,000 acres) of the chora that originally covered the entire Herakleian Peninsula. Here the grid of ancient roads (like that of the city but on a larger scale) and the ruins of about 140 impressive "rural estates" exist to this day. Some of the excavated examples have stone walls standing as high as the first

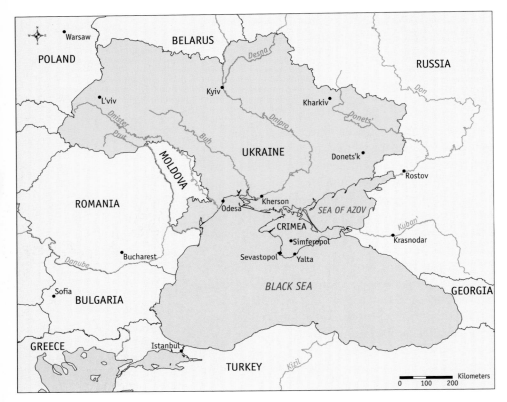

Map 1.1
*Modern political map of
Ukraine and Black Sea
littoral states. (J. Trelogan
after Magocsi, 1985)*

floor. Only here can the visitor have the sense of stepping into the rural past, into the lives of farm families of the fourth and third centuries BC. Here, as nowhere else, the ancient winemaking industry can be reconstructed, from the terraced "planting walls" (spaced 2 meters apart and occupying much of the 60 acres of the average estate), the wine presses, and the storage facilities of huge clay vessels with a capacity of 500 to 1,000 liters, to the locally made transport amphorae, the kilns in which they were produced, and the ships that carried them.

Chersonesos has been called a Slavic Pompeii. This description is only a slight exaggeration. None of the ancient structures is still standing to its original height, with the exception of part of the city walls—the largest extant monument of antiquity on the Black Sea. Yet the visitor walking along the main streets *(plateiai)* and the smaller streets that divide the city into a regular grid has the sensation of being transported back to various time periods. The approach through the southern gate in the city walls leads past the only Greek theater so far discovered in the Black Sea region and the only completely preserved Greek mint anywhere in the world. The mighty walls, which are most fully exposed in the southeastern part of the city, span nearly the whole of the city's history from the fourth century BC to the fourteenth or fifteenth century AD. They were constantly being repaired and modified as methods of siege warfare changed and in response to the attacks by practically every barbarian (literally "non-Greek speaking") group whose name has left its mark in history (and some whose names did not). Chersonesos was the ultimate prize and the key to control of the northern Black Sea coast.

Medieval Chersonesos, or Cherson as it came to be known in the sixth century AD, was a city of churches of various sizes and plans and often decorated with rich marble and mosaic flooring. The monumental Byzantine architecture dates predominantly to two periods, the sixth century and the ninth and tenth centuries. What is truly remarkable about

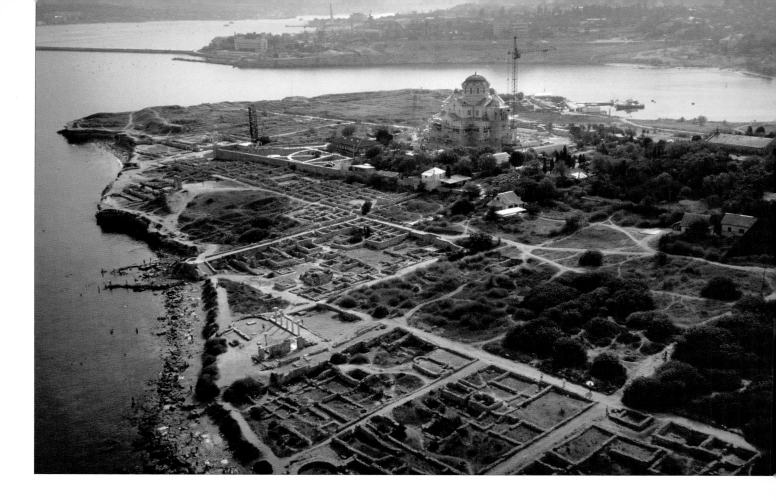

the site is that, like the Italian Pompeii, the city was never built over in the modern era. Though the city was not covered by a volcanic ash, it was almost as effectively preserved. A significant part of Chersonesos was destroyed by fire in the second half of the thirteenth century, after which the city slowly declined. Artifacts were found where they lay at that time, and organic materials such as rope and cloth were preserved because they were partially carbonized. Most other major Byzantine centers lie beneath modern cities. Chersonesos was abandoned for centuries. Fortunately, because Catherine the Great favored the larger harbor to the east, Sevastopol grew up around the remains, leaving the fabric of the ancient city almost intact. As a result, here as nowhere else, the whole pattern of life of a medieval Greek city can be reconstructed—houses, shops, industries, public buildings, chapels, and churches—in their original context. Some stones from Chersonesos, however, because they provided useful building materials, were appropriated for the new eighteenth-century city.

Figure 1.4
Aerial view of Chersonesos with the newly renovated St. Volodymyr's Church in 2001. The entrance to Sevastopol Harbor is in the distance.
(C. Williams)

History of the Site and Museum

Chersonesos can rightly claim to be the birthplace of archaeology in the Slavic world, especially classical archaeology. Excavations began as early as the third decade of the nineteenth century, a generation before Schliemann's work at Troy. The early excavators were naval officers and passionate amateur archaeologists, as the profession was only just beginning to develop. They included Count and Countess Uvarov, who founded the Moscow Archaeological Society, which, like the Odesa Society of History and Antiquities and the Society of Dilettanti in England, was later transformed into a formal scientific

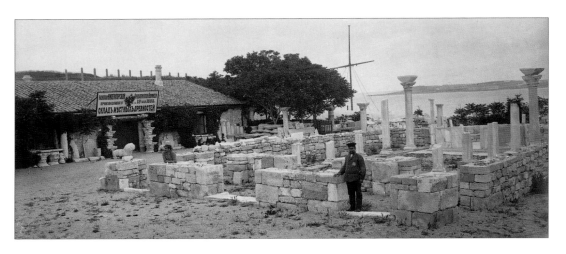

organization. The tsars funded the Chersonesos excavations, and a small museum—a "Warehouse of Local Antiquities"—was created on the site in 1892. A library, archives, and laboratories followed in the early twentieth century. It can be said, without exaggeration, that every classical archaeologist or ancient historian in Russia or Ukraine, living or deceased, has studied Chersonesos intensively, and many have visited and worked there.

The Collections

Nearly two centuries of excavation at Chersonesos have produced a great number of important discoveries. Many of the finest objects found during the early years now reside in the State Hermitage Museum in St. Petersburg and in the State Historical Museum in Moscow. Nothing, not even whole mosaic floors, was too big to move. The official policy

after World War II favored keeping the excavated objects in local museums if such existed. The result is that the Chersonesos Museum has one of the finest Ukrainian collections of Greek and Roman antiquities and medieval artifacts, comparable to those in museums of Kyiv and Odesa. Two very special components of the Chersonesos collection stand out.

The group of polychrome grave monuments—stelai, sarcophagi, and architectural elements—is virtually unparalleled in the world. In general, painting, which was greatly admired by ancient authors in the Greek world, has left few traces. The Chersonesos grave monuments, however, were employed in a hastily erected fortification against one of the countless barbarian assaults, thus preserving to an amazing degree the actual pigment, as well as the outlines, of painting. It may be claimed that this discovery, made in 1960–1961, sheds direct light on the secrets of the Greek art of painting even more than the recently uncovered, spectacular Macedonian frescoed tombs.

The other unsurpassed treasures of the Chersonesos Museum include its collection of medieval pottery. The brightly colored vitreous-glazed "sgraffito" (incised) ware, with its original abstract and sometimes whimsical figural designs of saints and monsters, makes an immediate impact. Several important styles, like the "Zeuxippos ware" appear here with great frequency. Chersonesos clearly imported much but also surely had its own local production of quality pottery. Less eye-catching, but of inestimable historical value, is the array of ninth-century pottery found in the main cistern of Chersonesos. This pottery is a unique documentation for a period that was considered a "dark age" elsewhere in Europe.

The medieval collection is truly outstanding in the way that it brings a whole civilization to life. In addition to the superb steatite icons and other works of religious art are the well-designed objects of everyday life: tools, buckles, fibulae, buttons, dice, patterned fabric, jewelry, magistrate seals, bone tools, fine bone boxes, and instruments of toiletry. These items are all housed in spacious galleries of appropriate shape and proportions in a former church of the nineteenth-century monastery.

Figure 1.6
Ram-shaped red slip unguentarium (oil bottle), 3rd century AD, perhaps a product of Asia Minor. h 7.7 cm. Strzheletskiy, 1962. (C. Williams)

Hero City

For nearly two millennia Chersonesos was a beacon of civilization in a turbulent world, an outpost that held firm against succeeding waves of barbarian invaders. No other city on the north coast of the Black Sea repelled all of them: Scythians, Goths, Huns, Khazars, Rus', and finally Mongols. The heroism of the many who died defending their homes, freedom, and civilization was relived by Sevastopol in relatively modern times. Writer Lev Tolstoy, who fought here, observed the heroism and the inhumanity of war firsthand. His earliest work, *Sevastopol Stories,* prefigures his later masterpiece, *War and Peace.* The horrors of the Crimean War foreshadowed the creation of the International Red Cross, as Florence

Figure 1.7
One plate from a
panorama set of eleven
taken by British
photographer Roger
Fenton in 1855 during
the Crimean War and the
siege of Sevastopol. The
motion blur in the
foreground is due to the
slow shutter speed of early
cameras. (Gernsheim
Collection, Harry Ransom
Humanities Research
Center, The University
of Texas at Austin)

Nightingale nursed wounded and dying British troops, while, in a little known episode, doctors from the United States assisted with Russian casualties in the besieged city. Less than a century later, the inhabitants of Sevastopol withstood the might of Hitler's armies for 247 days. Hardly a single building was left standing in 1944. The "hero city" was rebuilt in record time after World War II in the neoclassical style of its nineteenth-century predecessor.

The almost incredible ability to survive distinguishes Chersonesos from most other ancient centers. Survival into the future, however, is not guaranteed for what is arguably the most important archaeological site on the Black Sea coast. The rapid growth of the city of Sevastopol into the ancient chora, the possibilities of mass tourism to come, the obstacles to management of cultural treasures, the lack of sufficient funding, and the urgently needed conservation of objects and structures exposed to the weather threaten Chersonesos even at this writing. Up to now, the economic growth of newly independent Ukraine has been slow, which places a particular strain on its cultural institutions. Monuments that are

not continuously monitored and conserved eventually collapse and are silently removed from the world's cultural heritage. For the last several years, the National Preserve of Tauric Chersonesos, working in close collaboration with the Institute of Classical Archaeology (ICA) and the Packard Humanities Institute, has been developing and implementing a detailed plan for the preservation and management of both the Ancient City (referring to the excavated structures now part of the Preserve's open-air museum) and the sites in the chora and environs of Chersonesos, with the encouragement and support of the Ministry of Culture and Arts of Ukraine. To this end, a cultural-scientific nonprofit organization called *Pidtrymka Chersonesu* (Support for Chersonesos)—the first of its kind in Ukraine—was organized in 2001. Chersonesos is on Ukraine's shortlist of monuments to be nominated for UNESCO "World Heritage" status. Foundations in the United States, such as the Brown Foundation, the Samuel H. Kress Foundation, the Trust for Mutual Understanding, and the James R. Dougherty, Jr., Foundation, have responded to the urgent need to conserve Chersonesos's unique cultural heritage. This has been underscored by the World Monuments Watch's repeated listing of Chersonesos among the one hundred monuments of world cultural significance in immediate danger from natural and man-made threats.

The Future

The vision for the future includes an archaeological walking itinerary through the ancient chora, or countryside. A recent decision at the highest levels of the Ukrainian government has guaranteed the integrity of the twenty or so parcels (that have remained untouched since ancient times) as parkland. The total Preserve territory, as noted earlier, is about 500 hectares. Preliminary plans for this historic landscape development by the Preserve in collaboration with ICA include a visitors' center and an auxiliary museum of the history of wine making, just outside the largest intact parcel (about 150 hectares). In the chora are eight "rural estates" once engaged in wine production, including Sites 132 and 151. An itinerary of sites, each illustrating a different aspect of rural life, has been planned, with provisions for the best use and the most economical and effective conservation of these sites. A great deal of thought has gone into integrating the extended and scattered parklands into the individual neighborhoods, the urban fabric, and the local economy of Sevastopol.

The Ancient City has its own particular problems regarding conservation and management. It is foremost an archaeological site of the first magnitude. It is also a place with great and special significance for Orthodox Christianity. It is important, both for tourism and school visits, and as a place of recreation for generations of locals. The wrangling between the Church and excavators, beginning in the mid-nineteenth century, for the use of the territory revived with the fall of the Soviet Union. In 2000 the Ukrainian government resolved the issue: Chersonesos will remain state property and a "National Preserve" (the only purely archaeological one in the country), and St. Volodymyr's Church may be used by the Orthodox Church on special occasions. This peaceful resolution of a potentially volatile situation is a clear indicator that Ukraine recognizes the great importance that Chersonesos has played, and can continue to play, as a unique attraction of Ukrainian and, indeed, world culture.

Specific steps are being taken to assure the future of Chersonesos. Projects are now under way, funded by generous grants from the Packard Humanities Institute (PHI), to create a digital database of the library and archives. This collection of excavation journals, photographs, plans, and rare publications that go back to the eighteenth century is precious, and its loss would be irreparable. At the same time, work proceeds with PHI support on the

Figure 1.8
Portion of the Basilica within a Basilica, a 10th-century church inside a larger one of the 6th century, with mosaic decorations in situ, 2001. (C. Williams)

first modern archaeological research facility in the Preserve since the time of the tsars. Future projects certainly should include conservation of the unique Greek theater and repair of the handsome classical structure that houses the Greek and Roman Galleries. The extant remains of the theater could be left untouched but still become an innovative structure for stage productions, including revivals of ancient drama. As in many museums, some of the finest objects remain in storage because of the lack of adequate display cases or space. The Museum building should be remodeled, and its rare collection should be given a suitable setting.

These projects, among others, would enhance what is already a great cultural complex. They could find assistance from generous international donors or agencies. Ultimately, however, the future of the Preserve depends on the people and the government of Ukraine and on their determination to develop self-sustaining, viable plans for the

Figure 1.9
An architect's rendering of a proposed eastern approach to the Preserve from the 2001 development plan for the Ancient City. (C. Holiday)

conservation and intelligent management of the site. This will require cooperation at all levels—neighborhood, city, and state—while involving private citizens and volunteers, a wide-reaching educational campaign, and a carefully planned strategy for local, national, and international tourism. It is a tall order, but the potential rewards for Sevastopol, Ukraine, the world cultural community, and future generations are truly immense.

References
Chtcheglov 1992; Sorochan et al. 2000; Holiday and Maldonado 2001; Romey and Grinenko 2002; Ascherson 2002; Maldonado and Holiday 2003; Carter 2003.

Crimean Peninsula

Crimea is a peninsular extension of the Russo-Ukrainian steppe, with a low mountain range along the south coast breaking the monotony of the flatlands. The Black Sea connects Crimean shores with the Mediterranean world and beyond. Although not as hospitable as the Mediterranean with regard to weather or harbors, the Black Sea has currents friendly to wind- and oar-powered ships.

The Crimean Mountains are a world apart, displaying a landscape with a distinct biological and cultural character unlike that of the steppe to the north. Humans have found their most enduring homes and fertile lands in the foothills that lie between mountain and steppe, and also along the coast, where the three Crimean landscape features—sea, steppe, and mountain—converge.

The Herakleian Peninsula is the southwesternmost segment of the foothills that arc around the Crimean Mountains. To the west and south, the Black Sea washes and erodes its shores and has formed a sharp point in the extreme northwest—Cape Mayachnyy, or Lighthouse Point. The northeastern boundary of the peninsula is the deeply incised and now partially flooded canyon of the Chërnaya (Black) River, which forms Sevastopol Harbor. Finally, to the east, the peninsula is bounded by Sapun Mountain, a major escarpment, and several steep hills, all of which lie along a rough line from Sevastopol Harbor to Balaklava Harbor. The ancient Greek geographer Strabo described the coastline in terms recognizable even to the modern observer and made the guiding remark that the Herakleian Peninsula juts forth from another peninsula (Crimea as a whole).

The climate of southwestern Crimea is Mediterranean-like but not truly Mediterranean (defined as a winter-wet, summer-dry precipitation regime). In addition, from across the steppe come occasional very cold arctic air masses that produce hard freezes (−20° C), and from Asiatic Russia come dry, hot summer winds.

Figure 2.1
The Black Sea coastline from Cape Fiolent to Lighthouse Point.
(G. Mack)

Figure 2.2 (top)
Sheer face of the Crimean
Mountains along the
southern coast around
Yalta. (P. Lehman)

Figure 2.3 (bottom)
A summer thunderstorm
building over the steppe in
central Crimea.
(P. Lehman)

In contrast, the south coast of Crimea experiences relatively higher winter temperatures because the mountains protect it from northerly cold fronts. During the period of ancient settlement in southwestern Crimea, our best reconstructions show the climate to have been essentially the same as today's.

As with climate, the vegetation of southwestern Crimea is also partly Mediterranean and partly steppe. The dominant vegetation now is forest steppe, a woodland association of trees, mostly oak, with grasses and a mixture of herbs, though little "pristine" environment is left in southwestern Crimea. The area around Sevastopol has twice in the past 150 years been nearly completely stripped of vegetation, especially of trees. The defensive demands and battle damage of the Crimean War (1853–1856) and World War II are revealed in war photos. Our reconstructions of ancient vegetation show clearly that degradation had already been under way for millennia before Greek colonization. As for the introduction of foreign plants and the management of indigenous ones, pollen research identifies a significant increase in pistachio pollen with Greek settlement and later hints that pistachio trees may have been used by the ancient farmers, perhaps, as boundary markers or as parts of hedges.

Soil is the most important agricultural resource, and the nature of the available soil would have fundamentally conditioned the nature of Greek settlement and subsequent ancient economies. As can be readily seen all around the outskirts of Sevastopol, little topsoil remains today, and what does remain is thin and rocky. In the ancient period the topsoil was likely a bit deeper, but nowhere around ancient Chersonesos were the soils thick, rich, and workable. Indeed, reconstructions of the ancient agricultural economy indicate the importance of viticulture in the classical period and grazing in later periods, both of which are better suited for the thin, rocky soils of southwestern Crimea.

The physical environment of southwestern Crimea would have been familiar and likely comforting to a majority of Greeks. Although they might have preferred a location with better soils, they came equipped with the cultural and technological skills to thrive on the Herakleian Peninsula. Also familiar would have been the karstic terrain of the limestone peninsula (caves and springs) and the rocky coast. Although olive trees have never been successfully grown in the Herakleian Peninsula because of the low temperatures, other Mediterranean crops, such as grapes, and other fruit and nut trees of several sorts, have been

Map 2.1
Modern political map of
Crimea. (J. Lane)

farmed since the time of the Greek colonization. The familiar Mediterranean pattern of highland grazing was also potentially present in the higher foothills and mountains to the east of Chersonesos, although the availability of these resources would have critically depended on relations with indigenous inhabitants of those areas. Thus, the natural landscape of southwestern Crimea was a familiar landscape for the Greek colonists both functionally and aesthetically.

The landscape concept—the integrated pattern of features across a three-dimensional terrain—is an important one for understanding the natural world, as well as the dynamic of ancient settlement. Both the gorges of the major east-west rivers and the dry transverse valleys are the products of various phases and strengths of uplift and have been powerful factors in guiding settlement and transportation routes. Thus, it is curious to note that the Greeks were the only settlers not to follow these valleys. The imprint on the landscape left by classical settlers is partly the result of sheer numbers, settlement densities, and the use of stone

Figure 2.4 (left)
Lighthouse Point, or Cape
Mayachnyy, is also called
Cape Chersonesos and is
located on the westernmost
tip of the Herakleian
Peninsula. (A. Sobotkova)

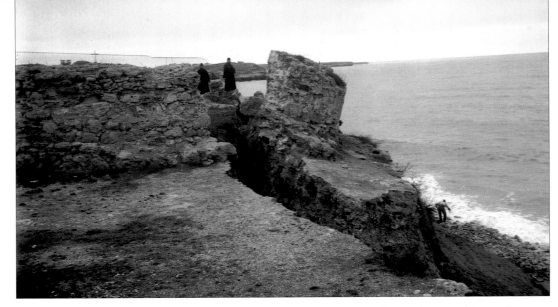

for building, and partly the result of an agricultural technology that could produce an abundance of walls, roads, and farmhouses.

That so much of this ancient countryside has survived is amazing, and all the more so because of the two damaging wars fought here in the last 150 years. For example, the prehistoric site of Uch-Bash is located on a terrace about 90 m above the Chërnaya floodplain. It also lies directly above a large cave used as a bunker by the Soviets during the siege of Sevastopol. Its storming by German combat engineers was concluded by the suicidal demolition of the entire cave bunker by the last defenders. This vignette is included in nearly every account of the battle and is often described as beyond imagination. That the site itself should have survived to be excavated in the 1950s is a miracle. Elsewhere, there exist similar, if less spectacular, cases of intact archaeology and the remains of war either side by side, as at Cape Fiolent, or intimately intermixed as, found at Bezymyannaya, or Nameless Hill, a Preserve-ICA excavation site.

That the ancient character of the landscape of Chersonesos and its chora largely endured through the wars is astounding. Unfortunately, a threat to the archaeological heritage exists in the construction and extension of the suburbs of Sevastopol. In the Soviet era, construction was tightly regulated and mainly

concentrated in the near downtown area, around which both extensive looting of ancient sites and graves, as well as damage by local inhabitants had previously occurred. Today, as modern settlement moves further afield and especially toward the southwestern portion of the chora, where traditionally there were only farms, sites are also damaged by current inhabitants

*Figure 2.7 (left)
Landsat 7 Enhanced
Thematic Mapper
(ETM+) satellite image of
the Herakleian Peninsula.
3,2,1 composite shown,
approximating true color.
(Image processing by
J. Trelogan)*

*Figure 2.8 (below)
Three-dimensional surface
view of the Herakleian
Peninsula, created by
draping a Landsat
Thematic Mapper (TM)
image over a digital
elevation model (DEM)
of the region (10x vertical
exaggeration). Lighthouse
Point in the lower right-
hand corner. (DEM by
Larry Teng, UT Center
for Space Research)*

searching for building materials and garden soil. What nearly a thousand years of grazing and two sieges could not obliterate, a few years of bulldozers and shovels might. Though Chersonesos is sometimes referred to as the Slavic Pompeii, geoarchaeologically speaking, this comparison is not correct. Pompeii has meters of volcanic deposits protecting its archaeological remains. Chersonesos does not. The incredible cultural heritage is literally there on the ground for us to see and also easily destroy.

References
Strabo 1924; Berg 1955; Borisov 1965; Podgorodetskiy 1988; Struk 1993.

Map 3.1
Greek colonies in the Aegean and Black Seas with overlapping Scythian, Greek, and Greek Bosporan spheres of influence. (J. Trelogan after Magocsi, 1985)

Greek Cities and Colonies in the First Millenium BC

Greek cities, colonies, and territories

Scythian influence, 7th to 1st centuries BC

Kilometers
0 125 250 500

16

Greek and Roman Chersonesos

During the initial period of expansion of Greek settlements from the eighth to sixth centuries BC, *apoikiai* (colonies) and *emporia* (trading posts) appeared throughout the Aegean and western Mediterranean areas. By the second half of the seventh century BC, they also emerged on the Black Sea coastline. Some Greek settlements (for example, Istria, Pantikapaion, Sinope, and Berezan [modern name]) soon began to spawn their own colonies, even as direct colonization from mainland Greece continued. Whether the result of population pressures, hunger, or simply commercial opportunities, Greek migration was not a premeditated or state-directed endeavor. Indeed, the north coast in particular offered vast expanses of arable agricultural land and an abundance of fish, as well as trading prospects. Chersonesos was one of the very last colonies to be established there, in extreme southwestern Crimea, which had previously been ignored by colonists. In fact, the surrounding territory, though rocky, was suited to grazing and the cultivation of grapes and it was ideally situated to take advantage of Black Sea trade routes and currents. Although the exact date of the founding of Tauric Chersonesos is still being argued, it is generally agreed that this colony of Herakleia Pontika, just opposite on the south coast of the Black Sea, was

Figure 3.1
Gold strap diadem with a central Herakles' knot flanked by lion heads, buried in the city wall.
300–280 BC,
0.95 x 30.4 x 1.2 cm.
Kostsyushko-Valyuzhinich, 1899. (State Hermitage Museum, St. Petersburg)

Map 3.2
Major Greek colonies in
the Black Sea area.
(J. Trelogan after
Tsetskhladze, 1994)

Figure 3.2
Clay cup, bowl strainer,
and sandstone hand-mill,
10th–8th centuries BC.
Local production, Kizil-
Koba culture, typical of
possible Taurian
settlements. (C. Williams)

founded in the late fifth century BC. Chersonesos and its neighbors represented the northeastern edge of the Greek *oikoumene,* or civilized world.

Chersonesos was distinguished from other Greek colonies, however, by its unique ability to survive and prosper long after its neighbors and rivals ceased to exist. It maintained good relations with the major powers in the Black Sea region—Athens in the fifth century BC, Macedonia in the second half of the fourth century, when Chersonesos controlled virtually all of western Crimea—and managed a delicate balancing act with Rome and the powerful Bosporan Kingdom in eastern Crimea. No less adroitly managed were relations with the ever-present barbarians, the indigenous Taurians, the late Scythians and Sarmatians, the Huns and Goths. This is not to say that these associations were always peaceful, but whereas many ancient and powerful colonies were destroyed in the third century AD, Chersonesos remained to become the major outpost of Byzantine civilization on the north coast of the Black Sea until its destruction in the fourteenth century. Besides its remarkable ability to survive, Chersonesos had a profound effect on world history, as a conduit of Mediterranean culture to the Slavic north.

The word "colony" and all its derivatives, because they are usually associated with the European land grab that began in the

sixteenth century, generally have a negative connotation today. The colony of the modern world was a source of raw materials and a market for exports manufactured in the mother country. Colonizers were known to dominate indigenous people, eliminate autonomy, and exploit resources. The Greek word *apoikia* literally means "a home away from home," a notion tied to settlement, cultivation, and trade. Although linked to a founding metropolis, the apoikia almost immediately became a separate entity, though often maintaining a religious and political organization similar to that of the mother city. In the normal course of development, the settlement became a *polis* (a self-governing unit consisting of an *asty*, or urban center, with an agricultural territory, *chora*) in its own right. Chersonesos was a typical Greek colony and was notably autonomous in its diplomatic relationships.

Greek colonization may be viewed as one of the truly progressive accomplishments in the ancient world. Despite the displacement or enslavement of local populations, characteristics that it shared with modern colonies, it provided a model for development. In a little more than three centuries, this movement profoundly transformed the populations who lived on the Mediterranean and Black Sea littorals. Chersonesos, for its part, influenced the barbaric mountain-dwelling Taurians and the nomadic Scythians. Greek language, art, literature, and political and military institutions became the common cultural property of the new poleis and neighboring non-Greek populations. This contact was naturally reciprocal, and the culture that emerged in the newly founded Greek and indigenous centers was neither purely Greek nor markedly barbarized. It was uniquely "colonial."

Greek colonization of the Black Sea lagged at least a century behind the push into Magna Grecia and Sicily. Ionian Greeks from the west coast of Asia Minor initiated efforts to create settlements around the

Figure 3.5
*Reconstructed lid of a
black figure lekanis and a
fragment of the vessel. The
decoration in concentric
bands consists of panthers,
swans, and rosettes. It
dates to the late 6th
century BC, imported
perhaps from Boiotia.
(NPTC archives,
C. Williams)*

Black Sea—the Pontos Euxeinos, literally "the sea friendly to strangers." Historical sources credit the Ionian city of Miletos with founding dozens of colonies in the region in the seventh and sixth centuries BC, but many other Ionian cities probably participated. Early contact with the Aegean during the Mycenaean period (the late Bronze Age, late second millennium BC) has been suggested by the mythological accounts of Jason and the Argonauts and of the tradition of Achilles' last resting place in the "White Isles," but thus far it has received very limited archaeological confirmation.

Archaeological excavations at the Greek sites of Istria, just south of the Danube River delta (ancient Ister River), and at Berezan, on the estuary formed by the Buh and Dnipro (Dnieper or ancient Borysthenes) Rivers, have been extensive. Early Berezan was a village of one-room circular or oval huts—partially underground (known as dugouts)—and contained large quantities of eastern Greek and Ionian imported pottery, mixed with handmade pottery. The ethnic composition of the population is still a matter of controversy among scholars, as is the case of similar early settlements in the western Greek world (for example, at Pithekoussai and Incoronata, near Metaponto), as well as at Chersonesos itself.

Colonial interest shifted from Berezan to Olbia, Pantikapaion, and Phanagoria, which during the sixth century BC became the major Ionian poleis on the north coast of the Black Sea, comparable in importance to those on the south coast at Sinope and Amisos. The extensive settlement of the chora of Olbia began in the later part of the sixth century BC and suggests that the purpose of the Ionian settlers, renowned as traders, was not purely mercantile but also agricultural, to develop the potential of the fertile steppe.

One stretch of the Black Sea coast deliberately avoided in the Archaic period (seventh through early fifth centuries) was the mountainous and scenic coast of southern Crimea. Dorian Greeks from Herakleia Pontika eventually chose the southwest corner of the peninsula for their colony, Chersonesos. Kallatis (on the west coast of the Black Sea) and Chersonesos, both offshoots of Herakleia, were among the few Doric colonies in the region. Megara in the Peloponnesos, with a contingent from Boiotia in central Greece, was the mother city of both Byzantion (controlling the Bosporos, the straits between the Black and the Aegean Seas) and, later, Herakleia.

The rocky landscape, as well as the reputation of the indigenous Taurians, restrained the Herakleiots and others from settling in southwestern Crimea earlier. The historian Herodotos (*Histories* 4.99,103) and the dramatist Euripides, both writing in the second half of the fifth century BC, describe the Taurians as ferocious and savage semi-nomads who lived in the southern mountains of Crimea and sacrificed shipwrecked sailors to their blood-thirsty goddess, Parthenos, "the Virgin" (associated with the Greek Artemis). This ritual is

portrayed in Euripides' tragedy *Iphigeneia among the Taurians* (produced in 414 BC, seven years after the putative founding date of Chersonesos). Orestes, son of the great king of Mycenae, Agamemnon, was sent by Apollo to the Taurians to return the sacred image of Artemis to Greece as a condition for curing his madness. His sister, Iphigeneia, who had been rescued from her father's sacrificial knife by Artemis, served the goddess in her temple on a high bluff above the Black Sea. Iphigeneia recognized one of the intended victims as her brother, and as instructed, they ultimately escaped with the image. Parthenos, as the main deity of Chersonesos, is celebrated in the art and coinage of the city, as well as in literature.

Though the whole of Crimea was at times referred to as Tauric Chersonesos by ancient sources like Strabo, the Taurians and the Kizil-Koba culture with which they have been identified were limited to the southern coastal mountains and closely adjacent areas. There they farmed small patches, hunted, and shunned their Crimean neighbors—the Scythians in the steppe to the north, as well as the Greeks of Kerkinitis (Yevpatoriya) and of Pantikapaion (Kerch) in eastern Crimea.

Powerful commercial incentives helped the Herakleiots overcome their suspicion of these unfriendly natives. Economic contacts between the Black Sea and Greece expanded enormously in the fifth century BC. Eastern Crimea, under the Spartokid dynasty, became a major grain supplier to Athens. Chersonesos is located near Kriou Metopon (Ram's Head Cape), a terminus of the shortest south-north route across the Black Sea, where strong currents aid vessels going in either direction even to the present day. The open-sea crossing (as opposed to coasting) was apparently first exploited in the fifth century BC. Amphorae from Sinope and Herakleia appeared along the Crimean coast in steadily increasing numbers throughout the fourth century BC.

Figure 3.6 Ionic cornice, with Lesbian and lotus palmette patterns, reused within a defensive tower. Local limestone, 3rd century BC. (C. Williams)

A short sail to the northwest of the Ram's Head takes one to an excellent small harbor, known today as Karantinnaya (Quarantine) Bay, the home port of Chersonesos. Ancient written sources give no reference, however, to a founder *(oikist)* or its founding date. The recent discovery of Greek pottery of the late sixth and early fifth centuries BC in the northeastern section of the city, some marked with graffiti, has raised the possibility of settlement on the site of Chersonesos from the Archaic period, as early as the late sixth century BC. Among the graffiti, Ionian, as well as Dorian (specifically Megarian), names have been identified. To consider the graffiti as *ostraka* (votes for exile of unpopular citizens),

as several scholars maintain, implies a functioning democratic government at the time. It would have been one of the earliest in the Greek world. Apart from the ambiguous "ostraka," no other evidence for a polis exists—in fact, no architecture that can be confidently dated before the early fourth century BC.

The first substantial evidence of an organized, sizeable settlement, in contrast to a polis, dates to the late fifth century BC. It consists of juxtaposed burials of two distinct types in the northern necropolis—a fact that could indicate a mixed settlement of Greeks and natives, though some scholars vigorously deny this possibility. Bodies in the supine position (typical of Greeks) are interspersed with those in a contracted position (found in the Iron Age Kizil-Koba burials), strongly suggesting that natives with their customs intact coexisted and probably cohabited with the Greeks. There are good parallels for "mixed" necropoleis in the Greek colonies of the west.

An alternative theory tries to resolve the question of the "Old Chersonesos," mentioned by the Greek geographer Strabo in the first century BC (*Geography* 742). It would place the earliest Doric settlement on Lighthouse Point, an obvious, small *chersonesos* (the Greek word for "peninsula"), where a sanctuary of Parthenos housing an ancient wooden image of the goddess supposedly stood. At its isthmus, a defensive wall was erected to protect the farms and presumably the sanctuary on the point. A second wall, creating a long, narrow, fortified enclosure, covered over traces of this first rural settlement. More than one scholar sees this area as the "Old Chersonesos," although there is no archaeological evidence to indicate a true settlement or to date the walls and farms before the first half of the fourth century BC. Strabo locates "Old Chersonesos," of which he says nothing remains, twenty stadia (20 km) by sea from the Quarantine Bay settlement, which would place it somewhere near the high cliffs of Cape Fiolent, or about twice the distance to Lighthouse Point. Excavations in 2001 near Fiolent located remains of a building and pottery of the fourth century BC and

established this dramatically high cliff-top site as the most recent and, in this writer's opinion, the strongest contender for the location of the Parthenos sanctuary. Herodotos (4.103), who may have visited it, placed the sanctuary of Parthenos on a high cliff—Lighthouse Point is at sea level—from which, he says, her victims' bodies were thrown, while their heads were raised on poles outside private homes for protection. This is an area of considerable and continuous coastal erosion, so that the sanctuary itself almost certainly has ended up, like the goddess' victims, in the sea.

Historians regard the foundation of Chersonesos not only as an opportunistic move by the Herakleiots to seize control of the northern terminus of a new express trade route but also as an occasion to resolve tensions within the mother city by resettling the excess population and malcontents in characteristic Greek fashion, in a colony. Aristotle, for one, was quite familiar with the constitution of Herakleia and reports in detail the conflict between oligarchs and democrats, as well as the strained relations with the pre-Greek population of the territory of Herakleia, the native Maryandinoi.

Figure 3.9
Aerial photograph (1960s) of a portion of the Herakleian Peninsula, two bays west of Chersonesos, between Omega and Streletskaya Bays. Dividing roads and agricultural planting walls are clearly visible as dark, linear features. (NPTC)

Scholars have linked the founding of Chersonesos to internal political and social problems of Herakleia. In Saprykin's view, the very regular division of the chora of Chersonesos into equal-sized lots indicates that the mother city had a democratic constitution. An example of the apparent similarity between mother and daughter was their treatment of their respective indigenous populations. Relations between the settlers and the Taurians were probably amicable at first while the colonists were building their strength. Once established, however, they drove the Taurians out of the Herakleian Peninsula into villages along the borders, adjacent to the fields where they surely served as the principal workforce. Chersonites, like the Herakleiots, seemed to have preferred a subordinate peasantry to outright slavery. The discovery of one manacled skeleton in the urban necropolis suggests that slaves existed, but slavery was probably not widespread in the colony or in the Black Sea region.

A remarkably complete document inscribed on marble, the Civic Oath of Chersonesos, reveals much about the democratic government of the city during a critical

Figure 3.10
A detail of the gold pectoral found in situ on the breast of a Scythian noblewoman in her burial chamber at Tolstaya Mogila (Dnipropetrovsk), in southern Ukraine. Two Scythians, arrows and quivers near, work with a sheepskin. 4th century BC. The full pectoral measures 30.8 cm in diameter. (Museum of Historic Treasures of Ukraine, Kyiv; C. Williams)

moment in its history. It dates to the period of Chersonesos's great territorial expansion over much of western Crimea, and it deals with a threat to the *demos* (all citizens in assembly) from enemies both internal and external. A conspiracy is suspected, and the citizens are forbidden to sell grain from the plain (western Crimea) on their own account. Chersonesos, like Herakleia in southern Italy (as is known from another remarkable inscription from the fourth century BC), attempted to keep a firm grip on the local economy and trade relations by controlling the price of grain. The oath calls on the pantheon of the city's gods to protect Chersonesos and its far-flung possessions in the "farther chora," which included at least one formerly independent colony, Kerkinitis.

The division of the "nearer chora" (Figure 9.1), which covered the entire Herakleian Peninsula, represented an enormous investment of labor. To build miles of stone-paved roads, flanking walls, and massive stone farm buildings—not to mention the internal dividing walls, terrace walls for vineyards, and the towered fortifications and watchtowers—was one of the most ambitious projects ever undertaken by a single polis. Whether the property was private or rented out by the polis to the demos or a limited group of oligarchs is open to discussion. In any case, few known Greek development projects can compare in size and complexity. Questions remain about the distribution of the plots, more than 400 large ones, which were then subdivided into more than 2,200 smaller units. The amount of land in one of the smaller blocks (210 x 210 m, 4.4 hectares, or almost 11 acres) would have sufficed for the entire estimated citizen population of colonial Chersonesos at the height of its prosperity in the second half of the fourth century BC when the division was made. This was the period when many of the 140 known "rural estates," or farmhouses, were constructed. With so many plots, why, one wonders, were farmhouses built on relatively so few of them? And why only in certain areas? Where could the owners or renters of the others have lived except in the city? These are just a few of the

Figure 3.11
Bronze arrowheads from the Greek Gallery, Hellenistic period. h 2.4 cm, 1.8 cm, 2.0 cm, and 3.0 cm. (C. Williams)

questions raised by this unique evidence. The chora of Chersonesos, as the great historian of antiquity Rostovtsev notes, offers an almost unparalleled fund of information about Greek and Roman life in the countryside. It has attracted scholars and, naturally, has aroused heated debates. Fortunately, the quantity and quality of the evidence are rapidly increasing.

The cities of Kalos Limen (Beautiful Harbor) and Kerkinitis mentioned in the Oath, and the fortified agricultural complexes of Bol'shoy Kastel' (Big Castle) and others like it, commanded the fertile steppe. Then as now, they were ideally situated for cereal production and contributed to Crimea's reputation as a strategic "breadbasket" for other Black Sea colonies that lacked such resources, like Sinope, and for the wider Greek world, including Macedon and possibly Rhodes. From about 300 BC, Chersonesos, in addition to having the 10,000 hectares of its nearer chora with its highly productive vineyards, controlled an additional 80,000 hectares of wheat land—virtually all the prime, arable land available in western Crimea, along the coast of the Tarkankut Peninsula. This very different terrain was divided, again, into rectangular lots similar to those of the "nearer chora," as the results of excavation and aerial photography have clearly shown. This added territory marked the height of Chersonesos's "empire," when it rivaled the size and wealth of the Bosporan Kingdom in eastern Crimea, long a major supplier of grain to Athens.

During this period of great prosperity, the city developed urban structures—defensive walls, a theater, a mint, private homes, temples, statues, and an agora—giving it the appearance of a truly Hellenic polis. The average size of most houses was relatively small for the Greek world in the Hellenistic period (about 180 m²), but some were considerably larger, with two to a city block, and quite luxurious. Apart from the imposing walls, relatively little from the colonial period has survived in its original form. Outside the walls in the southern necropolis stood elegant painted grave monuments (stelai and small funerary *naiskoi*, or chapels). Important architectural elements in the Ionic and Doric orders from these and more monumental buildings were often incorporated into later structures.

Already by the early third century BC, the resources of Chersonesos were under attack by the late Scythians, formidable barbarians who dominated much of Crimea from their capital of Neapolis (modern Simferopol). The Scythians probably were joined by the Taurians. The defense of the chora was reorganized by the citizens, and enhanced protection was provided to the city. The grave monuments just described were reused at this time as building material for a tower in the city wall, identified from a later inscription as the Tower of Zeno. An inscribed statue base honoring Agasikles, a *strategos* (military-political magistrate), dates to this period and cites his extraordinary contributions to the city's defense.

Widespread destruction in the nearer chora and loss of much territory in southwestern Crimea to the late Scythians mark the beginning of an economic decline for the city, but the city and nearer chora proved remarkably resilient. New gods of Egyptian

*Figure 3.12
Chersonesos-minted
dichalkos, 19 mm, dated
210–200 BC. **Obverse:**
Head of Parthenos with
wreath, facing right, and
with bow and quiver in
back. **Reverse:** Deer,
recumbent, facing left.
Above, abbreviated name
of city:* ΧΕΡ. *Below, an
official's name:*
-ΞΕΝΟΚΛΕ.
*From the joint Preserve-
ICA excavation of
farmhouse Site 151.
(C. Williams)*

origin—Isis, Serapis, and Anubis—internationalized Chersonesan religious life. An Indo-Iranian-speaking collection of nomadic tribes—the Alans and Rhoxolani, referred to collectively as Sarmatians—appeared at this time and were henceforth a major factor in Chersonesos's varying fortunes as they applied pressure on the familiar local barbarians.

In response to the Scythian attacks of the late second century BC, Chersonesos turned to the Bosporan Kingdom for help in its defense. The kingdom in the northwest corner of the Black Sea flourished until about 250 BC under the Spartokids and was revived by Mithradates VI Eupator, who incorporated it within his growing Pontic Kingdom. Mithradates was a Hellenophile, an Asiatic despot, and one of the grand, charismatic leaders of antiquity. He opposed the expansion of Rome, and in the early first century BC, he dealt stunning blows to its interests and armies. In about 113 BC, Mithradates sent his general Diophantes against the Scythians and successfully defended Chersonesos. From that point onward, Chersonesos and the Bosporan Kingdom were linked in a series of uneasy alliances for several centuries, contingent upon Rome's growing influence in the region and its current attitude toward the kingdom.

Figure 3.13
Clay lamp and vessels, assorted. Large pot (far right), local production, Sarmatian symbol cut in wall, 2nd–3rd centuries AD; molded lamp (center), gray clay, poor-quality black slip, Asia Minor, late 2nd–early 1st centuries BC; four handmade lamps, local production, 3rd–1st centuries BC. (C. Williams)

The influence of the Bosporan Kingdom on the chora of Chersonesos is seen in greatly enlarged defensive towers. Chersonesos's careful policy kept it largely independent of both Bosporos and Rome. Chersonesos nonetheless definitively entered Rome's orbit in the mid-first century BC. The city took the side of Rome against the renegade Bosporan king Pharnaces II, the treacherous son of Mithradates, whom Caesar defeated at the battle of Zela in 49 BC, pronouncing the famous phrase "Veni, vidi, vici." As a reward, it seems, Caesar gave Chersonesos the first of its grants of *eleutheria*, or "freedom"—meaning freedom from taxes and a semi-autonomous status vis-à-vis Rome. Chersonesos's apparent ability to pick the winner, avoid domination, and maintain its institutions was demonstrated even as it was drawn into the larger world of late Hellenistic power politics. Its physical appearance remained much the same, yet cattle raising in the chora grew in importance, at the expense of viticulture, and the trade in locally produced *garum*, or fish paste, increased in economic significance, as Strabo noted.

During the reign of Nero, Rome responded to a request from Chersonesos for military assistance, and in AD 63 sent in Tiberius Plautius Silvanus, the governor of the province of Moesia (corresponding to parts of Bulgaria and Rumania). In this period, Rome's

relationship with the state on the north coast of the Black Sea changed, and Rome drew closer. Trajan, in the early second century AD, strengthened the strategic role of the region, and Chersonesos came to Rome's side in the Bosporan wars when the emperor Hadrian reorganized the empire's defenses. Soon after, however, Chersonesos, again under the temporary and ineffective protection of the Bosporans, turned once more to Rome, seeking eleutheria and Rome's direct intervention.

In the second quarter of the second century AD, a Roman force, consisting of parts of several legions—the I Italica, V Macedonia, and XI Claudia—arrived and established bases along the southwestern coast of Crimea. They remained, it seems, for a little more than a century but had a profound and lasting effect on the city. A garrison was housed in the citadel of Chersonesos itself, where baths and administrative buildings, as well as barracks, were erected.

Every legion was assigned its own craftsmen, who engaged in the production of pottery, glass, bricks, and tiles, which provided support materials and income. To defray the cost of housing the Roman garrison, a tax was levied on houses of prostitution—an effective way of recycling cash, because Roman soldiers of this period were forbidden to marry. City authorities successfully petitioned the emperor on several occasions to have the tax more equitably divided between the city council and the military. By the second and third centuries, some soldiers had families with them, a fact revealed by numerous Roman tombstones with Latin inscriptions. This was a growing trend along the frontiers of the empire, as settlements and villages grew up next to camps. The troops were drawn for the most part from Moesia and were of Thracian, rather than Italian, ethnic extraction. A squadron of the Ravenna fleet was active along the coast where other bases were set up—for example, at Balaklava. In this lovely harbor town, a part of the Roman camp with a cult place of Jupiter Dolichenus has recently been excavated (1996–1998). Another fort at Charax, on the south side of the Crimean Mountains near the Ram's Head, first studied by Rostovtsev, was abandoned in the third quarter of the third century, when the troops on the northern Black Sea coast, including the city's garrison, were recalled to Moesia to strengthen its defenses.

Chersonesos, again granted eleutheria, then saw to its own defenses, relying now on the local militia after the at least partial Roman withdrawal. Fortunately, the Herakleian Peninsula was beyond the main path of the massive waves of nomadic migrations, which were moving westward. At Chersonesos, trade and prosperity actually increased during this period. In the first third of the fourth century, according to one source, the city even earned the special favor of Constantine the Great by coming to his aid in Moesia. Reputedly, Constantine, besides easing the city's taxation, also donated the funding for 1,000 Chersonesan artillerymen to counter heavy cavalry attacks.

Figure 3.14
Plain clay lamp, with a helmeted goddess of the type Athena Promachos, 3rd century AD.
(C. Williams)

The religious traditions from the period of Roman occupation and beyond were extremely varied. Hellenic and Roman gods were worshipped; some citizens apparently observed the imperial cult of emperor worship. There is evidence of a Jewish community in the fourth century, for artifacts with Jewish symbols, including a sculptured menorah and a recently uncovered Hebrew inscription, were found under the 1935 Basilica. The earliest Christians, perhaps a fifth of the population and mostly of the upper classes, began to worship openly in the early fourth century AD. This reflected the great changes introduced by Constantine, who legitimized Christianity after the violent repressions of his predecessor, Diocletian. But even in the emperor's new Christian capital, Constantinople, which he consecrated in AD 330, pagan priests were just as conspicuous as the Christians.

Warfare continued to evolve, and the cities' defenses were systematized, overhauled, and tightened in the late fourth and early fifth centuries. A good example of the changing nature of defense is Bezymyannaya, a late Roman/early Byzantine fortress currently being excavated by a joint Preserve-ICA team on the strategic Karan' Heights, at the southern edge of the chora. By the time of Justinian I, Chersonesos was firmly under Byzantine control, Christianity was the dominant religion, and there was a major shift away from late antique patterns of life and landholding, as new medieval forms began to take their place.

References
Strabo 1924; Belov 1948, 1950; Euripides 1955; Herodotos 1957; Solomonik 1964, 1973; Latyshev 1885, 1890, 1901, 1916; Anokhin 1980; Shcheglov 1981; Kadeyev and Sorochan 1989; Vinogradov 1992; Zolotarëv 1993, 2002; Randsborg 1994; Zubar 1994, 1995; Savelya 1996; Sarnowski and Zubar 1996; Saprykin 1997, 1998; Hind 1998; Sarnowski et al. 1998; Dupont 2002.

Medieval Chersonesos

The second millennium of Chersonesos's long history, in the medieval period, was defined by the dual forces of the Eastern Roman Empire on one side and the continuous waves of "barbarian" invaders on the other. Throughout the thousand years of greatness of the Byzantine Empire (a term introduced by scholars in the sixteenth century), its inhabitants referred to themselves as "Romaioi" long after the fall of Rome in the fifth century and even after the East-West schism in AD 1054. Triumphant Orthodox Christianity came to dominate the cultural and physical landscape, and Chersonesos, in turn, spread its influence farther north to Kyivan Rus'. During this time Chersonesos was called Cherson. While maintaining a degree of autonomy, the city became an official part of the Byzantine imperial organization (a *theme*) in the ninth century, which formalized its de facto role as one of the empire's northernmost outposts.

Figure 4.1
Reliquary casket,
engraved silver. Portraits
of Christ, Peter, and Paul
on one side, and the
Virgin Mary and two
archangels on the other,
found in the Reliquary
Church (pp. 113–114)
under the altar in 1894.
AD 550, 11 x 13 x 8.5 cm.
(State Hermitage
Museum, St. Petersburg)

Early Medieval Period: Fifth–Ninth Centuries AD

The split between the Eastern and Western Roman Empires began with the creation of a "new Rome" at Constantinople by Constantine the Great (AD 306–337). The city, on the site of the former Greek colony of Byzantion, served as the capital of the Roman Empire, even after Rome itself had fallen to the barbarians in the fifth century. Following the death of Theodosios I in AD 395, the Eastern Empire was assigned to his son, Arkadios, while the Western Empire was awarded to Honorius. The division became permanent.

Figure 4.2
Icon of St. Demetrios (left) and St. George. Dark shale, gilding. St. George holds a lance and an almond-shaped shield on the right. The saints are identified by inscriptions above them. Late 11th–12th centuries AD, import from Thessalonike, 19.9 x 14.0 x 1.0 cm. 1894. (State Hermitage Museum, St. Petersburg)

Urban society decayed in the West even though the richest farmland lay there. The cities of the East, however, flourished. Constantinople blossomed into the most impressive city in the world. Powerful Byzantine emperors such as Justinian I (527–565), Constans II (641–668), and Basil I (867–886) stubbornly attempted to reunite the West and the East without permanent success.

Justinian reestablished distant parts of the empire, beautified the capital with architectural adornments, such as Hagia Sophia, and codified the laws. The first golden age of the Byzantine Empire arrived. The cost, however, was so great that the whole empire was weakened for a century and a half after Justinian's rule. At one point, when the Arabs besieged Constantinople in 641, some even contemplated abandoning the capital for the West. Ultimately, the Arabs were repelled by the terrible "Greek fire," a prototype flame-thrower that ignited warships with highly flammable petroleum.

Chersonesos became helpful to the Romaioi as early as the time of Constantine the Great, and its services were rewarded. Chersonesos served Constantinople as an outpost in the midst of a predominantly barbarian world, as an invaluable trading port, as a lookout for the movement of barbarians from the east and north who threatened the borders, as a staging area to proselytize for political and religious ends, and as a convenient place to deposit political undesirables. The area was still within Byzantine authority, but far enough away to ensure that the exiles could do little damage. These included Pope Martin I and the emperor Justinian II.

Justinian I and his successors took a special interest in western Crimea. It is hypothesized that they built walls (following the example of Anastasios I [491–518] who enclosed Constantinople's surrounding territory with a new set of outer walls 45 km long) traversing the valleys between mountain ridges, creating a barrier that connected what are now known as the settlements of Kalamita (Inkerman), Eski-Kermen, and Mangup-Kale. Though remnants of the walls are found only at Mangup-Kale, the fortifications would have blocked the Crimean Mountain passes. Local Goths and Alans, who were *phoideratoi*, or allies of the empire, garrisoned the fortified settlements.

Local trade—in handicrafts, metal, ceramics, jewelry, and objects in bone—between the city and its surrounding chora and hinterland continued from the preceding period. A Roman garrison had returned to Chersonesos in the first quarter of the fourth century, and the cereal trade improved after the Goths were subdued, as previous trade with the western Mediterranean and Black Sea also revived. Chersonesos supplied Constantinople with

cereals in the 360s, according to the orator Themistios, and again in the fifth century as reported by the historian Zosimus. Under Emperor Zeno (474–491), after whom a city tower was later named, Chersonesos recommenced the minting of coins. Goods from all over the Mediterranean reached Chersonesos, as Justinian I strengthened its defenses in the sixth century.

Constantinople promoted its political and religious interests through Chersonesos, which served as a Greek-speaking enclave and as a natural springboard for evangelism in the midst of the hordes of potential barbarian converts. Orthodox legend attributes the beginning of Christianity in Slavic lands to the visit of the Apostle St. Andrew to Chersonesos in the first century AD. St. Clement (88–98), the fourth pope of Rome and the traditionally accepted author of the first Epistle to the Corinthians, was exiled to Chersonesos under the emperors Nerva and Trajan (98–117). It is claimed that St. Clement accomplished numerous conversions and that some seventy-five churches were built there during his stay. Trajan, to put an end to proselytizing, ordered that St. Clement be thrown into the Black Sea, weighted down by an anchor.

The earliest consistent archaeological evidence of Christianity at Chersonesos consists of isolated objects with Christian inscriptions and symbols that appeared in burials of the late third and first half of the fourth centuries. The earliest Christian vaults are found in the city necropolis and likewise date to the end of the fourth to early fifth century. The first excavated church in Chersonesos, the Minor Church in the necropolis outside the city walls, belongs to the same period. Some scholars believe that three churches—a small church in the northeastern part of Chersonesos with a triconch apse, the Kruse Basilica (near the Uvarov Basilica) with a similar triconch apse, and a cave church along the main street—all date to the fifth century. One can infer from the surviving stone ornament—a fourth-century "monster devouring the fish," a fourth- or fifth-century fragment of a Good Shepherd statuette, and several fifth-century fragments of a relief depicting fruit trees and fishes—that some churches functioned in the city during this period.

In the last quarter of the fourth century, a bishopric was established in Chersonesos, as is revealed by the signature of Bishop Aetherius in the Acts of the Second Ecumenical Council of 381 and by archaeological materials— for example, the top of an archbishop's staff, made of bone and carrying the late-fourth- or fifth-century inscription "...Christ's bishop... of the city of Chersonesos." Besides the Christian community, the early medieval city also had a Jewish community and a Monophysite community, whose basic tenet was that Christ had a single, purely divine nature.

By the sixth century, the reputation of Chersonesos as a religious center for neophytes extended far beyond the limits of Crimea. Later that century, the

Figure 4.3
Brooch fragment with birds molded in bronze, 5th–6th centuries AD, h 4 cm. Kostsyushko-Valyuzhinich.
(NPTC archives)

Figure 4.4
Reconstruction of a
Byzantine-era house the
in northern region of
Chersonesos, 12th–13th
centuries AD. (Drawing
by A. Shalkevich,
NPTC archives)

archdeacon Theodosios called Chersonesos one of the transit points where northern pilgrims took rest on their way to the Holy Land. Clay stamps with fifth- and sixth-century inscriptions are evidence of these pilgrims. They visited the churches in Chersonesos; received blessings from St. George, St. Theodore, and St. Phokas; and lodged in a hostel at the church or monastery located in the port region.

In addition to St. Clement, another distinguished exile was the Roman pope Martin I (649–655). He was an active opponent of the "monothelete heresy," which held that Christ had one will but two natures, human and divine, a belief also held by the Byzantine emperor Constantine IV. Pope Martin was exiled in 655 to Chersonesos, and this further raised the city's profile as a center of Christianity. The pope died there two years later and was buried in the Church of Blachernai outside the city walls. Writers of the eighth century described "the sepulchre of the great man, which is both intensively visited in the East, and is not buried in oblivion by the West," and stated that "the inhabitants of the North throng to divine Martin's mausoleum."

Justinian's mighty effort to reunite the western and eastern parts of the empire was at first brilliantly successful, but, as noted, the long-term consequences were negative. Chersonesos became in effect a part of the Eastern Roman Empire. In the late fifth and sixth centuries the city was governed by a *bikarios*, who had the administration of the polis under his control. Already in the second half of the fifth century, the name "Cherson" appeared in the Byzantine chronicles, and it replaced the ancient name altogether in the last quarter of the sixth century. Russian chronicles mention this new name as Korsun', Italian documents as Gorzon or Gorzona, and the Ottoman sources as Sary-Kermen (Yellow Fortress). During the reign of Justin II (565–578), Chersonesos became the residence of the *doux*, the commander of the Byzantine army in Crimea.

During the sixth and seventh centuries, the chora may have been largely abandoned or taken over by the Khazars. At nearby Bezymyannaya, however, local Chersonesan pottery was in circulation. Fine, red gloss sigillata wares and amphorae had been imported well into the seventh century, but the presence of foreign vessels declined from the late seventh to the

early eleventh century at this important frontier site guarding the approach to Chersonesos. Reflecting local administrative activity, coins were struck at Chersonesos from the time of Justinian I down to the time of Herakleios (610–641). The late sixth and the first half of the seventh century saw the apex of an economic and cultural revival in early medieval Chersonesos. New homes were built, and basilicas and cross-shaped churches became the dominant urban structures. From the fifth to the seventh century, Chersonesos's most important distant trading partners were in Asia Minor and Syria, and to a certain extent in North Africa. Glassmaking and pottery workshops were much in evidence, and the city's craftsmen fashioned buckles and brooches for the local population and nearby barbarians. However, the remark by Pope Martin, in his exile, that little bread was available hints of economic problems.

In the seventh century, a new force appeared in Crimea, the Khazars. After examining the rival religions of their neighbors—Christianity and Islam—these Turkic nomads eventually adopted Judaism as their creed. As nomads based in the southern steppes of present-day Russia and Ukraine, they quickly took control of the peninsula. In its southwestern region the Khazars built fortresses on the plateaus of Mangup-Kale and Kyz-Kermen (Red Fortress). These strongholds were managed by Bulgarians in the service of the Khazar Khanate. As with other invaders, the incoming groups gradually intermingled with the local populations, thus resulting in cultural and ethno-linguistic heterogeneity. The Byzantine-Khazar frontier included mountainous fortresses that dominated the adjoining valleys, as well as coastal areas.

The Khazars' penchant for Byzantine politics was displayed early on, when Justinian II Rhinotmetos was exiled to Chersonesos. The "Slit-Nosed" emperor was so named because his tongue was slit and his nose cut off as a farewell gesture from his erstwhile subjects. Justinian II took up with the Khazars and was offered the king's daughter in matrimony. Wearing a nose of solid gold, as recorded by Agnellus the Chronicler of Ravenna, Justinian II won back his throne in Constantinople and took his revenge on his former enemies. These included the Chersonites, who had conspired with the Khazars to place another man (Philippikos Bardanes) on the throne at Constantinople.

The Khazars permitted Christian worship. Probably sometime during the years 733–746, a list of eight bishoprics in Gothia was compiled. This territory, under Khazar rule, stretched from the hinterland of Chersonesos to the shores of the Caspian Sea. The eight dioceses were administered by the metropolitan bishop of Doros, later Mangup-Kale, which boasts the remains of a substantial sixth-century Byzantine church. Despite such an extended ecclesiastical province, Christianity never took hold with the Khazars, and

Figure 4.6
Conservation of a bowl
from Ottoman territory,
12th–13th centuries,
attesting to the extent of
Chersonesos's trading
partners. From the 2001
joint excavation of the
Preserve, University of
Lecce, and ICA.
(G. Mack)

they eventually embraced Judaism by the mid-ninth century. The early eighth century witnessed a major contraction of the Byzantine Empire in Asia Minor, Greece, and the Aegean, with some scattered outposts remaining in southern Italy and Sicily. Little is known about Chersonesos in the eighth century, but it appears to have been largely independent of the Byzantine Empire.

A major economic revival took place during the eighth or early ninth century. Recent research has shown that Chersonesos continued to be a regional center, with Chersonesan amphorae found along the Don and Dnipro Rivers. Pottery from the main cistern of the city dates to the first half of the ninth century. The finds include four types of commercial amphorae and a striking range of local ceramic vessels, some painted and some with incised decoration, all competently produced and recalling the well-made contemporary pottery from sites as far away as the Crypta Balbi in Rome. Indeed, the striking abundance of Glazed White Ware II vessels from excavations within the city, probably surpassed only by finds from Istanbul, likewise demonstrates that Chersonesos had reentered the sphere of long-distance commerce by the late ninth and early tenth centuries. This class of lead-glazed tableware was probably produced close to Constantinople itself. It is found alongside transport amphorae, some of which, by the eleventh century, clearly came from around the Sea of Marmara.

Trade had expanded to such a scale that by the following century all areas around the Black Sea, as well as various parts of the Aegean and Asia Minor (even as far away as Syria or Egypt), supplied the city with products. Most of the recognizable pieces are pottery, but also included are rhyolite lava querns from the island of Melos for making flour, fragments of silk, and presumably a host of other organic goods lost to the elements. Finds of similar pottery in other parts of Crimea and as far away as Kyiv demonstrate that Chersonesos had revived its role as commercial intermediary.

Medieval Chersonesos: Ninth Century to Mid-Thirteenth Century AD

The four centuries between the establishment of the theme of *Klimata* (a territorial unit under a military commander) and the great fire of the second half of the thirteenth century that destroyed much of the city correspond roughly with the second golden age of Byzantine

culture in Chersonesos. Some scholars divide this span into two exceptional periods—the ninth and the eleventh centuries—instead of one long one. The theme of Klimata, or southwestern Crimea including Gothia and Bosporos, was replaced by a unit called the theme of Cherson in the ninth century. The middle Byzantine period opened with the repeal of iconoclastic laws and closed with the Latin conquest of the capital, Constantinople, in 1204.

Just as Chersonesos was a key entry port in the classical period, the rise of trade between the Byzantine world and the north became a major achievement of the ninth century. Cultural exchange, most significantly of religion, accompanied trade. In the ninth century the city required more defense, and so the new theme was established in 841 based on an earlier unit created by the emperor Herakleios in the seventh century. The theme was ruled by a *strategos*, a military commander. Soldiers were given land, and in return each provided a man, a horse, and weapons when called upon, thus creating simultaneously an inexpensive army and an independent class of farmers. A typical theme consisted of about 3,000–4,000 soldiers, and thirty themes existed at the peak of Byzantine power around the year 1000.

Figure 4.7
Black steatite icon from the 2002 joint excavation of the Preserve, University of Lecce, and ICA.
(C. Williams)

Until the 830s, Chersonesos had been essentially a semi-autonomous center of power. The effect of the new military organization curbed local autonomy but also provided protection against the new power from the north, the Rus' who were centered around Kyiv. Petronas Kamateros participated in building the Khazar fortress of Sarkel and became the first strategos of the theme of Chersonesos after informing the emperor Theophilos (829–842) of the dubious loyalty of the local Chersonesan magistrates. The increasing prosperity was apparent with the reopening of the mint, which struck bronze coins with the marks "Π" (polis) and "X" (Cherson). Such symbols continued in use until the city was occupied by Prince Volodymyr and Kyivan Rus' in the late tenth century.

Trade routes emanating from Chersonesos reached the Dnipro River and extended well into the northern forest. From the Dnipro and down the Dvina and Lovat' Rivers, running more than 2,000 km, there stretched a thoroughfare that linked Constantinople to the Baltic. From the northern reaches a multitude of goods arrived at the shores of the Black Sea, including wood and slaves, honey and wax, furs and amber, all of which were difficult to obtain in Mediterranean areas. The flow of this commerce worked in two ways: it guaranteed the importance of Chersonesos through the first millennium, and it eventually attracted Scandinavians, who were to have a profound effect on later developments in the region.

Map 4.1
Main trade routes across the Black Sea connecting the Mediterranean area with the eastern and northern lands, from the 9th to 15th century. (J. Trelogan after Magocsi, 1985)

One of the most striking indices of trade between north and south is the more than 4,000 pink-slate spindle whorls unearthed at Novgorod. Produced near Kyiv, these items are also a common archaeological find at Chersonesos. By far the largest quantity of goods, however, that moved between Byzantium and the northern peoples was of an organic nature and no longer survives in the archaeological record. For example, historical sources tell of the Pechenegs, a nomadic horde from the East who, through contact with Chersonesos, were able to obtain purple cloth, ribbons, loosely woven cloths, gold brocade, pepper, scarlet or "Parthian leather," and other valuable items in the ninth century. The Rus' also brought slaves down the Dnipro Valley to the Black Sea. Through the Khazars, whose realm stretched to the Caspian Sea, a certain quantity of Islamic items may also have reached the city. The recently discovered bowl from the 2001 joint Preserve-ICA-University of Lecce excavation near the main cistern (Figure 4.6) in the southern residential block shows that contacts with the East continued for centuries.

CRIMEAN CHERSONESOS

During the second half of the ninth century, the Khazars struggled with the Magyars for possession of Crimea, but the latter were eventually pushed out by the Pechenegs, yet another nomadic Turkic group that migrated west from the Eurasian steppe. The interest of Chersonites and others in the northern route was not strictly commercial. A second motive was to reach into the barbarian heartland in order to find ways to subdue or placate potentially menacing peoples, bringing into play both imperial politics and the Eastern church.

The brothers Cyril and Methodios, born in Thessalonike in 827 and 826, left Constantinople for a mission to the north, at the request of the Khazars seeking a Christian teacher. They (or at least certainly Cyril) spent the winter of 860–861 at Chersonesos, where they began to learn the Turkic Khazar tongue. According to different traditions, Cyril reputedly found the bones of St. Clement either in a mound or beneath the sea at low tide. Cyril took the relics to Rome, where Pope Hadrian II deposited them in the church of St. Clement. The brothers later set off for the Khazar lands of the Volga-Don areas and succeeded in effecting many conversions. They eventually abandoned their mission in Khazaria, and the Khazars later converted to Judaism. Their great achievement, however, was yet to come. Having learned the Slavic tongue for a later mission to Moravia in 863, Cyril created a Cyrillic script and, with the help of his brother, translated the Gospels and the necessary liturgical books into Slavonic, thus paving the way for the future development of the Eastern Slavic Orthodox Church.

In the course of the ninth and tenth centuries, a new threat appeared on the northern horizon. Kyiv moved from the Khazars' domain to the Rus', and with 200 ships the Kyivan Rus' laid siege to Constantinople in 860. Although the Rus' and Byzantium were at war five times in the course of the tenth century, they also enjoyed a degree of cooperation. Most notably, Prince Volodymyr of Kyiv gave his support to Basil II (963–1025) against the usurper Nikephoros II Phokas (963–969). In return, Basil II gave his sister, Princess Anna, the daughter of Romanos II (959–963), in matrimony to Volodymyr, who agreed to be baptized. Thus, the first dynastic links were established between the Byzantine Empire and what was to become Russia. Early in 989, Volodymyr sent a fleet to Constantinople with a force of 8,000 Russified Scandinavians, known as Varangians, who afterward formed the emperor's bodyguard. Basil, however, reneged on his promise, because Anna had been "born to the purple" and could not marry a foreigner. Volodymyr seized Chersonesos and offered it as a gift for Anna's hand. The couple was surely married at Chersonesos. Whether Volodymyr was baptized there or in Kyiv is a matter of intense local interest, though, in the wider scope of historical developments, the issue remains largely unimportant.

Kyiv developed alongside Chersonesos as a Christian capital under Volodymyr's son Yaroslav the Wise. The intense religious contacts—the early priests in the Rus' capital probably came from Chersonesos—were paralleled by artistic exchange. A large number of Rus' artifacts dating to the eleventh century have been uncovered in Chersonesos. The Church

Figure 4.8 (top)
Graffito from the western wall of a vaulted cistern excavated in 2002, with the representation of a horseman holding a long spear, ~20 x 30 cm. Excavation of S. Ryzhov and A. Bernadski. (G. Mack)

Figure 4.9 (bottom)
Red clay dish, light yellow glaze, incised with analogous representation of a horseman fighting a serpent. 13th century AD, d 15.2 cm. Belov, 1931. (C. Williams)

Figure 4.10
Decorative bone
medallion with a carved
relief of a lion. 9th–10th
centuries AD, d 6 cm.
From excavations before
1888. (C. Williams)

of the Tithe, or Desyatynnaya Tserkva, probably the royal church, was dedicated in Kyiv in 996. The abundant well-published archaeological evidence from this church includes architectural fragments and wall paintings, which clearly show the strong links with Byzantium. Indeed, some reused classical and early Byzantine carvings were probably obtained from Chersonesos. Even more striking is the impressive cathedral of St. Sophia built by Yaroslav. It still stands and was clearly modeled on Justinian's church of Hagia Sophia at Constantinople, just as the Golden Gate of the Byzantine capital inspired that of Kyiv.

It was probably about the same time that a renewed campaign of church building took place at Chersonesos, rivaling in quantity, if not in quality, the spate of building activity that had taken place there in late antiquity. From the tenth century onward, dozens of small churches were erected, sometimes more than one in each insula block. They were generally unpretentious, single-nave buildings that could accommodate only small congregations, with the remodeled early Christian buildings likely serving as the major urban churches. These minor churches may have been private foundations, erected by families living in the various insulae to satisfy the needs of the parish. They certainly served as burial chapels, and it would be revealing to see if the skeletons found in them belonged to family groups.

Chersonesos took a central role in trade between the Byzantine Empire and barbarians in the northeast by the tenth century. Constantine VII Porphyrogennetos wrote in his treatise *De administrando imperio* (On Governing the Empire): "If the Chersonites do not receive cereals from Amisos, Paphlagonia, and Boukellarioi, and from the slopes of Armeniakon, they cannot exist." The market in the capital received merchandise—leather, honey, wax, fish, and many other goods—through Chersonesos, while Byzantium supplied the north with provisions, materials, and precious items. Hence, under Byzantine protection from the tenth to the twelfth century, both Chersonesos and the empire profited. After the Venetian fleet arrived during the Fourth Crusade and the Latins sacked Constantinople in 1204, Chersonesos came under the sway of another Greek successor state. Trebizond, the former Greek colony of Trapezos on the southern coast of the Black Sea, took the place of Constantinople

Figure 4.11
Fragment of icon of St. Theodore Stratelates. The hand of Christ holding a martyr's crown is also visible. Steatite with traces of gilding. 12th century, w 10 cm. Kostsyushko-Valyuzhinich. (C. Williams)

CRIMEAN CHERSONESOS

as suzerain of Chersonesos and continued in this role even after the restoration of Constantinople in 1261. As the city of Constantine regained some of its former glory, however, Chersonesos was swept by a devastating fire that burned a significant part of its area. This has been established by Ryzhov's excavation of large areas of major residential quarters during the last quarter-century.

Final Years of Chersonesos

Despite the intensive fire damage to the structures of the city, the urban grid was maintained. The main street continued to function as such, as did the minor axes. This fact makes Chersonesos one of the few cities of the ancient world that maintained its classical Greek plan into the late Middle Ages. Naples is another outstanding example.

Southwestern Crimea, including Chersonesos, was invaded again in the second half of the thirteenth century. Most scholars suppose that this was a punitive campaign of Nogay, a Golden Horde general. Already by 1240, Batu Khan, Chinggis Khan's grandson, had conquered Kyiv, cutting off the lucrative north-south trade, as Venetian and Genoese trading interests in the Black Sea expanded. Chersonesos's importance consequently diminished rapidly. The Genoese established a base at Kalamita, 10 km along the harbor from Chersonesos. From the mid-thirteenth century, Chersonesos was still indicated on Italian maps, and in the records of the next century, official representatives of Genoa are mentioned as residents of the city. One more invasion of the Mongols, this time under Khan Edigey, is dated in sources to 1399. We can say that Chersonesos survived until the second half of the fifteenth century. Although documents of the fourteenth and fifteenth centuries mention the city of Chersonesos, it was reduced to a small village of fishermen, occupying a part of the port region on Quarantine Bay.

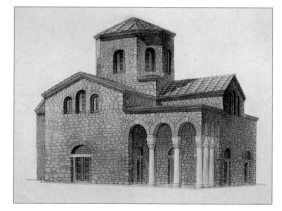

*Figure 4.12
Reconstruction of the
Reliquary Church by
O. I. Dombrovskiy.
(NPTC archives)*

During these turbulent years, Christianity made great advances in the territory of present-day Ukraine. The bishopric of Chersonesos received the rank of metropolis in 1280, lost it, and in 1390 regained it, when the whole southern coastline extending to Soldaia (Sudaq) was placed under the metropolitan, roughly the equivalent of a Catholic diocese, of Chersonesos. Numerous churches and monasteries existed at this time in the territory of Chersonesos and its environs.

The city received a Catholic bishop in the fourteenth century. The epistles of Pope John XXII record that in June 1333 an English Dominican, Ricardus, was appointed as the

Map 4.2
Territory of the
principalities that formed
Kyivan Rus' from the
11th century, showing the
general direction of later
Mongol invasions in the
13th century. (J. Trelogan
after Magocsi, 1985)

bishop of Chersonesos, and the decision was made to build a church in honor of St. Clement in the city. Although the metropolitan of Chersonesos left his bishopric in the late fourteenth century AD, the archbishopric survived into the fifteenth century. Even though abandoned, the city maintained its significance as a center of religion and pilgrimage. In the sixteenth century, written sources claim that "great crowds of people gathered together at the grave of Pope Martin" and that "pious Christian Greeks flocked together in extraordinary numbers to the annual celebration of St. George" at St. George Monastery on the Herakleian Peninsula. According to Dortelli d'Ascoli's *Description of the Black Sea and Tartaria*, a legend was still circulating in the seventeenth century about a chapel built by angels' hands for St. Clement's body. With the arrival of the Ottoman Turks in 1475, however, all this was swept away.

Medieval Chersonesos was a typical Byzantine provincial city for the most part, the multi-ethnic makeup of which was similar to that of the empire itself. Greek was the language of official documents, church liturgy, books, and conversations, as well as communication in daily life. Although the majority of the population was Greek by origin, the Romaioi of Chersonesos were certainly supplemented by other *ethnoi*: Alans, Hebrews, Armenians, Slavs, and Genoese lived side by side with Greek-speaking natives. The city was also densely populated. According to some, its inhabitants from the twelfth to the fourteenth century numbered between 5,000 and 6,000 souls. Constantinople fell to the Turks in 1453, and the Byzantine Empire ceased to exist. Even in its twilight, however, Chersonesos continued to play a role in matters of regional and religious importance.

References

Yakobson 1950, 1959, 1979; Cross and Sherbowitz-Wetzor 1953; Anokhin 1977; Smedley 1978; Sokolova 1983; Firsov 1990; Bogdanova 1991; Rybina 1992; Gertsen 1993; Sedikova 1995; Filippenko 1997; Aybabin 1999; Kazanskiy and Soupault 2002; Sazonov 2002.

Decline to Rediscovery

The Black Sea, a boundary and a unifying influence, conspicuously carved its mark on Crimea and Chersonesos. The Crimean Peninsula reflects both frontier realities and shifting loyalties as host to numerous cultures and outside controlling powers. As Chersonesos waned, imperial machinations from the thirteenth to the eighteenth centuries are primarily responsible for the current political and ethnic situation. During this time, Crimea passed from Byzantium to the Golden Horde and then to the Ottomans, only to be annexed by Catherine the Great in 1783.

The decline of Chersonesos began in the thirteenth century, though the site may not have been abandoned entirely until the mid-fifteenth century. The Mongol incursions into Crimea from 1223 onward probably weakened the city. Its territory thereafter contracted to the immediate area near the port and citadel. Later that century, it was razed, presumably by the steppe nomads, and never recovered its power as a commercial center. Chersonesos and the northern coast of the Black Sea had been a thriving center on the periphery of Mediterranean empires. During the ensuing six

Map 5.1
Beginning in the 13th century, Venetian and especially Genoese traders began to establish routes throughout the Black Sea with the consent of the Golden Horde, and by the 15th century, with the approval of the new regional power, the Ottoman Empire. (J. Trelogan after Magocsi, 1985)

Figure 5.1
Black Sea portulan chart by Portuguese cartographer Diogo Homem, AD 1559. Calomata and Zembalo are noted on the Crimean Peninsula, corresponding to Kalamita and Cembalo. 44.0 x 58.6 cm.
(Bibliothèque Nationale de France, Paris)

hundred years, beginning in the thirteenth century, the entire region was incorporated into a succession of Mongol-Turkic states and Eastern empires. Crimea in the Middle Ages witnessed an intriguing succession of influential entities: Judaic Khazaria, Moslem khanate, Catholic Genoa, and the Orthodox powers of Byzantium, Kyivan Rus', the Grand Duchy of Muscovy, and the Theodoro principality.

The demise of the city obviously coincided with the weakening of the Byzantine Empire. One of the great cultural achievements of Byzantium was the conversion of the Slavs to Christianity. Indeed, Crimea and Chersonesos played key roles as mediators between Constantinople and Kyivan Rus' (ninth to thirteenth centuries), the historical predecessor to the modern states of Belarus, Russia, and Ukraine. Batu Khan, grandson of Chinggis Khan, established the westernmost khanate of the Mongol Empire, the Golden Horde, in the mid-thirteenth century, which included all of Crimea. Early in the fourteenth century, the Golden Horde adopted Islam as its official religion and introduced new cultural and religious traditions to the peninsula.

After gaining control of the Silk Road, the Mongols hoped to revive its profitability. They encouraged Italian merchants from Genoa and Venice, already enriched from the Crusades, to trade along the Black Sea coastal towns, with the additional blessings of Byzantium. From the thirteenth to the fifteenth centuries, the Genoese built forts and founded prosperous commercial settlements on the Crimean coast at Caffa (Feodosiya), Soldaia (Sudaq), and Cembalo (Balaklava). Although Chersonesos was essentially reduced to a fishing village by this time, a statute in 1449 mentions the Genoese consul of Gorzona (Cherson), and the city still hosted Genoese traders, as revealed by portulan charts of the Black Sea. In addition to transporting silk, gunpowder, paper, and compasses from China, Genoese traders also became infamously associated with the spread of the Black Death from Asia to Europe in the fourteenth century via the ports of Caffa and Tana.

The Theodoro principality arose by the mid-fourteenth century and ruled southwestern Crimea from its mountainous plateau capital at Mangup-Kale. This Christian kingdom ruled over the remnants of Crimean Gothia, composed of Germanic tribes in the highlands of the peninsula who had migrated from northern Europe as early as the third century AD. Encircling Theodoro was the Khanate of Crimea, a splinter province of the Golden Horde, founded in 1443 by the Giray dynasty. The relations among the Crimean Khanate, the Genoese settlements, and the Theodoro principality at times resulted in hostilities. With control of Crimea thoroughly under the khanate, the Genoese ceased the formal homage to the Golden Horde, yet still battled Theodoro to keep coastal Gothia and Cembalo.

The dynamics of the Black Sea region changed significantly in 1453. Ottoman Turks captured Constantinople, and by 1475 they had conquered Crimea and secured the loyalty of the Crimean Tatar Khanate. The Crimean steppe and the coastal seaports were now

Map 5.2
Confluence of regional powers of the 16th and 17th centuries reaching toward Crimea in the form of the Polish-Lithuanian Commonwealth, Tsardom of Muscovy, and Ottoman Empire. (J. Trelogan after Magocsi, 1985)

united under Ottoman hegemony. By the late eighteenth century, a series of wars against European powers—particularly Venice, Austria, and Russia—greatly weakened the Ottoman state, and Russia emerged as a major power under Catherine the Great. Long forgotten as the birthplace of Slavic Orthodoxy, Chersonesos was now owned by the tsars, which paved the way for rediscovery, reevaluation, and revival of the ancient site.

References

Fisher 1978; Magocsi and Matthews 1985; Ratchnevskiy 1991; Ascherson 1996; Epstein 1996; Magocsi 1996; Christian 1998.

Modern Crimea

Chersonesos—according to *The Primary Chronicle,* a twelfth-century history of Kyivan Rus'—is the birthplace of Eastern Slavonic Christianity, the site of the transforming conversion of Prince Volodymyr in 989. To Slavs, Chersonesos and other Greek cities of the northern Black Sea not only represented a bond with Byzantine Christianity but also came to be seen as a direct link to Hellenic culture.

Field Marshal Grigoriy Potemkin, Catherine the Great's lover and newly appointed governor of Crimea, hinting of the symbolic significance of Chersonesos in a letter to her, argues that annexation of the peninsula would bring the empire tranquillity and adds earnestly, "Russia needs a paradise. Tauric Kherson!"—referring to Crimea as a whole. The military and political advantages, though unstated in his argument, could not be ignored. In 1783, Catherine abolished the Crimean Khanate and annexed its territory. These events precipitated a massive redistribution of the population.

The Tatar town of Aqmesjit, renamed Simferopol, was made a regional center. In line with Catherine's "Greek Project," other cities in the southern part of the empire acquired a Hellenic designation, e.g., Odesa, Feodosiya, Yevpatoriya, and Nikopol'. The city-fortress of Sevastopol became the main military port of the Black Sea Fleet in 1804, built between the main bay and the ruins of Chersonesos. The city was designated as a special administrative unit, leading to its rapid growth and development.

The Crimean War (1853–1856) had its origins in the recurring conflicts between the Russian and Ottoman courts. Sevastopol and southwestern Crimea became key theaters in the war because the British, French, and Ottoman powers

*Figure 6.1
Early Russian map of the ruins of Chersonesos from 1786. Drawn three years after Crimean annex-ation, it shows Greek roads dividing the chora into farm plots, still clearly visible in the 18th century. (NPTC archives)*

had the opportunity to destroy Russia's naval power in the Mediterranean and Black Seas with relatively little risk to their troops. The lack of a railroad link between Sevastopol and the Russian Empire meant that the Russians' key southern naval base would be easy to isolate and vulnerable to attack by sea-based Anglo-French forces.

The French and the British landed to the north of Sevastopol in September 1854 and defeated the Russian army in the field before beginning the siege of Sevastopol. The siege lasted for 349 days. Despite vigorous Russian attempts to break the siege from the outside and the stubborn resistance from within Sevastopol led by General Totleben, French armies finally succeeded in storming the key defenses in September 1855. Combined with the accession of a new tsar, the fall of Sevastopol effectively ended the Crimean War.

The Crimean War produced other significant historic consequences. It is considered the first war to be covered by news correspondents and photographers—notably Thomas Chenery, William Howard Russell, James Robertson, and Roger Fenton—who brought home the horrors of combat in word and image. Lev Tolstoy, then a young officer in the city's defense, also exposed the harsher side of war, the bravery of the foot soldier, and the arrogance of commanders in his acclaimed *Sevastopol Stories*. The plight of the wounded troops inspired the legendary work of Florence Nightingale and her nurse brigade. Her contribution laid the foundations for the modern nursing profession and influenced the founding of the International Red Cross. Flamboyant chef Alexis Soyer introduced cooking equipment and techniques to the British army that changed field cooking for future armies. Alfred Lord Tennyson further etched Crimea into world consciousness with his memorializing poem, *The Charge of the Light Brigade*.

Crimea suffered tremendously as a result of the war. Sevastopol had been badly damaged and its military importance much reduced. The economy was in a shambles. In spite of the tumultuous events, the United States initiated ties to Sevastopol. Even during the war, more than forty young American doctors volunteered for service on the Russian side during the siege. Many ships of the Black Sea Fleet had been destroyed, deliberately scuttled by Admiral Nakhimov, to prevent allied entrance to the harbor. In the 1860s, a U.S. firm from Boston dredged the harbor to make it freely accessible again. Shortly thereafter, Mark Twain remarked on Sevastopol in his travel account *Innocents Abroad:* "We have been in no country yet where we have been so kindly received." The tsars and the nobility constructed palaces along the spectacularly beautiful Crimean coast, particularly around Yalta. Resorts followed, and the area became a haven for aristocrats and artists, spurring a nascent tourism industry.

Having Islam and a Turkic language in common, more than 180,000 Crimean Tatars fled to modern-day Turkey as a result of the war; others were resettled in Russia proper. Tatars composed more than 80 percent of the population of Crimea at the time of annexation in 1783. The numbers of Russian and Ukrainian settlers increased considerably after 1861. Other colonists were lured to Crimea with land and tax incentives, among them Germans, Jews, Bulgarians, Greeks, Poles, Belarusians, Armenians, Moldovans, Balts, and Czechs.

Figure 6.2
Color print by historical Victorian artist William Simpson during the Crimean War, made as part of his Seat of War in the East *series. Kruse Basilica is visible in the foreground, corresponding to the left-wing French battery looking toward the Russian battery. In the distance is Sevastopol Harbor, and on the far side at the entrance to the bay is Fort Constantine, 1855. (NPTC archives)*

The situation in Crimea after the Russian revolution was nothing short of anarchy. Control of Sevastopol changed hands six times in a span of three years. The Socialist Soviet Republic of Taurida was established for all of Crimea in 1918, only to fall to the German army a few months later. After the Bolsheviks rid the peninsula of Germans and the White Army by 1920, Lenin's younger brother, Dmitriy Ul'yanov, was put in charge of the republic. The new power distinguished itself with extreme cruelty that included executions of the local elite. In a nod to rising national sentiment among Crimean Tatars, Moscow declared Crimea an autonomous region within the Russian Federation in 1921. Still, countless lives were lost in the continuing Red Terror. Clumsy politics and economics, together with droughts in 1921–1923, resulted in unprecedented starvation and the deaths of almost 100,000 people, with Crimean Tatars constituting 75 percent of the casualties.

Figure 6.3
Balaklava Harbor, the
base of British forces
during the Crimean War,
photographed by Roger
Fenton, 1855. Horses are
at the landing place on
the cattle pier, with
several ships at dock. Bell
tents are seen at the
water's edge, with the
hilly landscape in the
background.
(Gernsheim Collection,
Harry Ransom Humanities
Research Center, The
University of Texas at
Austin)

Two hundred years of Russian control over Crimea, however, was not all devastation and despair. The city of Sevastopol flourished as the base of the fleet and as a ship repair center. The economy greatly improved in the nineteenth century, mainly on the strength of agriculture and the food industry—notably the exports of commercial cereals. Large tobacco factories were established in Feodosiya and Kerch to match their regional cultivation of tobacco. Viticulture and winemaking, introduced by the Greeks more than two millennia earlier, again achieved prominence. Taurida National University was established in Simferopol in 1918.

Only a couple of generations removed from the calamities of World War I, revolution, and civil war, life in Crimea was again turned on its head in the mid-twentieth century. When Nazi troops entered Crimea in 1941, Sevastopol's defenses had been completely rebuilt and modernized. A hasty enemy assault on the city in December 1941 was repulsed by the defenders, who began the second heroic defense, which lasted 247 days. Although Sevastopol remained cut off from the remainder of the USSR by land, sea routes remained open and active throughout the following winter and spring.

Having defeated the Soviet armies in the field in the spring of 1942, the Germans renewed their siege. Reinforced by air and heavy artillery, they began a systematic assault on the outer defenses of Sevastopol in June 1942. After a month of fierce combat and a disruption in sea supplies, the German infantry occupied a ruined and burning city in early July. Local resistance had been truly heroic—the German victory was nearly Pyrrhic. The Soviet liberation of Sevastopol in May 1944 was swift. Only a few days were required to wrest the city from the already defeated Nazis. In contrast to its devastated state after the Crimean War, Sevastopol and its defenses were quickly rebuilt after World War II, and the city remains a naval base today, partitioned in 1997 between the Russian and the Ukrainian navies.

In 1945, while fighting still raged elsewhere, the victors Stalin, Churchill, and Roosevelt met in the Livadia Palace, the ultramodern villa of Tsar Nicholas II, for the Yalta Conference. Immediately after the war, Crimean autonomy was revoked, and three years

later Sevastopol again became a special administrative and economic unit. In the postwar years, agriculture and light industry, building and transport, and resort and tourist spheres of the economy recovered. Soviet premier Nikita Khrushchev then transferred Crimea to the Ukrainian Soviet Socialist Republic in 1954 to commemorate roughly 300 years of the united history of Ukraine and Russia.

From the eighteenth to the twentieth century, the peninsula was Russia's playground, visited by the wealthy and the famous—Russian tsars, writers, and artists, including Pushkin, Gogol, Chekhov, and Mendeleyev. Known for its natural splendor, Crimea became the preferred near-tropical destination for Russia, with its extensive system of spas and sanatoria. The calming winds, steady sun, and healing waters of Crimea have lured the aristocracy, dedicated laborers, and, later, the nouveau riche of post-communism. As in imperialist Russian days, Soviet leaders retreated from the harsher climes to Crimea. World history again visited Crimea in 1991 with the August putsch. President Mikhail Gorbachev was placed under house arrest in the southern coastal resort of Foros while on summer vacation.

Though still considered a natural paradise, Crimea today faces an uncertain future, due in no small part to the political, religious, and historical forces that formed it. The defeat of Nazi Germany coincided with the forceful deportation of Crimean Tatars, Crimean Germans, Bulgarians, Pontic Greeks, and others to Soviet Central Asia. About a quarter-million Crimean Tatars, who by this time had been reduced to roughly 20 percent of the population, were accused of collaboration with the enemy and then packed aboard east-bound trains. Since 1989, exiled Crimean Tatars have been allowed to return from Central

Figure 6.4 (above left) Victorious Soviet tank on Lenin Street, May 9, 1944, after the recapture of Sevastopol from the Nazis. (F. Khaldey, from photo-archives of Museum of the Historic Defense and Liberation of Sevastopol)

Figure 6.5 (above) Lenin Street, approximately at the same location as in Figure 6.4, taken nearly sixty years later. (G. Mack)

Figure 6.6
Pristine waters of
southern Crimean coast at
Fiolent. (C. Williams)

Asia to the peninsula. Under the tireless direction of Mustafa Jemiloglu, the leading Crimean Tatar political party restored the Mejlis, a plenipotentiary body voicing Crimean Tatars' concerns to the Verkhovna Rada in Simferopol and Kyiv.

Ukraine became an independent country in 1991, triggering national aspirations on every front. Questions of ethnicity, language, and culture were difficult to reconcile, especially after decades, if not centuries, of the state-directed nationalities' policies of the Russian Empire and of the Soviet Union. The 2001 census results show Crimea as 59 percent "ethnically" Russian, 24 percent Ukrainian, and 12 percent Crimean Tatar. Native Russian-speakers decreased from 89 percent in 1989 to 77 percent by 2001. Meanwhile, 11 percent now consider Crimean Tatar as their native language, and another 10 percent speak Ukrainian as a mother tongue. This three-way pull of demography has become the principal political issue in Crimea. The 1990s were particularly turbulent after the pro-Russian government of Crimea declared independence from Ukraine. Demands, demonstrations, and even violence were commonplace. By 1996, however, level heads prevailed, and a power-sharing arrangement was reached between Kyiv and Simferopol under the laws of Ukraine.

The current constitution of Ukraine, adopted in 1996, guarantees Crimean autonomy, allowing for a regional constitution and legislative body, the Verkhovna Rada. It also reaffirms the special status of Sevastopol as a city of central jurisdiction within Ukraine. The mayor of Sevastopol is appointed by the president of Ukraine. Among the newly acquired symbols of autonomy, the Crimean state emblem contains the Greek mythological griffin. The power of historical perception is recalled in the sweeping declaration that Potemkin made 200 years earlier: "Tauric Kherson [is] the origin of our Christianity and hence our humanity." Fifty years later, Aleksandr Pushkin, the universally admired Russian Romantic poet, evoked Crimea's enduring and mysterious charm: "As I gaze at the distant shore, a noonday view of a faraway magical land; with excitement and yearning I strive to go there, full of enchanted memories." Those memories remain in the many archaeological and architectural monuments, natural sights, and historical museums that will continue to lure visitors, worldwide, to Crimea in increasing numbers.

References

Drohobycky 1995; Magocsi 1996; Zarubin and Zarubin 1997; Allworth 1998; Schönle 2001.

From Warehouse to National Preserve

From the moment the Russian Navy entered Aqyar Bay in 1783 and "discovered" Chersonesos, the fate of the ruins took a dual course. Some visitors came to observe, to describe, and to draw the monuments, while others removed tons of stone to build the houses and fortifications of Sevastopol. As the Swiss scholar Frédéric Dubois de Montpéreux bitterly exclaimed in 1832, "The first day of Sevastopol became the last day of Chersonesos." Fortunately, this dire assessment proved untrue.

Admiral Aleksey Greyg, commander of the Black Sea Fleet from 1816 to 1833, is credited with the origins of archaeological excavations in Chersonesos. He yearned to erect a monument to Prince Volodymyr in Chersonesos and appointed naval engineer Karl Kruse to locate the very church where Volodymyr was reputedly

baptized. In 1827, Kruse discovered the ruins of three churches. St. Volodymyr's Church, built on the site of one of the churches, was consecrated in 1888 to mark the 900th anniversary of the coming of Christianity to Kyivan Rus'. The ancient church had occupied the highest point on the peninsula and its remnants are now on display on the ground floor of St. Volodymyr's Church. The second church is called Kruse Basilica in honor of the man who located it, and the third ancient church has yet to be definitively rediscovered.

From the beginning, the archaeology of Chersonesos was beholden to three main forces—religion, science, and the military. As in the rest of nineteenth-century Europe, antiquarians, treasure hunters, explorers, and well-intended gentlemen

Figure 7.1
Beginning in 1888, excavations at Chersonesos were administered by the Imperial Archaeological Commission, as indicated by the sign above the entrance. Kostsyushko-Valyuzhinich created the Warehouse of Local Antiquities in 1892 to house the numerous classical and medieval artifacts unearthed at the site. Many fine pieces, including large mosaics, were also sent to St. Petersburg and to other regional museums. (NPTC archives)

Figure 7.2
Photograph from the 1890s of a portion of the exhibit inside the Warehouse of Local Antiquities. The quantity of excavated artifacts soon overwhelmed the available space. (NPTC archives)

Figure 7.3
Karl Kazimirovich Kostsyushko-Valyuzhinich from late 19th century. The Museum began photographing excavations and artifacts as early as 1888 and still maintains a collection of more than 10,000 glass-plate negatives. (NPTC archives)

collected rare and curious objects for display in courtly collections or private residences. Imperial expansion to the Black Sea shores led to a dramatic shift from the search for collectibles to a full-blown pursuit of Slavic cultural heritage. Slavs generally consider Chersonesos the conduit and cradle of cultural and spiritual life from Byzantium. The excavations of the Christian churches of Chersonesos naturally attracted attention from the Russian Orthodox Church. A small monastery with a "museum of finds" was established on the territory of the ancient city in 1852. Excavations of antiquities in southern Ukraine and Russia had a significant impact on the development of Slavic archaeology. The Imperial Archaeological Commission in St. Petersburg, the Odesa Society of History and Antiquities, and the Moscow Archaeological Society (MAS) joined the investigations of Chersonesos. Count Aleksey Sergeyevich Uvarov, the founder of MAS, was also searching for the site of Volodymyr's legendary baptism in Chersonesos. He began investigations in 1853 on the largest basilica, which was also subsequently named after him. Given the magnificence of the finds, the budget for excavations in Chersonesos became the largest in the Russian Empire by 1902. For two centuries, aristocrats and scholars refined their scientific methods at this and other Black Sea sites, and several generations of archaeologists began their scholarly work on ancient Greek and medieval civilizations in Chersonesos. An examination of the history of the Chersonesos Museum also provides a valuable case study of the development of archaeology in the Russian, Soviet, and post-Soviet eras.

In 1888, the vice-chair of the Bank of Sevastopol Karl Kazimirovich Kostsyushko-Valyuzhinich was appointed the head of the excavations in Chersonesos. Historians of

Chersonesos excavations canonize this talented self-taught gentleman for his painstaking work and steadfast dedication to the site. His heroic work was rewarded with extraordinary finds, among which are included churches with magnificent mosaic floors; inscriptions, including the famous Civic Oath of Chersonesos; vaults with burial treasures; and amphorae, fine pottery, and classical sculpture. His selfless efforts revealed the outline of streets and houses, churches and temples, and walls and towers. The monuments became accessible to the public. Thus Chersonesos became the "Russian Pompeii."

In 1892 Kostsyushko organized the Warehouse of Local Antiquities, which became the prototype of the current Museum. Hurriedly constructing a few simple buildings on the shore of Quarantine Bay, he arranged a two-part exposition of the classical and medieval periods. Larger finds were displayed in the courtyard, including a reconstructed Christian basilica.

After Kostsyushko suddenly died in 1907, his successor Robert Löper excavated the areas around the main street and in the western part of the Ancient City, and continued work on the defensive walls and necropoleis. Löper also organized reconnaissance excavations in the area surrounding Sevastopol, in Laspi, Bel'bek, and Mangup-Kale. The guidebook of 1911 claims that tens of thousands of tourists visited the Museum of Chersonesos annually. Boats moored at its wharf and vehicles arrived from Sevastopol on a good roadway.

Wars and revolution interrupted excavations of the ancient monuments on several occasions. To prepare Sevastopol for World War I, the Museum closed its doors in 1914 and later evacuated its artifacts to the University of Kharkiv. L. A. Moiseyev, the director from 1915 to 1920, was given the task of protecting the site from vandals. Soviet power had abolished the working monastery of Chersonesos; its buildings were assigned first to serve as a concentration camp for the "counterrevolutionary elements," and then they were divided between a geriatrics infirmary and the Seventh Riflemen Regiment of the Kazan Division of the Red Army. While the invalids burned fenceposts to "warm their tea" and the soldiers chopped their meat on ancient marble fragments, everyone used the excavated Byzantine churches as trash dumps. Only in 1924 did Moiseyev win the transfer of the entire monastic estate to the jurisdiction of the Museum.

Perhaps in a continuation of the anti-intelligentsia furore of the revolution, Moiseyev's enemies falsely accused him of stealing artifacts, so that he was arrested and discharged from

Figure 7.4
St. Volodymyr's Church, consecrated in 1888 to mark 900 years of Christianity in Slavic lands. According to religious lore, the church was built over a basilica where Kyivan Rus' prince Volodymyr was allegedly baptized in AD 988/989. The main entrance to the church is at the right in this 1900 photograph of a view from the northwest. (NPTC archives)

Figure 7.5
General view of the
Chersonesos monastery
from the southwest in
1902–1904. In the
foreground, an arched
sign atop the Ancient
City walls leads to the
Warehouse of Local
Antiquities. To the left is
lodging for monastery
visitors, and surrounding
the territory are 19th-
century white walls.
From left to right in the
background stand the
Church of the Seven
Cherson Martyred
Priests, with its
belltower; the
archimandrite's (abbot's)
church; a temporary
belltower; and St.
Volodymyr's Church.
(NPTC archives)

Figure 7.6
Excavation team with
the Museum director
Löper, photographed in
the central territory of
Chersonesos, October
1911. (NPTC archives)

all his archaeological work. The "new" Museum was entrusted to the pragmatic Konstantin Grinevich. He established two new permanent exhibitions, issued scholarly works, and organized research and excursions. Grinevich recommended the archaeological excavations. In 1925–1926, the Museum systematized the artifacts in storage with catalogs and inventories and created a lapidarium for the epigraphic monuments. The Museum attracted numerous visitors and new employees, while students actively participated in the excavations. Grinevich continued excavations of Greek and other sites on the Herakleian Peninsula to explain the rural economy in the ancient period. From 1926 onward, the Museum issued *Khersonesskiy sbornik* (*Chersonesan Collected Articles*) and other monographs about its excavations and the history of Chersonesos, as well as museum guidebooks. The centenary of the excavations was celebrated in 1927 by the second USSR archaeological conference, hosted by Chersonesos. The results greatly influenced the scholarly studies of the Museum and other Crimean archaeological institutions. The conference summed up the results of the studies in the ancient Greek and Roman cultures in the territory of the southern USSR and planned further systematic research. The Chersonesos Museum gradually developed from a "warehouse" to an important center of scholarly research, education, and culture.

In 1931 the next director of the museum, G. D. Belov, began to organize annual excavations in the northern part of the ancient city, with particular attention given to

the medieval monuments. He obtained notable results—the limits and dimensions of the city during different periods of construction became clear, the grid of the ancient city emerged, and the changes in building types and construction technologies were analyzed. One of his most outstanding achievements was an explanation of the complex stratigraphy of Chersonesos. In 1954 the portrait of classical Chersonesos was considerably broadened when O. I. Dombrovskiy discovered the remains of a Greek theater.

World War II again interrupted the work of the Museum. From the first days of the war, Sevastopol suffered massive Nazi air attacks, and the most important exhibits, library holdings, photograph collections, and Museum archives were evacuated to the city of Sverdlovsk (Ekaterinburg) in the Ural Mountains. Stanislav Strzheletskiy, then a research assistant, escorted the collection. This led to close contacts between the Museum and Sverdlovsk University. During the occupation of Sevastopol, the Museum of Chersonesos nominally continued operations under Alexandr Takhtay. In 1949, he was unjustly accused of being a collaborator, arrested, and then sent to prison camp for a decade. Takhtay never returned to Chersonesos.

The Nazi occupation inflicted extraordinary damage on both the Museum and the monuments of Chersonesos. The Germans transformed the whole territory of the archaeological preserve into a fortified area and littered it with countless trenches, dugouts, and bomb shelters. Ancient buildings were reused for machine-gun and antiaircraft positions. Explosions damaged the ancient and medieval departments of the Museum and demolished dwellings and other buildings.

The Soviet army liberated Sevastopol on May 9, 1944, and later that year the collection was returned from Sverdlovsk. The Museum quickly restored the galleries and reorganized the storage area to be used for finds. In 1945, it created a new exhibit in a single gallery. The postwar years were consumed with repairs of the Museum buildings and consolidation of the damaged archaeological monuments. A detailed exhibition of the artifacts of the ancient and medieval departments, housed in two large halls where the galleries currently reside, was completed in 1952.

Figure 7.7
During a visit in 1902, Tsar Nicholas II exits a vault dating from 2nd century AD. The handwritten note below reads "Do not publish or sell," because it shows His Majesty in a compromised position of bowing. (NPTC archives)

*Figure 7.8
View of St. Volodymyr's
Church, with the exposed
ancient and Byzantine
ruins in foreground,
1913. (NPTC archives)*

Museum Timeline

1783 Crimea annexed
1787 Catherine the Great
 visits Sevastopol
1825 Alexander I visits
 Ancient City
1827 First excavation
1853 Count Uvarov's
 excavations
1853–1856 Crimean War
1861 Alexander II visits
1861–1892 Construction
 of St. Volodymyr's
 Church
1886 Alexander III visits
1888–1907 Kostsyushko-
 Valyuzhinich as director
1892 Warehouse of Local
 Antiquities
1902 Nicholas II visits
1907–1914 Löper
1914 Evacuation of
 Museum to Kharkiv
1914–1924 Moiseyev
1925–1928 Grinevich
1925 Exhibits move to
 current location
1931–1941 Belov
1942 Evacuation of
 Museum to Sverdlovsk
1941–1949 Takhtay
1955–1985 Antonova
1978 National Preserve
1992 ICA joint projects
1994 Under Ukrainian
 Ministry of Culture

From 1945, Strzheletskiy supervised the systematic research on the *kleroi* (plots of land) of the Herakleian Peninsula, and from 1950 onward, he headed the annual excavations in the chora. Strzheletskiy's large monographic study on the kleroi of Tauric Chersonesos summed up the results of the long-term studies in the Herakleian Peninsula and analyzed the types of agriculture and forms of landed property in Chersonesos during the Greek and Roman periods.

The Museum staff published a large number of works in academic periodicals. In 1948, the State Hermitage Museum in Leningrad (St. Petersburg) published *Khersones Tavricheskiy (Tauric Chersonesos)*, a monograph by Belov that contained a detailed description of the economy and culture of Chersonesos in the classical period. A. L. Yakobson's survey, *Srednevekovyy Khersones XII–XIV vv. (Medieval Chersonesos in the 12th–14th Centuries)*, is still considered a seminal history of Chersonesos in the late medieval period. The appropriations granted to the Museum for providing scholarly research and restoration works steadily increased from year to year.

A particularly flourishing period of the Museum was the tenure of Inna Antonova. Director from 1955 to 1985, she was more than simply an administrator of a museum—she became its builder and student, its protector and promoter. Antonova and her staff supervised the reconstruction of buildings demolished in the war, the redesign of the ancient and medieval galleries, the revival of *Khersonesskiy sbornik,* the introduction of *Soobshcheniya Khersonesskogo muzeya* (Reports of Chersonesos Museum), and the redesignation of the Museum as a National Preserve in 1978. Antonova also created a first-class restoration department with highly qualified specialists and made enormous contributions in the study of the defensive walls and fortifications.

Chersonesos attracted many famous scholars during Antonova's tenure, earning a reputation as a practical study center for scientists and students of history, classical philology, and even geophysics. Chersonesos continued to increase the number of its archaeological expeditions and fostered ties with institutions of higher learning and scholarly organizations, as well as attracting ever-growing numbers of tourists. This trend of cooperation continues under an independent Ukraine, which is breaking away from nearly a century of scholarly research that had been complicated and isolated by language barriers and state-imposed censorship. Since 1992, scholars and students from the United States, Russia, Poland, and many other countries have worked at Chersonesos, on joint projects with the Preserve staff. Much of this research, the preservation of irreplaceable archives, and the construction of new facilities has been possible through the extraordinary generosity of the Packard Humanities Institute. The current director, Leonid Marchenko, believes that the Preserve has entered a very promising new era.

Figure 7.9
Excavation of a 12th- to 14th-century church in the northern part of the Ancient City, viewed from the southwest, 1932. (NPTC archives)

Figure 7.10
Inna Antonova, director of Chersonesos Museum from 1955 to 1985, contributed significant work on the citadel and defensive structures. (C. Williams)

References
Grinevich 1927; Antonova 1959, 1997; Formozov 1986; Grinenko 2000; Tunkina 2001.

MAP OF MONUMENTS
NATIONAL PRESERVE OF TAURIC CHERSONESOS

N

0 10 30 50m

Items are classified in their estimated period of origination.

GREEK:

A. City Gates
B. Vault 1012
C. Tower of Zeno
D. "Barracks"
E. Agora
F. Main Street
G. Theater
H. Mint
I. Sacred Area (Temenos)
J. House of 4th-3rd c. BC
K. House with Mosaic floor
L. Paint Maker's Workshop
M. Potters' Quarters

ROMAN:

N. Citadel
O. Vaults 1013 & 1014
P. House with a Winery
Q. Fishmonger's House
R. Water Reservoir
S. Thermae (Baths)

BYZANTINE:

T. Uvarov Basilica
U. Basilica within a Basilica
V. 1935 Basilica
W. Western Basilica
X. Kruse Basilica
Y. Reliquary Church
Z. Cave Church
AA. Western Gates
BB. 1932 Basilica
CC. Arcosolia Church
DD. Church above the Vaulting

MODERN:

EE. St. Volodymyr's Church
FF. Historic Bell
GG. Greek and Roman Gallerie
HH. Byzantine Galleries
II. Packard Research Lab
JJ. Paustovskiy Dacha

Ancient City Monuments

The center of the ancient city of Chersonesos was located on a rather small peninsula on the west side of Quarantine Bay, the next bay to the west of the immense multiple bays of the harbor of modern Sevastopol, the finest deep-water port on the Black Sea.

Why did the Greeks choose the smaller harbor? Clearly, it was adequate and suited their requirements, and the city site, surrounded on three sides by water, was more easily defended. Artifacts and monuments of the Greek period (late sixth century BC) to the late medieval period (fifteenth century AD) document its history of nearly two millennia. During this period, its area expanded from about 10 to 26 hectares (25 to 65 acres), enclosed by defensive walls. Each successive phase of the city remodeled and reused, covered over, or obliterated its predecessors. Still, there are numerous monuments from all periods. Especially well represented is the late Byzantine city of the thirteenth century AD. The Greek theater (third century BC) was partially covered by a Christian church of the sixth century AD, but both structures are completely recognizable, and their original appearance is clear. There is good reason to believe that the Main Street of the Byzantine city and many lesser ones overlie the street grid of the

Figure 8.1 (above) Southeastern section of the defensive walls in the early 1900s, with handwritten notes by Kostsyushko-Valyuzhinich: Byzantine Gate (2), vaulted tombs (4–6), curtains 16–17 and 19, and Tower of Zeno (7). (NPTC archives)

Map 8.1 (opposite) Location of major city monuments that are mentioned within this book. (J. Lane)

Figure 8.2
Excavated foundations
nestled between the sea
and St. Volodymyr's
Church on the territory of
the National Preserve,
with the citadel and
Quarantine Bay in the
background.
(A. Sobotkova)

Greek city of the fourth century BC. A similar pattern of modification—an adaptive reuse of earlier Greek structures—is apparent also in the chora. Here, as nowhere else, it is possible to trace the interaction of a city and its surrounding agricultural territory for an amazingly long period that covers much of the ancient and medieval epochs.

Many structures of all phases are preserved to impressive heights—for example, the city walls (more than 15 m high at some points) and the Greek mint, the only complete example of this type of structure to survive from the Greek ancient world. The greatest damage to the architectural monuments was not caused by the great fire of the thirteenth century that destroyed up to half of the city, nor by the barbarian invasions of the late medieval period. Many ancient structures were obliterated by the construction of St. Volodymyr's Church and the related monastery buildings, built in the mid-nineteenth century. Since 1920 the former monastery buildings have housed the offices, storage, and laboratories of the Preserve. Large parts of the agora and the acropolis of the ancient city were cleared and used as building material for these structures. Yet they, too, are a significant part of the charm and beauty of this unique site and are now in the process of being creatively restored and transformed into modern research facilities. More than two-thirds of the area of the ancient and medieval city remains unexcavated and virtually intact.

Major Monuments of Chersonesos

Defensive Walls—Southeastern Fortifications

The southeastern part of the city is washed by the sea from the east at Quarantine Bay. Its gently sloping coast is convenient for beaching ships. The most ancient Greek settlement was probably established here, and a century later, this area was built up with city blocks and subsequently with harbor structures. By the late fourth to the early third century BC powerful defensive walls were already necessary to protect the residential and public structures of this quarter, which had the lowest elevation in the city.

The southeastern defensive line includes one of the most ancient and best preserved sections of wall in Chersonesos. Different building techniques provide dating evidence for the defensive walls and adjacent structures. For convenience, the original numbering of the towers and "curtains" (straight sections of the wall) is still used by scholars (p. 94). The walls and towers were made of large, carefully trimmed limestone blocks up to 2 m long, and look unassailable even now, after they have lost half of their original height. A cursory examination of the walls' construction quickly reveals that they represent many phases and building styles. The lower course of the masonry was constructed of rusticated blocks, typical of Greek defensive walls of the fourth century BC.

The ancient defensive line between the sixteenth and eighteenth curtains was excavated by Kostsyushko-Valyuzhinich in 1895–1905. Three distinct, superimposed levels of Greek, Roman, and Byzantine masonry can be seen along the walls. The lower level, dating from the late fourth to the early third century BC, has the marks of the masons in Greek characters on the untrimmed upper sides of the slabs. The first course can be seen at the curtain walls 16–18 and consists of "stretchers and headers" (alternating long, flat sides of blocks and narrow ends in the same course). This simple yet accurate technique, without limestone mortar, gives the structure a formidable look, enhancing the defensive capability of the city, and reinforces it. Examples of similar masonry are found in walls of poleis throughout the Greek world. In Pergamon, Priene, Assos—Greek cities on the Asia Minor coast—and the adjacent island of Samos there are relatively close

*Figure 8.3
Southeastern part of the defensive wall, including the 16th curtain and tower XV. (C. Williams)*

Figures 8.4 and 8.5 Detail of masonry work in the 16th curtain. The five lower rows are from the Greek period, the next five rows are Roman, and above that are Byzantine-era additions. Drawing by G. Asmyakov, 1927. (NPTC archives)

examples. Elsewhere in Chersonesos, this technique was used in the walls of the "barracks," the House of the Fourth–Third Centuries BC, and the mint.

The second level of the walls, consisting of the masonry of the early Roman period, can be distinguished easily by its technique and size. It has survived only partially. The masonry is not as regularly laid out as in the Greek level, and individual slabs are not dressed with recessed edges. It has a rougher, less careful look and consists of rows of big limestone slabs laid without mortar. It is contemporary with the attached crypts Nos. 1013 and 1014, near the well-preserved ancient gate (Figure 8.9). The masonry of the Byzantine period is very different from the previous two masonry types in the method of bonding the stones. Extensive use was made of mortar. The three levels of masonry of the different periods can be seen on most parts of the defensive walls.

From the moment the city was laid out, probably in the late fifth century or early fourth century BC, the defensive line underwent frequent reconstructions. The initial south-eastern boundary of the city was delineated by a defensive wall, where the theater was later built. In the northwest, the defensive wall lay north of the necropolis of the earliest settlers (fifth and fourth centuries BC). The early Hellenistic wall crossed the northern end of the peninsula, along a line connecting the southeast gate and the 1932 Basilica, enclosing an area about half the size of the final circuit. The position of the line has been confirmed by joint NPTC-ICA excavations in 2003. The reconstruction of the defensive line was due to the city's territorial expansion in the fourth and third centuries BC. The southern boundary moved to the narrow isthmus between Quarantine and Pesochnaya (Sandy) Bays, turning

north and connecting with the defensive line along the shore of Quarantine Bay. The walls are 900 m long, approximately 3.5–4 m wide, and 8–10 m high (higher in the port area), with the towers approximately 10–12 m high. The city and chora seem to be have been planned together. The overall area of the city enclosed by the early Hellenistic walls appears to be about one half of a large land plot in the chora. The defensive walls extended westward as the city doubled in size, corresponding approximately to a full chora plot, or 620 m x 420 m.

During another major reconstruction in the mid-third century BC, the area of the citadel was annexed on the southeastern flank. In the second century AD, a *proteichisma*, or rampart, was built along the perimeter of the main defensive wall, serving as the first line of defense. The narrow space between the main defensive wall and the proteichisma was excavated by Kostsyushko-Valyuzhinich between 1895 and 1900. Once trapped between the two walls, the enemy was exposed to direct attack from the main fortification and could not easily retreat. The corridor between these walls, the *peribolos,* was filled in with earth and rubble and served as the road to the city in the late antique period. Much pottery, pavements of different periods, some pottery workshops with kilns, and an ancient burial antedating the proteichisma were uncovered in the peribolos. Further changes to the fortifications took place in the fifth century AD, when additional area was annexed to the western defensive line, and in the ninth century, when it was reconstructed by following the relief of the landscape, adding more area to the city precinct. During the same time, the southeastern defensive wall was extended eastward.

The defensive system of Chersonesos was repeatedly reconstructed throughout the Byzantine period. New walls and towers were built, and ramshackle constructions repaired. These gradually covered the ancient walls, which soon afterward became an invisible base for the medieval fortifications. One can easily trace this effect, for example, at tower XIV, where a small, arched Byzantine gate was built above the Greek gate, which had been filled already in the Roman period (Figure 8.9). It is not difficult to recognize medieval masonry of the upper tier of the city walls (Figure 8.4). The stones are held together by limestone mortar mixed with fragmentary stamped brick and sea pebbles. The masonry has a veneer of non-rusticated stretchers and headers and is filled with rubble. Most of the Byzantine revetment was stripped for later construction, since it was exposed above ground level, while the Greek and Roman walls were protected by a thick fill on either side. An

Figure 8.6
Hypothetical reconstruction of the southeastern part of the defensive wall during the medieval period, based on a study by Inna Antonova. Towers XV and XVI are connected by a footbridge, and in the distance is the Tower of Zeno, or XVII. Drawing by A. Snezhkina. (NPTC archives)

inscription found at the city gate attests to the construction of the third level during the rule of Theodosios I (379–395) and his son Arkadios (395–408).

During this period, Chersonesos widened its urban territory by annexing an area to the west, where the Chersonites created a powerful defensive system aimed at strengthening their city even more. The western part of the city has scarcely been excavated, yet remains of

Figure 8.7
The remains of a tower and the western wall are gradually being claimed by the Black Sea.
(G. Mack)

defensive walls and towers are clearly visible. At the very bluff overlooking the sea, ruins of a tower, a gate, and a wall section bearing traces of repeated reconstructions are some of the remnants of structures at the city's western edge. A deep moat cuts the bedrock beyond the walls. The line of walls and towers continues southward along the slope of a ravine. An impressive foundation of a circular tower constructed of large blocks has only been partially uncovered. The defensive wall disappears at one point beneath a late nineteenth–century artillery battery embankment as the line heads south and east.

In the late fifth century AD, a new defensive line was constructed even farther west and intensively reinforced. This new wall passed through the largest necropolis of the first century AD, which covered the whole slope extending down to Pesochnaya (Sandy) Bay, the inlet on the west side of the ancient city. This wall added to the city's protection at a weak but vital point where main roads connected Chersonesos with its chora.

Though the western area has been sparsely investigated, we can sketch the history of its development. In the early fourth century BC, a defensive wall was located farther to the east. The remains of that ancient wall lie just behind the apse of the Western Basilica. In the mid-fifth or early sixth century AD, the defensive line was moved closer to the end of Pesochnaya Bay, and gates were added to the newly erected walls. The territory that had been occupied earlier by a necropolis was thus annexed to the city. In the seventh century AD, a large monastic complex with the Western Basilica (pp. 110–111) at its center was built between the more ancient walls and these new walls. Excavations around this complex have uncovered traces of residential buildings. The majority of the newly annexed territory was not built on and served perhaps to protect the farming population during hostile raids or sieges. The western fortification line was reconstructed and strengthened many times. Its important later additions date to the ninth and tenth centuries. Nearby stands a well-preserved section of a proteichisma built in the first or second century AD.

On the wall of one of the early Christian vaulted tombs not far from Pesochnaya Bay is a unique fresco with a cityscape that suggests how contemporary occupants of the city may have seen their fortifications. The tomb may have belonged to a military engineer or the head of the municipal watch. Another interpretation suggests that this painting was made after the tomb had been transformed into a small underground church and features, instead, a representation of Mary and Joseph leaving Nazareth for Bethlehem.

References: Minns 1913; Grinevich 1926, 1927; Antonova 1996; McNicoll and Milner 1997.

Vaulted Tombs

Along the perimeter of the defensive walls and in the peribolos lay an ancient necropolis that was frequented until the fourth century AD. One of the richest burial vaults, labeled No. 1012 by the Imperial Archaeological Commission, was excavated by Kostsyushko-Valyuzhinich next to the city gate in 1899. It had a T-shaped plan and lay underneath the defensive wall. Dating no later than the first phase of the ancient wall, the tomb belonged to a distinguished citizen and contained the richest collection of burial goods so far discovered in Chersonesos. Small niches were carved into the walls to face one another symmetrically and held three bronze *hydriai*, or water vessels, and one in terracotta with the ashes of the cremated deceased. The lead lids were opened to reveal some of the finest pieces of classical Greek jewelry known. They contained a treasure of gold and silver jewelry, including a braided necklace with arrowhead pendants; a gold braided diadem; a pair of gold earrings, one with rosettes; filigree work and amphora-shaped pendants of the goddess Nike riding a four-horse chariot; a large gold ring with an oval, plain surface; eleven gold plaques with

Figure 8.8
During a visit in 1902, Tsar Nicholas II and his entourage pass the vaulted tombs 1013 and 1014 (foreground) while onlookers gather behind the monastery walls above. (NPTC archives)

stamped designs; a silver ring depicting Aphrodite and Erotes; and two silver bracelets with attached gold plates decorated with rams' heads. The neck of one of the vessels is inscribed "Prize of Anakes."

It is possible that its owner won the competition at the festival of Anakes, the title under which the Dioskouroi—Kastor and Polydeukes, sons of Zeus—were worshiped in Attica, and that he received the hydria as a prize; his ashes were later buried in it. Because of the apparently simultaneous construction of the tomb and the defensive wall, it has been suggested that it may have been the family burial vault of Agasikles, the strategos whose services as a "wall builder" are inscribed on the base in the Museum that held a full-length portrait statue. The single ceramic vessel found in the vault, a black gloss hydria (Figure 10.12) with white decoration, had more Greek gold jewelry of higher quality than the others. It included the gold diadem (Figure 3.1), formed from seven strands of doubled chain flanked by lion heads of sheet gold with palmette decoration; in the center are a Herakles' knot with appliqué filigree decoration and a tiny figure of a siren playing the lyre are in the center. The hydria also contained a pair of coiled hoop gold earrings with lion-head terminals decorated with a frieze of spirals, and a golden ring with a figure of Athena seated on a stool with lion's-paw feet, one elbow resting on her shield and the other hand holding a winged Nike with a wreath. These items have been housed in the State Hermitage Museum in St. Petersburg since the time of their discovery.

Two other burial vaults, Nos. 1013 and 1014, also excavated by Kostsyushko-Valyuzhinich in 1899, were attached to curtain 16 of the defensive walls and date to the second and third centuries AD. It was commonly believed that both vaults were underground, but no descending corridor leading to the burials from above was found. The vaults were instead entered directly from outside. During the Roman period, the ground level reached the threshold of the entrances. By the end of the early medieval period, they were completely covered. The vaults were identical structures containing niches for urns. The bigger vault, No. 1013, had not been sacked and contained especially costly objects, including oval sheets of gold that were used to cover the eyes and the mouth of the deceased, plaques, a diadem with pendants made of gold filigree work, earrings, necklaces of semi-precious stones—chalcedony, carnelian, and crystal, as well as mirrors of polished bronze, lamps, terracotta statuettes of animals, dice, and coins. In the center was a stone sarcophagus that contained a lead coffin dating to the late first century AD or later. On top of it were the remains of a woman in a wooden coffin with numerous pieces of gold jewelry placed around her. The latest burial in the vaults dates to the early third century AD.

References: Belov 1927; Mantsevich 1932; Zherebtsov 1979; Williams and Ogden 1994.

City Gates

The oldest and most important of the city gates are located in the southeastern part of the defensive walls. They led to the port region and its residential area. The gates were excavated by Kostsyushko-Valyuzhinich in 1899. The lower level of masonry is contemporary with the lowest level of the ancient defensive wall and consists of carefully adjusted slabs without mortar, bonded together with lead clamps inserted at the joints of the slabs. Some of the slabs retain the Greek masons' marks. The construction technique and the letter forms point to a date for the city gates in the second half of the fourth century BC. The width of the opening in the ancient gates was nearly 4 m; the entrance was almost 9 m long, with pylons at each end creating a corridor-like space that made it difficult for an enemy to pass. This double-gated entrance, a *dipylon*, is akin to those found elsewhere in the Greek world, for example, at Troy and Pergamon on the Asia Minor coast, and at Athens. The wider southern pylon has the remains of steps that ascend the wall, as well as a trapezoidal opening where a beam had been inserted to block the gates. The gateway itself has vertical grooves on each side of the wall, which were used for the lifting and lowering of a heavy metal grate, the cataract. The space between the cataract and the sidewalls of the gate was filled with stones and earth when additional protection was necessary.

In the first centuries AD, the dipylon gate at Chersonesos was less traveled and finally went out of use altogether. The entrance to the city was moved to the south and west. An opening onto the main north-south *plateia*, on the east side of the city, known as Main Street (pp. 74–75), was built. In the ninth and tenth centuries AD, the pylons at both sides of the original dipylon and the most ancient walls were covered with earth, and an arch, as noted above, was constructed above the old gates. Its marble threshold, still in situ, marked the level of the renovated entrance to the city.

Reference: Grinevich 1926.

Figure 8.9
Example of layered history: a Hellenistic gate, 4th–3rd centuries BC, beneath an arched Byzantine entrance, from a 1899 photograph. (NPTC archives)

Figure 8.10 (above) Reconstruction painting by A. Snezhkina of a grave stele of Herakleios, son of Tibeios. The original stone is one of three stelai from the Tower of Zeno in the State Hermitage Museum. ca. 300 BC, h 1.4 m. (NPTC archives; imaging by C. Williams)

Tower of Zeno

The seventeenth tower of the fortifications of Chersonesos, known as the Tower of Zeno, occupies the extreme southeast corner of the circuit. This was the probable site of the first settlement on Quarantine Bay and the most animated part of the city, enlivened by trade, an artisans' district, and the harbor. It is also the lowest part of the city. The tower stands at a vulnerable point where the east-west curtain wall 19 forms an angle with the north-south curtain 20. It is relatively well-preserved in its final form and is the largest structure of its type on the northern coast of the Black Sea.

The tower consists of concentric cylindrical rings of masonry that grew progressively outward from the center. In its initial phase the tower measured 12 m in diameter—its final diameter was nearly double that. The first phase of the cylindrical tower has been dated by the most recent investigation (1960–1961) to the late second century BC, primarily based on historical circumstances. A more probable date, given the condition of the polychrome relief blocks that were reused in its construction discussed below, would be the first half of the third century BC. The walls were in active use for 1,800 years until the final abandonment of the city in the fifteenth century AD. Archaeologists have traced several stages of reconstruction of the tower, interpreting them, usually, as preparation for the threats constantly posed by neighboring barbarians: the late Scythians, Sarmatians, Huns, Rus', and others. The problem is that relatively little is known about the political history and wars of Chersonesos, and it is often impossible to date its remains more precise than a century at best. There were probably more wars than are known, and certainly not all of them resulted in the strengthening of fortifications. It is clear that in the late first century AD the damaged tower was strengthened with a supplementary ring of large blocks. In the fifth or sixth century, possibly during the reign of Emperor Zeno (474–491), a second

strengthening ring was constructed, visible in the peribolos near curtain wall 19. The last reconstruction dates to the ninth and tenth centuries, when the diameter of the tower reached 23 m. Inside it there was a hall for the guards. A footbridge led from there to a platform above the adjacent gate in the peribolos.

The unexcavated tower, then believed to be a hill, was first explored by Kostsyushko-Valyuzhinich at the end of the nineteenth century and

completely uncovered by his successor Robert Löper when he became director of the Museum. Its interior was fully excavated in 1960–1961 in a major project of conservation and restoration of the wall, under the direction of Stanislav Strzheletskiy. The inner revetment of the first phase reused the polychrome relief blocks noted above. These were fragments of grave monuments, numbering about 350 in all, removed from a necropolis just outside the south wall overlooking Quarantine Bay. The brightly decorated stelai and architectural elements collectively are one of the most remarkable records of Greek color to have survived from antiquity, and they form one of the major treasures of the Chersonesos Museum (pp. 141–149).

Analysis of the style of the stelai, their carved and painted decoration, and the inscriptions that occur on more than forty of them, indicates a date from the late fourth century to the first half of the third century BC. When were they gathered up and hastily reused as building material for the tower? Clearly in this case, because a necropolis was desecrated, it was a period of emergency for the city. From the third through the late second century BC, the late Scythians were constantly threatening Chersonesos, and early in the third century, they destroyed the chora and the possessions of Chersonesos in western Crimea. A date corresponding to a known attack in the late second century BC is probably too late. The most recent material in the fill of the tower has been dated to around 200 BC, but this is questionable. The space between two pairs of cylindrical walls and the core was filled with rubble containing fragments of black gloss pottery and stamped amphora handles possibly dating to the third century. In light of the excellent state of preservation of the painting on the stelai of the fourth century BC, which can hardly have retained this freshness after exposure to the elements for two centuries in the necropolis, an earlier date is proposed—the mid-third century BC. At about this time, "anti–battering ram" buttresses were added to many farmhouses in the chora. Both Greeks and Scythians were thoroughly trained in the use of such siege equipment, which had been introduced by the Macedonians in the second half of the fourth century. (Philip II [382–336 BC] eventually prevailed over the Scythians in 339 BC.) A round tower was the best way to protect an important corner from rams and catapults and the Tower of Zeno was a key element in the defense of the city for much of its history.

References: Strzheletskiy 1969; Danilenko and Tokareva 1974; Carter 2002.

Figure 8.12
The Tower of Zeno, the flanking tower of the defensive wall, was rebuilt or refortified at least five times from the mid-3rd century BC to the 10th century AD. h 9 m, d 23 m. (NPTC archives)

Figure 8.11 (opposite)
Core of the Tower of Zeno, constructed of gravestone monuments and architectural details from a nearby necropolis of the 4th–3rd centuries BC. (NPTC archives)

Citadel

A key defensive structure, the citadel of Chersonesos was located in the southeastern corner of the city wall beside Quarantine Bay. It was delimited on the east by curtain wall 18, making a roughly rectangular closed area with towers XVI, XVII, XVIII, and XIX at the corners, and curtain walls 19, 20, and 21 formed the other sides (p. 94). It was constructed for protection of the city port and the garrison, in the second half of the third and early second centuries BC.

Figure 8.13
Aerial view of a portion
of the citadel, looking to
the northwest.
(A. Sobotkova)

The ancient coastline of the bay was 25–30 m farther south than the modern one, which is why the initial eastern wall of the citadel (curtain wall 21) connecting towers XVIII and XIX is located inland. As the bay became shallower, the coastal wall of the citadel was extended westward to curtain wall 18, which was prolonged and ended at the final tower, XX, built in the second and third centuries AD. The expanded citadel added an area of 92 x 54 m—about half a hectare—to the city's total area.

The citadel became the center of the Roman garrison already in the second century AD. Inscriptions prove that the garrison was commanded by a tribune and included troops from the I Italian, V Macedonian, and XI Claudian legions. The Romans constructed numerous buildings in the citadel. Along curtain wall 19 were two rows of barrack rooms *(contubernia)*, investigated in 1926–1928 by Grinevich.

Ruins of the Roman baths *(thermae)* in the citadel were excavated by the beloved former Museum director Inna Antonova, who continued to work there in the last year of her life, 2000, with groups of young volunteers from Moscow and other cites of Ukraine and Russia. There was a well-preserved entrance to the furnace *(praefurnium)* area, with four furnaces that heated the floor of the neighboring hot bath *(caldarium)* from below. The floor, covered with waterproof mortar of lime and ground ceramics, was supported by pillars of square bricks *(suspensurae)* under which the hot air circulated—the typical Roman hypocaust system. The caldarium was attached to the unheated cold bath *(frigidarium)*, consisting of two long mortar-lined basins and drainage pipes. Great quantities of vessels *(balsamaria)* for perfumes and aromatic oils were excavated in these baths. A door

connected the caldarium to a square stone-paved dressing room (*apodyterium*) equipped with a drain and a wide bench along the wall.

In the center of the citadel at the crossing of its main longitudinal and transverse axes *(cardo* and *decumanus),* an administrative building, the headquarters *(praesidium),* was constructed; its three sides were encircled by colonnaded porticos. The interior walls were plastered and were partly decorated with wall paintings. To the northeast was a pool 8 x 3.7 m. A two-story building with a marble staircase, dubbed the "commander's house," and new baths arose to the south of the administrative building in the second half of the third century AD. Part of the "barracks" was occupied by pottery workshops from the fourth to seventh centuries, when the commander's house and the baths near it were reconstructed. After the Byzantine emperor Theophilos (829–842) organized a military and administrative unit (theme) in Crimea with its center in Chersonesos, the citadel was once more reconstructed. A large administrative complex of two buildings with a courtyard between them—a theme building and a church in the form of a basilica erected in its center—was probably the residence of the Byzantine military governor, or strategos. Along the walls of this complex were small, probably hastily built rooms, but the greater part of the citadel remained free of structures.

At the turn of the eleventh and the beginning of the twelfth centuries, changes again occurred in the defensive system of Chersonesos, which are reflected in the exterior of the citadel. A small building, containing a hoard of about forty coins, was formed from the decomposed walls of the theme building. The remains of a church near curtain wall 21 were covered with an embankment, in which graves were arranged. In the middle of curtain wall 19 a chapel was built, which served at the same time as a buttress for the fortification wall. This small chapel, measuring 5 x 5 m, was made of carefully squared blocks and had fresco paintings in the apse. Later, in the thirteenth and fourteenth centuries, a square vaulted structure with interior alabaster moldings appeared near the eastern tip of the theme building.

During the cholera epidemic of the 1830s, the territory of the citadel became a cemetery for the seamen of the Sevastopol squadron. The uppermost layer of the citadel contains numerous nineteenth-century burials, and there was a small chapel or surface vault in its northeastern corner. A morgue was located on the opposite shore of the bay—hence, its modern name, Quarantine Bay.

References: Antonova 1996, 1997; Vinogradov et al. 1999; Zubar and Antonova 2000; Sorochan et al. 2000; Sorochan et al. 2002; Zubar 2003.

Figure 8.14
Plan of the citadel of Chersonesos, based on a drawing by Grinevich. A complete plan of the citadel structures and baths may be found in Sorochan et al. 2000, pp. 522–540. (J. Lane)

N

0 10 30 50m

4th c. BC
Mid 3rd-Early 2nd c. BC
1st-2nd c. AD
2nd-3rd c. AD
9th-10th c. AD
unknown date

"Barracks"

The "barracks" are situated in the southeastern region of the defensive walls of Chersonesos, next to the old city gates. There are traces of habitation in this region from the city's earliest until its final days in the mid-fifteenth century AD. Earlier, it was believed that the ruins of the walls found at the city gates belonged to the barracks of the local garrison, which explains the name of the monument, but there is no indication that they were used as such.

According to one hypothesis, at an early stage of Chersonesan history a defensive wall was located in this area. Later on, the wall was moved forward, and at the turn of the fourth century BC, a large building occupied its site. Some rooms of this building may

*Figure 8.15
Area of the "barracks" in the southeastern portion of the city, with Quarantine Bay in the background. (C. Williams)*

have been used to serve the typically Dorian common meals *(syssitia)* for the assembled citizens of Chersonesos, which meant males only.

A new period for this monument begins in the early centuries AD, when it was converted into a large-scale manufacturing complex with a spacious yard, cisterns, a well, a kiln, living rooms, and commercial space. This establishment probably served the interests of the Roman garrison, accommodated in the neighboring citadel. During the reconstruction in the fourth century, the living rooms on the site of the "barracks" were converted into fish-salting cisterns, creating an enormous complex for fish preservation and the production of fish sauces. In the medieval period, the site was occupied by a large and elaborate urban residence.

References: D'yachkov 1994, 1999; Saprykin and D'yachkov 1994; D'yachkov and Magda 1995.

Agora

The *agora*, or main square, was an essential part of the original city plan. Most public affairs and commercial activity took place there. The precise location of the agora has not been established, but the most likely site was where St. Volodymyr's Church now stands. Numerous archaeological finds of marble inscriptions, official documents, and inscribed statue bases indicate that this area was filled with *stoai* (long covered rows of shops), administrative buildings, statues of gods, and altars. Inscriptions attest to the existence of temples of Dionysos and of Athena, and of the main altar of Parthenos, the patroness of Chersonesos. A temple of Aphrodite was also nearby. One of the most important monuments of the democratic government of the city—the Civic Oath of Chersonesos—was found there in 1890 (Figure 10.2).

The central square retained its function as an agora throughout medieval times. When Christianity triumphed (by the fifth or sixth century AD), the agora's temples were destroyed and replaced by churches. The excavations of the nineteenth century showed that at least seven Christian churches were located in or near the agora. One of them is under St. Volodymyr's Church, while the ruins of three more churches can be seen to the south of the modern church.

Modern St. Volodymyr's Church was erected at the site of a medieval cross-shaped church in the middle of the nineteenth century. It was consecrated in honor of the Kyivan prince Volodymyr, who, according to *The Primary Chronicle*, had been baptized in Chersonesos (or Korsun' in Old Slavonic). The architects of the new church, academician F. I. Chagin and architect D. I. Grimm, designed this two-story building so that there would be one church on each floor. The lower story was occupied by the Church of the Birth of the Mother of God of Korsun' and the upper level by St. Volodymyr's Church. Inside the building, on the first floor, the remains of the cross-shaped church where the prince of Rus' was allegedly baptized were preserved. Several famous Russian painters of the nineteenth century—Korzukhin, Naykov, and Neff—took part in designing the church and producing the wall paintings with scenes from the Bible. The church was heavily damaged during and after World War II, and the Ukrainian government decided to renovate it in the late 1990s. By presidential decree, the work began in earnest in the fall of 2000 and the church, with its crowning cross, was reconsecrated on July 28, 2001.

Figure 8.16
The Reunion of Citizens of Chersonesos, *a painting by R. Voskresenskiy, displayed in the Greek and Roman Galleries. The Civic Oath of Chersonesos stands in the center of the agora. The Main Street leads to the sea, where it ends at the temple of Athena Soteira in the temenos.*
(C. Williams)

References: OIAK 1893; Martin 1951; Gerlovina 1963; Meshcheryakov 1979.

Main Street

The major *plateia* (wide longitudinal street) crossed the city in a southwest-northeast direction, establishing a main axis. It was up to 6.5 m wide and approximately 900 m long. City blocks, or *insulae*, were situated on both sides of it. Each block consisted of two to six houses, a chapel, and public buildings. In the 1990s, in one of the blocks in the northwest quarter, excavations uncovered a small circular pit about 2 m in diameter, together with the remains of hearths and wattle and daub. The excavator hypothesizes that the structures appeared at the end of the fifth century BC and were the original dwellings of the first colonizers for about thirty years before the construction of the stone houses began.

The Main Street ended at the vertical drop to the sea, with a square paved with stone slabs that dates back to the third and second centuries BC. The square was among the oldest in Chersonesos and was probably a *temenos*, that is, a sacred area of the city where major altars and temples were located. A wide arch led to the square, and a temple of Parthenos, the divine patroness of the city,

Figures 8.17 and 8.18 View of Main Street leading to the temenos, with Sevastopol Bay and the white 19th-century Constantine Fortress in the background. Photos taken from St. Volodymyr's Church, facing northeast, 1891 and 2001. (NPTC archives; C. Williams)

stood there, in addition to her altar in the agora. There, too, was placed a colossal statue of Parthenos, as attested by a statue base with an inscribed dedication to the goddess, roughly analogous to the famous statue of Athena Promachos on the Acropolis of Athens. The figure's weight rested on a foot measuring about half a meter long. The inscription was on the back side of the base, and the statue was probably placed on the edge of the cliff facing the sea, thus being visible to approaching ships. The temenos had remained essentially unchanged for half a millennium, from the third century BC to the Christian era, when the Eastern Basilica was built over an ancient temple.

The regular layout of the city is best seen in the northeast region, which has been extensively excavated by Kostsyushko-Valyuzhinich, Löper, Zolotarëv, Ryzhov, and other scholars. Narrow streets, the *stenopoi*, run parallel to the Main Street, and perpendicular roads cross them at right angles. This orthogonal plan commonly (though inaccurately) referred to as the "Hippodamian plan," proved to be very efficient and survived virtually intact throughout the medieval period. There was growth within the original grid of regular blocks, but the few changes that were obviously made in the tenth and eleventh centuries did not seriously affect the original layout.

References: Castagnoli 1971; Solomonik 1984; Zolotarëv and Buyskikh 1994; Buyskikh 1996; Buyskikh and Zolotarëv 2001.

Theater

Figure 8.19 (right) Fragment of a frieze with image of battling gladiators and the Greek name of the winner— Xanthos. (NPTC archives)

Figure 8.20 (below) Reconstruction of the theater and the foundation of the Reliquary Church by V. Banko in 1993. It does not reflect any historical reality, merely a prospective idea for the possible reuse of the Greek theater with the remains of the church left in situ. (NPTC archives)

The theater of Chersonesos is located in the southeastern part of the city, north of the city gates, under the remains of the medieval Reliquary Church (pp. 113–114). It was built in the third century BC and is the only theater so far identified in a Black Sea colony. Olbia is known to have had a theater, though it has never been found. The theater of Chersonesos was discovered by O. I. Dombrovskiy during the excavation of a medieval church in 1954. It was built on the steep northern slope of a deep depression adjacent to the ancient defensive wall. At the bottom of the depression was a spring, later converted into a *nymphaeum,* or fountain. The place was also used as an early necropolis, and many fragments of pottery of the fourth century BC were found during the excavation. Metal wastes suggest that a foundry may have occupied part of the site. When the area of the city expanded in the fourth century BC, the old defensive wall was disassembled and a new wall was constructed farther south, which created a convenient location for a theater close to the Main Street.

The Chersonesos theater is most similar to the Hellenistic theater in Priene, considering their similar proportions, horseshoe shape, and stage building. The largest and most costly element of the theater was the *theatron,* or auditorium, which was divided into eight sections with narrow staircases between them. Originally, each section had eleven rows of seats, and the theater as a whole could seat about 1,800–2,000 spectators, a number perhaps representative of the city's citizen population. During the Hellenistic period, it is estimated that there were at least 9,000–10,000 inhabitants. Only a few rows of seats in their original form, under the medieval church, and a few steps of a staircase in the central sector remained in situ. On the left and right sides of the theatron were two entrances, the *parodoi,* each 2.5 m wide; they led to the spectators' seats and to the orchestra, a semicircular paved area for the chorus. The

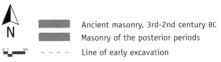

Ancient masonry, 3rd-2nd century BC
Masonry of the posterior periods
Line of early excavation

proskenion, or raised stone stage, faced the theatron and the orchestra. The proskenion was approximately 2 m high and decorated on the façade with an unbroken row of pilasters with engaged semicolumns. Behind the stage was the *skene,* a changing room and storage area for the performers and their props. There were several entrances to the stage. In the orchestra stood a sacrificial altar, the *thymele,* for sacrifices to Dionysos.

In the first century AD, the theater was reconstructed. The parodoi disappeared, and a few rows of benches were added. In the second and third centuries AD, when the Roman garrison was stationed in the citadel of Chersonesos, the theater became an arena for gladiatorial combats. A marble relief of fighting gladiators bears an inscription with the Greek name "Xanthos" engraved beneath one of the fighters. After Christianity became the leading religion of Chersonesos in the early Byzantine period, the theater was abolished, and the site was transformed again, this time into a city dump. Later on, perhaps in the sixth century, the Reliquary Church was erected on this once-sacred, pagan ground.

References: Dombrovskiy 1958, 1960, 1975, 1997; Bieber 1961; Shcheglov 1966; Zedgenidze 1976.

Figure 8.21 (left) Row of seats in the Chersonesos theater from the 3rd century BC. The Reliquary Church was built atop the theater area in the 10th century AD. (C. Williams)

Figure 8.22 (above) Plan of the theater based on Dombrovskiy. (J. Lane)

Figure 8.23
Archival photo of the
mint excavation from
1904. (NPTC archives)

Figure 8.24
Plan of the mint, based on
A. Karasëv. (J. Lane)

Mint

The spacious and luxurious structure almost universally identified as the "mint" is situated in the southeastern part of Chersonesos. It borders the "Byzantine Courtyard" (erected in 1955 by the director of the Museum, Inna Antonova, on the occasion of a visit from Nikita Khrushchev), and adjoins the Greek and Roman Galleries, as well as the main Museum building (which also houses the Byzantine collection). Kostsyushko-Valyuzhinich thoroughly excavated the area in 1904.

The western façade of the mint exited onto the Main Street, and its northern and southern sides, 30 m long, ran along two smaller transverse streets. A narrow stone staircase of seven extant steps led to the underground rooms connected by a T–shaped corridor, and then to the peristyle. The entrance was most probably located in the northeastern part of the building. The walls of the underground level are a little more than 2 m high and were made of carefully joined limestone blocks. This building technique is the same as that in the masonry of the lowermost tier of the defensive walls and reflects early Hellenistic style of the late fourth or early third century BC. The steep slope was a convenient location for the construction of the underground storage rooms of the mint. During the excavations, remains of a smelting furnace, foundry slag, and forty-three bronze disks, which probably were blanks for coins, were recovered. These elements are the main evidence that the building served as the mint.

The mint covered the area of an entire city block. Its great size and the plan suggest a luxurious version of the typical rural estate. The layout of rooms on the underground level was probably mirrored in the upper story as well. The building incorporated a large courtyard with a roofed portico supported by a large number of columns.

References: Robinson 1930, 1946; Karasëv 1955; Anokhin 1977, 1980.

N

▬▬ Remaining walls of ancient period
▭ Extrapolated wall locations

CRIMEAN CHERSONESOS

In choosing a place for a new city, one of the first conditions is a constant source of good water. At an early stage in the life of Chersonesos, underground water was used, and wells and cisterns in the courtyards of the houses collected rainwater from roofs. Together with the expansion of the territory and the growth of the urban population, the demand for water increased. In the first centuries AD, the Chersonites used the techniques of Roman engineering to provide the city with water. Underground aqueducts, or conduits, 8 to 10 km long, brought water from the springs in the vicinity of Chersonesos to a cistern that acted as a distribution center. There were at least two lines of ceramic pipes. The remains of these were discovered during the excavations of the western gates. This early cistern for water storage was no longer used in the late fourth or early fifth century. A four-apsed church was built over its ruins in the early seventh century AD. The cistern was replaced by a much larger one, not far away, on the southern side of the city. This new reservoir was the central part of a large architectural ensemble at the defensive wall of the city. It measures 28 x 13.5 m, with a surviving height of 3.75 m. The cistern wall has evidence of at least two different construction periods and consists of dressed limestone blocks bonded and made waterproof with a coating of lime and ground ceramics. Pipes were built into the walls of the reservoir from top to bottom to release water in case of an overflow. In the eastern corner of the reservoir was a square opening that marked the beginning of the drainage canal. Through it,

*Figure 8.25
Water reservoir in the southern part of the Ancient City that fed into the water supply network. (G. Mack)*

water was distributed to the branching network of the city's water supply. The lines consisted of ceramic pipes and rock-cut channels coated with mortar and covered with slabs. Such water pipelines were uncovered on the Main Street and along the walls in the area of the port and the citadel.

The water system supplied not only the residences and businesses of the city but also its public toilets near the theater and its public baths, or *thermae*. Thermae have been identified in the citadel for Roman military use (pp. 70–71), as well as near the main cistern, presumably for public use. Hypocaust heating of the caldaria was standard in the larger baths of the city.

In the medieval period, few small public baths were built in Chersonesos. Such constructions have been unearthed in the northern and northeastern sections, as well as in the citadel. In the northern section there was a private bath, very similar in its construction to the public baths but much smaller in size. Because the main city water reservoir was not functioning from the ninth century on, the dwellers had to return to the old system of water supply, and wells and cisterns reappeared in the courtyards of the houses. The city also had a complicated and extensive sewage system. Drain water usually flowed outside the city precinct into the sea through stone gutters. Such canals were found during the excavations of the streets and date to different periods in the life of Chersonesos.

References: Pyatysheva 1969; Boersma 1991; Kadeyev 1996; Sedikova 1994, 1995.

Daily Life in Chersonesos

Port Block

The city port occupied the low coastal area at the end of Quarantine Bay. This protected harbor could accommodate a fair number of ships. The docks, anchorages, and shipbuilding facilities were located nearby. In the blocks along the port lived timber dealers, carpenters, blacksmiths, seamen, merchants, and traders supplying the builders with hemp, resin, sailcloth, beeswax, and other necessary materials. They arranged warehouses for keeping goods and supplies for trading, so this area was one of the most densely populated, most frequented, and boisterous.

A medieval block belonging to the port settlement near the city gate was covered with two-story buildings surrounding courtyards. The walls of the dwellings were made of irregular stone-and-mortar. The gutters along the streets carried sewage away from the houses. During the long history of the city, the plan of the port area changed more than once. For example, in the eleventh century, or a bit later, two ancient blocks were reorganized into one with an inner square on which stood the small Arcosolia Church. Graves were, as usual, made within the church walls, and above them the builders arranged arched niches for lighting the walls. The entrance connected the church with the southern part of the square. The Arcosolia Church was destroyed in the thirteenth or fourteenth centuries AD.

Figure 8.28
Arcosolia Church, 11th century AD, built over a residential block of an earlier era, near the city gates in the port area. The niches are above graves in the church walls.
(G. Mack)

References: Kadeyev 1973; Romanchuk 1973, 1978, 1980, 1988, 1994, 1998.

Reconstruction of walls

0 3 6 18m

N

Early Hellenistic Houses

Houses dated to the end of the fourth or beginning of the third century BC, at the height of Greek Chersonesos's prosperity, are located in the northeastern part of Chersonesos on the Main Street, between two transverse streets. The area, which included two Hellenistic houses, was excavated by Löper in 1908–1909. The houses facing Main Street were separated by a wall and had two additional entrances from one of the transverse streets. The total area of the two houses was 1,250 m². They were palatial by Greek standards and much larger than the Hellenistic houses in the northern coastal area of Chersonesos, which are closer in size to those of contemporary houses in other parts of the Greek world, ranging from 150 to 300 m². The area that these exceptionally large houses covered is equal to or greater than that of many of the sizable rural estates in the chora. Large, private urban residences were not rare at commercial centers like Delos in the Aegean.

A typical Hellenistic house had a uniform plan: a narrow corridor leading to a central courtyard, with living spaces and storage rooms forming the perimeter; a well or a waterproofed cistern supplied by water from the roof; and a cellar. The courtyard was normally paved with sea pebbles or stone slabs. The floor of the house usually had a clay coating, and the walls were plastered and decorated with red-and-yellow paintings. The roof was tiled.

A plausible reconstruction of one of these large early Hellenistic houses was completed by Ryzhov in 1979. The house covered an area of nearly 650 m² (about 6,000 square feet); its walls were made of carefully dressed rusticated blocks, similar to the masonry of the "barracks," the mint, and the defensive walls. The building had a two-room basement, as well as a peristyle courtyard surrounded by thirteen limestone columns, with living quarters and workrooms opening off the open central space. Given its size, the peristyle courtyard, and the masonry of rusticated blocks, the house resembles similar, though smaller, Hellenistic houses on Delos, at Priene, Olbia, and Olynthos (the Villa of Good Fortune) and suggests that it probably belonged to a single wealthy family.

References: Belov 1963; Fëdorov 1977; Ryzhov 1985; Nevett 2001.

House with the Mosaic Floor

Another notable large house of the early Hellenistic period had a room paved with a pebble mosaic floor. Discovered in 1936–1937 by Belov, it once stood to the east of the 1935 Basilica. The room with the mosaic had an irregular shape, with the sides measuring 3.75 m, a short southwestern wall of 3 m, and a longer north-eastern one. Its floor was slightly inclined for drainage, and a cistern was located at the door. The mosaic represents two nude women standing beside a *louterion*, or shallow basin on a high pedestal. The northwestern part of the mosaic at the entrance is decorated with floral designs. A dove, the symbol of Aphrodite, sits on the rim of the basin; another bird flies over it. The composition is rather symmetrical yet has a subtle movement that gives the subject fluidity and vividness. An ablution, part of a scene of female *kosmesis*, perhaps in preparation for marriage, may be the subject. Or perhaps, as one scholar has (less convincingly) suggested, the two females were representations of different states of Aphrodite. Because the mosaic did not entirely cover the floor, leaving a blank strip along walls where benches may have stood, the mosaic may well have decorated an *andron*, or men's room used for symposia (male drinking parties often with female entertainers), which would favor a more explicitly erotic interpretation of the subject.

The Chersonesos pebble mosaic resembles most closely those in the House of the Comedian at Olynthos. Both used natural pebble and similar colors and technique. The difference is that the figures in the Chersonesos mosaic lack the outlines of lead-strip frames and pebble edging that were used at Olynthos to give them clearer definition. The volume of the figures and the curving surfaces are brought out by a careful variation in the shades of colored stones chosen for the contours. Similarly contoured figures are found in the mosaic floors at Pella. Stylistically, the figures of the women in the Chersonesos mosaic are later Hellenistic. They should be dated earlier than they appear to be on purely stylistic grounds, perhaps to the third century BC, before mosaics made of tesserae (small squares of colored stone or glass with a flat upper surface) became the norm. The figures are more svelte and fluid than the ones in the "Nereid" mosaic from Olynthos, worked in the strict style of red figure vase painting of the fourth century BC. The mosaic, along with a model of the house, has been displayed in the Greek Gallery since its reopening after World War II.

References: Belov 1953; Robertson 1975; Dombrovskiy 1994.

Figures 8.29, 8.30, and 8.31 (opposite) House of the 4th–3rd centuries BC, detail of the wall, and a plan as reconstructed by S. Ryzhov in 1979. (C. Williams; plan by J. Lane)

Figure 8.32 (above) Sea pebble mosaic from a Hellenistic house of the 4th–3rd centuries BC, most likely decorating an andron (men's room), as displayed in the Greek Gallery. (C. Williams)

House with a Winery

The House with a Winery is located southeast of the 1935 Basilica. Excavated by Belov in 1947–1948, the house was sizeable, with a paved courtyard, a well, and a water cistern. A deep cellar on the northeastern side of the courtyard was connected by a staircase; the winery was located in the eastern part of the house and was adjacent to the courtyard. It had three reservoirs, each with a capacity of 1 m³ (1,000 liters) of wine; large wine-pressing

Figure 8.33
Winepresses from a residential dwelling in the northern part of the city, 2nd–4th centuries AD. (C. Williams)

Figure 8.34
Iron plowshare, Roman or Byzantine period, h 30.5 cm. Kuzishchin, 1979. (C. Williams)

platforms; and a storage area on its southwestern and northwestern sides, with twenty-five holes cut into the rock for *pithoi* (large terracotta jars). Some of the platforms were used for trampling grapes with feet, while others had presses with wooden levers and stone counter-weights to facilitate the pressing. The grape juice flowed from the platforms into the reservoirs revetted with tile fragments. This house is the only firmly identified winery within the city limits. Others, using both pressing techniques, were regularly incorporated into the

Figure 8.35
Gravestone with an inscription "Doulon, son of Delphos" and a relief of a grapevine pruning hook in the Greek Gallery. (C. Williams)

Figure 8.36
Plan of a residential winery, based on Belov. (J. Lane)

N

0 1 5 10m

■ Wall of ancient period
■ Living implements
1. Living space
2. Courtyard
3. Wine production rooms

rural estates of the Herakleian Peninsula. The winery operated between the second and fourth centuries AD. Given the character and the size of this winery, along with other examples outside the city precinct, wine production, together with fishing, continued to constitute a crucially important element of the city's economy, despite a diversification into animal husbandry in the Roman period.

In 1911, a gravestone was found in the city necropolis, bearing the inscription "Doulon, son of Delphos," and a relief carving with a pruning hook or a small hatchet. Similar tools were excavated from the site. A recent hypothesis attempts to show that these tools had a function other than cutting vines: use by priests for making blood sacrifices of sheep or cattle. The deceased thus may have been a priest also, but was almost certainly involved in wine production. The name "Doulon" (slave) and the crude style of relief indicate that this was a modest memorial. Compare the fine style of the stele of "Kinolis, son of Pasichos," which has a similar yet more ornate hook, or pruning knife (Figure 10.26). The resurgence of a native, indigenous or "plebeian" current in memorial art, typical also of other parts of the Roman or Roman-influenced world, is clear at Chersonesos.

References: Belov 1952; Strzheletskiy 1959; Kadeyev 1996.

Figure 8.37
Iron pruning hook. A wooden handle was attached to slender point, h 23 cm. (G. Mack)

Fishmongers' Houses

Figure 8.38
Fish-salting cistern in the
northern part of the city,
Roman era, in a 1937
photograph.
(NPTC archives)

Figure 8.39
Assortment of bronze
fishhooks, flanked by
needles for net-making,
from Greek Gallery.
(C. Williams)

According to Strabo, fish-salting in Chersonesos in the first century AD constituted a large part of its economy. More than a hundred fish-salting cisterns have been excavated on the territory of the city. Most of them date back to at least the first century AD and were in use until the early medieval period. Remains of one fishmonger's house of the first century AD are located in the northeastern part of Chersonesos, north of the early Hellenistic houses (p. 82). Two pear-shaped water cisterns, wells, and holes for the pithoi survive in the courtyard. These pithoi were used to store salted fish. There are deep, rectangular cisterns on the east side of the house where the salting took place. The remains of fish pulp of light brown color and individual fish bones on the bottom of the cisterns identified the products as Black Sea khamsa, or anchovies.

Just to the southeast of the House with the Mosaic Floor stood another fishmonger's house built between the second and fourth centuries AD, when fish-salting seems to have truly flourished. The house had production rooms annexed to the courtyard and living rooms on the second floor. A storage room, with nine huge pithoi (large enough to hold a man) and three deep rectangular fish-salting cisterns, was without a roof, no doubt for purposes of ventilation.

References: Belov 1953; Romanchuk 1973, 1977.

Figure 8.40
Fragment of a red figure fishplate with a sheat-fish
(catfish). Early 4th century BC, Attica, 17.5 x 8.5 cm.
Belov, 1936. (C. Williams)

Medieval Residential Insulae

An *insula,* or block, of dwellings that date from the eleventh to the fourteenth century was excavated in the northern section of the city site, between the Church above the Vaulting and the Basilica within a Basilica. Here, houses of the type mentioned in the Port district were arranged very close to each other. During the Roman period there was a large estate with a fish-salting cistern in this area. Religious items—crosses, censers, and icons—excavated inside one of these houses indicate that it probably belonged to a priest. On the corner of the block, remains of a small twelfth-to-fourteenth-century chapel have been uncovered. Similar constructions are present in all neighboring blocks. They were built from the tenth century onward and served at the same time the daily religious needs of the block and as memorial burial churches. Excavation of one in a residential block across the Main Street from the main cistern began in 2001 (p. 88).

Figure 8.41
Reconstruction of a Byzantine-era residence, by V. Banko in 1993. (NPTC archives)

To the east of the House with a Winery, a medieval insula of unusual historical interest came to light. The plan of this insula was changed many times, but the idea of a residential house with a courtyard encircled with rooms of different functions remained constant. A number of ancient Rus' artifacts dating to the eleventh or twelfth century—like Novgorod *grivnas* (silver rod-shaped ingots, used as money), pink slate spinning whorls produced at Ovruch near Kyiv, crosses, and ceramic ware (now exhibited in the Byzantine Galleries)—make it all but certain that by this period the population of the northern section of Chersonesos included Rus' merchants and craftsmen. Three pottery kilns existed there for making roofing tiles.

Two more late medieval houses have been excavated on the Main Street nearly opposite the memorial Cave Church (p. 115). An entrance from the Main Street led to the first two-story building. A door connected its spacious vestibule to a corridor with a staircase to an upper floor and with two doors that led to residential quarters. The second house included a shop in the corner of the ground floor, with a wide opening into the Main Street. It was possible to reach the living quarters only from the street, through a vestibule, and then up a staircase. The presence of shops in residences, as here, is reminiscent of similar arrangements in Pompeii, Herculaneum, and Ostia, all of which were much earlier in date.

References: Belov 1941, 1962; Ryzhov 1999, 2001.

Medieval Quarter in the Southern Region

Excavations of a medieval quarter in the ancient city were started in 2001 by a joint team from the National Preserve, the University of Lecce (Italy), and ICA with strong contingents from the University of Kyiv Mohyla Academy, Taras Shevchenko University, and Tauric University, Simferopol in 2002. The Main Street, 5.2 m wide, separates this quarter from

Figure 8.42 Medieval quarter in the southern region of the city, with Main Street and the water reservoir also visible, 2002. (C. Williams)

the complex of the main cistern, the city's water reservoir. Two seasons of excavations have discovered much about the southern part of the late Byzantine block. The living quarter consisted of at least two complexes. One of the houses had a suite of four rooms with an exit to the Main Street. The largest and the earliest room was perhaps a dining room of an inn. Among the remnants were a pithos to store water, placed on an upper stone base; a fireplace and a stone pavement in the middle of the room, which may cover a cistern or cellar; and shelves with pottery, which were probably located in the eastern corner. The finds include high-quality glazed vessels, many locally made but with some from major centers like Constantinople and Thessalonike. There also were products of Eastern (probably Iranian) craftsmen. The last of the three rooms was perhaps a pantry. Several crushed pithoi, amphorae, and a portable iron cross with a silver incised appliqué in its middle were excavated inside. Similar crosses are used in the Orthodox liturgy.

The block's architectural assemblage included a small church with burials inside and outside; a large yard where, as the finds indicate, an iron-making shop was located; and a group of rooms in the northeastern part of the quarter. Narrow streets (stenopoi) to the north and south, intersecting Main Street at right angles, were uncovered in 2002. Two early Byzantine capitals (sixth to ninth century AD), which were used secondarily as benches, flanked the entryway to the yard off the north stenopos. Only a part of the remaining complex has been excavated so far. In one of the rooms was a hearth; in the other, a portable ceramic cooking stand, a great deal of fish bones, and a gutter indicate commercial fish processing. Based on the analysis of the artifacts, it appears that the dwellers hurriedly left their homes and businesses on this block in the late thirteenth century AD.

References: Arthur and Sedikova 2002; Sedikova and Arthur 2003.

Paint Maker's Workshop

The so-called paint maker's workshop was located west of the 1935 Basilica and was built in the third or second century BC. The walls of three oval basins, slightly more than 1 m long and under 0.5 m in depth, were covered with a layer of greenish clay and a thick coating of red-brown ochre. The owner of the workshop perhaps bought or collected mineral ochre from southwestern Crimean river valleys. The final product was a red paint and was most likely sold on the market for use in ceramic production and wall painting. Other local artisans of various periods competed and produced a range of more interesting colors, often from imported minerals from exotic places. Some of these can be observed on the famous painted stelai and funerary architecture in the Greek Gallery. In the late first century BC, the workshop was built over the house of Gordios, whose name appeared frequently on potsherds found there. In the fourth century AD, the house belonged to a fishmonger and had numerous fish-salting cisterns.

References: White 1984; Sorochan et al. 2000; Twilley 2002.

Figure 8.43 (above) Ingredients for paints (reddish-brown pieces are ochre), used to decorate fabrics and objects. Local production, 3rd–2nd century BC. Belov, 1934. (C. Williams)

Potters' Quarters

A series of ceramic workshops was concentrated in the southwestern part of the peribolos of the defensive walls, south of a major tower and clustered near the road that ran along the west coast of Quarantine Bay (p. 94). Excavations, begun in 1888 by Kostsyushko-Valyuzhinich, uncovered several kilns (no longer visible) dating from the third or the first half of the second century BC. Easier access to supplies of water, clay, and fuel, as well as the risk of fire, dictated the location of the potteries outside the defensive walls. The potteries, besides kilns, usually had water cisterns, as well as pits for purifying and impasting the clay. These contained numerous pieces of discarded amphorae, jugs, bowls, and other objects ("wasters" and kiln "furniture") of the late third to the mid-second century BC. As the city grew in a southeasterly direction, some potteries became inactive or were moved closer to the west coast of Quarantine Bay. Some were still in use until the ninth century AD. Although there is much evidence of metalworking associated with kilns and in other areas of the city, no foundry has yet been identified as such.

References: Borisova 1958, 1966; Sedikova 1994, 1995.

Figure 8.44 (left) Terracotta mold for a statuette of a sitting girl, muse, or goddess. Local production, 3rd century BC, h 20 cm. Belov, 1940. (G. Mack)

Figure 8.45 (below) Portion of clay mold for casting rings. Hellenistic. Kostsyushko-Valyuzhinich, 1890. (C. Williams)

The most important class of objects that testify to the strength of the ancient economy is the amphorae of Chersonesos. Made of refractory clay and fired at relatively high temperatures in special kilns, these ceramic containers usually have two solid handles and a special body design that permits easy handling. The fabric and the treatment of amphora walls are dictated by the large variety of products transported: liquids, such as wine and fish sauce, required a pitch coating applied on the inside walls; olive oil called for a hard and compact fabric without pitch; and solids, such as olives and fruits, demanded less rigorous production specifications.

Figure 8.46 (above)
Stamp from local amphora
in Fig. 8.47, end of
4th century BC. *(A. Opait)*

Figure 8.47 (middle right)
Local amphora,
end of 4th century BC.
md (maximum diameter)
28 cm, h 70 cm.
(A. Opait)

Figure 8.48 (far right)
Sinopean amphora,
1st century AD. *md 32 cm,*
h 83 cm. (A. Opait)

Local Production and Exports

Chersonesos soon became a hub for distributing the products of the southern Black Sea region, as well as for collecting the agricultural output of its own chora and that of its northern neighbors. The rapid development of its chora led to local production of amphorae, which is attested by their appearance in Hellenistic and medieval workshops.

Hellenistic pottery workshops (p. 94) were discovered southwest of the Tower of Zeno. The numerous amphora stamps, bearing the names of the city's magistrates (e.g., Kroton, Apollonios, Herakles, Nikeas, Xanthos) were applied on the upper part of the handle, rarely on the neck. The stamps indicate governmental involvement in amphora production and, perhaps, an official organization of wine export under the democracy.

Chersonesos was politically stable and militarily secure in the long period of Roman influence (first century BC to fourth century AD). No amphora workshops are conserved from these centuries. All that survives is some misfired pottery discovered in an area that produced Roman terracotta figurines. The lack of kilns should be attributed to the massive reorganization of the city during late Roman times, when the earlier Roman stratum had been erased, or to the chance of archaeological discovery, rather than to a complete hiatus of amphora production during this thriving period. The imposing winepresses and the many fish-salting cisterns recently excavated illustrate the existence of a strong economy. Proof of prosperity is found in the numerous

Figure 8.49 (left)
Chios amphora,
2nd century AD.
md 45.5 cm, h 96 cm.
(A. Opaiţ)

Figure 8.50 (below)
Local or provincial
amphora,
2nd–3rd century AD.
md 21.5 cm, h 47 cm.
(A. Opaiţ)

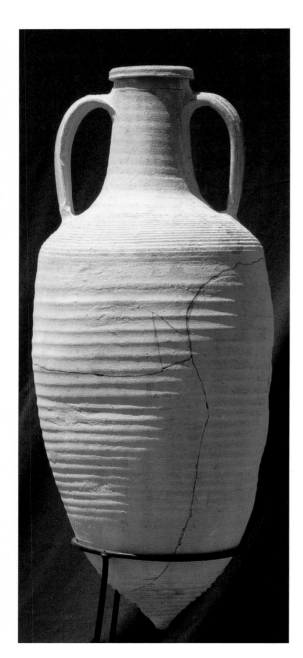

necropoleis discovered in the city and its territory. Some of the amphorae found in these necropoleis were made of clay similar to that used in the Hellenistic period.

The continuity of local amphora production is demonstrated throughout the medieval period, in pottery workshops of the eighth, ninth, and tenth centuries AD. During this time, generally considered the "dark age" in Europe, the high quality of production of Chersonesan amphorae was maintained. Local potters made two types of amphorae that have turned up as far away as the southern shores of the Black Sea.

Trade and Imports

Chersonesos's intense economic activity in all periods is evident in its local, regional, and long-distance trade. The morphological analysis of the imported amphorae gives some hints of the types of products exchanged and their origin.

The local Crimean trade was necessary to satisfy the daily needs of the city and its chora. In particular, throughout the Roman and Byzantine periods, amphorae made in the Bosporan Kingdom demonstrate that trade connections existed between the eastern and western ends of the peninsula. Such amphorae, many of them having a very large capacity, especially during the second and third centuries AD, have also been discovered farther inland. These ceramics indicate the existence of well-organized trade routes that supplemented the considerably easier and cheaper water transport. These relationships acted as an efficient tool for putting economic pressure on the Hellenized barbarian populations. The presence of fine tableware, wine, olive oil, salt, or garments reveals not only a more civilized lifestyle but also a greater dependence of these peoples on Chersonesos, the center that delivered these products.

The regional trade was especially significant. Chersonesos, founded by Herakleia Pontika on the south coast of the Black Sea,

processed a significant quantity of Pontic amphorae, made not only in its metropolis but also in Sinope and the Colchis areas. For centers like Sinope that had an inhospitable, rocky hinterland, the north Pontic colonies became, for all practical purposes, their actual agricultural territory. From the southern Black Sea, ships departed full of wine, olive oil, and perhaps minerals and manufactured goods like pithoi and roof tiles and came back with the staff of life—Crimean cereals.

The long-range trade of Chersonesos in the Hellenistic period was well established with the eastern Aegean world and continued during the Roman and early Byzantine periods. Amphorae from Chios, probably full of olive oil, or from Ephesos, full of precious wine, date from the first to sixth centuries AD. New wine productions from Syria and Palestine may also be added to the list of these centers that arose during the fifth and sixth centuries AD. In the later medieval period, this long-distance trade seems to have been restricted to an area close to the Byzantine capital, Constantinople.

These observations on the amphorae affirm that Chersonesos acted continuously as a nexus between the barbarians of the northern Black Sea and the flourishing, sophisticated civilization of the south. The fortunes of Chersonesos from the fourth century BC to the fourteenth century AD depended on its ability to fill its role as intermediary between economies and civilizations—all but the last of which, the Mongol, it survived. No further proof of its success is required.

References: Zeest 1960; Monakhov 1984, 1999; Kats 1994; Randsborg 1994; Whitbread 1995; Opait 2003.

Figure 8.51 (opposite top) "Table" local amphora, 3rd century BC. h 22 cm. (estimated). (A. Opait)

Figure 8.52 (opposite left) Provincial (Crimean) amphora, 3rd century AD. md 41 cm, h 98 cm. (A. Opait)

Figure 8.53 (left) Herakleian (?) amphora, 4th century AD. md 15 cm, h 47 cm. (A. Opait)

Figure 8.54 (middle) Colchian amphora, 4th century AD. md 24 cm, h 87.5 cm. (A. Opait)

Figure 8.55 (below) Local amphora, 9th century AD. md 21.6 cm, h 36.5 cm. (A. Opait)

NECROPOLEIS AND DEFENSIVE WALLS
NATIONAL PRESERVE OF TAURIC CHERSONESOS

N

0 10 50 100m

Volodymyr's Church

Site of 1888 Museum

Quarantine Bay

Tower Number
Curtain Wall Number

Location of Kiln 9 is beyond scope of map -near Mikailovskaya Battery

St. Volodymyr's Statue

Church Outside the City Walls

Necropoleis

Classical and Hellenistic period

Hellenistic and first centuries AD

From first centuries AD

Pottery Kiln Locations

○ Hellenistic period

◐ Roman period

● Medieval period

Necropoleis

The necropoleis of pagan Chersonesos, where the city dwellers buried their dead from the fifth century BC to the sixth century AD, stretched outside its defensive walls, a narrow, continuous strip from the Western Gate to Quarantine Bay in the south. The earliest burial area, outside the first settlement and near the 1935 Basilica, is actually inside the defensive walls, which were built farther out at a later date (pp. 62–63). It is referred to as the "northern necropolis." In the fourth to the second century BC, necropoleis covered about 15–20 hectares, but by the first century AD the burial grounds had grown considerably. At present, more than 2,500 burials have been excavated, and investigations are continuing.

The Greeks paid much attention to their dead, scrupulously performing the rituals that were considered essential for a proper burial. The elite used expensive cremations; the middle and lower social strata employed the rites of inhumation. Burials were accompanied with goods that, according to the Chersonites' beliefs, might be necessary for the dead in the other world. Above graves of the fourth to the first century BC, they placed limestone stelai with images carved in relief and painted, or simply painted. The names of the deceased and his or her father, and, in the case of a married woman, her husband, were carved and painted, or sometimes only painted (pp. 141–147).

The richest burials of the fourth century BC were excavated in vault No. 1012 in the wall near the city gate (pp. 65–66). The dead were cremated, and the ashes were placed in black gloss and bronze hydriai along with the finest quality gold jewelry (Figure 3.1).

The physical appearance of the necropolis changed in the first century AD. Burials in niches of rock-cut vaults became the fashion of the elite. Burial construction of this type originated in Chersonesos in the second and first centuries BC and was used in the early medieval period. The presence of the Sarmatians, beginning in the middle of the second century AD, resulted in further changes. Vaults with niches for placing cremation urns appeared. Two such vaults of the first to the third century AD were located near the city gates (Nos. 1013 and 1014). During the first century AD, the two main types of burial rites—cremation and inhumation—persisted. Cremation, however, continued only to the mid-third century; later, all burials were inhumations. Grave goods were numerous and quite different from the simple vases found in most early Greek burials. Vaults usually contained items of precious metal. Ornate clay and glass vessels for food and drink were common. These changes suggest an altered view of the afterlife among the population. The idea of the dead drinking and eating with the gods in the otherworld and participating in their immortality came to play a larger role in the beliefs of the elite.

In Chersonesos beginning in the late second century AD, burials of the most ostentatious sort were made in large marble sarcophagi, the walls of which were decorated with relief sculpture. These may be divided into various groups. They include monuments

Map 8.2 (opposite) Peninsula of Chersonesos, highlighting the defensive walls, necropoleis, and pottery kilns, based on Zubar. (J. Lane)

Figure 8.56 (below) Rock-cut burial, Roman era, along Quarantine Bay, in 1913 photograph. (NPTC archives)

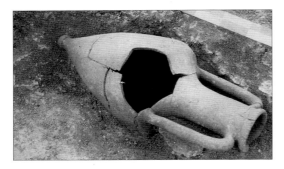

with inscriptions and "portraits" of the dead and with reliefs depicting Erotes bearing garlands and bunches of grapes on their shoulders. One slab represents a young Dionysos and an old bearded silenos; another, a young satyr and maenad; still others, mythological heroes like Herakles (pp. 158–160).

A thorough study of the necropoleis will show that although the Greeks constituted the main group in the population of the city, the ethnic structure of the population was far from homogeneous. In the city lived people originating from Asia Minor and the Danube provinces of the Roman Empire. The largest part of the Roman garrison (second quarter of the second century to the third quarter of the third century AD) in Crimea came from the province of Moesia. The persistence of classical traditions in art, including grave art, confirms a comment by the first century Roman writer Pliny the Elder that Chersonesos was the most brilliant of the sites on the Crimean coast because it preserved its Greek traditions.

The complete shift from a combination of cremation and inhumation rites to inhumation only, around the middle of the third century BC, no doubt reflects changing world views and the spread of new religious beliefs. The first identifiably Christian burials appeared in the city necropolis in the fourth or early fifth century AD. They resembled pagan graves but contained items with Christian symbols. Ten vaults with Christian wall paintings have so far been excavated in Chersonesos. The paintings, however, date to a later period, probably to the sixth century AD, when these grave constructions became places of worship and were connected to the legend of the first Christian martyrs in Chersonesos. According to historical sources, the wide-scale evangelization of Chersonesos's population started no earlier than the sixth century, promoted in Crimea by the politically active Byzantine emperor Justinian I (527–565). Vaults with Christian paintings, typical Christian funeral objects, and cross-shaped headstones date to this period. The evangelization of Chersonesos is marked by the construction of the first Christian basilica churches in the sixth century AD. After that, burials were often made inside the city walls, often on consecrated land around and under churches and basilicas.

References: Rostovtzeff 1914; Belov 1948, 1950, 1953; Zubar 1982, 1999; Puzdrovskiy 1999.

Figure 8.59
*Artist's conception of the
Chersonesos necropolis just
outside the southeastern
city walls. (J. Lane)*

Architectural Reconstruction - Ancient Necropolis

Religious Architectural Monuments of Medieval Chersonesos

Figure 8.60
View of the northern
coastline of Chersonesos,
with excavated territory
and the 1935 Basilica in
the background.
(C. Williams)

The architectural landscape of medieval Cherson, as the city was known in this period, retained many of the characteristics of its former Greek and Roman phases, especially with respect to its overall plan and individual domestic arrangements. At the same time, the medieval city reflected the events and transformations of this last and longest period of its history in a number of striking ways. The most obvious of these was the construction of many churches that were conceived in a variety of sizes and forms. Despite the decline of Rome in the West, the rise of Constantinople (formerly Byzantion) as the new capital ensured the continuation of Rome's empire in the eastern Mediterranean, Greek-speaking world. The East, however, introduced fundamental changes in politics, society, and economy that affected all regions in the Byzantine sphere of influence. Chersonesos suddenly found itself within the cultural and political orbit of the imperial city just across the sea. Although the consequences of this were not immediately felt, the city eventually acquired its own place within the

Figure 8.60
View of the northern
coastline of Chersonesos,
with excavated territory
and the 1935 Basilica in
the background.
(C. Williams)

Byzantine imperial political structure. As in the Greek and Roman periods, so in the Middle Ages it continued to be a crucial outpost on the northern periphery of the empire. At the same time the city retained its role as a key political and commercial intermediary—this time between the Byzantine Empire and the numerous peoples of the North and the East.

The early medieval period also witnessed the introduction of a new dynamic to the renamed city—that of Christianity. As a strategically important city in the Crimea, Cherson was to become a springboard for Christian missionaries to the region and peoples of the northern steppes. The city's various roles are clearly represented in the urban architectural fabric; in fact, the majority of surviving monuments visible today within the urban area of the Preserve date to the early Christian and Byzantine periods (fourth to fourteenth century), among them a large number of ecclesiastical structures.

Apart from its significance within the Byzantine Empire, Chersonesos, already a flourishing pagan city for more than a thousand years, had a continued life and momentum of its own. Its auspicious geographic location, combined with the ability of its inhabitants to adapt to new circumstances due to changes in political rule, were key to its survival. This adaptability—evident in various ways throughout its long history—is one of the most outstanding traits of the city's architectural monuments, especially those of the medieval period. Many of these buildings have been excavated during the last century and a half and, today, can be seen as individual structures, as well as components of entire city blocks.

The general framework of the earlier Greek urban landscape, which consisted of a few broad, main streets (plateiai) intersected at right angles by numerous narrower ones

(stenopoi) continued into the medieval period. This was unaltered except for some blocks, which were expanded, and in the port region, which in the later medieval period did not conform to the original orthogonal plan. Today the visitor can stroll along the track of the Hellenistic Main Street from the northeast and, proceeding westward, enter a medieval quarter, a section of which was uncovered in the excavations of 2001 and 2002. Then, continuing from the medieval Basilica within a Basilica complex and returning eastward along the cultural layer of the later Byzantine period, the visitor can be transported, one archaeological layer at a time, back to the early medieval period.

In the pre-Christian era, major public construction projects had been focused on the defense of city walls or the creation of large public spaces, such as the theater, baths, and temples dedicated to Greek and Roman gods. By contrast, the medieval builders' principal concern (aside from the defensive walls and the water supply) was the construction of Christian churches. These took the form of large-scale basilicas, smaller cruciform churches, and chapels. Some blocks, which in the ancient period consisted of one or two domestic estates, were reorganized in the medieval period so as to contain more buildings, and reconstruction projects are evident throughout the city at this time. According to written sources, the fortification walls of the city were enhanced at the end of the sixth and into the seventh century. These walls were again the focus of construction efforts in the ninth and tenth centuries. The tenth century witnessed the destruction of some churches, followed by a period of inactivity. Smaller churches were later constructed on these same sites. In the ninth and tenth centuries a new type of church emerged—the cruciform church, examples of which include the Church above the Vaulting and a church on the main square. The phenomenon of a chapel on almost every city block began in the eleventh century. The eleventh and twelfth centuries saw another period of major reconstruction efforts brought about, possibly, by an earthquake.

The following discussion about some of the best-preserved major architectural monuments of medieval Chersonesos reflects the many facets of the city's identity throughout this period of approximately nine hundred years. The brief sketch of the defensive walls (pp. 61–64) shows many stages of construction and renovation. This indicates the crucial nature of the line of defense of this northern Byzantine city, open as it was to attacks by northern and eastern enemies. The medieval residential quarter (pp. 87–88) has been treated together with the Greek and Roman quarter in the rapid survey of the urban fabric. What follows are descriptions of half a dozen of the most outstanding examples of Christian churches in Chersonesos that illustrate the significant role of Christianity in the life of the Chersonites. The presence of the churches also underscores the city's stature as the major center of Christianity in Crimea, the point from which that religion spread northward to the medieval state of Kyivan Rus' in the tenth century AD.

Uvarov Basilica

The Uvarov Basilica (variously identified as the Church of Saints Peter and Paul, the Church of the Holy Apostles, and the "Large Basilica") dates to the end of the sixth century, a period of intensive church construction in Chersonesos perhaps inspired by Justinian's movement to evangelize the empire. It was reconstructed in the tenth century and functioned until the end of the city's existence. This basilica and the buildings surrounding it—including a possible residence of the bishop of Chersonesos, a baptistery, another early Byzantine church, and an atrium with a large font—comprised the largest church complex in the city and, indeed, in all of Crimea. The main church, measuring 52.25 x 20.45 m, is a typical early Christian basilica. It consists of a central nave (measuring 31 x 11 m) with a semicircular apse at the east end where the altar was located; two narrow side aisles (4 m in width) separated from the central nave by two rows of eleven marble columns; a narthex, or antechamber (9 m in width); and an exonarthex, or covered entrance gallery (4.2 m

*Figure 8.62
Baptistery of the Uvarov
Basilica, 6th–7th century AD,
seen in a 1901 photograph
taken from the east
entrance. (NPTC
archives)*

in width). The basilica complex is named after Count A. S. Uvarov, who excavated the basilica and adjacent baptistery in 1853. Part of the apse and a corner of the northern aisle were destroyed by coastal erosion after the nineteenth-century excavations (Figure 2.5).

The decoration of this most important of basilicas was sumptuous. The floor of the central nave was paved with rectangular marble slabs, which were removed in 1855 during the siege of Sevastopol. At that time the French army, quartered on the territory of Chersonesos, dug trenches and kept its gunpowder in this location. The floors of the two side aisles, lower than that of the central nave, were covered with mosaics. A section of floor can be viewed today in the State Hermitage Museum in St. Petersburg. The geometric design of the mosaic floor consists of black, red, yellow, and white stone tesserae. The walls of the basilica were surely covered with fresco paintings.

Various celebrations and religious ceremonies occurred to the west of the basilica in a spacious atrium (25 x 15 m). This area contained a circular font for ablutions (approximately 3 m in diameter and 0.5 m deep), which was covered by a portico. Early

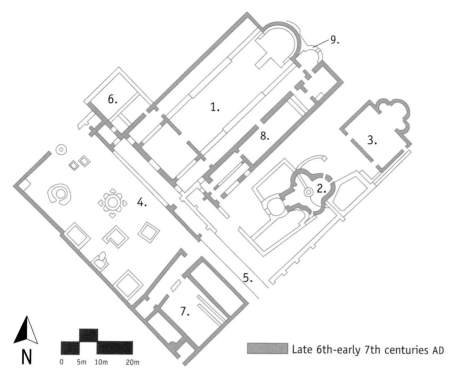

Figure 8.63 (above)
Plan of the Uvarov
Basilica based on
Yakobson and Zavadskaya,
from Alekseenko and
D'yachkov, 2001.
(J. Lane)

Late 6th-early 7th centuries AD

1. Uvarov Basilica **2.** Baptistery (5th-6th centuries) **3.** Early Byzantine church

4. Atrium (aula-original) with phial **5.** Street leading to exonarthex of Uvarov Basilica

6. Mausoleum **7.** Priest's residence **8.** South gallery with cave tomb **9.** 10th century addition

Christian atria were universal gathering places for parishioners and laypeople and sometimes included spaces for shops. By the seventh century they were no longer used, and instead, the exonarthex marked the western boundary of the church. In the Uvarov complex, however, the atrium functioned until the tenth century.

Archaeological investigation attests to the presence of ancient buildings on the site of the atrium with inner courtyards, wells, and seven cisterns. These structures were filled in or leveled during the construction of the basilica complex. An early Byzantine church consisting of one room with three apses on its eastern side, built over a cistern dating to the first centuries AD, lay to the east of the main basilica. The Uvarov Basilica may very well have stood on the site of an ancient temple precinct. The principal evidence for this is the presence of an inscription indicating a donation, by a citizen of Chersonesos, to a temple of Artemis. The inscription was found on an ancient column that was later reused in the interior of the medieval structure.

The baptistery within the Uvarov Basilica complex dates to the end of the sixth and the beginning of the seventh century, according to coins found in its water pipes. Three of its arms ended in semicircular exedrae. The eastern niche, the largest of the three, could have served as an altar space. The entranceway to the west is in the form of a square and was approached from the atrium by means of a staircase. The type of masonry construction used in the baptistery was *opus mixtum*, a technique

Figure 8.64 (right)
Drawing of the Uvarov
Basilica from the archives
of O. I. Dombrovskiy.
(NPTC archives)

102

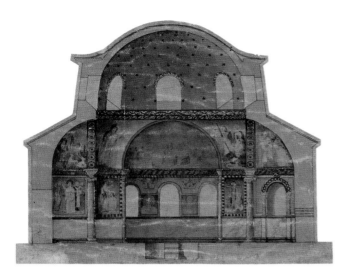

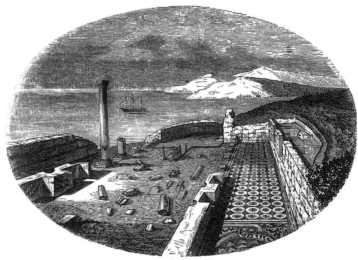

that alternates bands of brick with stone. The apses were covered with brick vaults and the central bay by a brick dome. The decoration of the building probably consisted of wall and dome mosaics; tesserae found in the area of the apse suggest that the subjects were possibly a gold cross or stars on a blue background. The central bay measured almost 7 m in diameter and was the location of a large basin (2.4 m in diameter, 0.74 m deep). This basin was carved out of the rock, and it was here that the rite of baptism took place. The sides and bottom of the basin were outfitted with marble sheathing. Water was channeled into the basin from an external reservoir by means of a pipe above ground and then channeled out through pipes beneath the floor of the baptistery. Three steps led down into the basin, whence the bishop or presiding priest would direct the faithful.

The Uvarov baptistery was possibly the location of the baptism of Volodymyr, prince of Kyivan Rus'. If he was, indeed, baptized in Chersonesos (called Korsun' in Slavic sources) about 989, as suggested in *The Primary Chronicle*, the rite probably would have taken place here because it was part of the cathedral, or bishop's church, and therefore the only site in Chersonesos befitting such an important ceremony. In 1997, a metal kiosk was surreptitiously lowered into place by helicopter on the foundation of the baptistery, an event that elicited vigorous protests by the Preserve, as well as the international cultural community. This resulted in a promise, as yet unfulfilled, by the Russian Orthodox Church (Moscow Patriarchate) that this eyesore would be removed.

References: Aynalov 1905; Yakobson 1959; Zavadskaya 1997.

Figure 8.65 (above left) Reconstruction drawing of the baptistery of the Uvarov Basilica, according to A.L. Berthier de Lagarde. (NPTC archives)

Figure 8.66 (above) Wood engraving of the Uvarov Basilica when it was first excavated in 1853. Parts of the mosaic now grace the floor of a room of the State Hermitage Museum, St. Petersburg. Drawing by Medvedev, woodcut by Bernardskiy. (NPTC archives)

Basilica within a Basilica

The Basilica within a Basilica complex was first discovered by Kruse and was later excavated by Kostsyushko-Valyuzhinich in 1889. Work was completed under Ryzhov in 1971–1974. The complex was built in the second half of the sixth century AD. It was destroyed in the tenth century, and a smaller church was later built within the area of the original central nave. The reason for this reduction is not entirely clear but is surely related to the general decline witnessed elsewhere—for example, the abandonment of the cistern in the ninth century. The original church was a typical three-aisled basilica measuring 23.5 m (including the apse) x 21.4 m; the width of the side aisles measures 2.7 m, while that of the narthex is 2.5 m. The central nave was separated from the side aisles by two rows of five columns each. The discovery of two more slender columns might suggest the existence of a second-floor gallery. This phenomenon of a smaller basilica's being constructed within a larger, earlier one is not unique in Chersonesos. Other examples include the Eastern Basilica, the Uvarov Basilica, the Northern Basilica, and the "1932 Basilica" (just west of 1935 Basilica).

Mosaic decoration covered the entire floor surface of the sixth-century basilica, and some original pieces still existed in situ until 2001, when they were removed to prevent further rapid deterioration. The narthex and side aisles contained geometric designs consisting of interlocking red circles on a white background; ivy with red-and-

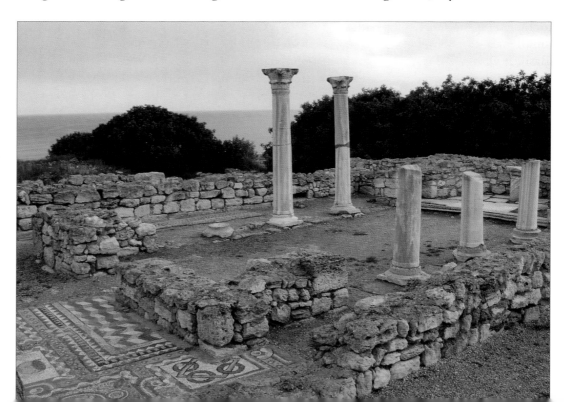

Figure 8.67
Basilica within a
Basilica, looking north to
the sea. (C. Williams)

black leaves; and images of birds, including ducks, herons, and an eagle, all arranged within circles. Other motifs included rectangles with red fruit on a light yellow background. The mosaic of the central nave extended into the threshold of the main entrance. Beyond this were rows of complex geometric designs: rhombi, triangles, squares, and rectangles, each containing a bird, the symbol of the human soul. On the sides of the raised platform in front of the altar were two registers of mosaic containing images of birds and fruit—symbols of paradise. Much of the original mosaic floor was destroyed during construction of the tenth-century church.

It is significant that the enclosed processional pathway, or *solea,* that typically extended out from the sanctuaries in the basilicas of Chersonesos followed the examples of the Constantinopolitan and Greek architectural schools. This fact, together with the existence of the atrium in most of these basilicas, leads to the conclusion that the city was under the architectural influence of Constantinople. However, small half-domes over the apses, present in the Basilica within a Basilica and the Western Basilica, may demonstrate stylistic connections with the Syrian architectural tradition.

6th century

10th century

Areas of excavated mosaic

N 0 1m 5m

Figure 8.68
Plan of the Basilica within a Basilica, based on a drawing by Ryzhov. (J. Lane)

Another instance where we see the employment of mosaic is found in one of the rooms adjoining a narrow corridor (1.4 m wide) running along the entire north wall of the basilica. This room probably functioned as a baptistery, as suggested by the existence of a small round depression in the floor that presumably accommodated a basin. The symbols represented in the mosaic decoration seem to support this notion. They include a peacock with its tail feathers extended (resurrection), doves (the Holy Spirit), and fruit (paradise). Each may refer to the rite of baptism, which according to the Scriptures, imbues the human soul with the Holy Spirit and ensures eternal life in the paradise of God's kingdom.

According to Ryzhov, the entire complex could have functioned as an early medieval baptistery, in which case the sequence of four adjoining rooms would have coincided with the first three stages of the liturgy of baptism. The narthex, as in all early Christian churches, served not only as an entrance to the church proper but also as the place where the unbaptized faithful stood during the Liturgy of the Word. Because they could not

Figure 8.69
Detail of a mosaic floor from
the Basilica within a Basilica.
(C. Williams)

directly participate in this part of the service, the catechumens would exit the main church before the liturgy of the Eucharist began, and they would subsequently listen from the narthex. During the rite of baptism, the faithful would disrobe and rub themselves with oils in the largest room of the corridor containing the basin. Then, one by one, they would proceed into the basin, over which the presiding priest would perform the rite. The ending ritual—the anointing with myrrh—took place in the room to the east of the baptismal font. Afterward, the newly baptized would don white robes and proceed to the main nave to receive the Eucharist for the first time.

The second church, built into the original nave during the second quarter of the tenth century, was paved with marble slabs. An altar comprising a fragmented column from the earlier church stood within its semicircular apse. Such altars were common in the later churches of Chersonesos. This second church, despite its relatively large size, probably served the same function as the small, omnipresent chapels that were built within each city block beginning in the tenth century. There were, as noted, multiple burials around and under the floors of these small churches. A typical example is the chapel on the Main Street opposite the main cistern. One burial or charnel pit (of three) contained the skeletons of eight individuals and the remains of 56 others. A similar grave is visible in the Basilica within a Basilica, in this case located just south of the main entrance into the narthex. A cross, inscribed in a semicircle, can be seen on the western side of this grave.

Later additions to the Basilica within a Basilica complex included a row of twelve rooms abutting the north wall of the basilica. These may have been shops or storage rooms. An open portico articulated by five columns stood adjacent to these rooms. Another chapel with its own burial vault was constructed on the south side. No attempts were made to rebuild this structure after it was destroyed by fire in the thirteenth century, probably in the same conflagration that ruined so much of the city.

References: Berthier de Lagarde 1893; Ryzhov 1997.

1935 Basilica

The 1935 Basilica, located in the northern region of the city, has become one of the symbols of Chersonesos, the National Preserve, and, indeed, Ukraine. Its white marble columns set against the blue waters of the Black Sea have been photographed, etched, and engraved in a large number of compositions. Among the more successful renderings are those by contemporary Ukrainian artist Yuriy Khymych (p. xv). Surely the most familiar image is that which appears on the Ukrainian one-hryvnya note. Excavations were first begun in 1935 by Belov, continued in 1957 under Belov and Strzheletskiy, and were most recently resumed between 1994 and 1998 by the Black Sea Project, a joint Ukrainian-American expedition under the sponsorship of the National Preserve of Tauric Chersonesos, Zaporizhzhya State University, and Macalester College.

The building functioned as a Christian basilica from the late sixth century until the end of the tenth or the first half of the eleventh century. Excavations have revealed evidence of a synagogue on the site dating to the end of the fourth century or the early fifth century. Plaster pieces from a wall fresco contain Greek and Hebrew inscriptions, one of which appears to read: "The one who has chosen Jerusalem [... will bless] Hananiah the Bosporos ... Amen Amen Sela." The inscription resembles dedications found in synagogues throughout the Roman and Byzantine Empires. In the foundation of the sixth-century basilica's apse was found a reused limestone slab (measuring 27 x 33 cm) with a menorah in relief, flanked

Figure 8.70
The 1935 Basilica,
named for the year that
its excavation began, has
become a symbol of the
National Preserve.
(C. Williams)

by a lulab (palm branch) and a shofar (ram's horn). Two Jewish lamps were also found in the vicinity. The images and inscription make it apparent that a Hebrew-speaking Jewish community existed at Chersonesos during the late antique period.

The decoration of the building included a mosaic, dated to the end of the fourth century AD by two coins found inside it. The latest of the two was minted during the reign of Theodosios I (379–395). The mosaic is embellished with geometric designs and representations of a double-handled crater, chalices with two bunches of grapes, and ivy leaves. Fragments of fresco painting, including the inscriptions mentioned above, also date to the fourth or fifth century. (This assessment is based on carbon 14 dating of the organic matter in the plaster.) These fragments are on display in the Byzantine Gallery of the Museum. The fresco includes geometric and floral motifs, as well as images of a pheasant and a peacock. Bordered below with painted panels and, above, with a plaster cornice decorated with palmettes, it offers a rare glimpse at the decoration of a synagogue from this period.

In the late sixth century, a new structure was erected on the site of the destroyed synagogue. This was the first period of large-scale basilica construction in Chersonesos, as seen in the examples of the Uvarov Basilica, the Basilica within a Basilica, and the Western Basilica. As in late antiquity, so in the early medieval period the Chersonites imported marble in substantial quantities from Prokonnesos in the Sea of Marmara (Propontis)

and used it in many architectural details, including the columns of the 1935 Basilica. The building measured 32.8 x 18.5 m and had a central nave (9 m wide), two side aisles (each 3 m wide), and a single, semicircular apse. Colonnades consisting of six columns separated these aisles and are still visible today. The narthex measured 4 m wide, the exonarthex 4.3 m wide. A section of the mosaic floor in the north side aisle preserves the motif of a fir tree. In the south side aisle the mosaic was ornamented with three rows of interlocking circles, while that in the narthex was bordered with ivy leaves. The surviving mosaics have been removed, but they can be viewed today in the long gallery located along the central promenade to the sea, approximately midway between the main Museum building (containing the Byzantine Galleries) and the nineteenth-century St. Volodymyr's Church. Some idea of the original appearance of the basilica is conveyed by the reconstruction (*anastylosis*) of the columns and a portion of the west wall of the narthex.

Figures 8.73 and 8.74 (left and below) Ukraine's pride in its cultural heritage is evident in the drawing of the 1935 Basilica found on the one-hryvnya banknote. The 1935 Basilica may be the most photographed monument on the National Preserve. (G. Mack)

The floor of the central nave was paved with marble slabs, which consist of the reused sides and ends of relief-decorated sarcophagi. These date to the Roman period and include two subjects. The first is that of Herakles in the scenes of three of his labors: the abduction of the cattle of Helios, the theft of the golden apples of the Hesperides, and the capturing of Kerberos (Figure 10.68). The second group contains the mask of Dionysos and members of his retinue, including the goateed satyr and winged cupids.

By the eleventh century AD, the large church had been converted into another city-block chapel. The later building retained the basilican form, with its minute central nave and two side aisles filling the footprint of the earlier church.

References: Belov 1938; Zherebtsov 1963; Zavadskaya 1996.

Western Basilica

The Western Basilica (36 x 19 m) was excavated by Kostsyushko-Valyuzhinich at the end of the nineteenth century and by Surov between 1958 and 1960. It dates to the middle of the sixth century AD and may have been part of a monastery. It took the same form as the basilicas described above. A central nave (29.3 x 9.5 m) was separated from two side aisles (each 4 m wide) by two rows of ten columns each. The apse at its eastern end was semicircular on the inside and pentagonal on the outside. A narthex (19 x 4 m) and an exonarthex closed the western end. An atrium outside the exonarthex, similar to the one within the Uvarov Basilica complex, contained a well. The side aisles were paved with mosaic floors, while the central nave was paved with small marble square slabs (0.26 m on a side). The floor of the solium

Figure 8.75
Western Basilica, from the south. (G. Mack)

was also paved with marble slabs, arranged so as to surround a mosaic circle. Within it the earlier excavators found a cross-shaped depression containing fragments of a marble reliquary. A baptistery was constructed immediately northeast of the basilica. This was later used as the burial place for high-ranking clergy.

The basilica is located close to the western defensive wall of the city. Its apse is only about 10 m away from the wall, which at that point measures about 3.5 m wide and contains a square tower (7 m on a side) constructed from an earlier, circular tower. The Western Basilica, then, would have been the first structure to be seen upon entering the western city gate. Its conspicuous location probably contributed to its destruction. In all likelihood, it was destroyed in 989 during the siege of Chersonesos by Prince Volodymyr; it was here, in the western region of the city, that fighting was concentrated. The most recent excavations have revealed a crypt in the defensive trench abutting the city wall. The crypt was active

from the seventh to the tenth century, and in it were found the remains of thirty-one skeletons, all under the age of thirty, and each showing traces of disease, trauma, or signs of deformity. This suggests that the southern gallery of the basilica had been used as a hospice for the sick. Other possible functions for this area include an

archive, a scriptorium, or a monastic school. The gallery was divided into several rooms and was entered from the south side aisle. It was terminated to the east by an apse, which was semicircular on the interior and rectangular on the exterior. A later reconstruction transformed the easternmost room into yet another chapel.

Immediately north of the basilica a square annex terminated to the east in a wide semicircular apse. This area contained a ten-sided (decahedron) cavity (0.83 x 0.65 m) in the floor. This feature was revetted in marble and probably functioned as a baptismal font. A single step led down into the basin, which was clearly too small to have accommodated multiple baptisms. As with the Uvarov Basilica, there were graves dug into the floor. More burials were discovered within a small cross-shaped church less than 3 m to the north of the basilica. This church had a mosaic floor and was probably contemporary with an adjacent mausoleum. On top of some of the cover slabs of the graves, notably those at the entrance and against the south wall, stood *mensae*, or altar tables, used for memorial meals.

References: Kostsyushko-Valyuzhinich 1893, 1902; Zavadskaya 1998.

N

0 2 5 10m

Hellenistic and first centuries AD

6th century AD

Kruse Basilica

The Kruse Basilica was one of the first churches to be excavated in Chersonesos. It was uncovered in 1827 by Lieutenant Karl Kruse under orders from the commander of the Black Sea squadron and governor of Sevastopol, Admiral Aleksey Greyg. It is located on a bluff overlooking the port, at the crossroads of two ancient main streets. The basilica is considered by some to be one of the earliest Christian churches built in Chersonesos. It was constructed of large limestone blocks, rubble, and lime mortar. The date of its construction, however, is problematic, and scholars' estimates range from the fifth to the seventh century AD. A central nave, flanked by two aisles, ended in a large triconch to the east. This type of construction featuring a trilobed eastern apse was rare in late antique architecture. In medieval Chersonesos the only other example was the apse of the small church of the Uvarov Basilica complex.

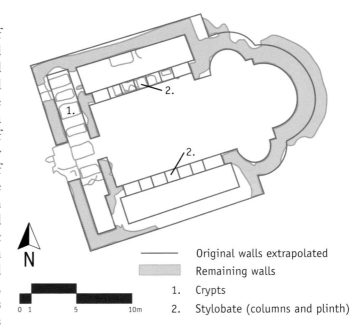

*Figure 8.78 (right)
Plan of the Kruse
Basilica, based on a
drawing by Yakobson.
(J. Lane)*

*Figure 8.79 (below)
Only the apse of the Kruse
Basilica, first excavated
nearly two centuries ago,
is still visible. (G. Mack)*

N

	Original walls extrapolated
	Remaining walls
1.	Crypts
2.	Stylobate (columns and plinth)

0 1 5 10m

Kruse did not finish excavating the church because of an outbreak of cholera in Sevastopol. Later, Kostsyushko-Valyuzhinich found various architectural members, including capitals, cornices, a sculptural fragment of a marble dove, remains of a Greek inscription, and marble slabs from the templon screen, or chancel barrier, embellished with carved crosses. As with the other churches at Chersonesos, it was reconstructed during the tenth or eleventh century on a smaller scale. Also like those churches, a number of graves were dug into the floor of its narthex, as well as the area immediately outside the building. It probably functioned until at least the mid-thirteenth century AD.

References: Aynalov 1905; Yakobson 1959.

Reliquary Church

The Reliquary Church was built within the ancient theater, which after the fourth century AD, was used as a landfill. The date of the building is problematic, with possibilities ranging from the sixth to the eighth century AD. It is so named because of a reliquary found during the 1897 excavations by Kostsyushko-Valyuzhinich. This object took the form of a small silver chest (13 cm long, 8.5 cm wide, 11 cm high) contained within a brick-lined cavity in the floor near the altar (Figure 4.1). The presence inside the chest of bones wrapped in silk (i.e., intact relics) supported the belief that the vessel functioned as a reliquary. Its long sides are decorated with embossed medallions containing busts of Christ flanked by Saints Peter and Paul and, on the opposite side, Mary between two archangels. Saints Sergius and Bacchus are depicted on the shorter ends. The lid is covered with four crosses. The reliquary dates to the reign of Justinian I (527–565), as attested by the emperor's monogram and control stamps on the bottom of the container and underneath its lid. Other churches in Chersonesos certainly sheltered similar reliquaries, but unfortunately, archaeologists were not the first to discover them.

*Figure 8.80
Reliquary Church on the site of the ancient theater.
(G. Mack)*

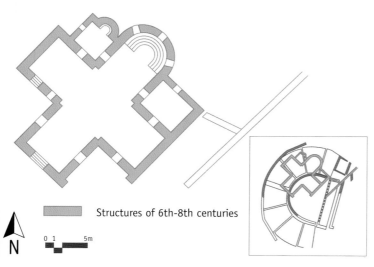

Structures of 6th-8th centuries

0 1 5m

N

Figure 8.81 (above) Plan of the Reliquary Church with the outline of the Greek theater beneath based on a drawing by Dombrovskiy. (J. Lane)

Figure 8.82 (above right) Foundation of the Reliquary Church atop reconstruction of the theater. (C. Williams)

Figure 8.83 (right) Baptismal font from the Reliquary Church, in situ. (G. Mack)

The church itself was cruciform in shape, with vaulted arms of equal length (5.94 m), except for the eastern one, which was longer (7.92 m), and terminated in an apse. The central bay was originally vaulted as well. The northern wall of the church survives to a height of 4 m, or about half its original height. One entered from the west through a wide door articulated by a massive stone threshold. The building was situated directly upon the curved rows of seats of the ancient Greek theater, which had been built a thousand years earlier.

The semicircular apse contains a *synthronon,* that is, a four-stepped bench reserved for priests that follows the curvature of the walls and follows closely the curve of the original theater seats of the third century BC, which it directly overlies. A sacristy was located immediately south of the apse. In the northern part of the church are a prothesis table and a small basin carved out of a single piece of limestone. The latter was used either for the washing of ecclesiastical vessels and utensils or for the baptism of infants. An aperture in the bottom of the basin served to drain water, which was then funneled into a well outside the church. The front surface is carved in low relief with stylized representations of cypresses or palm fronds and, above them, small crosses. The church survived the cataclysmic fire of the thirteenth century AD but ultimately burned down the following century.

References: Kostsyushko-Valyuzhinich 1900; Yakobson 1959.

114

Cave Church

The Cave Church is located in the northeast region of Chersonesos, on the Main Street in the third insula north of the nineteenth-century St. Volodymyr's Church. It is thought to be the first of the early Christian monuments constructed within the still predominantly pagan city. Its subterranean construction, therefore, may reflect the relative insecurity of the new converts and their desire to remain out of the public eye. It is the only Christian cave church in Chersonesos. In spite of numerous reconstructions and the reorganization of the third insula, this church was never demolished, rebuilt, or abandoned, as was so often the case. Rather, it seems to have been the object of special veneration and care, and this is probably the strongest argument for its designation as the earliest surviving church in the city.

Members of the Odesa Society of History and Antiquities discovered the church in 1888 during excavations. Theories about its chronology differ: some scholars date it to the first centuries AD; others, as late as the fifth century. It was not until the tenth century, however, that a chapel was erected above the church. Only a part of the apse of this building has been preserved.

The Cave Church was cut from the bedrock. It was gaunt and rectangular in plan, with three niches or conches on its sides. It measures 8.34 x 4.65 m. A narrow staircase led down into the church; its ceiling was cut from the rock, while its lower walls were finished in wood. It is possible to discern cuttings in the rock; these likely were meant to receive the wooden beams of the ceiling.

In Grinevich's view: "The apse-shaped niches were possibly places for shrines with remains of martyrs. The underground church was preserved as a sacred place with an above-ground, superimposed double, which repeated its forms." Yakobson hypothesized that it was a subterranean mausoleum. Some scholars have related the Cave Church to St. Basileios, one of the seven holy bishop-missionaries to Chersonesos. According to his *Life*, Basileios arrived in the city in the fourth century AD and hid himself from the pagans "in a cave inside the city." He was discovered in this cave by the parents of a dead boy, and after miraculously raising their child from the dead, the saint continued to live in the cave until his martyrdom. A recent study concludes that the cave was a memorial church, a monument to one of the saints of Chersonesos.

References: Mogarichëv 1999; Belyayev 1989.

Figure 8.84
Cave Church, just off the Main Street. (G. Mack)

Figure 8.85
Plan of the Cave Church based on drawing by Yakobson. (J. Lane)

N

0 1m 2m 5m

Church Outside the City Walls

A cross-shaped church outside the city walls of Chersonesos was the *katholikon,* or main church, of a small medieval monastery located in the necropolis, in the Karantinnaya (Quarantine) Ravine (p. 94). Stone walls enclosed Christian tombs, a chapel, residential and household rooms, a well, and an underground passageway leading to the church. The first excavation was organized in 1902 by Kostsyushko-Valyuzhinich, and Dombrovskiy conducted supplementary investigations in 1956.

Figure 8.86
The Church Outside the City Walls is south of Chersonesos near the Hellenistic necropolis along Quarantine Bay. (G. Mack)

At the turn of the fourth and the beginning of the fifth century AD, a small basilica was constructed on the site. The cruciform memorial was erected above the remains of this earlier building sometime between the fifth and sixth centuries. This later building had a typical cross-shaped form, with no eastern apse and an entrance at the terminus of each of the four crossarms. It was a centrally planned church, the altar of which was situated precisely in the middle of the building. In the second quarter of the sixth century, it was reconstructed according to a more conventional plan: three of its four entrances were filled in with rubble at this time, so that only the western entrance survived. A synthronon was also constructed in the eastern arm of the cross, and an altar and a *diakonikon,* or sacristy, were added. The conch of the sanctuary apse was decorated with polychrome smalt (dense glass) mosaics. The walls were covered with multicolored fresco paintings, a fragment of which contains an image of a young saint. This is on display in the Byzantine Galleries.

Mosaic floors were the main adornment of the church. The central section of the mosaic composition contains symbols of the Eucharist. Grapevines and peacocks issue from

Original walls extrapolated
Remaining walls

Figure 8.87
Plan of the Church
Outside the City Walls
based on a drawing by
Yakobson. (J. Lane)

a *kantharos*, or chalice, upon which pigeons rest. The same motifs are repeated in the south arm of the church. In the north crossarm there was a geometric pattern consisting of various repeating motifs that recall numerous ornamental patterns found in other Christian shrines of Chersonesos. In the west crossarm are a series of medallions featuring birds, fishes, fruits, flowering branches, and other elements. These mosaics are made up of white Prokonnesian marble, marmorized limestone, black sandstone, yellow Sarmatian limestone, and smalt. In 1953, the mosaic floors were transported to the courtyard of the Preserve of Chersonesos, where they can be seen today (Figure 11.8).

There can be little doubt that the second phase of the Church Outside the City Walls, with its luxurious mosaic floors and fresco paintings, was the building known from literary sources as the "beautiful house of the Mother of God of Blachernai." In these accounts the building was "within the necropolis of saints, one stadion [ca. 200 m] from the blessed city of Cherson." This church was famous as the burial place of Pope Martin I, who died in exile in Chersonesos in AD 655 and whose sepulchre was a center of pilgrimage. The church's name recalls the Virgin's most celebrated shrine—the fifth-century church of the Panagia of Blachernai, in Constantinople. This building had given its name to the peripheral region of the capital city, where an imperial palace also stood, and it was famous throughout the empire.

References: Kostsyushko-Valyuzhinich 1904; Yakobson 1959; Dombrovskiy 1993.

Figures 8.88
Detail of a mosaic from
Church Outside the City
Walls. The mosaic floor
from the church is on
display in the main
Museum courtyard.
Enlarged version, Figure
11.8. (C. Williams)

The underwater studies along the coast of Chersonesos have recently been revived. Throughout its history, Chersonesos was inseparably linked to the sea. From its founding onward, the Chersonites were destined to explore the sea and utilize its trade routes. The sea was vital to their historical and economic development and to the fabric of their daily life. It is not surprising, therefore, to discover that the sea bottom preserves so many archaeological remnants of their existence. Because the sea level has risen by more than 4 m around Chersonesos from the fourth century BC to the present, a wider range of archaeological sites than might be otherwise expected has survived: sunken port facilities adjoining the city quarters of Chersonesos,

Figure 8.89
Photographic recording of exposed amphorae of a medieval shipwreck. (V. Lebedinski)

submerged agricultural estates in the chora, ships, and anchor stations. They embrace the entire course of the city's long history, from the Greek era and before to the late medieval periods and later.

Studies of the underwater archaeological sites in the sea area around Chersonesos began in 1928, including more than ten underwater archaeological expeditions. Recently, a joint team of the Institute of Oriental Studies of the Russian Academy of Sciences and the National Preserve began systematically to investigate underwater sites in the area adjoining the Herakleian Peninsula. The 2001–2002 expeditions were aimed at discovering and marking the position of underwater archaeological sites within the administrative region of Sevastopol. The goals encompass site identification, georeferenced locations, and computer and paper mapping of all types of underwater archaeological sites. All data will be presented in a single computer map and entered into a single, comprehensive database, which will

include previously known sites and newly discovered ones.

Major results thus far include the discovery of archaeological materials that date from the Roman and Byzantine periods. These include a Roman ship of the third century AD, sunk near the village of Kacha, and three more ships of the Byzantine period—one of the late sixth and early seventh centuries found near Cape Tyubek, the second of the late ninth or early tenth century near the village of Uchkuyevka, and the third of the tenth century AD near the western cape of Omega Bay. The shipwreck sites yielded fragments of the ships themselves and their cargoes, mainly amphorae. The condition of the seabed, down to 23 m below the surface, and the nature of the seabed are encouraging and suggest that the sites will be well-preserved and suitable for further exploration. The Roman ship is remarkable for being one of the oldest vessels yet discovered in the Black Sea.

Figure 8.90
Recording descriptions of artifacts on the ship's deck.
(V. Lebedinski)

The underwater investigations in the coastal area of Tauric Chersonesos and its chora allow us to draw conclusions about areas that were dangerous for navigation and about the nature and conditions of underwater archaeological sites. This research provides archaeological data from old and recently discovered sites, together with information regarding paleogeography and geomorphology in the context of long-term changes in sea level (regression and transgression), and it facilitates broader efforts to reconstruct the ancient topography of the Black Sea coast.

The results of the investigation thus far augur well for a great future project already in the design stages—an archaeological park situated in the territory of Chersonesos and its outlying areas. For the first time, both land-based and underwater archaeological sites will be presented within the scope of a single program by the National Preserve. Among the items on display will be ancient and medieval anchors, ship parts, and amphorae, as well as the remains of shipwrecks along the shores of the Herakleian Peninsula and adjacent areas.

References: Blavatskiy 1961; Lebedinski 2002.

Map 9.1
Schematic illustration of the 4th-century BC division of the chora on the Herakleian Peninsula based on a drawing by G. Nikolaenko. (J. Trelogan)

Chersonesos

Quarantine Bay

Yuzhnaya Bay

Streletskaya Bay

Omega Bay

Kamyshovaya Bay

Kazach'ya Bay

Mayachnyy Point

Site 32

Site 133

Site 153

Site 132

Site 151

Site 338

Site 340

Bezymyannaya

Fiolent

Mramornaya Bay

Major dividing roads

Interior plot divisions

Agricultural planting walls

Farmhouses

0 2 4 km

CRIMEAN CHERSONESOS

Chora of Chersonesos

The ancient countryside, or chora, of Chersonesos, which extended over the entire Herakleian Peninsula, consists of a large number of unique monuments of Chersonesan archaeology, farmsites, and division roads. This is the premier example of an ancient Greek countryside in the world, relatively little disturbed until very recent times. Whereas other Greek landscapes contain similar evidence of land division—most notably Metaponto in Italy—none rival the visible and impressive roads, walls, and buildings of Chersonesos. This intricate system of demarcation covers approximately 10,000 hectares (or about 25,000 acres), extending south and east from the Ancient City and including areas of modern-day Sevastopol and its suburbs. Approximately 140 ancient farmhouses (of which about a quarter have been explored by archaeologists) are scattered throughout the chora. A goodly number are located on Preserve land. Modern apartment blocks, however, actually encircle some ancient farmhouses. Excavations at representative sites, mainly "rural estates," dramatically reveal the daily life in the countryside and the chora-polis relationship, which was both economic and defensive.

An innovation of Greek colonists, the divided chora on the Herakleian Peninsula was first observed and recorded in the eighteenth century by a military engineer three years after Sevastopol had been fortified by Catherine the Great (Figure 6.1). The territory rises from sea level at the coast on the north to an elevation of about 280 m on the south, encompassing winding valleys and abundant springs. It follows the natural topography (Map 9.2), bounded by the sea and the edge of the escarpment of the Karan' and Sapun Heights above the Valley of Balaklava. Remains of dwellings and burial sites in the area confirm settlements by Bronze Age and Iron Age inhabitants at least as early as

*Figures 9.1 and 9.2
Corona satellite image of the Herakleian Peninsula in 1969, with detail of the area south of Omega Bay. The ancient plot division lines of the chora were still the predominant feature of the landscape.
(J. Trelogan from the National Reconnaissance Office)*

121

Map 9.2
*Herakleian Peninsula,
with major geographical
references for the chora of
Chersonesos.
(J. Lane, P. Lehman)*

the second millennium BC. The ferocious (according to Greek accounts) indigenous people continued to live in and around the nearer chora on the Herakleian Peninsula even after the arrival in the fifth century BC of colonists from Herakleia Pontika. The new settlers arrived first in the area of modern-day Quarantine Bay, the site of what was to become the colonial city, and gradually spread into the countryside.

This coexistence of Greek and indigenous populations is evidenced by preserved huts, kurgans (burial mounds), and burial sites on the later Greek land plots. Taurians, as they were known to the Greeks, were an agricultural population that also depended on animal husbandry. The Greek colonists who supplanted them in the coastal areas developed the land to the utmost, utilizing every available plot for agriculture. Agricultural products of

Figure 9.3
Finds from the joint
Preserve-ICA excavation
at Bezymyannaya,
believed to be of the
Kizil-Koba culture,
6th-5th centuries BC.
(C. Williams)

the chora—primarily the grape—helped sustain the colony by providing a surplus for trade. Paleobotanical research has attempted to show that the Greek farmers domesticated the local wild grape. The Greek contribution to the introduction of wine to this still-famous grape-growing region would thus have been in the form of knowledge and advanced agricultural technology. In ancient times, wine from Chersonesos, though not of the highest quality, was widely traded in distinctive Chersonesan amphorae, which have been discovered around Scythian kurgans and as far away as Rome.

The Chora in the Late Classical and Early Hellenistic Period

Greek colonists moved cautiously into the surrounding countryside. Nonetheless, a little more than half a century after the colony's foundation, they completely dominated it. By the middle of the fourth century BC, the whole peninsula was divided into plots among its Greek citizens. A checkerboard grid of paved roads lined by stone walls formed more than 400 plots of two standard sizes, measuring either 420 x 420 m or 420 x 630 m (approximately 17 or 26 hectares) and consisting of either four or six units measuring 210 m². The tendency of recent scholarship is to view the uniform division of the entire chora (organized in combinations of the basic 210 m² units) as a single continuous event, which began about the middle of the fourth century BC and essentially ended by the early third century BC. Excavations of a number of Chersonesan farmhouses by the Preserve with Russian and Ukrainian missions, and during the last decade by a joint project of the Preserve and ICA, confirm this position. In addition to the main walls and cobblestone roads that

delineated the largest plots, each land parcel was internally divided and often included extensive terracing and vineyard planting walls. Vineyard walls were spaced about 2 m apart on most plots and are dramatically evident from the air. Some have been excavated. Near the limits of the divided land, rural sanctuaries were located at Lighthouse Point, Cape Fiolent, Mramornaya (Marble) Ravine, and perhaps in Khomutova Ravine. In the year 2000, a small sanctuary of Dionysos dating to the fourth century BC was found near Lighthouse Point. Greek rural sanctuaries and burials are surprisingly rare.

Of the plots identified so far, only about one-third contained a residential, commercial, or defensive structure. The farmhouses are often quite large by Greek standards and are therefore referred to as rural estates. They, as well as the roads and walls, were constructed from the abundant native limestone. Because of the durability of this building material, many of the chora monuments are still visible to the naked eye at or near the surface. In some instances, the farmhouse walls stand 3 m high or more. During the last century, more than three dozen have been partially or fully excavated. Beginning in 1910 on Lighthouse Point, these excavations were the first in classical archaeology to focus exclusively on Greek rural life. The great authority on ancient history Mikhail Rostovtsev foresaw the wealth of evidence for social and economic history that these farmsites would provide as they revealed for the first time everyday life in the Greek countryside, and he vigorously promoted their further study. Farmhouses, however, are only part of the story.

The variety of monuments of ancient life in the countryside is rare (only Metaponto can rival it), and the degree of the preservation is unique and, indeed, miraculous. Many tracts of this vast network of paved stone roads, though now threatened by the rapid urbanization of the peninsula, are still intact. Walking along them transports one back in time, into the Greek countryside and that of other periods as well. There are chora structures ranging from the sizeable country estates to more modest farmhouses and still smaller constructions, whose purpose must have been mainly defensive. Necropoleis of the Bronze Age, Scythian kurgans, and burial mounds of other cultures rise out of the plain; many are yet to be uncovered. The extensive system of aqueducts, with underground terracotta piping that supplied water from the heights along the frontier to the city in the Roman period, has been traced for most of its course. The major goal of the planned archaeological park of the chora (p. 185) will be to recreate this original agricultural landscape in certain areas, using the original planting walls and, insofar as paleobotanical research will allow, the original species of plants.

A typical countryside estate, Site 151, is located along Yukharina Ravine, 8 km southwest of Chersonesos. It was excavated by a joint Preserve-ICA project (1994–1996) and conserved (1996–2001). At an elevation of about 90 m above

Figure 9.4
Third-century terracotta figure of a silenos from the joint Preserve-ICA excavation at Site 151. h 36 cm. (C. Williams)

Figure 9.5
Overhead view of the farmhouse at Site 151 in the chora. The well-preserved walls—especially those of the tower—stand as high as 2 m at some points. The site was excavated and conserved by a joint Preserve-ICA project. (C. Williams)

sea level, Site 151 occupies an intermediate zone between the northern coast, whose plots lie at sea level (or below), and the impressive heights along the southeastern edge of the chora, which rise approximately 250 m above sea level. Several farmsites in this area, including Sites 132 and 150, were partially excavated between 1970 and 1990. Work on them resumed in 2001 by the joint team. These are currently being conserved in an area of 160 contiguous hectares (400 acres) of undisturbed ancient landscape, which will be the heart of the park of the chora. Other potentially well-preserved estates, like Site 133 and the huge Site 153, remain unexcavated. Some certainly should be left that way.

The edifice at Site 151 is smaller than many Chersonesan farmhouses but is generally representative. It grew by stages, with internal rooms and divisions erected in subsequent periods within the existing perimeter of the structure. The tower was constructed first and dates to the late fourth century BC. Fortified towers of farm sites provided a commanding view over the countryside and a means of detecting an approaching enemy. The towers of Chersonesos followed the general trend of countryside defense in mainland Greece (Attica, the Argolid), the islands (Thasos), and Asia Minor. The courtyard wall and white plaster pavement were added almost immediately afterward. Room 5 was the earliest of the covered spaces outside the tower. The structures served agricultural, storage, and residential purposes, with evidence of commercial production particularly prominent, as was typical of other ancient farmhouses of the Graeco-Roman world. The tower was

designed so that one ground-floor room was devoted to winemaking and the other, better protected, to wine storage. Huge pithoi, with a combined capacity of approximately 3,000 liters, were embedded in the floor of Room 2 of the tower.

The domestic purpose of the structure, however, is also evident in finds unearthed at the site, including fine black gloss pottery and large quantities of cookware. The family lived, presumably, in the upper story of the tower, which was completed in mud brick and connected to the ground floor by a wooden stairway (whose charred supports remain in situ).

Clear indications of domestic religious cults are also present. An aedicular shrine of Herakles was carved into a single huge stone of the exterior northwest wall of the tower. It contained two clubs—a knotty one in terracotta and a stone one, together with an incense burner—all left in place when the tower collapsed, probably early in the second century BC. There were remains of burned sacrifices on the altar block below. A small incense burner in terracotta, representing the sacred marriage of Dionysos and Ariadne, and a large image of a hairy satyr, or silenos, testify to a second cult, to Dionysos—he and Herakles were the main protectors of the chora.

In a neighboring plot 200 m to the west (Site 132) lies a larger but quite similar farmhouse. Here also, the tower was probably the first part to be built. In its cellar there were pithoi for storage, a winepress, and a round pool carved in bedrock. In the courtyard there was a deep pear-shaped cistern and several beds carved in the bedrock for more pithoi, this time probably for water storage. Toward the eastern corner of the farmhouse, during the late Roman period, a round tower protected access to the farm.

The Chora in the Late Hellenistic Period

Chersonesos during the third and second centuries BC experienced increasing pressure from barbarians (probably the late Scythians) on the nearer chora and its far-flung possessions on the Tarkankut Peninsula to the northwest. This is clearly reflected in alterations to structures in the nearer chora, as well as the "farther" one. At Site 151, for example, the courtyard and tower gates were narrowed and buttressed, and one side of the tower was given a sloping base meant to deflect battering rams (known in the literature as an "anti–battering ram" buttress). Clearly, attack, even siege, was anticipated and most likely occurred as the once nomadic Scythians adopted Greek technology in warfare. The farmhouse was briefly abandoned in the third century BC; finally, the tower was breached in the second century. This struggle destroyed the wider Chersonesan empire and led to temporary barbarian occupation of the nearer chora. The ancient city walls were reinforced. In desperation, Chersonesos turned to Mithradates VI Eupator, king of Pontos and new ruler of the Bosporan Kingdom, who sent his general Diophantes and successfully defeated the enemy in the late second century BC. A result of the Bosporan presence can be seen in the increased size of the towers and the defensive nature of the farmhouses of the nearer chora on the peninsula. In the mid-first century BC, a large army composed of late Scythians, Sarmatians, and possibly Taurians attacked

Figure 9.7
Reconstructions of a farmhouse at Site 151 in the late Hellenistic period, reflecting the appearance of the site in the various phases of its occupation. (C. Holiday)

320 BC · 250 BC · 210 BC

and started fires in the chora. According to one documentary source, some negotiations were held with the Scythian king, and a peaceful reconciliation was achieved. This marked the end of the Hellenistic period for Chersonesos, as it gradually moved under the protective aegis of Rome.

The Chora in the Early Roman Imperial Period

Figure 9.8 (right)
Altar from farmhouse
340. This small limestone
slab depicts the female
deity Parthenos. The only
completely preserved
picture of the main
protector of Chersonesos,
this folk art is probably
based on the canonical
image in the agora of the
ancient city. Courtesy of
L. Kovalevskaya.
(C. Williams)

Archaeological investigation clearly shows a partial revival of agricultural estates after Scythian incursions, though their number was considerably smaller than in the previous period. Located on the eastern slope of Sarandinakina Ravine, in a frontier area of the chora, farmhouse 338 (Figure 9.9) is an example of the rural buildings of this period. A square tower (13.5 x 13.5 m), strengthened with "anti-battering ram" buttresses on four sides, occupied the north corner of this rectangular structure. The tower probably was two-storied, like farmhouse 151, with living quarters located in the southwestern and southeastern parts of the courtyard. This establishment exemplifies the instability of political conditions in the chora in the early Roman era, from the late first century BC to the early third century AD. An extensive set of handmade ceramics of the first-century AD Scythian type, designed for everyday use, proves that at least some of the formerly Greek estates were populated by the late Scythians. From time to time, the raiders were successful. The barbarians apparently took one part of the chora and settled not far from the city, living in Greek fashion—in houses of the previous owners they displaced. Stabilization of the situation in the history of the chora of Chersonesos came with the appearance of the Roman military contingents in the Crimean Peninsula. The permanent presence of the Roman detachments (*vexillationes*) and the construction of Roman military strongholds in Charax, Balaklava, and Kazach'ya (Cossack) Hill began in the early second century AD. The presence of experienced and

Figure 9.9
Reconstruction of a
1st-century BC farmhouse
at Site 338, done as part
of a Preserve project with
the University of
Warsaw.
(L. Kovalevskaya and
J. Kaniszewski)

well-trained soldiers was a great support for Chersonesos in its struggle against the neighboring barbarian world in this period. Both the city and its chora achieved renewed prosperity. The building of rural estates was revived in the nearer chora as its agricultural potential was restored. The economy of the chora, however, changed significantly in the Roman period. Although grapes continued to be raised, wine was not exported on the same scale as earlier, and many vineyards were converted to cattle pens and even necropoleis. The number of farmhouses was a third smaller than it had been in the early Hellenistic period. As a result of the modified economy, the external limits of agricultural plots were altered somewhat, but the original checkerboard pattern of the chora remained. The architectural appearance and functional settings of the buildings of this period are distinguished by a greater variety, but the overwhelming majority of them retained the look of the Greek rural estate with some features characteristic of this period, such as round towers like those found in farmhouse 132.

*Figure 9.10
Reconstruction of a
Roman observation post
at Cossack Hill, mid-2nd
to early 3rd century AD,
done as part of a Preserve
project with the University
of Warsaw. (T. Sarnowski
and J. Kaniszewski)*

A new type of building not previously known in the chora of Chersonesos did appear at this time. It consisted of round towers up to 9 m in diameter, two or three stories high, located both in the central part of the Herakleian Peninsula and in its frontier zone. The Roman observation post at Cossack Hill is a prime example of a distinctly military type of construction (Figure 9.10).

Ceramic pipes, as noted above, supplied the city with clear spring water from the southern heights. The waterworks have been traced and excavated at several points—for example, in the Sevastopol city park known as Maksimova Dacha. The aqueducts operated for more than 500 years until they were abandoned sometime before the ninth century, when the cistern in the city was closed. The water from the western side came into the city through the pipe starting from Yukharina Ravine. But even under apparently serene circumstances, the barbarian menace remained real. The dwellers of the agricultural satellite settlements around Chersonesos turned for help not only to the palpable power of the military but also to the gods, as in the Greek period. The traditional cults of Herakles and especially of Parthenos, along with that of Dionysos—the main patrons and protectors of city and chora—received a special reverence. A relief from an altar (Figure 9.8) with an incised representation of Parthenos, the supreme patron goddess of Chersonesos, from the second century AD at farmsite 340 in Yukharina Ravine is a good example.

Crimean War Trench
Crimean War Berm
Hellenistic period
Roman period
Late Roman/Byzantine
Byzantine
----- Excavation area (2000)
............... unknown period

*Figure 9.11
Plan of superimposed
Greek, Roman, early
Byzantine, and
Crimean War structures
at Bezymyannaya done
as part of a Preserve
project with ICA,
showing site development
during those historical
periods. Based on plan
by S. Thompson, N.
Andrushchenko, T.
Bazhanova. (J. Lane)*

N

0 1 5 10 20m

The Chora in the Late Roman and Early Byzantine Periods

Larger forces came to bear during the third to the sixth centuries. A new stage in Crimean history may be related to the migration of the Alans and Goths and, later on, of the Huns. For the nearer chora of Chersonesos, the critical point was the presumed, but perhaps only partial, departure of the Roman army. The later Roman period was marked by tragedy. Traces of great fires in many estates and Roman strongholds date to the end of the first third of the third century AD. Life seems to have ceased almost completely for a while. Fourth- and fifth-century buildings are extremely rare. Small, round residential constructions with typical nomadic tents, or yurts, appeared, representative of the newly arrived nomadic tribes, who practiced cattle breeding and lived in small settlements. The center of Chersonesos, nonetheless, maintained relations with other centers, trading mainly for foodstuffs.

Besides a few isolated, fortified farmhouses and towers and the yurts, some villages flourished. Their locations in low-lying coastal areas near bays may indicate that not only fishermen but possibly also salt miners lived there. Salt, mentioned in written sources as a prominent business in Chersonesos during the first century BC and first or second century AD, probably continued to be an important commodity. Who lived in those villages—Greeks or barbarians? The names of the Roman period reflect the process of barbarization of the Chersonesan chora. Along with Chersonites, many non-Greeks

Figure 9.12
View of the Bezymyannaya
excavation and its
strategic position on the
heights above the city and
bays. Dacha encroachment
in the chora continues as
the number of undisturbed
ancient sites decreases
every year with new
construction.
(C. Williams)

Figure 9.13
Roman coin, silver
denarius, from the joint
Preserve-ICA excavation
of Bezymyannaya
depicting Emperor
Severus Alexander,
AD 222–235.
Obverse (left): Laureated
bust, surrounded by an
inscription IMP CM
AVR SEV ALEXAND
AVG, all within a dotted
circle. **Reverse** (below):
Jupiter standing, holding
a thunderbolt and scepter,
surrounded by an inscription
PM TR III COS PP,
all within a dotted circle.
(C. Williams)

were part of the local population. Objects found in the villages and funerary paraphernalia in burials in the abandoned vineyards could have belonged to indigenous and barbarian populations, permanently living in the nearer chora.

In the late Roman and early Byzantine periods, the job of defense apparently required additional structures on sites whose primary function was not agricultural but military. An exceptionally large site, known as Bezymyannaya (Nameless Hill) on the Karan' Heights, looks out from the southern boundary of the chora across the Zolotaya (Golden) Ravine, or Valley of Balaklava, toward the Crimean Mountains on the south coast. Since 1997 it has been the object of a large-scale multi-disciplinary investigation by the joint Preserve-ICA project. Its strategic position, overlooking the best land approach to Chersonesos (and modern Sevastopol), is obvious. It was a major battleground twice in modern times—during the Crimean War and World War II. The walls of a nineteenth-century Turkish or French fort covered successive settlements that range in date from the sixth century BC to the eleventh century AD, when pottery was still produced. Additionally, the valley below witnessed the "Charge of the Light Brigade" in 1854.

Figure 9.14
Crimean War wall at Bezymyannaya, built of ancient stones. According to General Totleben's maps, this was a Turkish redoubt. Archaeology confirms its use in both the Crimean War and World War II. This is the first Crimean War site that has been scientifically investigated. (J. Carter)

The original Hellenistic Greek fort occupying an earlier indigenous Taurian settlement was replaced by a fortified settlement in the Roman period, revealed by excavated finds, and a late Roman and early Byzantine fort, in which substantial architectural remains were found. This site, perhaps more than any other, encapsulates the vicissitudes of the chora during the whole of its life. In all the key periods, as the pottery clearly shows, it was in close touch with the city of Chersonesos.

The Medieval Chora

The medieval chora, from the sixth to the eleventh century AD, inherited the ancient system of roads and made use of part of the bordering walls in some cases, as well as the buildings themselves, especially the towers. A dozen medieval houses were built on the site of classical farmhouses outside the city walls in Bermana Ravine. At Kamyshovaya (Reed) Bay on the northwestern corner of the Herakleian Peninsula (Site 32), buildings used from the fourth century BC to the eleventh century AD have been excavated. Here, as at Bermana Ravine, the evolution of one of the regions of the chora of Chersonesos from the early Hellenistic villa to the medieval habitation can be traced. The medieval complex was a small settlement of communal nature, 70 x 50 m with a small church, a tower, a few houses, a courtyard enclosure, a storage area, and a commercial bakery.

At this point in the settlement history of the Herakleian Peninsula, there were six monastic complexes, both above ground and in caves. They included small monasteries, serving as warehouses of relics related to the activities of Christian ascetics. One such

monastery was located on a small island in Kazach'ya (Cossack) Bay; another, near the necropolis outside the city walls on the shore of Quarantine Bay (Figure 8.87). The latter has been plausibly connected with the Roman pope Martin I, who was exiled to Chersonesos in the seventh century AD.

Separate caves of the anchorites, or religious hermits, are another religious phenomenon of the Middle Ages present in the chora, together with small cave monasteries, the appearance of which is related to the spread of *hesychasm*, a method of monastic prayer and contemplation commonly associated with hermits or anchorites, throughout late medieval Taurica (Crimea). Two monastic cave complexes were located on the precipitous southwestern coast of the Herakleian Peninsula: on Cape Vinogradnyy (Grape) and below the active St. George Monastery near Fiolent. One more cave monastery—including a main three-tier complex with a church, a refectory, a large household basement, and a group of separate cave rooms spread along slopes—was located in the central part of the Herakleian Peninsula in Sarandinakina Ravine.

Figure 9.15
Medieval cave church of
St. Andrew "the first
called," part of the
St. Clement Monastery
at Inkerman, still in use
by Orthodox monks.
(Yu. Danilevskiy)

Chora Summary

The city and chora of Chersonesos coexisted during the whole of their long histories, interacting closely with each other, as studies of the material remains and the pottery, in particular, demonstrate. The Greek period has been the most fully studied and is the best understood period of the chora, but progress is being made in the pre- and post-Greek periods. There is continuity and change in the Roman period, as the indigenous and newly arrived barbarian elements made their presence felt. The deepest change was certainly the transformation from an agricultural to a largely pastoral economy. In the medieval period, religion, though ever-present, was more deeply felt and seen in the proliferation of monasteries throughout the Herakleian Peninsula. As has been noted before, there are few archaeological sites that embraced such a long and varied history, saw so many important changes, and yet survived in a recognizable form—both the city and its inseparable chora.

The magnitude of the investment of manpower and financial resources in the development of this highly structured farming industry, especially during the Greek period can hardly be exaggerated. Few other ancient agricultural areas in the world have left such abundant traces of their social and economic organization. What is being done now to protect this unique patrimony?

Figure 9.16
Hellenistic farmhouse at Site 10, 4th–2nd century BC, surrounded by apartment blocks. As Sevastopol grows, more chora sites will inevitably rest beneath modern foundations.
(NPTC archives)

To preserve the existing monuments of the chora, the Preserve, with the support of ICA and the Packard Humanities Institute, has proposed plans to incorporate outlying areas under its control into a unified archaeological park. Although the military secrecy of Sevastopol may have hindered archaeologists in earlier explorations of the peninsula, it also served to protect the ancient remains near the coastline and other sensitive areas. Many rural sites have been ruined or face imminent danger of obliteration because of the expansion of Sevastopol into previously rural areas of the chora. Another concern is the continual erosion along the coastline, estimated at almost 250 m since Greek colonization. A combination of traditional archaeological methods with modern technology at Chersonesos, such as remote sensing and geographic information systems (GIS), continues not only to define the unique patterns of human settlement in the chora, while underscoring the contributions of the rural population to any civilization, but also to monitor these unique monuments for posterity against threats, both human and natural. The chora of Chersonesos is a unique world cultural treasure that truly merits this immense effort.

References

Rostovtzeff 1941; Strzheletskiy 1961; Pecirka 1970; Pecirka and Dufkova 1970; Chtcheglov 1992; Saprykin 1994; Konecny 1997; Nikolaenko 1999, 2001; Carter et al. 2000.

Greek and Roman Galleries

The present exhibition of the Greek and Roman Galleries was established in 1968 under the direction of archaeologist Stanislav Strzheletskiy and designer V. Shuriga in a fine high-ceilinged nineteenth-century building conceived in the classical style. It is devoted to the history of Tauric Chersonesos during its ancient period—from the second half of the fifth century BC to the second half of the fourth century AD. There is a short section devoted to the pre-Greek population of the chora of Chersonesos. Items from late antiquity to the Middle Ages are displayed in the Byzantine Galleries. The Greek and Roman Galleries cover major stages of Chersonesos's independent existence, first as a Greek colony and city, then as an ally of the Roman Empire, reflecting links with the neighboring Scythian and Sarmatian tribes from the northern Black Sea region. The galleries contain the most significant and interesting finds from the excavations of the ancient city, chora, and environs, including epigraphic and numismatic collections, works of art, and objects of everyday life.

Among the highlights are the Civic Oath of Chersonesos carved on a marble stele of the late fourth or early third century BC and a pebble mosaic with a representation of two bathing women from a luxurious dwelling of the early Hellenistic period. The galleries also house a large, unique collection of painted grave stelai and architectural elements from an early Hellenistic necropolis of the fourth and third centuries BC, including the life-size representation of a young man, one of the few surviving masterpieces of Greek painting. The strength of this collection is an emphasis on daily life in ancient times. First-rate works of art are interspersed with craft and agricultural tools and organic remains.

Figure 10.1
Warehouse of Local Antiquities, one of the first exhibits of the Greek Gallery in 1892 established by director Kostsyushko-Valyuzhinich. (NPTC archives)

The Civic Oath of Chersonesos

I swear by Zeus, Gaia, Helios, Parthenos, the Olympian gods and goddesses, and all the heroes who protect the polis, chora, and forts of the people of Chersonesos. I shall act in concord with my fellow citizens on behalf of the protection and freedom of the polis and its citizens. I shall not betray to anyone whomsoever, whether Greek or barbarian, Chersonesos, Kerkinitis, Kalos Limen, the other forts, and the rest of the chora, which the people of Chersonesos inhabit or inhabited. But I shall carefully guard all of these for the demos of the people of Chersonesos. I shall not put down the democracy.

I shall neither rely upon nor help conceal either traitor or subverter, but I shall reveal them to the magistrates in the city. I shall oppose anyone who plots against, betrays, or revolts from Chersonesos, Kerkinitis, Kalos Limen, the forts, and the chora of the people of Chersonesos. I shall hold the office of *damiorgos*; I shall be, to the best of my ability and with the greatest fairness, a councilor to the city and its citizens. I shall guard carefully the *saster* for the demos; and I shall not reveal to either a Hellene or a barbarian any secret that is likely to harm the city. I shall neither offer nor accept a gift to harm the polis and its citizens.

I shall not contrive with evil intention against any citizen who has not revolted from Chersonesos; I shall neither rely upon one who plots against the city nor conceal anything from anyone, but I shall

lay an impeachment and determine the matter by vote according to the laws. I shall pledge my oath to a conspiracy against neither the commonwealth of the people of Chersonesos nor any citizen who has not been shown to be an enemy of the demos. If I conspire with anyone and am bound by oath or solemn curse, may it be better for me and my possessions if I am reconciled to the state, but the opposite if I stand fast to the conspiracy.

I shall report to the magistrates any conspiracy that I perceive to exist already or to be forming. Neither shall I sell grain suitable for exportation that comes from the plain, nor export grain from the plain to another place, except to Chersonesos. Zeus, Gaia, Helios, Parthenos, and the Olympian gods, as long as I abide by these covenants, may it be better for me, my family, and my possessions. But if I do not abide, may it be ill for me, my family, and my possessions; may neither the earth nor the sea bear their fruit for me; may the women not be happy in children. [. . .]

—Translated by T. Lytle

Figure 10.2
Civic Oath of Chersonesos. The inscription reveals much about the economic and social life of the polis, about the religion and customs of the inhabitants of Chersonesos. Hellenistic period, early 3rd century BC, locally inscribed on imported marble, 139 x 42 x 13 cm. Excavations of Kostsyushko-Valyuzhinich, 1890–1891. (C. Williams)

Sculpture—Greek Period

Figure 10.4 (left)
Head of Karyatid. Marble. A Doric abacus rests on a cushion and a wide headband. This type is close to the Karyatids of the Erechtheion on the Athenian Acropolis. The Karyatids inspired grave monuments in Asia Minor (e.g., Limyra). This example is more nearly like its Athenian counterparts. Late classical or early Hellenistic period, h 34 cm. From Tower of Zeno, Strzheletskiy, 1961. (C. Williams)

Figure 10.5 (below)
Marble relief fragment. The figure of an Amazon in high relief may have come from the right corner of a small pediment. She wears the high-belted chiton typical of Amazons and appears to hold a compound bow in her left hand. A pillow, perhaps made from an animal skin, cushions her against her rocky perch. The relief is remarkable for its extensive use of landscape and its three-dimensionality. It is a product of the early Hellenistic period by a sculptor, perhaps from Asia Minor, 39.5 x 29 x 16.5 cm. Löper, 1908. (C. Williams)

Figure 10.3 (above)
Headless male torso preserved to knees. Limestone. Weight resting on left leg. The upper torso is covered by a snugly fitting chiton; a belt runs diagonally from the right shoulder to the waist. The lower part of the body is draped in a thick himation with the end thrown across the outstretched left arm. The right arm and the left hand, as well as the head, were perhaps separately carved. Similar figures have been found on Rhodes and Kos in contexts of the later Hellenistic period. Local production, h 28 cm. Löper, 1909.a (C. Williams)

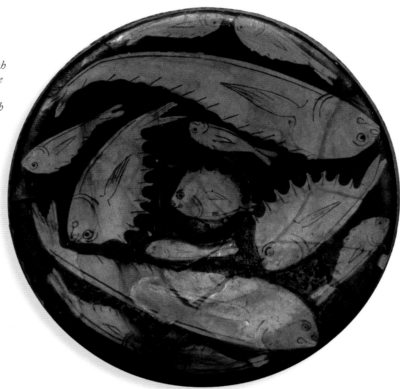

Figure 10.6 (right)
Red figure fish plate, imported from Attica. Thirteen fish of at least four different species on the upper surface. The central depression for sauce is completely filled with a perch. The vertical edges (not visible) are decorated with an ovolo pattern. Early Hellenistic period, d 24.5 cm. Kostsyushko-Valyuzhinich, 1903. (C. Williams)

Figure 10.7 (left)
Attic pelike in the Kerch style, with typical use of white overpainting (intended for the Black Sea market). This complete vessel is a good example of the work of a painter of Group G (Boardman). It represents the combat of Arimasp or Amazon and griffin. Late 4th century BC, h 21.5 cm, d 13.6 cm. Gidalevich collection. (C. Williams)

Figure 10.8 (right)
Attic red figure krater fragment. The upper part of a running ivy-crowned satyr or silenos with left hand extended to grasp a nude female lower right leg and foot. His right hand held a thyrsos. Late 4th or 3rd century BC, h 8.7 cm. Kostsyushko-Valyuzhinich. (C. Williams)

Figure 10.9 (right)
Fragment, inside center medallion of black gloss drinking cup, made in imitation of prototype in silver representing a kiss (Eros and Psyche?). 3rd–2nd centuries BC, h 10.5 cm. Löper, 1909. (C. Williams)

Figure 10.10 (above right)
Dark gray gloss interior of cup bottom. Facing female busts in high relief, of the Hellenistic period, 3rd–2nd centuries BC, d 7 cm. Belov, 1931. (C. Williams)

Figure 10.11 (below)
Cult vessel, decorated with molded heads of maenads(?), the companions of Dionysos. The heads were separately applied. Hellenistic period, 3rd century BC, local production, h 39 cm. Kostsyushko-Valyuzhinich, 1902. (C. Williams)

Figure 10.12 (left)
Black gloss hydria with overpainted decoration in white. The decoration is similar to that on Attic and south Italian Greek pottery of the early Hellenistic period, but this may be from a center in Asia Minor or a local product. This vessel contained the golden "Herakles' knot" diadem (see Figure 3.1) and earrings from burial vault 1012 in the city wall. First half of 3rd century BC, h 51 cm. Kostsyushko-Valyuzhinich, 1899.

Figure 10.13 (upper left)
Terracotta statuette of a Greek divinity, variously attributed to Nike, Thanatos, and Iakchos. The high headdress (polos) is unusual. The figure, in a diaphanous chiton that reaches to the feet, is framed by huge folded wings. The quality is unusually high. Remains of reddish brown and pink paint are visible over the white undercoat. First half of 3rd century BC, Asia Minor, h 11.5 cm. Löper, necropolis, 1912. (C. Williams)

Figure 10.14 (left)
Votive half-figure of a goddess in terracotta. This bust, wearing a crested helmet and with her right arm raised as if brandishing a spear, may well represent the protectress of the city, Parthenos. Early Hellenistic, local production, h 20.5 cm. Löper, 1913. (C. Williams)

Figure 10.15 (right)
Mold-made terracotta dancing girl, depicted with her right hand extended to the side and her left foot forward; wearing a chiton and himation, with round earrings, on a circular base. Painted terracotta (reddish brown paint over white undercoat). Such figures were produced all over the Greek world. The discovery of molds of similar figures in Chersonesos workshops strongly suggests that this is a local product. Hellenistic period, h 21.5 cm. (C. Williams)

Figure 10.16 (above)
Fragmentary terracotta statuette of Pan, god of forests and woods and patron of herds, sitting on a rock and playing a syrinx. The right shoulder and back are covered with a goatskin. Extensive remains of red paint are present. This ambitious and successful large-scale composition is without obvious parallels from other Greek centers. It argues for the creativity of Chersonesos's terracotta artisans; nor is it the only example of their skill with big works. 3rd–2nd centuries BC, local production, h 29 cm. Kostsyushko-Valyuzhinich. (C. Williams)

Grave Monuments—Greek Period

The grave stelai of Chersonesos as a group, with rare exceptions, differ from those of other Greek centers in that the human figure is not represented—only symbols are used to indicate the deceased's sex, age, and social status. These are sometimes carved but always painted. The typical symbol of women is a looped *tainia* or sash, sometimes with a suspended alabastron in blue. Young men are represented with a red strigil and a yellow aryballos; the mature male with a shield, sword, and sword belt, always carved and painted, or with a grape-pruning hook. The symbol for old men is a knotty walking stick, always painted. The painted stelai and other funerary monuments were discovered in the Tower of Zeno in 1961 and originally published by Strzheletskiy, Danilenko, and others. The tower was built in such a hurry that, as the building material was systematically collected from the necropolis, the markers of a family plot ended up in the same row of stones in the tower, united in death, again, a second time. The stelai and other remains offer a unique opportunity to reconstruct family burying groups from their monuments. Recent work by ICA, Richard Posamentir, and a new group of collaborators has done much to interpret and advance the earlier work.

Palmette Anthemion

This complex and finely carved palmette anthemion, at right, like other less remarkable examples, almost certainly crowned a grave stele. The upper surfaces of a class of stelai with mortises were clearly prepared to receive such elements. This is the most elegant and best-preserved of the surviving examples. The background was a bright blue, the floral decoration a reddish brown with some yellow. This design is indistinguishable from a group of anthemia in Athens. The local limestone proves that it was carved in Chersonesos, probably by an itinerant Athenian sculptor.

Figure 10.17
Anthemion used as the crowning element of a stele, in the form of a palmette rising from acanthus leaves with blue in background, and yellow and reddish brown on the leaves. Early Hellenistic period, late 4th–early 3rd centuries BC. Produced from local limestone, it shows the strong influence of Athenian funerary art of this period. The double palmette is not common, even in Attica. 56 x 37 x 17.5 cm. Strzheletskiy, 1961. (C. Williams)

Figure 10.18
Stele of Megakles, son of Sannion, characterized as a mature warrior; inscription is carved and painted. Limestone. Sword in a scabbard and sword belt, hung on a small nail, flanked by two rosettes. Relief decoration retains pigment: yellow, black, blue, and red. Early Hellenistic period, late 4th century BC, local production, maximum 92 x 37 x 16 cm. Strzheletskiy, 1961. (C. Williams)

Stelai of Megakles and Sannion

One of the best preserved of the warrior stelai is that of a son of Sannion, Megakles (Figure 10.18). It has been tentatively associated with a base with the best-preserved painted decoration in the current Museum display. The moldings of the base copy those of the stele itself—an ovolo with alternating blue and green eggs against a red ground above, and a cyma reversa with alternating black and green leaves against red below. Recent research shows that the attached base belonged to another fragment and has also identified the lower part of the original stele slab. Megakles' sword belt is carved in relief, with the projecting handle tip and round tip of the scabbard in the round. A black painted nail, rendered perspectively, appears to hold the belt to the surface of the stele. This concern with realism is found on many of the stelai, not just the military ones. The sword and the aryballos of an athlete's stele alike have weight and required in the artist's view a visible means of support. Megakles' reddish purple scabbard had dark blue clamps with red tassels, as revealed under ultraviolet light. In the center is a rectangular area painted orange in contrast to the handle and the hilt, which are yellow. The projecting round tip of the scabbard was also painted yellow. The inner ring of six petals of the frontal rosettes is painted yellow on a black background. In the outer ring, eight wide petals alternate in dark blue and red.

It was tradition for a son to be called by his grandfather's name. Here it is likely that the warrior Megakles on the left was the son of the same Sannion on the right, whose father's name was also Megakles.

Figure 10.19
Stele of Sannion, son of Megakles. Limestone. Representation of a knotty walking stick between two rosettes. The inscription was carved and painted. Sannion was evidently an older man. The upper mouldings represent the horizontal cornice of a naiskos (colors: red, black, and yellow). Early Hellenistic period, late 4th century BC, local production, 127 x 36 x 14 cm. Strzheletskiy, 1961. (C. Williams)

Stelai of Hero, Daughter of Eumareios and Hermodoros, Son of Alkimos

These finely carved and painted stelai have the symbols typical of a young woman (tainia or sash and alabastron containing perfumed oil) and of a young man (strigil and aryballos), both carved and painted. The inscriptions were carved and colored dark blue. This fact and the identical form of the rosettes and tool marks prove that both were from the same workshop. The young people may have been a betrothed couple.

Figure 10.20 (left)
Stele of Hero, daughter of Eumareios. Limestone. Carved and painted sash and alabastron hung on a cord, with two rosettes and an inscription. Colors are red, blue, and yellow. Early Hellenistic period, late 4th century BC, local production, 105 x 30 x 16 cm. Strzheletskiy, 1961. (C. Williams)

Figure 10.21 (below)
Fragment of Attic red figure cup. Youthful athlete, nude, seated, with a strigil in his right hand. First half of 4th century BC, w 4.3 cm. Löper, 1912. (C. Williams)

Figure 10.22 (below right)
Strigil for scraping oil from the skin after a bath. Iron. Hellenistic period, h 15.5 cm. Kostsyushko-Valvuzhinich. (C. Williams)

Figure 10.23 (above)
Stele of Hermodoros, son of Alkimos. Limestone. Rosettes in relief; a strigil and an aryballos (oil bottle), both hanging on a cord over a nail. Colors are red, dark blue, light blue, and yellow. Early Hellenistic period, late 4th century BC, local production, 67 x 28 x 15 cm. Strzheletskiy, 1961. (C. Williams)

Stele of the Doctor's Son

This is the only known example of a Chersonesan grave stele representing human figures, a pair of nude males in a gesture of solidarity and farewell. The figures are painted only in monochrome red brown with shading. The stele is also unique in having more than simply the name of the deceased and the patronymic (father's name), and sometimes that of the husband. The elegiac couplet set off from the scene in a once-colored panel reads: "To his son, the deceased Leschanoridas, his father Eukles, the doctor from Tenedos [an island in the Aegean opposite Troy], built this tomb."

Figure 10.24 (left)
Stele of Leschanoridas, son of Eukles. Limestone. Two nude figures with a verse inscription (above). Representations of medical tools appear to hang from the cornice above the men: forceps, pincers, and phlebotomizing or "cupping" jar. Contour painting (red and yellow ochre). Early Hellenistic period, late 4th–3rd centuries BC, local production, 115 x 37 x 14 cm. Antonova, 1968–1969. (C. Williams)

Figure 10.25 (below)
Medical instruments. Bronze. Roman period. 2nd century AD. From a burial in the necropolis, Löper, 1910. (C. Williams)

Figure 10.26 (above)
Stele of Kinolis, son of Pasichos. Limestone, top section. Low relief of a knife (probably for the pruning of grapevines) and an inscription. Colors: blue and red. Early Hellenistic period, late 4th– early 3rd centuries BC, local production, full stele 200 x 37 x 22 cm. Strzheletskiy, 1961. (C. Williams)

CRIMEAN CHERSONESOS

Figure 10.27a
Head of a youth on a stele fragment,
polychrome representation on
limestone. Late 4th century BC,
36 x 57.5 x 14 cm, length of face–
20.2 cm. (C. Williams)

Figure 10.27b (below)
Composite of nine infrared images
of the head in 2001. (J. Twilley)

Head of a Youth, circa 325 BC

Among the large-scale paintings from the Tower of Zeno, the head of a youth stands out. The head, the top of the left shoulder, and the arm of a young man survive—on the right, perhaps, a spear. The light illuminates the subject from the right and above. The powerful neck of an athlete turns three-quarters to the right; the head tilts slightly upward toward the right. Drapery folds cover the shoulder but leave the arm bare.

Five colors were used on the surviving fragments: red, yellow, black, green, and blue. Beside the presumed spear were traces of light and dark blue. The hair is brown, thicker in the shaded areas and turning to reddish-brown in the lighted areas. The folds of drapery were drawn with black outlines; the cloth itself is painted a light pinkish-orange that turns crimson on the shaded edge at the neck. The eyes are especially good, and in them are the substance and sense of the whole painting. The clear, steady gaze is directed at space above and beyond the observer. The face conveys serenity, thoughtfulness, nobility.

The head is a work of an anonymous master—let us call him the Chersonesos Master. Even after the discovery of the Macedonian tomb paintings at Leukadia and Vergina, the head by the Chersonesos Master can and will take its place among a handful of the finest works of Greek painting to survive from the early Hellenistic period.

Figures 10.28 and 10.29
Principal long face of limestone sarcophagus recomposed from five
fragments, and detail. Its total length is 198 cm; the thickness of
the slabs is 20 cm, and the container was originally 125 cm wide
and stood 40 cm high. The upper cornice consists of a painted
dentil frieze above a meander, both three-dimensionally rendered.
The recessed panel in the center has battling real and mythological
animals against a dark blue background. The lower edge is
recessed and painted solid red. Strzheletskiy, 1960–1961.
(Photos and imaging, C. Williams, M. Zappi Paine)

Sarcophagus

Decorated sarcophagi in wood and stone were often
used for elite burials in the Greek-occupied areas of
Crimea, at Pantikapaion at the eastern end of the
peninsula, as well as Chersonesos at the western tip.
This is the only stone sarcophagus (among a half
dozen or more Chersonesan examples) where much
of the painted decoration survives: sirens against a
blue ground on the vertical elements at the ends,
and a horizontal frieze of fighting mythological
animals (griffins) and real animals (deer, bulls)
in gold against a deep blue background. The
perspectively rendered meander and dentil friezes
are unusually sophisticated.

CRIMEAN CHERSONESOS

Figure 10.30
Sarcophagus reconstruction, color wash made at the time
of discovery (1961) by A. Snezhkina and A. Kozlov.
(NPTC archives; montage by C. Williams, 2002)

Ionic Cornice

Several dozen fragments of this richly decorated Ionic cornice, belonging to a single building, were recovered from the Tower of Zeno. Of the two types of Ionic cornice to survive, this is the more original with a more variegated color scheme. The quarter-round moldings at the base are decorated with alternating spiral stripes of reddish brown and yellow. The eggs of the ovolo, alternately in blue and yellow against a reddish purple background, are separated by darts, outlined, and divided by spearlike leaves that were originally black. The color of the fascia above the ovolo was a yellow-pink, mixed from red and yellow, on a white primer. The cyma reversa above the fascia was decorated with yellow Lesbian leaves against a red ground. Above the projecting hawk's beak and fascia, left unpainted, is an ovolo, with yellow eggs on a reddish purple background over a white primer. The crowning element was a cyma recta in dark blue with a reddish purple fascia along its upper edge. This must, indeed, have been part of a very eye-catching monument—a *naiskos*, or enclosure for stelai.

Doric Cornice with Acroteria, as a Relief Sculpture

Figures 10.31 (opposite) and 10.32 (left)
Straight section of an Ionic cornice and corner element. Limestone. Early Hellenistic period, 4th–3rd centuries BC, local production, 42 x 53 x 14 cm, corner element- 14 x 23 x 15 cm. Strzheletskiy, 1961. (C. Williams)

Figure 10.33 (below)
Doric cornice of a small funerary naiskos with painted coffers on a soffit. 18 x 41 x 20 cm. Strzheletskiy, 1961. (C. Williams)

Doric Cornice with Perspectively Rendered Coffers

The colors of the details of the exterior Doric frieze of triglyphs and mutules in blue set off by a red tainia and the illusionistic coffers of the soffit, of contrasting blue, red, yellow, and brown have parallels—for example, in Athens. The colors themselves have rarely, if ever, survived—only the outlines of where color was.

Figure 10.34 (opposite and left)
Two sections of an entablature of a funerary naiskos or some other type of monument. Limestone; bright blue triglyphs on frieze, red on horizontal tainia beneath them, yellow on acroteria at the ends. Hellenistic period, 3rd century BC, local production. Left piece, 89 x 20 x 21 cm; right, 61 x 20 x 21 cm. Strzheletskiy, 1961. (C. Williams)

Figure 10.35
Cameo, Egyptian faience (vitreous-glazed molded sand), decorated with opaque colors: green, blue, yellow, and orange. Parrot on a branch. Engraving in high relief, Roman period, d 2 cm. Kostsyushko-Valyuzhinich. (C. Williams)

Figure 10.36
Carnelian (dull red variety of chalcedony). Reverse: Name of a god Abrasax, patron of planets. Intaglio, Roman period, 3rd century AD, 1.6 x 1.0 cm. Kostsyushko-Valyuzhinich, necropolis, 1907. (C. Williams)

Figure 10.37
Jasper. God Pan. Intaglio, Roman period, 1.7 x 1.2 cm. Löper, necropolis, 1913. (C. Williams)

Figure 10.38
Cameo, milky-yellow opaque stone. Head of Medusa. Relief, Roman period, 1.5 x 1.4 cm. Kostsyushko-Valyuzhinich. (C. Williams)

Figure 10.39
Sardonyx. God of medicine, Asklepios, with a snake winding around his staff. Intaglio, Roman period, 1.5 x 1.2 cm. Accidental find near Chersonesos, 1963. (C. Williams)

Figure 10.40
Carnelian. Goddess of luck, Fortuna, with a cornucopia. Intaglio, Roman period, 1.2 x 1.1 cm. Accidental find in Chersonesos, 1972. (C. Williams)

Figure 10.43 (left)
Bead necklaces and bracelet. Carnelian, glass, faience. Roman period, first centuries AD, imported and local materials. (C. Williams)

Figure 10.44 (right)
Glass decorative plaque. Head of Medusa (Gorgo). Glass is dark and opaque, Roman period, 3rd century AD, h 1.6 cm. Kostsyushko-Valyuzhinich. (C. Williams)

Figure 10.41
Carnelian. God Hermes, messenger of the gods and patron of trade, holding a purse and caduceus. Intaglio, Roman period, 0.9 x 0.7 cm. Kostsyushko-Valyuzhinich. (C. Williams)

Figure 10.42
Carnelian. Goddess of retribution, Nemesis, making a sacral gesture and holding a bridle. Intaglio, Roman period, 1.4 x 0.9 cm. Kostsyushko-Valyuzhinich. (C. Williams)

Figure 10.45 (above)
Necklace of eyebeads imported from the eastern Mediterranean. Roman period; largest bead, d 2.8 cm. (C. Williams)

Figure 10.46 (above right)
Composite bracelet. Black opaque glass, Roman period, 3rd–4th centuries AD, bead d 1.1 cm. Kostsyushko-Valyuzhinich. (C. Williams)

Figure 10.47 (left)
Head of young Dionysos. Marble. Dionysos' head is framed with voluminous hair entwined with grapevines and leaves. Possibly a copy from a Hellenistic original, 2nd century AD, h 12.5 cm. Löper, 1909. (C. Williams)

Figure 10.48 (right)
Head of Herakles. Marble. Fragment of a statue, vaguely like Farnese type, supposed to reflect an original by Lysippos. The wrinkle on the bridge of the nose and the skin folds on the forehead and cheeks and under the eyes emphasize the age of the mythical hero. Possibly a copy of an early Hellenistic original, 2nd century AD, h 13 cm. Kostsyushko-Valyuzhinich, 1907. (C. Williams)

Figure 10.49 (right)
Aphrodite with two Erotes. Marble. Aphrodite is standing seminude. A sleeping Eros sits to her right, and to her left another Eros stands on a dolphin, holding a garland of flowers. 2nd century AD, imported (most likely, from Roman provinces on Danube), h 27.5 cm, w 20.5 cm. Accidental find in chora of Chersonesos, 1978. (C. Williams)

Figure 10.50 (left)
Head of a more mature Dionysos or Ariadne, his bride. Marble. To her left, remains of a wreath (leaf and grapes); to the right, the coiffure has the appearance of that of an archaic kore. Probably first half of 2nd century AD, Asia Minor, h 10 cm. (C. Williams)

Bronze Sculpture—Roman Period

Figure 10.53 (above)
Bronze matrix in relief for stamping metal votive plaques. Dionysos, in an aedicular shrine flanked by grapevines. The god holds a thyrsos in his left hand and a kantharos, another of his symbols, in his right. One of his panthers rears up in the lower left corner. 2nd century AD, *perhaps from the Roman province of Lower Moesia, the origin of much of the Roman garrison, h 13 cm, w 9 cm. Accidental find near Chersonesos, 1966. (C. Williams)*

Figure 10.51 (above)
Bronze horse. Spirited, walking horse on a rectangular base cast in bronze. 2nd–3rd centuries AD, *Pontic region, h 5.5 cm. Borisova, 1955. (C. Williams)*

Figure 10.52 (right)
Cast bronze statuette of Asklepios. The doctor, who became a god and a patron of the medical profession, wears a himation. He stands like a miniature cult statue on a proper base, his left hand holding a staff with an entwined snake for support. 1st–2nd centuries AD, *Eastern Roman provinces, h 9.4 cm. Belov, 1931. (C. Williams)*

Figure 10.54 (above)
Two-handled cup, red slip with applied "barbotine"
ornament. 1st century AD, Asia Minor, h 7 cm.
Strzheletskiy, 1962. (C. Williams)

Figure 10.56 (left and above)
Both sides of a table amphora for wine with
extensive, molded relief decoration, red slip.
Asklepios with staff stands near the shaded
cylindrical altar; Hygieia with a snake and a
small figure of Telesphoros (a healing deity)
surrounded by trees occupy the reverse. 2nd
century AD, from Knidos, h 17.5 cm.
Strzheletskiy, 1956. (C. Williams)

Figure 10.57 (right)
Lamp, red slip. Rosette in the
middle and two snakes in relief
along the sides. 2nd century AD,
Asia Minor, d 8.5 cm, 4.8 cm.
Kostsyushko-Valyuzhinich,
necropolis, 1907. (C. Williams)

Figure 10.55 (above)
Red slip oinochoe, handle decorated with a
molded flat medallion, graffito of Greek letters
around the belly. 3rd century AD, local production,
h 12.5 cm. Löper, necropolis, 1910.
(C. Williams)

Coarseware Ceramics—Roman Period

Figure 10.58 (below)
Unusual cinerary urn. Handmade one-handled, flat-bottomed jug. Hands emerge from the handle with open fingers on the belly, and a wavy rope relief decoration around the base of the neck. Complete except for a chip on the lip. 3rd–4th centuries AD, h 30 cm. Strzheletskiy, necropolis, 1956. (C. Williams)

Figure 10.59 (left)
Mold-made lamp. Two gladiators in combat and rosettes along edge. First half of 3rd century AD, an Aegean-type (Hayes), d 8.4 cm, h 3 cm. Löper, necropolis, 1912. (C. Williams)

Figure 10.60 (below)
Mold-made lamp. Sea creatures and Eros riding a dolphin occupy the center, while a vine and grape ornamentation cluster on the edge. 2nd century AD, Asia Minor, d 9.5 cm. From Gidalevich collection. (C. Williams)

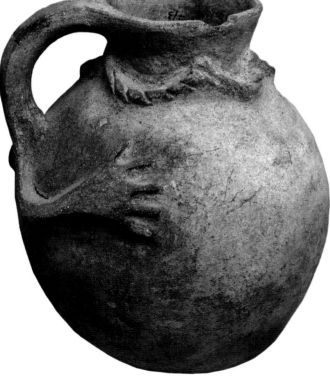

Figure 10.61
Glass bowl with a golden decorative band. The rim and walls are gracefully profiled. The chicken eggs, a potent symbol in the context of a burial, are the original grave goods and are almost as perfectly preserved as their container. Glass, transparent, greenish; mimics the shape and reflective qualities of the silver vessel that inspired it. Dated to the late 4th–early 5th centuries AD though it has the exact form of a silver bowl of the 1st century AD—an heirloom? Eastern Mediterranean, d 16.2 cm, h 6.5 cm. Strzheletskiy, necropolis, 1966. (C. Williams)

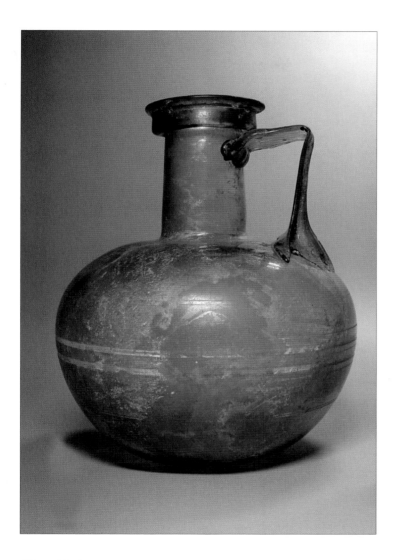

Figure 10.62
Glass pitcher with the rim turned down, cylindrical neck, spherical body,
ribbon-shaped ribbed handle, flat bottom. Free-blown glass, transparent and
polished. 3rd century AD, eastern Mediterranean, h 21.3 cm. Kostsyushko-
Valyuzhinich. (C. Williams)

Figures 10.63 and 10.64
Glass pitcher with detail of handle. Rim embossed,
bottom slightly concave. The handle is wide and flat,
with dense ribbing. Late 1st–first half of 2nd centuries AD,
eastern Mediterranean, h 14.5 cm, d 9.8 cm.
Strzheletskiy, necropolis, 1962. (C. Williams)

The funerary sculpture shown in this section illustrates the variety of styles and subject matter chosen to commemorate the deceased at Chersonesos during the first centuries of Roman hegemony on the Black Sea. The sarcophagus in the classical style, with Greek mythological subject matter, might be found in elite burials anywhere in the empire. The conflation of the labors that led to the apotheosis of Herakles—in a single panel, as in Figure 10.68—is, however, unusual. His knotty club, carved in the round (Figure 10.67), may have stood on its own as a grave marker. Equal in terms of cost, the garland sarcophagus, a widely used type, has here been adapted to include the funeral meal, so popular in the mortuary art of Asia Minor and Chersonesos. The result is not a success aesthetically, but it must reflect the buyer's taste and requirements. Always in recognizable Graeco-Roman style is the simple relief (Figure 10.70), inscribed (like the funeral meal garland sarcophagus) in Greek, which seems to revert to the convention found on the Greek stelai representing the deceased with the tools of his trade—in this case, clearly that of a warrior.

The primitive-seeming "indigenous," "barbarian," or "plebeian" style emerges in a pair of funerary busts below, as it does in many areas of the empire, including the center, Rome, beginning in the early centuries. The grave markers of the Roman garrison are naturally inscribed in Latin, though the troops themselves in many cases were not native Latin-speakers. The image of the deceased as a victorious cavalryman has a long history in Greek and Roman art. There is here, however, in the stele of Iulius Vales (Figure 10.70), an undeniable resemblance between the figure and representations of the "Thracian horseman," whose cult flourished in the western Black Sea region.

Figure 10.65 (far right) Burial marker, male bust with a pointed, bearded chin. Limestone. Schematic anthropomorphic representations. First centuries AD, h 44 cm. Kostsyushko-Valyuzhinich, 1900. (C. Williams)

Figure 10.66 (right) Limestone relief depicting a woman with a round face wearing a chiton, himation, and necklace in a primitive style. Roman period, first centuries AD, local production, 42.5 x 30 x 25 cm. Kostsyushko-Valyuzhinich, 1894. (C. Williams)

Figure 10.67 (far left)
Marble club of Herakles on an altar. Early Empire, h 80 cm.
Kostsyushko-Valyuzhinich, 1902. (C. Williams)

Figure 10.68 (left)
Slab from a marble sarcophagus depicting the three labors of Herakles.
Center, Herakles and Kerberos, with the cattle of Helios and gathering
the apples of the Hesperides. Late 2nd–early 3rd centuries AD,
100 x 95 x 16 cm. Belov, 1935. (C. Williams)

Figure 10.69 (below)
Side of the marble sarcophagus of Themistos, son of Stratonikes and
husband of Basilike. Couple reclining together, not a very common
scene; below, the following inscription: "Themistos, son of Stratonikes,
who had lived wonderfully for 70 years. Basilike, daughter of Iulian,
wife of Themistos, who had lived 50 years. Farewell." Eros on either
side, holding a garland with grapes; above, masks of Medusa. 2nd–
early 3rd centuries AD, 100 x 240 x 16 cm. Belov, 1935. (C. Williams)

Figure 10.70
Marble grave stele of Gazourios,
son of Metrodoros, partial view.
Rare example of a tombstone of the
Roman period with armor (quiver,
greaves, helmet, shield, and
sword). Inscription in Greek:
"Gazourios, son of Metrodoros,
first archon protarchonteuon, who
had lived 50 years, farewell."
1st century AD, full stele, h 85 x 60
x 12 cm. Kostsyushko-Valyuzhinich,
1892. (C. Williams)

Figure 10.71 (right)
Limestone relief of a rider on horseback, cloak flying; two figures in front, one taking the reins. Clearly
carved Latin epitaph: "To gods Manes. Iulius Vales, a cavalryman of ala (wing) Alectorigiana, turma
(squadron) of Celsios, lived 40 years. Iu[lius] Vales, the heir, erected to the well-deserving [one]." Late
2nd–early 3rd centuries, local production, 190 x 65 x 20 cm. Accidental find in Balaklava, 1980.
(C. Williams)

Figure 10.72 (below)
Limestone ossuaries and terracotta urns and amphorae for ashes. 2nd–3rd centuries AD. From Sovkhoz 10
necropolis in the region of Inkerman. Strzheletskiy, 1954. (C. Williams)

Byzantine Galleries

Chersonesos was a thriving center of Byzantine culture and civilization from the fifth to the fourteenth century. The exhibition of the medieval history of Chersonesos is located on the second floor of the administrative building of the Preserve, in the former archimandrite's (abbot's) church of the monastery. Among the best-preserved Byzantine cities in the world, Chersonesos is renowned for the significance and beauty of finds from the Middle Ages. Particularly rich are the artifacts from the thirteenth century, when the city was partially destroyed by fire that preserved many objects of organic nature (rope, fabric, seeds, and wood) in carbonized form.

In the exhibition of the first large gallery, the following themes are illustrated with objects, maps, and reconstructions: management and administration of Byzantine Chersonesos, army, religion, architecture, monumental art, economy, metalwork, ceramic production, agriculture, and crafts. The second gallery shows weaving, wood and bone carving, daily life, trade, and a large collection of crosses, some demonstrating a Slavic presence in the city. A third gallery presents objects from Chersonesos from the late twelfth to the first half of the fifteenth century that point to its progressive decline.

The city essentially lay dormant until its rediscovery in the nineteenth century. The exhibit contains stunning examples of sculpture, architectural details, icons, epigraphy, applied arts, a wide variety of tools, and decorative work in metal and bone. The collection of Byzantine ceramics is one of the finest in the world. The items on display are finds from the archaeological excavations of the ancient city and chora, beginning in 1827.

*Figure 11.1
Interior of Byzantine
Galleries with a display of
medieval ceramic
amphorae, pithoi,
and water pipes.
(C. Williams)*

Figure 11.2 (left)
Marble Theodosian capital decorated with two rows of notched acanthus leaves. 5th century AD, h 42 cm. 1935. (C. Williams)

Figure 11.3 (below)
Marble Byzantine capitals. 6th–7th centuries AD. (NPTC archives)

Figure 11.4 (above)
Detail of a marble capital with acanthus leaves. 6th century AD, h 28 cm. (C. Williams)

Figure 11.5 (left)
Detail of a marble capital with a ram's head protome. 6th century AD, h 30.5 cm. 1889. (C. Williams)

Mosaic and Painting

Figure 11.6 (right)
Fragment of a relief depicting fruit trees.
Champlevé technique: marble with red mastic
inlay. 5th century AD, 43.5 x 19.0 x 2.9 cm. 1897.
(C. Williams)

Figure 11.7 (below)
Detail of a mosaic floor with a chalice. Marble,
ceramic, limestone, and sandstone tesserae.
6th century AD. From excavations of
1935 Basilica, 1935. (C. Williams)

Figure 11.8 (left)
Center of a mosaic floor with a chalice and peacocks. Marble, limestone, sandstone, and terracotta tesserae removed from the Church Outside the City Walls (Figure 8.87) at Quarantine Bay to the Byzantine Courtyard of the Museum. 6th century AD. Dimensions of the main nave are 4.94 x 12 m and the transept measures 15.13 x 5.08 m; detail shown on the opposite page is approximately 6 x 6 m. 1902 and 1953. (C. Williams, A. Sobotkova, and R. Posamentir; photo imaging M. Zappi Paine)

Figure 11.9 (right)
Fresco fragment with a peacock and garlands. 5th–6th centuries AD. From the 1935 Basilica excavations, 1935. (C. Williams)

Figure 11.10 (below)
Fragment of a fresco painting. Image of Mother of God, probably Theotokos, with a maphorion (type of cloth cover for the head, shoulders, and chest). 9th–10th centuries AD, 58.1 x 29.9 x 16.7 cm. 1889. (C. Williams)

Figure 11.11 (right)
Ancient Rus' six-pointed cross cast in bronze. Crucifix in the center, Mother of God (Theotokos) to the right of Christ, St. John to the left has not survived. On the crossbeam, depictions of the apostles St. Peter (right) and St. Paul (left); above the crossbeam, busts of the archangels Michael and Gabriel; above Christ's head, a cross and monogram; on the upper crossbeam, four saints and a Greek inscription; hetoimasia (preparation of the throne) at the pinnacle. Slavonic inscriptions written on reverse. First half of the 13th century AD, 24.5 x 9.5 cm. 1940. (C. Williams)

Figure 11.12 (below)
Diptych. Bronze, chased, engraved, and gilded. Two crosses with flared arms under an arcade; above, flanking spiral columns with a shell motif in the niches above. 13th century AD, 26.0 x 15.0 cm. 1988. (C. Williams)

Figure 11.13 (below)
Processional cross. Iron with silver
inlay, found in 2001, southern
medieval quarters near the cistern
(p. 88). 13th century AD. (C. Williams)

Figure 11.14 (left)
Encolpion (reliquary worn around
the neck). Relief crucifix, engraved
images of saints at the terminations of
the arms. Cast and engraved bronze.
13th century AD, 8 x 7 cm. 1963.
(C. Williams)

Figure 11.15 (below)
Bronze encolpia. Signet ring with an
engraved image of a saint. Silver, cast,
engraved, and gilded. 12th–13th
centuries AD, upper right pair–
7.1 x 5.6 cm. (C. Williams)

Steatite Icons

Figure 11.16 (left)
Three Military Saints Icon. Steatite, gilding, blue paint. St. Theodore Stratelates (left), St. George (center), and St. Demetrios of Thessalonike (right); above, Christ extends a martyr's crown; busts of the archangels in medallions fill spandrels. 12th century AD, Constantinopolitan import, 17.5 x 13.4 x 0.7 cm. Belov, 1956. (C. Williams)

Figure 11.17 (below)
Icon. Virgin and Child. Steatite, identifying inscriptions flank the Virgin and child. Traces of gilding and red paint. Silver frame. 11th–12th centuries AD, 8.4 x 5.8 cm. Romanchuk, 1990. (C. Williams)

Figure 11.18 (below top)
Nativity icon. Steatite, traces of red-brown paint covered with gilt. The upper part of the fragment on right displays an angel who blesses the swaddled child. A bull and ass huddle over the child. The second fragment reveals a reclining Virgin above, and below, a scene of the bathing of the Christ child. Joseph and a bearded shepherd with a staff on the right. 11th–12th centuries AD, 4.2 x 3.3 cm. Belov, 1936. (A. Zabusik)

Figure 11.19 (below bottom)
Annunciation icon. Steatite, traces of gilding on nimbus and garments. Archangel Gabriel and the Virgin Mary, who is seated under the canopy of a ciborium holding a distaff and yarn. "Annunciation" has been inscribed under the sun, which extends a single ray to shine on Mary. 12th century AD, Constantinople. 13.4 x 10.5 x 0.7 cm. Belov, 1937. (A. Zabusik)

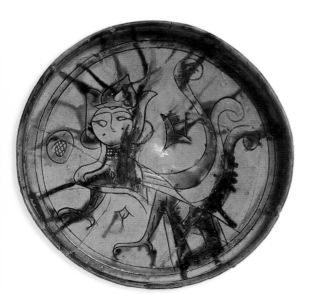

Figure 11.20 (above left)
Glazed bowl, decorated with a six-pointed star and spirals within rectangles around the rim. (More than half the vessel has been restored.) 13th–14th centuries AD, d 20.3 cm. 1940. (C. Williams)

Figure 11.21 (above right)
Glazed tureen, decorated with concentric circles, red fabric. 13th–14th centuries AD, d 20 cm. 1956. (C. Williams)

Figure 11.22 (left)
Sgraffito ware, glazed bowl with a siren (part maiden, part bird). Red fabric, light yellow glaze with yellow-brown and green color splashes. 13th century AD, d 24.0 cm. 1941. (C. Williams)

Figure 11.23 (right)
Glazed oinochoe, Zeuxippos ware, red fabric. 13th century AD, h 24.1 cm. 1894. (C. Williams)

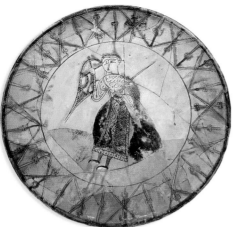

Figure 11.26 (left) Sgraffito ware, glazed polychrome plate with a warrior, saber in his left hand, a shield in his right. Red fabric, incised design. 12th–13th centuries AD, d 33.5 cm. 1987. (C. Williams)

Figure 11.24 (right center) Sgraffito ware, glazed polychrome plate. Red fabric. 14th century AD, d 26 cm. 1950. (C. Williams)

Figure 11.25 (below) Sgraffito ware, glazed plate with a lion and a snake. Red fabric, olive-colored glaze, incised design. 13th century AD, d 30 cm. 1978. (C. Williams)

Figure 11.27 (above) Sgraffito ware, glazed polychrome plate. Two crescents dividing the decorative field into four sectors. Red fabric. 13th century AD, d 29 cm. 1986. (C. Williams)

Figure 11.28 (right) Sgraffito ware, glazed polychrome plate with a lion devouring a fallow deer. Red fabric, glazing, incised design. 12th–13th centuries AD, d 34.5 cm. 1984. (C. Williams)

Figure 11.29 (above)
Carved-bone appliqués for small boxes or books.
10th–11th centuries AD, upper left square- ~5 cm. (C. Williams)

Figure 11.30 (below)
Clay mold for making imprints with an image of a Warrior
Saint, two cypress trees, and an inscription: "Blessing from St.
Lu[...]a." 5th–6th centuries AD, d 9.8 cm. 1989. (C. Williams)

Figure 11.31 (above)
Exagia (Byzantine units of weight).
Glass, One logarike litra = 12 ouggiai =
72 exagia. 5th–7th centuries AD.
(C. Williams)

Figure 11.32 (below and right)
Figured bronze locks. 10th–13th
centuries AD, top right - 4.8 cm.
Kostsyushko-Valyuzhinich.
(C. Williams)

Figure 11.33 (right)
Small bone box. Decorated with an incised ornament of rosettes on bone plates within square and triangular frames.
10th century AD, 14.5 x 26.0 x 14.0 cm.
1909. (C. Williams)

Figure 11.34 (below right)
Beads. Glass, semiprecious stones, and faience. 4th–6th centuries AD, from top to bottom, lengths of necklaces: 42, 49, 28, 16.5, and 40 cm. (C. Williams)

Figure 11.35 (below)
Glass bracelets. 10th–14th centuries AD, d 4-6 cm. (C. Williams)

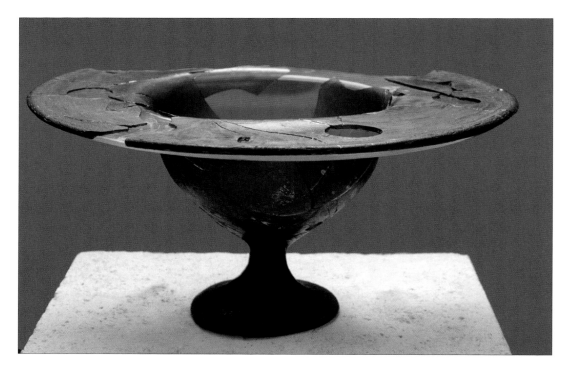

Figure 11.36
Blue glass polykandelon *(lamp stand). First half of the 5th century AD, h 12.5 cm, d 24.5 cm. Excavated near the theater, 1973. (C. Williams)*

Numismatics and Sigillography

The numismatic material of Chersonesos—coins covering nearly two millennia discovered in the ancient city and chora—allows us to trace, over an unusually long period of time, the development of the minting craft and the monetary circulation of this political and economic center on the northern Black Sea coast. Founded on the very edge of the Greek-inhabited world, the *oikoumene,* Chersonesos early in its existence became one of the most important strongholds of the Greek merchants on the northern Black Sea coast. Sigillography, the study of seals, reflects the development of Chersonesos under Byzantine administration.

During the initial period of its existence in the fifth century BC, Chersonesos did not enjoy the right to mint its own currency and, instead, used coins issued by its metropolis, Herakleia Pontika. The appearance of its own coins from the beginning of the fourth century indicates that by this time Chersonesos had completely evolved from a trade hub into an autonomous state and a polis.

Locally minted coins that depict the most popular Chersonesan deities dominated the city's monetary circulation in the fourth and third centuries BC. First among the gods was Parthenos, who, in the text of the famous Chersonesan Civic Oath, was ranked even higher than the Olympian gods. Some inscriptions describe her as a protector, guarding the city from a barbarian invasion. Coins with her image and attributes dominate the coin types throughout the early period of the polis. Only slightly less popular was that most revered of ancient Greek heroes—Herakles. However, coins with the impressions of Herakles and his attributes completely disappear from the repertoire of coin types by the end of the second century BC. Other popular coin types display images of Zeus, Athena, Helios, and Hermes on the obverse (main face) and a griffin, bull, fallow deer, or other animals on the reverse.

Appearing about the same time as the local coins, imported coins also began to circulate on the market, introduced mostly by the main trade partners of Chersonesos. These include the most important economic centers of the northern and southern Black Sea coasts: Olbia, Pantikapaion, Tyras, Amisos, and Sinope. The coins minted by cities of Anatolia and the Mediterranean region, west and east, were rarer. Cappadocia, Euboea, Apollonia (on the east coast of the Adriatic), and the main centers of Magna Grecia (southern Italy) and Sicily are represented.

Figure 12.1
Chersonesos-minted drachma, 20 mm, 210–200 BC (chronology based on Anokhin 1977, 1980).
Obverse: *Parthenos head right, a bow and quiver in background.* ***Reverse:*** *Parthenos, full body left, striking a deer with a spear. Name:* ΜΕΝΕΣΤΡΑΤΟΥ. *Below is abbreviated name of the city:* ΧΕΡ. *(C. Williams)*

Figure 12.2
Chersonesos-minted copper dichalkos, 20 mm, 310–300 BC.
Obverse: *Griffin left; abbreviated name of the city:* XEP. *Countermark: "dolphin."* (C. Williams)

Figure 12.3
Chersonesos-minted tetradrachm, 26–28 mm, 290–280 BC. **Obverse:** *Parthenos, head right; with a bow and quiver in the background. Countermarks: "dolphin," "thunderbolt," and the abbreviated name of the goddess:* ΠAP. *(C. Williams)*

Reverse: *Kneeling Parthenos, body right, with a bow and arrow, and with a name under the line:* EΥΔPOMO.

Reverse: *Charging bull left, with a club above; below, the name of a magistrate, probably the famous Agasikles:* |AΓ|AΣIKΛEO. *On top is the abbreviated name of the city:* XEP.

The study of coin technology, as well as types and weights, helps to illustrate cultural and economic ties between various regions of the Greek world. Close ties with far-off Sicily, for example, at the end of the fourth century BC are indicated by the fact that minters of Chersonesos borrowed a technique of making coin molds that was specific to the cities of Sicily and southern Italy. Some images on the Chersonesan coins minted at the end of the third century BC show the undeniable influence of the Sicilian city of Alaisa. The presence of various imported coins reveals the broad circle of trade and economic ties with Egypt and Italy in the south and west and with the entire Black Sea region, including Colchis, Tyras, and Olbia in the east and north. Coin evidence often confirms the existence of close economic relations that are also mentioned in written sources and epigraphic monuments.

The Pontic-Bosporan influence was felt in the late second and early first centuries BC. Coins of cities of the Pontic Kingdom (Amisos, Sinope, Amastria, and Pharnakeia) actively penetrated the city's monetary markets. In addition, some local coin mints imitated some Pontic coin types—for example, the eagle on a thunderbolt.

Chersonesos's spirit, ever independent, is evidenced by its coins during the time of Caesar. After 45 BC, the city adopted extraordinary minting practices, as seen in the release of golden staters. Gold coins remained relatively rare in the Greek world and were usually associated with an important event. Several years later, there followed a regular minting of low- and high-value copper coins with the inscription "eleutheria" (freedom) and the image

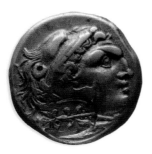

Figure 12.4
Chersonesos-minted silver tridrachm, 22–25 mm, 250–230 BC. **Obverse:** *Herakles, head right; below, a club. Countermark: "thunderbolt." (C. Williams)*

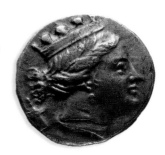

Figure 12.5
Chersonesos-minted silver drachma, 17 mm, 120–110 BC. **Obverse:** *Mural-crowned Parthenos, head right; with a bow and quiver behind. (C. Williams)*

Reverse: Parthenos, enthroned, body left. To right, abbreviated name of the city: ΧΕΡ. *To the left, a name:* -ΔΙΩΝΟΣ. *Countermark: "dolphin."*

Reverse: Hind right and abbreviated name of the city: ΧΕΡ. *Beneath, a name:* ΜΟΙΡΟΣ.

of Nike bearing a palm branch and a garland. After the death of Caesar (44 BC), however, the city lost its recently acquired independence, and under Bosporan control, its coins no longer mentioned "freedom." Celebrating its liberation from Bosporan rule, Chersonesos began a new chronology in 24 BC. Parthenos wears a "tower crown," representing the defensive walls and towers, and grasps a bow and arrows in one hand and a raised spear in the other. This became one of the main coin types during the entire period that followed. It copied, most likely, the widely known type of the "Tyche of Antioch," which had been designed to express the idea of freedom and self-rule.

According to Pliny the Elder, the Romans gave the city its freedom a second time (*Natural History*, 11, 4, 85), which was reflected in the coins. Sometime later, however, the city again fell into a state of dependence on the Bosporan Kingdom. Nonetheless, Chersonesos, beginning with Hadrian (AD 117–138), was regularly minting coins that conformed to the Roman weight standard. Local motifs were used, as a rule, for the coin types: Nike, bull, and fallow deer. The most popular image remained that of the goddess Parthenos. The divinities Asklepios and Hygieia, who were especially popular among the Roman legionaries, are found on the coins of Chersonesos. The eponymous Chersonas, who represented the well-being of Chersonesos, became extremely popular in the second and third centuries AD. During the rule of the emperors Caracalla and Elagabalus, Chersonas' image took on characteristics of the Roman rulers. Coins depicting Chersonas and the goddess Parthenos were last used by Chersonesan minters in the fourth century AD.

Figure 12.6
Chersonesan Byzantine copper coin (8 pentanummia), 31 mm, Justin II (AD 565–578). **Obverse:** Emperor with his spouse, full facing. Inscription around: |XEP|CONOC. (C. Williams)

Figure 12.7
Cast Chersonesan Byzantine copper coin, 19 mm, Basil I (AD 867–886). **Obverse:** Large letter B, standing on a base. (C. Williams)

Reverse: Standing figure, facing, holding a long staff with a chrism at top, and an orb with cross. Nominal symbol H on the right of figure.

Reverse: Cross on a two-step base, a dot on either side.

During the reign of the emperor Honorius (395–423), other historical sources indicate that Chersonesos enjoyed certain economic privileges and was allowed to trade with neighboring peoples. The large quantity of imperial coins found during excavations at Chersonesos and in the chora prove overwhelmingly that the city was actively participating in Roman trade. Mints, represented on the coins, to a certain degree introduce us to the trading partners of Chersonesos, the most important of which were Constantinople (formerly Byzantion), Thessalonike, Kyzikos, Antioch, and other centers of Asia Minor and the Mediterranean. Some coins discovered in Chersonesos were produced as far away as Alexandria, Sicily, and London. In the first quarter of the fifth century, the Chersonesan mint resumed its function, striking traditional imperial coins that conformed to the standards of the capital, Constantinople. Even so, it preserved its originality to some degree. A brilliant example is the local coin production of the fifth century, dated to the times of Theodosios II, Valentinian III, and Zeno. Quite possibly, the coins of Leo I (the Butcher) and Verina, which are found only in the territory of southwestern Crimea, can be added to this list.

By the first quarter of the seventh century AD, the city ceased minting coins and turned to casting them, until the middle of the eighth century, when the city mint ceased to exist altogether. Especially significant are the types of the Chersonesos-minted coins that have no analogies in the imperial mint at Constantinople. As a rule, these include the first

Figure 12.8
Chersonesan Byzantine copper-cast coin, 17 mm, John I Tzimiskes, coemperor (AD 969–976). Obverse: Monogram of the name of Ioannes. (C. Williams)

Figure 12.9
Chersonesos copper-cast coin, bronze, 25 mm, Romanos IV Diogenes, coemperor (AD 1068–1071). Obverse: Monogram, combining letters P and ω, first letters of the emperor's name inside a raised edge. (A. Semënov)

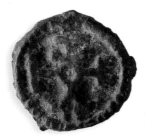

Reverse: Monogram of the title of δεσποτης (despot).

Reverse: Cross on two-stepped base, bounded by two dots, within a double-raised edge.

letters of emperors' names on the obverse, and on the reverse, images of a cross on Golgotha or monograms of the title "despot." Less frequently the portrait of a ruler might occur.

Despite the originality of its coins, the Chersonesan mint produced coins of nearly all the Byzantine emperors. The Chersonites were sensitive to the smallest changes in the ruling house. The coins represent both rightful emperors and usurpers who temporarily captured the throne, and even family members of the individual rulers. This is a further illustration of the political acumen and adroitness that ensured the city's amazing survival.

Coins from the Middle East also found their way into the Chersonesan market—for example, the Kufic fals (copper denomination) of the eighth century AD clearly indicate the existence of contacts between the city's merchants and traders beyond the eastern borders of the empire. Seljuk coins actively began to penetrate the city, becoming the most commonly used foreign currency in Chersonesos in the first quarter of the eighth century.

The disintegration of the Byzantine Empire (1204) after the Fourth Crusade and formation of the Nikean and Latin empires resulted in the production of coins of the Nikean emperors and Latin imitations. The city continued to produce its own anonymous coins with the monogram "P and ω," Greek letters rho and omega for Romanos, until the middle of the eighth century. The last of these coins probably remained in circulation on the internal market until the partial destruction of the city some five centuries later.

Chersonesos's passing into the sphere of the Trebizond Empire (1204–1461) was marked by the flow into the city of silver and copper coins of the Komnenos family. At the same time, the first Juchi coins of the khans of the Golden Horde also found their way into the city. In the fourteenth century, the Golden Horde dominated the monetary circulation not only of Chersonesos, but also of the entire Crimean peninsula. Examples of silver coins of Khan Uzbek (1313–1341), minted both in Crimea and in other cities of the Golden Horde (Saray, Ordu, Bulgar), are prevalent.

The Juchi coins were still predominant in the fifteenth century, but they were rivaled by the Tatar-Genoese coins of Caffa (Feodosiya), which became the international currency in the Black Sea region. Despite the destruction in the city, not all economic activity ceased. Discovered among the upper layers of the city's ruins were rare finds of Tatar and Turkic coins minted in the sixteenth and seventeenth centuries. These coins, without doubt, are vestiges of another page of history that point to the "majestic and famous place," Chersonesos, visited either by travelers and antiquity hunters or by neighboring groups in search of construction stone.

Figure 12.10
Byzantine hyperpyron coin, gold, 27 mm, John II Komnenos (1118–1143).
***Obverse:** Bearded Christ, nimbate bust facing, enthroned, holding a book of the Gospels in his left hand, his right hand outstretched in benediction. (N. Alekseenko)*

Figure 12.11
Ottoman silver coin, 1834, Sultan Mahmud II (1808–1839) found at Bezymyannaya in 2000.
***Obverse:** Tugra, or the sultan's official monogram, and the name of sultan. (C. Williams)*

***Reverse:** John II, bearded, standing; crowned or blessed by the Virgin Mary, who stands on his right.*

***Reverse:** Four-line inscription in Arabic: "Minted in Constantinople in the year 1223" (reckoned on the Islamic lunar calendar from the Hegira, in AD 622). On top, the year of governing: 26.*

Byzantine Seals

Sigillography is of considerable importance for research in the field of administrative-political and trade-economic development of Chersonesos during those periods when the city received special attention from the Byzantine administration. Among the lead seals, or *molybdoboulloi,* that survive from the end of the fifth to the first half of the seventh century AD are those of Justinian I, Maurice, Tiberios, Phokas, and Herakleios. The study of seals provides a glimpse into the history of Byzantine provincial elites and confirms that the Byzantine emperors took extraordinary measures to fortify Byzantine positions on the northern Black Sea coast, especially in Crimea.

From the mid-ninth to the mid-eleventh century, seals include those of the emperors Michael III, Constantine VII Porphyrogennetos, Basil II, Constantine VIII, Constantine IX, and empress Theophano. After the city was organized administratively as a theme, it began to receive increased attention from the empire. The medieval city enjoyed its highest level of prosperity during the ninth and tenth centuries AD, when it played multiple roles as a large handicraft center and trade port and as a base for the Byzantine diplomatic delegations to the northern Black Sea region, not to mention being a religious center for missionary work and conversion of heathens. Among the rich sphragistic material that survived are the seals of the officials of the imperial chancellery and treasury: the *arkarioi,* the *chartoularioi,* and the *sakellarioi.* Events that occurred between the end of the tenth and the beginning of the eleventh century—Prince Volodymyr's military expedition to Chersonesos in AD 989, the rebellion of Chersonites in AD 1016, and the incipient theme system crisis—reflect Chersonesos's changing relationship with Byzantium. The seals of Basil II and Constantine IX demonstrate that, in the first half of the eleventh century, the city remained in the Byzantine sphere of influence, and imperial interests apparently continued to dominate the affairs of Chersonesos.

Figure 12.12 Lead seal of Leon, tourmarches of Gothia, d 22 mm, end of 10th–early 11th centuries AD. **Obverse:** *Facing bust of St. Philipp, holding a scroll. On either side, a vertical inscription:*
Ο | Α | Γ |
-Φ | Η | Λ |

From the twelfth century AD, however, Chersonesos began to distance itself from Byzantium and to develop its own interests autonomously. Afflicted by its foreign problems, Byzantium could no longer exert significant influence upon the distant peninsula. Changes in imperial foreign policy toward the western Crimea elicited changes in Chersonesos's own political orientation. Literary sources report that, beginning in the thirteenth century AD, the city came under the influence of the Trebizond Empire. The seals from the fourteenth century AD of the Trebizond emperor Manuel II Palaiologos reflect intimate contacts between Chersonesos and Trebizond, the offshoot Byzantine capital of the Komnenian dynasty on the southeastern shore of the Black Sea.

Reverse: Five-line inscription, with a border of dots:
+ ΛΕΩΝΤ
ΒΣΠΑΘΑΡ
ΣΤΡΟΥΜΑ
ΡΧΙΓΩΤ
ΘΙΑΣ
(K. Zykova)

References
Wroth 1908; Zograf 1951; Anokhin 1977, 1980; Sokolova 1983, 1993; Hendy 1985; Sear 1987; Alekseenko 1990, 1996, 1997; Shandrovskaya 1990; Tolstoy 1991; Price 1993.

Figure 12.13
Lead seal of Manuel II (patriarch of Constantinople, AD 1244–1254), d 40 mm, field 36 mm, Constantinople, 13th century AD. **Obverse:** *Virgin, seated facing on a throne with a high back, holding the Child in her lap. Inscription on either side of Virgin, with a border of dots:* MHP *and* ΘΥ. *(M. Vaniosova)*

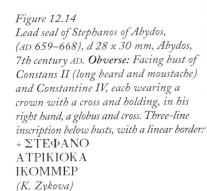

Figure 12.14
Lead seal of Stephanos of Abydos, (AD 659–668), d 28 x 30 mm, Abydos, 7th century AD. **Obverse:** *Facing bust of Constans II (long beard and moustache) and Constantine IV, each wearing a crown with a cross and holding, in his right hand, a globus and cross. Three-line inscription below busts, with a linear border:*
+ ΣΤΕΦΑΝΟ
ΑΤΡΙΚΙΟΚΑ
ΙΚΟΜΜΕΡ
(K. Zykova)

Reverse: *Inscription of seven lines with many ligatures and a border of dots:*
+ ΜΑΝΟΗΛ
ΕΛΕΩΘΥΑΡΧΙ
ΕΠΙΣΚΟΠΟΩΝ
ΣΤΑΝΤΙΝΟΠΟΛΕ
ΩΣΝΕΑΣΡΩΜΗΣ
ΚΑΙΟΙΚΟΜΕΝΙΚΟΣ
ΠΡΙΑΡΧΗΣ

Reverse: *Facing busts of Herakleios and Tiberios, each wearing a crown with cross and holding, in the right hand, a globus and cross. Three-line inscription below, with a linear border:*
ΚΙΑΡΙΟΑΠ
ΟΘΗΚΗΣΑ
ΒΥΔΟ

Figure 12.15
Lead seal of N. Sinadinos (sebastos), 37 mm, Byzantium, 12th century AD. **Obverse:** *St. Michael, standing on a dais with open wings, holding in his right hand a long scepter ending in trefoil, and a globe in his left hand. On either side, a vertical inscription:* . | . | . | - A | MI | X *(M. Vaniosova)*

Figure 12.16
Lead seal of Damian (kommerkiarios), 21 mm. Chersonesos, 11th century AD. **Obverse:** *Mother of God, nimbate bust facing, holding the Christ child. Border inscription:* ΘΚΕβΟΗΘ[…]ΔΟΥ *(A. Semënov)*

Reverse: *Inscription of eight lines, preceded by a crosslet, and with a border of dots:*
ΣΦΡΑΓΙ.
ΣΕΒΑΣΤΟ.
ΣΥΝΑΔΗΝ.
ΜΗΤΡΑΘΕΗ.
ΤΟΥΤ . . .
. ΟΜΗΧΑΗ .
ΕΚΠΑΤ .
ΟΕΝ

Reverse: *Inscription of four lines, with a cross above:*
ΔΑΜΗΑ
Ν.ΥΚΟΥΜΕΡ
..ΑΡΗΟΥΧ
…ΟΝΟϹ

CRIMEAN CHERSONESOS

National Preserve of Tauric Chersonesos

According to its charter, the National Preserve of Tauric Chersonesos is a cultural, educational, and research establishment that conducts the study and documentation of material and religious culture. It also provides for the protection, conservation, and restoration of monuments and promotes public outreach activities. The Preserve serves as an international archaeological school and a scientific base for the archaeological training of Ukrainian students, in addition to those from other countries. The Ukrainian Ministry of Culture and Arts supports the activities of the Preserve, which encompasses almost five hundred hectares of territory—the Ancient City, the necropolis along Quarantine Bay, ancient farm plots throughout the Herakleian Peninsula, and the additional sites of Kalamita fortress at Inkerman and Cembalo fortress at Balaklava.

The Preserve Museum offers two permanent expositions: the Greek and Roman Galleries and the Byzantine Galleries. The "pearl" of the Preserve is the partially excavated Ancient City encircling the Museum buildings. The Preserve boasts a scientific library of more than 30,000 volumes, a scientific archive of about 90,000 items, and the Fondi, or storage, which houses more than 200,000 archaeological finds. Professional restorers skillfully convert the new finds into museum objects for display. After an initial decrease of visitors to Chersonesos during the post-communist period, the number of tourists continues to mount steadily. More than 200,000 tourists visited Chersonesos in 2002.

In 2001, the Cabinet of Ministers of Ukraine authorized a program of development for the Chersonesos Preserve, promising significant financial investment

*Figure 13.1
Formerly the
Archimandrite's quarters,
the main building of the
Preserve's administration
and scientific staff also
houses the Byzantine
Galleries on the second
floor. (C. Williams)*

for conservation and equipment. The state, along with the city of Kyiv, has provided funds for the restoration of St. Volodymyr's Church, located on the territory of the Preserve and damaged during World War II. The Packard Humanities Institute has donated funds for a new facility for storage and study of archaeological materials in 2002.

Preservation of the unique monuments of ancient civilization for future generations is the chief task of the nearly 120 members of the Chersonesos Museum staff. Among them are experts in history and archaeology, who conduct extensive research and produce publications about the Greek, Roman, and Byzantine periods. The Preserve frequently hosts scientific conferences with distinguished speakers from around the world, and it also regularly supports ten archaeological expeditions annually, exploring the Ancient City of Chersonesos and its environs, with participation, by invitation, from Ukraine, Russia, and other nations. Collaborators include the Universities of Kharkiv (Ukraine) and Ekaterinburg (Russia), the Institute of Archaeology at the National Academy of Sciences of Ukraine, and the Universities of Warsaw and Poznan. The Preserve also conducts programs in religious studies, particularly in concert with Jagiellonski University.

As part of a joint project with the Preserve, the Institute of Classical Archaeology at The University of Texas at Austin (ICA) is providing long-term scientific and technical support, as well as archaeological field-work and conservation in the

Ancient City and the chora of Chersonesos. A major goal of the project is the creation of an archaeological park on the territory of ancient Chersonesos and its chora. To assist in the development of a viable process, schedule, and budget outlining implementation of the archaeological park, ICA, Preserve staff, and collaborators have taken the lead in creating development plans for the Ancient City and the chora of the National Preserve.

Figure 13.4
It was the dream of
Kostsyushko-Valyuzhinich
to have portions of the
Ancient City excavated as
an extension of the
Museum displays. Visitors
can enjoy the still majesty
of the ruins from the
Greek, Roman, and
Byzantine periods.
(C. Williams)

Continued Development of the National Preserve

The development plans are a collaborative work in progress involving Ukrainian and U.S. architects and archaeologists, the Preserve authorities, and planners from Sevastopol and Kyiv. The plans document the existing state of the Ancient City and the chora and make specific proposals about its architectural and land-use development as a tourist and educational center. Stakeholders in the development plans include the Ukrainian Ministry of Culture and Arts, regional and municipal authorities, the citizens of Sevastopol, archaeologists and other scholars, students, tourists, and recreationalists. The long-term goals of the development plans are to protect the cultural heritage of the Herakleian Peninsula, to promote a mutually beneficial and cooperative relationship among all stakeholders, to encourage a dramatic increase in the Preserve's degree of fiscal self-sufficiency, and to foster conservation of one of the world's great archaeological treasures.

Ancient City Development Plan: A Proposal

The proposal for the Ancient City in its present state consists of three phases of construction and renovation that will provide for the Preserve's needs during the next twenty years in the areas that encompass the Ancient City and the Preserve's administrative headquarters. Phase I concentrates on property currently under the Preserve's unilateral control. The immediate needs of the Preserve—adequate artifact storage, infrastructure improvements, and additional space for scientific work—are outlined in this first phase. Structural improvements along the western and northern shores will defend the Preserve from erosive wave action and accommodate swimmers by incorporating an attractive and unique linear shoreline promenade. Development of the southern and eastern edges of the Ancient City will enhance the organization and compatibility of the shops and restaurants at the entrance to the Preserve, creating lease space around an entry plaza.

Phase II will confine its scope to the ancient port, which requires cooperation from the

Figure 13.5
Artist's conception of the inner campus of the Preserve as found in the Development Plan for the Ancient City, integrating existing Museum buildings, squares, and walkways with the excavated monuments that surround the territory. (A. Maldonado and C. Holiday)

military, maritime authorities, and other agencies in order to be developed. A renovated Quarantine Bay Beach will be added to the shoreline promenade established in the work of Phase I. The structures defining the swimming area will conceal bulkheads that will establish the cofferdam necessary to effectively excavate the ancient port down to the elevations of ancient Chersonesos.

Phase III will establish entirely new facilities for the Preserve's administrative staff, a visitors' center, a hotel, and a physical plant for the proposed international archaeological field school. This final phase will require a high degree of cooperation among the Preserve, the Ministry of Culture and Arts, and municipal authorities. It is in this phase that the master plan will have the greatest beneficial impact on the generation of income for the Preserve, the local infrastructure and economy, and this seashore district's level of public amenities.

Figure 13.6
Preserve staff restore, record, and maintain the hundreds of thousands of artifacts in the Fondi, or storage areas. (G. Mack)

Chora Development Plan: A Proposal for Intelligent Development

As with many historic sites around the world, there is a complex array of political, social, and economic interests affecting Chersonesos. One specific challenge is the largely invisible nature of the cultural resources in the chora. Relatively few sites have been fully excavated, and very few have been adequately conserved. During the many years that it will take to excavate and conserve more structures and produce adequate on-site interpretive materials, the chora must be protected from encroaching development, looting, and thoughtless or inadvertent abuse.

These challenges can be addressed by establishing a unique physical presence in each of the metropolitan districts of the thirty-one individual Preserve areas across the Herakleian Peninsula. Further public awareness and support

Figure 13.7
Artist's conception of a visitors' center in the Development Plan for the chora. (A. Maldonado, C. Holiday, and M. Fougerat)

of the restoration of existing and historic landscapes will allow the Preserve to become a distinctive and integral part of the evolving Sevastopol,. The proposed chora plan outlines three stages to be implemented during the next fifty years, overlapping with the development of the Ancient City. After an initial twenty years of buffer-land acquisition and creation of satellite visitors' centers at three chora sites, the middle decade will focus on leasing acquired land to desirable enterprises, funding peninsula-wide excavation of chora monuments, and augmenting Preserve income. The final twenty years will be used to complete the system of transportation, maintenance, and supply links among all Preserve elements.

Map 13.1
Territories that fall within jurisdiction of the National Preserve are scattered throughout the Herakleian Peninsula. (A. Maldonado, C. Holiday, J. Trelogan, and J. Lane)

The development plan of the chora focuses on preservation of the existing fabric as its fundamental goal. The primary design elements are the existing grid of Greek roads and their subsequent cultural layers. This proposal uses the familiar Herakleian elements to create a region-wide continuum of interpretive, parklike environments that support the daily lives of neighboring inhabitants and educate visitors, while protecting the ancient artifacts. Distinct guidelines have been proposed for each Preserve territory and area based on its unique location, historical importance, interpretive program, and preservation needs. Three new visitors' centers will host tourists, serve as field laboratories, display recent finds, and generate income. These facilities will enforce the Preserve's physical presence in areas away from the administrative headquarters and will directly foster broader infrastructure improvement and economic activity across the Herakleian Peninsula.

References
Holiday and Maldonado 2001; Maldonado and Holiday 2003.

14

Sevastopol

The Russian Empire quickly made its most indelible mark in Crimea with the fortress of Sevastopol, rising alongside the ruins of ancient Chersonesos. Early builders used Chersonesos as a quarry for construction material, and the foundations of many structures in Sevastopol contain Greek, Roman, and Byzantine stones. Few cities have had such a tortured, yet heroic, history. Ravaged by war and decorated for valor, the city is a symbol of strength and resilience. Officially part of Ukraine, Sevastopol, with its predominantly Russian-speaking population of 400,000, is now striving to make its mark on the world as a regional center of commerce and tourism rather than a base of military power.

Geography has blessed Sevastopol, one of the largest nonfreezing harbors in the world. Here the plateau with high clay precipices meets the sea. The Herakleian Peninsula, a rolling incised plateau, is deeply carved with valleys and bays, surrounded by heights on all sides. Because of its military and strategic significance, the city has enjoyed a special administrative status since its founding in 1783. Vice Admiral Mikhail Petrovich Lazarev, commander of the Black Sea Fleet and governor of Sevastopol, is credited with the city's intensive development in the 1830s. The town center was designed in a grid pattern by a British engineer, John Upton, and constructed in the neoclassical architectural style of the nineteenth-century. Sevastopol was built around numerous large squares and boulevards,

Figure 14.1
The Monument to the Scuttled Ships was built in 1904 to commemorate the 50th anniversary of the sinking of Russian vessels during the Crimean War to prevent British and French navies from entering Sevastopol Harbor. It is considered the emblem of the city, its most recognizable landmark. (G. Mack)

Figure 14.2
Detail of the Panorama *canvas devoted to the first assault of Sevastopol in June 1855. Artist Franz Rubeau, son of a French merchant, is also known for the panorama of the Battle of Borodino in the Russian-Napoleonic War, as well as his series of paintings depicting the Russian 19th-century conquest of the Chechens in the Caucasus Mountains. (G. Mack)*

filled with shops, restaurants, hotels, theaters, and an opera house. At the outbreak of the Crimean War, Sevastopol contained seven Russian Orthodox churches, as well as Lutheran and Catholic churches, a synagogue, and a mosque. In 1875, a railway servicing Simferopol and Sevastopol connected the peninsula with St. Petersburg and the rest of the Russian Empire.

By the end of the nineteenth century, Sevastopol clearly established itself as a major industrial and trade center, as well as a resort area. Realizing the profitability of tourism, the head of the city council, A. A. Maksimov, began a massive campaign of infrastructure investment in 1901, including refurbishing city buildings, enlarging and repairing streets and bridges, and improving water supply and sanitation to encourage tourism and trade. A century later, Sevastopol faces an identical situation. As the home of the Black Sea Fleet, Sevastopol inherited the military support complex, including a naval dockyard, ship-building and repair facilities, precision-instrument factories, and specialized scientific, technical, and research institutes. Food processing and fisheries are still vital to the municipal economy. The current Sevastopol city administration hopes to use the existing infrastructure to position the city as a center for international trade, business,

Figure 14.3
Grafskaya Wharf dates to the founding of the city. Named for Count (or "Graf" in Russian) Voynovich, commander of the Sevastopol squadron (1785–1789) that used to dock there, it is located on the east side of Southern Bay, in the central part of the city. A colonnade and white columns were added in 1846. (G. Mack)

and tourism. Plans for a free economic zone include developing a marine–air cargo terminal, forming an industrial and technological complex, and attracting Black Sea ferries and cruise ships. The natural setting, the climate, the military history, and the National Preserve of Tauric Chersonesos are all major factors in establishing Sevastopol as an international tourist center.

Among the many contentious property issues arising after the disintegration of the USSR was the fate of the Black Sea Fleet. A 1995 agreement allotted four-fifths of the fleet to Russia. As a closed military city in the USSR, Sevastopol opened to outside trade and visitors only in 1996. A year later, Kyiv and Moscow permitted foreign ships to enter Sevastopol Bay. In 1997, Russia agreed to lease the naval base from Ukraine for a period of twenty years. In theory, the Russian and Ukrainian navies collaborate jointly but operate independently in Sevastopol and the Black Sea region.

Figure 14.4
Ukrainian soldier stands at attention at a war memorial during a joint U.S.–Ukrainian wreath-laying ceremony. Officers and sailors from the U.S. Sixth Fleet flagship USS La Salle spent two days in Sevastopol in 2001 with their local counterparts to enhance the spirit of cooperation. (U.S. Navy Photo, Jeremy Johnson)

Figures 14.5 and 14.6
St. Volodymyr's Church in 1988 (the 1,000-year anniversary of the coming of Christianity to Rus') and after external renovation and reconsecration in 2001. (NPTC archives and G. Mack)

Sevastopol boasts many museums and monuments dedicated to military achievements. One highlight is the museum Panorama: The Defense of Sevastopol in 1854–1855, housed in a round, late nineteenth-century building with a view of the entire city and the bay below. Unveiled in 1905, a brilliant color panoramic diorama, 14 m high and 115 m in circumference, depicts the fighting during the Crimean War. Another museum, Diorama: The Assault of Sapun Mountain on May 7, 1944, on the southern hills of the city, commemorates the liberation of Sevastopol during World War II. It houses a more modest diorama than the one in the Panorama, with a canvas merely 5.5 m in height and 22.5 m in circumference. The Military History Museum of the Black Sea Fleet, located downtown, was established in 1869. It contains a collection of more than 32,000 exhibits, illustrating the history of the

Figure 14.7
Palace of Youth and
Children on Primorskiy
Boulevard, opposite
Artillery Bay.
(C. Williams)

Russian fleet during 200 years of service in Sevastopol. The Kroshitskiy Sevastopol Museum of Fine Art exhibits more than 8,000 pieces of western European and Russian fine art from the sixteenth to the twentieth century.

Tsar Alexander II laid the first brick in 1861 for the construction of St. Volodymyr's Church, which was fashioned in the Byzantine architectural style and completed by 1888. The church served as a Bolshevik jail during Russia's civil war. Communist authorities closed it in 1924, and during World War II the church suffered extensive damage. In 2001, after the church was newly renovated, Russian and Ukrainian presidents Putin and Kuchma participated in the consecration ceremony. The Russian Orthodox Church (Moscow Patriarchate) and the Autocephalous Ukrainian Orthodox Church (Kyiv Patriarchate) dispute the use of the church.

The city of Sevastopol is a verdant modern city, with restored buildings and countless historical war monuments attesting to its resiliency. A stroll along the board-walk, Artillery Bay, or the main street, Bol'shaya Morskaya, provides an opportunity to visit some of the many new shops, outdoor cafes, and clubs. Travel agencies offer excursions and water sports, as well as the obligatory tour of the harbor. With cruise service to Istanbul and other Black Sea ports, Sevastopol is developing its nascent tourist facilities. During a few days of exploration in Sevastopol, one will encounter centuries of historical treasures and unexpected charms that captivated the likes of Lev Tolstoy, Anna Akhmatova, Konstantin Paustovskiy, and Mark Twain.

References
Doronina and Lyakhovich 1983; Venikeyev 1983; Dobryy and Borisova 2001.

Historic Sites of Southwestern Crimea

Chapter 15

Within easy driving distance of Sevastopol are several remarkable sites that add much to a visitor's appreciation of Chersonesos and its regional setting (Map 15.1, p. 203). Cave towns, fortresses, monasteries, and other monuments of southwestern Crimea shed light on the various political powers, peoples, eras, and conflicts that impinged on the ancient city. Although Greek, Roman, and Byzantine culture flourished along the Crimean coast, that history reveals only a portion of the events in Crimea as a whole.

Atop the interior ridge of the Crimean Mountains, running roughly parallel to the Sevastopol-Simferopol highway, stretches a line of medieval fortresses. Mangup-Kale, Eski-Kermen, Chufut-Kale, Tepe-Kermen, Kyz-Kule, Kalamita, Baqla, Kyz-Kermen, Syuren', Kachi-Kal'on, Shuldan, Assumption Cell, Chelter-Koba, and Chelter-Marmara—all these marvelous sites of medieval Crimea are collectively known as cave towns. Located on alpine plateaus, these abandoned settlements, with their enigmatic dark cave windows hewn in rock, have excited the imagination of travelers through the centuries and have become a source of astonishment, admiration, and, of course, fantastic legends.

"Hard stones were toys for people of those days," a seventeenth-century Turkish traveler wrote. "They smashed rocks to pieces in a moment, as they sliced cheese, and thus built palaces, dwellings, and meeting rooms also." Currently, most scholars link the origins of the civil cave towns to the Byzantine emperor Justinian I (527–565) and his heirs. He attempted to restore the previous frontiers of the Roman Empire from his capital in Constantinople. To accomplish these ends, the emperor began a series of wars in the East and the West and expanded the sphere of Byzantine influence along the northern Black Sea coast. He organized wide-ranging fortifications across southwestern Crimea. According to Prokopios of Caesarea, Justinian erected long walls, which probably traversed the valleys between the mountain plateaus, in order to protect this area from nomads. The local

Figure 15.1
Balconies at the Monastery of St. Clement, Inkerman. Atop the cliff above the monastery are the 15th-century AD ruins of the Kalamita fortress, also part of the National Preserve. (G. Mack)

Figure 15.2 (right)
View from Eski-Kermen
of the limestone cliffs and
valley below. The mountain
plateaus provided protection
for cave city settlements of
the medieval period.
(G. Mack)

Figures 15.3 and 15.4
Gothic brooches and eagle-
headed buckle from Eski-
Kermen. 7th century AD,
11.7 cm and 13.4 cm.
(I. Teplitskiy, courtesy of
A. Aybabin)

population, supervised by Byzantine military officers and engineers, built walls and settlements, with assistance from the construction guilds of Chersonesos.

In the ninth through thirteenth centuries, a few fortresses exhibited distinct urban features. By the fifteenth century, the two most important strongholds became regional capitals: Mangup-Kale of the Theodoro principality and Chufut-Kale of the Crimean Tatar Khanate.

The Mongols first arrived in Crimea in 1223 and subsequently seized the northern steppes of the Crimean Peninsula as their grazing land. Khan Uzbek (1312–1341) made Islam the state religion of the Golden Horde. In the first half of the fifteenth century, the Khan Haji-Giray (1426-1456) proclaimed Crimea independent from the Golden Horde. At the beginning of the sixteenth century, his son Mengli-Giray (1466-1474) decreed that the city of Bahçesaray would be his capital.

Genoese settlements appeared in Crimea from the thirteenth to the fifteenth century. Venetians were the first Europeans to receive access to the Black Sea after the knights of the Fourth Crusade (1202–1204) took Constantinople. Soldaia (present Sudaq) became a Venetian stronghold in the thirteenth century, and many Venetians, including the uncle of the famous traveler Marco Polo, Maffeo Polo, visited there. To reduce Venetian gains in the Black Sea market, the Genoese allied themselves with Byzantium in 1261 and thereby achieved commercial superiority over their rivals in the region.

The first and most important Genoese settlement was Caffa (present Feodosiya), the "Queen of the Black Sea." In the fourteenth and fifteenth centuries, its riches and beauty rivaled those of its metropolitan city, Genoa. Other Genoese centers were installed in Soldaia and Vosporo and along the southern coastal strip of Gothia. In 1357, the Genoese began the construction of Cembalo fortress at Balaklava Bay (p. 199), in the vicinity of Chersonesos. A 1449 statute mentions the Genoese consul of what was then known as Gorzona (Cherson).

The Theodoro principality was established at the plateau capital of Mangup-Kale in southwestern Crimea in the 1360s. In

the first half of the fifteenth century, Prince Alexios of Theodoro secured an outlet to the sea for his principality and established international trade contacts. For this purpose, he reconstructed and strengthened the port of Kalamita. The princes of Theodoro sought dynastic marriages with the sovereigns of Wallachia and the grand duke of Moscow. When the Golden Horde collapsed in the first half of the fifteenth century, the three Crimean powers struggled for dominance over the peninsula. However, the threat posed by the invading Ottomans temporarily united the khanate, Theodoro, and the Genoese. In May 1475, an Ottoman squadron attacked Caffa, and by June, the city fell.

Speedily capturing Caffa and Soldaia, the Ottoman army approached the walls of Mangup-Kale. After a half-year siege and five assaults, the Ottomans took the capital of Theodoro. The inhabitants of Mangup-Kale were slaughtered; the last prince, Alexander, was executed, and the females of the royal family were placed in the sultan's harem. Alexander's young son was spared; he converted to Islam and headed a noble Turkish family while retaining the title of the prince of Mangup-Kale. The Crimean Tatar Khanate also lost its independence and became a vassal of the Ottoman Empire.

Thus, by late 1475, the entire peninsula was controlled by the Ottomans. This new period of Crimean history lasted until the early eighteenth century. The Ottoman administration remained in direct control of the lands of the southern coast and a great part of southwestern Crimea. The sultan appointed the Crimean mufti (spiritual leader of the Moslems) and khans from the Giray family. Although military assistance was the primary responsibility of the Crimean khans, the Ottomans exhausted Crimea with endless campaigns against the north. This period was marked by Turkic cultural influence in all aspects of daily life within the upper stratum of Tatar society.

The fortress of Kalamita is located just east of Sevastopol, where the harbor becomes the Chërnaya River. In the sixth century, a Byzantine fortification was erected

Figure 15.5 (above) View, across the Chërnaya River, of St. Clement monastery and the ruins of Kalamita fortress, part of the National Preserve. (G. Mack)

Figure 15.6 Ruins of Kalamita. In 1427, Mangup prince Alexios reconstructed the fortress in an attempt to rival the Genoese trade in the area. It was captured by the Turks in 1475. The fortress lost its strategic significance with the Russian annexation of Crimea. (G. Mack)

that connected a number of fortresses in mountainous Crimea. In the fifteenth century, Prince Alexios of Mangup-Kale rebuilt this fortress, which he intended to defend the port of his principality. When the Ottomans conquered Crimea in 1475, they renamed the fortress Inkerman (literally "cave fortress"), and in the late sixteenth and early seventeenth centuries, they equipped the walls and towers with modern artillery. By the mid-eighteenth century, the fortress and port of Kalamita lost military and commercial significance. After Crimea was annexed by Russia, the medieval monastic cells were renewed and consecrated in the name of St. Clement, the fourth Roman pope, who, according to a legend, languished in exile in Crimea in the late first century AD. Apart from this monastery, the rocks of Inkerman valley include nine medieval Christian cave cells and twenty-seven cave churches.

Rising at the foot of the medieval fortress, the modern town of Inkerman was a significant battleground during the Crimean War and World War II. Inkerman limestone was used to build many cities, including Sevastopol and Livadia Palace near Yalta, and the microclimate and soils of the Valley of Balaklava create an ideal environment for the production of table and sparkling wines.

Mangup-Kale, the most outstanding of all the cave towns, greatly impressed travelers through the centuries. It is located on the mountain plateau of the same name about 600 m above sea level. Inaccessible from three sides, with vertical precipices 40–70 m high and a northern slope cut by deep ravines, it is formidable.

Established in the mid-sixth century as part of Justinian's defensive plan, Mangup-Kale, also known as Dory and Doros, was under the power of the Khazars from the late eighth to the mid-ninth century. After a period of decline from the late tenth to the thirteenth century, it witnessed a revival and prosperity in the fourteenth and fifteenth centuries. The capital of the Theodoro principality, Mangup-Kale was taken by the Ottoman army in 1475. It became an

Figures 15.7 and 15.8 Aerial view of Mangup-Kale, showing the Turkish defensive wall and, beyond it, excavation of the medieval city. The long trek up to the heights of Mangup leads past a Jewish cemetery of the Karaite sect.
(C. Williams, G. Mack)

important outpost of Ottoman power in Crimea until the eighteenth century. Climbing to the plateau by a mountain path, the visitor will see three lines of fortifications, a basilica, an octagonal church, the prince's palace, and other constructions.

One of the most picturesque cave towns, Eski-Kermen (Old Fortress), located less than 40 km from Chersonesos, is situated on a plateau 1,000 m long and nearly 200 m wide. Steep precipices served as a natural defense for the fortress. In the late sixth century, a Byzantine boundary fortress was established here, manned by a garrison of Goths and Alans. A road leading to the main town gate is cut into the stone on the western slopes of the mountain. The most important defensive structure was in the southern part of the site near the main gate of the town. On the opposite side of the plateau, the northern patrol complex was arranged. Casemates, cells for guards controlling approaches to the fortress, were built along the edge above the precipices. A siege well was built into the eastern part of the plateau, cutting a narrow corridor or tunnel that forms a steep staircase of six flights in the rock. Each flight finishes with a landing, one of which contains a window hole to light the staircase. At the very end of the tunnel, was a 10-m-wide gallery with a natural spring.

In the eighth century AD, the Khazars took the fortress, most likely destroying the defensive structure. From the late tenth to the thirteenth century, Eski-Kermen represented a small town with rectangular residential blocks and churches both above ground and carved into caves. At the crest of the plateau, a basilica was erected in the sixth century, which was devastated together with the town during the raid of the Tatar khan Edigey in the fourteenth century.

Figures 15.9 and 15.10 Aerial view of the plateau spur that forms Eski-Kermen. Main entrance of Eski-Kermen, showing a road and structures cut into limestone rock. (C. Williams, G. Mack)

The ruins of the late medieval fortress of Kyz-Kule (Tower of Virgins), dated to the thirteenth and fourteenth centuries, are located to the northwest of Eski-Kermen, on the plateau of the opposite side of the canyon. Picturesque ruins of a tower with gates, a small one-apse chapel with graves cut into the rock, and a group of buildings of unknown purpose occupy the territory of this fortification.

Established in the late sixth and seventh centuries AD as a Byzantine stronghold, Chufut-Kale became the first capital of the Crimean Tatar Khanate in the fifteenth century. After the capital was moved to Bahçesaray in the sixteenth century, the population of the town consisted of a small Armenian community and the Karaites, a group who adhered to a non-Talmudic Judaism that had its origins in Egypt, and the settlement became known as Chufut-Kale (Jewish Fortress). The last inhabitant, the Karaite scholar and well-known collector of antiquities Avraam Firkovich, left Chufut-Kale in the late nineteenth century.

The site incorporates remains of fortifications, southern and eastern gates, streets with narrow sidewalks, dwelling houses, praying houses (kenassas) of the Karaites, and the mausoleum of Janike-Qanym, the daughter of Khan Toqtamysh and the wife of Khan Edigey, the Mongol ruler who is often associated with an attack on Chersonesos in 1399.

Bahçesaray (Palace among Gardens) is located halfway between Simferopol and Sevastopol in the foothills of the coastal mountain range. In the early sixteenth century, Khan Mengli-Giray moved his capital from Chufut-Kale to Bahçesaray. This valley city, built on the bank of a mountainous stream, was the administrative center of the Crimean Khanate until 1783.

The Khan's Palace is notable for its Major Palace Mosque with two minarets, the Minor Palace Mosque, and the Fountain of Tears. A royal cemetery, a Turkish bathhouse, and stables are also found among the large courtyards. The complex was eventually converted to the Museum of History and Culture of the Crimean Tatars in the 1960s. It attracts a quarter-million visitors annually.

A dozen kilometers to the southwest of Chersonesos and Sevastopol, some areas of Balaklava, including the Genoese Cembalo fortress, form an important part of the National Preserve of Tauric Chersonesos, which is currently excavating the difficult upper site at cliff's edge. The majestic, well-preserved ruins of the fortress sit atop a cliff at the entrance to Balaklava Harbor, (Symbolon of the ancient Greeks) on the southern coast of Crimea. The Greek geographer Strabo described the excellent location of the harbor, the abundance of fish in the littoral waters, and the fertile soils good for growing grapes and other crops. All promoted the rapid development of the territory.

Although the port was important in the Greek period and served as a base for a Roman garrison, as revealed by the recent discovery by a joint Ukrainian-Polish mission of the legionary barracks and the altar of Jupiter, Balaklava achieved its greatest renown during the medieval period.

The Genoese began large-scale fortifications of their Black Sea colonies in the fourteenth century. The Genoese fortification of Balaklava Harbor probably began shortly before a

Figure 15.14 Aerial view of the remains of the Genoese Cembalo fortress, part of National Preserve, at entrance the to Balaklava Harbor. (C. Williams)

Figures 15.15 and 15.16 Cembalo contained a fortress, towers, and the consul's residence. The site is a unique archaeological and architectural monument of the medieval period, and the National Preserve conducts annual excavations on the territory. (C. Williams, G. Mack)

devastating Mongol raid in 1345. It became the western-most Crimean district of the Genoese republic and home to the Cembalo consulate. The district's borders stretched along the shore from the mouth of the Chërnaya River near the tower of Kalamita at Inkerman on the southeast side of Sevastopol to Cape Sarych on the southern coast of Crimea. The fortress of St. Nicholas, standing on the crest of the coastal cliff that shelters the entrance to the bay, housed the administrative part of the colony, including the consul's elaborate residence. The preserved structures on the rocky ledges and special terraces clearly show that the upper fortress was densely populated. Water was supplied to the heights by an intricate system of cisterns and ceramic pipes.

Most of the population lived in the newly fortified city of St. George at the foot of the cliff, where the port and marketplace were located. It was famous for its mackerel, sturgeon, oysters, and crabs but renowned for flounder and red mullet, which were the most popular seafood. Cembalo played an active role in the trade of the Black Sea region. Besides fish, it exported bread, leather, and textiles, while the slave trade also served as a source of profit.

The juridical position of the new colony was determined only in 1383, when the Crimean Tatar khan concluded a peace treaty with the Genoese, in which he recognized the right of the latter to own the fortress. Only then did it take the name of Cembalo fortress. Although the Genoese, who governed and controlled trade, represented the majority of the population, Greeks, Armenians, and Tatars also settled within the fortress walls and on the outskirts of town. There, they engaged in fishing and producing wine and handcrafted goods, which they supplied to the Genoese.

In 1433, a wave of popular uprisings began in the fortress and some nearby villages. The fortress was occupied by rebels and came under control of the Theodoro principality. Unable to suppress the rebels on its own, the Genoese administration asked

Genoa for assistance. In 1434, a large fleet sent by Genoa approached Cembalo. It broke the blockade at the entrance to the bay and reclaimed the fortress. Naval artillery destroyed one of the towers and part of the city wall. The 1449 Charter of the Genoese Colonies dictates the conditions under which the colonists and resident population lived in the fortress until the Ottoman conquest of 1475. Cembalo was renamed Balikaya (Turkic for "fish rock") and the name was transformed, over time, to Balaklava. It entered the pages of history again, during the Crimean War, when it served as the base for the British Fleet.

Fiolent offers one of the most picturesque views in southwestern Crimea, with the St. George monastery and a semi-cave church, a freshwater spring, and an 800-step staircase leading to the beach. According to legend, Greek sailors in the ninth century were spared from a horrific storm after praying to St. George to save them. Afterward, they reputedly found an icon of St. George among the rocks on shore, which is now exhibited in the National Fine Arts Museum in Kyiv. To honor this event, a picturesque cross was placed just offshore on top of a tiny rock island.

This entire area of southwestern Crimea is densely packed with war monuments and military cemeteries. During the Crimean War and World War II, foreign troops besieged Sevastopol. In addition to the countless Russian troops who perished there, several hundred thousand foreign soldiers lost their lives fighting over Sevastopol and Crimea. After the wars, memorial military cemeteries were constructed for French, English, Sardinian, and German troops. The battlefields and historical markers have attracted great interest among foreign and local military buffs. After Ukrainian independence (1991), a German memorial military cemetery was built near the village

Figure 15.17 Shoreline at Fiolent, popular as a tourist destination, with its dramatic cliffs and inviting waters. (C. Williams)

*Figure 15.18
Memorial to those who
fell in the Battle of
Balaklava, October 25,
1854, erected by the
British Army in 1856.
(G. Mack)*

of Goncharnoye for the more than five thousand German war dead whose bodies were not transported back to Germany. The Sardinian cemetery and a chapel on Gasfort Hill near Sevastopol, completed in 1882, honor the 2,000 Italians who fell during the Crimean War. The cemetery was unfortunately destroyed during World War II. A marker located between Balaklava and Sevastopol indicates the last resting place of 50,000 Frenchmen who were buried in common graves. The cemetery is in ruins, and only a memorial plaque remains. Local authorities are planning a rededication of both the Italian and the French cemeteries. A British cemetery on Cathcart's Hill dates to 1882. In 1992, the city of Sevastopol began construction of a new Crimean War memorial complex, 100 m from the dilapidated cemetery. The Prince of Wales visited the memorial in 1996. A modest obelisk erected in a vineyard marks the spot where the 600 cavalrymen of the Light Brigade, eulogized in Alfred Lord Tennyson's poem, met the harrowing barrage of the Russian artillery and were decimated. It is a monument to the heroism, stupidity, and brutality of war and to the power of poetry.

References
Yakobson 1950; Aybabin 1999; Kogonashvili 1995; Werner and Ludwig 1999.

..............................
*When can their glory fade?
O the wild charge they made!
All the world wonder'd.
Honour the charge they made!
Honour the Light Brigade,
Noble six hundred!*

 —Alfred Lord Tennyson, 1864

*Map 15.1 (opposite)
Major historic and
touristic sites of south-
western Crimea.
(J. Lane)*

1. Kalamita, Cave Monastery of
 St. Clement
2. Kyz-Kule (Krasnyy Mak)
3. Eski-Kermen (Krasnyy Mak)
4. Chelter cloister (Ternovka)
5. Shuldan cloister* (Ternovka)
6. Mangup-Kale (Ternovka Marmora)
7. Chelter-Koba cloister (Malo-Sadovoye)
8. Syuren'
9. Kachi-Kal'on cloister (Predushelnoye)

10. Kyz-Kermen (Mashino)
11. Tepe-Kermen (Kudrino)
12. Chufut-Kale
13. Cave Monastery of the Assumption
14. Khan's Palace Museum
15. Baqla (Skalistoye)
16. Nikitskiy Botanical Garden
17. Massandra Winery
18. Livadia Palace
19. German cemetery (Goncharnoye)

20. Italian cemetery
21. Cembalo
22. Charge of the Light Brigade
23. Battle of Balaklava (Pervomayka)
24. English cemetery
25. French cemetery (Nikolaevka)
26. St. George Monastery

* cloister = cave monastery
(nearest settlement in parenthesis)

	Rivers
	Roads
	Urban area

Scenes inside and outside of the Warehouse of Local Antiquities, organized by the first museum director, Karl Kazimirovich Kostsyushko-Valyuzhinich, from glass-plate negatives dating to the late 19th century. (NPTC archives)

Selected Bibliography

This bibliography is extensive, but far from all-inclusive. It is a selection—one made to provide a starting point for those interested in the Museum's collections and monuments, which are almost completely unknown to non-Russian speaking audiences. Many of the photographs of objects included here have been published in excavation reports and specialized articles in Russian and Ukrainian. Most are not readily available outside of Ukraine, Russia, or even Chersonesos. We also have included some relevant bibliography in other scholarly languages, much of which is unavailable in the libraries of Ukraine.

Chapter 1 Tauric Chersonesos
By Joseph Coleman Carter

Ascherson, N. 2002. Chersonesos: Public Archaeology on the Black Sea Coast. *Archaeology International*. London: Institute of Archaeology. 54–56.

Carter, J. C., ed. 2003. *Study of Ancient Territories: Chersonesos and Metaponto, 2002 Annual Report*. Austin, Texas: Institute of Classical Archaeology-University of Texas at Austin.

Chtcheglov [Shcheglov], A. 1992. *Polis et chora: cité et territoire dans le Pont-Euxin*. Translated by Jacqueline Gaudoy. Paris: Université de Besançon.

Holiday C., and A. Maldonado. 2001. *Master Plan for the Continued Development of the National Preserve of Tauric Chersonesos*. Austin, Texas: Institute of Classical Archaeology.

Maldonado, A., and C. Holiday. 2003. *Development Plan for the Chora of the National Preserve of Tauric Chersonesos*. Austin, Texas: Institute of Classical Archaeology.

Romey, K., and L. Grinenko. 2002. Legacies of a Slavic Pompeii. *Archaeology Magazine*. November-December 2002. 6:18–25.

Sorochan, S. B., V. M. Zubar, and L. V. Marchenko. 2000. *Zhizn' i gibel' Khersonesa*. Kharkiv: Maydan. This book is the most up-to-date and comprehensive Russian-language source on Chersonesos. Future reference given by title only. A newer guidebook by same authors *Khersones, Kherson, Korsun'* was published by Stilos, Kyiv, 2003.

Further Reading

Edgerton, R. B. 2000. *Death or Glory: The Legacy of the Crimean War*. Boulder: Westview Press.

Minns, E. H. 1913. *Scythians and Greeks: a Survey of Ancient History and Archaeology on the North Coast of the Euxine from the Danube to the Caucasus*. Cambridge: University Press.

Romanchuk, A. I. 2000. *Ocherki istorii i arkheologii vizantiyskogo Khersona*. Yekaterinburg: Izdatel'stvo Ural'skogo universiteta.

Tolstoy, Leo. 1986. *The Sebastopol Sketches* (1856), ed. David McDuff. Harmondsworth: Penguin.

Ziemke, E.F. 1968. *Stalingrad to Berlin: The German Defeat in the East*. Washington, DC: Dorset Press.

Ziemke, E.F., and M.E. Bauer. 1987. *Moscow to Stalingrad: Decision in the East*. Washington, DC: Dorset Press.

Figure 1.6 Ram-shaped unguentarium
Vysotskaya, T. N., and G. I. Zhestkova. 1999. Rel'yefnaya krasnolakovaya keramika iz mogil'nika 'Sovkhoz 10'. *Khersonesskiy sbornik* 10:34–35, fig. 4.a, 6.

Chapter 2 Crimean Peninsula
By Paul Lehman and Carlos Cordova

Berg, L. S. 1955. *Natural Regions of the USSR*. New York: MacMillan.

Borisov, A. A. 1965. *Climates of the USSR*. Chicago: Aldine.

Podgorodetskiy, P. D. 1988. *Krym. Priroda*. Simferopol: Tavriya.

Strabo. 1924. *The Geography of Strabo*. Translated by H. L. Jones. Cambridge, MA: Loeb Library. Vol. III, Book 6.

Struk, D. H., ed. 1993. *Encyclopedia of Ukraine*. Toronto: Toronto University.

Further Reading

Lebedinskiy, V. I. 1976. *Geologicheskiye ekskursii po Krymu*. Simferopol: Tavriya.

Sosnovskiy, S. K., ed. 1982. *Krym: Putevoditel'*. Simferopol: Tavriya.

Yena, V. G., I. T. Tverdokhlebov, and S. P. Shantyr'. 1996. *Yuzhnyy bereg Kryma. Putevoditel'*. Simferopol: Biznes-Inform.

Yena, V. G. 1973. *V gorakh i na ravninakh Kryma*. Simferopol: Tavriya.

Chapter 3 Greek and Roman Chersonesos
By Joseph Coleman Carter, Stanislav Ryzhov, Miron Zolotarëv, Vitaly Zubar

Anokhin, V. A. 1980. *The Coinage of Chersonesos: IV Century BC–XII Century AD. British Archaeological Reports, International Series* 69. Translated by H. B. Wells. Oxford.

Belov, G. D. 1948. *Khersones Tavricheskiy*. Leningrad: Gosudarstvennyy Ermitazh.

Belov, G. D. 1950. Nekropol' Khersonesa klassicheskoy epokhi. *Sovetskaya Arkheologiya*. 13:272–284.

Dupont, P. 2002. Le Pont-Euxin archaïque: lac milésien ou lac nord-ionien? Point de vue de céramologue. In *Cités grecques,*

sociétés indigènes et empires mondiaux dans la région nord-pontique: origines et développement d'une koinè politique, économique et culturelle (VIIe s. a.C. - IIIe s. p.C.). Bordeaux 14–16 novembre, 2002 Résumés. Bordeaux.

Euripides. 1955. *Iphigenia in Tauris*. Translated by W. Bynes. In Grene, D. and R. Lattimore, eds. *The Complete Tragedies of Euripides*. Chicago: University of Chicago Press, 340–409.

Herodotus. 1957. *History, Book 4*. Translated by A. D. Godley. Loeb Library, Vol. II. Cambridge: University Press.

Hind, J. 1998. Megarian Colonization in the Western Half of the Black Sea. In Tsetskhladze, G.R., ed. *The Greek Colonization of the Black Sea Area*. Stuttgart: F. Steiner, 131–152.

Kadeyev, V. I., and S. B. Sorochan. 1989. *Ekonomisheskiye svyazi antichnykh gorodov Severnogo Prichernomor'ya v I v. do n.e.–V v. n.e.* Kharkiv: Vyshcha shkola, 1989.

Latyshev, V.V., ed. 1885, 1890, 1901, 1916. *Inscriptiones antiquae orae septentrionalis Ponti Euxini [IosPE]*, Vol. 1–4. St. Petersburg: Akademiya Nauk.

Randsborg, K. 1994. A Greek Episode: The Early Hellenic Settlement on the Western Crimea. *Acta Archaeologica*. 65:171–196.

Saprykin, S. J. [Yu.] 1997. *Heracleia Pontica and Tauric Chersonesus before Roman Domination: VI–I centuries B.C.* Amsterdam: A. M. Hakkert.

Saprykin, S. J. [Yu.] 1998. The Foundation of Tauric Chersonesos. In Tsetskhladze, G. R., ed. *The Greek Colonisation of the Black Sea Area: Historical Interpretation of Archaeology*. Stuttgart: F. Steiner, 227–248.

Sarnowski, T., and V. M. Zubar. 1996. Römische Besatzungstruppen auf der Südkrim und eine Bauinschrift aus dem Kastell Charax. *Zeitschrift für Papyrologie und Epigraphik* 112:229–234.

Sarnowski, T., V. M. Zubar, and O. Ja. [Ya.] Savelya. 1998. Zum religiösen Leben der niedermoesischen Vexillationen auf der Südkrim. *Historia* 47, 2:321–341.

Savelya, O. Ya. 1996. Arkheologicheskiye materialy k istorii Gerakleyskogo poluostrova dokolonizatsionnogo perioda. *Khersonesskiy sbornik* 7:13–18.

Shcheglov, A. N. 1981. Tavry i grecheskiye kolonii v Tavrike. In *Demograficheskaya situatsiya v Prichernomor'ye v period velikoy grecheskoy kolonizatsii: materialy II Vsesoyuznogo simpoziuma po drevney istorii Prichernomor'ya, Tskhaltubo, 1979*. Tbilisi: Metsniereba.

Solomonik, E. I. 1964, 1973. *Novyye epigraficheskiye pamyatniki Khersonesa* 1–2. Kyiv: Naukova dumka.

Strabo. 1924. *The Geography of Strabo*. Translated by H. L. Jones. Cambridge, MA: Loeb Library. Vol. III, Book 6.

Vinogradov, Ju. [Yu.] G. 1987. Der Pontos Euxeinos als politische ökonomische und kulturelle Einheit und die Epigraphik. In *Acta Centri historiae "Terra antiqua Balcanica,"* II. Trinovi: 9–77.

Zolotarëv, M. I. 1993. *Khersonesskaya arkhaika*. Sevastopol: Khersonesskiy gosudarstvennyy istoriko-arkheologicheskiy zapovednik.

Zolotarëv, M. I. 2002. Chersonesos Taurike and its Periphery on the Transition from Classical to Hellenistic Period. In *Cités grecques, sociétés indigènes et empires mondiaux dans la région nord-pontique: origines et développement d'une koinè politique, économique et culturelle (VIIe s. a.C. - IIIe s. p.C.)*. Bordeaux 14–16 novembre 2002 Résumés. Bordeaux.

Zubar, V. M. 1994. *Khersones Tavricheskiy i Rimskaya imperiya. Ocherki voyenno-politicheskoy istorii*. Kyiv: Kiyevskaya Akademiya yevrobiznesa.

Zubar, V. M. 1995. Zur römischen Militärorganisation auf der Taurike in der zweite Hälfte des 2. und am Anfang des 3. Jahrhunderts. *Historia* 44,2:192–203.

Figure 3.1 Herakles' knot
Belov, G. D. 1927. Rimskiye pristavnyye sklepy NN 1013 i 1014. *Khersonesskiy sbornik* 2:107–146.

Mantsevich, A. P. 1932. *Ein Grabfund aus Chersonnes*. Leningrad.

Williams, D., and J. Ogden. 1994. *Greek Gold: Jewelry of the Classical World*. London: British Museum Press.

Zherebtsov, Ye. N. 1979. Novoye o Khersonesskom sklepe N 1012. *Kratkiye soobshcheniya Instituta arkheologii*. 159:34–37.

Figure 3.3 Black gloss sherds
Zolotarëv, 1993. 87, Pl. XII.

Figure 3.4 Household objects
Kostsyushko-Valyuzhinich, K. K. 1906. Otchët o raskopkakh v Khersonese Tavricheskom v 1904 g. *Izvestiya imperatorskoy arkheologicheskoy komissii*. 20:62.

Figure 3.5 Boiotian lekanis
Zolotarëv, 1993. 96, Pl. XXI.

Zedgenidze, A. A. 1993. K voprosu ob udrevnenii daty osnovaniya Khersonesa Tavricheskogo. *Rossiyskaya arkheologiya* 3:52.

Figure 3.6 Ionic cornice
Borisova, V. V. 1963. Raskopki v tsitadeli v 1958–1959 gg. *Soobshcheniya Khersonesskogo muzeya* 3:48, fig. 2.

Figure 3.10 Scythian pectoral
Mozolevskiy, B. N. 1972. Kurgan Tolstaya Mogila bliz g. Ordzhonikidze na Ukraine. *Sovetskaya arkheologiya* 3:268–308.

Mozolevskiy, B. N. 1979. *Tovsta Mohyla*. Kyiv.

Mozolevskiy, B. N. 1983. *Skifs'kyy step*. Kyiv.

Figure 3.12 Dichalkos from Site 151
Anokhin, 1980. 140, fig. 143.

Chapter 4 Medieval Chersonesos
By Larissa Sedikova, Paul Arthur, Tatiana Yashaeva, Joseph Coleman Carter

Anokhin, V. A. 1977. *Monetnoye delo Khersonesa.* Kyiv: Naukova dumka.

Aybabin, A. I. 1999. *Etnicheskaya istoriya rannevizantiyskogo Kryma.* Simferopol: DAR.

Bogdanova, N. M. 1991. Kherson v X–XV vv. Problemy istorii vizantiyskogo goroda. In Karpov, S. P., ed. *Prichernomor'ye v sredniye veka.* Moscow: Izdatel'stvo Moskovskogo gosudarstvennogo universiteta, 9–172.

Cross, S.H., and O.P. Sherbowitz-Wetzor. 1953. *The Russian Primary Chronicle: Laurentian text.* Cambridge, MA: Medieval Academy of America.

Filippenko, V. F. 1997. *Kalamita-Inkerman: krepost' i monastyr'.* Sevastopol.

Firsov, L. V. 1990. *Isary: ocherki istorii srednevekovykh krepostey yuzhnogo berega Kryma.* Novosibirsk: Nauka.

Gertsen, A. G. 1993. Vizantiysko-khazarskoye pogranich'ye v Tavrike. In Mogarichëv, Yu., ed. *Istoriya i arkheologiya yugo-zapadnogo Kryma.* Simferopol: Tavriya, 58–66.

Kazanski, M., and V. Soupault. 2002. Les sites archéologiques de l'époque romaine tardive et du haut moyen âge en Crimée (IIIe–VIIe s.). État des recherches (1990–1995). *Colloquia Pontica* 5:253–293.

Rybina, E. A. 1992. Trade Links of Novgorod Established through Archaeological Data. In Brisbane, M. A., ed. *The Archaeology of Novgorod, Russia: Recent Results from the Town and its Hinterland.* Lincoln. 193–205.

Sazanov, A. 2002. Les ensembles clos de Chersonèse de la fin du Ve–troisième quart du VIIe siècle: la chronologie de la céramique. *Colloquia Pontica* 5:123–149.

Sedikova, L. 1995. Keramicheskiy kompleks pervoy poloviny IX v. iz raskopok vodokhranilishcha v Khersonese. *Rossiyskaya arkheologiya* 2:170–177.

Smedley, J. 1978. Archaeology and the History of Cherson: A Survey of Some Results and Problems. *Archaion Pontou* 35:172–192.

Sokolova, I. V. 1983. *Monety i pechati vizantiyskogo Khersona.* Leningrad: Iskusstvo.

Yakobson, A. L. 1950. *Srednevekovyy Khersones (XII–XIV vv.). Materialy i issledovaniya po arkheologii SSSR* 17. Moscow: Nauka.

Yakobson, A. L. 1959. *Rannesrednevekovyy Khersones. Ocherki istorii material'noy kul'tury. Materialy po arkheologii SSSR* 63. Moscow: Nauka.

Yakobson, A. L. 1979. *Keramika i keramicheskoye proizvodstvo srednevekovoy Tavriki.* Leningrad: Nauka

Further Reading

Arrhenius, B. 1990. Connections between Scandinavia and the East Roman Empire in the Migration period. In Austin, D. L. and L. Alcock, eds. *From the Baltic to the Black Sea: Studies in Medieval Archaeology.* London: Routledge, 118–137.

Cameron, A. 1993. *The Mediterranean World in Late Antiquity: AD 395–600.* London: Routledge.

Ioannisyan, O.M. 1990. Archaeological Evidence for the Development and Urbanisation of Kiev from the 8th to the 14th Centuries. In Austin D. L., and L. Alcock, eds. *From the Baltic to the Black Sea: Studies in Medieval Archaeology.* London: Routledge, 285–312.

Laiou, A. E., ed. 2002. *The Economic History of Byzantium: From the Seventh through the Fifteenth Century.* Dumbarton Oaks Studies XXXIX. Washington, DC.

Mathews, T. F. 1998. *Byzantium: From Antiquity to the Renaissance.* New York: Abrams.

Obolensky, D. 1971. *The Byzantine Commonwealth: Eastern Europe 500–1453.* London.

Poppe, A. 1976. The Political Background to the Baptism of Rus'. *Dumbarton Oaks Papers* 30:195–244.

Teall, J. L. 1971. The Byzantine Agricultural Tradition. *Dumbarton Oaks Papers* 25:35–59.

Toynbee, A. J. 1973. *Constantine Porphyrogenitus and his World.* London: Oxford University Press.

Zalesskaya, V.N. 1988. Svyazi srednevekovogo Khersonesa s Siriyey i Maloy Aziyey v X-XII vekah In *Vostochnoye Sredizemnomor'ye i Kavkaz IV-XVI vv.* Leningrad: Iskusstvo, 93–104, English summary: 162.

Figure 4.1 Reliquary casket

Belyayev, N. 1929. Ocherki po vizantiyskoy arkheologii. Khersonesskaya moshchekhranitel'nitsa. *Seminarium Kondakovianum* 3. Prague. 15–131, Pl. XVII, XIX

Buschhausen, H. 1971. Die spätrömischen Metallscrinia und frühchristlichen Reliquiare. *Wiener Byzantinische Studien* IX. Wien. 252–254, Taf. 59–60.

Cruikshank-Dodd, E. 1962. Byzantine Silver Stamps. *Dumbarton Oaks Studies* VII. 86–87, fig. 17.

Cruikshank-Dodd, E. l973. *Byzantine Silver Treasures.* Bern: Mongraphiender Abegg-Stiftung. 86–87 no. 17.

Figure 4.2 St. George and St. Demetrios icon

Bank, A. V. 1966. *Vizantiyskoe iskusstvo v sobraniyakh Sovetskogo Soyuza.* Moscow. Cat. no. 157.

Bank, A. V. 1968. Dva pamyatnika melkoy plastiki iz Fessaloniki. *Vizantiyskiy vremennik* 29:265.

Darkevich, V. P. 1975. *Svetskoye iskusstvo Vizantii*. Moscow: Iskusstvo, 145, 280.

Gaydin, S. 1923. Reznaya shifernaya ikona sv. Dmitriya i Georgiya. *Sbornik Gosudarstvennogo Ermitazha* II. Petrograd. 31–42.

Rydina, A.V. 1975. Shifernaya ikona Borisa i Gleba iz Solotchi. In *Drevnerusskoye iskusstvo*. Moscow: Nauka, 116–119.

Figure 4.3 Facing birds brooch

Chichurov, I. S., ed. 1991. *Vizantiyskiy Kherson. Katalog Vystavki*. Moscow. Nauka. 43, no. 31.

Figure 4.5 Fish plate and pitcher

Vizantiyskiy Kherson. 155, no. 163.

Yakobson, 1979. 138; 134, fig. 84.2.

Figure 4.6 Ottoman bowl

Carter, J., ed. 2003. Excavations in the Ancient City. In *2002 Annual Report*. Austin, Texas: Institute of Classical Archaeology.

Figure 4.7 Black steatite icon

Sedikova, L., and P. Arthur. 2003. Excavations in the Ancient City. In *2002 Annual Report*. Austin, Texas: Institute of Classical Archaeology.

Figure 4.9 Dish with horseman

Vizantiyskiy Kherson. 158, no. 166.

Belov, G. D. 1941. Raskopki v severnoy chasti Khersonesa v 1931–1933 gg. *Materialy i issledovaniya po arkheologii SSSR*. 34. 216, fig. 31.

Figure 4.10 Lion medallion

Vizantiyskiy Kherson. 107, no. 106.

Yakobson, A. L. 1973. *Krym v sredniye veka*. Moscow: Nauka, 71, 73.

Figure 4.11 St. Theodore Stratelates icon

Bank, A. V. 1981. Nekotoryye skhodnyye pamyatniki srednevekovoy plastiki, naydennyye v Konstantinopole, Khersonese i Bolgarii. *Byzantinobulgarica* 7:114–115, fig. 5.

Vizantiyskiy Kherson. 89, no. 88.

Chapter 5 Decline and Rediscovery
By Tatiana Yashaeva, Glenn Mack

Ascherson, N. 1996. *Black Sea*. London: Hill & Wang Publishers.

Christian, D. 1998. *A History of Russia, Central Asia and Mongolia*. Malden, MA: Blackwell Publishers.

Epstein, S. A. 1996. *Genoa and the Genoese, 958–1528*. Chapel Hill, NC: University of North Carolina Press.

Fisher, A. W. 1978. *The Crimean Tatars*. Palo Alto, CA: Hoover Institute Press.

Magocsi, P. R. and G. J. Matthews. 1985. *Ukraine, A Historical Atlas*. Toronto: University of Toronto Press.

Magocsi, P. R. 1996. *A History of Ukraine*. Seattle, WA: University of Washington Press.

Ratchnevsky, P. 1991. *Genghis Khan: His Life and Legacy*. Translated by Nivison Haining. Cambridge, MA: Blackwell Publishers.

Further Reading

Yakobson, 1973.

Chapter 6 Modern Crimea
By Vyacheslav Zarubin, Glenn Mack, Tatiana Yashaeva, Paul Lehman

Allworth, E., ed. 1998. *The Tatars of Crimea*. Durham, NC: Duke University Press.

Drohobycky, M. 1995. *Crimea: Dynamics, Challenges, and Prospects*. Lanham, MD: University Press of America.

Magocsi, 1996.

Schönle, A. 2001. Garden of the Empire: Catherine's Appropriation of the Crimea. *Slavic Review* 60,1:1–23.

Zarubin, A. G., and V. G. Zarubin. 1997. *Bez pobediteley. Iz istorii grazhdanskoy voyny v Krymu*. Simferopol: Tavriya.

Further Reading

Altabayeva, Ye. B., and V. V. Kovalenko. 2002. *Na rubezhe epokh: Sevastopol' v 1905–1916 godakh: uchebnoye posobiye*. Sevastopol: Art-Print.

Chernomorskiy flot Rossii. Istoricheskiy ocherk. 2002. Simferopol: Tavrida.

Markevich, A. I. 1994. *Tavricheskaya guberniya vo vremya Krymskoy voyny. Po arkhivnym materialam*. Simferopol: Biznes-Inform.

Sevastopolyu 200 let. 1783–1983. Sbornik dokumentov i materialov. 1983. Kyiv: Naukova dumka.

Chapter 7 Warehouse of Local Antiquities
By Ludmila Grinenko

Antonova, I. A. 1959. Khersonesskiy muzey za gody sovetskoy vlasti. *Khersonesskiy sbornik* 5:3–12.

Antonova, I. A. 1997. Osnovatel' Khersonesskogo muzeya. *Krymskiy arkhiv* 3:57–67.

Formozov, A. A. 1986. *Stranitsy istorii russkoy arkheologii*. Moscow: Nauka.

Grinenko, L. O. 2000. Iz istorii Khersonesskogo muzeya (1914–1924 gg.). *Drevnosti 1997–1998*, 187–198.

Grinevich, K. E. 1927. *Sto let Khersonesskikh raskopok: istoricheskiy ocherk s ekskursionnym planom*. Sevastopol: Izdaniye Khersonesskogo muzeya.

Tunkina, I. V. 2001. K istorii izucheniya Khersonesa-Korsunya v kontse XVIII–seredine XIX vv. *Moskva-Krym: Istoriko-publitsisticheskiy al'manakh* 3:96–120.

Chapter 8 Ancient City Monuments

By Stanislav Ryzhov, Larissa Sedikova, Taissa Bushnell, Tatiana Yashaeva, Joseph Coleman Carter, Vitaly Zubar, Sergey D'yachkov, Roman Sazonov, Douglas Edwards

General

Kadeyev V. I. 1996. *Khersones Tavricheskiy. Byt i kul'tura (I–III vv. n.e.).* Kharkiv: Biznes-Inform.

Khersonesskoye gosudarstvo i Kharaks. In Koshelenko, G. A., I. T. Kruglikova, and V. S. Dolgorukov, eds. *Antichnyye gosudarstva Severnogo Prichernomor'ya.* Moscow: Nauka, 1984, Chapter 4.

Minns, 1913.

Romanchuk, A. I. 2000. *Ocherki istorii i arkheologii vizantiyskogo Khersona.* Yekaterinburg: Ural'skiy gosudarstvennyy universitet.

Zhizn' i gibel' Khersonesa.

Vinogradov, Yu. G., and M. I. Zolotarëv. 1999. Khersones iznachal'nyy. In Podosinov, A.V., ed. *Drevneyshiye gosudarstva vostochnoy Yevropy.* 1996–1997. Moscow: Vostochnaya Literatura, 91–129.

Defensive Walls

Antonova, I. A. 1996. Yugo-vostochnyy uchastok oboronitel'nykh sten Khersonesa. Problemy datirovki. *Khersonesskiy sbornik* 7:101–131.

Grinevich, K. E. 1926. Steny Khersonesa Tavricheskogo. Part I. *Khersonesskiy sbornik* 1:3–71.

Grinevich, K. E. 1927. Steny Khersonesa Tavricheskogo. Part II. *Khersonesskiy sbornik* 2:7–97.

McNicoll, A.W., and N. P. Milner. 1997. *Hellenistic Fortifications from the Aegean to the Euphrates.* Oxford: Oxford University Press.

Minns, 1913.

Further Reading

Foss, C. 1986. *Byzantine Fortifications: An Introduction.* Pretoria: University of South Africa Press, especially chapters 1, 2 and 4.

Klinkott, M. 2001. Die Stadtmauern der byzantinischen Besfestigungsanlagen von Pergamon. In *Altertümer von Pergamon.* Berlin.

Lawrence, A. W. 1979. *Greek Aims in Fortification.* Oxford: Clarendon Press.

Winter, F. E. 1971. *Greek Fortifications.* Toronto: University of Toronto Press.

Vaulted Tombs

Belov, G. D. 1927. Rimskiye pristavnyye sklepy NN 1013 i 1014. *Khersonesskiy sbornik* 2:107–146.

Mantsevich, A. P. 1932. *Ein Grabfund aus Chersonnes.* Leningrad.

Williams, D. and J. Ogden. 1994. *Greek Gold: Jewelry of the Classical World.* London: British Museum Press.

Zherebtsov, Ye. N. 1979. Novoye o Khersonesskom sklepe N 1012. *Kratkiye soobshcheniya Instituta arkheologii* 159:34–37.

Further Reading

Boardman, J. 1970. *Greek Gems and Finger Rings: Early Bronze Age to Late Classical.* London: Thames & Hudson.

Pfrommer, M. 1990. *Untersuchungen zur Chronologie früh- und hochhellenistischen Goldschmucks.* Tübingen: E. Wasmuth. 52–54, Pl. 4.4; 239, Pl. 23,6.

City Gates

Grinevich, K. E. 1926. Steny Khersonesa Tavricheskogo. Part I. *Khersonesskiy sbornik* 1:3–71.

Further Reading

McNicoll, A., and N. P. Milner. 1997. *Hellenistic Fortifications from the Aegean to the Euphrates.* Oxford: Oxford University Press. 46–105, 183–227.

Tower of Zeno

Strzheletskiy, S. F. 1969. XVII bashnya oboronitel'nykh sten Khersonesa (bashnya Zenona). *Soobshcheniya Khersonesskogo muzeya* 4:4–29.

Carter, J., ed. 2002. Excavations in the Ancient City. In *2001 Annual Report.* Austin, Texas: Institute of Classical Archaeology.

Danilenko, V. N., and R. Tokareva. 1974. *Bashnya Zenona.* Simferopol: Tavriya.

Further Reading

Foss, C. 1996. *Cities, Fortresses, and Villages of Byzantine Asia Minor.* Brookfield, VT: Variorum.

Citadel

Antonova, I. A. 1996. Yugo-vostochnyy uchastok oboronitel'nykh sten Khersonesa. Problemy datirovki. *Khersonesskiy sbornik* 7:101–131.

Antonova, I. A. 1997. Administrativnyye zdaniya Khersonesskoy veksilyatsii i femy Khersona (po materialam raskopok 1989–1993 gg.). *Khersonesskiy sbornik* 8:10–18.

Sorochan, S. B., et al. 2002. O rabotakh v tsitadeli Khersonesa Tavricheskogo v 2001g. In *Arkheologichni vidkryttya v Ukrayini.* Kyiv: Naukova dumka, 246–247.

Vinogradov, Yu. G., V. M. Zubar, and I.A. Antonova. 1999. Schola principalium v Khersonese. *Numizmatika i epigrafika.* 16:72–81.

Zhizn' i gibel' Khersonesa. 522–540.

Zubar, V. M., and I. A. Antonova. 2000. Novyye dannyye o rimskom garnizone Khersonesa v pervoy polovine III v. *Vestnik drevney istorii* 1:66–70.

Zubar, V. M. 2003. Po povodu interpretatsii odnoy postroyki na territorii rimskoy tsitadeli Khersonesa Tavricheskogo. *Vestnik drevney istorii* 1:120–130.

Further Reading

Freeman, P., and D. L. Kennedy. 1986. *The Defence of the Roman and Byzantine East: Proceedings of a Colloquium held at the University of Sheffield in April 1986. British Archaeological Reports.* Oxford.

Johnson, A. 1983. *Roman Forts of the 1st and 2nd centuries AD in Britain and the German Provinces.* New York: St. Martin's Press.

Johnson, S. 1983. *Late Roman Fortifications.* London: Batsford.

Barracks

D'yachkov, S.V. 1994. Raskopki XIV prodol'noy ulitsy v portovom rayone Khersonesa Tavricheskogo. *Drevnosti* 1994:141–152.

D'yachkov, S.V. 1999. Khersonesskaya arkheologicheskaya ekspeditsiya v 1996–1998 gg. *Drevnosti* 1997–1998:210–213.

D'yachkov, S.V., and A.V. Magda. 1995. Raboty Khersonesskoy arkheologicheskoy ekspeditsii Kharkovskogo universiteta v 1994 godu. *Drevnosti* 1995:176–177.

Saprykin, S. Yu., and S. V. D'yachkov. 1994. Grafitto iz 'kazarmy'. *Drevnosti* 1994:169–173.

Agora

Gerlovina, F. I. 1963. K voprosu o Khersonesskoy statuye Devy. *Soobshcheniya Khersonesskogo muzeya* 3:30–32.

Martin, R. 1951. *Recherches sur l'agora grecque; études d'histoire et d'architecture urbaines.* Paris: E. de Boccard.

Meshcheryakov, V. F. 1979. O kul'te bogini Devy v Khersonese Tavricheskom. In *Aktual'nyye problemy izucheniya istorii religii i ateizma.* Leningrad: Gosudarstvennyy muzey ateizma, 104–119.

Otchët Imperatorskoy Arkheologicheskoy Komissii za 1890 god. 1893. St. Petersburg: Akademiya nauk.

Otchët Imperatorskoy Arkheologicheskoy Komissii za 1891 god. 1893. St. Petersburg: Akademiya nauk.

Main Street

Buyskikh, A.V. 1996. Nekotoryye problemy izucheniya doricheskogo ordera Khersonesa. *Khersonesskiy sbornik* 7:49–60.

Buyskikh, A.V., and M. I. Zolotarëv, 2001. Gradostroitel'nyy plan Khersonesa Tavricheskogo. *Vestnik drevney istorii* 1:111–132.

Castagnoli, F. 1971. *Orthogonal Town Planning in Antiquity.* Cambridge, MA: MIT Press.

Solomonik, E. I. 1984. O kul'te Afiny v Khersonese v 4th–3rd vv. do n.e. In *Antichnaya i srednevekovaya ideologiya.* Sverdlovsk: Izdatel'stvo Ural'skogo universiteta, 7–14.

Zolotarëv, M. I., and A.V. Buyskikh, 1994. Temenos antichnogo Khersonesa. Opyt arkhitekturnoy rekonstruktsii. *Vestnik drevney istorii* 3:78–101.

Further Reading

Wycherley, R. E. 1962. *How the Greeks Built Cities.* London: Doubleday.

Theater

Bieber, M. 1961. *The History of the Greek and Roman Theater.* 2nd ed. Princeton: Princeton University Press.

Dombrovskiy, O. I. 1958. *Otchët o raskopkakh antichnogo teatra v Khersonese za 1957 god.* Archive of NPTC.

Dombrovskiy, O. I. 1960. Antichnyy teatr v Khersonese (raskopki 1954–1958 gg.). *Soobshcheniya Khersonesskogo muzeya* 1:29–36.

Dombrovskiy, O. I. 1975. Stratigraficheskiye nablyudeniya na uchastke raskopok antichnogo teatra v Khersonese. In *Noveyshiye otkrytiya sovetskikh arkheologov* II. Kyiv. 74–75.

Dombrovskiy, O. I. 1997. Ob odnom iz dekorativnykh rel'yefov khersonesskogo antichnogo teatra. In *Arkheologiya Kryma* I. Simferopol: Yuzhnogorodskiye vedomosti, 35–42.

Shcheglov, A. N. 1966. K voprosu o gladiatorskikh boyakh v Khersonese Tavricheskom. *Eirene* 5:99–105.

Zedgenidze, A. A. 1976. Issledovaniye severo-zapadnogo uchastka antichnogo teatra v Khersonese. *Kratkiye soobshcheniya Instituta Arkheologii* 145:28–34.

Figure 8.19 Gladiators relief

Bibikov, S. N., ed. 1976. *Antichnaya skul'ptura Khersonesa.* Kyiv: Mystetstvo, 159, fig. 200, no. 502. Contributors: A. P. Ivanova, A. P. Chubova, L. G. Kolesnikova, A. N. Shcheglov, Y. A. Babinov, with full bibliography. Future reference given by title only.

Mint

Anokhin, V. A. 1977, 1980.

Karasëv, A. N. 1955. Monetnyy dvor v Khersonese. In *Antichnyye goroda Severnogo Prichernomor'ya* I, Moscow: Akademiya Nauk, 202–203.

Robinson, D. M. 1930. Architecture and Sculpture. In *Excavations at Olynthus*, Vol. 2:107. London.

Robinson, D. M. 1946. *Excavations at Olynthus* 12. Baltimore: Johns Hopkins University.

Further Reading

Otchët Imperatorskoy Arkheologicheskoy Komissii za 1904 god, 1907. St. Petersburg: Akademiya nauk.

Water System and Public Baths

By Larissa Sedikova

See bibliography for Citadel, p. 209 .

Boersma, J. 1991. Le terme tardoromane di Valesia. In Lenoir, M., ed. *Les thermes romains: actes de la table ronde organisée par l'Ecole française de Rome,* Rome, 11-12 novembre 1988. Rome. Ecole française de Rome. Paris. Diffusion de Boccard, 161–173.

Kadeyev V. I. 1996. *Khersones Tavricheskiy. Byt i kul'tura (I–III vv. n.e.).* Kharkiv: Biznes-Inform.

Pyatysheva, N. V. 1969. Raskopki Gosudarstvennogo Istoricheskogo muzeya v Khersonese. In *Ekspeditsii*

Gosudarstvennogo Istoricheskogo muzeya. Doklady na sessii Uchënogo soveta GIM 5–7 fevralya 1969 g. Moscow: Gosudarstvennyy Istoricheskiy muzey, 141–158

Sedikova, L.V. 1994. Raskopki vodokhranilishcha v Khersonese. In *Arkheologicheskiye issledovaniya v Krymu.* Simferopol: Tavriya. 238–240.

Sedikova, L. 1995. Keramicheskiy kompleks pervoy poloviny IX v. iz raskopok vodokhranilishcha v Khersonese. *Rossiyskaya arkheologiya* 2:170–177.

Further Reading

Suceveanu, A. 1982. *Les thermes romains.* Bucarest: Editura Academiei Republicii Socialiste Romania.

Nielsen, I. 1990. *Thermae et Balnea: The Architecture and Cultural History of Roman Public Baths.* Aarhus: Aarhus University Press.

White, K. D. 1984. *Greek and Roman Technology.* Ithaca, NY: Cornell University Press.

Yegul, F. K. 1992. *Baths and Bathing in Classical Antiquity.* New York: MIT Press.

Figure 8.26 Clay water pipes

Pyatyshyeva, 1969. 144.

Port Block

Kadeyev, V. I. 1973. Raskopki v 'tsentre uchastka'. *Antichnaya drevnost' i sredniye veka* 9:13–27.

Romanchuk, A. I. 1973. Kompleks VII v. iz Portovogo rayona Khesonesa. *Antichnaya drevnost' i sredniye veka* 10:246–251.

Romanchuk, A. I. 1978. Izucheniye Portovogo kvartala Khersonesa. *Arkheologicheskiye otkrytiya.* 1977 g. Moscow: Nauka, 378–379.

Romanchuk, A. I. 1980. Izucheniye Portovogo kvartala Khersonesa. *Arkheologicheskiye otkrytiya.* 1979 g. Moscow: Nauka, 379–380.

Romanchuk, A. I. 1988. Raskopki v Portovom kvartale Khersonesa. *Arkheologicheskiye otkrytiya.* 1986 g. Moscow: Nauka, 331.

Romanchuk, A. I. 1994. Raskopki v Portovom kvartale 2. Khersonesskogo gorodishcha. In *Arkheologicheskiye issledovaniya v Krymu.* Simferopol: Tavriya, 227–230.

Romanchuk, A. I. 1998. Gorodskaya pozdnevizantiyskaya usad'ba kak otrazheniye statusa yeë vladel'tsa. *Antichnaya drevnost' i sredniye veka.* 24:112–119.

Further Reading

McCann, A. M., and J. Bourgeois. 1987. *The Roman Port and Fishery of Cosa: A Center of Ancient Trade.* Princeton: Princeton University Press.

Meiggs, R. 1973. *Roman Ostia.* 2nd ed. Oxford: Clarendon Press.

White, K. D. 1984. *Greek and Roman Technology.* Ithaca, NY: Cornell University Press.

Early Hellinistic Houses

Belov, G. D. 1963. Ellinisticheskiy dom v Khersonese. *Trudy Gosudarstvennogo Ermitazha* 7:143–184.

Fëdorov, B. N. 1977. Ob"ëmno-planirovochnaya rekonstruktsiya dvukh zhilykh domov ellinisticheskogo vremeni (IV–II vv. n.e.) v Khersonese. *Problemy razvitiya zarubezhnogo iskusstva* 7:10–17.

Nevett, L. C. 2001. *House and Society in the Ancient Greek World.* Cambridge: Cambridge University Press.

Ryzhov, S. G. 1985. Dom IV–III vv. do n.e. v Khersonese. *Sovetskaya arkheologiya* 4:155–162.

Further Reading

Robinson, D. M. and J. W. Graham. 1938. *The Hellenistic House. Excavations at Olynthus* 8. London: Oxford University Press.

House with the Mosaic Floor

Belov, G. D. 1953. Ellinisticheskaya mozaika. *Materialy i issledovaniya po arkheologii SSSR* 34:279–295.

Dombrovskiy, O. I. 1994. Khersonesskaya galechnaya mozaika i nekotoryye aspekty istorii antichnogo iskusstva. In *Severo-zapadnyy Krym v antichnuyu epokhu.* Kiev: Akademiya Nauk, 159–208.

Robertson, M. 1975. *A History of Greek Art.* London: Cambridge University Press.

House with a Winery

Belov, G. D. 1952. Khersonesskiye vinodel'ni. *Vestnik drevney istorii* 2:225–237.

Kadeyev V. I. 1996. *Khersones Tavricheskiy. Byt i kul'tura (I–III vv. n.e.).* Kharkiv: Biznes-Inform.

Strzheletskiy, S.F. 1959. Vinodeliye v Khersonese tavricheskom antichnoi epokhi. *Khersonesskiy sbornik* 5:121–159.

Further Reading

Amouretti, M.-Cl., and J.-P. Brun, eds. 1993. *La production du vin et de l'huile en Méditerranée*: actes du symposium international, Aix-en-Provence et Toulon, 20-22 novembre 1991. Athènes. Ecole française d'Athènes. Paris: Diffusion de Boccard.

White, K. D. 1984. *Greek and Roman Technology.* Ithaca, NY: Cornell University Press.

Figure 8.34 Iron plowshare

Kuzishchin, V.I. 1980. Raskopki pozdneantichnoy villy bliz Sevastopolya. *Arkheologicheskiye otkrytiya* 1979 g. Moscow: Nauka, 294.

Belov, G. D. 1941. Raskopki v Severnoy chasti Khersonesa v 1931–1933 gg. *Materialy i issledovaniya po arkheologii SSSR* 4:261, fig. 104.

Figure 8.35 Relief of Doulon, son of Delphos
Antichnaya skul'ptura Khersonesa, 78, fig. 111, no. 215.

Fishmonger's House

Belov, G. D. 1953. *Materialy i issledovaniya po arkheologii SSSR* 34:18–22.

Romanchuk, A. I. 1973. Novyye materialy o vremeni stroitel'stva rybozasolochnykh tsistern Khersonesa. *Antichnaya drevnost' i sredniye veka* 9:45–53.

Romanchuk, A. I. 1977. Plan rybozasolochnykh tsistern Khersonesa. *Antichnaya drevnost' i sredniye veka* 14:18–20.

Further Reading

Curtis, R. I. 1991. *Garum and Salsamenta: Production and Commerce in Materia Medica*. New York: E. J. Brill.

Gallant, T. W. 1985. *A Fisherman's Tale*. Ghent.

Medieval Residential Insulae

Belov, G. D. 1941. Raskopki v severnoy chasti Khersonesa v 1931–1933 gg. *Materialy i issledovaniya po arkheologii SSSR* 4:202–267.

Belov, G. D. 1962. Ellinisticheskiy dom v Khersonese. *Trudy Gosudarstvennogo Ermitazha* 7:226–237.

Ryzhov, S. G. 1999. Srednevekovaya usad'ba XIII v. v Severnom rayone Khersonesa (postoyalyy dvor). *Drevnosti* 1997–1998: 168–181.

Ryzhov, S. G. 2001. Srednevekovyye zhilyye kvartaly X–XIII vv. v Severnom rayone Khersonesa. *Materialy po arkheologii, istorii i etnografii Tavrii* 8:290–312.

Further Reading

Boethius, A. 1960. *The Golden House of Nero: Some Aspects of Roman Architecture*. Ann Arbor, MI: University of Michigan.

Stillwell, R. 1961. Houses of Antioch. *Dumbarton Oaks Papers* 15:45–57. Cambridge: Harvard University Press.

Wallace-Hadrill, A. 1994. *Houses and Society in Pompeii and Herculaneum*. Princeton: Princeton University Press.

Medieval Quarters in Southern Region

Arthur, P., and L. Sedikova. 2002. Excavations in the Ancient City. In *2001 Annual Report*. 9–22. Austin, Texas: Institute of Classical Archaeology.

Sedikova, L., and P. Arthur. 2003. Excavations in the Ancient City. In *2002 Annual Report*. Austin, Texas: Institute of Classical Archaeology.

Paintmaker's house

Zhizn' i gibel' Khersonesa. 628–630.

Twilley, J. 2002. Pigment Analyses for the Grave Stelae and Architectural Fragments from Chersonesos. In Tiverios, M.A. and D.S. Tsiafakis, eds. *Color in Greek Art: The Role of Color in Ancient Greek Art and Architecture 700–31* BC. Thessaloniki.

White, K. D. 1984. *Greek and Roman Technology*. Ithaca, NY: Cornell University Press.

Potter's Quarters

Borisova, V. V. 1958. Goncharnyye masterskiye Khersonesa. *Sovetskaya arkheologiya* 4:144–153.

Borisova, V. V. 1966. *Keramicheskoye proizvodstvo antichnogo Khersonesa*. Leningrad.

Sedikova, L.V. 1994. Keramicheskiye pechi IX v. v Khersonese. *Materialy po arkheologii, istorii i etnografii Tavrii* 4:434–40.

Sedikova, L. V. 1995. Keramicheskiy kompleks pervoy poloviny IX v. iz raskopok vodokhranilishcha v Chersonese. *Rossiyskaya arkheologiya* 2:170–177.

Further Reading

Sparkes, B. A. 1991. *Greek Pottery: An Introduction*. Manchester: St. Martin's Press.

Zedgenidze, A. A. 1978. Atticheskaya krasnofigurnaya keramika iz Khersonesa. *Kratkiye soobshcheniya Instituta Arkheologii* 156:69–78.

Amphorae and Pottery Workshops

By Andrei Opait

Kats, V. I. 1994. *Keramicheskiye kleyma Khersonesa Tavricheskogo: katalog-opredelitel'*. Saratov: Izdatel'stvo Saratovskogo Universiteta.

Monakhov, S. Yu. 1984. Proizvodstvo amfor v ellinisticheskom Khersonese. *Vestnik drevney istorii* 1:109–130.

Monakhov, S. Yu. 1999. *Grecheskiye amfory v Prichernomor'ye : kompleksy keramicheskoy tary VII–II vekov do n.e.* Saratov.

Opait, A. 2003. *The Eastern Mediterranean amphorae in the province of Scythia*. Forthcoming.

Randsborg, K. 1994. A Greek Episode: The Early Hellenic Settlement on the Western Crimea. *Acta Archaeologica* 65:171–196.

Whitbread, I. K. 1995. *Greek Transport Amphorae: A Petrological and Archaeological Study*. Athens: British School at Athens.

Zeest, I. 1960. *Keramicheskaya tara Bospora. Materialy i issledovaniya po arkheologii SSSR* 83. Moscow: Nauka.

Further Reading

Antonova, I. A. et al. 1971. Srednevekovyye amfory iz Khersonesa. *Antichnaya drevnost' i sredniye veka* 7:81–101.

Borisova, V. V. 1958. Goncharnye masterskiye Khersonesa. *Sovetskaya Arkheologiya* 4:144–53.

Borisova, V. V. 1960. Srednevekovaya goncharnaya pech'. *Soobshcheniya Khersonesskogo muzeya* I:42–46.

Opait, A. 1996. *Aspecte ale vietii economice din provincia Scythia (secolele IV–VI p.Ch.). Productia ceramicii locale si de import*. Bucharest.

Opait, A. 2003. *'Table' amphora versus 'Table' pitcher in Roman Dobrudja*. Forthcoming.

Ryzhova, L. A. 1982. Goncharnaya pech' VIII–IX v.v. vblizi Khersona (v rayone Radiogorki). *Antichnaya drevnost' i sredniye veka* 19:149–56.

Sedikova L.V. 1994. Keramicheskiye pechi IX v. v Khersonese. *Materialy po arkheologii, istorii i etnografii Tavrii* 4:434–40.

Tezgör Kassab, D., and I. Tatlican. 1998. Fouilles des ateliers d'amphores à Demirci près de Sinop en 1996 et 1997. *Anatolia Antiqua* 6:423–42.

Tsetskhladze, G. R., and S. Y. Vnukov. 1992. Colchian Amphorae: Typology, Chronology, and Aspects of Production. *Annual of the British School at Athens* 87:357–86.

Uzhentsev, V. V., and V. Yu. Yurochkin. 1998. Amphory s voronkovidnym gorlom iz Prichernomor'ya. *Khersonesskiy sbornik* 9:100–109.

Vnukov, S. Yu. Psevdokosskiye ampfory Prichernomor'ya. *Rossiyskaya Arkheologiya* 4:54–63.

Vysotskaya, T. N. 2000. Amfory redkikh tipov iz mogil'nika Sovkhoz no. 10 (Sevastopol'skiy). *Donskaya Arkheologia* 3–4:83–92.

Yakobson, A. L. 1951. Srednevekovyye amfory Severnogo Prichernomor'ya. *Sovetskaya Arkheologiya* 15:325–344.

Yakobson, A. L. 1979. *Keramika i keramicheskoye proizvodstvo srednovekovoiy Tavriki.* Leningrad.

Zolotarëv, M. I. 1982. Khersonesskiy goncharnyy kompleks VIII–IX vv. *Antichnaya drevnost' i sredniye veka* 19:145–48.

Necropoleis

Belov, G. D. 1948. Nekropol' Khersonesa klassicheskoy i ellinisticheskoy epokhi. *Vestnik drevney istorii* 1:155–163.

Belov, G. D. 1950. Nekropol' Khersonesa klassicheskoy epokhi. *Sovetskaya Arkheologiya* 13:272–284.

Belov, G. D. 1953. *Materialy i issledovaniya po arkheologii SSSR* 34:18–22.

Puzdrovskiy, A. Ye. 1999. Etnicheskaya istoriya Krymskoy Skifii (II v. do n.e.–III v. n.e.). *Khersonesskiy sbornik* 10:208–225.

Rostovtzeff [Rostovtsev], M. I. 1914. *Antichnaya dekorativnaya zhivopis' na yuge Rossii.* St. Petersburg.

Zubar, V. M. 1982. *Nekropol' Khersonesa Tavricheskogo I–IV vv. n.e.* Kyiv: Naukova dumka.

Zubar, V. M. 1999. K interpretatsii odnogo iz syuzhetov rospisi sklepa 1912 g. iz Khersonesa. *Khersonesskiy sbornik* 10:298–302.

Figure 8.58 Detail of painted wall of tomb

Zubar, V. M. and A.I. Khvorostyanyy. 2000. *Ot yazychestva k khristianstvu.* Kyiv: NAS Ukraine, Institute of Archaeology. Pl. 65, fig. 4.

Religious Architectural Monuments of Medieval Chersonesos
By Taissa Bushnell, Tatiana Yashaeva, Larissa Sedikova, Sergey Sorochan, Amy Papalexandrou
General

Alekseenko, N. A., and S. V. D'yachkov. 1999. *Khersonesskiye arkheologicheskiye progulki.* Kharkiv: NMC MD.

Antonova I. A., et. al. 1985. *Khersones.* Simferopol: Tavriya.

Belyayev, S.A. 1989. Baziliki Khersonesa: Itogi, problemy i zadachi ikh izucheniya. *Vizantiyskiy vremennik* 50:171–81.

Dix, G. 1945. *The Shape of the Liturgy.* 2nd ed. Westminster.

Grabar', A. 1946. *Martyrium. Recherches sur le culte des reliques et l'art chrétien antique,* 2 vols. Paris. Collège de France.

Khatchatrian, A. 1962. *Les baptistères paléochrétiens: plans, notices et bibliographie.* Paris. Ecole pratique des hautes études-Section des sciences religieuses.

Krautheimer, R., and S. Curcic. 1986. *Early Christian and Byzantine Architecture.* New Haven: Yale University Press.

Mango, C. 1985. *Byzantine Architecture.* New York: Rizzoli.

Mathews, T.F. 1971. *The Early Churches of Constantinople: Architecture and Liturgy.* University Park: Pennsylvania University Press.

Saxer, V. 1988. Les rites de l'initiation chrétienne du IIe au VIe siècle. *Centro italiano di studi sull'alto medioevo* 7.

Smedley, J. 1979. Archaeology and the History of Cherson: A Survey of Some Results and Problems. *Archaion Pontou* 35:172–92.

Soteriou, G. 1929. Ai palaiochristianikai basilikai tes Hellados. *Archaiologike Ephemeris.* 161–248.

Ward-Perkins, J. B. 1966. Memoria, Martyr's Tomb and Martyr's Church. *Journal of Theological Studies* 18/1:20–37.

Yakobson, A. L. 1950. *Srednevekovyy Khersones (XII–XIV vv.). Materialy po arkheologii SSSR.* 17. Moscow: Nauka.

Yakobson, A. L. 1959. *Rannesrednevekovyy Khersones. Ocherki istorii material'noy kul'tury. Materialy po arkheologii SSSR.* 63. Moscow: Nauka.

Zavads'ka [Zavadskaya], I. A. 2000. *Khristiyanstvo v rann'ovizantiys'komu Khersonesi (za kul'tovymy pam'yatkamy).* Kyiv.

Further Reading

Brunov, M.N. 1932. Une église byzantine à Chersonèse. In Uspenskij, T., ed. *L'art byzantin chez les Slaves: l'ancienne Russie 2,* Paris: Librairie Orientaliste Paul Geuthner. 25–34.

Izmajlov, N. 1932. Une stéatite byzantine du Musée de Chersonèse. In Uspenskij, *L'art byzantin chez les Slaves* 2:35–48.

Tichanov-Klimenko, M. 1932. Les chapiteaux de l'église Saint-Jean-le-Précurseur à Kertch. In Uspenskij, *L'art byzantin chez les Slaves* 2:3–24.

Zalesskaya, V. 1995. Quelques bronzes byzantins à Chersonèse (les liens avec l'Asie Mineure et les Balkans aux XIIe–XIVe siècles. In Moss, K. and K. Kiefer, eds. *Byzantine East, Latin West: Art-historical Studies in Honor of Kurt Weitzmann*. Princeton. 669–673.

Uvarov Basilica

Aynalov, D. V. 1905. Razvaliny khramov. *Pamyatniki khristianskogo Khersonesa* 1. Moscow: Imperatorskoye Moskovskoye Arkheologicheskoye Obshchestvo.

Yakobson, 1959. 152–160.

Zavadskaya, I. A. 1997. Nekotoryye problemy datirovki kompleksa Uvarovskoy baziliki Khersonesa. *Bakhchisarayskiy istoriko-arkheologicheskiy sbornik* 1:304–311.

Basilica within a Basilica

Berthier de Lagarde, A. L. 1893. Raskopki Khersonesa. *Materialy po arkheologii Rossii* 12:22–36.

Ryzhov, S. G. 1997. Novyye dannyye o 'Bazilike v bazilike'. In Meshcheryakov, V. F., ed. *Antichnyy mir. Vizantiya*. Kharkiv: Biznes-inform, 290–300.

Figure 8.69 Mosaic floor from Basilica within a Basilica
Yakobson, 1959. 222–247.

1935 Basilica

Belov, G. D. 1938. *Otchët o raskopkakh v Khersonese za 1935–1936 gg.* Sevastopol: Gosudarstvennoye izdatel'stvo Krymskoy ASSR. Sevastopol, 80–138.

Zherebtsov, Ye. N. 1963. K izucheniyu rannesrednevekovykh pamyatnikov Khersona. *Vizantiyskiy vremennik* 23:205–213.

Zavadskaya, I. A. 1996. Problemy stratigrafii i khronologii arkhitekturnogo kompleksa 'Bazilika 1935 goda' v Khersonese. *Materialy po arkheologii, istorii i etnografii Tavrii* 5:94–105

Western Basilica

Kostsyushko-Valyuzhinich, K. K. 1893. Raskopki v Khersonese. *Otchët Imperatorskoy arkheologicheskoy komissii za 1891 g.* 2–20.

Kostsyushko-Valyuzhinich, K. K. 1902. Otchët o raskopkakh v Khersonese v 1901 g. *Izvestiya Imperatorskoy arkheologicheskoy komissii.* 4:51–119.

Zavadskaya, I. A. 1998. Rannesrednevekovyye khramy zapadnoy chasti Khersonesa. *Materialy po arkheologii, istorii i etnografii Tavrii* 6:327–343.

Kruse Basilica

Aynalov, D. V. 1905. Razvaliny khramov. *Pamyatniki khristianskogo Khersonesa* 1. Moscow: Imperatorskoye Moskovskoye Arkheologicheskoye Obshchestvo, 67–70.

Yakobson, 1959. 188–190.

Reliquary Church

Kostsyushko-Valyuzhinich, K. K. 1900. Raskopki v Khersonese. *Otchët Imperatorskoy arkheologicheskoy komissii za 1897 g.*:26–29.

Yakobson, 1959. 197–200.

Cave Church

Mogarichëv, Yu. M. 1999. K voprosu o 'Peshchernom khrame' na glavnoy ulitse Khersonesa. *Problemy istorii, filologii, kul'tury* 8:229–238.

Belyaev, S. A. 1989. Peshchernyy khram na glavnoy ulitse Khersonesa. In Vagner, G., ed. *Vizantiya i Rus'*. Moscow: Nauka, 26–55.

Church Outside the City Walls

Kostsyushko-Valyuzhinich, K. K. 1904. Izvlecheniye iz otchëta o raskopkakh v Khersonese v 1902 g. *Izvestiya Imperatorskoy arkheologicheskoy komissii.* 9:1–62.

Yakobson, 1959. 125–221.

Dombrovskiy, O. I. 1993. Arkhitekturno-arkheologicheskoye issledovaniye Zagorodnogo krestoobraznogo khrama Khersonesa. *Materialy po arkheologii i etnografii Tavrii* 3:289–318.

Figure 8.88 Mosaic from Church outside city walls
Yakobson, 1959. 222–247.

Underwater Archaeology
By Victor Lebedinski

Blavatskiy, V. D. 1961. Podvodnyye raskopki Fanagorii v 1959 g. *Sovetskaya Arkheologiya* 1:277–279.

Lebedinskiy, V. V. 2002. Rezul'taty noveyshikh podvodnykh arkheologicheskikh issledovaniy v akvatorii g. Sevastopolya v ramkakh realizatsii proyekta Sostavleniye fundamental'nogo svoda podvodnykh arkheologicheskikh pamyatnikov Chernomorskogo basseyna i sozdaniye podvodno-arkheologicheskoy karty. In *Podvodnaya Arkheologiya: sto let issledovaniy*. Moscow. 15–23.

Chapter 9 Chora of Chersonesos
By Joseph Coleman Carter, Galina Nikolaenko, Ludmila Kovalevskaya, Tadeusz Sarnowski, Tatiana Yashaeva

Carter, J. C., M. Crawford, P. Lehman, G. Nikolaenko, and J. Trelogan. 2000. The Chora of Chersonesos in Crimea, Ukraine. *American Journal of Archaeology*. 104:707–741.

Chtcheglov [Shcheglov], A. 1992. *Polis et chora: cité et territoire dans le Pont-Euxin*. Translated by Jacqueline Gaudoy. Paris: Université de Besançon.

Konecny, A. 1997. *Hellenistische Turmgehöfte in Zentral- und Ostlykien*. Vienna: Phoibos Verlag.

Nikolaenko, G. M. 1999. *Khora Khersonesa Tavricheskogo. Zemelnyy kadastr IV–II vv. do n.e.* Chast I. Sevastopol.

Nikolaenko, G. M. 2001. *Khora Khersonesa Tavricheskogo. Zemelnyy kadastr IV–II vv. do n.e.* Chast II. Sevastopol.

Pecirka, J. 1970. *Country Estates of the Polis of Chersonesos in Crimea. Ricerche storiche ed ecnomiche in memoria di Corrado Barbagallo.* Naples.

Pecirka, J., and M. Dufkova. 1970. Excavations of Farms and Farmhouses in the Chora of Chersonesos in Crimea. *Eirene.* 8:123–174.

Rostovtzeff [Rostovtsev], M. I. 1941. *Social and Economic History of the Hellenistic World.* Oxford: Oxford University Press. 3 vols.

Saprykin, S. Yu. 1994. *Ancient Farms and Land Plots on the Chora of Chersonesos Taurike: Research on the Heraklean Peninsula 1974–1990.* Amsterdam: J. C. Grieben.

Strzheletskiy, S. F. 1961. Klery Khersonesa Tavricheskogo. *Khersonesskiy sbornik* 6.

Figure 9.3 Kizil-Koba statuettes and vessel
2002 Annual Report. Austin, Texas: Institute of Classical Archaeology. 2003.

Figure 9.4 Satyr statuette
Carter, J. C., et al. 2000. 104. fig. 17.

Figure 9.13 Silver denarius
2000 Annual Report. Austin, Texas. Institute of Classical Archaeology. 2001.

Anokhin, V. A. 1977. *Monetnoye delo Khersonesa (IV v. do n.e.–XII v. n.e.).* Kyiv: Naukova dumka.

Chapter 10 Greek and Roman Galleries
By Joseph Coleman Carter, Antonina Shevchenko, Stanislav Ryzhov, Olga Grabar', Richard Posamentir, John Twilley

Sculpture—Greek Period

Figure 10.2 Civic Oath of Chersonesos
Latyshev, V. V. 1892. Grazhdanskaya prisyaga khersonestsev. *Materialy po arkheologii Rossii* 9:1–14.
IosPE. I².401.
Saprykin, S. 1997. *Heracleia Pontica and Tauric Chersonesus before Roman Domination.* Amsterdam. Ch. 2. 179–208 with recent bibliography.

Figure 10.3 Headless male torso
Antichnaya skul'ptura. 59, fig. 84, 85 no. 139.
Grinevich, K. E. 1930. Severo-vostochnyye kvartaly Khersonesa Tavricheskogo po dannym raskopok R. Lepera. *Khersonesskiy sbornik* 3:44.
Linfert, A. 1976. *Kunstzentren hellenischer Zeit.* Wiesbaden. 70, figs. 135–136. Cf. figs. 18–19.

Figure 10.4 Head of Karyatid
Antichnaya skul'ptura. 53, figs. 72, 73 no. 116.
Ridgway, B. S. 1981. *Fifth Century Styles in Greek Sculpture.* Princeton, NJ: Princeton University Press. 105–108, figs. 82–83 with bibliography.
Strzheletskiy, S. F. 1969. XVII bashnya oboronitel'nykh sten Khersonesa (bashnya Zenona). *Soobshcheniya Khersonesskogo muzeya.* 4:12–13, figs. 9a, b.

Figure 10.5 Relief with seated Amazon
Antichnaya skul'ptura. 39, figs. 53. no. 85.
Budde, L., and R. Nicholls. 1964. *A Catalogue of the Greek and Roman Sculpture in the Fitzwilliam Museum.* Cambridge. Cambridge. 60 Pl. 32.
Isler-Kerényi, K. 1993. Griechen und Skythen am Schwarzen Meer. In Karabelnik, M., ed. *Aus den Schatzkammern Eurasiens. Meisterwerke antiker Kunst.* Zürich: Kunsthaus. 172–173.
Praschniker, C., and M. Theuer. 1979. *Das Mausoleum von Belevi, Forschungen von Ephesos* 4. fig. 61, especially. This monument is dated to the mid–third century BC.
Ridgway, B. 1990. *Hellenistic Sculpture I: The Styles of 321–200 bc.* Madison, Wisconsin. 19–20, ill. 5.

Decorated Vases—Greek Period
Figure 10.6 Fish plate
Kostsyushko-Valyuzhinich, K.K. 1903. Otchët o raskopkakh v Khersonese Tavricheskom v 1903 g. *Izvestiya imperatorskoy arkheologicheskoy komissii.* 16:64, fig. 25.
McPhee, I. and A.D. Trendall. 1987. *Greek Red Figured Fish Plates.* Basel.
Zedgenidze, A. A. 1978. Atticheskaya krasnofigurnaya keramika iz Khersonesa. *Kratkiye soobshcheniya Instituta arkheologii* 156:71, fig. 1.

Figure 10.7 Kerch style pelike
Boardman, J. 1989. *Athenian Red Figure Vases: The Classical Period.* London. fig. 408.

Figure 10.8 Krater fragment with satyr
Zedgenidze, 1978. 156:69, fig. 1.1.

Figure 10.9 A kiss in a black gloss cup
Belov, G. D. 1941. Raskopki v severnoy chasti Khersonesa v 1931–1933 gg. *Materialy i issledovaniya po arkheologii SSSR* 4:203, fig. 1.
Bieber, M. 1961. *The Sculpture of the Hellenistic Age.* New York, fig. 638. (The kiss of Eros and Psyche was represented in large scale sculpture.)

Figure 10.10 Facing female busts in a greyware cup bottom
Belov, G. D. 1931. Terrakoty Khersonesa iz raskopok 1908–1914 gg. *Khersonesskiy sbornik* 3:242, fig. 32.

Gehrig, U. 1967. *Hildesheimer Silberfund*. Berlin. Pl. 3, figs. 13, 14. (Individual busts of gods and heroes were used as emblems in silver drinking cups.)

Figure 10.11 Cult vessel with molded heads

Kostsyushko-Valyuzhinich, K. K. 1906. Otchët o raskopkakh v Khersonese Tavricheskom v 1904 g. *Izvestiya Imperatorskoy arkheologicheskoy komissii*. 20:42, fig. 20.

Figure 10.12 Black gloss hydria

Grinevich, K. E. 1926. *Steny Chersonesa Tavricheskogo*, Part 1. Sevastopol. 14, fig. 8.

Kostsyushko-Valyuzhinich, K. K. 1901. Izvlechenie iz otchëta a raskopkakh v Khersonese Tavricheskom v 1899 g. *Izvestiya Imperatorskoy arkheologicheskoy komissii*. 1, 6.

Terracotta—Greek Period

Figure 10.13 Nike or Thanatos

Belov, G. D. 1931. Terrakoty Khersonesa iz raskopok 1908–1914 gg. *Khersonesskiy sbornik* 3:228, fig. 14.2.

Mollard-Besques, S. 1954. *Catalogue raisonné des figurines et reliefs en terre cuite grecs, étrusques et romains*. Musée du Louvre, Département des antiquitésgracques, étrusques et romaines. Ed. de la Réunion des musées nationaux. Paris. II. n. B. 568. Pl. 54. Cf. an example in Berlin, Heres, H., V. Kästner and I. Kriseleit. 1985. *Griechische und etruskische Kleinkunst. Antiken Sammlung*, III. Berlin. 53–54, fig. 38, identified as a Nike and dated to the fourth century BC. The superior quality of the Chersonesan example is immediately apparent.

Figure 10.14 Votive goddess

Belov, G. D. 1970. Terrakoty iz Khersonesa. In *Terrakoty Severnogo Prichernomor'ya*. Moscow. 75, Pl. 15.3. Belov interprets the figure as a Persephone and dates her to the 2nd century BC.

Leper [Löper], R. 1927. Dnevniki raskopok khersonesskogo nekropolya. *Khersonesskiy sbornik* 2:232, fig. 15.3.

Figure 10.15 Terracotta dancer

Belov, G. D. 1930. Terrakoty Khersonesa iz raskopok 1908–1914 gg. *Khersonesskiy sbornik* 3:223–224, fig. 6.

Belov, G. D. 1970. Terrakoty iz Khersonesa. *Svod arkheologicheskikh istochnikov*. G 1–11:70, 73, Pl. 10.4.

Schurmann, W. 1989. *Katalog der antiken Terrakotten im Badischen Landesmuseum, Karlsruhe*. Gothenburg. 168 no. 614 Pl. 102.

Figure 10.16 Pan terracotta

Shevchenko, A. V. 2000. Terrakoty antichnogo Khersonesa. *Materialy po arkheologii, istorii i etnografii Tavrii* 7:26, Cat. no. 36.

Further Reading

Rusyayeva, A. S. 1982. *Antichnyye terrakoty Severo-zapadnogo Prichernomor'ya VI–II do n.e.* Kyiv.

Uhlenbrock, J. P. (ed.) 1990. *The Coroplast's Art: Greek Terracottas of Hellenistic World*. New Rochelle, NY.

Grave monuments—Greek Period

Figure 10.17 Anthemion

Conze, A. 1893. *Die attischen Grabreliefs*. Berlin. 332, Pl. 329.

Figures 10.18–20, 23, 24, 26, 27 Stelai-general

Carter, 2002. In *Color in Ancient Greek Art*. 161–166

Danilenko, 1969. 29–54.

Solomonik, E. I., and I. A. Antonova. 1974. Nadgrobiya vrachey iz antichnogo Khersonesa. *Vestnik dreveney istorii* 1974:93–105.

Twilley, J. 2002. Pigment Analyses for the Grave Stelai and Architectural Fragments from Chersonesos. In *Color in Ancient Greek Art*. 171–178.

Wasowicz, A. 1985. Stèles à attribut de la Chersonèse taurique. *Terra antiqua balcanica* II (1984):465–472.

Figure 10.18 Stele of Megakles

Kolesnikova, L. G. 1969. Voinskiye nadgrobiya. *Soobshcheniya Khersonesskogo muzeya* 4:48–49, fig. 22.

Solomonik, E. I. 1973. *Novyye epigraficheskiye pamyatniki Khersonesa* 2. Kyiv. 148, Cat. no. 148.

Figure 10.19 Stele of Sannion

Danilenko, V. N. 1969. Nadgrobnyye stely. *Soobshcheniya Khersonesskogo muzeya* 4:41, fig. 19.

Solomonik, 1973. 145–146, Cat. no. 146.

Figure 10.20 Stele of Hero

Danilenko, 1969. 42, fig. 20.

Solomonik, 1973. 162–164, Cat. no. 160.

Strzheletskiy, S. F. 1969. XVII bashnya oboronitel'nykh sten Khersonesa (bashnya Zenona). *Soobshcheniya Khersonesskogo muzeya* 4:16, figs. 10.24

Solomonik, E. I., and I. A. Antonova. 1974. Nadgrobiya vrachey iz antichnogo Khersonesa. *Vestnik drevney istorii* 1:94–99, fig. 1.2.

Solomonik, E. I. 1988. *Drevniye nadpisi Kryma*. Kyiv: Nakova dumka, 52–54.

Figure 10.25 Medical instruments

Leper [Löper], R. 1927. Dnevniki raskopok khersonesskogo nekropolya. *Khersonesskiy sbornik* 2:250, fig. 22.

Figures 10.27a, 10.27b Head of Youth

Carter, 2002. In *Color in Ancient Greek Art*. 169–170.

Strzheletskiy, S. F. 1969. Zhivopis' i polikhromnyye rospisi monumental'nykh nadgrobnykh sooruzheniy IV–III vv. do n.e. *Soobshcheniya Khersonesskogo muzeya* 4:85–89.

Figures 10.28–30 Sarcophagus

Carter. In *Color in Ancient Greek Art*. 167–169.

Danilenko, V. N. 1996. Khersonesskiye kamennyye sarkofagi ellenisticheskogo vremeni. *Khersonesskiy sbornik* 7:63–65, fig. 1.

Strzheletskiy, 1969. *Zhivopis' i polikhromnye rospisi*. 81–85, fig. 40–41.

Figures 10.31–34 Ionic and Doric architecture
Carter, 2002. In *Color in Ancient Greek Art*. 166–167.
Fëdorov, B. N. 1977. Tri monumental'nykh nadgrobiya Khersonesa IV–III vv. do n.e. *Pamyatniki kul'tury. Novyye otkrytiya.* Yezhegodnik. 352. Strzheletskiy, 1969. 77–80.

Further Reading
Leper [Löper], R. 1927. Dnevniki raskopok khersonesskogo nekropolya. *Khersonesskiy sbornik* 2:250, fig. 22.
Tiverios, M. A. and D. S. Tsiafakis, eds. 2002. *Color in Ancient Art: The Role of Color in Ancient Greek Art and Architecture 700–31 bc.* Thessaloniki.

Gemstones—Roman Period
Figures 10.35–42 Intaglios and cameos
Boardman, J. 1968. *Engraved Gems: The Ionides Collection.* Evanston, Illinois: Northwestern University Press.
Neverov, O. Ya. 1979. Gnosticheskiye gemmy, perstni i amulety yuga SSSR. *Vestnik drevney istorii* 1, Cat. no. 2; Pl. 1.2.
Solomonik, E. I. 1973. Iz istorii religioznoy zhizni v Severopontiyskikh gorodakh. *Vestnik drevney istorii* 1:59, fig. 1.
Figures 10.43, 10.45 Necklaces and beads
Stern, M. E., and B. Schlick-Nolte. 1994. *Early Glass of the Ancient World 1600 bc–ad 50.* Ostfildern, Germany: Hatje Cantz, 198–199.

Figure 10.44 Medusa Head
Richter, G. M. A. 1971. *Engraved Gems of the Romans: A Supplement to the History of Roman Art.* London: Phaidon Press.
Stern, E. M. 1994. *Early Glass of the Ancient World 1600 bc–ad 50: Ernesto Wolf Collection.* New York: Distributed Art Publishers.

Marble Sculpture—Roman Period
Figure 10.47 Head of Dionysos
Antichnaya skul'ptura, 16, figs. 7, 8 no. 6.
Figure 10.48 Head of Herakles
Antichnaya skul'ptura, 30, figs. 35, 36, no. 57.
Pagett, M., ed. 2001. *Roman Sculpture in the Art Museum.* Princeton University. 130–132. Cf. Head of Herakles, dated to the second half of the second century AD.
Comstock, M. B., and C. C. Vermeule. 1976. *Sculpture in Stone: The Greek, Roman and Etruscan Collections of the Museum of Fine Arts, Boston.* Boston. 66, no. 104a. Cf. also, a head of Herakles after the weary Herakles of Lysippos.
Figure 10.49 Aphrodite and two Erotes
Saprykin, S. Yu. Afrodita s dvumya Erotami iz Khersonesa Tavricheskogo. *Khersonesskiy sbornik* 9:59–71, fig. 1–4.

Cf. Brinkerhoff, D. 1978. *Hellenistic Statues of Aphrodite.* New York. Aphrodite groups, with the goddess often nude, are typical of the late Hellenistic and Roman periods. No close parallel for this one comes to mind.
Figure 10.50 Mature Dionysos or Ariadne
Antichnaya skul'ptura, 17: figs. 3, 4, no. 9.
Bronze Sculpture—Roman Period
Figure 10.51 Bronze horse
Borisova, V. V. 1977. Bronzovaya statuetka konya iz Khersonesa. *Sovetskaya arkheologiya* 2:232–235, fig. 1.
Kadeyev, V. I., and S. B. Sorochan. 1989. *Ekonomicheskiye svyazi antichnykh gorodov Severnogo Prichernomor'ya v I v. do n.e.–V v. n.e.* Kharkiv. 51.
Warden, G. P. 2000. Roman Provincial Bronzes in the Hilprecht Collection, University of Pennsylvania. In Mattusch, C., A. Brauer, and S. E. Knudson, eds. *From the Parts to the Whole: Acts of the 13th International Bronze Conference, held at Cambridge, Massachusetts, May 28–June 1, 1996. Journal of Roman Archaeology, supplementary series* 39:128–134.
Figure 10.52 Asklepios
Belov, G. D. 1941. Raskopki v severnoy chasti Khersonesa v 1931–1933 gg. *Materialy i issledovaniya po arkheologii SSSR* 4:204, fig. 3.
Leper [Löper], R. 1927. Dnevniki raskopok khersonesskogo nekropolya. *Khersonesskiy sbornik* 2:234, fig. 14.
Shcheglov, A. N. 1960. Skul'pturnoye izobrazheniye Asklepiya. *Soobshcheniya Khersonesskogo muzeya* 1:9–11, fig. 1.
Figure 10.53 Dionysos votive plaque
Kadeyev, V. I. 1981. *Khersones Tavricheskiy v pervykh vv. n.e.* Kharkiv: Vyshcha shkola. 30.
Treister, M. 2001. Hammering Techniques in Greek and Roman Jewellery and Toreutics. *Colloquia Pontica VIII.* Leiden, 355-361, fig. 120.
Treister, M. 1990. A Bronze Matrix from Chersonessus, *Bayerische Vorgeschichtsblätter* 55, 309-313.
Red Slip Ceramics—Roman Period
Figures 10.54–10.57
Hayes, J. W. 1972, 1980. *Late Roman Pottery with Supplement.* London.
Vysotskaya, T. N., and G. I. Zhestkova. 1999. Rel'yefnaya krasnolakovaya keramika iz mogil'nika 'Sovkhoz 10'. *Khersonesskiy sbornik* 10. 31–38
Zhuravlëv, D. V. 1998. Krasnolakovaya keramika Severnogo Prichernomor'ya rimskogo vremeni: osnovnye itogi i perspektivy izucheniya (kratkiy obzor otechestvennoy literatury). In Zhuravlëv, D., ed., *Ellenisticheskaya i rimskaya keramika v*

Severnom Prichernomor'ye. Moscow: *Trudy Gosudarstvennogo Istoricheskogo Muzeya* 102: 31–51.

Figure 10.55 Oinochoe with Greek letters

Leper [Löper], R. 1927. Dnevniki raskopok khersonesskogo nekropolya. *Khersonesskiy sbornik* 2:234, fig. 14.

Figure 10.56 Asklepios and Hygieia relief amphora

Anokhin, V. A. 1959. Kuvshin s rel'yefnymi izobrazheniyami Asklepiya i Gigiyei. *Kratkiye soobshcheniya Instituta arkheologii AN Ukrainy* 8:166–168.

Vysotskaya, T. N., and G. I. Zhestkova. 1999. Rel'yefnaya krasnolakovaya keramika iz mogil'nika Sovkhoz 10. *Khersonesskiy sbornik* 10:32–33, fig. 2.

Hayes, J. W. 1997. *Mediterranean Roman Pottery.* London.

Figure 10.57 Lamp with snakes

Kadeyev, V. I., and S. B. Sorochan. 1989. *Ekonomicheskiye svyazi antichnykh gorodov Severnogo Prichernomor'ya v I v. do n.e.* Kharkiv. 55, fig. 27.6.

Kostsyushko-Valyuzhinich, K. K. and M. I. Skubetov. 1911. Izvlecheniye iz otchëta o raskopkakh v Khersonese v 1907 godu. *Izvestiya imperatorskoy arkheologicheskoy komissii.* 42:10, fig. 11.

Coarseware Ceramics—Roman Period

Figures 10.58–60 Coarseware ceramics

Hayes, J. W. 1980. *Ancient Lamps in the Royal Ontario Museum. I. Greek and Roman Clay Lamps.* Toronto 70–71, no. 293 Pl.

Figure 10.59 Lamp with gladiators

Shcheglov, A. N. 1966. K voprosu o gladiatorskikh boyakh v Khersonese Tavricheskom. *Eirene* 5:99–105.

Figure 10.60 Lamp with Eros on dolphin

Chrzanovski, L., and D. Zhuravlëv. 1998. *Lamps from Chersonesos in the State Historical Museum, Moscow.* Rome. 107, fig. 59, no. 59 (cf. Figure 10.59) lamp with Eros on dolphin dated late second century AD to early third century.

Further Reading

Zhuravlëv, D. B., ed. 1998. *Ellinisticheskaya i rimskaya keramika v Severnom Prichernomor'ye.* Moscow: *Trudy Gosudarstvennogo Istoricheskogo Muzeya* 102.

Glassware—Roman Period

Figure 10.61 Vessel with eggs

The form of the bowl holding eggs almost as perfectly preserved as it is, is found also in silver of the early Empire. Cf. Gehrig, V. 1967. *Hildesheimer Silberfund.* Berlin. 25–26 figs. 29,30, and 31.

Figures 10.63–64 Glass bottle

Cylindrical glass bottle with one (broad) handle, dated last quarter of first to first quarter of second century AD. Transparent dark yellowish-green color. Examples found in Pantikapaion necropolis. From a workshop in Asia Minor? Spherical bottle

with one handle. Cf. two examples without handle dated second half of first century BC.

Stern, E. M. 2001. *Roman, Byzantine and Early Medieval Glass 10 BCE–700 CE.* Ost filden–Ruit Germany. Cat. 207.

Further Reading

Hayes, J. W. 1975. *Roman and pre-Roman glass in the Royal Ontario Museum: a Catalogue.* Toronto.

Funerary Sculptures—Roman Period

Figures 10.65 Male bust

This male bust resembles a sculptural version of the plain anthropomorphic grave markers that were an integral part of some, at least, of the monuments with stelai that marked graves of the early Hellenistic period [R. Posamentir, personal communication, 2002]. Similar figures were found at other North Black Sea Coast sites, including Olbia and at Cyrene on the north coast of Africa.

Bianchi-Bandinelli, R. 1970. *Rome, the Center of Power.* London, 80, fig. 82. (discusses emergence of a distinctly "plebeian" style in contrast to the classical Greek preferred by the upper classes in Rome and Italy in the early Empire)

Antichnaya skul'ptura, 130, fig. 168, no. 401.

Kolesnikova, L. G. 1977. Znacheniye i mesto antropomorfnykh nadgrobiy v nekropole Khersonesa. *Sovetskaya Arkheologiya* 2:87–99.

Kostsyushko-Valyuzhinich, K. K. 1902. Izvlechyeniye iz otchëta o raskopkakh v Khersonese Tavricheskom v 1900 g. *Izvestiya imperatorskoy arkheologicheskoy komissii.* 2:32.

Rusyaeva, A. S. 1992. *Religiya i kul'ty antichnoy Ol'vii.* Kyiv, 166–167, fig. 55.

Figure 10.66 Female relief

Antichnaya skul'ptura, 119–120, fig 152, no. 371.

Kostsyushko-Valyuzhinich, K. K. 1896. Otchët zaveduyushchego raskopkami v Khersonese za 1894 g. *Otchët imperatorskoy arkheologicheskoy komissii* za 1894 g. 76.

Figures 10.67–68 Club of Herakles and Herakles' labors

This seems to be the end of a sarcophagus, where a single labor is usually represented. Here are three, symbolizing his harrowing of the Underworld (Kerberos), passage to the blessed world (cattle of Helios) located in the West (apples of the Hesperides), all leading up to his apotheosis. No figure of Greek mythology was as often represented in the Black Sea as Herakles and his club, which often stands by itself as here (10.67), and in the naikos at Site 151 in the chora, Ch. 9. See Shcheglov, A. N. 1964. *Podvigi Gerakla.* Leningrad.

Belov, G. D. 1938. Otchët o raskopkakh v Khersonese za 1935–1936 gg. Simferopol: Krymgiz. 55–56, fig. 33.

Belov, G. D. 1940. Khersonesskiye rel'yefy. *Vestnik drevney istorii* 3(4). 280–281, Cat. no. 16, fig. 17.

Antichnaya skul'ptura, 147–148, fig. 193, no. 465.

Kostsyushko-Valyuzhinich, K. K. 1904. Raskopki v Khersonese 1902. *Otchët imperatorskoy arkheologicheskoy komissii.* 33, fig. 54.

Robert, C. 1897. *Die Antiken Sarkophag–Reliefs* III. Berlin. Pls. 27–43.

10.69 Garland sarcophagus with funeral feast

This example is unusual in that the couple reclines together (as typically in Etruscan representations) not at either end of the couch, and the relief fills the triangular space of the tympanum of the naikos-shaped relief.

Antichnaya skul'ptura, 149–150, figs. 186–188, no. 469.

Belov, G. D. 1938. *Otchët o raskopkakh v Khersonese za 1935–1936 gg.* Simferpol: Krymgiz, 38, fig. 23. Garland sarcophagi are a common type. See Robert, C., and E. Rohde, 1968 (1897). *Griechische und römische Kunst in den Staatlichen Museen zu Berlin.* Berlin, 34–35. fig. 18. The garlands are sometimes supported by Erotes, as here. What is unusual is the incorporation of the funeral feast, in the center, where it seems out of place. The relatively high quality of the carving, which is uniform, and the carefully made inscription contrast sharply with the other funeral feasts at Chersonesos.

Ivanova, G. P. 1970. Stsena 'zahrobnoy trapezy' na khersones'kykh nadgrobnykh rel'yefakh. *Arkheolohiya* 23.

Pfuhl, E., and H. Möbius. 1979. *Die ostgriechischen Grabreliefs.* Mainz. 444, no. 1850. Pl. 266 dated early Empire from Pergamon. Cf. also, 382 no. 1553 Pl. 224 from Sardis dated to the first half of the second century AD.

Figure 10.70 Stele of Gazourios

Antichnaya skul'ptura, 100, fig. 132. no. 316.

Kieseritzky, G. and C. Watzinger. 1909. *Griechische Grabreliefs aus Südrussland.* Berlin, Pl. 76.3.

Kostsyushko-Valyuzhinich, K. K. 1892. *Raskopki v Khersonese.* 26, fig. 23.

Latyshev, V. V. 1895. Grecheskiye i latinskiye nadpisi, naydennyye v yuzhnoy Rossii v 1892–1894 gg. *Materialy po arkheologii Rossii.* 17: Cat. no. 9, p. 12.

Figure 10.71 Iulius Vales stele

Savelya, O. Ja. [Ya.], and T. Sarnowski. 2000. *Balaklava: Römische Militärstation und Heiligtum des Iupiter Dolichenus.* Warsaw: Institute of Archaeology, Warsaw University, 191–196.

Schleiermacher, M. 1984. *Römische Reitergrabsteine. Die kaiserzeitlichen Reliefs des trumphierenden Reiters.* Bonn.

Zubar, V. M., I. A. Antonova, and O. Ya. Savelya. 1991. Nadgrobok ryms'kogo kavalerysta z okolytsi Balaklavy. *Arkheologiya* 3:102–108.

Chapter 11 Byzantine Galleries
By Tatiana Yashaeva, Joseph Coleman Carter, Taissa Bushnell

General Reference

Chichurov, I. S., ed. 1991. *Vizantiyskiy Kherson. Katalog Vystavki.* Moscow. Nauka. Many of the objects illustrated here appear in this catalog with full bibliography. Authors whose work is included in the catalog: L. A. Golofast, A. L. Romanchuk, S. G. Ryzhov, I. A. Antonova. Future reference given by title only.

Architectural Decorations

Figures 11.2–11.5

Grabar', A. 1976. *Sculptures byzantines du Moyen Age*, II. Paris 75–81. Pl. 50, no. 73.

Tichanov-Klimenko, M. 1932. Les chapiteaux de l'église, Saint-Jean-le Precurseur à Kertch. In Uspenskij, *L'art byzantin chez les Slaves* 2:3–24.

Further Reading

Bréhier, L. 1973. *La sculpture et les arts mineurs byzantins.* Paris: Les Editions d'art et d'historie.

Firatli, N., C. Metzger, J–P. Sodini, A. Pralong, and A. Arel. 1990. *La sculpture byzantin figurée au Musée Archéologique d'Istanbul.* Paris: Libraire d'Amérique et d'Orient.

Krautheimer, R., and S. Curcic. 1989. *Early Christian and Byzantine Architecture*, revised ed. Harmondsworth: Penguin Books.

Mango, C. A. 1986. *Byzantine Architecture.* New York: Abrams.

Figure 11.2 Theodosian capital

Yakobson, 1959. 133–134.

Figure 11.4 Mable capital detail

Vizantiyskiy Kherson. 17, no. 1.

Figure 11.5 Ram's head capital

Yakobson, 1959. 134 and fig. 46.1.

Durand, J., ed. 1992. *Byzance, l'art byzantin dans les collections publiques françaises.* Exposition 3 novembre 1992-1 février 1993. Musée du Louvre. Editions de la Réunion des musées nationaux 39.

Mosaic and Painting

Kitzinger, E. 1965. Israeli Mosaics of the Byzantine Period. New York: New American Library by arrangement with UNESCO.

Kitzinger, E. 1951. Studies on Late Antique and Early Byzantine Floor Mosaics: The Mosaics of Nikopolis. *Dumbarton Oaks Papers* 6:95–108.

Yakobson, 1959. Mozaichnyye poly. 222–247.

Figure 11.6 Fruit tree relief

Vizantiyskiy Kherson. 23, no. 7.

Otchët imperatorskoy arkheologicheskoy komissii. 1897. 1900. 109 and fig. 218.

Figure 11.7 Detail of mosaic from 1935 Basilica
Yakobson, 1959. Mozaichnyye poly. 224.

Figure 11.8 Mosaic of Church Outside the City Walls
Yakobson, 1959. Mozaichnyye poly. 224.

Figure 11.10 Mother of God Fresco
Aynalov, D. V. 1905. Razvaliny khramov. *Pamyatniki khristianskogo Khersonesa* 1. Moscow.

Berthier de Lagarde, A. L. Raskopki Khersonesa. *Materialy po arkheologii Rossii* 12:36, Pl.7.2.

Further Reading
James, L. 1996. *Light and Colour in Byzantine Art*. New York: Clarendon Press.

Maguire, H. 1987. *Earth and Ocean: the Terrestrial World in Early Byzantine Art*. University Park: published for the College Art Association of America by Pennsylvania State University Press.

Metalwork in the Christian Era
Cotsonis, J. A. 1994. *Byzantine Figural Processional Crosses*. Washington, DC, 56–64. A special category of large processional crosses (in Cleveland, Geneva and Paris) unknown until 1960. These consisted of silver revetment over an iron core. Some silver but none of the figural design preserved.

Figure 11.11 Rus' six-pointed cross
Vizantiyskiy Kherson. 148–149, no. 156.

Korzukhina, G. F. 1958. O pamyatnikakh 'korsun'skogo dela' na Rusi. *Vizantiyskiy vremennik* 14:135–136, Pl. 4.1.

Figure 11.12 Diptych
Vizantiyskiy Kherson. 207, no. 221.

Putsko, V. G., and S. G. Ryzhov. 1995. O dvukh nakhodkakh proizvedeniy vizantiyskoy plastiki v Khersonese. In *Problemy arkheologii drevnego i srednevekovogo Kryma*. Simferopol. 165–166.

Figure 11.13 Processional Cross
2001 Annual Report, Institute of Classical Archaeology. 2002. Pl. I.

Figure 11.14 Encolpion leaf
Vizantiyskiy Kherson. 201, no. 205.

Kolyesnikova, L. G. 1978. Khram v portovom rayone Khersonesa. *Vizantiyskiy vremennik* 39:166 and fig. 5a.

Figure 11.15 Encolpia
Vizantiyskiy Kherson. 163–167, 199–202.

Steatite Icons
Bank, A. V. 1978. *Byzantine Art in the Collections of Soviet Museums*. New York: Abrams.

Bank, A. V. 1981. Nekotorye skhodnye pamyatniki srednevekovoy plastiki, naydennyye v Konstantinopole, Khersonese i Bolgarii. *Byzantinobulgarica* 7.

Izmajlov, N. 1932. Une stéatite byzantine du Musée de Chersonèse. In Uspenskij, T., ed. *L'art byzantin chez les Slaves* 2:35–48.

Kalavrezou-Maxeiner, I. 1985. *Byzantine Icons in Steatite*. Wien: Verlag der Osterreichischen Akademie der Wissenschaften.

Figure 11.16 Three military saints
Vizantiyskiy Kherson. 84, no. 83.

Bank, A. V. 1966. *Vizantiyskoe iskusstvo v sobraniyakh Sovetskogo Soyuza*. Moscow. Cat. no. 56.

Belov, G. D. 1960. *Shifernyye ikony iz Khersonesa*. Sovetskaya arkheologiya 2:257–263.

Pevny, O.Z. 1997. Kievan Rus'. In Evans, H. C., and W. D. Wixom, eds. *The Glory of Byzantium*, New York Metropolitan Museum. 300–301, fig. 203, no. 203.

Figure 11.17 Virgin and Child
Vizantiyskiy Kherson. 237, no. 256.

Figure 11.18 Nativity icon
Bank, A. V., 1977. *Vizantiyskoe iskusstvo v sobraniyakh SSSR*. 118, fig. 620.

Darkevich, V. P. 1975. *Svetskoye iskusstvo Vizantii*. Moscow: Iskusstvo, 281–282.

Vizantiyskiy Kherson. 88, no. 87.

Figure 11.19 Annunciation icon
Bank, 1966. 304, fig. 154.

Vizantiyskiy Kherson. 86, no. 85.

Ceramics
Yakobson, A. L. 1950. Srednevekovyy Khersones. *Materialy po istorii i arkheologii SSSR* 17.

Yakobson, A. L. 1973. *Krym v sredniye veka*. Moscow: Nauka.

Further Reading
Dark, K. 2001. *Byzantine Pottery*. Stroud, England.

Figure 11.20 Bowl with six-pointed star
Vizantiyskiy Kherson. 162, no. 170.

Figure 11.22 Bowl with siren
Vizantiyskiy Kherson. 157, no. 165.

Yakobson, A. 1979. *Keramika i keramicheskoye proizvodstvo srednevekovoy Tavriki*. Leningrad, 138, fig. 88.1.

Figure 11.23 Glazed oinochoe
Yakobson, 1950. 172 and Pl. 2.9.

Figure 11.24 Green and orange sgraffito ware
Yakobson, 1950. 194, Pl. XL. 98.

Figure 11.25 Lion and snake dish
Vizantiyskiy Kherson.178, no. 188.

Romanchuk, A. I. 1982. Materialy k istorii Khersonesa XIV–XV vv. In *Vizantiya i yeë provintsii*. Sverdlovsk. 111, fig. 25.

Figure 11.26 Dish with warrior with saber
Vizantiyskiy Kherson. 219, no. 237.
Figure 11.27 Bowl with cresents
Vizantiyskiy Kherson. 225, no. 243.
Figure 11.28 Lion and deer dish
Vizantiyskiy Kherson. 186, no. 197.
Articles of Daily Life
Figure 11.29 Bone appliqués
Vizantiyskiy Kherson. 113, no. 115.
Romanchuk, A.I. 1981. Izdeliya iz kosti v srednevekovom Khersonese. *Antichnaya drevnost' i sredniye veka* 18:96.
Figure 11.30 Warrior saint mold
Vizantiyskiy Kherson. 32, no. 17.
Figure 11.32 Locks
Treteyskiy, N. 1911. O drevnikh khersonesskikh zamkakh i klyuchakh. *Izvestiya imperatorskoy arkheologicheskoy komissii.* 42. Pl. 1.18.
Figure 11.33 Bone box
Vizantiyskiy Kherson. 103, no. 102.
Figure 11.34 Jewelry
Buckton, D. 1994. *Byzantium: Treasures of Byzantine Art and Culture from British Collections.* London.
Figure 11.35 Glass bracelets
Von Saldern, A. 1980. *Ancient and Byzantine Glass from Sardis.* Cambridge, MA: Harvard University Press.

Chapter 12 Numismatics and Sigillography
By Nikolay Alekseenko

Alekseenko N. 1990. Patriarshiy molivdovul iz Chersonesa. *Antichnaya drevnost' i sredniye veka* 25:25–29.
Alekseenko N., ed. 1996. Un tourmarque de Gothie sur un sceau inédit de Cherson. *Révue des Études Byzantines* 54, 271–275.
Alekseenko N. 1997. Molivdovuly adresantov Chersona VII–XI vv. *Drevnosti* 1996. Kharkiv: Biznes-inform, 122–123.
Anokhin, V. A. 1977. *Monetnoye delo Khersonesa.* Kyiv: Naukova dumka.
Anokhin, V. A. 1980. *The Coinage of Chersonesos: IV Century BC– XII Century AD. British Archaeological Reports, International Series* 69. Translated by H. B. Wells. Oxford.
Hendy, M. 1985. *Studies in the Byzantine Monetary Economy, c. 300–1450.* Cambridge: Cambridge University Press.
Price, M. J. 1993. *Sylloge Nummorum Graecorum 9. The British Museum, Part 1: The Black Sea.* London: British Museum Press.
Sear, D.R. 1987. *Byzantine Coins and their Values.* London. p. 390–391, n. 1939, 1940.
Shandrovskaja, V. 1990. Pechati predstaviteley roda Synadinov v Ermitazhe. *Vizantiyskiy vremennik* 51:181–182.
Sokolova, I. V. 1983. *Monety i pechati vizantiyskogo Khersonesa.* 61, Pl. XII, 4.
Sokolova, I. V. 1993. Les sceaux byzantins de Cherson. *Studies in Byzantine Sigillography* 3:110, Pl. VIII, 4.
Tolstoy, I. I. 1991. *Vizantiyskiye monety.* Barnaul, 114–116, Pl. 87, 3.
Wroth, W. 1908. *Imperial Byzantine coins in the British Museum.* II, 558–559, Pl. LXVII. 5–10. London.
Zograf, A. N. 1951. Antichnyye monety. *Materialy i issledovaniya po arkheologii SSSR.* 16. Moscow: Nauka.

Chapter 13 National Preserve of Tauric Chersonesos
By Larissa Sedikova, Carl Holiday, Alma Maldonado, Joseph Coleman Carter

Holiday, C., and A. Maldonado, 2001. *Master Plan for the Continued Development of the National Preserve of Tauric Chersonesos.* Austin, Texas: Institute of Classical Archaeology.
Maldonado, A., and C. Holiday. 2003. *Development Plan for the Chora of the National Preserve of Tauric Chersonesos.* Austin, Texas: Institute of Classical Archaeology.

Chapter 14 Sevastopol
By Glenn Mack, Tatiana Yashaeva

Doronina, E. N., and A. A. Lyakhovich. 1983. *Po ulitsam Sevastopolya.* Simferopol: Tavriya.
Venikeyev, Ye. V. 1983. *Arkhitektura Sevastopolya.* Simferopol.
Dobryy, A., and I. Borisova. 2001. *Sevastopol.* Sevastopol: Art-Print.

Chapter 15 Historic Sites of Southwestern Crimea
By Tatiana Yashaeva, Glenn Mack

Aybabin, A. 1999. *Etnicheskaya istoriya rannevizantiyskogo Kryma.* Simferopol: DAR.
Kogonashvili, K. 1995. *Kratkiy slovar' istorii Kryma.* Simferopol: Biznes-inform.
Yakobson, A. L. 1950. *Srednevekovyy Khersones (XII–XIV vv.). Materialy po arkheologii SSSR* 17. Moscow: Nauka.
Werner, T., and R. Ludwig, eds. 1999. *Unbekannte Krim, archäologische Schätze aus drei Jahrtausenden.* Heidelberg: Kehres Verlag.

Further Reading

Archéologie de la Mer Noire: La Crimée à l'époque des Grandes Invasions, IVe–VIIIe siècles, 1997. Exposition organisée par le Conseil régional de Basse-Normandie, 30 mai - 1er septembre 1997. Caen: Musée de Normandie. 110–135.

Belyayev, S. A. 1989. Peshchernyy khram na glavnoy ulitse Khersonesa. In *Vizantiya i Rus'*, Moscow.

Filippenko, V. F. 1997. *Kalamita-Inkerman: krepost' i monastyr'*. Sevastopol.

Figures 15.3 and 15.4 Gothic brooches and buckle

Aibabin [Aybabin], A. 1991. Khronologiya mogil'nikov Kryma pozdnyerimskogo i rannesrednevekovogo vryemyeni. *Materialy po arkheologii, istorii i etnografii Tavrii* 1:5–86.

Aibabin [Aybabin], A. 1994. I Goti in Crimea (secoli V–VII). In *I Goti*, Milan: Electa. 110–135.

Aibabin [Aybabin], A., and E. Khairedinova. 1997. La nécropole d'Eski-Kermen. In *Archéologie de la Mer Noire: La Crimée*. 79–82.

Plan of the southeastern portion of the Ancient City from the excations of 1905-1906. Drawing by M. Skubetov.
(NPTC archives)

223

Byzantine World

Laiou, A. E. 2002. The Economic History of Byzantium: From the Seventh through the Fifteenth Century. *Dumbarton Oaks Studies* XXXIX. Washington, D.C.

Mathews, T. F. 1998. *Byzantium: From Antiquity to the Renaissance.* New York: Abrams.

Obolensky, D. 1971. *The Byzantine Commonwealth: Eastern Europe 500–1453.* London: St. Vladimir's Seminary Press.

Obolensky, D. 1994. *Byzantium and the Slavs.* London: St. Vladimir's Seminary Press.

Runciman, S. 1975. *Byzantine Style and Civilization.* Harmondsworth.

Treadgold, W. T. 1997. *A History of the Byzantine State and Society.* Stanford, CA: Stanford University Press.

Vlasto, A.P. 1983. *Entry of the Slavs into Christendom: An Introduction to the Medieval History of the Slavs.* Cambridge.

Crimea

Ascherson, N. 1996. *Black Sea.* London: Hill and Wang Publishers.

Belianskiy, I. L. et al. 1997. *Krym. Geograficheskiye nazvaniya: kratkiy slovar'.* Simferopol: Tavriya-plus.

Biodiversity of Crimea. International Workshop Seminar. Biodiversity Support Program. 1999. Simferopol.

Twain, M. 1996. *Innocents Abroad.* New York.

Crimean Populations

Abdulhamitoglu, N. 1974. *Turksuz kirim, yuz binlerin surgunu.* Istanbul: Bogazigi Yayinlari.

Allworth, E. A., ed. 1998. *The Tatars of the Crimea: Return to the Homeland: Studies and Documents.* Central Asia Book Series.

Bachrach, B. S. 1973. *A History of the Alans in the West.* Minneapolis: University of Minnesota Press.

Billington, J. H. 1966. *The Icon and the Axe: Interpretive History of Russian Culture.* London: Weidenfeld and Nicholson.

Brook, K. A. 1999. *The Jews of Khazaria.* Northvale, NJ: Jason Aronson.

Fisher, A. W. 1978. *The Crimean Tatars.* Stanford, CA: Hoover Institute Press.

Fisher, A. W. 1998. *Between Russians, Ottomans and Turks: Crimea and Crimean Tatars.* Istanbul: Isis Press.

Hamant, Y., ed. 1992. *The Christianization of Ancient Russia.* UNESCO, Paris.

Inalcik, H. 1997. *An Economic and Social History of the Ottoman Empire: 1300–1600.* Cambridge: University Press.

Kirimli, H. 1996. *National Movements and National Identity among the Crimean Tatars (1905–1916).* Leiden: Brill.

Origine, S. 1997. *Bisanzio e Genova.* Genova.

Rolle, R. 1989. *The Scythians.* Berkeley: University of California Press.

Rostovtzeff [Rostovtsev], M. 1969. *Iranians and Greeks in South Russia.* Oxford NY: Russell and Russell.

Taheri, A. 1989. *Crescent in a Red Sky: The Future of Islam in the Soviet Union.* London.

Williams, B. G. 2001. *The Crimean Tatars: The Diaspora Experience and the Forging of a Nation.* Leiden: E. J. Brill.

Wolfram, H. A 1987. *History of the Goths.* University of California Press.

Crimean Wartime

Anderson, M. S. 1966. *The Eastern Question.* London: CJ Bartlett.

Edgerton, R. B. 2000. *Death or Glory: The Legacy of the Crimean War.* Westview Press.

Footman, D. 1961. *Civil War in Russia.* London: Farber and Farber.

Gernsheim, H. 1954. *Roger Fenton: Photographer of the Crimean War.* London: Secker & Warburg.

Kerr, P., et al. 1997. *The Crimean War.* London: Boxtree.

Neumann, H–R. 1991. *Sewastopol-Krim: Eine Literatursammlung.* Regensburg: S. Roderer.

Seaton, A. 1977. *The Crimean War: A Russian Chronicle.* London: Batsford.

Sweetman, J. 2001. *The Crimean War.* Oxford: Osprey Military.

Todleben, E. I. 1864. *Die Vertheidigung von Sebastopol.*

Tolstoy, L. 1986. *The Sebastopol Sketches* (1856), ed. David McDuff. Harmondsworth: Penguin.

Hellenic World

Boardman, J. 1999. *The Greeks Overseas.* New York.

Minns, E. H. 1909. *Scythians and Greeks.* Cambridge.

Robertson, M. 1975. *A History of Greek Art* I. Cambridge: University Press.

Rostovtzeff, [Rostovtsev] M. I. 1941. *Social and Economic History of the Hellenistic World.* Oxford. 3 vols.

Tsetskhladze, G. R., ed. 1998. *The Greek Colonisation of the Black Sea Area: Historical Interpretation of Archaeology.* Stuttgart: Franz Steiner Verlag.

Roman Era

Jones, A. H. M. 1964. *The Later Roman Empire, 284–602: A Social, Economic and Administrative Survey*. Oxford.

Rostovtzeff, [Rostovtsev] M. I. 1957. *The Social and Economic History of the Roman Empire*. Oxford. (Special rev. 2nd edition).

Ward-Perkins, J. B. 1977. *Roman Architecture*. New York: H. N. Abrams.

Slavic Archaeology

Miller, M. O. 1954. *Arkheologiia v SSSR*. München.

Mongait, A. L. 1961. *Archaeology in the USSR*. Baltimore: Penguin Books.

Ukraine

Baehr, S. L. 1991. *The Paradise Myth in Eighteenth-Century Russia: Utopian Patterns in Early Secular Russian Literature and Culture*. Stanford, CA: Stanford University Press.

Christian, D. 1998. *A History of Russia, Central Asia and Mongolia*. Blackwell Publishers Ltd.

Doroshenko, D. 1973. *History of the Ukraine*. Translated from the Ukrainian and abridged by Hanna Chikalenko-Keller. Edmonton, Canada.

Magocsi, P. R., and G. J. Matthews. 1985. *Ukraine, A Historical Atlas*. Toronto: University of Toronto Press.

Wilson, A. 2000. *The Ukrainians: Unexpected Nation*. New Haven and London.

Hrushevsky, M. 1997. *History of Ukraine-Rus'*. 1. Edmonton, Canada: Canadian Institute of Ukrainian Studies Press.

Hrytsak, Ya. 2000. *Historia Ukrainy 1772–1999: narodziny nowoczesnego narodu*. Lublin: Instytut Europy Srodkowo-Wschodniej.

Lysiak-Rudnytsky, I. 1987. *Essays in Modern Ukrainian History*. Cambridge, Mass : Harvard Ukrainian Research Institute.

Magocsi, P. R. 1996. *A History of Ukraine*. Toronto; London: University of Toronto Press.

Firkovich, Avraam, 198
fishhooks, **86**
fishing, 17, 38, 86, 89, 130, 190, 200
fishmongers, houses of, 86, 89
fonts: for ablutions, 101; baptismal, 103, 106, 111, **114**
food processing, 190
fortifications, 24, 28, 198. *See also* defensive walls; walls
forts: Hellenistic Greek, 132; late Roman/early Byzantine, 132. *See also* specific forts
founder *(oikist)*, of Chersonesos, 21
foundry, 76
Fountain of Tears, 198, **198**
Fourth Crusade, 38, 194
France, and Crimean War, 46–47
frescoes, 64, 71, 107, **108**, 108, 116
furs, imported, 35

Galleries: Byzantine, **161**, 161–174; Greek and Roman, 135–160
garum (fish paste), 26
Gasfort Hill, 202
gates, 62, 64, **67**, 198; city, 63, 65, 67, 72, 110
gemstones, Roman period, **150–151**
Genoese, 2, 39, 40, **41**, 43, 194, 195, 199–201
George, St., 32; monastery, 133, 201. *See also* St. George (city)
Germans, Crimean, 47, 49
Giray dynasty, 43, 195
glassware, 27, 33, **156–157**, **174**
Golden Horde, 39, 41, 43, 180, 194, 195
Gorbachev, Mikhail, 49
Gordios, house of, 89
Gorzon (Cherson), 32
Gorzona (Cherson), 32, 43, 194
Gothia, 43, 194
Goths, 18, 30, 130, 197
graffiti, **19**, 21, **37**
Grafskaya Wharf, **190**
grapes. *See* viticulture
grave monuments, 7, 25, 141–149, **141–149**. *See also* sarcophagi; stelai; tombstones
graves, 81, 111, 112, 198. *See also* burials
grazing, 13, 17. *See also* animal husbandry
Greek Chersonesos, 3, 4, 5, 17–25, 47, 121–124
Greek period: grave monuments, **141–149**; sculpture, **137**; terracotta, **140**; vases, **138–139**
Greeks, 49, 200; colonies, **16**, **18**; language, 40
Greyg, Aleksey, Admiral, 51, 112
Grimm, D. I., 73
Grinevich, Konstantin, 54

grivnas, Novgorod, 87
gunpowder, trade in, 43

Hadrian, 27, 177
Hadrian II, Pope, 37
Haji-Giray, Khan, 194
head of a youth, painting of, 145, **145**
Hebrews, 40
Helios, on coins, 175
Hellenic gods, 28
Herakleian Peninsula, 11–15, **13, 15, 23, 120, 121, 122,** 129
Herakleia Pontika, 17–18, 23, 92–93, 122, 175
Herakleios, 33, 181; grave stele, **68**
Herakleiots, 20, 21, 23
Herakles, 91, 96, 109, 126, 129, 158, **159,** 175
Hermes, on coins, 175
Hermitage Museum, St. Petersburg, 6
Herodotos, 20, 23
hesychasm, 133
historic sites of southwestern Crimea, 193–202, **203**
Hitler's armies, in Sevastopol, 8
honey, 35, 38
Honorius, 29, 178
House of the Fourth–Third Centuries BC, 62, **82**
House with a Winery, **84,** 84–85, **85**
House with the Mosaic Floor, 83, **83**
household objects, **19**
houses, 25; in Bermana Ravine, 132; Byzantine-era, **32, 87;** early Hellenistic, 82; fishmongers', 86. *See also* farmhouses; *specific houses*
hryvnya, 1935 Basilica on, 107, **109**
Huns, 18, 68, 130
hydriai, 65, 66, 95
Hygieia, on coins, 177
hypocaust heating system, 70, 80

icons, 7, **38, 168–169**
Imperial Archaeological Commission, 52
inhumation, 95, 96
Inkerman. *See* Kalamita
Inkerman Monastery of St. Clement, **193**
insulae (city blocks), 74, 87
International Red Cross, 7-8, 46
Ionians, 20, 21
Ionic architectural elements, **21,** 25, 148, **148–149**
Iphigeneia among the Taurians, 20–21
Iron Age, xviii, 22, 121-122
Isis, 25-26
Islam, 36, 43, 195

Ister River. *See* Danube River
Istria, 17, 20
Italy, southern (Magna Grecia), 175, 176; trade with, 176
itinerary, walking, 9

jewelry, classical Greek, **17,** 65–66, 95
Jewish community, 28, 31, 47, 108
John XXII, Pope, 39
Juchi, coins of, 180
Judaism, 33
Jupiter Dolichenus, 27
Justin II, 32, **178**
Justinian I, 28, 30, 31, 32, 33, 96, 196; and cave towns, 193; church building, 101; reliquary, 113; seals, 181
Justinian II Rhinotmetos "the Slit-Nosed," 30, 33

Kachi-Kal'on, 193
Kalamita (Inkerman), 30, 39, 193, 195; fortress, 183, 193, 195–196, **195**; tower, 198
Kallatis, 20
Kalos Limen, 25
Kamyshovaya Bay, 132
kantharos (chalice), 117
Karaites, 198
Karan' Heights, 28, 131
Karantinnaya (Quarantine) Bay, 21. *See also* Quarantine Bay
Karantinnaya (Quarantine) Ravine, 116
katholikon (main church), 116
Kazach'ya (Cossack) Bay, 133
Kazach'ya (Cossack) Hill, 128, 129
kenassas, 198
Kerkinitis (Yevpatoriya), 21, 24, 25
Khan's Palace, 198
khans, Crimean, 195. *See also* specific khans
Khazars, 32, 33, 36, 37, 196, 197
Khersones Tavricheskiy, 56
Khersonesskiy sbornik, 54
Khomutova Ravine, 124
Khrushchev, Nikita, 49, 78
Khymych, Yuriy Ivanovich, xv, 107
kilns, 4, 63, 72, 87, 89, 90, 91, **94**
Kizil-Koba culture, **18,** 21, 22, **123**
kleroi (plots of land), 56
Klimata, theme of, 34–35
Komnenos dynasty, 180, 181
Korsun' (Cherson), 32, 73, 103
Korzukhin, 73
kosmesis, 83

Pharnaces II, 26
Pharnakeia, coins from, 176
Philip II, 69
Phokas, and seals, 181
Phokas, St., 32
phoideratoi (allies of the empire), 30
Pidtrymka Chersonesu, 8
pilgrimages, 31–32, 40
pistachio trees, 12
pithoi, defined, 84, 86, 88, 93, 126
plans, development. *See* development plans
plateiai (main streets), 4, 74, 99
Pliny the Elder, 96, 177
Poles, as colonists, 47
polis, defined, 19
Polish-Lithuanian Commonwealth, **44**
Polo, Maffeo, 194
Pontic Kingdom, 26, 176
Pontos, 127
Pontos Euxeinos, 20
port block, 81
Potemkin, Grigoriy, 45, 50
potters, quarters of, 89
pottery, 53, 63, 88, 128; assorted, **26**, **27**, **37**, **86**;
 Glazed White Ware II, 34; medieval, 7, 88;
 Ottoman, **34**; production, 4, 7, 27, 33; trade,
 132; workshops, 63, 71-72, 89. *See also*
 amphorae; kilns; potters; terracotta
praefurnium (entrance to furnace), 70
praesidium (headquarters), 71
Preserve. *See* National Preserve of Tauric
 Chersonesos
Primary Chronicle, The, 45, 73, 103
Prince of Wales, 202
Prokonnesos, 108
Prokopios of Caesarea, 193
proskenion (raised stone stage), 77
prostitution, 27
proteichisma (rampart), 63
pruning hook, **85**, 141

Quarantine Bay, 21, 62, 68, 71, 89, 122
Quarantine Bay Beach, 187
quarter, medieval, 88, **88**
querns, rhyolite lava, 34

Ram's Head (Kriou Metopon) Cape, 21
Ravenna fleet, 27
relics, at monasteries, 132–133
reliquary, 110, 113; casket, **29**
Reliquary Church, **39**, 76, 77, **77**, **113**, 113–114,
 114

research facility, archaeological, 9–10
reservoir, water, 79, **79**, **88**
residential section, Byzantine-era, **184**
Rhodes, trade with, 25
Rhoxolani, 26. *See also* Sarmatians
Ricardus (bishop of Chersonesos), 39
rituals, religious, 105–106
roads, 4, **23**, 24, 121, 132
Robertson, James, 46
Romaioi, 29, 40
Roman Empire, 18, 26–28, 29, 70, 96, 128, 130
Roman gods, 28
Roman period: ceramics, **154**, **155**; gemstones,
 150–151; glassware, **156–157**; sculpture, **152**,
 153, 158, **158–160**; sarcophagus, 158, **159**
Romanos II, 37
Rostovtsev, Mikhail, 3, 25, 27, 124
rural estates, 3, 4, 9, 24–25, 121, 124, 127–129.
 See also specific sites
Russell, William Howard, 46
Russia, 37, 43, 45
Russian Empire, **46**
Russian Federation, 47
Russian Navy, 51, 191
Russian Orthodox Church (Moscow
 Patriarchate), 52, 103, 192
Russian Pompeii, 53
Russian revolution, 47

St. George (city), 200
St. Nicholas (fortress), 200
St. Volodymyr's Church, **xv**, **5**, 9, 51, **53**, **54**, **56**,
 60, **60**, 73, 184, **191**, 192
sakellarioi, and seals, 181
salt, 130
Sapun Mountain, 11
Sarandinakina Ravine, 128, 133
Saray, coins from, 180
sarcophagi, 66, 95–96, 109, 146, **146–147**, 158,
 159. *See also* grave monuments
Sarkel, 35
Sarmatians, 18, 26, 68, 127. *See also* Alans;
 Rhoxolani
Sarych, Cape, 200
Sary-Kermen (Chersonesos), 32
Scandinavians (Varangians), 35, 37
sculpture, 53; Greek period, **137**; Roman period,
 152, **153**, 158, **158–160**
Scythians, late, 18, 19, 25–26, 68, 69, 127, 128;
 cultural objects, **24**
seals, Byzantine, 175, 181–182, **181–182**

Seljuk dynasty, coins of, 179
Serapis, 26
settlement, modern, 15
Sevastopol, 5, 47, 50, 189–192, 196; and
 Crimean War, 7–8, **8**, 14–15, 46, 101;
 museums, 191–192; and Preserve, 187–188;
 and World War II, 48, 55
Sevastopol Harbor, **5**, 11
sewage system, 80
sgraffito ware (incised ware), 7, **33**
ships, sunken, 119
Shuldan, 193
Shuriga, V., 135
Sicily, and coins, 175, 176, 178
sigillata wares, trade in, 32
sigillography, 175, 181–182
Silk Road, 43
silk, trade in, 34, 43
Sinope, 17, 25, 93, 175, 176
Site 10, **134**
Site 32, 132
Site 132, 9, 125, 126, **126**, 129
Site 133, 125
Site 138, 128
Site 150, 125
Site 151, **3**, 9, **124**, 124–126, **125**, 127, **127**, 128
Site 153, 125
Site 338, **128**
Site 340, **128**, 129
skene, 77
slaves, 23, 35, 36, 200
"Slavic Pompeii," Chersonesos as, 4, 15
Slavs, 40
soil, 12–13
Soldaia (Sudaq), 39, 43, 194, 195
solea, 105
Soobshcheniya Khersonesskogo muzeya, 57
Sophia, St., cathedral of, 37–38
Soyer, Alexis, 46
Spartokid dynasty, 21, 26
spindle whorls, 36, 87
Srednevekovyy Khersones XII–XIV vv., 56
State Hermitage Museum, St. Petersburg, 6
State Historical Museum, Moscow, 6
stelai, 25, **68**, 69, 95, 141–144, **142–144**, 158,
 160. *See also* grave monuments
stenopoi (narrow streets), 75, 88, 100
steppe, 11, 12, **12**
stoai, defined, 73
Strabo, 11, 21, 22, 199
strategos (military-political magistrate), 25, 71

Sevastopol

I remember Sevastopol:
City of hills
And black waters:
Slur of waves, wind,
Leap and pause of heart blood,
Grass like running feet;
Harbor like a cold hand
Beckoning the homebound.

I remember Sevastopol:
August city,
Stained with siege flame,
Blood-black yet
The lost waters
Dusk-deepened,
Fogged with antiquity,
Iced by moonlight.

I remember Sevastopol:
The sun a huge
Antonoff's apple,
Gold-red, receding
Into the blue-green water
Of the seasons,
Billows breaking on the shore
Like prayer!

—Fania Feldman Kruger
(1893–1977)